19th-Century Art

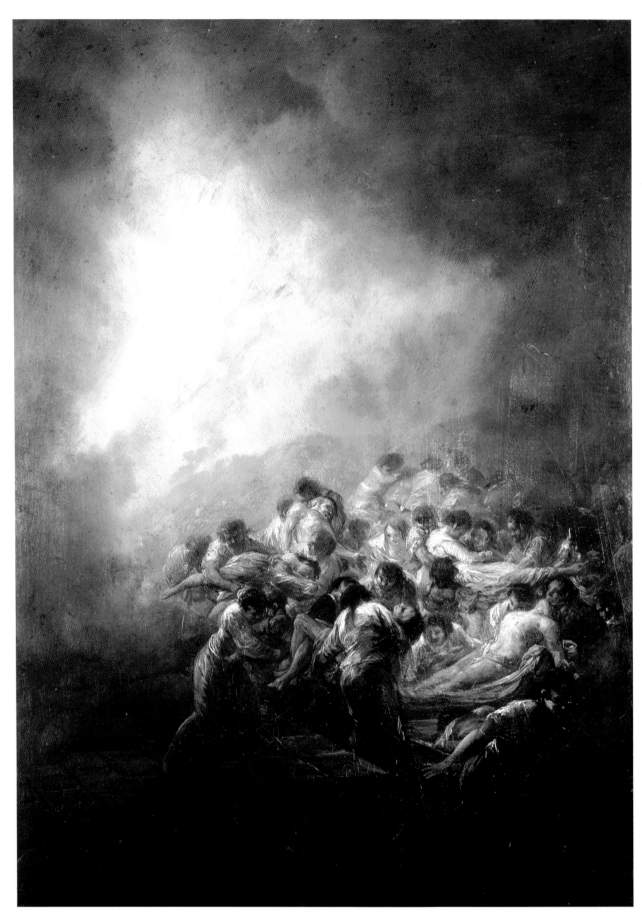

Francisco de Goya y Lucientes, *The Fire*, c. 1793. Oil on tin plate, 19¾ × 12⅝".
Collection José Bárez, San Sebastián.

19th-Century Art
REVISED AND UPDATED EDITION

PAINTING
Robert Rosenblum

SCULPTURE
H. W. Janson

PEARSON
Prentice Hall

Upper Saddle River, N.J. 07458

Library of Congress Cataloging-in-Publication Data

Rosenblum, Robert.
 19th century art / painting, Robert Rosenblum ; sculpture, H.W. Janson.-- Rev.
and updated ed.
 p. cm.
 Includes bibliographical references and index.
 ISBN 0-13-189614-8 (trade) -- ISBN 0-13-189562-1 (pbk.)
 1. Art, Modern--19th century. 1. Title: Nineteenth century art. II. Janson, H. W.
(Horst Woldemar), 1913- III. Title

 N6450.R67 2005
 709'.034--dc22

 2004046660

Editorial Director: Charlyce Jones Owen
Editor-in-Chief: Sarah Touborg
Editorial Assistant: Sasha Anderson
Manufacturing Buyer: Sherry Lewis
Executive Marketing Manager: Sheryl Adams

Credits and acknowledgments borrowed from other sources and reproduced, with
permission, in this textbook appear on pages 530–31.

Pearson Education LTD. Pearson Education, Canada, Ltd
Pearson Education Australia PTY, Limited Pearson Educación de Mexico, S.A. de C.V.
Pearson Education Singapore, Pte. Ltd Pearson Education–Japan
Pearson Education North Asia Ltd Pearson Education Malaysia, Pte. Ltd

This book was designed and produced by
Laurence King Publishing Ltd, London
www.laurenceking.co.uk

Every effort has been made to contact the copyright holders, but should there be
any errors or omissions, Laurence King Publishing Ltd would be pleased to insert
the appropriate acknowledgment in any subsequent printing of this publication.

Editor: Jessica Spencer
Picture Researcher: Peter Kent
Design: Newton Harris Design Partnership

Front cover: Vilhelm Hammershøi, *Interior, or The Corner of a Dining Room*, 1899.
Oil on canvas, 28½ x 26". Tate Britain, London.

Back cover: Sir George Gilbert Scott, Albert Memorial, 1863–72. Hyde Park,
London. Photograph © A.F.Kersting, London.

Frontispiece: Francisco de Goya y Lucientes, *The Fire*, c. 1793. Oil on tin plate,
19 ¼ x 12 ⅜". Collection José Bárez, San Sebastián.

10 9 8 7 6 5 4 3 2 1
ISBN 0-13-189614-8

Contents

Part 2 ◆ 1815–1848

PAINTING

SCULPTURE

Part 3 ◆ 1848–1870

PAINTING

Part 4 ◆ 1870–1900

Dedication

For my wife, Jane, and for
my children, Sophie and Theodore—the 21st century.

R.R.

To my wife–collaborator, Dora Jane, without whose assistance
this book could not have been completed.

H.W.J.

Preface and Acknowledgments

About Nineteenth-Century Art

Two decades have passed since the first publication of this book in 1984; and in that time, our knowledge of nineteenth-century art has made countless quantum leaps. For one, there is the often overwhelming quantity of new information that monographs and exhibition catalogues have brought us, a bounty that is reflected in this new edition's updated bibliography. But there is also the constant changing of viewpoints from which the nineteenth century can be seen. Many issues began to loom large. Feminists made us aware of the hundreds of nineteenth-century women artists who seemed to be buried forever but who deserved resurrection. And feminists also made us look differently at how women fitted into the various social structures implied by the roles they play in nineteenth-century paintings. For a century that witnessed one dehumanizing crisis after another—slavery, factory life, slums, famine, desperate migrations of workers—it also became necessary to come to grips with the ways in which artists confronted or concealed these painful truths. There were, comparably, new questions about the issues of nationalism and imperialism, which required a new reading of the way in which Western artists generated patriotic fervor or confronted the problem of depicting people and cultures remote from their own. And a waning of modernism's inherited hostility to academic art opened yet another huge vista, demanding reconsideration of hundreds of painters who had been thrown into the dustbin of history. Moreover, the welling interest in photography similarly fostered new ways of looking at those nineteenth-century painters whose hyper-realism had once disqualified them from the category of respectable art.

About the Revised and Updated Edition

Revising and republishing a historical survey now twenty years old entailed, among other things, a reconsideration of how old- or new-fashioned the text would be today. The answer, of course, should be left to the readers, young or old; but this author, at least, has his own strong opinions. As for the section on sculpture, written by the late H.W. Janson, this was, in fact, the first survey that approached the subject in a democratic way, rejecting the earlier twentieth-century's exclusive focus on an underpopulated pantheon of great sculptors, from Canova to

Rodin, and exploring a multitude of lesser figures from both sides of the Atlantic and from all parts of Europe. Inherited standards of what was boring, silly, or ugly in nineteenth-century sculpture were swept away in favor of fresh readings of this vast, unstudied body of work. Pointing forward, not backwards, this survey laid many of the foundations of books and exhibitions to come. It now stands as a pioneering work for charting new maps in the ongoing explorations of nineteenth-century sculpture, and this revision benefits from the inclusion of additional illustrations to accompany Janson's original text. Thanks go to Pamela Potter-Hennessey for her advice and suggested changes to the text, which have helped to enhance the links between painting and sculpture in the nineteenth century.

As for the section on painting, in retrospect, this also seems future-oriented, not only in its interpretations but in its selection of works. There are, for instance, far more works by women than had ever before appeared in a comparable survey; and the social roles of women in the nineteenth century, whether as ideal mothers, adulteresses, prostitutes, or mythical temptresses, were emphasized. Grinding poverty, class structures, social reforms were also viewed as essential to understanding the period, much as the rapidly changing image of the ruler, whether king, empress, or president, was seen in its role as mirroring political history. Academic art, vilified by almost all earlier surveys, was for the first time given its due, looked at with an eye to integrating it with the acknowledged masters of modern painting instead of using it as a foil for the avant-garde. And for the first time in an international survey, American painting was treated together with its European counterparts, and an African-American painter made his textbook debut. This reach for less familiar material also extended far beyond the conventional Franco-centric confines. Not only were European artists from countries as far afield as Portugal, Russia, Denmark, and Hungary part of this new United Nations of painters, but even artists from Canada, Mexico, and Australia appeared for the first time in a general history of nineteenth-century art. In short, in 1984 this survey was a path-breaker, pointing to many new directions that have become ever more relevant to the early twenty-first century.

Publishing this revised edition has provided the happy possibility of correcting not only the kind of error that gives authors sleepless nights, but of offering new information about many of the works discussed. Moreover, this updated edition has allowed me not only to add several paintings by artists whose reputations have soared since 1984 (Boilly and Hammershøi), but also many illustrated references to the history of photography, from Nadar to Strindberg, which I hope will clarify both the range and variety of this new medium as well as the ways in which it may now be seen as an essential part of the history of nineteenth-century painting. My greatest wish is that this new edition will continue to offer an open-minded guide to the endless possibilities of seeing and interpreting nineteenth-century art.

For the rejuvenation of this book, I must offer four different kinds of gratitude. One, to Sarah Touborg, of Prentice Hall, who first asked me what I thought about bringing things up to date, and then set the wheels in motion. Two, to Jessica Spencer, of Laurence King, who with endless patience and humor, held my hand throughout the arduous process of reconfiguring text and illustration and checking the new text word by word. Three, to Ariel Plotek, who brought the long bibliography, now

twenty years old, to the state of the art. And four, to Jason Rosenfeld, who, in boxed inserts, contributed an ongoing selection of fresh critical anthologies that mirror the changing historical responses to specific works discussed in the text. Without their contributions, this book could never have been steered ahead into the twenty-first century.

<div align="right">Robert Rosenblum, New York, February 2004</div>

Publisher's Acknowledgments

Thanks are due to the following academic reviewers:

Michelle Facos, Indiana University
Joyce Polistena, Pratt Institute
James H. Rubin, State University of New York, Stony Brook
Gary Wells, Ithaca College

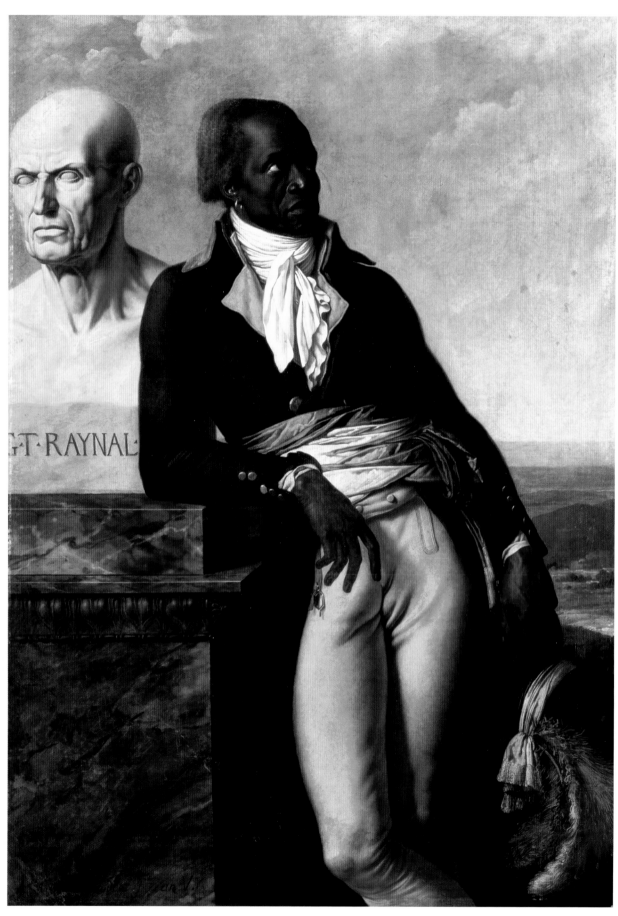

Anne-Louis Girodet-Trioson, *Jean-Baptiste Belley*, 1797. Oil on canvas, 63 × 45″.
Musée National du Château de Versailles.

Part 1

❖

1776–1815

Part 1

❖

1776–1815

PAINTING

Changes in History Painting

In 1776, that landmark year in transatlantic history, an astute visitor to the Royal Academy exhibition in London might well have noticed how frequently new ideas began to appear in, at first, familiar guises. There Sir Joshua Reynolds (1723–92), the president of the Royal Academy and the major force in its foundation in 1768, exhibited a full-length standing portrait not of an English intellectual or nobleman, but rather of a Polynesian named Omai (or in another Anglicized variant, Omiah; **fig. 1**). This handsome young man was a kind of anthropological trophy, brought back from the South Seas by Captain Cook in 1775, on the *Adventure*, and during his year-long visit, he charmed the British aristocracy, including King George III himself. With the witty adaptation of old and new typical of these years of change, Reynolds here re-creates Omai in the guise of the *Apollo Belvedere*, the classical marble that, displayed in the Vatican since the early sixteenth century, had already provided many artists with a touchstone of ideal masculine grace. Reflecting the new idea that man in an unspoiled primitive society, whether Western or exotic, would be both physically and morally finer than man in the late stages of what many thinkers considered to be the terminal decadence of the mid-eighteenth century, Reynolds shows Omai almost literally as a noble savage. The marks of his exoticism are clear—the palm trees in the landscape setting, the hand tattoos, the pointed fingernails, the native turban and robes—but so too is the ease with which he assumes the posture of the Greek statue that then marked the ideal summit of a long-lost classical beauty.

Reynolds's flexibility in accommodating new eighteenth-century experiences to the great traditions of Western art was shared by many of his contemporaries. A landscape painter, William Hodges (1744–97), who had traveled with Cook on the captain's second expedition (1772–75), was faced with a similar problem, for he too had to record

unfamiliar natural facts within the framework of prevailing pictorial traditions. At the same exhibition of 1776, he showed a view of Otaheite Peha Bay in Tahiti (**fig. 2**), in which the orderly landscape conventions of his master, Richard Wilson, in turn inherited from such European seventeenth-century masters as Claude Lorrain, are greatly altered to encompass the fresh observations about exotic

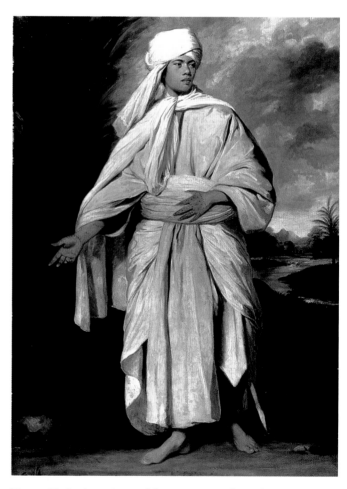

Fig. 1 **Sir Joshua Reynolds**, *Omai*, Royal Academy 1776. Oil on canvas, 93 × 57″. Private collection.

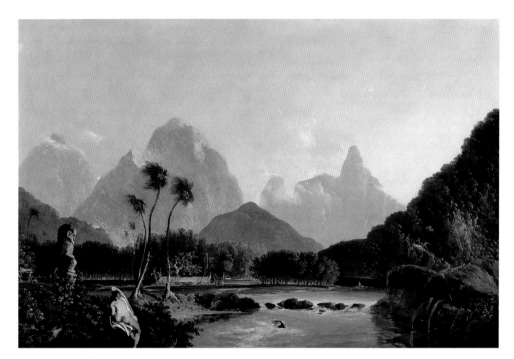

Fig. 2 **William Hodges**, *A View Taken in the Bay of Otaheite Peha*, Royal Academy 1776. Oil on canvas, 35½ × 53½". National Trust, England. Anglesey Abbey, Fairhaven Collection.

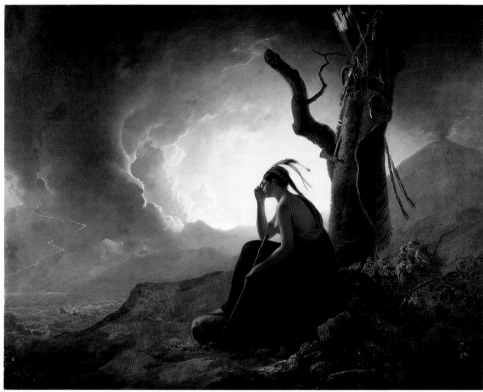

Fig. 3 **Joseph Wright**, *The Indian Widow*, 1783–85. Oil on canvas, 40 × 50". Derby Art Gallery, England.

botany, meteorology, and anthropology that pertained to this newfound Garden of Eden. For at second glance, this Italianate landscape formula reveals tattooed Tahitian bathers instead of classical nymphs, and coconut palms and breadfruit plantations instead of lemon and orange groves. Hodges even documents, at the right, a towering *tiki* monument, an ancestral totem that, like the tombstone in the classical story of shepherds in Arcadia, casts a melancholy spell of mortality over this heaven on earth. Over a century later Gauguin would still be inventing ways to translate the landscapes and myths of a South Pacific Eden into the language of Western culture.

In both cases, Reynolds's Polynesian Apollo and Hodges's tropical paradise, the artist has stretched traditional formulas to accommodate an ever vaster range of encyclopedic knowledge about the world. Such flexibility became more and more the rule, as artists included increasingly unfamiliar subjects and emotions. In 1785, Joseph Wright of Derby (1734–97) exhibited to Londoners *The Indian Widow* (**fig. 3**), a painting that carries the viewer to

a domain no less exotic than the voyages of Cook. Wright has here illustrated one of the many legends that crossed the Atlantic about the uncommon heroism and nobility of the American Indian, in this case recording the stoical tradition that obliged the widow of an Indian chief to sit under her husband's war trophies for an entire day on the occasion of the first full moon after his death. The rigors of this ritual are extravagantly underlined by Wright's imagination, which has dreamed up a repertory of natural terrors that include a swirling storm, illuminated by flashes of lightning over agitated waters, and, at the right, an erupting volcano, the North American equivalent of Vesuvius, whose sound and fury Wright had observed and recorded in the 1770s. Modeled like the most polished classical marble, imperturbable in her melancholy contemplation of the departed warrior and husband, the widow personifies an imaginary ideal of simple, noble virtue and grief that might give the London spectator of 1785 material for moral introspection. And in addition to such edification, Wright's painting, like those by Reynolds and Hodges, provided factual data about strange peoples, funeral rites, and, in this case, Indian costumes and artifacts.

This mixture of unfamiliar facts and ideal fictions, of conventional structures and unconventional narratives, was a frequent sign of change in the 1770s and 1780s, especially in London, where artists and their new popular audiences worked together to break the traditional molds of Western painting. The most spectacular and far-reaching of these pictorial innovations often came from artists of provincial training. Having, as it were, less to lose of the venerable traditions in which sophisticated masters like Reynolds were steeped, they had fewer inhibitions about breaking rules, about substituting the journalistic immediacy of here-and-now experiences for the idealized statement of timeless themes. Wright of Derby himself, a product of the rapidly expanding industrial society of the

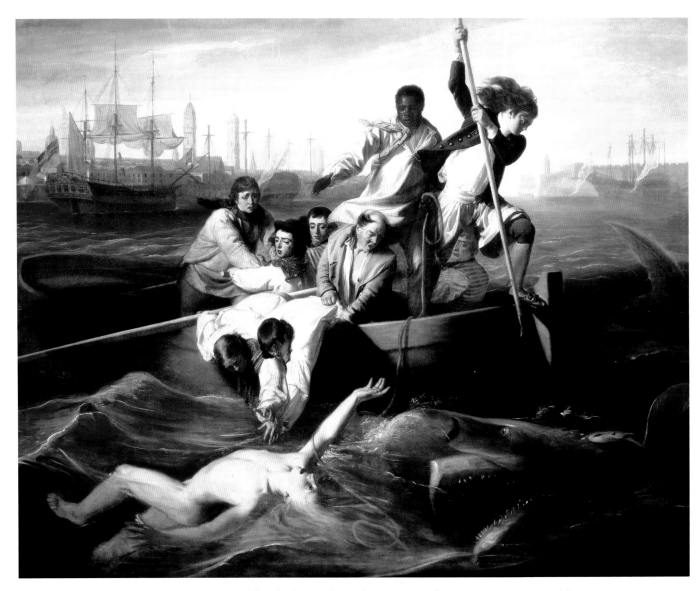

Fig. 4 **John Singleton Copley**, *Watson and the Shark*, Royal Academy 1778. Oil on canvas, 71¾ × 90½".
National Gallery of Art, Washington, D.C.

CROSSING THE ATLANTIC: ANGLO-AMERICAN CONNECTIONS AND THE WOOING OF JOHN SINGLETON COPLEY

How could a talented artist from the east coast of America reach the wider audience he craved? In 1766, more than a decade before he created the historical pyrotechnics that characterize such works as Watson and the Shark *(see fig. 4) and* Death of Major Peirson *(see fig. 6), John Singleton Copley was a sought-after portraitist working in provincial Boston. However, recognizing the limited horizons of the American arts scene, he was sufficiently ambitious to exhibit a picture of his half-brother at the Society of Artists in London. Titled* Boy with a Squirrel (Henry Pelham) *it is now in the Museum of Fine Arts, Boston. Copley wrote tentatively to the man who was to bring the picture, and his aspirations, across the Atlantic, Captain R. G. Bruce of the merchant vessel the* John and Sukey. *"I confess I am under some apprehension of its not being so much esteem'd as I could wish ... ," but he was committed to trying his hand in the center of the English-speaking art world.*[1]

Captain Bruce subsequently conveyed to Copley the opinions of Joshua Reynolds, eminent portraitist and eventual first president of the Royal Academy of Arts (established 1768):

... the sentiments of Mr. Reynolds, will, I suppose, weigh more with You than those of other Criticks. He says of it, "that in any Collection of Painting it will pass for an excellent Picture, but considering the Dissadvantages ... you had laboured under, that *it was a very wonderfull Performance.* ... That it exceeded any Portrait that Mr. West ever drew. ... That he did not know one Painter at home, who had all the Advantages that Europe could give them, that could equal it, and that you are capable of producing such a Piece by the mere Efforts of your own Genius, with the advantages of the Example and Instruction which you could have in Europe, You would be a valuable Acquisition to the Art, and one of the first Painters in the World, provided you could receive these Aids before it was too late in Life, and before your Manner and Taste were corrupted or fixed by working in your little way at Boston." ... He observed a little Hardness in the Drawing, Coldness in the Shades, An over minuteness, all which Example would correct. "But still," he added, "*it is a wonderful Picture* to be sent by a Young Man who was never out of New England, and had only some bad Copies to study."[2]

The endorsement of the American painter Benjamin West, already well established in London, was even more ringing. With it came an offer to oversee Copley's further artistic development, as West made clear to him in an eccentrically spelled letter of August 4, 1766:

On Seeing a Picture painted by you and meeting with Captain Bruce, I take the liberty of writeing to you. ... while it was Excibited to View the Criticizems was, that at first Sight the Picture struck the Eye as being to liney, which was judged to have arose from there being so much neetness in the lines, which indeed as fare as I was Capable of judgeing was some what the Case.[3]

West wrote that Copley's artistic evolution depended on sending further oil paintings to exhibitions in England. He concluded,

As I am from America, and know the little Opertunities is to be had their in they way of Painting, made the inducement the more in writeing to you in this manner, and as you have got to that length in the art that nothing is wanting to Perfect you now but a Sight of what has been done by the great Masters, and if you Could make a viset to Europe for this Porpase for three or four years, you would find yourself then in Possession of what will be highly valuable. if ever you should make a viset to Europe you may depend on my friendship in eny way thats in my Power to Sarve.[4]

On June 10, 1774, Copley left Boston for England, landing at Deal in Kent on July 9. He never again returned to the United States.

British Midlands, worked in a style that insisted upon the hard facts of empirical observation; and this almost photographic literalness of vision, which could even be used to describe remote or imaginative subjects in a way that seemed truthful to the senses of sight and touch, typified the work of several other painters of provincial origins who came to London to seek their fame and fortune.

Of these, the most conspicuous are the two expatriate heroes of American painting, Benjamin West (1738–1820) and John Singleton Copley (1738–1815), exact contemporaries whose enormous ambitions could be fulfilled only in London. It is telling that, as early as 1765, Copley had sent a portrait from his native Boston to London for exhibition, and that it was there mistaken for a work by Wright of Derby. Leaving behind him a career as colonial America's finest portraitist, Copley settled in London in 1775. And there, just as his native country changed startlingly from colony to nation, from provincial to international status, his art suddenly demanded and deserved full-scale attention. Like Wright of Derby, Copley quickly learned to make a fresh fusion of prose fact and poetic imagination, a mixture certain to appeal to a growing audience which sought out new adventures that, like the pages of a novel, could transport them to unfamiliar places.

Few adventures were as breathtaking as the one Copley depicted in *Watson and the Shark* (fig. 4). Although it was

exhibited at the Royal Academy in 1778, it had, on the face of it, little to do with the hallowed world of high art that Reynolds had hoped to encourage within the academy's precincts. It was commissioned by a rich London merchant, Brook Watson, not to restate yet again one of the noble themes from the Bible or from Greco-Roman history or legend, but rather to commemorate a unique, cliff-hanging moment in his own life. Swimming in Havana harbor in 1749, when he was fourteen, Watson was attacked by a shark. In two assaults, the monster stripped the flesh off his right leg and bit off the foot but, on returning a third time, was diverted by a rescue boat. If it was extraordinary that the peg-legged Watson would wish to document pictorially this harrowing biographical moment, it was even more so that he found an artist, Copley, who could do it so successfully. With a journalist's sense of fact-finding, Copley, like many other artists of the late eighteenth century, tried to reconstruct accurately the precise event, including such particularities as the fortifications and tower of Morro Castle on the right. Moreover, the glassy, almost photographic truth of his style, with its palpable distinctions of linen, wood, flesh, hair, and tooth, contributes to the painting's irrefutable documentary reality, which was further confirmed by the catalogue entry's reference to the incident as "a fact which happened." The instant impact of the painting, with this close-up, split-second horror of an unresolved conflict of helpless man versus horrendous beast, is the stuff of yellow journalism. On other levels, however, Copley's story is saturated with references to more lofty themes that give it an unexpected aura of academic respectability. Thus, the compositional patterns depend, in general, upon the traditional illustrations of the Miraculous Draught of Fishes, as well known in Raphael's and Rubens's interpretations; and the narrative horror, at first so shockingly reportorial, begins to transcend literal truth and to approach a whole range of other jaws-of-death biblical themes, from Jonah and the Whale or St. Michael and the Dragon to the saved-or-damned terror of the Last Judgment itself. Like many other artists of his era, Copley introduced new subjects of fresh appeal to large popular audiences, yet at the same time brilliantly elevated these ignoble themes to unexpected heights by providing rich allusions to those traditional subjects and compositions which the academies strove to perpetuate in purer form. Moreover, the imagery of a limbless youth may even have echoed contemporary political cartoons that allegorized Britain's loss of the American colonies.

Copley's rearrangements of the conventions of history painting were closely paralleled by those of his compatriot Benjamin West, who had settled in London before him, in 1763, and had already, in 1771, exhibited at the Royal Academy the epoch-making *Death of General Wolfe*, which skillfully blended the immediate demands of journalistic fact (the tragic loss of a young British hero in the battle of Quebec, 1759) and the more timeless, ideal demands of a noble art for the academy (a solemn narrative and compositional structure redolent of classical and Christian lamentations for a hero-martyr). Although West, far more than Copley, explored the widest possible range of biblical, classical, and literary subject matter, he was equally attuned to the grand-scale commemoration of modern, newsworthy events. It is hardly surprising then that both he and Copley turned their pictorial attention to a dramatic moment that had shocked all of London. On April 7, 1778, in the House of Lords, the Earl of Chatham, better known as William Pitt the Elder, was giving an impassioned speech in favor of continuing, rather than severing, ties with the new American nation, when he suddenly fell in a faint, suffering a stroke from which he was to die a month later. In a small sketch that came to light again only in the 1970s, West reconstructed this tragic scene, which had so many ramifications for the tense problems of Anglo-American relations (**fig. 5**). To ennoble what, in fact, must have been the chaos of the moment, and to lend major and minor accents to what might otherwise have been an enormous and incoherent group portrait, West restaged the episode in a theatrical tableau of old-master dignity. Beginning with the two figures who solemnly watch the event from above, and continuing with the fainting figure of the gouty Earl of Chatham himself, who sinks upon his crutch while his fellow peers lean over to help him, the entire grouping becomes almost a secular translation of a more traditional image of tragic descent, that of Christ from the Cross. Like the dramas of Wolfe or Watson, that of the Earl of Chatham was seen through eyes familiar with biblical imagery.

Although West never made a large public version of this study, Copley, in effect, did it for him, offering his own, more famous interpretation of the event and employing the same pictorial formula. Indeed, with a shrewdness that testified to his keen awareness of the changing conditions that existed between artist and public, and of the demand for an art that was thoroughly modern, Copley arranged in 1781 to show his own version of *Chatham* not at the Royal Academy, which was having its annual exhibition at the same time, but privately, as a commercial enterprise, in a rented London gallery. His competition with authority was successful: some twenty thousand Londoners paid to see his painting during a ten-week period. The very fact of his organizing a private exhibition in virtual competition with the establishment was a significant one in the social history of art, and one which would have many successors, from Blake and Courbet to the countless secessionist groups of the twentieth century.

Paralleling the role of a theater director who produced a higher class of popular entertainment, Copley continued to display his wares in the most public and commercial way. In 1784, he not only re-exhibited his *Chatham*, but with it a new work that presented another journalistic illusion of

on-the-spot drama, the *Death of Major Peirson* (**fig. 6**). Like West before him in the *Death of Wolfe*, Copley essayed here the topical and popular subject of young national heroes felled in battle. In this case, the scene takes place at St. Helier, on the island of Jersey, depicted like a theatrical backdrop in a sharply rendered architectural setting. In the middle of the city street, we see the hair-raising but noble facts of a patriotic death and its revenge. For on January 5–6, 1781, the twenty-four-year-old Francis Peirson had courageously led a counterattack on invading French troops, only to be shot by the enemy at the very moment of his victory. In turn, Peirson's black servant avenged his master's death by firing on the enemy. These simultaneous dramas are all condensed in a flamboyant spectacle of national pride and grief, recorded with such stage-lit clarity and meticulous detail that, for a modern audience, the painting resembles a frame from a carefully directed wide-screen movie. Again, the instant sense of documentary fact

is elevated by a more traditional pictorial and dramatic rhetoric. The almost balletic fall of the young Peirson into the arms of his fellow officers is as elegant and noble as the scene of Achilles mourning the dead Patroclus in the new wave of Homeric illustrations that began in the 1760s; and the graceful rush of women and children off-stage to the right (modeled for by members of Copley's own family) similarly smacks of Renaissance and classical groupings. Even more, the painting coalesces in a realm of uncommon patriotism, with a wounded soldier at the lower left saluting, with perhaps his last gasp, his glorious commander, and a crowning flurry of red, white, and blue British flags, triumphantly waving against clouds of gunpowder above, and resonantly echoing, coloristically, in the costumes of the soldiers and civilians below. The horrors of war, the unavoidably ugly facts known to all, are here translated into a high-minded drama that might almost bring the Trojan War up to date.

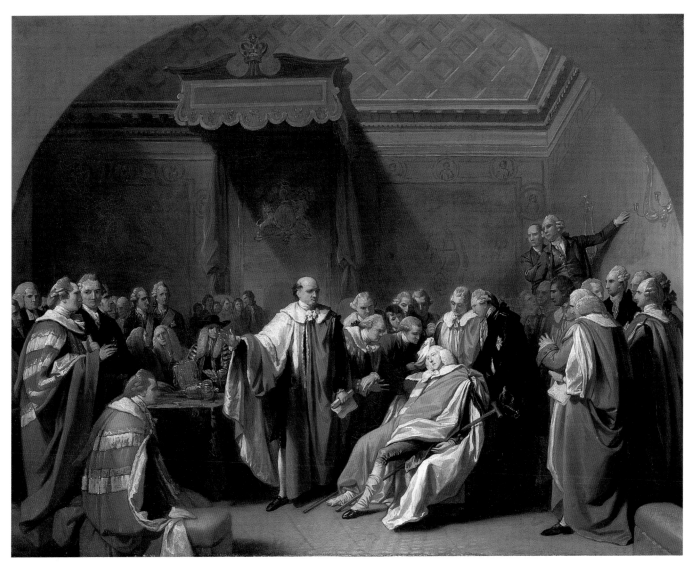

Fig. 5 **Benjamin West**, *The Death of the Earl of Chatham*, c. 1778. Oil on canvas, 28 × 35¾". Kimbell Art Museum, Fort Worth, Texas.

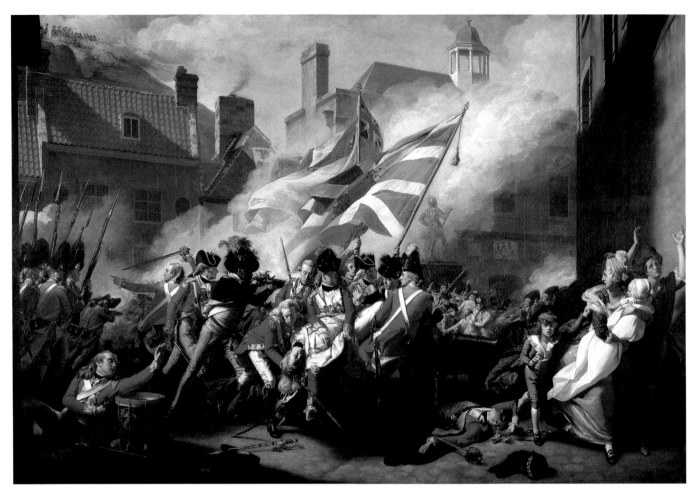

Fig. 6 **John Singleton Copley**, *Death of Major Peirson*, 1782–84. Oil on canvas, 8′ 3″ × 12′. Tate Britain, London.

It was predictable that this kind of painting of contemporary heroism would quickly be used to celebrate the military birth pangs of the newest republic, the United States of America. For in 1784, while studying with West in London, the young American artist John Trumbull (1756–1843) began, with Thomas Jefferson's encouragement, a series of twelve paintings that would unfold for posterity the most epoch-making events of the American Revolution. In one of the first, *The Death of General Warren*, of 1786 (**fig. 7**), Trumbull records, in a small format and with a more heated brushstroke than Copley's or West's, the last moments of Warren, wounded by the British at Bunker's Hill, as his tattered aides, with rifle and bare hand, attempt to fend off the bayonet of the British enemy. The formula of pathetic, Christ-like martyrdom and a thrilling surge of flags, clouds, and armed men is once again a plausible means of raising the bloody facts of war to an ideal domain of justifiable human sacrifice for a loftier cause. Such paintings, predating the French Revolution, also prefigure the epic canvases that in Napoleonic France, in particular, would provide the proper mixture of authentically grim fact and nationalistic fiction that could persuade spectators at home that the means of war and the rhetoric

of painting were compatible, and that patriotic goals could compensate for the particular truths of individual lives lost in battle.

It was not only the edifying reconstruction of contemporary history that occupied artists and spectators in the Anglo-American world as well as on the Continent. In fact, by the 1770s, almost any moment in history was susceptible to pictorial illustration, providing as it were a visual counterpart to the widening range of historical knowledge that was constantly consulted for examples of high-minded behavior. Benjamin West himself was probably the most prolific illustrator of countless scenes culled from past and present: between 1771 and 1773, for instance, he exhibited paintings of not only the death of General James Wolfe (1759 A.D.), but shortly after this, of the deaths of the Theban general Epaminondas (362 B.C.) and of the noble French knight Bayard (1524 A.D.).

By the 1780s, West could use this historical mobility, comparable to the skills of a novelist evoking with accurate and colorful detail the milieu of a distant epoch, to fulfill a royal commission for the state rooms at Windsor Castle, a series of eight glorious moments from the half-century reign of Edward III (1327–77). In a study for one of these, he

dramatizes the moving story of the burghers of Calais (told first in Froissart's fourteenth-century *Chronicles*) (fig. 8), the six local heroes who presented themselves to Edward III as the hostages the English had demanded for execution before they would stop hostilities. But the king and especially his queen, Philippa, were so moved by this offer of self-sacrifice that they spared not only the burghers, but their city, Calais. Again, West presents the episode as a theatrical tableau, with a backdrop and costumes meant to conjure up a late medieval world; and again, the demeanor of the figures is idealized, with a lucid confrontation between the French prisoners and the English court, and with such rhythmic pairings as Philippa's and Edward's rhetorical gestures of intercession and pardon. The grave, relief-like disposition of the figures recalls, in fact, the statuary style of many of West's earlier illustrations to Greco-Roman history; the pictorial formula is altered here only by a change of setting and costume. West's production of this potentially tragic, heart-rending scene may appear pedestrian by comparison with Rodin's world-famous Calais monument of a century later (see fig. 488), but his precocious use of a noble legend from medieval history at least suggests how important the late eighteenth century was in

establishing a wide repertory of subjects for later generations to explore.

Historical legends of virtuous behavior were common pictorial coin by the 1780s, and could shift easily from the public field of battle to the private domain of domestic life. In a period that so seriously reconsidered both the theoretical and the practical aspects of child rearing, whether in the writings of Rousseau and Pestalozzi or in the correspondingly new attitudes toward the importance of personal maternal care (as opposed to boarding schools and callous wetnurses), it was predictable that many paintings would sing the praises of motherhood, whether in peasant families, in classical lore, or even in the cases of famous contemporaries. A particular favorite was the Roman story of the virtuous mother Cornelia, who, when another Roman noblewoman visited her and asked to see her jewels, pointed to her own three children—Tiberius, Gaius, and Sempronia—and explained, "These are my most precious jewels." Among the many artists attracted to this edifying tale was the Swiss-born Angelica Kauffmann (1741–1807), one of the founding members of the Royal Academy in London and one of the most internationally successful artists of her time. As a woman artist, Kauffmann seems to

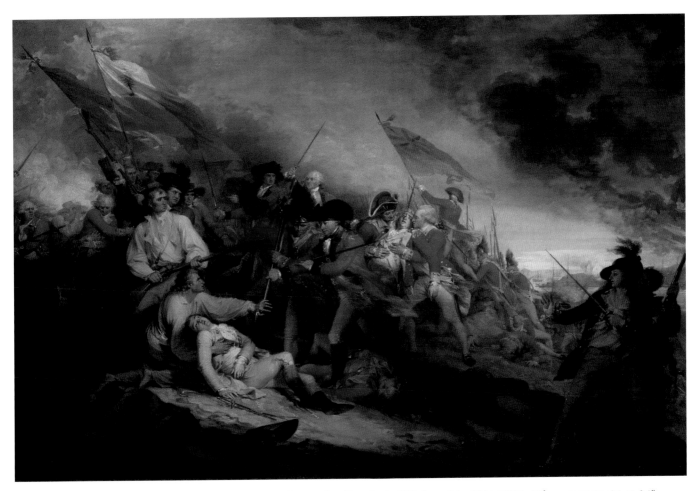

Fig. 7 **John Trumbull**, *Death of General Warren at the Battle of Bunker's Hill, June 17, 1775*, 1786. Oil on canvas, 24 × 34". Yale University Art Gallery, New Haven.

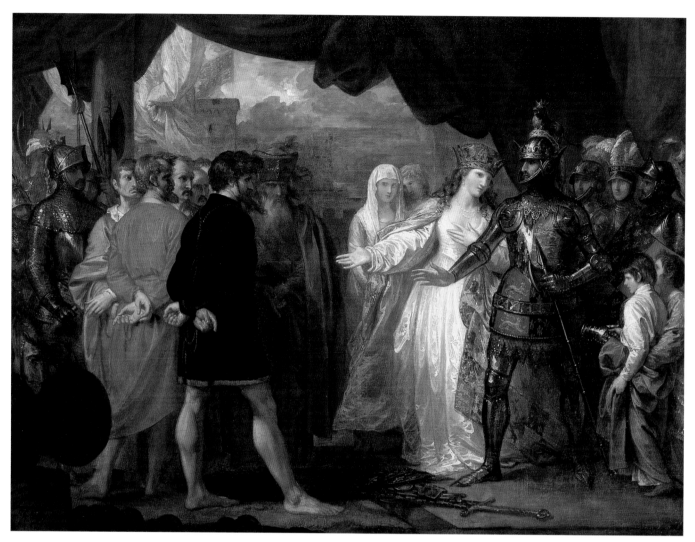

Fig. 8 **Benjamin West**, *Queen Philippa Interceding for the Burghers of Calais*, 1788. Oil on canvas, 39½ × 52¼″. Detroit Institute of Arts.

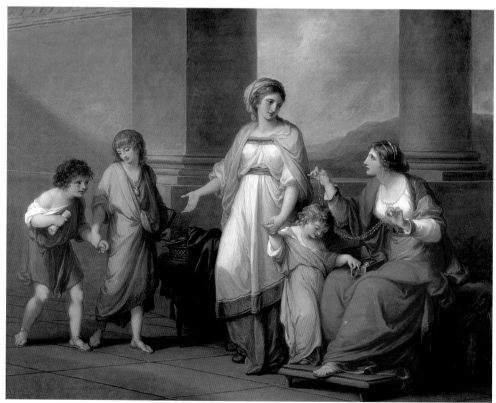

Fig. 9 **Angelica Kauffmann**, *Cornelia, Mother of the Gracchi*, 1785. Oil on canvas, 40 × 50″. The Virginia Museum of Fine Arts, Richmond.

have found most appropriate the veneration of the heroines rather than the heroes of classical and medieval history and legend; and Cornelia's star was so high in her female pantheon that she made multiple versions of the theme for patrons in England, Naples, and Poland. In an early version (**fig. 9**), painted for her loyal patron George Bowles in 1785 and exhibited at the Royal Academy in the following year, the domestic drama unfolds with the lucid, theatrical rhetoric typical of the period. Against a Roman architectural setting, whose undecorated severity of cubic pier and cylindrical column conforms to the purist stripping of forms in many buildings and unexecuted projects of the 1780s, the women and children enact their tale. The austere Cornelia, standing beside her sewing basket, is a kind of female Hercules-figure who has chosen between the virtues of family duty and the vices of feminine luxury represented by the seated visitor, who displays a necklace and, in her lap, a box of jewels that momentarily distracts the daughter. The moral message is as clear as the simplified figures and narrative, although an aura of sweetness and grace immediately distinguishes Kauffmann's vision of Roman antiquity from that of her great French contemporary Jacques-Louis David.

France

Here in classical guise, the ideal rendering of noble and happy motherhood reflected a ubiquitous theme in the late eighteenth century that even penetrated to the official image of the Queen of France herself. Thus, at the Salon of 1787, Parisians could see a remarkable interpretation of Marie-Antoinette by the wealthy and cosmopolitan Mme. Élisabeth Vigée-Lebrun (1755–1842). Instead of the traditional royal portrait that presented the monarch as a remote glory, the queen is shown at home in Versailles— the Galerie des Glaces is just visible at the left—together with her three rewards of maternity (**fig. 10**). With a loving gaze upward, Marie-Thérèse Charlotte (later to be the Duchess of Angoulême) tenderly holds her mother's arm, while the two-year-old Duke of Normandy (later to be the pathetic Louis XVII) squirms like a real baby on her lap. At the right, the dauphin, who was to die just before the outbreak of the Revolution, raises the drapery of his infant sister's crib, which is so closely integrated into this at once dignified and informal composition that it seems a member of the family unit. Like the self-portraits of Vigée-Lebrun with her own loving daughter, this is almost a secular translation of the ideal harmonies found in a Renaissance Holy Family, but one whose propagandistic message was becoming suspect. In fact, the painting, which was meant to emanate an aura of loving maternity that could help bridge the widening gulf between Versailles and the taxpaying spectators in Paris, was quickly nicknamed

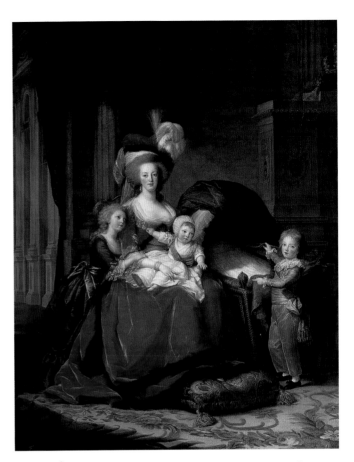

Fig. 10 **Élisabeth Vigée-Lebrun**, *Marie-Antoinette and Her Children*, Salon of 1787. Oil on canvas, 8′ 8″ × 6′ 10″. Musée National du Château de Versailles.

"Mme. Deficit." And with even grimmer irony Vigée-Lebrun's gentle icon of royal motherhood was hung at the Paris Salon only one picture away from David's *Death of Socrates*, a scene of high-minded sacrifice to the state painted by an artist who, just six years later, would not only vote for the death of Marie-Antoinette but, with chilling indifference, would draw her on her way to the guillotine.

In France, as in England, the tempo of pictorial change seemed to accelerate swiftly in the years before 1789, with a comparable growth in the repertory of styles and subjects as well as in the ennobling of the more crowd-pleasing themes that would earlier have been considered too lowly for the highest domain of art. The work of Jean-Baptiste Greuze (1725–1805) is a perfect Geiger counter of the many rumblings of innovation in these years: as in his *Father's Curse* (or *The Ungrateful Son*) of 1777 (**fig. 11**). The scene is one of passionate domestic drama, played out in the shallow theatrical space familiar to British painting of these years. Amid the desperate entreaties of the family's women and children, a father curses his son, who, in turn, gesticulates in rage and turns toward the door where a recruiting officer, with a promise of money, waits to transfer him from the family hearth to the army.

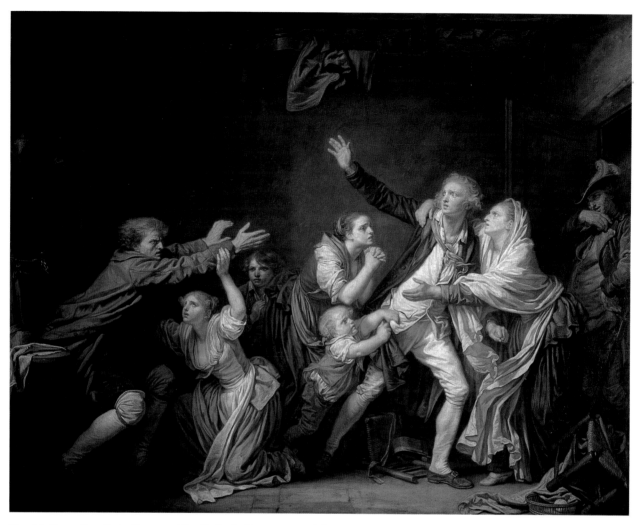

Fig. 11 **Jean-Baptiste Greuze**, *The Father's Curse*, 1777. Oil on canvas, 52 × 64¾". Louvre, Paris.

Before the generation of Greuze and his most ardent supporter, Denis Diderot (who, in his vivid and supple art criticism of the Paris Salons, began to sing Greuze's praises in the 1760s), such a family skirmish in a simple rural home would have been deemed worthy only of the attention of painters who wished to smile at the rowdy behavior of country bumpkins. Here, however, the theme has been elevated to a moral solemnity and grandeur that smack of a biblical sermon, such as the story of the Prodigal Son. (In the pendant to the painting, Greuze represents the son's remorseful return home to find his father on his deathbed.) As in Copley's *Watson and the Shark* (see fig. 4), what might be a trivial theme has been rephrased in a language filled with noble narrative and artistic associations. In the case of Greuze's drama, the pictorial structure evokes, in its ideal disposition of rhetorical poses and expression, the abstract language of the French Academy, applicable in principle only to venerable historical subjects; and the particular postures recall the kind of classical marbles—from the Niobid group to the Borghese warrior—that were freshly studied and assimilated by many of Greuze's contemporaries who wished to evoke the look and feel of the Greco-Roman world. And of course, Greuze's message—the miseries wrought by disruption of the family unit—neatly filled Diderot's didactic prescription that the purpose of painting was to make virtue look attractive and vice repellent. Greuze's mixture of a new, more popular kind of subject with an old kind of drama and style was, almost predictably, offensive to the Paris art establishment, which refused in 1769 to recognize his credentials as a history painter when he submitted a Roman theme that was judged to be tainted by a puny here-and-now style more appropriate to genre painting. The ensuing rift meant that, thereafter, Greuze would work in competition with the academy and its official biennial Salon and would exhibit his work privately in his own studio at the Louvre, where visitors as distinguished as Benjamin Franklin or Marie-Antoinette's brother, Emperor Joseph II, would come to see his latest paintings. The growing friction between officialdom and an artist with ideas geared to a larger audience was as apparent here as in the case of Copley's private exhibitions in London in the 1780s.

The visitor who moved from Greuze's studio in 1777 to the Salon Carré at the Louvre, where the official Salon itself

was held, could see that year the kind of picture supported by an academic authority which, under Louis XVI's artistic director, the Count of Angiviller, propagated themes as uplifting as Greuze's, but instead of culling them from the dreary lives of anonymous members of the Third Estate, took them rather from the lives of the noblest men and women of antiquity, the Middle Ages, or more recent French national history. A typical and prominent painting at the 1777 Salon by Louis Lagrenée the Elder (1725–1805) illustrated an edifying example of stoical Roman behavior in the early days of the republic. The consul Fabricius Luscinus, famous for his moralizing rejection of any worldly possessions, is here seen refusing the luxurious gifts of Pyrrhus—money, golden vases, statues—preferring, instead, to remain steadfast with his large family in his simple country home, whose rude post-and-lintel architecture nestled into a natural growth is symbolically contrasted with the glimpse of an ornate triumphal arch on the right (fig. 12). Like its didactic message, the stagelike rhetoric of this classic story of a male Cornelia is akin to Greuze's pictorial dramas; harsh oppositions of yes-and-no

gestures, sharp distinctions of major and minor players spell out the conflict in no uncertain terms. But ironically, Greuze's figures, despite their ignoble milieu, are more heroic and passionate in their clashes of will and body than are Lagrenée's somewhat mincing and diminutive characters, who seem more attuned to the artificial gestures and stances of eighteenth-century opera than to the more full-blooded conflicts of the new middle-class drama. Moreover, despite Lagrenée's efforts to re-create a Roman milieu for a Roman narrative, it is Greuze who offers far more specific borrowings from classical statuary, extracting from Hellenistic models a sense of lucid, heroic action and pathos that is then distilled into what might be called the Platonic ideal of the dramatic situation at hand.

Lagrenée's combination of a moralizing subject with a would-be accuracy of setting and costume can be found as well in medieval scenes presented at the same Salon. Louis Durameau (1733–96), in his *Continence of Bayard* (fig. 13), illustrates a noble, but unbloody page from the life of the exemplary French medieval knight, whose dying moments, in 1524, had already been shown to Londoners

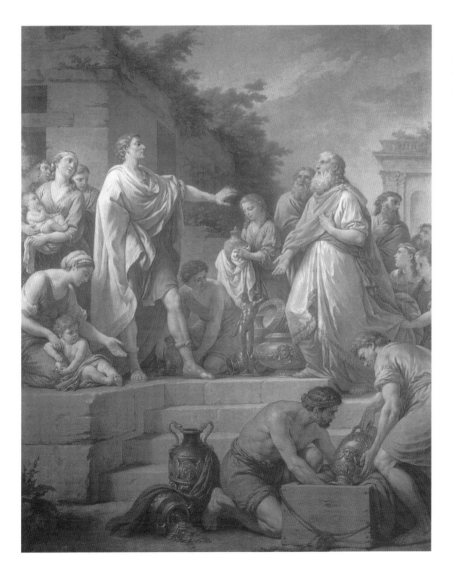

Fig. 12 **Louis-Jean-François Lagrenée**, *Fabricius Luscinus Refusing the Gifts of Pyrrhus*, Salon of 1777. Oil on canvas, 10′ 7″ × 8′. Musée René-Princeteau, Libourne.

Fig. 13 **Louis Durameau**, *The Continence of Bayard*, Salon of 1777. Oil on canvas, 10′ 9¼″ × 7′ 6¾″. Musée de Peinture et de Sculpture, Grenoble.

in West's painting of 1773. Here, the story concerns the Chevalier Bayard's exceptional virtue and kindness. One night, his valet had brought for the Chevalier's pleasure a beautiful young lady; but on seeing her tears, Bayard learned that although she was in financial straits dire enough to sell herself, she was in fact a lady of honor and high birth. In response, he gave her separate sleeping quarters and then offered her mother enough money for a dowry and trousseau that would ensure a proper marriage for her daughter. This last scene, whose sentimental mixture of uncommon chastity and charity is almost Victorian in its resolution, is played out in a "period reconstruction" typical of the late eighteenth century. The costumes are those used on the French stage for the many new dramas set in the Middle Ages; and the setting, with its beams, tapestries, and paneling of pointed arches, provides a late Gothic interior whose attenuated laciness parallels the neo-Gothic designs of many late eighteenth-century architcts. Again, as in Lagrenée's scene of Roman virtue, the postures and gestures have a minuet-like sweetness and grace that recall the pleasurable world of the reign of Louis XV.

Jacques-Louis David

It took a genius to make great art from the various new interpretations of history, drama, and morality so apparent in the 1770s and 1780s. His name was Jacques-Louis David, and his life-span, 1748–1825, crossed and reflected every major change in French art and politics from the reigns of Louis XV and XVI through the Revolution, Napoleon, and finally, the Bourbon Restoration. The perfect example of what the French call an "artiste engagé," that is, a committed artist, David came to believe, even before the Revolution, that the power of his work could serve human needs far more important than those of aesthetic delectation alone; and, after 1789, he painted primarily to propagate first Republican and then Napoleonic faith. His beginnings were slow, and his early choices hesitant. In 1777, the year of those paintings by Greuze, Lagrenée, and Durameau discussed above, he was still a student in Rome, in the middle of a five-year sojourn (1775–80) under the aegis of the French Academy. There, he labored not only on the absorption of the lessons of Greco-Roman art and the old masters of Italian painting, from Raphael through Caravaggio, but on what he planned to be an enormous painting on the kind of Homeric subject, *The Funeral of Patroclus*, that, from the mid-eighteenth century on, became a touchstone of seriousness to which only the most ambitious artists could aspire. In 1779, David finally completed a large painted sketch of this lugubrious scene from the *Iliad*, and deemed the result worthy of sending home to Paris for academic judgment (fig. 14). A fascinating reflection of many crosscurrents in the late 1770s, David's painting looks in all directions. At first glance, the tripartite composition seems confused and crowded: in the center, Achilles mourning Patroclus before the wooden funeral pyre; at the left, the killing of twelve Trojan princes to add to the sacrifice; and at the right, not only another sacrificial procession of animals, but the attaching of Hector's corpse to a chariot that will drag it around the walls of Troy. The fluttering light and agitated brushstrokes almost belong to the Rococo world of a Boucher or a Fragonard. But underneath this restless surface of rolling clouds, picturesque silhouettes, and animated figures, there is a sense of solemn, epic drama that constantly counters the initial impression of flickering pageantry. The grave rhythms of sacrificial processions, the full-blooded energies of the chariot-bearing horses, the gloomy sky—such passages are straws in the winds of David's mature style.

That style was swiftly to crystallize in time for David's first opportunity to show his work to the Paris public, at the Salon of 1781. He included among his dozen entries the two-year-old *Funeral of Patroclus*, but must have realized that relative to his latest work, this was hopelessly old-fashioned. (In 1782, in fact, instead of executing, as planned, a

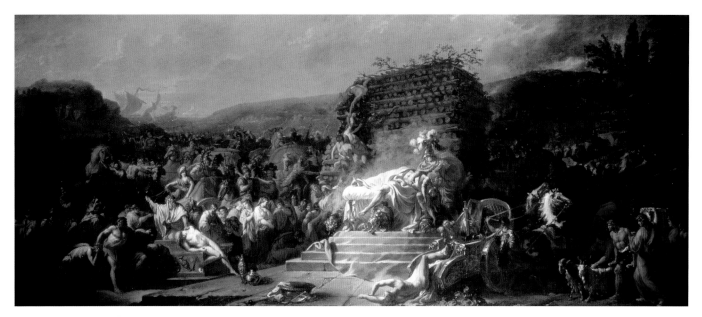

Fig. 14 **Jacques-Louis David**, *The Funeral of Patroclus*, 1779 (Salon of 1781). Oil on canvas, 37½ × 87¼". The National Gallery of Ireland, Dublin.

larger version of this already sizable painted sketch, he used it as a tabletop for lunch and then quickly sold it.) Of the more recent paintings exhibited, it was the newest, the *Belisarius* of 1781 (**fig. 15**), that proved the most startling and prophetic; for here, suddenly, all of the diffuse energies of the 1770s joined forces in a work whose rock-bottom clarity of form and narrative structure inaugurates the high-minded vision of a new and great artist. At the last Salon he reviewed, Diderot was lucky to see what was virtually the youthful answer to his long-standing prayers for a noble, edifying art, and he quickly proclaimed David's genius.

The legend of Belisarius was noble and lachrymose. He had been a victorious general under Justinian, but was then falsely accused of treason, banished, and, according to even more extreme accounts, blinded. In his pathetic later life, when he wandered about as a beggar, he was one day recognized by a former soldier. It was this moment that David chose to paint. The legend was especially popular in the late eighteenth century, not only because of its dramatic ingredient of grim misfortune, but because it offered a historical counterpart to the contemporary scandal of a French general, the Count of Lally, who, after mismanaging a French expedition in India, was wrongly convicted of treason and executed in 1766, but then officially exonerated in 1781, the year of David's painting. It was the kind of parallel between contemporary events and distant history that David's art would evoke more and more as the Revolution approached.

David's distilled account of a Byzantine ruler's injustice seems to take place in the kind of Roman milieu already envisioned by the masters of seventeenth-century French classicizing painting and drama. With the genius of a stage director who can extract maximum narrative and pathos

from minimal means, David has here told an intricate story with a cast of only four. In ironic distinction to the heart-rending group of a woman giving alms to a blind old beggar and his child companion, the soldier at the left suddenly recognizes this former hero from another world of armies and battles. The solemn motif of tensely raised and out-stretched arms and hands is orchestrated for multiple meanings (surprise, charity, desperate need), just as the four figures offer a rich spectrum of human types and ages. All of this drama is measured in lucid shapes and rhythms that, as in Poussin, permeate every last detail. The rectilinear masonry of the ground plane, the cylindrical columns, even the beggar's diagonal stick resting on the cubic block at the right (with its noble Latin inscription—DATE OBOLUM BELISARIO, "Give a coin to Belisarius")—all these purified planar and solid geometries define an ideal realm of perfect volumes and intervals. Within this immutable environment, the figures are no less concise in their interplay of gesture and emotions, transforming what might be simply a sentimental drama by a follower of Greuze into tragic theater worthy of Corneille or Racine.

David's power to re-create a complex story as a timeless emblem, at once frozen and passionate, reached its height in the *Oath of the Horatii* (**fig. 16**), a work that might well qualify as a point of no return in the history of painting, and that, like a visual manifesto, seemed to propose a totally new order. Recognizing that he wanted to create an epochal masterpiece, David actually returned to Rome in 1784 to reimmerse himself in an antique milieu appropriate to the Roman legend he was to illustrate. When the painting made its private debut in David's Rome studio in that year, all the connoisseurs who came to see it knew that something momentous had happened; and when in the

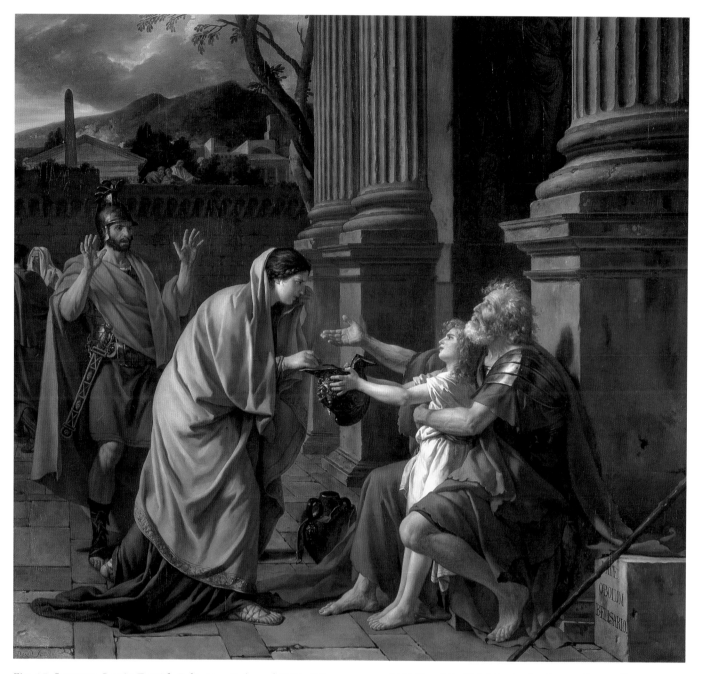

Fig. 15 **Jacques-Louis David**, *Belisarius*, Salon of 1781. Oil on canvas, 9′ 7¼″ × 10′ 4¾″. Musée des Beaux-Arts, Lille.

following year, 1785, the *Horatii* was seen at the Salon, all of Paris was electrified by this pictorial call to arms.

It is a tribute to David's genius that, even without knowing the convoluted narrative of the Horatii legend, the modern spectator can instantly grasp the two-part theme: among the men, a patriotic emblem of swords and oath taking; among the women, a wave of grief and abandonment. The family collisions of a work like Greuze's *Father's Curse* (see fig. 11) have now resulted in an absolute rift between male and female worlds: a virile strength that leads from the home to the battlefield, and a feminine passivity that remains sorrowfully within the domestic confines of mothers and children. In a perfect stage space that revives the rational clarity of Renaissance one-point

perspective systems, we see first the noble father, Horatius, who will hand over swords to his triplet sons after they take their oath to fight for their country against the enemy Curiatii (who, with mythical coincidence, are also triplet brothers). United by this patriotic cause, the group of four men presents a military discipline of mind, soul, and body. Their wills are as controlled as their tautly outstretched limbs; together, the quartet becomes a tense fusion of clashing metal and muscle, a heraldic pattern of crisscrossing arms, weapons, forked legs. By contrast, the group of women is united in slow, descending rhythms that flow in rounded patterns through flesh and drapery. Even without knowing the rest of the complex story—that the sister, Camilla (far right), is betrothed to one of the Curiatii who will be killed

in battle by her own brother who, in turn, will slay her for mourning one of the enemy and then be exonerated by his father for this patriotic crime—we sense in the women the tragic events to come, though their grief is overshadowed by the men's energetic rally of allegiance to the state.

For all its utopian newness and clarity, the *Horatii* is hardly the first painting of its time to express the concerted moral force of a group of Roman men who swear their fidelity to a higher cause. Already in the 1760s, the Scottish artist Gavin Hamilton (1723–98) had painted comparable themes that were disseminated throughout Europe in engravings. His *Oath of Brutus* (**fig. 17**), in fact, with its polarity beween a vengeful group of Roman oath takers and an expiring Lucretia (who has taken her own life after the dishonor of having been raped by Tarquinius), is probably the pictorial nugget of David's own choice of theme and legend. But, as in David's other recastings of earlier classicizing images by Hamilton and his French contemporaries, the debt to his sources is more than repaid. Hamilton's

tentative steps in the direction of a classical nobility of style and subject take on, in David, a passionate authority. The somewhat flaccid anatomies and smoothly generalized surfaces of the earlier work are replaced, in the *Horatii*, by a masterful, almost Caravaggesque, realism of light and texture that sharply records and differentiates the palpable facts of hair, flesh, muscle, metal, drapery; and the circuitous, swaying movements of Hamilton's figure groups are changed into postures of heraldic clarity and permanence. It has also been convincingly suggested that David was inspired by a group of six antique warriors he saw at the Palazzo Farnese in Rome, a work now usually identified as the Tyrannicides but that was thought in the 1780s to represent the very theme of David's painting, the opposition between the Horatii and the Curiatii. This image of the stark confrontation between two pairs of triplets was rendered in a taut, geometric style whose archaic flavor perfectly suited David's goals of severe simplification. Similarly, even the architecture in this Roman atrium seems stripped to a stark

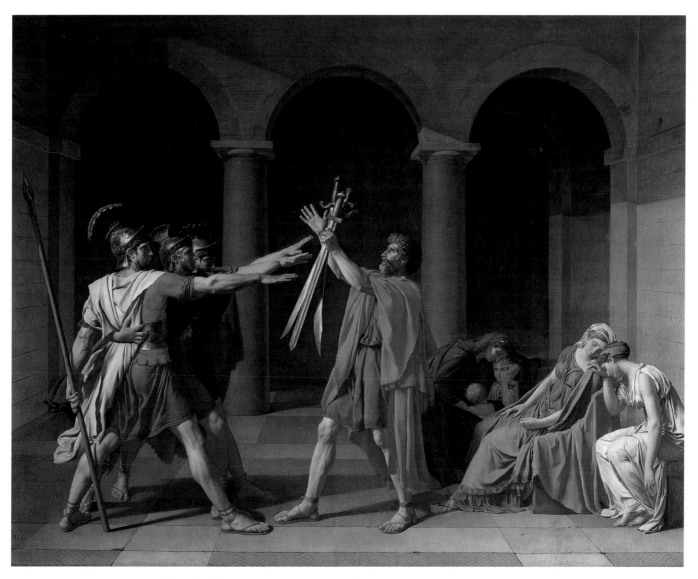

Fig. 16 **Jacques-Louis David**, *Oath of the Horatii*, 1784 (Salon of 1785). Oil on canvas, 10′ 10″ × 14′. Louvre, Paris.

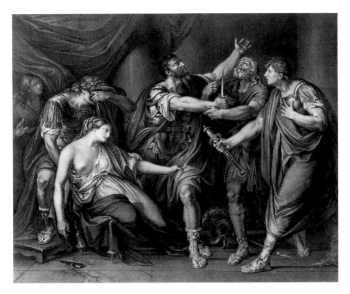

Fig. 17 **Gavin Hamilton** (engraving by Domenico Cunego), *Oath of Brutus*, 1768. Engraving, 11½ × 14⅝". British Museum, London.

purity; its unfluted, baseless Doric columns regress beyond the intricacies of the engaged, fluted columns in the *Belisarius* as if to reach the very rudiments of architecture. Indeed, David's impulse to purge his painting of all that was inessential, and to arrive thereby at the basic alphabet of form and feeling, was characteristic of the most thoroughgoing innovations in all the arts of the 1780s, whether the architecture of Ledoux or the sculpture of Canova.

Given the stunning impact of the *Horatii*, with its virtual proclamation of a new aesthetic and moral order, it is no surprise to find immediate and potent repercussions. Of these, the most memorable is *Marius at Minturnae* (**fig. 18**), completed in Rome in 1786 by the short-lived Jean-Germain Drouais (1763–88), who, as an intimate friend and protégé of David, had assisted the master in painting parts of the *Horatii*. If anything, *Marius* pushes David's drastic simplifications even further. In this story from Plutarch, the noble Roman general and consul is seen as a political refugee, after the state has unjustly sentenced him to death. But the Cimbrian soldier who has come to execute him is unable to do so, for the actual confrontation with a

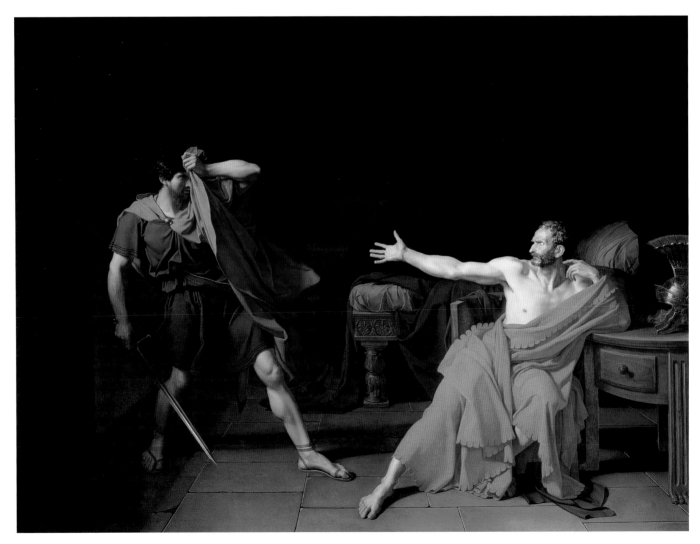

Fig. 18 **Jean-Germain Drouais**, *Marius at Minturnae*, 1786. Oil on canvas, 9' × 12' 2". Louvre, Paris.

hero of such rare virtue as Marius stays his hand. In this drama, Drouais uses a spare cast of two, dividing the stage into what is almost an opposition of physical thrust versus moral counterthrust. This daring reduction of a complex narrative situation to the tensest equilibrium of two potent forces goes even beyond the *Horatii* in its stark, emblematic clarity, although the style of the earlier picture is evident throughout. As in David's stoical vision of ancient Rome, Drouais uses cold, almost metallic hues, which seem to evoke the moral rectitude of the people revered by such classical Roman authors as Plutarch and Valerius Maximus; and the contours are defined with a marmoreal precision that locks the figures into profile and frontal postures. The setting, too, is of a chilling austerity that befits an arena of heroism and sacrifice. Clearly, the ethical tone of both these works is matched by the almost puritan style, providing, in historical retrospect, blueprints for the kind of idealistic moral behavior that the Revolution would soon demand of its heroes and martyrs.

Hero worship, in fact, escalated in the years before the Revolution, whether in terms of Greco-Roman history or of the history of France. In 1787, at the same Salon that featured David's rendering of Socrates' final discourse to his disciples before drinking hemlock, a painter of David's generation, Joseph-Benoît Suvée (1743–1807), offered an interpretation of the *Death of Admiral de Coligny* (**fig. 19**), venerating a sixteenth-century French Protestant hero, whose courage in the midst of bloody religious wars had already been praised by Voltaire in his poetic account of the reign of Henri IV (*L'Henriade*) and whose moral force almost became the French national equivalent of a Socrates or a Marius. During the bloody St. Bartholomew's Day massacres of 1572, the great Protestant leader was ambushed in his home by would-be assassins who, in fact, were to kill him. But Suvée shows the moment when the hero stands apart from the ugly crowd, many of whom, like the soldier who has come to execute Marius, are so awed by the old man's nobility that they fall at his feet or, as if to shield themselves from his ethical radiance, turn in retreat. To the accuracy of setting and costume that became a commonplace in late eighteenth-century history painting are added the special drama of a spookily torchlit corridor and victim, and an almost frightening immediacy of the invading, murderous rabble. The ingredients here not only prefigure, in terms of life, the actual events of the bloodiest pages of the Revolution but, in terms of art, the formulas of many nineteenth-century paintings of national history, whether as thrilling as those by Delacroix or as routine as the acres of historical illustration produced by countless painters of later generations. Looking backward, it is a particular irony that Socrates and Coligny shared the 1787 Salon walls with Vigée-Lebrun's complacent image of Marie-Antoinette and her children (see fig. 9).

From the vantage point of 1789, it is easy to see how quickly these pictorial lessons in heroism, courage, and utopian purity could be put to the use of contemporary experience, and no master exemplifies this better than David himself. A fervent Jacobin and follower of Robespierre, David, after the Fall of the Bastille, quickly became the artist who would memorialize the heroic events of the present, of which these earlier historical works could now be viewed as Old Testament prophecies, as it were, of the new religion to come.

No political moment symbolized the beginnings of a new republican world more decisively than the Tennis Court Oath of June 20, 1789, when the deputies of the Third Estate, then meeting in the Salle du Jeu de Paume at Versailles, swore never to disband until a new constitution had been drafted. To celebrate this, a commemorative society was formed in 1790, on the anniversary of the oath, and predictably chose David as the artist who could record for posterity this epoch-making event. David planned a work period of four years to realize a canvas immense and heroic enough to correspond to this thrilling prelude to a new era of French, and indeed, Western history; but thanks to the rapid change of political fortunes after 1790, he was able to produce no more than many preparatory portrait sketches and drawings, both swift and labored, and a large, incomplete canvas with some preliminary figure studies upon it. At the Salon of 1791, he presented a large pen-and-ink drawing (**fig. 20**) that let Parisians see the abbreviated statement of his first interpretation of a contemporary historical event; and with it, he re-exhibited three classical history paintings of the 1780s, one of which, the *Horatii*, must suddenly have appeared a prototype in classical guise of this modern oath of allegiance. Like Trumbull, who at the same time was preparing his pictorial celebration of the American Declaration of Independence, David was faced with the problem of giving a sense of unique drama and importance to what was essentially an intellectual action. The structure of the *Horatii*, with its combination of heraldic clarity and surging moral passion, came to his rescue. Again, David set the scene in a box space of absolute perspectival purity; and within this ideal environment, he presented an image of communal will, in which all figures but the dissident Martin d'Auch at the extreme right unite with fervently raised arms around the central group of President Bailly (standing on a table) and a trio of clerics. The oath-taking quartet of the *Horatii* has now multiplied to a cast of hundreds, a reflection of what must have been, just after the Revolution, an intoxicating sense of the power of the people. To add to this communal drama, the very weather seems to recognize a new Creation of Man. In the upper left-hand corner, an enormous drapery blows into the vast and lofty space of the high-ceilinged court, and behind it, we see an umbrella blown inside out as, in the distance, a bolt of lightning strikes the Royal Chapel at Versailles.

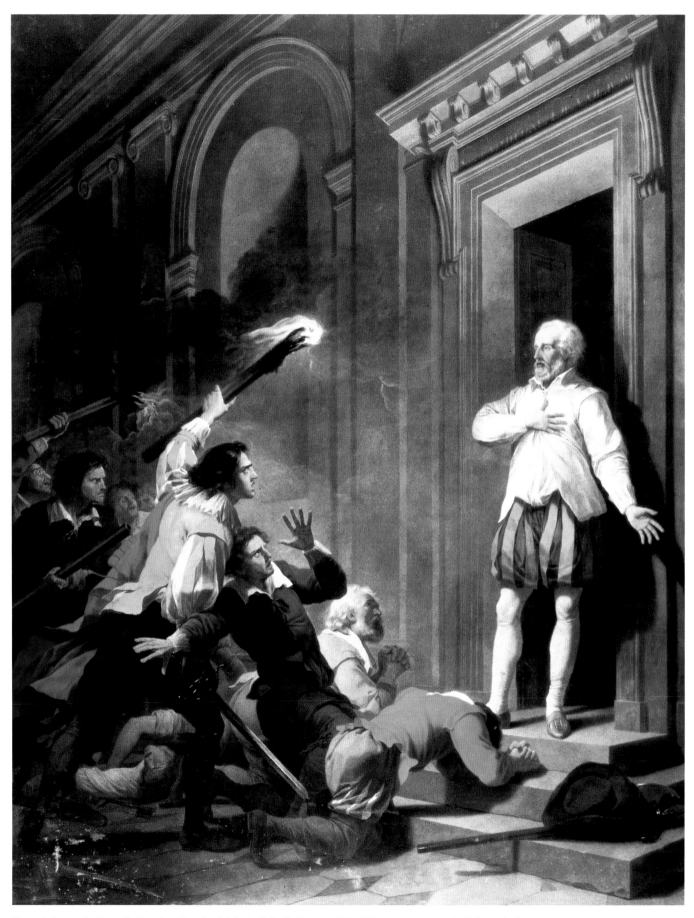

Fig. 19 **Joseph-Benoît Suvée**, *Death of Admiral de Coligny*, 1787. Oil on canvas, 10′ 9½″ × 8′ 8″.
Musée des Beaux-Arts, Dijon.

Like many of Claude-Nicolas Ledoux's and Étienne-Louis Boullée's projects for vast civic buildings in some as yet unbuilt utopian world, *The Tennis Court Oath* never, in fact, passed from this conceptual stage to the huge painting David envisioned. Finally, the most ambitious and high-minded project in his entire career was abandoned. The principle, however, of translating the venerable themes of the Western tradition, whether Christian or Greco-Roman, into a language that could be of immediate service to contemporary political causes was to be continued. Thus, in 1793, the bloodiest year of the Reign of Terror, David was called upon to mourn and commemorate in paint a series of martyrs who had lost their lives for the Republic. In the greatest of these, the *Death of Marat* (**fig. 21**), David took on the staggeringly difficult task of turning a gruesome murder into timeless art. An obsessively committed Jacobin, Jean-Paul Marat suffered from a skin disease that obliged him to do most of his political work in the soothing waters of his bathtub. On July 13, 1793, Charlotte Corday, an adherent of his political foes, the Girondists, gained access to his apartment and killed him with a butcher knife. A political martyr was instantly made, and elaborate rites that virtually translated a Christian sanctification into a secular one took place in Paris three days later. As a friend of Marat's who shared the same political goals, David was both personally and patriotically committed to the pictorial record of his death, and the painting, completed three months after the murder, reflects both private and public passions. In the foreground is a rude wooden packing crate that not only establishes, like the cube in the foreground of the *Belisarius* (see fig. 15), a solemn and abstract geometric module for an ideal image, but also becomes a surrogate tombstone, upon which is inscribed À MARAT, DAVID. L'AN DEUX, in the simplest Roman lettering. A personal dedication of the artist to his friend, it is also a kind of public funerary monument. Its date, the year two, proclaims the event as occurring in the second year of the new French revolutionary calendar, which, like David's new art, was to inaugurate a new epoch in the Western world. This metamorphosis of common fact into eternal symbol continues in the treatment of Marat's corpse itself, which not only bears all the marks of a real murder—the knife wound on the right side, the hand still holding a quill, the ghastly pallor of the skin—but also transcends these empirical details to enter a more heroic realm in which the body begins to recall not only the martyrdom of Christ or his saintly disciples, but the no less venerated corpse of one of those Homeric heroes—a Patroclus or a Hector—whom David

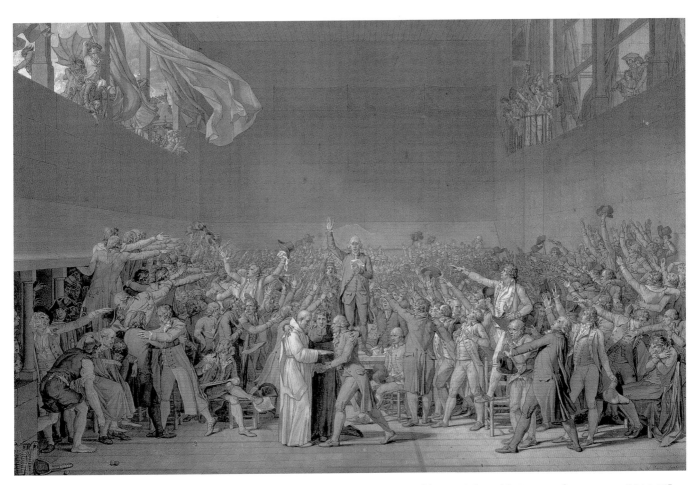

Fig. 20 **Jacques-Louis David**, *The Tennis Court Oath*, Salon of 1791. Pen and brown ink and brown wash on paper, 26 × 42″. Louvre, Paris (on long-term loan to the Musée National du Château de Versailles).

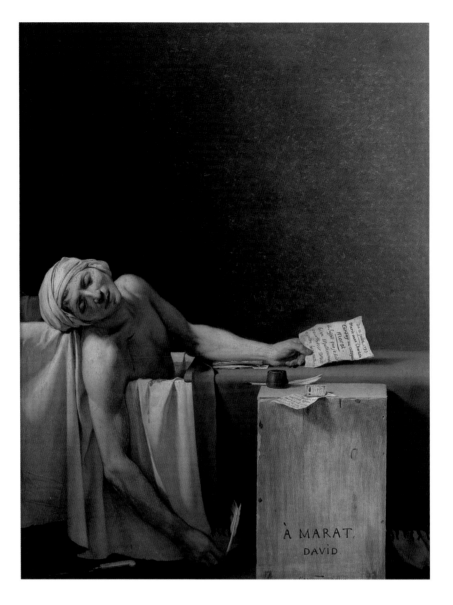

had painted before the Revolution. The ascent from the natural to the supernatural here leads us to the haunting upper half of the painting, which becomes a mysterious void, a nowhere environment, illuminated by an almost holy light that, from an unspecified source above, is cast upon the poignant terrestrial facts below. Atheists though they were, David and Marat, like so many other fervent social reformers of the modern world, seem to have created a new kind of religion. Lenin's tomb in Red Square is one of the most overwhelming of these pious mutations from the secular to the sacred.

David's allegiances followed breathlessly the political events of his country, and in the figure of that Corsican upstart Napoleon Bonaparte, he found, as did most of his compatriots, a new hero to worship. He also found a new patron, who demanded, like the revolutionary leaders before him, that official art support the goals of the ruler and the government. In his first full-scale commission for the new First Consul of France, David was to record a glorious military event of May 20, 1800: Napoleon leading his troops in victory across the perilous Alpine pass at the Grand-St.-Bernard (**fig. 22**). As in *Marat*, documentary fact turns into ennobling political fiction. Shown "calm on a fiery steed," as he himself requested, Napoleon belongs here to a venerable tradition of equestrian portraiture in which, as in the legend of Alexander the Great taming his wild horse Bucephalus, monarchs and noblemen serenely master their horses. But David has suddenly inflated this image to give a sense of uncommon energy and authority to the new hope of France. As antlike foot soldiers crawl their way upward into the narrow pass at the left, Napoleon and his horse majestically dominate this fresh plan of leadership. Horse and rider, their heads now on the same level, are fused in a disciplined combination of animal power and human control; and both rise upward, with rearing hooves and upraised hand, toward a symbolic future as utopian as that promised in *The Tennis Court Oath*. Even nature contributes to this momentous recognition of France's new ruler: a gust of icy wind seems to sweep the horse's tail and mane and Napoleon's cloak together in a dramatic ascent

to an unseen goal. And the Alpine vista of snow-capped mountains and a stormy blue-gray sky (a sublime natural setting which had already elicited powerful emotional responses among late eighteenth-century artists and spectators) again contributes a heroic backdrop against which the figure of Napoleon and his horse seem all the more heated, not only in the almost Rubensian warmth of their colors and textures, but in the passionate domination of their destiny. In even more literal terms, David has inscribed in the icy rocks of the left foreground BONAPARTE HANNIBAL KAROLUS MAGNUS, thereby providing a historical pedigree for Bonaparte in the evocation of two great military

and political heroes, Hannibal and Charlemagne, who, centuries before, had prophesied his triumph in their own arduous crossing of the same Alpine pass. This kind of noble genealogy is bestowed upon Bonaparte in other ways as well, for the sharply chiseled profile silhouette of horse and rider has an ideal clarity that is virtually Greek in character, a modern reincarnation of the Parthenon marbles. That Napoleon actually crossed the Grand-St.-Bernard pass on a mule (as later nineteenth-century artists would render the scene) is one of many indications of David's—and Napoleon's—ability to transform the prose of everyday facts into the rhetorical poetry of historical myth.

CHALLENGING APOLLO: DAVID AND THE MARTYRDOM OF JEAN-PAUL MARAT

Passionate supporter of the French revolutionary cause, Jacques-Louis David created in oil paint a secular martyr out of his murdered friend, the leading Jacobin Jean-Paul Marat. The success of David's picture (see fig. 21) depended in good part on its swift production, which immediately tapped into the public grief over the death of the politician and editor. Its popularity also stemmed from the range of textual information within the image that dramatically unlocked the story. As such, it provides a good example of how an image functions as a narrative, combining moralizing tale with sentiment. In addition to the text on the writing desk, there are two letters clearly visible. Charlotte Corday's deceitful letter (in his left hand) appealed to Marat's generosity so that she could gain entry to his apartment:

du 13 juillet, 1793
Marie anne Charlotte
Corday au citoyen
Marat
————
It suffices that I am truly Unfortunate for me to have a Right to your benevolence[5]

Marat's own letter on the desk reveals his altruism and patriotism:

You will give this banknote to the mother of five children whose husband is off defending the fatherland [de la patrie].[6]

On July 15, 1793, two days after Marat's murder, David addressed the National Convention, and by extension, the public, when Marat's embalmed corpse was presented under a damp sheet in the church of the Cordeliers. David's lines presage how he would construct the picture to show Marat in a virtually sacred light:

He met his death, this friend of yours, giving you his last morsel of bread; he died without even having enough money for his own funeral. … Come gather round, all of you! mothers, widows, orphans, downtrodden soldiers – all you he defended, to his own peril. Approach! and contemplate …[7]

In August and September of that year, David painted the picture. It was displayed on October 16, 1793 atop a sarcophagus in the courtyard of the Palais du Louvre. Pinned to the sarcophagus were Gabriel Bouquier's stirring lines of verse:

People, Marat is dead; the lover of the Fatherland,
Your friend, your supporter, the hope of the afflicted
Has fallen under the blows of blighted infamy.
Weep! But remember that he must be avenged.[8]

In the next century, the writer and critic Charles Baudelaire turned his attention to the painting. He avoided the populist and nationalist rhetoric of

the Revolution, adopting a poetic prose style that chimed with the image itself:

The *divine* Marat, one arm hanging out of the bath, its hand still loosely holding on to its last quill, and his chest pierced by the *sacrilegious* wound, has just breathed his last. … The bath water is red with blood, the paper is blood-stained; on the ground lies a large kitchen knife soaked in blood; on a wretched packing case, which constituted the working furniture for the tireless journalist, we read: 'À Marat, David'. All the details are historical and real, as in a novel by Balzac; the drama is there, alive in its pitiful horror, and by a strange stroke of brilliance, which makes this David's masterpiece and one of the great treasures of modern art, there is nothing trivial or ignoble about it. What is most astonishing … is the fact that it is painted extremely quickly, and when one considers the beauty of its design, it is all the more bewildering. … this painting has the heady scent of idealism. What has become of that ugliness that Death has so swiftly erased with the tip of its wing? Marat can henceforth challenge Apollo; Death has kissed him … and he rests in the peace of his transformation. There is in this work something both tender and poignant; a soul hovers in the chilled air of this room, on these cold walls, around the cold and funereal bath.[9]

Fig. 22 **Jacques-Louis David**, *Napoleon at St.-Bernard*, 1800. Oil on canvas, 8′ 11″ × 7′ 11″. Musée National du Château de Versailles.

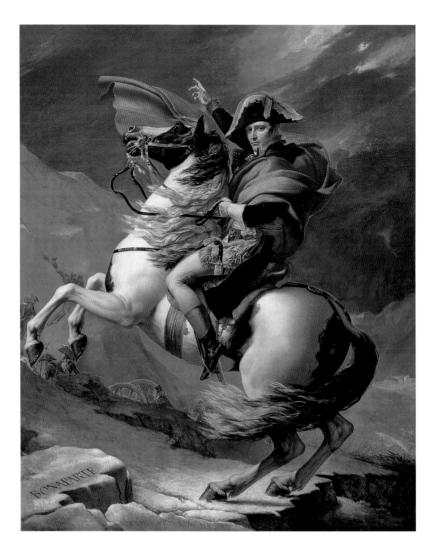

Although glorification of Napoleonic events was more the rule than the exception in French painting from 1800 on, it is worth noting an alternative view of the same military campaign by another artist of David's generation, Nicolas-Antoine Taunay (1755–1830). Painted in 1808 as a wall decoration (**fig. 23**), it shows not the famous hero but a different side of military life. Against a ravishing Alpine landscape of falling snow and pine trees, we see a woman bandaging a wounded soldier's leg, as a dog and other soldiers look on and another Good Samaritan tends to the impromptu bonfire. Taunay's reading of the facts of history, of the often poignant realities of the everyday, was prophetic of the new century, which slowly undermined the myths of Napoleon and his successors by recognizing that the ordinary activities or wartime hardships of nameless men and women were no less worthy subjects for painting than the high moments in the lives of a ruler extolled by Plutarch or the lives of Napoleonic generals and consuls.

David himself, for all his genius in turning contemporary events into new historical myths, had essentially an artistic vision that seized the palpable, here-and-now fact. Even in the *Horatii*, we sense this intense realism of detail, whether in the harsh differentiation of textures of flesh, hair,

plumes, or metals, or in the irregular cracks of the atrium floor; and in *Napoleon at St.-Bernard*, too, the vision keeps moving from the ideal, emblematic image of mythic horse and rider to the particularities of gilded tassels, tautly held reins, glistening hooves and boots. It may not be a surprise, then, to realize how frequently in his portraiture David could record a specific human presence with a total candor that almost prefigures photography. Thus, in 1802, two years after *Napoleon at St.-Bernard*, David could swiftly fulfill a business-like commission to paint, for two hundred gold louis, the portrait of an Irish merchant and collector, Cooper Penrose, then visiting Paris (**fig. 24**). The result is disarming in its seeming artlessness and truth. Against a dark monochrome background that offers no distraction from the essential facts of a portrait situation, Mr. Penrose sits before us with the startling immediacy of a one-to-one confrontation. His aging head, whose expression reveals the strain of someone not used to posing for posterity, is placed somewhat lower than in traditional portrait formulas, and his legs and chair seat are cropped by the lower edge of the frame at an unfamiliar and graceless point. This surprising rejection of even the customary placement of the figure in a routine portrait is supported by the penetrating

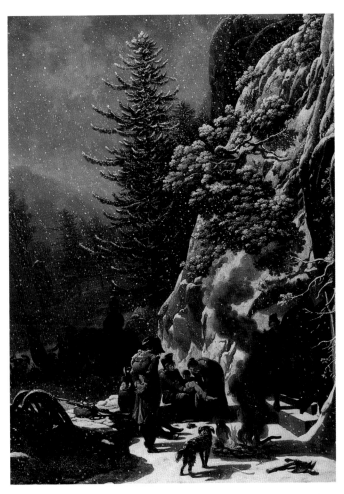

Fig. 23 **Nicolas-Antoine Taunay**, *French Army Crossing the St.-Bernard Pass*, 1808. Oil on canvas, 73¼ × 65¼". Musée National du Château de Versailles.

is as elevated from mundane matters as the slowly coiling rhythms of serpentine limbs, shawl, and robe perfectly locked into the profile of a modishly antique chair. This at once elegant and aloof austerity is further underlined by the slate blankness of a totally flat wall plane, against which only the thinnest of linear moldings, the artist's signature and date, and a few geometrically patterned floor tiles provide any decorative relief at all. Yet even here, for all the marble chill of an immobilized figure who seems to reign from the otherworldly climes of a rigorously abstract and eternal order, the sharp-focus details of a foreshortened arm, of vibrantly wayward strands of curling hair, of a nervous fringe at the bottom of a shawl speak of David's underlying contact with immediate visual experience. David himself, at least in principle, clung to the traditional hierarchies of the academy, which would locate a portrait below an image of important human events; and when he heard that M. de Verninac proposed that his wife's portrait be exhibited at the next Salon, he objected to being represented there by a mere portrait, especially when he was exhibiting outside the Salon (and also, in the tradition of West and Copley, for a fee) an ambitious history painting, *The Sabine Women*, which fully amplified the Greek

observation of what seems to be nothing but the truth: the fidgeting of the wrinkled hands, the sense of constraint and slight discomfort in the way Mr. Penrose sits up in a chair as stiff and sober as his clothing (he was of Quaker background). In what must have been the most casual of portrait commissions, David has wiped the slate clean of earlier pictorial artifice, leaving us with an image of such intense respect for fact that were he to rise from the dead, the sitter, we feel, would be instantly recognizable. Such an experience of a particular human being, presented, it would seem, without the veils and distortions of art, is only matched at the time in the portraiture of David's great contemporary Goya.

Nevertheless, the pendulum of David's art, even in the domain of portraiture, could swiftly swing back to icons of such frozen perfection that we feel the human race has been crossbred with deities from Olympus, an illusion often fostered in the terrestrial world of 1800 by the adaptation of Neo-Greek clothing and furniture. In his Juno-like image of Mme. Henriette de Verninac of 1799 (**fig. 25**), the frontal but remote stare of the sitter (who happens to have been the older sister of the then one-year-old Delacroix)

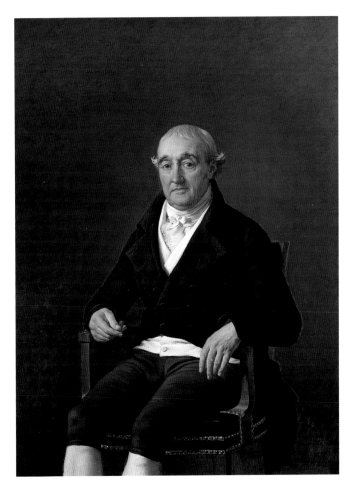

Fig. 24 **Jacques-Louis David**, *Portrait of Mr. Cooper Penrose*, 1802. Oil on canvas, 51 × 38". The Putnam Foundation, Timken Museum of Art, San Diego.

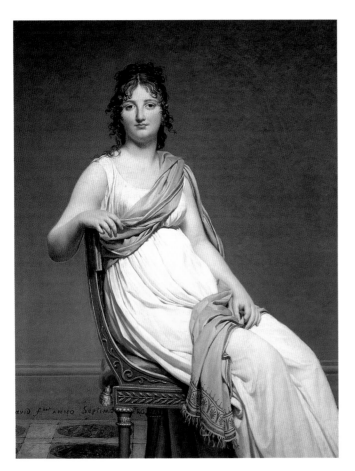

Fig. 25 **Jacques-Louis David**, *Mme. Henriette de Verninac*, 1799. Oil on canvas, 56¼ × 43¼″. Louvre, Paris.

style of *Mme. de Verninac* and which could elevate the spectator as well with its recounting of ancient classical legend.

Still, it was the urge to record a more earthbound vision that began to accelerate in David's art after 1800, an urge that reached fruition not only in his later portraiture but in his official commissions to document the pageantry of Napoleon's reign. As the emperor's First Painter, David was called upon to commemorate in huge canvases the epoch-making events at the beginning of the Empire. Of these, the imperial coronation, which took place at Notre-Dame Cathedral on a miserable winter day (December 2, 1804), was the most important historically and the most demanding pictorially. David, with much assistance from his enormous studio, labored for three years on this immense canvas, finally completing it in time for exhibition at the Salon of 1808 **(fig. 26)**. Not the least of the problems was exactly which moment of Napoleon's coronation rites to choose for posterity. At the last minute, to the surprise of all the spectators, Napoleon, instead of permitting Pius VII to crown him (for which reason the pope, almost as a political prisoner, had been sent from the Vatican to Paris), decided

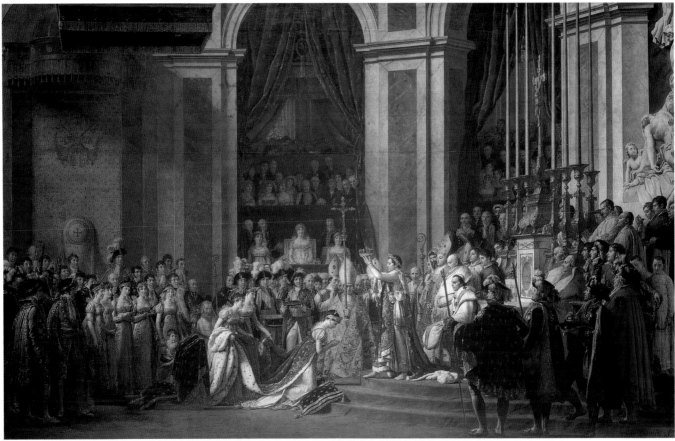

Fig. 26 **Jacques-Louis David**, *The Coronation of Napoleon*, 1805–07 (Salon of 1808). Oil on canvas, 20′ × 30′ 1½″. Louvre, Paris.

to usurp holy authority and to crown himself. Since this moment was a prickly one, it seemed advisable to record, in its place, the more gracious aftermath of Napoleon crowning the kneeling Josephine.

In his rendering of this vast spectacle, David again seemed now to outweigh inherited myths with observable facts. To be sure, the general format of this glittering display of ermine, velvet, brocade, and jewels evoked many glorious prototypes, of which Rubens's *Coronation of Marie de Médicis*, a classic of the French national collection, was the most conspicuous, not only in its sense of traditional royal pomp and circumstance but in the vibrant warmth of its palette. Moreover, the silhouetting and singling out of the imperial protagonists, with their Augustan profiles and frozen postures, provide an ideal, heraldic contrast to the oblique movements of the crowds that surround them. But apart from these allusions to distant monarchs and empires, the ceremony, as recorded by David, has an astonishing sense of journalistic truth, as if a photographer had been sent in to document it fully. Like a dollhouse

reconstruction of the event (and David, in fact, used just such a model to assure the accuracy of setting, costume, and figure placement), the painting seems crammed with particularities that often have the ugly ring of unidealized fact. The cathedral interior itself (with its rendering of a gilded crucifix and, on the extreme right, a Baroque marble *Pietà*, by Nicolas Coustou, ironically reminiscent of the *Death of Marat*) is like a stage set that is separated from the crowds of players below. And amid the surfeit of imperial and clerical costumes, we are constantly jarred by the prosaic truths of individual faces and movements, from the sallow, nervous head of the pope himself, seated behind Napoleon with nothing to do, to the portraits of bishop, cardinal, or acolyte, each one of whom is as distinct a human fact as Cooper Penrose. And within the court itself, there is a disturbing disjunction between the trappings of aristocracy and the mundane faces and figures who now bear this inheritance of regal grandeur. The nouveau-riche world of the nineteenth century seems to have its origins in this glittering pageant, in which somehow the great traditions of

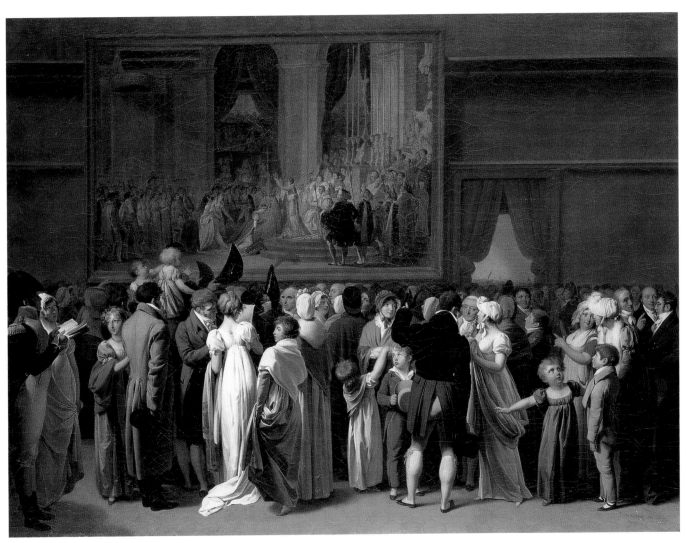

Fig. 27 **Louis-Léopold Boilly**, *The Public at the Salon of the Louvre*, begun 1808. Oil on canvas, 31⅞ × 35⅜". Private collection.

Baroque painting have been hardened, stilled, and soured by the harsh light of truth. Intentionally or not, David seems to have seized here the rupture between the splendors of a monarchic past and the realities of a modern present. It was a devastating insight rivaled only by Goya in his portraits of the Spanish court, and it pinpointed a conflict between inherited myths and contemporary experience that was to be even more apparent in the art of David's many students.

As a fascinating footnote to David's huge show-stopper, a painting by Louis-Léopold Boilly (1761–1845) offers a very different angle of vision (**fig. 27**). A painter who specialized in the depiction of anonymous Parisian crowds who might be watching conscripts going off to a Napoleonic war or pleasure-seekers roaming the boulevards, Boilly chose to record David's painting from the viewpoint of the hundreds and thousands of spectators who had come to see it at the Salon of 1808. The subject here is the ever-growing audience that attended the ever-increasing size of public exhibitions. Dressed in their Sunday best, these anonymous spectators, a small part of what must be a vast whole, seem to be milling about the galleries, usually paying more attention to each other than to the painting while also trying to keep their children from becoming restless. The off-center placing of David's painting and the arbitrary cropping of the dense crowd, right and left, give the impression of a casual, journalistic record of public art life in Paris, an offshoot of those eighteenth-century engravings that depicted the crowds at the Salons, but that focused more on the works exhibited. In terms of traditional hierarchies, Boilly's painting falls into a far more modest rank than the grand subjects David preferred, representing only nameless city-dwellers of all ages who are eager to see what the newsworthy event of Napoleon's coronation actually looked like. And Boilly's manner of painting is similarly more homely, since, like many of his French contemporaries, he revives the exquisite craftsmanship of rendering on a miniature scale the polished, immaculate look of those seventeenth-century Dutch paintings that also depicted ordinary urban life in modest dimensions, paintings more suitable for private than for public consumption. Seen against the grand-style rhetoric and size of David's art, Boilly's small canvases may shrivel to the level of inconsequential charm. But seen against the art of the mid-century, they may be viewed as an unpretentious prophecy of the way in which the commonplace facts of Parisian public life would become a primary theme for such major artists as Daumier, Manet, or Degas.

Francisco de Goya y Lucientes

In many ways, the art of Francisco de Goya y Lucientes (1746–1828) may be considered a close and often sinister parallel to David's. The two long-lived artists were almost exact contemporaries, both having been born into an eighteenth-century world that was to question more and more the divine right of kings; both having recorded, though from drastically different vantage points, the Napoleonic era; and both surviving beyond 1815, to end their careers with a private art of growing disconnection from the decades of political change they had witnessed. Trained in a provincial Rococo style, Goya, had he not been a genius, might have rotted away as an anachronistic court painter to the succession of Bourbon monarchs who tried to preserve a pre-revolutionary status quo in Spain. But he quickly began to explore not only private worlds of strange commentaries on true or imagined events, but also offered, in official commissions, the most sharply accurate mirror of the collapse of the great religious and monarchic traditions of the West.

Called upon in 1788 to paint a Christian deathbed scene for the Borgia Chapel in Valencia Cathedral, he turned inside out the rituals of Catholicism. The seventeenth-century patron saint Francis Borgia is shown exorcising a dying impenitent who is assaulted by demons, but this Catholic theme of repentance and miracle working becomes, in Goya's hands, a kind of voodoo rite that

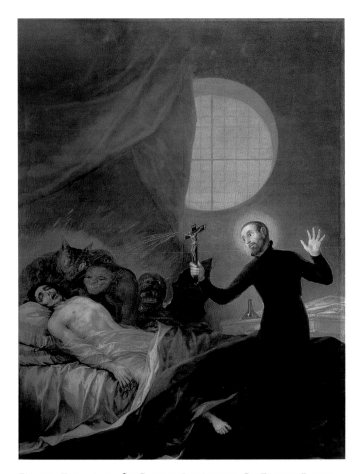

Fig. 28 **Francisco de Goya y Lucientes**, *St. Francis Borgia Exorcising a Dying Impenitent*, 1788. Oil on canvas, 11′ 8″ × 10′. Valencia Cathedral.

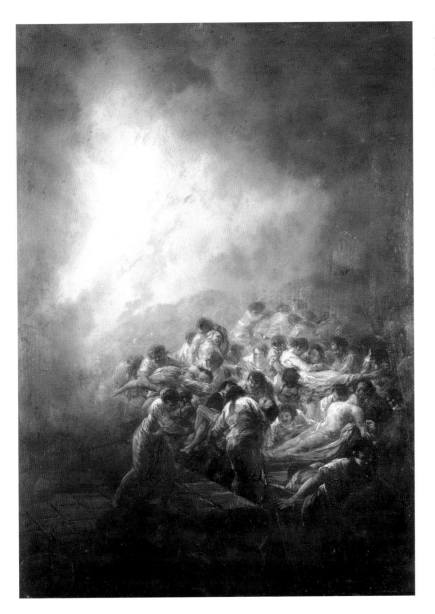

Fig. 29 **Francisco de Goya y Lucientes**, *The Fire*, c. 1793. Oil on tin plate, 19¾ × 12⅝". Collection José Bárez, San Sebastián.

suddenly has more to do with popular witchcraft than the universal pieties of the church (**fig. 28**). The dying man himself is shocking in his agonized expression and mortuary pallor and stiffness—not an idealized nude corpse like David's *Marat* (see fig. 21), but something that reeks of the ugly truths of death—and the fiery demons who hover over him unleash the furies of a pre-Freudian world of nightmares, monsters, and obsessions, nocturnal creatures that will gradually darken Goya's vision of human behavior and that had already begun to be explored by Henry Fuseli (see pages 48–50). By contrast to the hellish potency of this group, St. Francis, despite his being armed with the magic of a crucifix, seems a feeble figure. And his small halo, like the circular window above, provides a wan light that is threatened by the forces of darkness. It is already as easy to tell which aspects of the human mind held the stronger spell over Goya as it is to see how great an assault such a painting is on the pious miracle working of earlier Christian imagery.

By the 1790s, Goya seemed more and more eager to explore the irrational potentials of the human animal, a searching inward that was accelerated by his struggle, in 1792, with a severe illness that left him stone deaf. After this, he began to alternate his many official commissions with the production of small cabinet pictures that gave freer rein to his feverish imagination. In one of these, *The Fire*, of c. 1793 (**fig. 29**), we see at first a dazzling surface of rapid, bravura brushstrokes that almost evoke the Rococo idiom of a Fragonard; but we quickly realize that this is a scene of communal terror. Inspired by contemporary events, like so many late eighteenth-century British and French paintings, it presumably depicts the burning of the Coliseo Theater in Zaragoza in 1778, but the description of the place, and even of the clothing, is so generalized by the flickering bluish lights and shadows that the specific event becomes almost a fantasy of crowd hysteria, of a directionless sense of desperate movement as billowing clouds of dark smoke invade the space. The facility and buoyancy of a Rococo

style have here turned into a flashing nightmare, just as the ritual dignity of a classical funeral pyre, such as David's for Patroclus (see fig. 14), has been turned into the grim task of carrying anonymous naked corpses through the blurred confusion. One of them, a martyr without a cause, ironically resembles a Christian *Pietà*. From the memory of a minor civic disaster, Goya has created an apocalyptic image of panic, of a world in which order and reason have given way to chaos and fear. It was, after all, the time of the Reign of Terror in France.

Although in the 1790s, Goya began to move into more subjective realms, he always remained a prominent public artist, patronized by the aristocracy, befriended by intellectuals, and in 1799, even becoming First Painter to the king, Charles IV. From such vantage points, he was also to comment more responsibly on the public facts of life as he saw them at the turn of the century, and many of his energies were dedicated to the eighteenth-century tradition of social commentary in the form of didactic prints. Following in the path of such early eighteenth-century British artists and writers as Hogarth and Fielding, he could aim at the widest popular audience as well as at noble patrons. On February 6, 1799, a Madrid newspaper announced the publication of his *Caprichos*, a series of eighty etchings in which, as Goya explained in a prefatory statement that perpetuates the Age of Enlightenment's cool pursuit of reason, "the artist, persuaded that the censure of human errors and vices ... may be the object of painting, has chosen as appropriate subjects from the multitude of extravagances and follies which are common through our civilized society ... those he has believed most suitable to provide an occasion for ridicule as well as for the exercise of his imagination." This edifying social and artistic goal would hardly sound foreign in the milieu of Greuze and Diderot, but the results explored strange new territory. With an ever-growing mordancy worthy of a Swift, Goya redirected the eighteenth-century tradition of moralizing social commentary from a world of empirical observation toward the threshold of a dark, private imagination.

In a typical etching from the beginning of the series, *The Bogeyman Is Coming* (fig. 30), Goya pokes fun at the way many mothers threaten their misbehaving children with the appearance of a frightening specter. Using the voice of a Rousseau in a treatise on child rearing, Goya comments on this plate: "Bad education. To bring up a child to fear a bogeyman more than its own father is to make him afraid of something that doesn't exist." But the cool reason of this written advice to parents is instantly belied by the image itself. Instead of a sweet domestic scene of a mother and children common to the late eighteenth century, Goya rushes us into a nightmare, where the mother seems transfixed rather than bemused by the vision she has conjured up, and the children recoil in a sudden, shrill terror that plunges us into a world of primal fears. The bogeyman

himself is a ghostly white sheet of menacing stature, harshly lit as if by a lightning flash in an unspecified nocturnal setting. Masterfully exploiting the etching medium in its capacity to render inky blackness and intense white light, Goya plays these value extremes against each other in a manner that metaphorically suggests, as do so many of these plates, the gradual extinction of the Age of Enlightenment by an era of benightedness.

That sense of an acute observer who watches the world in which he was born go sour and crumble is nowhere more disarming than in Goya's royal portrait commissions. As the most prominent Spanish painter of his time and as a perpetuator of the tradition of artist to the ruler's court, Goya often found himself a misplaced heir of his seventeenth-century predecessor in this role, Velázquez, and many of his official images of the royal family are to be considered almost conscious restatements of this glorious heritage. But in a late eighteenth-century world where the divine right of kings had been so decisively challenged and overthrown, the myths of Goya's ancestors could no longer be sustained. In the equestrian portrait of his royal patron, Charles IV (fig. 31), painted about 1800, Goya conjures up

Fig. 30 **Francisco de Goya y Lucientes**, *The Bogeyman Is Coming (Los Caprichos, no. 3)*, 1799 edition. Etching and aquatint, 8⅝ × 6⅛". Hispanic Society of America, New York.

Fig. 31 **Francisco de Goya y Lucientes**, *Charles IV on Horseback*, c. 1800. Oil on canvas, 10′ 2″ × 9′ 8½″. Prado, Madrid.

the ghosts of a past where Hapsburg and Bourbon kings sat with unquestioned grandeur and ease upon their horses, quietly dominating the landscape and the spectator. But here, the faith in royalty's absolute authority is subtly undermined by an insistence on the awkward but demonstrable truths of things seen. Both royal horse and rider provide graceless silhouettes, from the narrow-shouldered contours of the king to the oddly inert stance of the horse. More swallowed by than dominating a landscape vista of strange aridity, Charles and his horse are dethroned, as it were, pictorially, for the discrepancy between the realities of the royal present and the royal past now seems irreconcilable. It is worth remembering that such a portrait is almost an exact contemporary of David's *Napoleon at St.-Bernard* (see fig. 22), for together they mark the dilemma of the postrevolutionary artist who must still deal with the inheritance of prerevolutionary myths. In a world where the concept of the natural, God-given rights of kings had been refuted, Goya deflates the great Baroque tradition to reveal the humble and clumsy facts of humanity; whereas David, in a heroic effort to resurrect this tradition, must inflate it

with what seems a willful, almost hollow rhetoric and propaganda.

There is no more famous image of the collapse of monarchic ideals than Goya's group portrait of Charles IV and his family (**fig. 32**), a royal commission of 1800 completed in the following year. It offers, like so many of Goya's other works, a revision of an old-master prototype in the face of modern experience. In this case, the point of earlier reference is Velázquez's group portrait of the court of Philip IV, *Las Meninas*, which Goya had already copied in an etching. Once again, the idols of the past have toppled to disclose the harsh, earthbound truths of an assembly of men, women, and children who, only by accident of birth rather than by inherent nobility, are the heirs to the regal costumes, jewels, and power that they display with such vulgar candor. While the watchful Goya stands in shadowy darkness behind them at his easel—an allusion to Velázquez's comparable self-portrait in *Las Meninas*—his royal patrons line up before us, imposing our closest scrutiny. Even the flat wall plane behind forces the group into a constructed theatrical space from which, as in a

Fig. 32 **Francisco de Goya y Lucientes**, *Family of Charles IV*, 1800–01. Oil on canvas, 9′ 2¼″ × 11′ ¼″. Prado, Madrid.

shooting gallery, there is no exit from our, or from the observant Goya's, gaze.

The incompetence and promiscuity of the sitters were well known. Charles was among the most reactionary and feeble of kings, and his wife, María Luisa, was notorious for her licentiousness and ongoing affair with the prime minister, Manuel Godoy, who had actually fathered one of her children. The two of them awkwardly preside over their family, which includes, at the left, their eldest son, Ferdinand VII (in turn, to become Goya's patron), and a shrill assortment of human types, from the ugly and aging infanta, María Josefa, whose head peers from behind, to the younger royal chidren, who seem as yet uncorrupted by their mother, who stands between them, to María Luisa Josefina, at the right, who holds her infant child with a prosaic gracelessness that shatters the aura of royal maternity proposed by Vigée-Lebrun for Marie-Antoinette (see

fig. 10). For us, the spectacle is an indictment—a verdict all too imaginable after the executions of Marie-Antoinette and Louis XVI—that this royal family is a mockery of the very idea of monarchy, and that this myth is thereby destroyed. But one continues to wonder what the members of the royal family, not to mention Goya, felt about this portrayal. For there is here so strong a sense of empirical fact that it has even been suggested that, as in the case of earlier portraits by Goya, the artist actually had the sitters compare the painted image with that in a mirror, in order to verify the accuracy of the depiction. In any event, the court was apparently sufficiently satisfied with its likeness to accept the painting, as if it were a group photograph; and it is this closeness to the observed visual truths that leaves the extent of the artist's commentary uncertain. To be sure, the possible identification of the dark painting behind the queen as an early painting by Goya of *Lot and His*

GOYA AND THE IMAGING OF ROYALTY IN SPAIN

In the nineteenth century the French critic Théophile Gautier described the principal subjects of Francisco de Goya's portrait, the Family of Charles IV *(see fig. 32) as "the owner of the corner grocery and his wife after they won the lottery." The idea that Goya's royal portrait was meant as a satire in keeping with postrevolutionary times has long held sway. How, it is argued, could Goya paint a hymn to mythic kingship when absolutism had been so decisively challenged in the eighteenth century? Recent art historians have read it quite differently, and seen Goya's modernity as more than simply an interest in caricature, a focus on everyday subjects and breadth of brushwork.*

In the 1970s, Fred Licht outlined the painting's status as an art-historical enigma:

The uncompromising realism of the individual portraits, the renewed paradox of ornate court dress against a shabby setting, the position of the artist behind rather than in front of his sitters, and the overly insistent, almost caricatural reference to Velázquez's *Las Meninas* are all part of what may well be the most sardonic and elaborate riddle of Western painting.[10]

Janis Tomlinson expanded on these ideas in her 1994 study of the artist:

Their unglamorous naturalism is at odds with the ostentation of their formal court dress. But as the viewer moves closer to the painting, these costumes and decorations dissolve into strokes of colour and impastoed highlights. The illusory nature of the pageantry is revealed, as is the very human nature of the royal family. The painting offers an unintended visual metaphor for the monarchy after a decade of revolution. To maintain the appearance of regal splendour, a certain distance must be kept.[11]

In a subsequent study, Tomlinson interpreted Goya's homage to Velázquez in terms of a new-found nationalism:

Why did Goya choose to look to Velázquez? At first, the choice seems natural—one Spanish painter looking back to another. But for Goya, the choice was not so obvious. By 1800, the concept of "Spanish" painting, and the history of painting in Spain, was only beginning to be defined. Painting for Bourbon monarchs, Goya may well have turned to the tradition of Bourbon portraiture ... One reason for which he chose Velázquez may have to do with the tumultuous politics in Spain in 1800, and indeed of the whole era. It was eleven years after the French Revolution—the fall of the Bastille in Paris—and seven years after the king of France, Louis XVI—cousin to Spain's Carlos IV—met his end at the guillotine. The Bourbon monarchy was no longer French, for in France, the general Napoleon Bonaparte (1769–1821) had assumed power as first Consul in 1799. It was time for the Spanish Bourbon monarchy to define its unique image—and the image was to be purely "Spanish"...

Although the general positioning of his sitters and the inclusion of his own self-portrait standing before an easel in the murky left-hand background are clearly indebted to Velázquez, Goya transforms his model. In *Las Meninas*, Velázquez implies a narrative of servants waiting on the princess, of the king and queen standing in (or possibly entering into) the room, of the artist painting. In contrast, narrative is denied by Goya. There is no story told here: this is a painting of people posing. This might suggest that the theme is the artist painting, but this is hard to support, given his relegation to the murky shadows. In contrast to Velázquez, Goya does not wish to paint a perspectival *tour de force* or narrative conundrum: he paints a modern group portrait.

Coronation robes and ermine are absent in this revolutionary age, where the fashionably dressed family is identified as royal only by the decorations and orders worn by its members. It shows the monarchy modernized, steadfast in familial strength, even in these troubled times. It is also an idealized image of family solidarity, since the young Ferdinand forced his parents to abdicate eight years later, to become himself king of Spain in March 1808.[12]

Finally, Robert Hughes in his 2003 monograph on the artist, poured scorn on the idea that Goya would have bitten the hand that fed him:

The idea that he had set out to satirize the patrons he depended on—who, we must implausibly suppose, must have been too dumb to see what he was up to—dies hard, but it is of course the merest nonsense. First of all, satire requires an audience, and Goya's portrait, hanging in the Royal Palace, had no audience but royalty and the court. Second, there isn't the slightest evidence in the painting of any satirical intent—which is only to be expected, since if it had contained any detectable barbs, Goya's career as first painter portraitist would have been finished there and then. And third, Goya, in the summer of 1800 at the royal retreat at Aranjuez, did no fewer than ten preliminary portrait studies for his sitters, all of which would have had to be approved by their subjects before he began work on the big picture. ...

The surface is Goya at his most energetic, a free, spotted, impasted crust of pigment that keeps breaking into light, full of vitality with never a dull touch. Far from being an exercise in satire, this amounts to an excited defense of kingship: not its divinity, to be sure, but what later ages would call its glamor, its ability to bedazzle the commoner and the subject.

Carlos IV was lucky. Did ever so dim a monarch deserve such virtuoso treatment?[13]

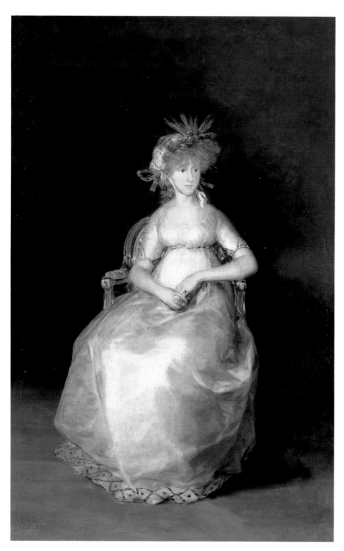

Fig. 33 **Francisco de Goya y Lucientes**, *Portrait of the Countess of Chinchón*, 1800. Oil on canvas, 83⅛ × 54¾". Prado, Madrid.

glistening of silks, satins, and brocades in a breathing, luminous atmosphere—such pictorial mastery has turned sour, detached from the prerevolutionary world to which it belonged, and applied in an almost desultory way to ordinary mortals who are no longer convincing when rendered in what has become an anachronistic style. As a truthteller, Goya never stopped displaying the difference between the way things were supposed to be and the way they really were when he saw them. Even his infamous pair of paintings of the same model clothed and naked offers an empirical demonstration that literally divests the Western nude of her traditional aura of timeless, ideal beauty.

Goya's sense of the primacy of specific observations can be sensed throughout his portraiture, but seldom with such penetration of psychological facts as in his portrait of the Countess of Chinchón (**fig. 33**). For Machiavellian reasons, Godoy had arranged to marry in 1798 this young cousin of the king and queen, and when Goya painted her, in April 1800, she was twenty, pregnant, and in effect, abandoned by her philandering husband. Elegantly clothed in a white, high-waisted dress so fashionable at the time, she sits uneasily in her chair, looking more like a lost child than a countess of the royal family. Like David, in his portrait of Cooper Penrose (see fig. 24), Goya seems to upset the conventions of portraiture in order to seize the truth. The countess is overwhelmed by a bleak, darkening environment, where her loneliness is intensified and her fragility almost menaced. Every detail—from the rendering of the ears of corn in her headdress (probably intended as an appropriate symbol of fertility) to the protective and nervous clasping of her hands—speaks of a particular human being in a particular plight. Again, the sense of reportorial fact is so acute that the modern observer may think ahead to photography to find a comparable insistence on the unedited truth. But again, as with the finest photographers, Goya has somehow chosen exactly *what* to record, so that we sense, beneath the surface of documentary fact, the contours of his own personality and vision. Perhaps we feel here Goya's own empathy, especially as a deaf man, with a somber world of frightening isolation, as well as his sense of being both an official member of, as well as an outsider to, the royal circles. The mood is not alien to that of Goya's lonely self-portrait in the rear of the *Family of Charles IV*.

Even when at its most macabre and irrational, Goya's art, as in *Los Caprichos*, or in his records of witchcraft, madhouses, prisons, or cannibalism among savages, always seemed to mirror an actual event, or a specific potential of human behavior. But before 1808, these strange explorations of the irrational or the barbaric may have been viewed as private eccentricities that pertained only to a nocturnal world of dreams and sadistic fantasies. After that year, these images could almost be seen as prophecies of hideous public truths, for between 1808 and 1814, Spain was occupied by Napoleonic forces and, through

Daughters introduces, in biblical guise, a comment on the morality of the court; and Goya's own detachment from the group can easily be viewed as quiet scorn. But more important is his insistence on the facts. It is a situation paralleled in the photographs of Diane Arbus, where documentary records of a grotesque humanity can be interpreted as derisive, compassionate, or voyeuristic. Essentially, Goya is saying, as he was later to inscribe on his prints of the horrors of war, "I saw this." The judgment is left to us.

Like David's *Coronation* (see fig. 26), Goya's *Family of Charles IV* announces a new, earthbound world by destroying an old, ideal one. In both paintings, we feel that the inherited style of Baroque court art, so attuned to the rendering of regal pageantry, has gone out of joint. In David's case, the warmth and fluency of the Rubens tradition are turned chill and stiff; in Goya's, the dazzling virtuosity of Velázquez is left, as it were, homeless. The bravura rendering of the constellations of medals and diadems, of the

passionate guerrilla warfare, maintained a bloody resistance to the foreign invaders. Goya quietly recorded, like a photographer at the front, his eyewitness experience of rape, pillaging, murder, mutilation, compiling a grisly, but all too factual anthology that was not published until 1863, when it appeared as a series of eighty etchings, the *Disasters of War*. But in 1814, at the time of Napoleon's demise, he took the opportunity to synthesize these terrible jottings in a more imposing, permanent form. He proposed to the interregnum regency council in Madrid that he paint the most heroic moments of the Spanish resistance, and they agreed. The results were two enormous paintings that provide a two-part documentation of (1) the popular insurrection against the French mercenary forces at the Puerta del Sol, Madrid, on May 2, 1808, and (2) the reprisals of May 3, 1808, when the French shot, without trial, all the Spaniards suspected of complicity. It is the latter painting that became, for posterity, the first full-scale and potent disclosure of the facts of war, stripped, as the royal family had

been in their group portrait, of the received myths of earlier centuries (fig. 34).

The initial effect is of a blinding, momentary terror, as if a flash-bulb photograph had caught the split second between the pulling of the rifles' triggers and the extinction of the victims' lives. Although we first see only one kneeling victim, shrilly illuminated by the intense white light of the lantern under a night sky, we soon realize that he is only one of many in a group, and that another group has preceded him, and yet another will follow. For all the sense of an instant's documentation, Goya has arranged his cast of Napoleonic murderers and Spanish victims in a way that suggests a terrible and infinite extension in both time and space. Thus, the eight executioners at their rifles imply only the beginning of a regiment that could continue endlessly to their right, and their victims are forced into a beltline cycle of which we see a three-part drama of the moments before, during, and after execution. Indeed, Goya presents almost a cinematic sequence of three figures who lead each

Fig. 34 **Francisco de Goya y Lucientes**, *The Third of May 1808*, 1814. Oil on canvas, 8′ 8¾″ × 11′ 3⅞″. Prado, Madrid.

group in a symbolic passage from life to death—first, the man ascending the mount with his hands shielding his eyes; second, the central victim, agonizingly alive in this penultimate moment before the bullet reaches its human target; and third, the gruesome corpse, which has fallen at our feet, its head a bloody pulp, its outstretched arms echoing those of its living counterpart.

This merciless account of the physical and physiological facts of a military execution is so harsh in its documentary realism that we may accept it too quickly as photographic truth, without realizing the extent to which Goya has edited the scene in order to extract the widest range of dramatic and moral impact. Like West, Copley, and David before him, Goya belongs to a new tradition of the painting of contemporary history in which a primary level of reportorial fact (e.g., the accuracy of the Napoleonic soldiers' uniforms or of the actual setting, Madrid's Montaña del Príncipe Pío) is aggrandized to heroic dimensions by reference to the great moral structures, Christian or classical, of the past. But in *The Third of May 1808*, Goya has inverted the message, putting into question whether there are any moral ends to justify these immoral means. The central sacrificial victim, singled out from his companions by a piercing light, is almost a pathetic re-creation of the Christian themes of the Crucifixion (even his right hand seems to be wounded) or, even more, the Agony in the Garden; and the motif of an outrage to Christianity is further echoed in the monastery complex on the horizon, an architectural backdrop that seems deathly and inert, as if the church, too, had been extinguished with the people it had once protected. And the same sense of an irrevocably violated Christianity is conveyed by the helpless friar, who bends his tonsured head forward in a final, useless prayer. Even the strident contrasts of light and dark take on a symbolic resonance, as in so many of *Los Caprichos*, implying here that the forces of night and death are engulfing an ever more irrational world. And the regimental grouping of the faceless executioners becomes an ironic restatement of the kind of noble, patriotic unity of such warrior heroes as David's *Horatii* (see fig. 16), their forked legs and outstretched arms turning them into a robot factory of death, in which their bodies are almost at one with their rifles. In contrast to this military precision, the victims fall to their knees in confusion, each of their faces desperately individualized. For here, too, Goya has turned a Western tradition upside down. In place of a Christ or a Hector or their modern reincarnations in a Peirson or a Marat, Goya's hero is really an antihero, a nameless civilian who dies ignobly with his compatriots. Goya has revealed a new view of history, in which the ideal moral and political structures of the West have rotted, leaving as raw fact only the collision of anonymous masses. At the time it was painted, 1814, Goya's vision of mechanized inhumanity in a bleak nocturnal setting must have looked like the end of Western civilization, but for later

generations, it has become, rather, a grim prophecy that inaugurated a new historical era. And it was a prophecy, too, of the direction Goya's art would take after 1815 (see pages 121–25), when he ventured even further into a world shockingly out of joint with those eighteenth-century principles of intellectual order that could still inspire his contemporaries in revolutionary and Napoleonic France. In the words of his most famous *Capricho*, "The Sleep of Reason Produces Monsters."

The Rise of Romanticism in England

In Goya's art, the conflict between the traditional demands upon the artist to make official, public statements and the personal need to explore a private, irrational world became acute. It was a dilemma common to many artists of his and later generations, and one which was especially intense in the milieu of British art. Already in works like Copley's *Watson and the Shark* (see fig. 4) or Wright of Derby's *Indian Widow* (see fig. 3), the spectator was treated to a new range of uncommonly powerful sensations, whether the escape from the jaws of death in faraway Havana, or the terrors of nature that threaten the heroic devotion of an exotic mourner in North America. Such a search beyond the traditional canons of pictorial experience accelerated in the late eighteenth century in both the public domain of official exhibitions and the more personal one of introspective disclosures. By the 1780s, the London spectator could see all kinds of terrors and fantasies, some as meretricious as the many theatrical spectacles of the time that featured bloodcurdling adventures or natural disasters, and others as authentic as a private confession of despair or anxiety.

One of the pioneers of this exploration of the irrational is the Swiss-born but thoroughly cosmopolitan Henry Fuseli (1741–1825), who, after his return to London from the Continent in 1779, thrilled audiences with his prolific displays of the stuff that dreams are made of. After shocking Londoners in 1782 with an interpretation of a woman having a violently erotic nightmare, he continued to reveal the potentials of the irrational, usually through the inspiration of an erudite range of printed words, from Homer and Dante to Milton and Shakespeare. The last poet provided him, as well as his contemporaries, with an especially wide spectrum of imaginative possibilities, which were channeled commercially by Alderman John Boydell. This clever entrepreneur commissioned a group of British artists to paint illustrations for his new "Shakespeare Gallery," which opened in 1789 and which quickly offered for sale engravings of the paintings as they were put on public display. In a typical contribution by Fuseli, an illustration to *A Midsummer Night's Dream* (IV. 1), we are levitated to a gravity-defiant world presided over by Titania, the Queen of the Fairies, who has just conjured up an ectoplasmic whirlwind

Fig. 35 **Henry Fuseli**, *Titania and Bottom (A Midsummer Night's Dream, IV. 1)*, c. 1790. Oil on canvas, 7′ 1½″ × 9′ ½″. Tate Britain, London.

of her elves, sprites, and gnomes to attend to Bottom (fig. 35). All grasp upon reason is pried loose as we marvel before this delirious realm where tiny creatures like Mustard-Seed and Pease-Blossom can crawl upon a man with the head of an ass, where figures, both minuscule and gigantic, can fly and hover, where, as in a spirtualist's séance, all may suddenly disappear. Moreover, this murky, fluid world seems charged with a curious erotic fantasy in which voluptuously attenuated women, like the one at the right who leads the tiny old dwarf on a string, dominate the scene like giddy, but imperious courtesans. An almost exact contemporary of the Marquis de Sade, Fuseli seems also to be investigating the more extravagant regions of the sexual imagination, though here given more public propriety through the Shakespearean source.

Fuseli's demonic rejection of reason was both pictorial and emotional. His images flee from Renaissance perspective systems in order to enter the domain of the irrational, his figure types violate the lessons of the anatomy class in order to invent new creatures of sensual fantasy. But if the bizarre and morbid character of his art has an intensely pesonal ring, it is hardly unique in its search for stronger and stranger stuff. In Northern Europe especially, artists were drawn to exactly those aspects of literature which broke with classical rules and explored the unfamiliar terrains of myth, fantasy, and terror that one could find not only in Dante and Shakespeare, but in folklore and ancient sagas. Of these rediscoveries of a powerful, primitive literature, untainted by later literary decadence and restricting rules, none was more remarkable than the poems of Ossian, a literary hoax perpetrated in the 1760s by James Macpherson, who claimed to publish the sagas of dreams, heroes, and battles written and sung by a blind Scottish bard who was easily labeled a Nordic Homer. Although these poems were later disclosed to be fakes written by Macpherson himself, they had meanwhile

Fig. 36 **Nicolai Abraham Abildgaard**, *The Ghost of Culmin Appears to His Mother*, c. 1794. Oil on canvas, 24¾ × 31¼". Nationalmuseum, Stockholm.

inflamed the imagination of artists and readers all over the Western world, including such famous statesmen as Jefferson and Napoleon. Ossianic illustrations usually had a Fuselian look of weird, nocturnal magic, as may be seen in a painting shown at the Copenhagen Salon of 1794 by a Danish master of Fuseli's generation, Nicolai Abildgaard (1743–1809). The subject is typically ghostly, to be identified probably as a passage describing the spirit of the dead warrior Culmin appearing to his mother, while two hounds bark in terror at this spooky apparition in a night sky lit by a silvery crescent moon (**fig. 36**). All the apparatus of mystery and magic is called into play here, as if we were watching a scene of witchcraft in some remote civilization. And as in Fuseli's work, the figural style borrows from the most idealized extremes of Italian sixteenth-century painting, appropriate here to a world of mythic heroes and heroines.

Not all artists needed such literary vehicles and such abstract styles to peer into an irrational world. Some, like George Stubbs (1724–1806), the finest animal painter of the eighteenth century, could work with premises so empirical that his pictures and drawings, whether of a domestic English horse or of an imported rhinoceros, are often rendered with sufficient scientific accuracy to be important documents in the history of zoological

Fig. 37 **George Stubbs**, *A Monkey*, 1774. Oil on canvas, 27¾ × 23¾". Private collection.

illustration. But even if he painted primarily the simple composure of elegant, well-bred horses (the equine counterpart to the portraiture of their owners among the landed gentry of England), he also sought out the wilder side of nature, representing exotic beasts in a natural setting and occasionally exhibiting a surprising empathy with experiences that lie beyond the fringe of the human. A particularly poignant example is his scrupulous record of a green monkey, painted in 1774 and exhibited at the Royal Academy the following year with the near-human title, "A Portrait of a Monkey." Here, the creature is seen in the forest, seated on a rock and, with prehensile fingers, nervously gathering peaches from a growing branch (fig. 37). But what might be an impersonal study of a primate takes on a surprising psychological force. The animal's eyes gaze back at us as intensely as those in any human portrait, and the sharp contrasts of light and shadow that obscure half the face and body lend a mystery that pertains both to the monkey's quasi-human emotions and the fears and uncertainties of life in a wild state. Suddenly, we are communicating, close up, with another kind of being, whose resemblance to man makes its revelation of an irrational world in nature all the more disquieting. For Stubbs, as for many other artists of the early nineteenth century who were to record natural facts—whether Constable with clouds or Audubon with birds—there was no split, as there often later seemed to be, between the precise documentation of empirical observations in nature and the implicit expression of wonder before these phenomena of life on earth.

However drawn he may have been to the world of sub-human experiences, Stubbs always presented even the most violent scenes of animal conflict with a kind of grave and noble clarity that almost corresponded to a mid-eighteenth-century idea of Greco-Roman simplicity. Among younger artists, however, this decorum might be grotesquely shattered in the interest of eliciting the most immediate, spine-tingling responses that could occasionally reach almost preposterous extremes. Exploring ever further the topical theme of beasts in a natural setting, Philip Reinagle (1749–1833) presented for his diploma piece at the Royal Academy of 1801 a scene that takes the spectator to what is virtually an animal version of hell (fig. 38). A vulture and a no less monstrous hyena are seen disputing over the body of a gentle hare, while a hideous condor looks on from a higher rock. Although the bestial conflict looks prehistoric in its wild mountain locale and in the terrifying ferocity of its protagonists, the grouping, like that in *Watson and the Shark* (see fig. 4), nevertheless strikes familiar chords in Western imagery. For this diabolic battle over the body of a gentle creature conjures up not only visions of the Last Judgment, with devils disputing the souls of the saved and the damned, but also the then popular Miltonic theme of the battle of Satan, Sin, and Death at the Gates of Hell, which had been singled out

Fig. 38 **Philip Reinagle**, *A Vulture Disputing with a Hyena*. Royal Academy 1801. Oil on canvas, 57½ × 57½". Royal Academy of Arts, London.

by the philosopher Edmund Burke, in an important theoretical essay of 1756, as the most potent example of "the Sublime" in literature. Indeed, Burke had newly defined, in terms of aesthetic theory, this freshly relevant category of experience, "the Sublime," which seemed to correspond to the ever-growing needs of artists and spectators to abandon reason and conventional beauty for irrational realms. Reinagle's febrile efforts to frighten us are part of this new repertory of sublimity, from the stark and sudden contrasts of light and dark to the precipitous chasms above and below our precarious foothold. Terrifyingly remote from man and his orderly works, we are meant to confront here an abyss that would devour the Age of Reason.

For us, Reinagle's painting may seem ludicrously melodramatic, but at the least, it represents accurately the bloodcurdling extremes of fantasy and terror that artists in England had attained by the turn of the century. Even the sedate Benjamin West, who had become president of the Royal Academy upon Reynolds's death in 1792, had already begun in the 1770s to explore the possibilities of the Sublime in art, and was more and more drawn to subjects culled from the visionary passages in the Book of Revelation. Of these, the most harrowing was the description of the thundering apparition of death on a pale horse, a skeletal rider who, with his companions, wreaks upon earthbound mortals an apocalyptic deluge of pestilence and death. West was fascinated by this theme, which he first essayed in 1783 and was to repeat with variations; and when, on a state visit to Paris in 1802, he had occasion to

Fig. 39 **Benjamin West**, *Death on a Pale Horse*, 1796. Oil on canvas, 23½ × 50½″. Detroit Institute of Arts.

offer to that year's Salon a specimen of his and his country's art, he chose the painted version which had already been seen at the Royal Academy in 1796 (**fig. 39**). Almost fulfilling Burke's theoretical description of sublimity, it plunges the spectator into an image of upheaval, with lightning-flash visions of horror amid the murk. Pathetically succumbing to the ferocious onslaught of the rider, Death, a family group falls to the ground at center stage, while the other horsemen rush off in all directions to fulfill their grim, universal mission. The grand, rolling rhythms of these frantic groups of vengeful destroyers and their helpless victims resurrect the full-blooded energies of Rubens, but such a Baroque prototype is translated now into a hellish operatic spectacle attuned to an audience that enjoyed shuddering.

Although in England spectators had become accustoned to these pictorial trips to hell, in France, in 1802, when the official style of epic painting was dominated by Davidian concepts of a lucid and stable order, West's painting must have struck an alien note of chaos. Even compared with French interpretations of the ever more popular theme of the Deluge, West's apocalyptic vision seems a volcanic eruption, centrifugal and molten. It must have left a strong impression on younger French artists, who would need such dramatic and pictorial means to convey the terrors not only of Napoleonic history, but of extravagant imaginative passages in literature. In fact, it seems to herald the most turbulent achievements of Delacroix himself in the 1820s.

In its function as a public spectacle, West's *Death on a Pale Horse* has a truly theatrical character, adapting in this case an appropriate old-master style, that of the Baroque,

and presenting what seems to be a kind of emotional charade which conforms more closely with an audience's demands for grisly horror than to the artist's personal need to explore an irrational realm. In England, in particular, a distinction became clearer between those establishment artists, like West, whose renderings of terror were essentially only part-time, impersonal productions, and a new breed of fervently introspective artists, who seemed to be one-man revolutionaries, probing the intense truth of their personal beliefs against what they considered the falsehoods of publicly acceptable traditions.

No more extreme example of this view can be found than that of the poet-artist-thinker William Blake (1757–1827), a private rebel who wished to reject virtually the entire system of art, society, and religion into which he was born in favor of a grandiose private structure of new myths, new moral truths, even new visual vocabularies that might provide vehicles for the eradication of what he saw as the corrupt status quo. Like many of his British contemporaries, he was thrilled by the vast human potentials of the American and French revolutions, transforming these earthly, time-bound historical events into complex spiritual allegories that were almost like the Book of Genesis in their pronouncement, in both his words and his illustrations, of a new universe. And when not depicting the fiery creations of his cosmologies, he could also illustrate the most apocalyptic passages from the Bible, from Dante, or from Milton. It is telling that like West and so many other British artists, he was fascinated by the Book of Revelation, which offered a scriptural metaphor of what so many Americans and Europeans witnessed in the years around 1800—a period of devastating and high-minded revolutions, of radical

Fig. 40 **William Blake**, *The Great Red Dragon and the Woman Clothed with the Sun*, c. 1800. Watercolor, 15¾ × 12¾". National Gallery of Art, Washington, D.C. Rosenwald Collection.

change that could evoke new visions of heaven and hell on earth.

Unlike West, Blake offers no doubts about his total commitment to the moral and visionary realities of the biblical text. His illustration (fig. 40) to the passage describing the heaven-born conflict between the "woman clothed with the sun," anguished in childbirth, and the "great red dragon," who threatens to devour her male child, a ruler-to-be, completely leaves below on earth not only the thunderclap histrionics of West's *Death on a Pale Horse*, but even the ethereal, fairy realm of Fuseli's *Midsummer Night's Dream* (see fig. 35). Blake, a generation younger than these artists, is deadly serious; and within the small format of a watercolor drawing, he transports us instantly and totally to a cosmological domain of infinite extension and fearful portent. In the upper zone, the monstrous dragon, half humanoid, half reptilian, hovers effortlessly in a sky rent by zigzag lightning flashes and the spiraling coils of his own tail; in the lower zone, his prey, the childbearing woman enclosed by glowing sun and crescent moon, responds to his assault with protectively outstretched hands that echo his gesture.

Not a shred of earthly reality is left here. The space, for all the violent foreshortening of the dragon, is shallow and gravity-less, and the vertical ordering of the image in two floating zones contributes to this rejection of art as the mindless imitation of material, weight-bearing things on earth, imposing instead a heraldic pattern of, in Blake's words, "fearful symmetry." Moreover, the figures, delineated by contours of wiry clarity and precision, are strangely incorporeal, more ectoplasm than flesh, almost transparent in their spiritual glow. And the colors are equally unreal, pure tints that seem as disembodied from objects as the lines that contain them. Blake's vision destroys matter, leaving nothing but bolts of imaginative

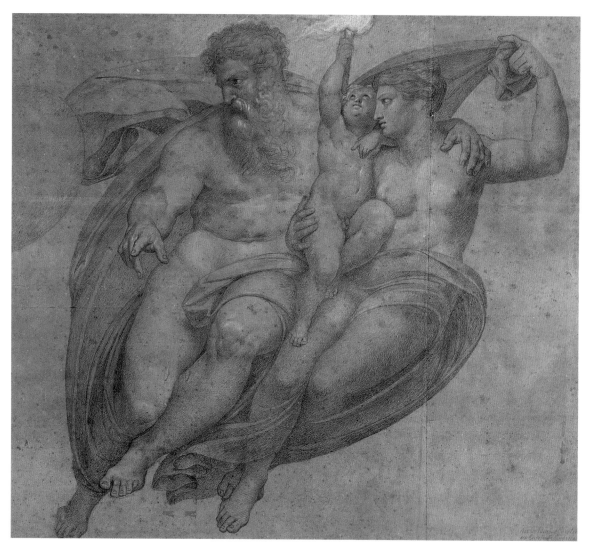

Fig. 41 **Asmus Jacob Carstens**, *The Birth of Light*, 1794. Black chalk on pencil drawing on brownish gray paper heightened with white, 24¾ × 28″. Kunstsammlungen, Weimar.

energy. Its force, so much greater than the modest dimensions that contain it, releases us from the rational, scientific world of Newton, whose thinking Blake despised, and locates us instead in an otherworldly, mythic realm of good and evil, heaven and hell. It is a world that resurrects the spirit not only of the Middle Ages, whose art Blake found an antidote to the materialism of the post-Renaissance tradition, but of any distant historical period, whether Western or Eastern, that believed ideas, symbols, and visions could be more real than the copper pennies and Satanic mills that Blake referred to in his prose and poetry as benighting the life of his country and his time. The personal and passionate conviction of Blake's visionary world is light-years away from the publicly oriented horrors and fantasies that covered the walls of the Royal Academy during his long life. Although he had some private patrons who were eager to support him (such as Thomas Butts, who commissioned the series of Bible illustrations that included the apocalyptic themes) and even arranged to have what

turned out to be an unpopular private exhibition in London in 1809, his position remained that of an artist and writer who worked against the establishment, fervently proclaiming his own universal systems.

The intensity and magnitude of Blake's vision may well have been unique, but many aspects of his concept of art were shared by contemporaries both in England and on the Continent. Among the closest in outlook was the short-lived German artist Asmus Jacob Carstens (1754–98), who, like Blake, had rebelled against the authority of patrons and academies and vowed he would live as a free citizen of the world. He often invented abstruse symbols that, at times, could approach Blake's airy realm of flying figures. In *The Birth of Light*, executed in Rome in 1794 (**fig. 41**), Carstens shares Blake's rejection of the material world in favor of a Michelangelesque reinterpretation of an ancient, Phoenician cosmology in which the original creative force and the symbol of night are shown as the symbolic mother and father of the infant light. Preferring, like Blake, to work

Fig. 42 **John Flaxman**, *Thetis Calling Briareus to the Aid of Jupiter* (from Flaxman's *Iliad*), 1793. Engraving, 6¾ × 9¾". British Museum, London.

in media other than oil paint (the use of which both artists considered responsible for a corrupt virtuoso technique fit to describe only what the eye could see and the hand could hold), Carstens sharply draws the figures of his own version of Genesis, letting them surge and float with mighty, airborne power on an abstract ground that removes us completely from the terrestrial world of Renaissance perspective systems.

Carstens's impulse to reject material facts, and to inhabit a domain liberated from the space-time co-ordinates on earth below, was common to many artists of the turn of the century, whether their goals were circumscribed within the domain of art or were stretched, like Blake's, to encompass the experience of the prophet and seer. A more modest and, in his lifetime, infinitely more popular contributor to this idealist vein was another Englishman, John Flaxman (1755–1826), who was famous both as a sculptor and an illustrator. A friend of Blake's, he also rejected the postmedieval medium of oil painting in favor of something that had a more purified, naïve look, in Flaxman's case line drawings that, in turn, were distilled into even more emblematic simplicity in books of his engravings. These widely disseminated publications, which began to appear in 1793, provided imaginative illustrations to the classics of Greek literature as well as to Dante and, later in his career, to Milton and Bunyan.

In a typical plate from the first of many international editions of Homer, Flaxman wafts the spectator to the Olympian realm described in the *Iliad* (**fig. 42**). Here Thetis helps Jupiter by summoning the aid of the monstrous hundred-handed Briareus, while, at the right, Neptune, Minerva, and Juno flee, cloud-borne, at the sight of this terrifying titan. To depict this realm of primitive myth, Flaxman uses what seems an appropriate language, the incisive outlining of forms, characteristic not only of the

world of Greek vase paintings but of any ostensibly uncorrupted, archaic period in Western art, such as the late Middle Ages in Italy, whose painting and sculpture Flaxman also admired. Again, as in Blake's visions, the rational, earthbound systems of a post-Renaissance mimetic art are left behind. Inhabiting an airless void of supernatural signs and symbols, Flaxman's figures are far less material than even Fuseli's fantasies. Abruptly shifting in size from the huge to the tiny, and, in space, from the frighteningly near presence of the giant crawling upward on the rock with six of his hundred hands to the unattainable remoteness of the Olympian Jupiter framed by pure arcs, these creatures are frozen in frontal and profile positions that distill them to mythic and visual essences. Devoid of light, color, and texture, Flaxman's outlines provided an almost puritanically incorporeal image bank for the Western world, a pictorial language of spirit and idea rather than of flesh and matter. Countless artists, including David and Goya, were fired by the possibility of using Flaxman's clean pictorial slates, with his pristine alphabet of outlined forms, as the sources for what would inevitably be more sensuous and complex images.

The Neoclassic-Romantic Dilemma

Confronted with Flaxman's Homeric illustration, it may be well to pause, at last, over the ever-problematic words Neoclassicism and Romanticism, which, in historical surveys of the years around 1800, are constantly called into play to categorize the staggering diversity of the period. Of the two terms, Neoclassicism is perhaps the less imprecise, since it at least is clear that the art it is meant to describe pays some homage to sources in Greco-Roman history, literature, and art. And as we have already seen, the inspiration of classical antiquity colored in many ways works as unlike as Greuze's *Father's Curse* (which is based largely on classical statuary) and Flaxman's outline engravings to Homer (which, after all, are classical in their very subject and which are based on figures from Greek vase painting and sculpture). But this said, these classical ingredients are only parts rather than wholes. Greuze's painting is nonclassical in milieu; and Flaxman's engraving, were we to interpret the classical as suggesting something like reason and order, conjures up a world as strangely unreal in its fantasies as Fuseli's Shakespearean scenes. Moreover, of the artists of the period who delved into what was overtly Greco-Roman in form or subject, almost all worked in other modes as well. Flaxman himself illustrated Dante and was inspired by Italian Gothic art; David could paint scenes of contemporary pageantry in a style drawn from the Rubensian Baroque; West could constantly switch from illustrating scenes of Greco-Roman history or literature to scenes of other historical periods, whether the fourteenth or the

eighteenth century. At the most, the term Neoclassicism can describe only a recurrent, but hardly exclusive kind of inspiration from that Greco-Roman past which had always been available to Western artists, and which became in the late eighteenth century just one of many coexistent options.

If Neoclassicism is a slippery term (more so in the history of painting than in the history of sculpture and architecture, where Greco-Roman prototypes were more abundantly available), Romanticism is even vaguer. According to some conventions, it may refer to the welling fascination from the 1770s on for non-classical literature and history (such as the Middle Ages, Dante, Spenser, Nordic myth); but if this is the case, where do we locate artists like West, whose range is all-encompassing, from pagan to Christian, from Homer to Shakespeare? Would it not be here more useful to think of Greco-Roman sources as just one of many possible and even simultaneous choices, like the different historical sources borrowed by architects of the period? According to other traditions, Romanticism is better defined as a state of feeling, describing a condition of emotional unrest that seems to become more intense with the passing of time, reaching a climax in the 1820s. This view at least accommodates the widest range of phenomena, from the restless urge to explore, if only in imagination, the distant worlds of exotic or primitive societies, to the fervent, near-hysterical proclamations of public morality in David's literally "classical" dramas of the 1780s, for which the hybrid phrase "Romantic Classicism" has been used. But the assessment of the degree of emotional intensity of these states is, of course, a subjective judgment; and we may never be able to agree on the depth or even authenticity of the feelings evoked by this or that painting. At the very least, however, most would agree that by the turn of the century—witness many works by Copley or Fuseli, Stubbs or Goya—artists throughout the world seemed to be exploring new dimensions of irrational experience that are couched in images of awe, terror, hallucination, mystery. And whether presented theatrically as a public spectacle or privately as a personal confession, these images are increasingly abundant from the 1770s on.

Such new dimensions of feeling both inside and outside the artistic establishment may be discerned not only by contrasting West's and Blake's interpretations of apocalyptic visions, but also by considering two portraits painted in a London milieu around 1800. One is by Sir Thomas Lawrence (1769–1830), an early work by a child prodigy who rose so swiftly within the academic establishment that in 1792, at the age of twenty-three, he could succeed Reynolds as Painter in Ordinary to the King. His full-length portraits perpetuate the elegant formulas for the aristocracy inherited from his predecessor, yet they offer as well a new emotional inflection already evident in the famous portrait of "Pinkie," the nickname of the twelve-year-old sitter Sarah Barrett-Moulton (fig. 43). Exhibited at the Royal

Fig. 43 **Sir Thomas Lawrence**, *Sarah Barrett-Moulton ("Pinkie")*, Royal Academy 1795. Oil on canvas, 57½ × 39¼". The Henry E. Huntington Library and Art Gallery, San Marino, California.

Academy in 1795 (in a grim twist of fate, the child had died a week before the opening), the picture maintains that sense of aristocratic attenuation and haughty composure attained in Reynolds and Gainsborough, but the mood also has such strange emotional undercurrents that *"Pinkie"* has even been called the first British Romantic portrait. Such a singular honor might be challenged (for who could pinpoint such a subjective experience so exactly?), but at least we may register the almost Fuselian fantasy of this fairy-tale figure, a modern Titania, who, with the imperious gaze of an enchantress, stands in wild nature, her dress and pink ribbons swept by the wind. Her otherworldly majesty and grace are set against a dark and turbulent landscape, whose startlingly low horizon and breathtaking, panoramic vista add towering height to the sitter, and whose broadly brushed, crackling storm clouds lend an aura of impulse and mystery. Yet for all this exaggerated drama, we may still feel this to be a charming charade, in which a public repertory of fantasy and terror has been applied to the sitter like

Fig. 44 **James Barry**, *Self-Portrait*, completed 1803. Oil on canvas, 76 × 63″. National Gallery of Ireland, Dublin.

a costume. It is no surprise that Lawrence was equally known for his portraits of actors, for example John Philip Kemble in the role of Coriolanus, seen tearing a passion to tatters.

Overtly or covertly theatrical, such portraits express more of a public taste than a private anxiety. But in the case of James Barry (1741–1806), an Irish artist who was an exact contemporary of Fuseli, we are plunged into a completely introspective world, experienced, as it were, behind the closed doors of a studio or a bedroom rather than in the make-believe world of a theater. The cantankerous Barry, unlike Reynolds and West, had strained relations with the Royal Academy throughout his life, and was finally expelled in 1799, after a career dedicated to the exploration of the kind of lofty, sublime themes earlier described by his close friend Edmund Burke. In the last years of his ever more embittered life, this outcast painted

an astonishingly poignant self-portrait (**fig. 44**) that speaks volumes about the degree to which a Romantic artist may use, among other things, classical sources as vehicles for feeling. In this lonely reflection upon his life, Barry represents himself in imagination as a young artist again, now identified with a legendary Greek painter, Timanthes, described by Pliny as an artist who attempted difficult, fantastic subjects (like the Gulliverian painting of the giant Cyclops surrounded by tiny satyrs which Barry holds in his hand). Above Barry's head, we see a huge foot, that of Hercules, crushing the serpent of Envy, a reference to his efforts to squelch his jealousy toward other more fashionable and successful painters who, unlike him, did not set their goals at so high an imaginative level. Although in words this allegory of the painter's professional and emotional life might sound bookish and impersonal, the painting itself instantly compels the spectator (even one

totally ignorant of the classical references) to empathize with Barry's phantom world. The environment is almost hallucinatory, with irrational leaps in size and scale that approach the empyrean visions of Blake, conjuring up demons and monsters of an unconscious realm of dreams. But above all, we are transfixed in this unreal ambience by the haunting, almost glazed stare of the wide-eyed artist who seems to be trying to fathom the mysteries of his own psyche. Claustrophobic in its crowded intensity, Barry's self-portrait takes us to the same brink of personal anxiety, fantasy, and terror approached by Goya, although it is couched in erudite references to Greek art and symbolism. Unlike the fashionable melodrama of, say, Lawrence's portraits or even of Fuseli's strangest excursions to domains of ghosts and goblins, Barry's probing of the dark and fearful side of human psychology carries with it a personal passion and conviction that belong more to the intimate world of private journals than to the public one of wealthy patrons and annual exhibitions.

Painting in France after David

Both in public and private terms, British art, like its literature, seemed to establish by the turn of the century most of the new themes and emotions associated with that all-inclusive term Romanticism. But in France, too, despite the more stable and traditional structure of its art world, with its biennial Salons, government commissions, and deeply entrenched system of academic training, many cracks in

the official facade could be seen after 1789, when artists of a younger generation began to alter the lessons of their masters to conform to new, more emotive needs. Of these masters, it was David who reigned supreme. Although he had been the most powerful force in the abolition in August 1793 of what the revolutionaries considered the Bastille of the art establishment, that is, the Royal Academy of Painting and Sculpture, he swiftly helped to resurrect it under a new name, the Institut National, preserving, in effect, the prerevolutionary academic system and changing the authorities only to those with more radical political persuasions. David's studio was the most obvious place for a young French artist to choose after the Revolution (or, for that matter, even for foreign artists who had come to Paris from as far away as Russia or the United States); but for all the rigor of his training, his young disciples, the heirs of a postrevolutionary world, inevitably began to transform his art, at times subtly, at times almost beyond recognition.

Such a new inflection can be seen in a painting shown at the Salon of 1801, *Melancholy* (**fig. 45**), by Constance Charpentier (1767–1849), one of the many new women artists who had studied with, among other masters, David. It is easy to recognize the source of this dejected young woman: she seems a sibling of the equally disconsolate Camilla at the right of the *Horatii* (see fig. 16). As in David's prototype, the figure drawing has a fluent, incisive quality, as of highly polished marble, and the profile posture and generalized surfaces add a kind of ideal, almost allegorical tenor to what might otherwise be a genre painting of a grieving woman. But the emotional ambience of the *Horatii*

Fig. 45 **Constance-Marie Charpentier**, *Melancholy*, Salon of 1801. Oil on canvas, 52 × 66″. Musée de Picardie, Amiens.

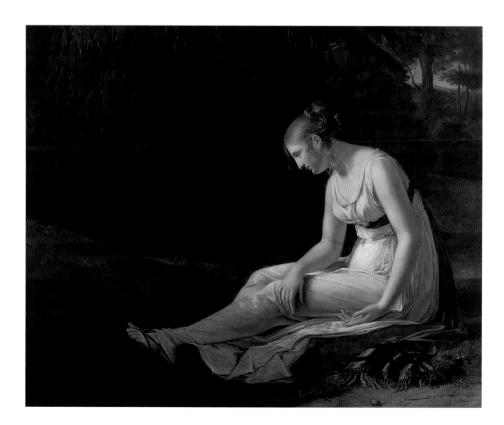

THE PRIMITIFS: AN EARLY ARTISTIC BROTHERHOOD IN THE NINETEENTH CENTURY

The Primitifs, also known as the Barbus because of their bearded faces, serve as an early precedent for a surprising number of artistic brotherhoods in the nineteenth century. Their countercultural stance was as evident in their paintings, the mystery surrounding their aims and even their name, as it was in their odd appearance. Their contemporary, the writer Charles Nodier, described the group's distinctive way of life in a letter of 1800:

Have you heard anything about this society of painters and poets to whom common people referred as the *Illuminati of the Arts*, who were more generally called the *Observers of Man* and who unassumingly named themselves *Mediators of the Antique?* You must have often heard of these young men who took pride in having resurrected among themselves the beautiful forms, the beautiful customs, and the beautiful clothes of the first centuries; of these artists who wore the Phrygian costume, who ate nothing but vegetables, who lived in common, and whose pure and hospitable life was a living picture of the golden age? Well, I have found them.[14]

The Primitifs' formation of a brotherhood, as the modern art historian William Vaughan has written, helped to reconceptualize the notion of fraternité *in the decades that succeeded the French Revolution. But it had a long history:*

It should be remembered that this ideal of male fraternity was seen not as an innovation, but as the restoration of an ancient ideal condition. The democratic model provided by Periclean Athens was particularly important; but there was a more general assumption that a fraternal form of organization was a feature of the earliest civilized societies.[15]

What was new was the Primitifs' embrace of difference as a form of protest. But what at first seemed like a rejection of modern values could be interpreted as a commercially shrewd ploy:

The Barbus have long held honoured places in the history of the avant-garde. Their ill-fated fraternal protest has been seen as one of the early signs of that development of alternative artistic practices that was eventually to generate a fully-fledged avant-garde in France in mid-century. For the most part the accounts of the brotherhood, even by those who were members of the group ... or had first-hand experience of the group ... were not written until the 1820s and 1830s, by which time the romantiques and the vogue for the *vie bohème* were dominating the artistic world. Indeed, it was the experience of this new form of oppositional art and artistic life that caused the reminiscences to be written down, and it is hard to avoid the conclusion that the prescient nature of the

group was exaggerated in part to provide more recent developments with a genealogy. Such accounts almost certainly exaggerated the idealism of the group ... since such matters helped to reinforce the elevated view of art and the dedicated nature of the work produced. Above all it seemed to secure the concept of art from contamination with practical and commercial considerations.

Yet in the end, can one be so certain that this really was what was going on? For the establishment of an alternative group identity ... was also an attention-seeking device, and one that was practised by other groups with success. While turning their backs on society in one sense, the Barbus still made their presence felt and, most important of all, sought a public arena for their art through the Salon. ... Were these intense young men togged up in Greek gear ... genuine or part of some elaborate show? Like most of the artistic brotherhoods that followed them, this group of "separated" individuals were using their separateness as a marketing ploy, as a means of drawing attention to themselves, or stressing originality and sincerity.[16]

Ahead of its time, the Primitifs' project proved a failure, but later groups would find that such a gambit could both make their work attractive to art buyers and secure their reputations for posterity.

has been altered drastically. Instead of a dynamic scene, directed to action and public welfare, Charpentier offers a passive, introspective icon that conveys a mood of eternal sorrow, like a mourner on a tomb by Canova (see fig. 95). Moreover, this bittersweet emotion—the pictorial counterpart to the lachrymose passages in the sentimental literature of the time—is echoed in nature itself, for the lonely, desolate figure's drooping posture finds its response in the weeping willow tree that seems virtually to grieve with her. We are meant to feel that all the world, both figure and landscape, responds to this unspecified sorrow.

The same exploration of tender, tearful moods is found in another painting at the Salon of 1801, by Jean Broc (1771–1850), a member of a rebellious group of David's students who called themselves the "Primitifs." Wishing to purify their art far beyond David's own austere reductions and to conjure up a kind of artistic dawn, they tried to adapt the looks and themes of distant epochs—the linear purity of Greek vase painting and Italian primitive painting; the stark literary power of Homer, Ossian, and the Bible. It was a goal not foreign to Flaxman's, and his outlines, in fact, were treasured by these young artists in search of

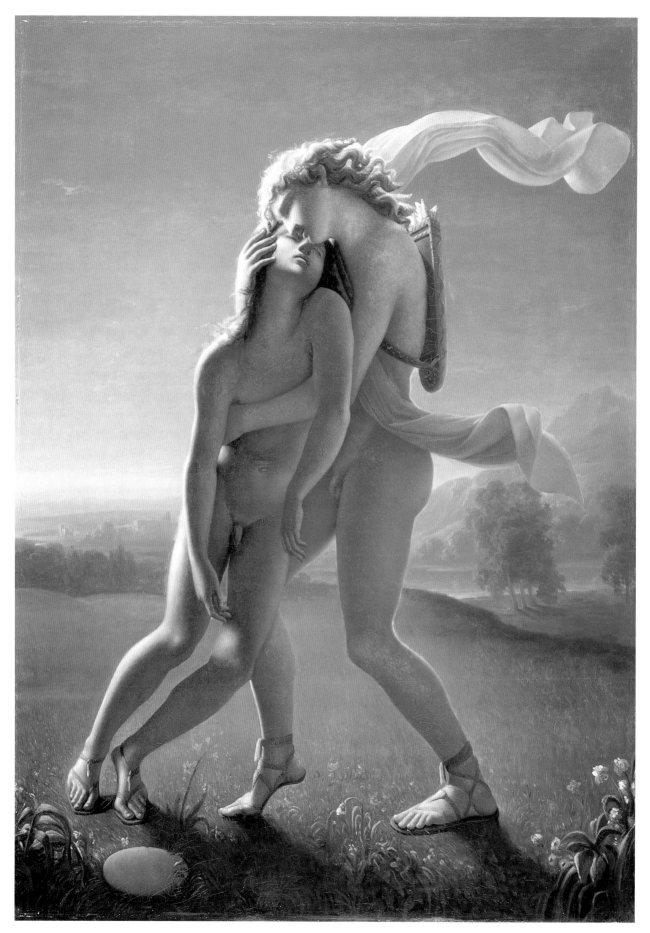

Fig. 46 **Jean Broc**, *Death of Hyacinth*, Salon of 1801. Oil on canvas, 70 × 49½″. Musée des Beaux-Arts, Poitiers.

the poignant simplicity and truth of an archaic moment in civilization.

The results of these sophisticated regressions, prophetic of the goals of many later Western artists who wished to return to childlike states of experience, are suggested in Broc's *Death of Hyacinth* (fig. 46). Oblivious of the socially conscious, patriotic themes of Greco-Roman history that inspired David, Broc chooses here a homoerotic Greek myth about Apollo's tragic love for the young Hyacinth. One day, when the two were playing discus, the jealous wind, Zephyr, also in love with the youth, killed him by redirecting Apollo's discus. On the ground, the flower to be named hyacinth grows from the dying boy's blood. This amorous legend of magical metamorphosis is interpreted by Broc as a scene of tender passion set in a world of Arcadian remoteness and innocence. Apollo himself recalls the famous marble at the Belvedere, which Reynolds had also used for his beautiful Tahitian sitter, *Omai* (see fig. 1), but his body now sinks in grief as he holds the expiring Hyacinth. In the fluent contours of their love-death union, the pair recalls not only the elegant figural distortions found in Greek vase painting but also in works by such Italian masters, then considered "primitive," as Perugino and Botticelli. And the dewy, crepuscular landscape also evokes an unpolluted, mythic realm appropriate to the narrative.

By the standards of David's earlier style, with its rigorous evocation of a stoical Greco-Roman world, all is turned inside out here. The lighting, for instance, just touches the edges of the contours, with strangely radiant, bizarre effects; and the colors reverse the harsh, metallic hues and tones of the Davidian style of the 1780s (see figs. 14 and 15) in favor of delicate pastels, with Apollo's pink draperies, still fluttering from Zephyr's fatal breeze, seen against the softest blue sky and above a pale green meadow. Even the modeling of the figures, though nominally sculptural in the Davidian sense, takes on a waxen, malleable quality that contributes to the voluptuous tenor of the scene. And the lucid perspective spaces of David now give way to an image that in some ways resembles a cameo, with figures like bas-reliefs sharply silhouetted against an atmospheric landscape background no longer measurable by rational systems. Like Keats, who also recounted this myth in his poem *Endymion* (1818), Broc takes the public experience of classical art and legend and translates it into a world of private reverie. Seldom has "Classicism" seemed more "Romantic."

David must have been shocked again and again by the ways in which his own progeny belied his aesthetic and moral canons, exploring instead peculiar effects and introspective emotions. Even within the domain of contemporary history, it was possible for them to offer erratic interpretations of public facts, as seen in many paintings by the brilliantly eccentric Anne-Louis Girodet-Trioson

(1767–1824). There is, for instance, the high-minded portrait of Jean-Baptiste Belley (fig. 47), painted in 1797 and shown at the following year's Salon, which exemplifies the egalitarian beliefs of the Revolution. A free black man who had been a slave, Belley had been sent to the convention of the new republic as a deputy from the French Caribbean colony of St.-Dominique, together with a white man and a mulatto. Girodet shows him in the posture of a Praxitelean statue, leaning against a white marble bust of the philosopher Abbé Guillaume-Thomas-François Raynal, who was of utmost relevance to the sitter. For Raynal, a close associate of the Encyclopedists, had written a treatise against slavery in 1770, and had died in 1796, in time to be commemorated in a new France where all human rights were to be respected. From this mixture of the Age of Enlightenment's high moral ideals and contemporary political and biographical actualities, Girodet has constructed a strangely disquieting public image. Fascinated by this exotic man from across the ocean, as Reynolds was by Omai, Girodet bizarrely contrasts the intense black of his flesh with the equally intense white of the marble bust of Raynal. This dialogue is made even stranger by the slight difference in head size and, still more, by the divergent gazes away from the spectator: Belley looks across a tropical vista evocative of his native island, while Raynal, whose pupil-less white eyes (like those in many other classicizing portrait busts of the period) stare blindly in the opposite direction. The sober Davidian lucidity of incisive contours, palpable modeling, and sharp-focus textural differentiations is weirdly sabotaged by the disquieting effects achieved in this double portrait of the living and the dead, of black flesh and white marble.

Girodet's flights of fantasy could soar far higher than this, and nowhere more so than in a commission of 1800 to paint an allegory for Napoleon's country home at Malmaison, just outside Paris. Like his master, David, he was to paint a scene from Napoleonic history that would glorify the First Consul, but unlike him, he chose not an actual military or ceremonial event that occurred at a terrestrial time and place, but rather invented a crazy allegory in which the facts of contemporary history and the fictions of literature unexpectedly collide (fig. 48). Sharing the late eighteenth-century enthusiasm for the poems of Ossian (whose star was particularly high among the Primitifs of David's studio), Girodet conjures up on the left, as if in a séance, the foggy spirit world of Ossian himself and his entourage of warrior-ancestors and music-making maidens. But their arms are extended to welcome not their own mythic kind to this almost Wagnerian Valhalla, but rather to receive a group of identifiable Napoleonic officers, in military garb, who had lost their lives for their country.

This strange alliance of the remote and the contemporary, of spirit and substance is further complicated by a teeming abundance of strange symbols that scholars have

Fig. 47 **Anne-Louis Girodet-Trioson**, *Jean-Baptiste Belley*, 1797. Oil on canvas, 63 × 45". Musée National du Château de Versailles.

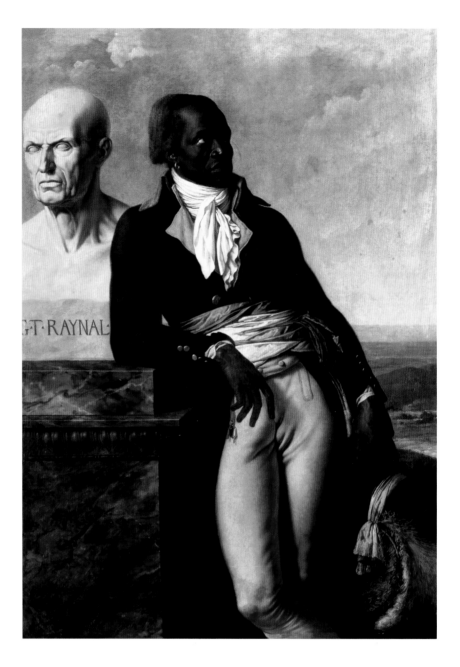

had to puzzle over like cryptograms. For example, the skirmish between the birds may allude to a brief cessation of Napoleonic hostilities in 1801 between Austria (represented by the imperial eagle) and France (the Gallic cock), while a dove of peace flutters between them. And the two dogs, which sniff a welcome to each other, express in canine terms the meeting of Ossian's rugged hounds with the elegant female greyhound that was a real pet of the young Napoleonic martyr, General Desaix, who, in the foreground, heads this procession.

Even in a post-Surrealist world, Girodet's painting is startling, and we can easily undersand that David, seeing the work for the first time, called Girodet a lunatic who made "figures from crystal," and that spectators who saw it publicly at the Salon of 1802 were so flabbergasted that the work was removed early. For here, all semblance of Davidian pictorial law and order has been flouted in a giddy

hallucination that stuns the eye, the intellect, and the imagination. In a visionary world that has no beginning, middle, or end, everything is pushed to irrational extremes. Innumerable figures float in airborne spaces that seem both infinitely expansive and oppressively congested. And the crystalline modeling, pinpointed by David, is made still odder by the chilly, interplanetary light that radiates from the bursting meteors above. But for all its personal eccentricity, Girodet's painting telescopes the recurrent dilemma of so many French artists of the period who had constantly to move back and forth from the ideal realm of literature and myth to the glorification of contemporary history. That fusion had come easily for earlier masters like Rubens, who could intelligibly translate the lives of their monarchs into a public language of well-known classical symbols; but by the beginning of the nineteenth century, such an allegorical interpretation of current events might have looked

Fig. 48 **Anne-Louis Girodet-Trioson**, *Ossian Receiving Napoleonic Officers*, Salon of 1802. Oil on canvas, 37 × 73½".
Musée National du Château de Malmaison.

like a dreary anachronism unless revitalized by the wildest
imaginative leaps.

The Image of the Ruler

The hero worship surrounding Napoleon made it easier for
artists to metamorphose his physical reality into something
that might exist in a timeless realm, and no artist tested this

premise more adventurously than David's greatest student,
Jean-Auguste-Dominique Ingres (1780–1867). Even
without an official commission, Ingres was impelled to
commemorate the new emperor, in this case to show him
enthroned in his imperial robes. While David was still
working on his almost reportorial record of the earthbound
facts of *The Coronation* (see fig. 26), Ingres completed, in
time for the Salon of 1806, his astonishingly otherworldly
image of a modern head of state (**fig. 49**). Located in a

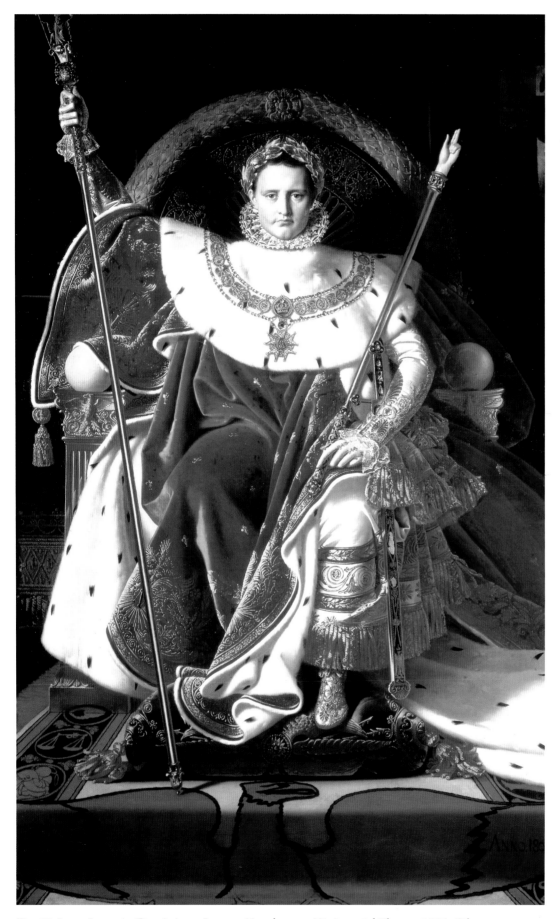

Fig. 49 **Jean-Auguste-Dominique Ingres**, *Napoleon on His Imperial Throne*, 1806. Oil on canvas, 8′ 8″ × 5′ 5¼″. Musée de l'Armée, Paris.

frozen, timeless realm, separated from his subjects on earth by his high throne and the almost magical, primitive force of the imperial eagle, heraldically outlined in the rug in front of his foot cushion, Napoleon seems to have presided for eternity. His imperturbable, frontal posture recalls, in fact, many archaic images of the supreme being, from the famous Phidian statue of the Olympian Zeus (the source, as well, of Flaxman's vision of the Greek god in his Homeric illustrations; see fig. 42), to such late medieval representations of the Christian deity as Jan van Eyck's *God the Father*, then visible in Paris as Napoleonic booty taken from Ghent. Ingres's head was as filled as Girodet's with these remote, mythic images from what must have then seemed thrillingly distant cultures, and he welcomed the official opportunity to transform Napoleon's flesh-and-blood persona into an abstraction of implacable authority. Historically supported by the trappings of French royal power (the scepter of Charles V and the sword and hand of justice of Charlemagne), Napoleon, as conceived by Ingres, is really a fictional god and emperor, interchangeable with dreams of Byzantium or Olympus. The stange archaism of this conception of a modern ruler was fully supported by the archaism of Ingres's style, which baffled critics at the Salon. They commented on the icy lunar light, the medieval stiffness of the pose, the obsessive intensity of the description of sumptuous velvet, ermine, ivory, and gold. For David, this student's work must have been no less lunatic than Girodet's, turning his own rational doctrines into a private fantasy of chilling splendor and omnipotence more suitable to an ancient than to a modern civilization. In a historical epoch when governments were crumbling and the very titles of rulers—king, president, consul, emperor—were constantly changing, Ingres's vision of Napoleon represented an extreme idealization of timeless authority, going far beyond David's more plausible Napoleonic propaganda and totally inverting Goya's vision of all-too-human monarchs.

How to represent a modern head of state in a postrevolutionary era was, in fact, a problem faced by many artists not only in France, but especially in the young United States of America, where the first president, among other founding fathers, had to be commemorated for posterity. When in 1796 in Philadelphia, the American portraitist Gilbert Stuart (1755–1828) was commissioned by the English Whig Lord Lansdowne to make an enduring, official portrait of George Washington, he moved from his customarily immediate and informal approach to portraiture to something more literally stately which might resonate with the authority of Washington's role as the general-hero who had become the venerated president of a new republic (fig. 50). Just as David and Ingres provided their Napoleonic images with rich allusions to earlier achievement and power, so too did Stuart raise his sitter to a historical pantheon. Seen addressing Congress for the last time,

Fig. 50 **Gilbert Stuart**, *George Washington*, 1796. Oil on canvas, 96¼ × 60¼". Pennsylvania Academy of the Fine Arts, Philadelphia.

Washington strikes a pose that recalls a rich pedigree of everything from Roman imperial portraiture, in which an outstretched hand suggests both legal and military authority, to the grand full-length portraits of the French Bourbon court, from Louis XIV to Bishop Bossuet, as rendered by Rigaud. And in this tradition, Washington is surrounded by symbolic attributes of his and his country's public life—the sword, the still life of quill and papers, the American eagles and fasces on the leg of the writing table. Painted just before the advent of Napoleon, Stuart's Lansdowne portrait, whose official importance demanded many replicas, clearly introduces the difficulties and the often awkward resolutions of the modern artist's image of a temporal ruler chosen by the people and not of a divine monarch. We sense here both the rupture in tradition and the noble effort to resurrect it in what was hoped to be a brave, new world. In the case of Washington's image, it was an effort that was to reach almost Ingresque extremes of deity in the famous

Fig. 51 **Pierre-Paul Prud'hon**, *Portrait of Empress Josephine*, 1805–09. Oil on canvas, 96 × 70½". Louvre, Paris.

posthumous marble of the president by Horatio Greenough (see fig. 193).

Other alterations of earlier traditions can be sensed, too, in the portraiture of the public figures of the time. There is, for one, the surprising full-length portrait of Empress Josephine (**fig. 51**) by Pierre-Paul Prud'hon (1758–1823), an artist in whose work so many languorous new moods can be felt. Begun in 1805, just after her coronation and still incomplete in 1809 at the time of her divorce from Napoleon, it records not the public persona we might expect from a large painting of the new Empress of France, but a private glimpse of her alone in a wood in the grounds of Napoleon's house at Malmaison just outside Paris. Instead of meeting our gaze or staring us down, she turns away, preoccupied with her own thoughts. Even though she wears a double diadem and a fashionable white Empire dress, she seems to be caught in so private and informal a mood that we almost become stealthy intruders. The slow, serpentine rhythms of her red cashmere shawl and her elegantly attenuated body (so close to the female figural canons in Canova's sculpture; see figs. 95 and 98) suggest, with a gesture of hand poised on head, a dreamy lassitude that belongs to the introspective range of Mme. Charpentier's

Melancholy (see fig. 45). Indeed, Prud'hon, too, uses a natural setting as a sounding board for emotions. Except for the glimpse of a rectangular classicizing base and vase at the left, a reminder of the formal, man-made world to which Josephine belongs, all is simple, unspoiled nature. Moss grows on the rugged rocks the empress uses as a chair, the flowers she studied as an amateur botanist bloom beside her, and in the background, clumps of trees are silhouetted mysteriously against a twilit sky, whose darkening tones provide a landscape corollary to the sitter's downcast mood. Far from the demands of state occasions, Josephine finds in untamed nature a refuge for what seems her somber meditations. Prud'hon's interpretation of the empress would hardly be alien to the image of a Romantic writer of her time, of a Chateaubriand or a Wordsworth in lonely reverie.

In the search for more intense emotions, extremes of passivity alternated with extremes of violence. For French artists working under Napoleon, the official demands to record the glorious moments of his military campaigns provided an especially rich vehicle for the exploration of uncommon experiences, both harrowing and heroic. Early in his career, Napoleon realized the propagandistic value of having France's finest artists commemorate his and his army's most heroic deeds, and less than three weeks after the hair-raising but victorious battle at Nazareth, on April 8, 1799, he decided that a contest should be held for the best painting of the combat. When the contest was finally organized, in 1801, the jury's decision was unanimous. The prize was won by a young student of David's, Antoine-Jean Gros (1771–1835), who had already recorded Napoleon's heroism during the Italian campaigns. The lessons of Gros's master, David, seem so remote in Gros's large painted sketch (**fig. 52**) that we can hardly recognize the pedigree, especially by comparison with David's almost contemporary painting of *Napoleon at St.-Bernard* (see fig. 22). Instead of a frozen icon, Gros offers us the heat of battle, an orgy of bloodshed so instantaneously engulfing and chaotic that we can hardly get our bearings. Like Copley's *Death of Major Peirson* (see fig. 6), the *Battle of Nazareth* purports to present a cinematic truth, a split-second record of the brutal but potentially glamorous facts of war for the spectator at home to savor vicariously. But Gros, unlike Copley, explodes the ideal choreography of battle into a bewildering tumult of gunpowder, scorching desert sand, slashing sabers, thrusting bayonets, rearing horses, and exotic costumes. Only when the dust settles can we begin to piece out some of the harrowing action that characterized the stunning victory in the Holy Land of French troops, just five hundred strong, led by General Junot against a combined Turkish and Arab force of some six thousand men. The hero, Junot, is seen only in the distance (at the left, on a white horse), defending himself with his saber against attacking Mamluks; but this life-and-death skirmish

Fig. 52 **Antoine-Jean Gros**, *Battle of Nazareth*, 1801. Oil on canvas, 54 × 78″. Musée des Beaux-Arts, Nantes.

is only one small episode in a desert battlefield that teems with grisly sights, like the fresh corpses of a French soldier and an Arab horse in the immediate foreground or the agonizing, sword-point desperation, in front center, of an Arab about to be slain. To add to this confusion of narrative event, French soldiers at the right are shooting outside the confines of the painting, whereas at the left, a terrified horse, his tail and mane a blur of paint, rushes outward in the opposite direction.

All sense of major and minor is lost in this centrifugal eruption of violence and death, and although the painting is meant to document and to venerate the heroism of Napoleon's army, the scene has almost a fictional character of carnage in some exotic locale. Indeed, the splendor of the Mamluks' military costumes, like the parched slopes of Mount Tabor, where the battle took place, lend the enchantment of a travelogue to a record of human courage and brutality. For Gros, the Near Eastern setting seemed to permit a relaxation from the rigors of Davidian training and an excuse to explore, among other things, an almost molten brushwork and a hot, sunbaked atmosphere that thaws the glacial emblems of David and leaves us stunned by the emotional and visual potentials of a language of impulse,

movement, and disorder. For all its insistence on journalistic, military fact, and for all its patriotic message, Gros's plunge into the spectacle of hell on earth is not so different from West's vision of the horsemen of the apocalypse, seen just one year later in Paris (see fig. 39). The *Battle of Nazareth*, in fact, was prophetic, for after 1815, it was to become a touchstone of inspiration for the great rebels of French Romantic painting—for Géricault, who paid one thousand francs for the privilege of copying it, and for Delacroix, who praised it in his 1848 essay on Gros.

Like David, Gros venerated Napoleon, and in subsequent paintings, he presented a virtual sanctification of his patron's charity, nobility, and heroism. For the Salon of 1804, he recorded another episode from the Near Eastern campaigns of 1799, but one that takes us from the unfocused turbulence of the battlefield to a solemn tribute to Napoleon's supernatural courage. This time, a whitewashing was demanded, for in fact, at the city of Jaffa, Napoleon had ordered the shooting of countless prisoners whom he could not afford to house or feed. Conditions then worsened with the outbreak of bubonic plague, which spread among both French and Arabs. Acting out his own legend as almost a divinity on earth, Napoleon entered the

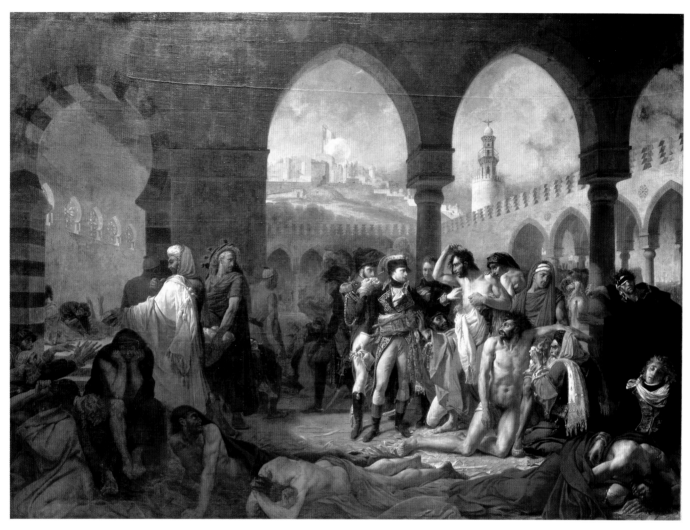

Fig. 53 **Antoine-Jean Gros**, *Napoleon in the Pesthouse at Jaffa*. Oil on canvas, 17′ 5½″ × 23′ 7½″. Louvre, Paris.

pesthouse at Jaffa on March 11, 1799, and tried to calm the growing panic by demonstrating that he was unafraid of contagion. He walked among the plague-stricken and comforted them, and presumably, he was even willing to touch the buboes of some of the victims in order to prove how exaggerated the fear had become. Gros's interpretation of this myth-making event (**fig. 53**) follows many earlier paintings of contemporary history in its translation of traditional Christian imagery into modern experience; but it does so with a vivid originality that almost re-creates heaven and hell. The foreground of the painting is strewn with the agonized bodies of the dead and the dying, whose semi-nudity makes associations with a Dantesque inferno or a Last Judgment all the stronger. Within this realm of the damned, Napoleon has entered with what seems not only immunity to disease, but also a miraculous power to heal, as if Christ himself or a traditional plague saint like St.-Roch had been resurrected in 1799 in the form of the leader of France. And if the image of Napoleon's miracle-working powers evokes Christian imagery, including even the conventional grouping of Christ and the doubting Thomas, so too does it

reawaken traditional Western belief in the divine touch of kings, who, even during the Age of Enlightenment, were popularly considered to embody supernatural gifts of healing. Even more than David, Gros helps to add extravagant pedigrees, both Christian and monarchic, to his ruler, and at an especially opportune time. By 1804, five years after the fact, the legend had grown in magnitude, and at the Salon, it must have helped to bolster Napoleon's almost supernatural qualifications for sitting, as he was to do by the end of the year, on an imperial throne. Gros shows him imperturbable and fearless amid a scene of such revulsion that even the officer behind him holds a cloth to his face to stave off the stench. Around this holy figure, there is almost an uncanny awe and luminosity among those who have the strength to observe the miracle; and at the extreme right, a blind man, supporting himself by a column, tries to approach the general.

That the legendary scene occurs in faraway Jaffa, in the Holy Land, certainly contributed to its credibility; and Gros, expectedly, amplified the picturesque aspects of the miracle's environment. The horseshoe arches and pointed

arcades of the mosque courtyard provide a piquant variation on the familiar Greco-Roman architecture of David's noble settings, and the steep background vista of minarets and white cubic houses translates Poussin's architectural landscapes into a colorful new dialect. As for the harsh, glaring sunlight of the Holy Land, as it intensifies the lush hues of the strange native costumes with their turbans and patterned shawls, this further adds to the almost fictional glamor and sensationalism of the scene. Unlike Goya, who presents human horror with an ugly, unidealized immediacy, Gros veils his journalistic truths in exotic luxury and idealized, Michelangelesque terror. And unlike Goya, whose image of traditional Christian morality in *The Third of May 1808* (see fig. 34) is shrilly assaulted by the outrage of one who has seen it ruthlessly destroyed, Gros preserves conventional moralities by suggesting in his narrative structure of good and evil that the horrible means of war are nevertheless justified by the noble ends of Napoleonic mercy and courage. But as clear as this patriotic message is, Gros's painting also permitted, via the documentation of contemporary history, a virtual invasion of experiences that could take the spectator to a remote and sensuous world. The Near Eastern costume and architecture, the heated colors, the shattering extremes of physical and psychological sufferings—all provided a vicarious escape from the everyday realities of Paris, an escape that, for later generations, would delete entirely the political content and let the artist and spectator wallow in a distant travelogue, far from the prosaic sights and constraints of nineteenth-century life in the West.

Even under Napoleon, many artists favored with governmental commissions were happy to turn away from imperial glory to a less politicized realm. Ingres, for instance, could switch easily from the resurrection of his emperor as the Olympian Jupiter back to the classical source itself; for in the same year, 1806, he had begun to contemplate a work illustrating the passage from the *Iliad* that tells of how the nymph Thetis begged Jupiter on Olympus to aid her son Achilles in the wars taking place on earth (fig. 54). The painting was completed in 1811 in Rome, where Ingres had been living for five years at the French Academy as a winner of the Prix de Rome. Although it relocates the enthroned Napoleon to his proper origins, a well-known archaeological reconstruction of Phidias' statue of Jupiter, the painting is no less startling in its fantastic excursion to a world of primitive mythology, both terrifying and sensual. Cloud-borne, like Girodet's *Ossian* (see fig. 48), it takes the spectator to a literally Olympian height where we are confronted by Jupiter in all his omnipotent grandeur. Guarded by his symbolic eagle and spied on, at the left, by his jealous wife, Juno, he seems to have reigned for all time in splendid symmetry. In drastic contrast to this immutable giant with his ferociously leonine head, the nymph Thetis, like a cooing bird, is all quivering mobility

and supplication. Viewed in profile against her god's frontality, she seems made of an eroticized, malleable flesh, which can swell and contract around him in a desperate entreaty. The contours of her profiled body, like those of some marine creature, ebb and flow, creating astonishing anatomical distortions (the goitrous throat, the elbowless arms, the invertebrate hand). Ingres has virtually re-created the human form as a vehicle of sensual manipulation and of an abstract linear pattern that, as in the outlines of Flaxman (who illustrated this and comparable scenes; see fig. 42), has an archaic quality appropriate to the Homeric subject.

Nominally Neoclassical, *Jupiter and Thetis* is a fantastic invention, not only in the clash of fearful, masculine power against highly charged feminine sexuality, but in the irrationality of this archaeologically erudite reconstruction of the Homeric world. Gravity is defied (Juno, Jupiter's left arm, and the throne itself float effortlessly on clouds); space is bizarrely contracted (Thetis fits, like the relief on a cameo, into the oddly shallow cavities of Jupiter's mighty torso and lap); figural size is arbitrary (Thetis is a pygmy next to the gigantic Jupiter); and even the level of perceived reality is contradictory (some passages of drapery, relief carving, and flesh are rendered with almost photographic minuteness of glossy, palpable detail, while others, like Thetis' Greek profile and engorged neck, are total fictions). As Ingres's obligatory Roman school piece, to be sent back to Paris for academic examination, *Jupiter and Thetis* startled the authorities, who found his reincarnation of the oddly "primitive" stylizations of early phases of Greek or Italian art, with their simple outlines and flattened spaces, eccentric deviations from proper classical canons. But as was to be the case with many artists of the nineteenth and twentieth centuries, Ingres's espousal of a more "primitive" mode was a highly sophisticated choice whose complex results may belie the simplifying intentions. Throughout his long and ever more official career, which cast its shadow on the entire century, Ingres would explore with unparalleled subtlety what seemed to be the purifying stylistic regressions of painting in earlier phases, whether Northern European or Mediterranean—on the one hand, an intense, sharp-focus surface description of the visible world; and on the other, an equally intense abstraction of the linear arabesques that define a form.

Given the stylistic diversity of David's own art, it is no surprise to find how many different directions his students could pursue, evoking an entire history of Western art, from the limpid purity of Greek vase painting to the muscular energies of Rubens. Some students—often including Ingres himself—even followed the growing penchant for medieval painting and subject matter, a taste which had already taken root in the late eighteenth century but which, in France, had been temporarily squelched by the revolutionary hatred for anything reminiscent of a Christian

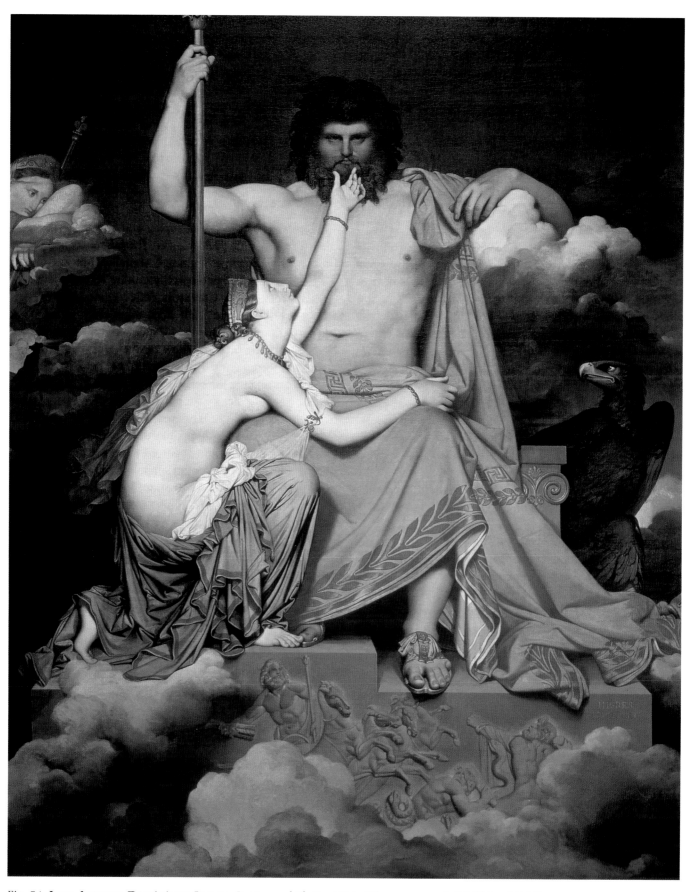

Fig. 54 **Jean-Auguste-Dominique Ingres**, *Jupiter and Thetis*, 1811. Oil on canvas, 10′ 10⅝″ × 8′ 5¼″.
Musée Granet, Aix-en-Provence.

civilization (a hatred which had resulted in the vandalizing of many French Gothic buildings). But peace with Christianity was to be quickly re-established, and after Napoleon's Concordat of 1801, by which Catholicism once more became the official religion of France, many artists continued to be drawn to a world which must have seemed as remote as that of Homer and Ossian and which was given renewed aesthetic and religious magic through Chateaubriand's literary veneration of medieval faith, *The Genius of Christianity*, published in 1802.

It was primarily two of David's students from Lyons, Pierre-Henri Révoil (1776–1824) and Fleury-François Richard (1777–1852), who propagated what was later to be dubbed the Troubadour Style, that is, a pictorial style and subject that were meant to revive the look of art and life in the Middle Ages. Révoil's *Tournament*, seen at the Salon of 1812, exemplifies the mode (**fig. 55**), disclosing a highly polished vision of chivalric pageantry, in which the kind of archaeological erudition David had applied to his reconstruction of a Greco-Roman world is now used to reconstruct a scene in fourteenth-century Rennes. In an accompanying text, Révoil carefully explained to the Salon visitor the details of the joust, in which a mysterious, invincible knight is suddenly disclosed to be the great Bertrand du Guesclin. Révoil, who even composed medieval romances, is scrupulous about his historical detail, from the Gothic architecture (both sacred and secular) and gleaming coats of arms to the inscriptions in old French (A BIAUX FAIOTS, BIAUX LOS—"For fine deeds, fine praise") on the two pennants that wave, in fairy-tale rhyme, above this enchanting scene.

Artists in the late eighteenth century, such as West and Durameau (see figs. 8 and 13), had painted and engraved many episodes from medieval history and legend, but their styles seldom attempted to conjure up the look of the actual art of that period. For Révoil, however, a style appropriate to the subject was necessary, and here he reconstructs the dollhouse world of those late Gothic illuminated manuscripts and paintings which had begun to be esteemed throughout Europe. In the center, David's

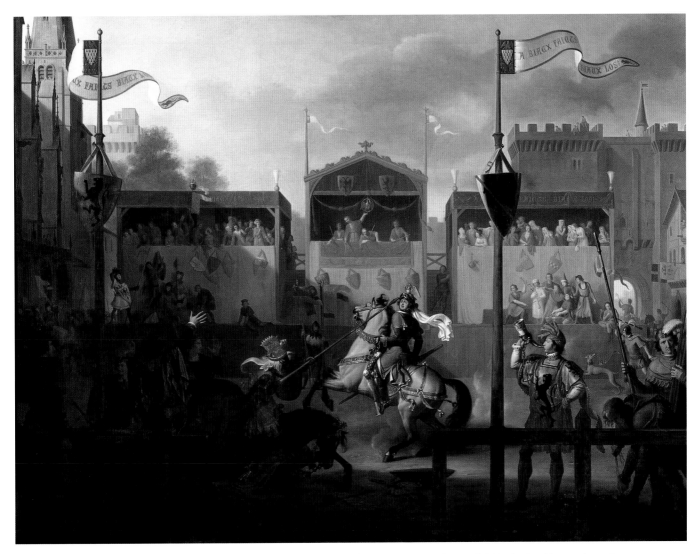

Fig. 55 **Pierre-Henri Révoil**, *The Tournament*, Salon of 1812. Oil on canvas, 52¾ × 69″. Musée des Beaux-Arts, Lyons.

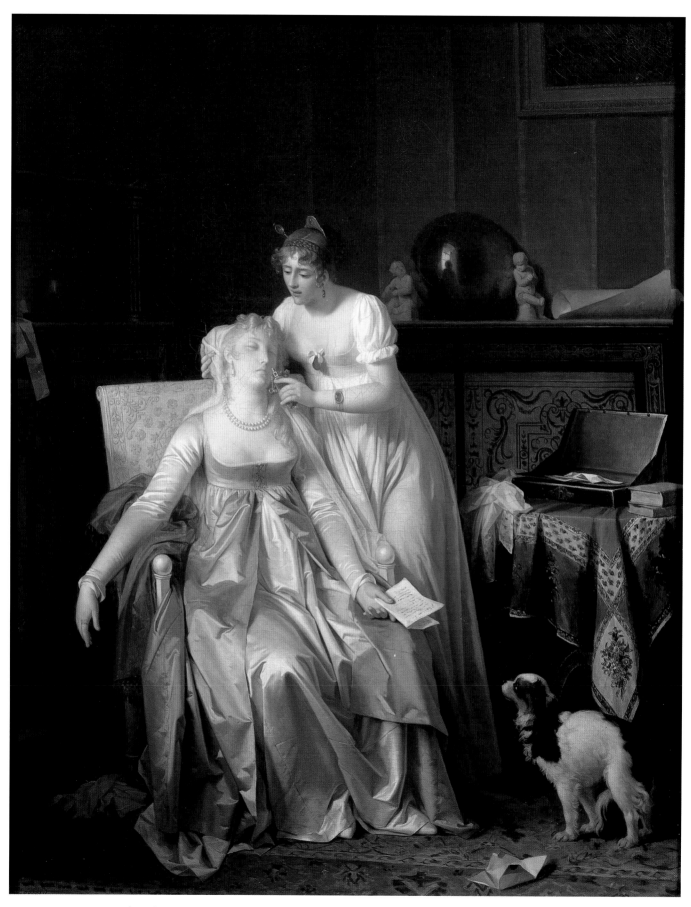

Fig. 56 **Marguerite Gérard**, *Bad News*, Salon of 1804. Oil on canvas, 25½ × 20¼″. Louvre, Paris.

Napoleon at St.-Bernard (see fig. 22) almost seems to have been re-created through the wrong end of a telescope, transformed now into a medieval knight jousting in a Gothic fantasy of clockwork precision. Within these diminutive spaces so tidily defined by the rectilinear setting, everything glistens like a precious object. The local colors, reduced to tiny areas, have the blazing intensity of brightly lit gems in a museum case, and the meticulous description of richly ornamental surfaces conjures up the painstaking craftsmanship of those medieval liturgical objects which had survived the pillaging of the Revolution. Here the Middle Ages, far from evoking an era of monstrous ignorance and superstition, could turn into an entrancing world, where art, faith, and craftsmanship were beautifully united. Révoil's vision, in fact, was one of many prophecies of the recurrent belief that medieval art and life could somehow come to the aid of the growing problems of a modern society.

Like the architects of the time who could so easily adapt a wide range of Western and non-Western styles to their repertory, painters, too, became masters of art-historical paraphrase, seeking inspiration, as we have seen, in the most varied and even contradictory sources—Phidias, Rubens, Poussin, Greek vase painting, Italian primitives, medieval manuscripts. One of the less conspicuous modes of this kind of stylistic revival pertains to the look as well as subject of those "little Dutch masters" of the seventeenth century who were concerned with the minor pleasures of a prosaic middle-class world. For French audiences, in particular, a relief was needed from the high-minded subjects of revolutionary or Napoleonic history, Greco-Roman heroism, or imaginative literature; and the Salons of the time were filled, in fact, with more modest paintings of still lifes or charming genre episodes, usually executed in that meticulously sharp-focus style which often created a materialistic environment for the ideal forms of David's own Neoclassical painting or for the heroic episodes of Napoleonic history.

Visitors who paused in awe over the miraculous drama of Gros's *Napoleon in the Pesthouse at Jaffa* (see fig. 53) could find at the same Salon of 1804 paintings that originated in another world entirely, whether of fasionable groups in the public places of Paris, as represented by Louis Boilly, of wonderful objects like alabaster vases and birds' nests, as represented by Antoine Berjon, or of sweet or mildly distressing anecdotes from domestic life, as represented by Marguerite Gérard (1761–1837), whose *Bad News* (**fig. 56**) may typify the mode. A pioneer in the development of this elegant genre style, Gérard learned to polish and to quiet the impulsive Rococo brushwork of her famous brother-in-law Fragonard in favor of a lucid, mirror-like image clearly inspired by such seventeenth-century Dutch masters of upper-class genre scenes as Metsu and Ter Borch. Although the unspecified content of the lady's missive is apparently grave enough to call for the use of

smelling salts, her swooning predicament is clearly a minor parlor charade, of no greater seriousness than the mournful expression of the pet spaniel. We are quickly moved from this gently lachrymose episode (probably a disappointment in love) to the material wonders of the anonymous heroine's exquisite costume and home, a discreet profusion of Persian carpet, satin, pearls, and flocking all rendered with the kind of glossy miniaturist perfection that is exemplified in the optical marvel of a distorted mirror reflection in the glass globe behind the standing confidant. Like Révoil's *Tournament*, it takes us to a diminutive world of lacquered refinement. Far from the masculine heroics of Napoleonic history paintings, its aura of feminine domesticity belongs to the growing realm of pictures oriented for wealthy, private consumption. Unpretentious as they are, pictures like *Bad News* represent a major undercurrent in early nineteenth-century art. Their consequences, in the form of carefully executed paintings of minor domestic dramas played out in wealthy middle-class interiors, were to be found throughout the nineteenth and even twentieth centuries, crowding the walls of homes and salesrooms.

Varieties of Landscape Painting

In many paintings of the late eighteenth and early nineteenth centuries, as in the natural environments designed for the architecture of the period, landscape plays a vibrant role as a resonator for the mood at hand. Willows weep with Mme. Charpentier's melancholic figure (see fig. 45); volcanoes erupt behind Wright of Derby's resolute Indian widow (see fig. 3); idyllic meadows are suffused with quiet light in Broc's *Death of Hyacinth* (see fig. 46). In fact, from the mid-eighteenth century on, landscape was to become a vehicle for as wide a range of emotional and pictorial exploration as art dominated by human events.

By the 1770s, many landscape painters had begun to seek out aspects of nature that broke with formulas inherited from the seventeenth century, and we have already seen how William Hodges, in 1776, stretched a Western landscape pattern to accommodate the newness of a South Pacific paradise (see fig. 2). Given the search for sublime experiences of terror and awe, it is no surprise to discover that one of the great new themes of landscape painting, not to mention of the new metaphors of Romantic writers from Rousseau to Shelley, resided in the splendor of mountains. Before the Romantics, mountain ranges, and most conspicuously the Alps, were usually considered ugly assaults to refined visual sensibility, as well as unfortunate hindrances to easy travel. It was only from the mid-eighteenth century on that such marvels of landscape could become visual and emotional ends in themselves, goals rather than obstacles. Predictably, it was a Swiss artist, Caspar Wolf (1735–83), who was among the first to look at, rather than

Fig. 57 **Caspar Wolf**, *Snow Bridge and Rainbow in Gadmental*, 1778. Oil on canvas, 32¾ × 21½″. Kunstmuseum, Berne.

away from, the Alps as a great subject that could elicit uncommon emotional responses to remote natural phenomena clearly beyond the grasp of human reason. In his view of the Rosenlaui region near Berne of 1778 (**fig. 57**), a pair of mountain climbers and their dog are reduced, in the foreground, to Lilliputian scale as tier after tier of breathtaking natural spectacles ascend to dizzying Alpine heights. First, the Reichenbach River emerges in a natural gorge, framed by a rainbow arcade that provides the only geometric anchor in a scene of wild irregularities. Above this zone, a more distant dark range is seen, topped by almost invisibly minuscule silhouettes of figures and animals; and finally, in the uppermost zone above the pine trees, the inaccessible twin peaks of the most remote mountains crown the vista. This steep vertical ascent, with its virtual

rejection of a rational perspective space, takes us beyond man's domain to a strange environment, fit no longer for human, animal, or even botanical life, but only for the contemplation of the mysteries of nature in its wildest, most irregular forms.

Even stronger stuff was sought out by other late eighteenth-century artists, especially by those in Naples who could observe with rapt wonder the eruptions of Vesuvius, which, in the nick of time for these new spectators of sublime nature, was especially active in the 1770s. Such an experience lies behind a volcanic fantasy of about 1780 by the Austrian Michael Wutky (1739–1822), who shows himself with his sketchbook at the very rim of this hellish fury, his arms thrown back in awe as his guide turns to flee (**fig. 58**). Before this sulfurous inferno, in which smoke and

rock, blinding flame and inky shadow merge into one molten vortex, we, too, are meant to be terrified by nature's apocalyptic potential, a vision of disaster that might evoke not only the destruction of Pompeii in 79 A.D. or of Lisbon in the earthquake of 1755, but also of biblical catastrophes. Dense with such associations—from science-fiction fantasy and actual historical disasters to the power of some vengeful deity—Wutky's painting prophesies the nineteenth century's exploration of nature in its most primordial and malevolent aspects.

Such a view of nature's awesome power could even be imposed upon man-made spectacles, like the astonishing new sights of England's growingly industrialized countryside. Tourists, both native and foreign, often added to their itinerary of British mountains and waterfalls the unfamiliar thrills of mechanized furnaces, factories, and mills, which could produce *son et lumière* spectacles almost worthy of Vesuvius itself. An artist to exploit this odd phenomenon was the French-born Philip James de Loutherbourg

(1740–1812), who settled in London in 1771, and in 1781 began to produce, in addition to many paintings, theatrical performances that imitated, with complex light and scenic effects, a vast repertory of wondrous things, from biblical deluges, modern shipwrecks, and the Great Fire of London of 1666, to Neapolitan sunsets, the Niagara Falls, and Derbyshire gorges. In his *Coalbrookdale by Night* of 1801 (**fig. 59**), de Loutherbourg offers a pictorial visit by moonlight to one of the first monuments of the Industrial Revolution, the Shropshire iron foundries, established by Abraham Darby as early as 1709, where pig iron was smelted by the use of coke. In the foreground, we first see remnants of the kind of quaint, pre-industrial village extolled by such painters and writers as Gainsborough and Goldsmith: a peasant mother and child at the left stand below a ramshackle, rustic house, so often imitated in contemporary garden architecture, while dray horses pull a cart across a dirt road. But even within this pastoral, there are huge cylindrical pieces of cast rion littered about, like architectural fragments of a

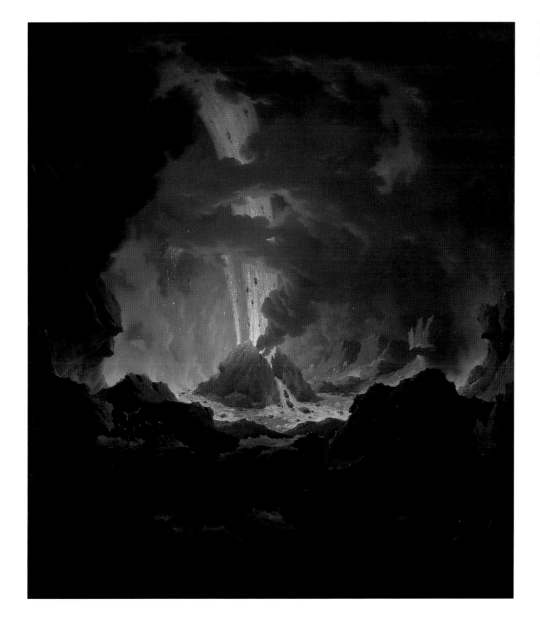

Fig. 58 **Michael Wutky**, *Volcanic Eruption*, c. 1780. Oil on canvas, 54¾ × 48½". Kunstmuseum, Basel.

Fig. 59 **Philip James de Loutherbourg**, *Coalbrookdale by Night*, 1801. Oil on canvas, 26¾ × 42″. Science Museum, London.

remote civilization, and beyond we see, from a safe distance, a stunning pyrotechnical explosion of gold-red, billowing smoke clouds that belch forth from the mills and then merge dramatically at the right with a silvery-blue patch of full moon and natural cloud. In 1801, in the early years of the Industrial Revolution, it was still possible to see factories as part of what the period called "Romantic" scenery, and to ignore the appalling lives of the adults and children who worked there or the blighting effects these symbols of progress were to have upon adjacent towns and countryside.

De Loutherbourg's theatrical vision of a factory is closely allied to the fantasy excursions to remote places created by his French contemporary Hubert Robert (1733–1808), who specialized in re-creations of the true or imaginary remains of ancient and modern civilizations, where tiny figures wander among the ruins like displaced persons from another era. In 1798, Robert painted a haunting vista of the great monuments of Egypt (**fig. 60**)—the three pyramids of Gizeh and the Sphinx—in a historical moment so imprecise that it can combine, in shifting memory images, what seem to be musicians and wanderers in modern peasant costume with dancing figures who wear classical costumes appropriate to some Bacchic rite. These maidens encircle the broken shaft of an obelisk whose upper half has fallen to

the ground, perhaps recently, perhaps centuries ago. Around this fluid historical spectacle of the remote wonders of Egyptian civilization, nature creates an omnipotent and timeless ambience, so that the vast sweep of desert and the darkening storm clouds become the ultimate heirs to man's most staggering achievements. Even the awesome pyramids, whose purified geometry and sublime scale often inspired the prospective, utopian designs of such contemporary architects as Boullée, may prove to be as ephemeral as the broken obelisk. Past and future merge in a melancholic but thrilling fantasy that unravels before us like one of de Loutherbourg's theatrical extravaganzas. That Robert's painting was probably inspired by the mounting excitement in France over Napoleon's imminent Egyptian campaign is testimony to the period's constant merging of contemporary fact and imaginative fiction. Both factories and pyramids could become the catalysts for Romantic speculations on the mysteries of man, history, and nature.

The spectacular orchestration of multiple and diverse components found in de Loutherbourg's or Robert's panoramic vistas was only one side to the new exploration of the wonders of nature. Especially in England, many artists had more modest, limited visions that concentrated on the particular truths of observed facts. One of the oldest

Fig. 60 **Hubert Robert**, *Young Girls Dancing around an Obelisk*, 1798. Oil on canvas, 47¼ × 39″. Musée des Beaux-Arts/ Museum of Fine Arts, Montreal.

of these, Alexander Cozens (1717–86), composed a treatise called *A New Method of Assisting the Invention of Drawing Original Compositions of Landscape*, which, published in 1785, was to present to young landscape painters a systematic glossary of individual aspects of nature, such as mountain-tops or close views with little sky. He was inevitably concerned with varieties of cloud formations— weather phenomena so conspicuous to an observer living under the low and changing skies of Britain—and recorded them for his treatise. In one of these preparatory studies (fig. 61), a small gray-and-black wash drawing, we glimpse an intense fragment of nature: billowing cumulus and streaky cirrus clouds at sunset, seen over a darkening landscape. In his isolation and study of these ephemeral aspects of the sky, Cozens shared the concern of such later meteorologists as Luke Howard, who in 1803 began

Fig. 61 **Alexander Cozens**, *The Cloud*, c. 1775–85. Gray-and-black washes on thin india paper, 8½ × 12½″. Tate Britain.

Fig. 62 **Thomas Jones**, *Buildings in Naples*, April 1782. Oil on paper, 5½ × 8½". National Museum of Wales, Cardiff.

publishing his basic classifications of cloud types, and once again demonstrated the frequent compatibility in the work of artists of his period between nominally scientific documentation and images that also convey a profound empathy with the marvels of nature. For, like Stubbs, whose animals belong to the realms both of zoological fact and of Romantic emotion (see fig. 37), Cozens found in clouds and other natural phenomena something mysterious, beautiful, and free, far from the rational confines of man-made environments. Small wonder that later landscape artists, most conspicuously John Constable, followed his lead in their accurate, but nonetheless heartfelt records of shifting cloud patterns in the liberating, uncharted regions of the sky above.

In their search for new empirical truths, many landscape artists observed things with such seeming directness that we may even feel cut off from traditional concepts of style or art. We often sense this in the on-the-spot views of Neapolitan buildings recorded by the Welsh artist Thomas Jones (1742–1803) from adjacent rooftops or verandas. In one of these, inscribed April 1782 (fig. 62), the small oil-on-paper sketch is almost the equivalent of a viewfinder, through which we seem to see exactly what lay before Jones's own eyes at a particular time and place. What we focus on is of no greater consequence than a near-and-far glimpse of vernacular buildings, cubic and spherical; and the surprisingly arbitrary cut-off points at the framing edge insist on the casualness of the view. The most literal details are also recorded, from the streaked paint, patched stucco, and balcony door on the near facade, to the passing cloud formations that extend past the restricted field of vision. Yet Jones's seeming naïveté and artlessness, so prophetic of the Realist impulses of the mid-nineteenth century, were clearly a matter of choice, for he also painted pictures in

more conventional landscape modes derived from masters like Salvator Rosa and Jones's own teacher, Richard Wilson. Moreover, this ostensibly ingenuous record of simple things seen in a simple way artfully transcends documentary fact in its remarkably unforced rendering of geometric planes and volumes. In his intuitive ability to impose upon the prosaic data of things seen a timeless Mediterranean order of measured, almost abstract spaces in a limpid atmosphere, Jones unpretentiously rejuvenates a classical landscape tradition. It was an achievement to which other Northern artists working in Italy, from Pierre-Henri de Valenciennes to Camille Corot, contributed. In effect, they were already redoing Poussin after nature, foreshadowing a goal Cézanne would set for himself in the later nineteenth century.

The freshness and modesty of Jones's vision were shared by many British artists at home, some of whom, like John Sell Cotman (1782–1842), captured in small oils, watercolors, or etchings the humblest, most easily overlooked facts of the countryside. In a view of a crumbling farmhouse of about 1809 (fig. 63), Cotman pauses to record the kind of homely, rural sight that Wordsworth was beginning to describe in his poetry, and does so with such an absence of pictorial rhetoric that we again feel an almost one-to-one relationship between what we see and what was seen. Although Cotman himself extracted more overtly dramatic associations from famous architectural ruins, especially of Gothic buildings in England and in France, here he works, as it were, in an unaffected, direct style equivalent to the simple poetic diction, the language of common men recommended by Wordsworth in his famous preface to the *Lyrical Ballads* of 1798. For another artist, the abandoned, dilapidated farmhouse could easily become the vehicle of many Romantic associations about man, time, nature, but its

Fig. 63 **John Sell Cotman**, *A Ruined House*, c. 1809. Watercolors over pencil, 13 × 10¾″. Ashmolean Museum, Oxford.

rendering by Cotman on a brilliantly sunny day is so straightforward that such melancholy speculations are here put in abeyance. We are suddenly taught to respect the most ordinary of rural facts conveyed in what purports to be an honest layman's style, innocent of the false rhetoric of inherited conventions. It was a goal, as we shall see, sought by countless nineteenth-century painters who wanted to rejuvenate landscape painting by looking more at nature than at art.

For many Northern artists around 1800, the traditions of Dutch seventeenth-century landscape masters like Hobbema and Ruisdael provided support in the pursuit of the more humble and transient phenomena of nature. So it was with the French master Georges Michel (1763–1843), who, like many of his contemporaries, could turn his interest away from the compelling political and social events of the period to contemplate the more timeless world of landscape and agriculture. It was probably about 1794, the year David was imprisoned for his political beliefs, that Michel painted nothing more eventful than a passing storm somewhere in the rural suburbs of Paris, where he lived

(fig. 64). As in many earlier Dutch landscape paintings, we see more sky than earth, in this case a swift movement of darkening clouds that cast ephemeral patches of light and shadow over a panoramic sweep of cultivated land. Farm animals and the silhouette of a windmill are dimly discernible in the foreground; but such details are finally subsumed in what seems almost an instantaneous, impulsive record of nature at its most dramatic. Especially when considered within the context of Davidian academic ideals, Michel's painting seems a startling intruder, not only in the remarkable looseness and breadth of its brushwork, but in its very willingness to interpret so homely a subject with such brooding grandeur. Suddenly, human passions seem to be relocated in the most ordinary sights of rural landscape.

In the late eighteenth century, landscape could also aspire to the noble realm of Greco-Roman history and legend, an ambition reflected in the work of Pierre-Henri de Valenciennes (1750–1819). Like his contemporary David, he spent most of the critical years of his artistic education in Rome, where he lived off and on between 1777 and

Fig. 64 **Georges Michel**, *A Storm*, c. 1794. Oil on panel, 15¾ × 22¾".
Musée des Beaux-Arts, Nantes.

Fig. 65 **Pierre-Henri de Valenciennes**, *A Landscape of Ancient Greece*, 1786 (Salon of 1787). Oil on canvas, 39½ × 60".
Detroit Institute of Arts.

1787; and like Thomas Jones, he was capable of executing surprisingly fresh studies of the buildings and landscapes of Italy. Yet he wanted to be not only an accurate observer of the Roman campagna, but also "the David of Landscape," recomposing the immediate data of his Mediterranean experience in complex, fictional reconstructions of a noble landscape in the historical past. In one of these, *A Landscape of Ancient Greece*, dated 1786 (**fig. 65**), nature is, as it were, elevated to the realm of David's own reconstructions of ancient Greece, such as the *Death of Socrates*, which in fact was seen with Valenciennes's painting at the 1787 Salon. Although rugged mountains and waterfalls (the potentially terrifying components of sublime nature) are present here, all is subordinated to the rational control of human civilization, whose works—temples, dams, statues, fountains, villas—serenely measure out the rectilinear volumes that carry us stepwise to the edge of a less cultivated landscape beyond. A golden vision of Greco-Roman antiquity seems reborn here, re-creating for the moment an Arcadian world that, like Hodges's vision of Tahiti (see fig. 2), appears magically distant in time and space. In its heroic tenor, further humanized by the presence of figures

in ancient costume, Valenciennes's painting resurrected, as contemporary critics noted, the classical landscape tradition of Claude and Poussin; but in its somewhat melancholy flavor of an inaccessible dream, it explores the new Romantic potential of investing landscape with rich associations about the passing of time, about the poignant gulf between past and present, between man's work and nature's omnipotence. It is not surprising that in an imaginary view of the Greek colony of Agrigento exhibited together with this painting, Valenciennes littered the foreground with the ruins of a classical temple—a reminder, like Edward Gibbon's *Decline and Fall of the Roman Empire* (1776–83), of the transience of a long-lost civilization only retrievable in art and memory.

Valenciennes's successful efforts were symptomatic of the way nature, by the turn of the century, began to convey for artists, as well as for writers, musicians, and travelers, an ever-increasing body of emotions and speculations about man's place in a cosmic scheme. German artists, in particular, pursued these dreams for landscape, sometimes turning to the Mediterranean, sometimes to the Northern European world for inspiration. In the case of Joseph Anton Koch

Fig. 66 **Joseph Anton Koch**, *Heroic Landscape with Rainbow*, 1805. Oil on canvas, 46½ × 45". Staatliche Kunsthalle, Karlsruhe.

(1768–1839), a shepherd boy who grew up in the Tyrol and was then trained in German academies, it was the lure of Italy and Greco-Roman antiquity that won. First drawing and painting his native mountains and waterfalls with an exquisite precision almost worthy of Dürer's own Alpine studies, he then moved south, settling in 1795 in Rome, where he was to remain for most of his life. In this, Koch followed a late eighteenth-century tradition of German expatriate aestheticians, like Winckelmann, and artists, like Mengs and Carstens (whose friend and student he was), who had happily fled what they considered the triviality and decadence of their mother country's art in order to take up residence in the Eternal City, where they could saturate themselves with the artistic relics of beautiful but alien civilizations, those of Greece and Rome and the Italian Renaissance.

Like Valenciennes before him, Koch took multiple landscape components, each based on close empirical observation, and put them together into a fictional whole redolent of a serene and harmonious world millenniums away from the devastating wars on the other side of the Alps. In *Heroic Landscape with Rainbow* of 1805 (**fig. 66**), Koch aggrandized an earlier, more literal observation of a view near Salerno into a mythical vision which he himself referred to as one of his "Great Greek Landscapes." Painted for Carnesecchi, the Italian owner of the Caffè Greco, a meeting place for Northern artists in Rome, it is, like the landscapes of Valenciennes or Hubert Robert, a kind of meditative time machine. The particular data of observed landscape in contemporary Italy are re-created in an Arcadian world where a shepherd in classical costume pipes away, sheep safely graze, and a verdant vista of landscape is crowned first by the rectilinear harmonies of a distant city that rises before the mountain ranges beyond, and then by the encompassing arc of a double rainbow (a fragment of the second rainbow is just visible in the upper right corner), which bestows nature's ultimate blessing on this fertile classical valley. Especially by contrast to such prototypes as Poussin's own imaginative reconstructions of a Greek landscape, Koch's Arcadian world is constructed in a new way. Implying a vista of great depth, it nevertheless seems shallowly contracted into ascending tiers, so that distant areas, like the antique city, have a surprising clarity and immediacy, whereas foreground areas, like the figures and sheep, seem diminutive and remote. This odd and intuitive shifting of scale between near and far, a disruption of the rational systems of continuous spaces plotted by one-point perspective, is a common phenomenon around 1800, when it often contributes to the emotional effect of something elusive and unattainable. Despite the limpid atmosphere and precise sculptural drawing, hard won through academic training, the landscape almost appears a distant mirage of composite images, each inspired by a different memory of the classical past.

The Nazarenes

For German artists as well as writers, the great traditions of the West began to be polarized between a classical Mediterranean tradition and a more spiritual Northern one that reached its apogee in the Gothic cathedral, whose origins were assumed to be German, rather than French, and whose symbolic embodiment of an art and society united in Christian faith could become for many a source of inspiration for the reform of nineteenth-century art and life. Goethe himself gave precocious definition to this viewpoint in his 1772 essay on Gothic architecture and the German spirit, though his first voyage to Italy, 1786–88, turned him into a fervent worshiper of Greece. Contrariwise, Germany's great champion of Romanticism, Friedrich Schlegel, began as an ardent admirer of exclusively Greek civilization, but in the 1790s converted to the art of a late medieval Christian world, and then even converted to the Catholic religion itself. This kind of conceptual duality between Christian and classical, Germanic and Mediterranean traditions was constantly reflected in the painting of the period. And for some artists, it was possible to reconcile Northern and Mediterranean traditions, at least under the common aegis of a late medieval art whose seeming purity of style and feeling were the product of a shared faith in Catholicism.

The clearest example of this surging enthusiasm among German artists for what then seemed to be a primitive Christian art is found in the work of an odd pair of painters, Franz Pforr (1788–1812) and Friedrich Overbeck (1789–1869), who had first met in 1808 at the Vienna Academy, where they chafed under the rigorous instruction based upon Greco-Roman sculpture and the familiar canons of great sixteenth- and seventeenth-century art. For them, art's highest moments stemmed from the earliest periods of medieval and Renaissance painting, those which finished, rather than began, with Raphael and Dürer. These remote centuries seemed to speak in a language of pious feeling and meticulously described forms that could offer an antidote to what they saw as the pagan sensuality and deceitful virtuoso techniques of such later artists as Correggio, Titian, or Guido Reni. On July 10, 1809, in Vienna, these twenty-year-olds founded, with a group of other rebellious young artists, the Brotherhood of St. Luke, resurrecting the idea of a medieval artists' guild; and in 1810, they left for Rome, where instead of pursuing, like so many other Northern artists before them, a lost classical world, they hoped to re-create a lost Catholic one, emulating such artist-monks as Fra Angelico. Settling in the cells of a deconsecrated monastery, Sant'Isidoro, they let their hair grow long and tried to lead a life that would mix medieval vows of chastity and poverty with a total dedication to the making of a devout and innocent art whose innocence and purity would pretend that Titian and Rubens had never

Fig. 67 **Franz Pforr**, *Entry of Emperor Rudolf into Basel in 1273*, 1808–10. Oil on canvas, 35⅝ × 46⅞".
Städelsches Kunstinstitut, Frankfurt.

existed. Their strange appearance and holy ambitions earned them the nickname "Nazarenes," which, unlike the different names they gave themselves (such as "Dürerists"), stuck.

In their retrogressive goals, reaching back across the centuries to art and civilization in an uncorrupted state, the Nazarenes joined the ranks of artists like Blake and Flaxman, or the Primitifs in David's studio; but their peculiarly neo-Catholic bias produced an art that was sometimes closer to the medieval look of the French Troubadour Style. In Pforr's *Entry of Emperor Rudolf into Basel in 1273*, a painting begun in Vienna in 1808 and completed in Rome in 1810, the Northern branch of this medieval revival style can be discerned (fig. 67). Like Révoil in his *Tournament* of 1812 (see fig. 55), Pforr attempts to reconstruct the pageantry of the Middle Ages in an appropriate style that would evoke the exquisite craftsmanship of the medieval artist. Here, he minutely describes the costumes and faces of even the tiniest background figures

who crowd the windows and the cobblestone streets of thirteenth-century Basel in order to welcome the triumphant new Hapsburg emperor, who had ended his own siege of their city. Although, in fact, many of the period details, such as the costumes, are anachronistic (as they often are in West's or David's historical reconstructions), what matters more is the intense desire to revive the look and feel of this lost epoch. And in terms of style, Pforr has even adapted such pictorial archaisms from late Gothic painting as the steeply tilted ground plane with its swift rush from near to far, the intense clarity of local colors, the emblematic precision of the contours that so often freeze figures in profile views, and the total rejection of those softening effects of shadow and atmosphere which the Nazarenes considered a decadent shorthand device of later Western painting that blurred the crystal-clear truths of nature.

For Pforr, as for Overbeck, the two deities of Christian art were Raphael (in an early phase) and Dürer, the very artists

◆ —— THE NAZARENES AS ROMANTICS IN ROME AND GERMANY —— ◆

In their deconsecrated monastery outside Rome, the Nazarenes attempted to lead the lives of early Christian brethren. They sought to regenerate German painting by emulating certain early Renaissance artists, in particular Dürer, Perugino, and the young Raphael.

In what sense was the life supposed to reflect the work? Art historian Mitchell Frank explored this question in relation to one of the founder members of the brotherhood, Johann Friedrich Overbeck:

One of the tenets of Romanticism … was that one must be true to oneself. No longer a technician, the Romantic artist defined himself as a spiritual being and, most importantly, as someone whose work reflected his essence. Overbeck, of all the German Romantic painters, held this belief most ardently. By assuming the persona of the monk-artist, he attempted to become authentic by playing a role in which the personal, the public, and the artistic were all united.[17]

According to Françoise Forster-Hahn, Overbeck's allegorical painting Italia and Germania *(see fig. 68) was an ambitious attempt to fuse northern Gothic and Catholic Mediterranean traditions—an attempt that flew in the face of the political realities. But the painting also expressed a more univer-sal yearning—to reconcile the irreconcil-able loves of homeland and adopted country:*

… *Italia and Germania* [was] begun in 1811, when Pforr was still alive, and completed in 1828. … this project was commissioned by the art dealer and publisher Wenner and as such is more "public" in conception. Its symbolism at first sight has to do with aesthetic concerns. … fusing the southern Italian with the northern Gothic ideal. This vision of harmony belied the concrete reality of a very conflicted present: when the Nazarenes settled in Rome, the French occupied Italy, the Papal States had been dissolved, Pope Pius VII was a prisoner of Napoleon. In fact, it was Napoleon's confiscation of Church property that provided them with a home, since the monks had been forced to leave their monastery of Sant'Isidoro. The Nazarenes lived in exile: a group of German artists forming a community in Rome. They were separated by culture and language from their Italian environment, emphasising their "otherness" in life-style, dress and creative work. Does the pictured union between north and south not also articulate the longing for a union between their homeland and their land of exile? The unity that did not exist in their concrete historical present was visualised in the idealised state of the work of art. Thus the reconciliation of opposites which … [the painting] so poetically configure[s] conveys a harmony that was entirely imaginary.

When Overbeck explicated his painting to his patron in a letter from Rome in 1829, many years after its conception, he reflected upon the melding of two foreign elements in the harmony brought by art, upon the intertwining of memory and present time, and the endurance of friendship: "My choosing the idea of a Germania and Italia is explained by my particular standpoint as a *German* in *Italy*. These are, as it were, two elements, which indeed face each other on the one side [sic] as foreign, but to blend them, at least in the external shape of my work, is and should henceforth remain my task … On the one hand the remembrance of *Heimath* (homeland) unforgettably imprinted on the soul, and on the other hand the charm of everything magnificent and beautiful which I gratefully enjoy in the present; both conceived as separate and mutually exclusive, but imagined as being in harmony and as mutually appreciative. What is meant finally is the yearning which constantly draws the north towards the south, towards its art, its nature, its poetry; and [they are] in bridal dress, [because] both [represent] the yearning as well as the object of their desire, because both are ideas that constantly rejuvenate … one may thus simply name the picture 'Friendship'." No one has written more perceptively of the dislocation the German artist experienced in Italy …[18]

who had been singled out for tearful sanctification in Wilhelm Wackenroder's *Outpourings from the Heart of an Art-Loving Monk*, a historical-literary fantasy published in 1797 that cast its holy spell on many young German artists who saw the necessary connection between Christ-ian faith and artistic beauty. In 1812, the year of his premature death, Pforr had completed a complex diptych for Overbeck, representing in allegorical female figures the polarities of Northern and Italian art; and in 1811, Overbeck began to expand this idea in another historical fantasy, *Italia and Germania*, which was to be completed only in 1829 (fig. 68). In it, two saintly women, one

dark-haired, one blonde, clasp hands and join foreheads in what seems a chaste and spiritual union of two poles in European culture, Italy and Germany, whose respective architecture is also contrasted in the symbolic landscape behind. In distinction to Pforr, whose style usually evokes a more angular, German Gothic sensibility, Overbeck re-creates, even for the Düreresque figure of Germany, the fluent harmonies of Raphael's most graceful contours and surfaces, an artistic preference he would maintain through the mid-century in his long and influential career as a painter of Christian subjects. But this ostensible paragon of late medieval piety, simplicity, and truth is, like so many

Fig. 68 **Friedrich Overbeck**, *Italia and Germania*, 1811–29. Oil on canvas, 37¾ × 41⅞". Bayerische Staatsgemälde-sammlungen, Munich.

passionate nineteenth-century efforts to turn the clock back, oddly complex in form, symbolism, and psychology. The archaisms of style seem willful and sophisticated in their historical self-consciousness; and the symbolism is of so private an invention that it remains disturbing and elusive, especially since that union of these two brides, as Overbeck called them, probably projects unconsciously the passionate friendship between the two founders of the Nazarenes. In its discrepancy between willed naïveté and the complexities of nineteenth-century public and private experience, the art of Pforr and Overbeck is prophetic of a recurrent modern dilemma, and one that will especially haunt the art of the Pre-Raphaelite Brotherhood (pages 256–64), whose goals in 1848 would be so similar to those of the Nazarenes themselves.

Romantic Meditations in Germany and England

The impulse to destroy the immediate historical past and to found a new art, even a new religion, on the basis of the purest prototypes was found not only among those German artists who turned to Italy for its Greco-Roman or Christian traditions, but also among those who remained at home. Of these, none was more ambitious in his desire to create a completely new symbolic language of art, nature, and

religion than Philipp Otto Runge (1777–1810), who, like William Blake, felt that, with his own vision of the cosmos, he was destined to resurrect, virtually singlehanded, a moribund civilization. In Runge's case, it was landscape itself, intensely and innocently observed, that was to provide the components of a new artistic language which he hoped would be intelligible to all in conveying spiritual ideas about God, man, and nature. This heady program, lengthily articulated in letters to his brother Daniel, preoccupied Runge throughout his short life; yet even had he lived past 1810, he might never have been able to realize his vast projects. But what he left, in paintings, drawings, and words, remains one of the most poignant demonstrations of the Romantic artist's passionate efforts to rejuvenate the dying religious traditions of the West.

His dream was to be called the *Times of Day* (*Tageszeiten*), and was intended as a four-part natural cycle that evoked through landscape and allegorical figures not only the times of day and the four seasons, but also a densely allusive range of human, Christian, and even political symbols. And prefiguring the Wagnerian ambitions of the *Gesamtkunstwerk* (a total work of art), Runge envisioned this quasi-religious series in a specially designed chapel where specially composed music would be heard. Of Runge's many projects for this shrine of a new religion that was clearly private but intended to be universal, the one

that tells us most is a painted version of *Morning*, of 1808 (fig. 69). Even the spectator ignorant of Runge's abstruse intentions must read this as a new kind of altarpiece; for its rigorous symmetry and enframing marginal images immediately convey, as in Blake's work, a medieval mystic's world of cult and spirit. In the floating nude figure above the horizon, in the luminous patterns of flying and adoring children, we sense an odd conglomerate of many known classical and Christian symbolic languages—an Aurora-like figure for dawn, angels protecting a newborn Christ-like infant, an infinite choir of cherubim above the frame gazing at the miraculous events on earth below. But these allegorical creatures are also merged with the most accurate observations of natural phenomena. Like Goethe, Runge

was a student of botany and color, and these wonders were for him earthly manifestations of a spiritual force. The flowers, whether huge, in the near margin, or tiny, in the distant meadow, are rendered both as botanical truths and symbolic mysteries (the lilies, for example, evoke a Christian purity). Similarly, the magically translucent color, which emanates from the sun's golden orb (seen as if rising after an eclipse), slowly irradiates earth, sky, and heavens with a spectrum sequence of green, violet, yellow, and blue which belongs both to the realm of color theory and to that of Romantic awe before the luminous hues that dawn brings to a pristine landscape. In this intensely personal language, we alternate between fact and idea, between a scientist's rendering of the wonders of heaven and earth and a

Fig. 69 **Philipp Otto Runge**, *Morning*, 1808. Oil on canvas, 42⅞ × 33⅝". Kunsthalle, Hamburg.

Fig. 70 **Philipp Otto Runge**, *The Hülsenbeck Children*, 1805–06. Oil on canvas, 52½ × 57½″.
Kunsthalle, Hamburg.

medieval theologian's efforts to reveal an elaborate symbolic structure beneath the surfaces of nature. Runge's icon of a new religion conveys a sense of radiant regeneration, even alluding, in more topical terms, to the rebirth of Germany after the disasters of the Napoleonic wars, a passionate hope expressed more explicitly elsewhere in Runge's art and writing. Thus, the vast public domain of nature, religion, even contemporary history has been translated, as in Blake's work, into a private system, at once universal and hermetic. For Runge, as for many other Romantics, the terrible void left by the collapse of so many Western traditions demanded the creation of a totally new art and even cosmology.

In his less lofty moments, Runge also painted the commonplace facts of the people and places he knew in and around Hamburg; but even here on earth, as in the portrait he painted in 1805–06 of the three children of his brother's friend Friedrich August Hülsenbeck (**fig. 70**), his search for the underlying mysteries of nature could transform an ordinary family painting into one of the strangest documents of Romantic psychology. Before the late eighteenth century, children had usually been represented as small adults or cuddly angels; but Runge broke with this tradition by suddenly seeing the human infant as a reflection of nature's vital forces, a still irrational being that belongs to an organic realm of animals, trees, flowers. In an abrupt change of scale drom the distant view of Hamburg across the meadow and the glimpse of the family house at the right, the childrem loom before us like giants, the elder son and daughter, August and Maria, seeming to rise to twice the height of the picket fence behind them. These young giants—only, in fact, age four and five—are pulling with what seems heroic force a wheelbarrow barely containing their two-year-old brother, Friedrich, who clings to the tough stalk of a wild clump of sunflowers. The infant, even more than the older children, exerts strange pressures of mind and body. The pudgy cheeks, grasping hands, and pneumatic flesh seem virtually to be growing before our

Fig. 71 **Caspar David Friedrich,**
Monk by the Sea, 1809–10.
Oil on canvas, 42½ × 67".
Nationalgalerie, Berlin.

eyes, irradiated by the same solar light that gives life force to the sunflowers that bloom above him; and his intense stare, like that of his older brother, obliges the spectator to gaze back into the mysterious life of the child, who becomes a vessel of nature's miraculous energies. Runge insists that we empathize with this most primitive human state and that we explore the fairy-tale spaces of a child's world, with its sudden Alice-in-Wonderland leaps between the enormous and the tiny, between the palpably near and the inaccessibly remote.

Runge's desire to penetrate to the organic core of nature, to its mysteries of life and death, was shared by his great contemporary Caspar David Friedrich (1774–1840), who, far more than Runge, rejected the lure of Greco-Roman and Italian art, with its idealized, corporeal forms, in favor of what he could discover in the world of his native north Germany. But, in his own words, "a painter should paint not only what he sees before him, but also what he sees within himself," which in this case meant the conversion of the material world into a domain of spirit. That he achieved what were virtually religious goals within the traditions he inherited from the most secular seventeenth-century Dutch tradition of landscape, marine, and genre painting is a tribute to the intensity of his genius.

In 1810, at the Berlin Academy exhibition, Friedrich stunned spectators with a pair of pictures related in their gloomy theme. In the first, *Monk by the Sea* (**fig. 71**), which privileged visitors had already puzzled over in his studio in 1809, Friedrich created one of the most daring and prophetic images in modern art. Even some two centuries later, we can still understand how this picture of almost a void could perplex viewers. Although it was originally to include two ships on the choppy sea, Friedrich decided to eliminate them, so that his odd work eluded even the

conventional category of marine painting. Moreover, Friedrich's reduction of those three landscape elements—land, water, sky—that were a daily experience for him in his birthplace, Greifswald, on the Baltic Sea, becomes so extreme that they take on a symbolic, elemental quality, as if the skeleton of nature had been laid bare in a bleak trinity. But above all, the mysterious conversion of a painting of observed nature into a new kind of icon is achieved by the lonely, diminutive figure of a monk, who, head on hand, his back turned toward the spectator, stands at the brink of nothingness. Our intuition may tell us that, as has been demonstrated, this is, in fact, a self-portrait. That we experience this as almost a religious painting, in which a solitary figure confronts the unknowable void before him, is a testimony not only to Friedrich's genius in elevating landscape to a level of full emotional power, but also to his capacity to translate the most spiritual goals of Christian art, traditionally conveyed through the figural narrative of the Passion of Christ, into a new secular language that the modern viewer may well find more convincing as religious experience than the efforts to perpetuate conventional Christian iconography throughout the nineteenth and twentieth centuries. Like the Protestant theologian Friedrich Schleiermacher, who pleaded in 1798 that the true Christian could preserve, in personal terms, the spirit of Christianity without its rituals and dogmas, Friedrich re-created religious art as a private creed, instilling the bleak facts of a cloudy, darkening sky, a murky sea, a narrow stretch of dune, and a flurry of low-flying gulls with the sense of awe and doom we expect at the Last Judgment.

Spatially, the painting is no less remarkable, locating us, together with the meditative monk, at the very brink of the material world, and confronting us first with a narrow but immeasurable expanse of sea that then becomes, at the

unbroken, uncommonly low horizon line, an infinitely extendible void of fog and cloud accessible only by emotional projection. The poignant contrast of near and far, of the earthly and the spiritual, is conveyed through this drastic rejection of conventional perspective systems, leaving us at the edge of a hazy, unbounded world that seems at once as close as the picture surface itself and as distant as the regions of the afterlife. In its stark economy, *Monk by the Sea* seems to pinpoint for the first time not only the modern experience of what Søren Kierkegaard would soon identify as alienation and what would later be called by twentieth-century Existentialists the gulf between "Being and Nothingness." Moreover, it heralds the daring pursuits of many modern artists, from Turner to Rothko, who, escaping from the natural world, tried to distill the mysteries of nature and spirit in veils of atmospheric color.

For those spectators who complained in 1810 that *Monk by the Sea* offered almost nothing to look at, its pendant, *Abbey in an Oak Forest* (**fig. 72**), at least provided more narrative and landscape components. Through the sepia fog, against the inky silhouettes of leafless trees and the ruins of a Gothic abbey, we can dimly make out a procession of monks who walk through a snow-covered graveyard carrying a coffin that is seen from behind, just at the entrance to the roofless nave. Again, Friedrich creates a symbolic spatial contrast between the immediate, traversable foregound and a remote, immaterial beyond; for the Gothic arch of the entrance seems to mark a physical point of no return, after which all is ghostly shadow rather than substance. Echoing the familiar Romantic theory that Gothic architecture is a metaphor for nature, its aspiring arches and naves offering a kind of forest of trees, Friedrich clearly equates the irregularity and verticality of the Gothic ruins with the adjacent oak trees, as if the spirit of Christianity and the mysteries of the afterlife were at one with the landscape. Indeed, the grim choice of a winter setting provides an appropriately skeletal and chilling environment for this scene of Christian burial that, in the surging heights of the distant Gothic choir, in the promise of spring and summer to come, and in the just-visible crescent of the new moon above, evokes the hope of resurrection. But the overwhelming mood is of a profound melancholy, like that created by Schubert in his song cycle of 1827 *Die Winterreise* (The Winter's Journey), which also takes the bleak facts of a prosaic winter setting and turns them into a meditation upon the transience of life.

As always, Friedrich here begins with the world of close observation—the Gothic ruins are those of the Cistercian monastery at Eldena, which he often sketched; the gnarled, leafless oak trees were as much a winter commonplace in

Fig. 72 **Caspar David Friedrich**, *Abbey in an Oak Forest*, 1809–10. Oil on canvas, 44 × 68½″. Nationalgalerie, Berlin.

Fig. 73 **James Ward**, *Gordale Scar, Yorkshire*, 1811–15. Oil on canvas, 10′ 11″ × 13′ 10″. Tate Britain, London.

Northern Europe as the dense and chilling fogs. But the casual data of nature have now been frozen in a heraldic symbol, fixed immutably upon a symmetrical, cruciform skeleton of stark vertical and horizontal axes. Perhaps more successfully than any other Romantic painter, Friedrich can make us feel the divinity inherent in nature.

In these early paintings by Friedrich, the study of nature's most awe-inspiring aspects reached a scale and intensity that could occasionally be paralleled in works by his British contemporaries. Bringing to a mammoth climax Edmund Burke's prescriptions for sublime effects, James Ward (1769–1859) began in 1811 a painting of one of Britain's wildest sites, the high and craggy limestone cliffs and gorge at Gordale Scar in Yorkshire (fig. 73). This spot for adventurous tourists (which the graveyard poet Thomas Gray had already visited in 1769, "not," as he wrote, "without shuddering") had been thought unpaintable; but Ward rose to this challenge in a painting of vast dimensions—about eleven by fourteen feet—which still stuns

spectators today at Tate Britain in London, as it did when first seen at the Royal Academy in 1815, and which makes Caspar Wolf's Alpine mountains of 1778 (see fig. 57) look almost like Rococo molehills. As in the *Monk by the Sea* (see fig. 71), *Gordale Scar* locates the spectator in a narrow foreground whose diminutive relation to the vista of nature's infinities is exaggerated by the low horizon and the colossal scale (emphasized here by what seems a tiny bull). In place of the uncharted regions of sky and atmosphere, we now see the irregular formations of a geological marvel that takes us back to prehistory. To lend further drama, rolling storm clouds darken the sky, joining forces with the terror elicited by this gigantic chasm. Again, nature is revealed as omnipotent, even crushing, in its ability to dwarf us and our deeds to pitiful insignificance.

This fearful message, ubiquitous in Romantic literature, was one of the major themes to be treated by Joseph Mallord William Turner (1775–1851), that great painter who, together with Friedrich, his senior by less than a year,

best succeeded in dematerializing the face of nature in an effort to reveal its internal powers and mysteries. In 1812, Turner exhibited at the Royal Academy his *Snowstorm: Hannibal and His Army Crossing the Alps* (**fig. 74**), a work that finally realized his earlier goals of rendering the most impalpable forces of the natural world—the pulverizing effects of light on matter, the devastating power of storms. He had already painted scenes of disaster, whether contemporary shipwrecks or biblical plagues; and he had already studied the phenomenon of light filtering through the sky and virtually dissolving the substance of the earth below. But here, these pictorial resurrections of such seventeenth-century prototypes as Dutch marine painting or Claude's luminous sunsets give way to a work of breathtaking originality, in which the very destiny of man and history is challenged by nature. We see first a dizzying vortex, that abstract configuration of energy which Turner would continue to explore throughout his long career (see pages 147–51), in which are fused whirlwinds of snow and storm clouds against the distant pale glow of an Alpine sun above. Gradually, we can make out the human drama below, which begins with episodes of rape, murder, pillaging, and then expands to epic dimensions, with suggestions of antlike armies in the mountain passes and then, in the far middle distance, the tiny, almost illegible silhouette of Hannibal on an elephant, at the brink of the promised, sunlit land of Italy. We can find neither terrestrial nor historical bearings, for we seem located in a molten caldron of the imagination. Turner's painting, in fact, merges a multitude of real and fictional experiences. He had witnessed a violent thunderstorm in England and predicted he would paint it later in a scene of Hannibal crossing the Alps; he had seen and read earlier illustrations and descriptions of this event of 218 B.C.; he had visited the Alps in 1802 and made on-the-spot sketches of its sublime wonders; and not least, he had pondered, like his contemporaries, the drama of current Napoleonic events in the context of the sweep of history. Indeed, while in Paris in 1802, Turner had seen David's *Napoleon at St.-Bernard* (see fig. 22), on which the name of Hannibal had been inscribed. Turner's painting, among other things, may well offer an allegorical comment on the British fear of Napoleonic conquest. Dense in association, this apocalyptic vision is both timely and timeless, translating sublime landscape and history into a grandiose metaphor of man versus destiny. In its numbing destruction of matter, it foreshadows, like many of Friedrich's works, a major direction of modern painting; and in its meditative fusion of past, present, and future, it defines one of the major concerns of art between the American Revolution and the fall of Napoleon.

Fig. 74 **Joseph Mallord William Turner**, *Snowstorm: Hannibal and His Army Crossing the Alps*, Royal Academy 1812. Oil on canvas, 57 × 93″. Tate Britain, London.

Part 1:
1776–1815

SCULPTURE

Introduction

Since Johann Winckelmann, whose *Thoughts on the Imitation of Greek Works* (1755) sets the tone for the period that concerns us here, art historians have been taught to assume that the arts march through history in a kind of lockstep: architecture, sculpture, painting, literature, music at a given time or place all express the "genius," the basic qualities, of the civilization that produced them and therefore must necessarily exhibit the same style. When he contrasted the "noble simplicity and calm grandeur" of Greek art with that of his own time, Winckelmann took this as evidence of the superiority of ancient Greece as a whole. Later art historians, no longer mesmerized by the unique greatness of Greek art, would apply his method to other phases of the past, postulating some central *Zeitgeist* (spirit of the times) as the glue that holds period styles together, but today *Zeitgeist* is rarely invoked. Indeed, our faith in the very existence of period styles has been severely shaken, even though we keep referring to them as a convenient shorthand in discussing the past. Yet we cannot deny that works of art created at the same time and in the same place do have something in common. What they share is not a vague *Zeitgeist* but the social and cultural environment, which must have affected artist and patron alike to some degree. We have also come to realize, however, that artistic developments cannot be fully understood as direct responses to such factors. Insofar as "art comes from art," its history is directed by the force of its own traditions, which tend to resist the pressure of external events or circumstances. These traditions, moreover, although interdependent, are not the same in all the arts. Thus Winckelmann's simple lockstep has given way to a far more differentiated view that might be likened to an ever-varying counterpoint pattern.

We must not expect, then, to see the history of sculpture simply following that of painting. The phenomenon of Neo-classicism, which in painting is often hard to distinguish from Romanticism, stands out far more clearly in sculpture. To understand how this came about, we must first acquaint ourselves with the typical working procedure of the nineteenth-century sculptor. The preliminary forms are defined in a small model of clay or wax, the three-dimensional counterpart of drawings. There is no specific term for such models in English. We refer to them either by the Italian word *bozzetto* or the French *maquette*, which implies not only small scale but also spontaneity and sketchiness of execution. (To preserve clay maquettes, they can be fired in the kiln, converting them into more durable terracotta.) The sculptor next produces a full-scale clay model, which is expected to correspond in every detail to the final work. This model, however, is destroyed in the process of making a plaster cast of it, the so-called "original plaster."

Having replaced the clay model with its "ghost," the sculptor has a choice: he can have the original plaster copied in marble by professional carvers (usually called by the French term *praticiens*) with the aid of a mechanical device, the "pointing machine," adding the finishing touches himself if he cares to and has the necessary skill; or he can turn the plaster over to a foundry for casting, often through the lost-wax (*cire-perdue*) process, resulting in a hollow bronze duplicate of the original model. The sculptor may be involved only in choosing the kind of patina he prefers. ("Patina" refers to the color of bronze if the surface has been modified, usually by applying various chemicals.) The advances in mining and smelting that came with the Industrial Revolution finally brought bronze sculpture within the economic range of a larger public. By 1800 it had, for the first time in history, become cheaper than marble sculpture. Soon new techniques, such as electro-plating and zinc casting, began to compete with the lost-wax process, further lowering the cost.

The original plaster can yield any desired number of marble or bronze replicas, which can be enlarged or

reduced with the aid of mechanical devices, so that a successful model may be issued in several sizes and materials to suit the pocketbooks of prospective buyers. As a consequence, the reduction of large-scale sculptures became an industry employing thousands of workmen to turn out the countless replicas that were the nineteenth-century sculptors' bread and butter. Be that as it may, both marble and bronze were far too expensive to allow the sculptor to produce monumental sculpture on his own. Unlike painters, who could work for private patrons or simply paint pictures for the "art market," the sculptor was severely limited by the cost of his materials. Large-scale sculpture continued to be dependent on its two great patrons, church and state, for commissions that had to fit the predetermined needs of the patron.

When Winckelmann published his essay advocating the imitation of Greek works, enthusiasm for the virtues of classical antiquity was already well established among the intellectuals of the Enlightenment. Archaeology had caught everyone's imagination: richly illustrated books on the excavations at the recently discovered sites of Pompeii and Herculaneum, on the Acropolis at Athens, and on the other monuments were being published in England and France; in Rome, the restoring of ancient sculpture and its sale to wealthy visitors from abroad was a flourishing business. The same patrons, then, also collected ancient sculpture, and these "classics," such as the *Laocoön* group or the *Apollo Belvedere* (two of the most famous), belonged to a different world: they were venerated as embodiments of an aesthetic ideal, undisturbed by the exigencies of time and place. To enter this world, the modern sculptor set himself the goal of creating "modern classics," that is, sculpture demanding to be judged on a basis of equality with its ancient predecessors. This was not merely a matter of style and subject matter; it meant that the sculptor had to find a way of creating monumental sculpture in the hope that critical acclaim would establish such works as "modern classics" and attract buyers. The solution to this problem was the original plaster, which permitted him to present major works to the public without a ruinous investment in expensive materials.

Quite aside from the cost factor, there were physical limitations related to the exhibition of sculpture that favored the original plaster. Winckelmann's essay had signaled a new concern with the education of artists along properly classicistic lines. The Royal Academy of Painting and Sculpture, founded by Louis XIV in Paris in 1648, assumed an undisputed lead in training the mind as well as the hand, and during the second half of the eighteenth century similar academies were founded throughout Europe. Of particular importance among the activities of the Paris Academy were the exhibitions it sponsored, known as Salons. The Salon gave rise to a new phenomenon in the mid-eighteenth century, the critic, and art journalism

attracted some of the most distinguished minds of the time, such as Diderot. It is in these Salons that we first encounter the original plaster. Until the Revolution, Salons were held in a large room on the second floor of the Louvre, an arrangement that made it impossible to show large-scale sculpture in marble or bronze because of its weight. Sculptors could exhibit only maquettes or works in plaster. The original plaster, then, was an established working method that helped prepare for the "modern classic."

Thus during the second half of the eighteenth century, original plasters became aesthetically acceptable, and it was standard procedure to exhibit them. Nineteenth-century sculptors, from Canova to Rodin, treasured their original plasters and often bequeathed them to posterity (Canova's Gipsoteca in his birthplace, Possagno, was the first of many such memorials). Moreover, the neutral quality of the plaster encouraged one to view modern and ancient classics as equivalents. After all, many of the surviving masterpieces of classical sculpture were themselves copies of lost originals, often as marble copies after bronzes, and because of their fame these copies, in turn, were constantly reproduced as plaster casts for the benefit of students and connoisseurs.

The only difference between a modern original plaster and a cast from an ancient statue was that the latter transmitted the essence of a work that was not directly accessible to the viewer, while the former offered a "preview" of a marble or bronze statue that did not yet exist. In either case, the sculptural classic, whether ancient or modern, came to be viewed as something akin to a Platonic idea; what mattered was the conception, the design, irrespective of the material in which it happened to be presented. The original plaster thus unites practical, mundane considerations with a revolutionary new definition of the sculptor's role. Neoclassical sculpture enjoyed a prestige that made the style a far more significant and persistent phenomenon in sculpture than in painting. Napoleon is said to have remarked, "If I weren't a conqueror, I would wish to be a sculptor."

If Paris remained the artistic capital of the Western world, Rome during the second half of the eighteenth century became the birthplace and the spiritual home of Neoclassicism. Until the advent of Canova at the end of 1779, however, it was the resident foreigners from north of the Alps, rather than Italians, who pioneered the new style. That Rome should have been an even stronger magnet for sculptors than for painters is hardly surprising: after all, it was in ancient sculpture that the "noble simplicity and calm grandeur" praised by Winckelmann were most strikingly evident, and Rome offered an abundance of sculptural monuments but only a meager choice of ancient painting. In the shadow of these monuments, Northern sculptors trained in the Baroque tradition awakened to a new conception of what sculpture ought to be and thus

paved the way for Canova, whose success as the creator of "modern classics" was the ultimate fulfillment of their aspirations.

England

The leading role of the Anglo-Roman artists before 1780 in the formulation of Neoclassicism is no surprise if we consider England's enthusiasm for classical antiquity since the early years of the century. This precocious appreciation was political, philosophic, and literary, with a new nationalism as its common denominator; but this soon turned into a demand that England become "the principal seat of the arts" as well. The primary needs were improved facilities for training and a wider and more informed patronage. The first culminated in the establishment of the Royal Academy in 1768. As for the second requirement, it was met largely through the increased appetite for travel on the Continent; the Grand Tour, as it came to be called, became an indispensable part of the gentleman's education, and

Fig. 75 **Joseph Nollekens**, *The Second Marquess of Rockingham*, 1784. Marble, life-size. Birmingham Museums and Art Gallery.

with it went a fashion for collecting while abroad and for more lavish expenditures on art at home. For sculpture, this created opportunities that attracted a succession of foreigners who brought the full repertory of Baroque sculpture to England and left a profound imprint on the next generation.

The two chief tasks the foreigners faced—monumental tombs and portrait sculpture—were familiar enough, but increasingly there were new, specifically English projects, such as monuments to men of genius, the heroes of culture—a privilege hitherto reserved to sovereigns. The idea of such monuments was nourished by Lord Burlington and William Kent, his favorite architect, who in about 1735 designed a Temple of British Worthies, containing busts of distinguished English thinkers, for the landscape garden at Stowe, in Buckinghamshire. Three years later François Roubiliac, the most talented of the immigrant sculptors, carved a marble statue of George Frederick Handel for the owner of Vauxhall Gardens, in London, a pleasure park where Handel's music was often performed. The first monument to a culture hero made within his lifetime, it cannily served two purposes, homage and advertising.

Hints of dawning Neoclassicism first appear among the English sculptors who began their careers in the 1750s and 1760s, among whom was Joseph Nollekens (1737–1823), the most sought-after English portrait sculptor of his day. Nollekens spent the entire decade of the 1760s in Rome, restoring antiques and supplying them to British collectors while he established his reputation as a portraitist. The busts of those years, such as that of Laurence Sterne, are far more austerely Roman than those of the following decades. Besides Nollekens's remarkable grasp of individual character, which accounts for his success (at the time of his death, his fortune amounted to two hundred thousand pounds), he had an instinct for what his sitters preferred. As a rule, the more elevated the sitter's rank, the stronger the Baroque elements. The bust of the Second Marquess of Rockingham (**fig. 75**) is characteristic in its use of a toga-like drapery which hides the truncation and allows for the discreet display of an order pinned to the sitter's chest. Similarly, the hair is curled above the ears so as to suggest a wig without actually being one. Throughout, there is a concern with surface texture that echoes the Baroque tradition. Only after 1800, when the Neoclassical wave reached its crest, did Nollekens revert to the type of bust represented by his *Sterne*. Aside from portraits, Nollekens also did some statues of classical subjects and sculptured tombs, but none of these would justify his claim to being a major artist.

It was another member of Nollekens's generation, Thomas Banks (1735–1805), who came closest to establishing the creation of "modern classics" as the sculptor's true goal. Little is known of Banks's career before he went to Rome in 1772 for seven years. *The Death of Germanicus*

(fig. 76) of 1774, a large relief, shows his close study of classical sources, as well as his admiration for the two chief Anglo-Roman painters, Gavin Hamilton and Henry Fuseli (see pages 29–30 and 48–50). On his return to England, Banks found little demand for his "new classics," although they were enthusiastically received by the Royal Academy. Devoted to the nude and to heroic drama, he sought commissions in the only other area that held the prospect of steady employment, that of funerary monuments. During the last few years of his life, Banks was commissioned to carve two of the numerous memorials in St. Paul's Cathedral honoring military officers who had died in the war against France.

The monuments to war heroes, a valuable source of income for sculptors, were the culmination of a campaign of public patronage that had been urged upon Parliament by the Royal Academy since the 1770s "for the encouragement of the arts." Originally, the academy's plan had been to honor not military men but cultural heroes, and these did indeed receive their share. Joshua Reynolds, the guiding spirit behind the plan, strongly favored the "timeless" mode for them.

Banks eagerly seized what he regarded as a wholly appropriate occasion for "heroic timelessness," only to discover that, on this larger and more ambitious scale, he could not reconcile the ideal and the specific. The monument to Captain Richard Burgess (fig. 77) consists of a high oval base supporting the statues of a winged Victory and the classically nude captain. However, there was no way to avoid putting a modern portrait head on this antique body; the committee in charge of these public commissions may also have insisted that Burgess be identified as a naval officer, a demand satisfied by a ship's cannon, a coil of rope, a chain, and some cannonballs—modern objects incongruous in such a setting. Even the relief on the base, at first glance wholly antique, with its trophies and mourning captives, is not entirely free of modern intrusions: the ship behind the seated Roman sailor is a cross between an ancient vessel and a modern man-of-war (note the open portholes for guns).

If Thomas Banks was at his best as a relief sculptor, John Flaxman (1755–1826) may be considered his true heir. Sickly and precocious during his childhood, Flaxman started exhibiting at the age of twelve and entered the

Fig. 76 **Thomas Banks**, *The Death of Germanicus*, 1774. Marble. Holkham Hall, Norfolk, England.

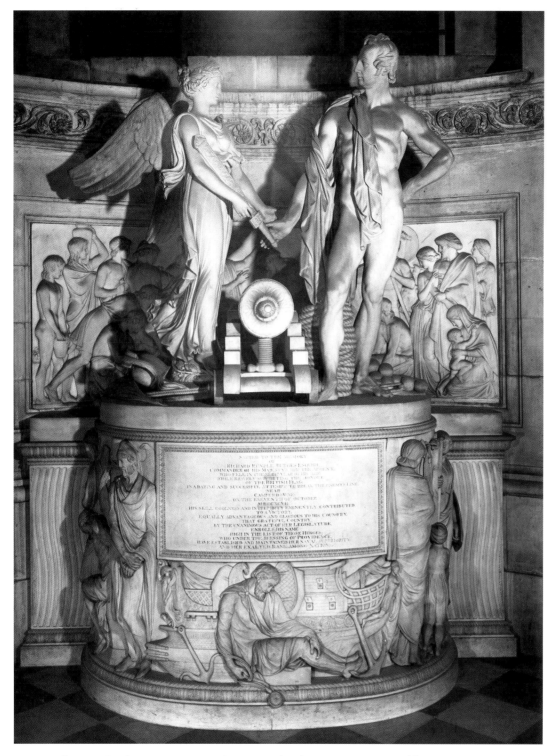

Fig. 77 **Thomas Banks**, Monument to Captain Richard Burgess, 1802. Marble.
St. Paul's Cathedral, London.

Royal Academy schools at fifteen. Soon after, he started working for Wedgwood's pottery factory, modeling compositions in low relief to be reproduced in white on colored ground, in a style based on engravings after ancient reliefs and Greek vases but with a residue of Rococo playfulness and grace. At the same time, however, Flaxman evinced a notable interest in medieval art. In part, this may have been stimulated by the Gothic Revival which had been going on in English architecture, but a more important factor was Flaxman's deep interest in the spiritual and mystic aspects of religion, which he shared with his friend William Blake (see pages 52–55).

Flaxman did not go to Italy until 1787, but then he stayed for seven years. His sketchbooks of that period

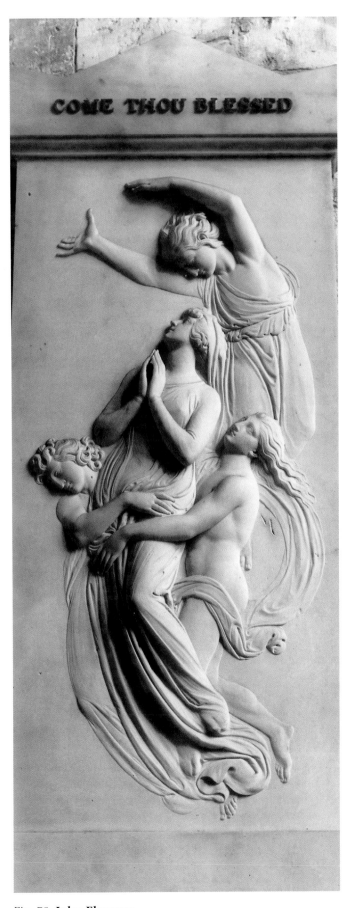

reveal an astonishing catholicity of interest, if not of artistic sympathy. He admired Michelangelo, but he also made drawings after Baroque sculpture, which he despised. The return to antiquity, for Flaxman, meant recapturing the simplicity of "olden times," whether Greek or medieval—the earlier, the more "primitive," the better.

During his Roman years, Flaxman received commissions from British collectors, for two "modern classics" (freestanding marble groups of *Cephalus and Aurora* and *The Fury of Athamas*), but his international fame was based on a series of illustrations, in pure outline, of the *Iliad* and *Odyssey*, first published as engravings in 1793, and of Aeschylus (1795) and Dante (1802) (see page 55 and fig. 42). It is in these austerely simple drawings, with their purposely limited repertory of gestures and expressions, that Flaxman was able to unite Greek and Gothic under the common denominator of the primitive—an awkward directness and sincerity proclaiming itself aesthetically, and hence morally, superior to the overblown rhetoric of the Baroque.

Flaxman returned to London shortly before the Napoleonic wars put an end to the Anglo-Roman community. He became a member of the Royal Academy and received his share of public commissions for monuments in Westminster Abbey and St. Paul's, including that to Lord Nelson (1808–18). Still, his finest works were the very numerous smaller tombs ordered by private patrons, most of them simple relief panels like the monument to Agnes Cromwell (**fig. 78**) of 1797–1800, subtly modeled and of beautifully rhythmic design. The young woman being carried heavenward by celestial spirits is the soul as well as the idealized likeness of the deceased, in accordance with the doctrine of the Swedish mystic Emanuel Swedenborg that the soul has the shape of the body, its earthly "garment."

If the Cromwell monument betrays Flaxman's kinship with Blake and Blake's sources, another type is represented by his contemporary monument to Sir William Jones (**fig. 79**), who, as the inscription tells us, "formed a digest of Hindu and Mohammedan laws." The relief on the sarcophagus shows him doing his fieldwork, with three Eastern sages seated on a low platform in front of him. Apart from a few reminiscences of the drapery of classical Greek sculpture, the style is vigorously realistic: the Wise Men bear every mark of ethnic authenticity, and the banana plants in the background are so convincing that the artist probably went to the trouble of studying live specimens in a hothouse instead of copying them from botanical engravings. The realism of the scene is further enhanced by the combination of high, medium, and low relief, which creates a sense of spatial depth unusual for Flaxman. Yet the whole has a contemplative air that reflects the Neoclassical ideal of "timelessness." Moreover, the idea of a memorial showing a characteristic scene from the life of the deceased

Fig. 78 **John Flaxman**, Monument to Agnes Cromwell, 1797–1800. Marble. Chichester Cathedral.

Fig. 79 **John Flaxman**, Monument to Sir William Jones, 1795–98. Marble. University College, Oxford.

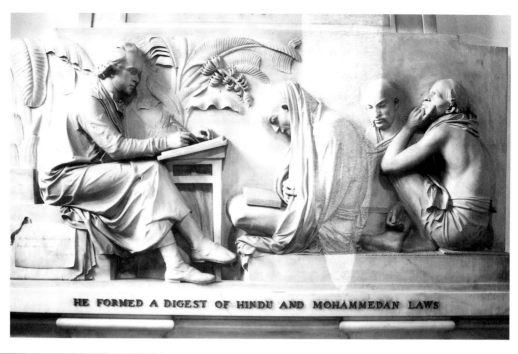

HE FORMED A DIGEST OF HINDU AND MOHAMMEDAN LAWS

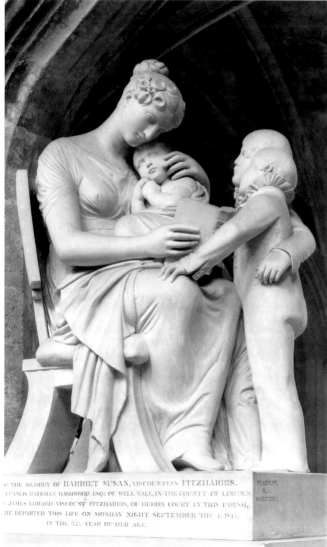

O THE MEMORY OF HARRIET SUSAN, VISCOUNTESS FITZHARRIS,
FRANCIS BATEMAN DASHWOOD ESQ! OF WELL VALE, IN THE COUNTY OF LINCOLN,
JAMES EDWARD VISCOUNT FITZHARRIS, OF HERON COURT IN THIS PARISH,
HE DEPARTED THIS LIFE ON MONDAY NIGHT SEPTEMBER THE 1, 1815,
IN THE 32! YEAR OF HER AGE.

Fig. 80 **John Flaxman**, Monument to Lady Fitzharris, 1816–17. Marble, life-size. Christchurch Priory, Hampshire.

is derived from Greek grave steles. In selecting the scene, Flaxman—and his public—favored "good deeds": gathering the wisdom of the East, charity, teaching. The last two are combined in his most successful free-standing private monument, that to Lady Fitzharris of 1816–17 (fig. 80). The original design, which was in relief, has been most successfully transposed into a compact three-dimensional group carved from a single block of marble, showing the young mother reading to her three children. Their physical closeness effectively conveys the bond of affection that binds them together. All four are in contemporary dress; only the Greek Revival chair and the simplified handling of the surfaces, characteristic of Flaxman's later work, are Neoclassical.

Flaxman most nearly fits the label "Romantic Classicist," because of his double allegiance to the Greek and the medieval "primitives," his belief in the value of religious experience, and his devotion to sentiment, which he termed "the life and soul of fine art."

Flaxman's effect on private monuments in England lasted well into the second half of the century. Richard Westmacott (1775–1856) had been a disciple of Canova in Rome for four years in the mid-1790s; yet, after his return, his work reflected Flaxman's style rather than his master's. Soon the young sculptor, still in his twenties, received the first of several commissions for public monuments in Westminster Abbey and, in St. Paul's, the memorial to General Ralph Abercrombie (fig. 81). He created a design in complete contrast to the static groups of Banks (see fig. 77) or Flaxman, and the very opposite of Canovian "timelessness": no allegories or personifications, only the pathos of death in action as the general, mortally wounded, falls from his rearing horse into the arms of a soldier who has rushed

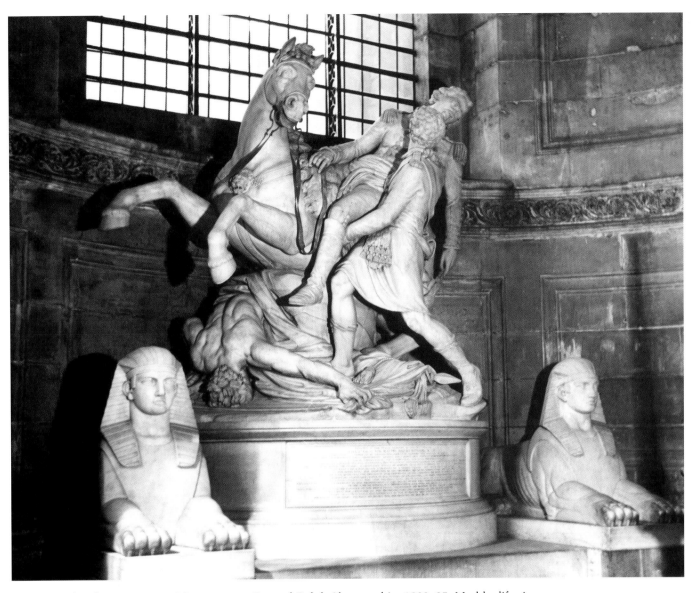

Fig. 81 **Richard Westmacott**, Monument to General Ralph Abercrombie, 1802–05. Marble, life-size. St. Paul's Cathedral, London.

up to help him. One is tempted to call the monument Baroque, yet the only Baroque quality here is the choice of a specific moment in a dramatic event, which necessitates showing the figures in motion. Westmacott no doubt knew the Baroque tombs of Roubiliac and his followers, but none of them offers a real precedent. Westmacott's is a free-standing group on an oval base. He also avoids any hint of Baroque exuberance and sensuousness in the carving. Surely Westmacott thought of the Abercrombie Memorial as the modern counterpart of ancient multi-figured groups such as the *Farnese Bull*. He would have been mortified had any of his contemporaries accused him of reverting to the despised style of the past (in 1805, he praised Banks for having "stemmed the torrent of false taste"). The Abercrombie Memorial remains the most original creation of Westmacott's career. So bold was the idea of honoring a military hero by showing the moment of his death in action

that no other sculptor dared to repeat it as a free-standing group for more than forty years.

Scandinavia

Among the Scandinavian sculptors in Rome who prepared the advent of Neoclassicism, the Swede Johan Tobias Sergel (1740–1814) was the most gifted. He studied with French masters of the late Baroque, first in Stockholm, then in Paris. On returning home, he was appointed sculptor to the king, a position he held for the rest of his career. In 1767 he went to Rome on a fellowship from the Swedish Royal Academy. According to his own account, the art treasures there so overwhelmed him that for the first four months he could do no work of his own. That Rome was indeed the great experience of his life is confirmed by the

Fig. 82 **Johan Tobias Sergel**, *Diomedes*, c. 1770. Terracotta. Nationalmuseum, Stockholm.

Had he had more orders for finished marble statues, he surely would have preferred to take his chances in Rome as an independent artist instead of heeding the king's command and returning to the less congenial tasks of a court sculptor in Stockholm. After 1779, his work shows a quick waning of his Neoclassical ambitions and a recrudescence of the Baroque tradition.

France

The creation of the Rococo style in the early years of the eighteenth century confirmed the position of France as the artistic leader of Europe. During the reign of Louis XV (1715–74) France produced enough sculptors of high rank to supply not only its own needs but those of the courts and academies in the rest of the Western world. While the demands of state and church for monumental sculpture were decreasing, there was a sufficient number of such

Fig. 83 **Jean-Baptiste Pigalle**, *Voltaire*, 1770–76. Marble, life-size. Institut de France, Paris.

fact that he stayed on long after his fellowship had run out, for a total of eleven years. During those years, the Anglo-Romans were in full flower, and Sergel soon made friends with a number of them, especially Henry Fuseli. Sergel's pre-Roman works include only one classical subject; while in Rome, however, he explored a wide variety of ancient themes, Greek rather than Roman. Many of them retain a sensuous and playful air, echoing Sergel's familiarity with the French Rococo, but others, such as his *Diomedes* (fig. 82), are close to the style of Thomas Banks in their heroic idealism. Clearly, Sergel aspired to the creation of "modern classics." Unfortunately, most of his rich Roman production never went beyond the stage of terracotta sketches.

Fig. 84 **Étienne-Maurice Falconet**, Monument to Peter the Great, 1766–82. Bronze on granite base, over life-size. Decembrists' Square, St. Petersburg.

PETRO PRIMO
CATHARINA SECUNDA
MDCCLXXXII·

commissions for the best talents to keep a healthy balance with works on a more intimate scale for private patrons. After the middle of the century, the Rococo tradition was increasingly challenged by the call for a return to the antique, issued by the thinkers of the Enlightenment, the new intellectual heroes of the age, on both moral and aesthetic grounds. Voltaire, already famous then as a wit and playwright, had achieved an exalted status as a hero of the Enlightenment by 1770 when the Society of Men of Letters of France decided to sponsor a monument to him. The strange result, a portrait statue from Jean-Baptiste Pigalle (1714–85; **fig. 83**) shows Voltaire nude, with the intention of likening him to the Roman philosopher Seneca. Needless to say, Voltaire did not pose for Pigalle undressed; the sculptor had hired an aged veteran as a model and grafted Voltaire's features onto his body. It was this "unclassical" realism that made the statue seem so unsatisfactory (few, apparently, understood the reference to Seneca). Voltaire himself gave it the *coup de grâce* by wondering why Pigalle had chosen to represent him "in the

guise of Venus." Obviously Pigalle had difficulty coping with the new vogue for antiquity, and his main work, the monumental tomb of Field Marshal Maurice de Saxe in Strasbourg (1762–70), is wholly in the Baroque tradition.

Étienne-Maurice Falconet (1716–91) adapted more easily to the new conditions prevailing after the middle of the century. From the start, he showed a preference for a "cool Rococo" on an intimate scale, gaining particular success with his graceful female nudes, akin to the type popularized by François Boucher. They lent themselves well to reproduction, on a still smaller scale, in porcelain at the newly founded manufactory at Sèvres, which Falconet directed from 1757 to 1766. The original models, shown at the Salon, brought him extravagant praise from Diderot, whose recommendation led Catherine II of Russia to choose Falconet in 1766 to execute a colossal equestrian bronze monument to Peter the Great (**fig. 84**). He spent the next twelve years in St. Petersburg modeling and casting the statue, by far his greatest achievement. There were long periods of enforced leisure due to local difficulties, during

which Falconet wrote an essay on the Marcus Aurelius monument in Rome (although he had never seen it) and a translation of parts of Pliny's account of ancient painting and sculpture. One might well expect his *Peter the Great* to reflect this preoccupation with classical antiquity, but actually the statue is of a type introduced by Bernini for his equestrian *Louis XIV*. Peter the Great, in a vaguely classical costume and riding without stirrups as the ancients did, is shown as a Hero of Virtue who has reached the pinnacle of his endeavors (the great granite rock, whose transport and emplacement strained all the engineering knowledge of the time), while his mount tramples the snake of Evil underfoot. Yet we must not overlook the differences, which to Falconet, who hated Bernini, were decisive: the absence of swelling, expansive Baroque modeling, the far more realistic horse, the avoidance of windblown drapery in the emperor's costume. Falconet's design thus maintains a careful balance between Baroque élan and a rationalist critique of it; it seeks to project the image of an enlightened ruler rather than of an absolutist monarch.

Fig. 85 **Jean-Antoine Houdon**, *Denis Diderot*, 1771. Marble, life-size. Louvre, Paris.

While for Falconet and his contemporaries portrait sculpture was a comparatively minor aspect of their work, Jean-Antoine Houdon (1741–1828) built his career on it. His training at the Royal Academy, followed by four years in Rome, certainly did not predispose him toward portraiture. He would have been glad to accept state commissions had they been available; however, he discovered quite soon his special gift for portraits, for which there was a growing demand. Indeed, he established entirely new standards of physical and psychological verisimilitude that reflect Enlightenment thought.

During his Roman stay, Houdon modeled a life-size *écorché* (the French term for a "flayed man" with the skin stripped away to reveal the muscles) that became standard equipment in almost every art academy. As a portraitist, he would study his subjects in the same way he had the cadavers for his *écorché*, taking exact measurements and making casts of the face and hands whenever possible. Miraculously, this preoccupation with external accuracy did not have the deadening effect one might expect; on the contrary, in his hands at least, it yielded images filled with life and enhanced by a new authenticity.

Houdon's first great triumph as a portraitist, the bust of Diderot (**fig. 85**), in 1771, may have been a calculated stratagem to attract the attention of the noted critic and *philosophe*. The public admired the bust as much as did the sitter, and Houdon produced a large number of replicas in plaster, terracotta, and bronze during the following years. The praise lavished on the *Diderot* by the Salon critics invariably stresses its "naturalness," the way it projects the sitter's personality. What distinguishes it immediately from all earlier portrait busts is the seeming absence of a recognizable style, as if the sculptor had suppressed his own individuality for the sake of a painstaking fidelity to the sitter's appearance. The format of the bust is antique-timeless, but there is nothing even faintly Roman about this head. *Diderot* projects a sense of "living presence" that is due entirely to Houdon's genius for conveying the mobility of Diderot's features. Nevertheless, the bust also embodies a new ideal personality type. Here, for the first time in the long history of portraiture, is an image of modern man—unheroic, skeptical, and commingling rationality with emotion. The apparent lack of style in his portraits, then, is deceptive: his style consists of the uncanny ability to make all his sitters into Enlightenment personalities while remaining conscientiously faithful to their individual physiognomies.

Critics acclaimed Houdon's *Voltaire*, modeled from life a few weeks before the author's death in May 1778, as towering above all other sculpted portraits of him. Houdon's Voltaire busts were offered to the public not only in the usual variety of materials but in four different models: in contemporary dress, with wig; bald-headed, with or without Roman drapery; and as an "excerpt" from the seated

Fig. 86 **Jean-Antoine Houdon**, *Voltaire Seated*, from a plaster model of 1778–80. Terracotta, life-size. Musée Fabre, Montpellier.

life-size figure. Although no one had commissioned the statue, the sculptor's hope that it would become a monument proved valid. Voltaire's niece ordered a marble version which she gave to the Comédie Française. The original plaster has not survived, but a terracotta cast from it, retouched by Houdon, offers a close approximation (**fig. 86**). As contemporary critics quickly pointed out, the *Voltaire Seated* was a "heroicized" likeness, enveloping the frail old man in a Roman toga and even endowing him with some hair he no longer had so as to justify the classical headband. Yet Voltaire wears the toga as casually as a

dressing gown, and his facial expression and the turn of his head suggest the atmosphere of an intimate conversation. Unlike Pigalle's unsuccessful effort, this *Voltaire* is not cast in the role of classical philosopher; he is the modern counterpart of one.

Voltaire Seated became a public monument through private initiative. The official projects for such monuments during those years usually came to nothing; however, the head of the academy, the Count of Angiviller, committed the available moneys to a series of statues of the "Great Men" of France for the Grand Gallery of the Louvre, which

was then in the process of being turned into a museum. The aim, in keeping with the "new moralism" of the reign of Louis XVI, was to "reawaken virtue and patriotism" among the public. The idea originated in France, but it was the English who first carried it out, though on a far less ambitious scale, in the Temple of British Worthies (see page 94).

Beginning in 1776, four statues were commissioned every two years, the models to be shown at the Salon for public critique. The Count of Angiviller not only chose the subjects but laid down two rules: each Great Man must be in correct historical costume and "at the most significant moment of his life." Moreover, the sculptors had to provide small-scale replicas of their statues for reproduction in

Fig. 87 **Jean-Antoine Houdon**, *Admiral de Tourville*, 1781. Marble, over life-size. Château de Versailles.

porcelain at Sèvres so as to make the series accessible to a wider public.

Houdon, who as a mere *bustier* was not held in very high regard at the academy, did not have a chance to participate until the third round, which included the subject of Admiral de Tourville, who had commanded the French fleet at its disastrous defeat by the English in the battle of La Hogue in 1692. How did this somewhat inglorious hero enter the ranks of the Great Men of France? Not because he fought bravely, but because he had committed his forces, which he knew were greatly inferior to those of the enemy, to battle at the command of the king. Houdon's statue (**fig. 87**) has the admiral pointing with his sword to the king's written command, with his head turned as if addressing an invisible group of officers to his left. Behind all the Baroque finery, the pose is in essence that of the *Apollo Belvedere*. Some contemporary critics complained that the figure was "overdressed," even though they all admired the sculptor's virtuosity in rendering textures, especially the windblown hair and lace jabot. The chief shortcoming of the statue, however, is Houdon's failure to convey the emotional conflict between prudence and loyalty.

The entire series of Great Men suffers because none of them is self-explanatory. On the other hand, without Angiviller's insistence on historic authenticity and the significant moment, his Great Men would probably have resulted in a deadly uniform sequence of idealized figures. In any event, they set the precedent for the century to come.

In 1778, when Houdon became a freemason, he met and modeled Benjamin Franklin (**fig. 88**). Replicas of the Franklin bust spread the artist's fame in the New World. Thus, when the Virginia legislature decided to commission a marble statue of George Washington (**fig. 89**), the natural choice was Houdon. Houdon insisted on coming over to model his sitter directly; in October 1785, he spent two weeks at Washington's family mansion at Mount Vernon, taking measurements, making casts of the general's shoulders and hands (he would not permit one of his face), and modeling a bust from life. By January 1786, Houdon was back in Paris. Two years later, the final form of the statue had been decided upon, although the figure was not erected in the rotunda of the State Capitol in Washington until 1796.

Washington no longer held public office; he was simply a gentleman farmer. Houdon has given him a general's uniform, but the sword, no longer needed in peacetime, is suspended from a bundle of thirteen rods (representing the original states of the Union) and his right hand rests on a cane. Behind his feet is a plow, the symbol of peace. These attributes, with their classical allusions, blend easily with the contemporary dress, and the *contrapposto* stance of the figure is so well motivated that the beholder is hardly aware of its antique origin. Above all, Houdon has created an

of one foot. The latter idea may well have been derived from Giambologna's *Flying Mercury*, yet Diana's elongated proportions, even the suggestion of weightlessness, derive from the School of Fontainebleau, thus reviving a specifically French tradition. This is not her only distinction: far more daring, indeed unprecedented, is her complete and unselfconscious nudity. Houdon's *Diana* was to have countless successors in the nineteenth century. In 1777, however, the work could not be shown at the Salon because of the figure's "indecency," so it could be viewed only in Houdon's studio. The critics were unanimous in their praise, comparing Diana's beauty with that of ancient statues. Houdon had no trouble exhibiting the statue at the Salon of 1802, by which time the critics were less enthusiastic. "At a time when we did not yet understand the beauties of the antique," wrote one of them, "this statue might

Fig. 88 **Jean-Antoine Houdon**, *Benjamin Franklin*, 1779. Marble, height 16½". The Philadelphia Museum of Art, Pennsylvania.

impressive image of Washington's character along with a meticulous record of his physical appearance.

A contemporary painting of the artist in his studio, by Louis-Léopold Boilly, shows Houdon at work in Paris, on a bust of the astronomer Pierre-Simon Laplace (**fig 90**). Houdon's wife and three daughters look on while he works in his typical manner—modeling directly from the figure. The studio is decorated with his own works, including *Voltaire* and *Diana* (see below), displayed on pedestals for interested customers to admire and to be used as models for himself. The scene is not only a family portrait, but an intimate view into the artist's working life, with room for domestic details in the midst of the crowded studio space.

During the turbulent years 1789–1800, from the start of the French Revolution to the Empire of Napoleon, Houdon produced unexpectedly few portraits. The critical response to his *Diana* (**fig. 91**), conceived in 1774 and later exhibited at the Salon, tended to treat him as a relic from an earlier era. Diana the Huntress, her identity fixed by the tiny crescent in her hair, is running at a very leisurely pace, without the slightest sense of strain, balancing on the toes

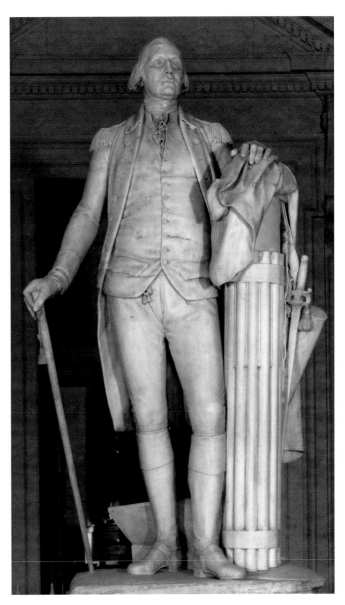

Fig. 89 **Jean-Antoine Houdon**, *George Washington*, 1786–96. Marble, life-size. State Capitol, Richmond, Virginia.

A "PEDESTRIAN STATUE":
HOUDON, JEFFERSON, AND WASHINGTON

The Frenchman Jean-Antoine Houdon was an acknowledged master, perhaps the finest portrait sculptor at work in the late eighteenth century. So when the young Virginia government commissioned him to commemorate George Washington, America's military hero and future political leader, it was, first and foremost, an act of profoundly enlightened artistic patronage (see fig. 89). But the finished work was also a celebration of Enlightenment values, a solemn memorial to a great man, yes, but one with a strongly democratic bent.

Although the expense of securing Houdon was great, Thomas Jefferson had no trouble in persuading him to accept the commission and cross the Atlantic. Jefferson wrote to Governor Benjamin Harrison of Virginia on January 12, 1785, outlining the sculptor's credentials:

There could be no question raised as to the Sculptor who should be employed; the reputation of Mons. Houdon, of this city [Paris], being unrivalled in Europe. He is resorted to for the statues of most of the sovereigns of Europe. ... Mons. Houdon ... was so anxious to be the person who should hand down the figure of the General to future ages, that without hesitating a moment he offered to abandon his business here, to leave the statues of Kings unfinished, and to go to America to take the true figure by actual inspection and mensuration.[19]

Houdon left Le Havre for Southampton and then Philadelphia on July 22, 1785, accompanied by Benjamin Franklin, two workmen, and a 25,000 livres (1,000 guineas) commission. He took out an additional life insurance of 10,000 livres and a few thousand more for passage, equipment, and expenses, as his tools, materials, and luggage had been lost between Paris and Le Havre.[20]

On his arrival in September, Houdon received a modest letter from Washington which stated, "I wish the object of your mission had been more worthy of the masterly genius of the first statuary in Europe; for thus you are represented to me."[21]

Washington was even diffident about how he should be represented, as his letter of August 1786 to Jefferson indicates :

In answer to your obliging inquiries respecting the dress, attitude, &c., which I would wish to have given to the statue in question, I have only to observe, that, not having sufficient knowledge in the art of sculpture to oppose my judgment to the taste of connoisseurs, I do not desire to dictate in the matter. On the contrary, I shall be perfectly satisfied with whatever may be judged decent and proper. I should even scarcely have ventured to suggest, that perhaps a servile adherence to the garb of antiquity might not be altogether so expedient, as some little deviation in favor of the modern costume, if I had not learnt from Colonel Humphreys, that this was a circumstance hinted in conversation by Mr. [Benjamin] West to Mr. Houdon. This taste, which has been introduced in painting by West, I understand is received with applause, and prevails extensively.[22]

The contemporary art critic and historian, Robert Hughes, has neatly summarized the significance of this sculpture as part of the aesthetic imagination of the new republic. He sees it as the product of a dialogue, outlined above, between men quite conscious that they had an opportunity to capture the symbolic power of the new political landscape through artistic expression:

The first American political statue of serious esthetic quality was a life-size portrait of Washington by Jean-Antoine Houdon. Jefferson commissioned it, on behalf of the Virginia legislature. ... The "pedestrian statue," as Jefferson called it (meaning a standing figure, on its own feet), was the by-product of a larger deal, for in 1783 Congress had authorized the commissioning of an equestrian statue of the *pater patriae*, and Houdon was to do that too ...

In the end, the bronze Washington on horseback was never done, but the marble one was delivered and installed in the rotunda of the Virginia State House in 1792. It is a superb display of neo-classical style and intelligence. Insofar as a single figure can, it expresses democracy. Jefferson had insisted that "the size should be precisely that of a man." Anything bigger would have been pretentious. It shows the statesman as citizen, *primus inter pares* in the Latin phrase that meant so much to the Founding Fathers—not a king, not a god, but first among equals. Divine presence, however, is implied by its placement in the State House; Houdon's Washington stands where the effigy of the god would have stood in a real Roman temple. ...

We do not see Washington as victorious general. He is presented as a new Cincinnatus. Washington was a Virginia planter, summoned to lead the patriot armies. Cincinnatus, a legendary Roman hero, was called from farming life to become dictator of the Republic in 485 BC and save the Roman army. He defeated the enemy, resigned his powers after only sixteen days, and returned to his farm, thus becoming the very archetype of Roman-Yankee civic integrity.

... The final, almost subliminal touch is a missing button on the right lapel of Washington's coat, which lets you know that the great man is capable of a certain negligence in *tenue* and is not a stickler for protocol—democracy in dress, as it were.[23]

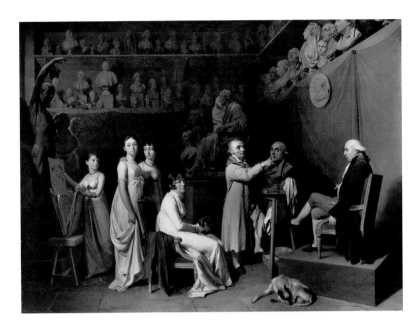

Fig. 90 **Louis-Léopold Boilly**, *Houdon in His Studio*, 1803–04. Oil on canvas, 34⅝ × 45¼". Musée des Arts Decoratifs, Paris.

have given us pleasure; but today, when we insist on purity of design . . . we cannot help laughing at this unfortunate *Diana*, who, moreover, lacks any bit of clothing to hide her French build." Yet it is exactly this element of "realism," hardly perceptible to present-day eyes, that constitutes the modernity of Houdon's *Diana*.

In painting, the Revolution had produced at least one great masterpiece, David's *Death of Marat* of 1793 (see fig. 21). If sculpture can boast of nothing comparable during those years, the reason is not that it was neglected: the Revolution commissioned a great deal of sculpture, in fact, but most of it was meant to be temporary, occasioned by the countless revolutionary festivals. Permanent projects, such as the colossal statue of the French people proposed by David, either failed to be carried out for lack of funds or, if they were completed, fell victim to the shifting political tides.

Joseph Chinard (1756–1813) had a prolific and cosmopolitan career, yet he spent most of his life in his home town of Lyons and never had more than a visitor's status in Paris. After a thoroughly provincial training, he found a private patron in 1784 who enabled him to spend three years in Rome, where he somewhat hesitantly joined the Neoclassical trend. He experienced the early phase of the Revolution in Lyons but returned to Rome at the end of 1791, having absorbed a certain amount of revolutionary iconography, as evidenced by two groups originally commissioned as bases for candelabra, *Jupiter Smashing the Aristocracy* and *Apollo Trampling Superstition Underfoot* (**fig. 92**). Both present the problem of how to convey a new message in a traditional vocabulary. If Jupiter, recognizable by his thunderbolt, is smashing the aristocracy, he must represent the French people, but what entitles him to this unaccustomed role? Apollo retains his legendary identity as the god of Light, hence now also of Enlightenment and

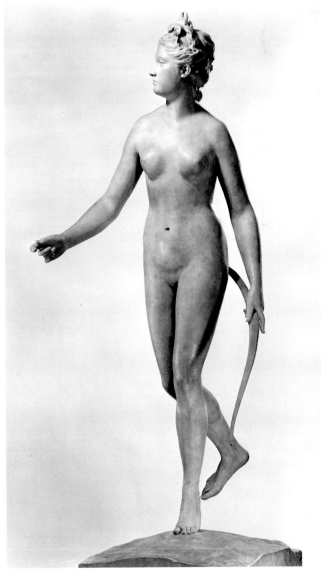

Fig. 91 **Jean-Antoine Houdon**, *Diana*, from a plaster model of 1776. Terracotta, life-size. The Frick Collection, New York.

behalf), he was back in Lyons by the end of 1792. Before long, however, he found himself in jail once more; he had been denounced by revolutionary zealots for "moderation and counter-revolutionary tendencies" on iconographic grounds: his *Liberty* did not hold her civic crown high enough, an insult to this "Republican diadem." After four months, the "people's court" heard his case and released him. The *Liberty* and its companion, *Equality*, decorated the facade of the city hall, where they replaced an equestrian figure of Louis XIV destroyed by revolutionaries. They in turn, however, were removed in 1810, and some decades later, with a further turn of political fortune, an equestrian *Henri IV* was put up instead. Such politically motivated destruction of sculpture old and new occurred all over France during the Revolution, reminiscent of the assault on pagan idols in Early Christian times. The political leaders of the Revolution, aware of the special emotional weight attached to sculpture, sponsored hundreds of statues personifying such new idols as Liberty, Equality, and the Republic. They are now known only through a small number of maquettes and some engravings and drawings.

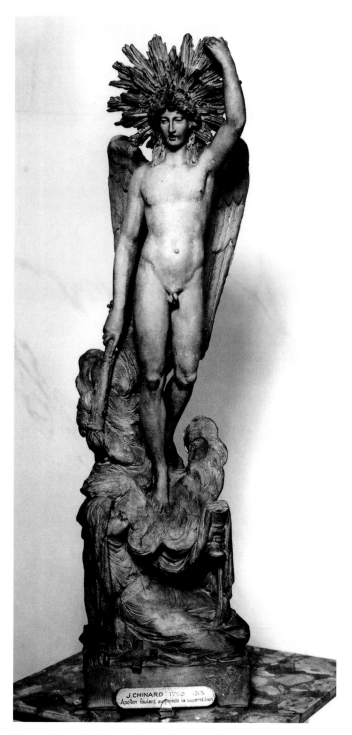

Fig. 92 **Joseph Chinard**, *Apollo Trampling Superstition Underfoot*, 1792. Terracotta, height 20½".
Musée Carnavalet, Paris.

Reason, which makes him the adversary of unreason as represented by Superstition, for which, however, there was no ready-made image, so Chinard had to use the traditional personification of Faith, with chalice and cross. It was Superstition that got him into trouble: somebody denounced him to the papal police, who clapped him into jail for anti-religious activities. Released after two months (the revolutionary government had intervened on his

Fig. 93 **Joseph Chinard**, *The Republic*, c. 1793. Terracotta.
Louvre, Paris.

Chinard's terracotta *The Republic* (fig. 93), also known as *Revolutionary and Law-Giving France*, conveys a fair idea of what these monuments looked like. Classically draped, Republican France sits immobile between two large tablets, inscribed "The Rights of Man" and "Laws," respectively. She wears the Phrygian cap—originally worn by freedmen in ancient Rome—that will be the identifying attribute of either Liberty or Republican France from now on. She is actively unveiling the Rights of Man with her right hand, while her left holds an oak branch that frames the Laws. But this very slight asymmetry is not sufficient to mitigate the rigid immobility of the image as a whole. Carried out on a large scale, it might inspire awe but would hardly evoke an emotional response.

Despite his sculptural services to the Revolution, Chinard's best talent and his finest work was that of a portraitist. His busts date almost entirely from the years of Napoleon's Consulate and Empire. Napoleon himself as well as many members of his entourage posed for him, but Chinard was far better at portraying women than men, as is evident in his busts of the Empress Josephine and his enchanting portrait of Mme. Récamier, the most admired beauty of the period.

Antonio Canova

Antonio Canova (1757–1822) was not only the greatest sculptor of his generation, but the most famous artist of the Western world from the 1790s until long after his death. Both his work and his personality became a model for every sculptor during those years. Canova was born in the small town of Possagno in the hinterland of Venice, a region long famous for its great painters rather than its sculptors. His early works are all in the waning Baroque tradition. His first visit to Rome, in the winter of 1779–80, was a revelation: his Roman contemporaries had little to offer him—they were mostly engaged in restoring or copying antique statues for export—but the Anglo-Romans impressed him deeply. A year later, having settled in Rome, Canova received a most unusual commission from the Venetian ambassador to the Holy See, for a work whose subject was left to the artist's choice. The result, *Theseus and the Minotaur* (fig. 94), embodies Canova's new artistic credo. Instead of showing the struggle between the two, it represents the victorious hero seated on the body of the slain monster, calmly contemplating it (the looped strands under the Minotaur's body refer to the thread of

Fig. 94 **Antonio Canova**, *Theseus and the Minotaur*, 1781–83. Marble, life-size. Victoria and Albert Museum, London.

Fig. 95 **Antonio Canova**, Tomb of Maria Christina, Archduchess of Austria, 1798–1805. Marble, height 18′ 10″. Church of the Augustinians, Vienna.

Ariadne that enabled Theseus to find his way out of the labyrinth).

The smooth, cool surfaces of the *Theseus* group, the idealized bodies, even the facial type of the hero, all betray a close study of ancient sculpture, yet the design and the conception of the subject are wholly original. The work is created in the spirit of the antique without in any sense being a copy, and the lack of action consciously emphasizes its "timelessness." The group was greeted with tremendous acclaim from the start, among its most enthusiastic admirers being Gavin Hamilton (see pages 29–30), who helped to procure Canova's next commission. This was the most ambitious any sculptor could hope for: a papal tomb, that of Clement XIV, which the artist completed in 1787, after four years' labor. The basic elements of the design—the pyramidal composition culminating in the enthroned figure of the pontiff above the sarcophagus flanked by mourning Virtues—had been a firmly established tradition ever since the great papal tombs by Bernini. Canova did not dare depart from it, but his interpretation is the very opposite of Baroque. The emotional drama of death vanquished by eternity has given way to a timeless calm dominated by the simple stereometric units of the monument. The structure would be almost unbearably severe were it not for the asymmetrical placement of the two Virtues. The statues of Meekness and Temperance are separated not only physically, each being placed at a different level; they seem unaware of each other's presence.

Canova's career is well attested by his numerous prestigious commissions, including a second papal monument, that of Clement XIII. The pontiff kneels in prayer on a blocklike structure flanked by a pair of mourning lions; the figure of Religion stands opposite a winged genius leaning on an extinguished torch, the classical personification of death and a favorite device in Neoclassical funerary art.

A monument to Titian, abandoned in 1795, became the framework of the tomb of Maria Christina, Archduchess of Austria, in the Church of the Augustinians in Vienna (fig. 95). It was commissioned by her husband soon after her death in 1798, but its salient features had been anticipated by what was to have been a monument to the undying fame of a great artist long since deceased: the pyramid, symbol of things everlasting; the cameo portrait above the entrance, framed by a snake biting its own tail, another emblem of eternity, and sustained by two floating genii; the funerary procession entering from the left and the mourning winged genius on the right. The pyramid is not a three-dimensional structure but a low relief, while the steps leading up to it and the figures occupying them are "real," like actors performing before a backdrop. The slow procession, directed away from the beholder, represents "eternal remembrance," all references to Christianity

being conspicuously absent. The tomb is admired as much for its "timeless" beauty as for its gently melancholic sentiment.

Among the many statues and groups of classical subjects that Canova produced after the spectacular success of his *Theseus*, the most daring is the colossal *Heracles and Lichas* (figs. 96 and 97). The artist completed the full-scale plaster model in 1796, but the marble version was delayed until 1815. The subject, one of the most gruesome in Greek mythology, shows Heracles, driven mad with pain after he has donned the poisoned shirt of Nessus, killing the youthful messenger who had brought him the fatal garment. The sculpture's almost unbearable tension and violence are contained within a firm, simple contour. Yet the frontal view does not reveal the whole of the action; unlike the *Laocoön* group, *Heracles and Lichas* demands to be seen from the rear as well if we are to comprehend the desperate resistance of Lichas—his left hand gripping the

Fig. 96 **Antonio Canova**, *Heracles and Lichas*, 1795–96. Plaster model, over life-size. Gipsoteca, Possagno (on deposit from the Accademia, Venice).

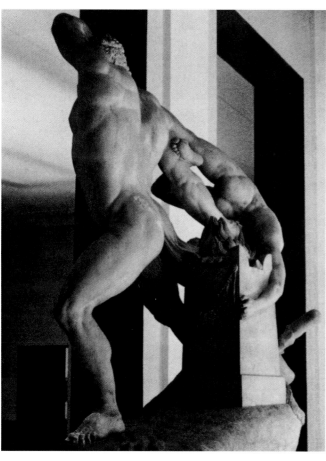

Fig. 97 **Antonio Canova**, *Heracles and Lichas*, completed 1815. Marble, over life-size. Galleria d'Arte Moderna, Rome.

edge of the altar, his right foot hooked behind Heracles' arm. With this piece, Canova proved that he could create a "new classic" competing with the *Laocoön*.

Canova always inveighed against copying the antique, but when the French had carried off the *Medici Venus*, the most admired classical statue in Florence, he agreed reluctantly to carve a copy. Instead he produced an unmistakably modern work, the *Venus Italica* (**fig. 98**) whose fame soon rivaled that of the ancient statue. Canova's *Venus* imitates its classical predecessors only in the cool, smooth treatment of the marble; the proportions, the pose, even the coiffure are Canova's own invention. This Venus has been surprised during her bath: she covers her nudity as best she can to escape the unwelcome glance while looking back at the intruder. The figure thus displays two distinct aspects. In the frontal view, her movement is barely perceptible, but

Fig. 98 **Antonio Canova**, *Venus Italica*, 1804–12. Marble, life-size. Palazzo Pitti, Florence.

Canova's friends included Jacques-Louis David (see pages 26–40) and the influential critic and theorist of Neoclassicism Antoine-Chrysostome Quatremère de Quincy, who helped to spread the sculptor's fame in France. In 1802, Canova was invited to Paris by Napoleon, who wanted his portrait done by this luminary. His attitude toward Napoleon was strangely ambiguous: he resented the conquest of Italy and especially the abduction of classical masterpieces to Paris, yet he also admired Napoleon for having unified Italy and for modernizing its institutions. In 1806, with Napoleon's approval, Canova made a colossal nude figure in marble showing the conqueror as a victorious and peace-giving Mars (fig. 99). The head is an idealized but thoroughly recognizable version of Canova's earlier bust, but the figure is based on statues of ancient rulers in the guise of nude classical deities. As Napoleon's favorite sculptor, Canova produced many portraits of the emperor's family, including the famous semi-nude reclining figure of his sister, Pauline Borghese, with the apple of the victorious Venus. Canova's statue of Napoleon himself, however, had an ironic fate: by the time it reached Paris in 1811, the emperor was embarrassed by its nudity, and the catastrophic Russian campaign of the following year rendered so godlike an image even less fit for public display. It was hidden away in the Louvre until it emerged in 1815 as a souvenir for the Duke of Wellington.

The Early Thorvaldsen

The Napoleonic era was thus not a propitious one for sculptors who wanted to emulate Canova in being independent, beholden to no single patron, free to create "modern classics." The only one who succeeded, and on whom Canova's mantle ultimately descended, was a young Dane, Bertel Thorvaldsen (1770–1844), who arrived in Rome in 1797 on a fellowship from the Royal Academy in Copenhagen. When his money ran out in 1802 and he was on the point of returning home, a lucky chance made it possible for him to stay on: for a few months that year, there was peace between France and England, so British artists and collectors could travel on the Continent. An important art patron from London, Thomas Hope, visited Thorvaldsen, who had just finished the plaster model of a statue of Jason, his first monumental work. Hope paid the artist a generous advance for a marble version (not finished until 1828). Canova himself praised *Jason* as a novel and daring achievement, and the statue (fig. 100) does indeed challenge Canova on his own ground; instead of absorbing the Hellenistic style, as Canova did, it reflects the far more severe Greek style of the mid-fifth century B.C. Thorvaldsen thus became the first Neoclassical sculptor to revive the most heroic phase of Athenian art. Compared with the

Fig. 99 **Antonio Canova**, *Napoleon*, 1806. Marble, over life-size. Apsley House, London.

as we follow the direction of her glance and assume the place of the intruder, the forward movement becomes the dominant feature. Psychologically, the *Venus Italica* is Canova's most subtle and complex creation, as well as his least classical.

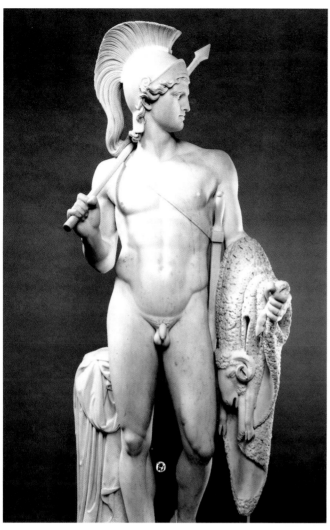

Jason, any work by Canova has a sensuous softness that Thorvaldsen was at pains to avoid.

In his third version of *Ganymede and the Eagle*, begun in 1815 (fig. 101), Thorvaldsen chose to show the shepherd king kneeling, a pose taken from a Roman gem in his own collection of antiquities. Thorvaldsen returned to the theme in the 1830s and in 1831 he presented a copy to the Acadamy of St. Luke in Rome, where he had been elected president in 1827.

Demand for Thorvaldsen's work remained consistently high, so he produced numerous copies of his sculptures. Like Canova, he would create a life-size clay model (rather than a small sketch), from which his assistants then made marble versions, the surfaces of which Thorvaldsen finished himself. Visitors flocked to Thorvaldsen's studio to see the master overseeing all phases of production. He stayed on in Rome until 1838, so the greater part of his career belongs to the post-Napoleonic era, when he attracted patrons from all over Europe.

Austria and Germany

The gospel of Winckelmann spread the quest for "new classics" among many younger German and Austrian artists. Franz Anton Zauner (1746–1822), after five years in Rome on a fellowship from the Vienna Academy, returned in 1781 to Austria with a personal style heavily dependent on antique models. His most ambitious product, the bronze

Fig. 100 **Bertel Thorvaldsen**, *Jason*, 1802–28. Marble, over life-size. Thorvaldsens Museum, Copenhagen.

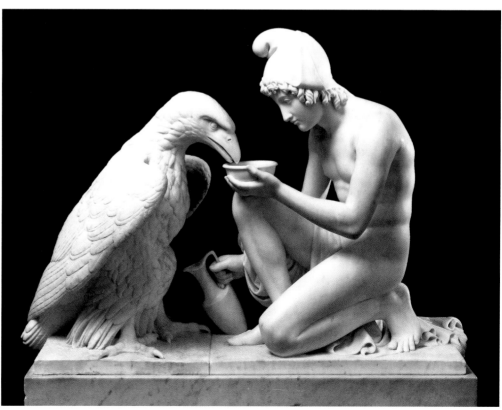

Fig. 101 **Bertel Thorvaldsen**, *Ganymede and the Eagle*, 1815–17. Marble, height 32¼". Chrysler Museum of Art, Norfolk, Virginia.

equestrian monument to the Emperor Joseph II (fig. 102), designed in 1795 and unveiled in 1806, may claim to be the earliest fully Neoclassical version of this long-established type. The horse and rider, on a severe rectangular base, evoke the Roman monument to Marcus Aurelius, although Zauner's animal is slenderer and anatomically more correct than its ancient model. The work also exemplifies the ultimately insoluble problem of reconciling the "timeless-ness" of such a monument with the specific personality and achievements of the ruler thus honored. How is the beholder to know that this is Joseph II unless he happens to be familiar with the emperor's features? And how can he be expected to understand the meaning of the reliefs on the base celebrating the emperor's achievements if all the figures except Joseph II himself are personifications? The panel on the right side shows the emperor's promotion of

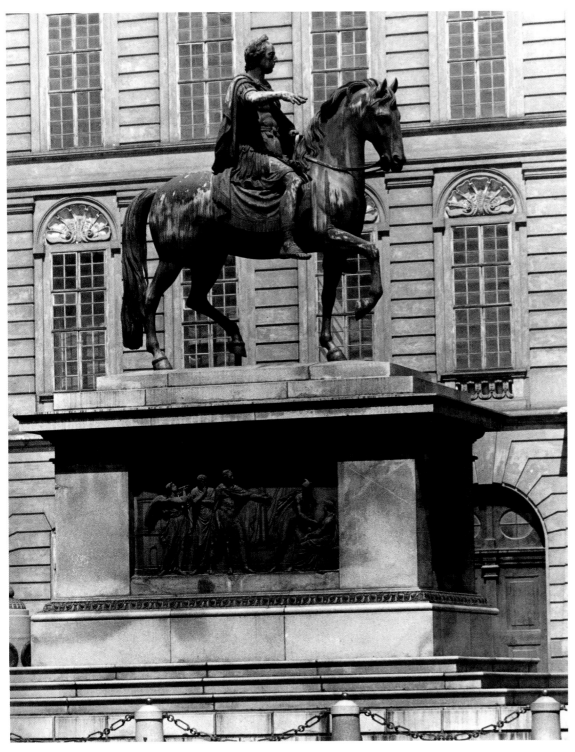

Fig. 102 **Franz Anton Zauner**, Monument to Emperor Joseph II, 1795–1806. Bronze, over life-size. Vienna.

Fig. 103 **Heinrich Dannecker**, *Ariadne on the Panther*, 1803–14. Marble, life-size. Städtische Skulpturensammlung im Liebieghaus, Frankfurt.

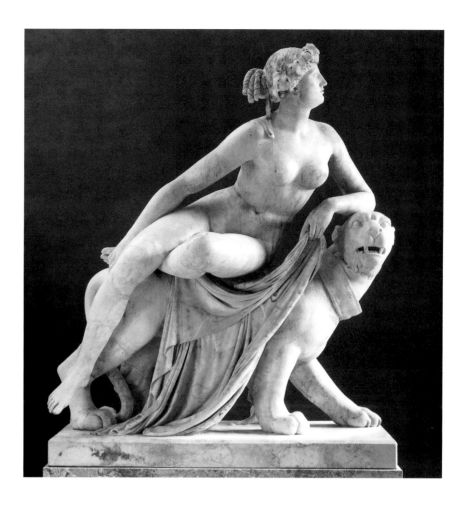

commerce—he commands Mercury to untie the hands of Trade, a young woman sitting on a bale of merchandise.

By coincidence, the two most important German sculptors of the time, Heinrich Dannecker (1758–1841) and Johann Gottfried Schadow (1764–1850), had their Rome experience in the same years, 1785–87, at the time of Canova's first artistic triumphs. Dannecker, the son of a stable hand in the service of the Duke of Wurttemberg in Stuttgart, attended a school founded by the duke for the children of the deserving poor; it was intended to produce officers and doctors for the army and artist-craftsmen for the ducal estates. On graduating, the pupils had to sign a solemn pledge that bound them to remain in the ruler's service for the rest of their lives. Once his artistic bent was discovered, young Dannecker was sent for further training to Paris, before he went to Rome on a tiny ducal stipend to experience the masterpieces of antiquity at firsthand. It was not the antique, however, but his encounter with Canova that became a pivotal experience for Dannecker. He returned to Stuttgart, hoping to create "modern classics," but few of them reached the stage of the full-scale plaster, and only one was executed in marble, *Ariadne on the Panther* (fig. 103), modeled in 1803–04 but not finished until a decade later. The patron who acquired it was a Frankfurt banker who admired it so much that, on the artist's advice, he built a classical round temple as its setting. The

Minton china factory in England reproduced it in the 1840s on a small scale in unglazed white Parian ware.

Unlike Dannecker in Stuttgart, Schadow found almost unlimited opportunities for his talent. The son of a tailor, he attracted the attention of the Belgian Octave Tassaert (see fig. 247), who trained him as his assistant, and when Schadow returned from two years in Rome, he succeeded his master at the Berlin Academy.

As early as 1769, Frederick II, King of Prussia, known as Frederick the Great, had initiated a program of honoring his generals by erecting public portrait statues of them, a series completed during the reign of his successor, Frederick William II. Schadow's monument to General von Zieten, dressed in meticulously correct uniform, signals the sculptor's shift away from Neoclassicism. Even for the long-projected equestrian statue of Frederick the Great, Schadow argued against Goethe in favor of contemporary dress, on the ground that classically timeless costume "does not mean anything to us." Between 1787 and 1835, dozens of proposals were submitted and disputed, including several by Schadow, who submitted some "classical" solutions before definitively advocating modern dress. The realistic figure he envisaged finally won out when the monument was at last commissioned in 1836, although the task fell not to him but to Christian Rauch, his most brilliant disciple (see pages 209–11).

Just after Schadow's return, Frederick William II com-
missioned a tomb for his illegitimate son, Count von der
Mark, who had died as a child (**fig. 104**). The ensemble is
still enveloped in "timelessness"; the half-nude boy, with
the attributes of a classical warrior, slumbers peacefully, an
image found on children's sarcophagi that the artist must
have seen in Italy. Above, the Three Fates perform their
ever-recurring tasks, made dramatic by the gesture of
Atropos, who violently tears the thread of life. In relief on
the face of the sarcophagus, the boy strives vainly for
Minerva as Saturn pulls him toward the gate of the nether-
world.

Schadow found a happy solution to the vexing problem
of ancient versus modern costume for his statue of the
Princesses Louisa and Frederika (**fig. 105**); taking advan-
tage of the classicizing fashions of the day, he clothed them
in dresses that combine both elements. In 1794, all Berlin

Fig. 105 **Johann Gottfried Schadow**, *Princesses Louisa and
Frederika*, 1795–97. Marble, life-size. Nationalgalerie, Berlin.

Fig. 104 **Johann Gottfried Schadow**, Tomb of Count von
der Mark, 1790. Marble (original condition, Dorotheenstädt-
ische Kirche, Berlin, before 1940).

had been charmed by the two sisters who had just married
the Crown Prince of Prussia and his brother. A year later,
Schadow modeled a life-size group of the princesses, but by
the time the marble was finished in 1797, Frederick
William III had succeeded his father as king, so that Louisa
had become Queen of Prussia. Her husband found the
group "embarrassing"; he had it crated and stored away. Its
well-deserved fame as Schadow's finest achievement is
thus of quite recent date. What the king had disliked was
the way in which it conveyed a sense of intimacy and
youthful grace, exactly those qualities that make the group
so attractive to modern eyes. Schadow captured the charm
of the two girls; their delicate balance of repose and move-
ment endows the group with formal self-sufficiency yet
avoids any hint of Neoclassical coldness. They represent
an Age of Innocence that proved incompatible with the
austere, power-conscious Prussia which was to emerge
from the struggle against Napoleon.

Alexei Gavrilovich Venetsianov, *Summer*, c. 1830. Oil on canvas, 24 × 19⅓″. Tretyakov Gallery, Moscow.

Part 2

❖

1815–1848

Part 2
❖
1815–1848

PAINTING

Retrospection and Introspection: The Congress of Vienna and Late Goya

By 1815, both the grandeur and the horror of the Napoleonic epic could at last be thought of in the past tense, and the Congress of Vienna could finally try to reconstruct the map and the rulers of Europe in the long shadow of those traditions that had been ruptured by both the French Revolution and the Napoleonic wars. Boundaries were changed; kings were restored to thrones that had been usurped; and thinking Europeans were alarmed by the growing frictions between the swiftly changing realities of nineteenth-century experience and the anachronistic efforts to revive a remote world where kings, emperors, and church were united in unshaken faith and power.

Working with or against the reactionary mood of their patrons and governments, artists mirrored these collisions of past and present. In 1815 in Vienna—the very seat of these attempts to turn the clock back to a world that existed long before 1789—a young German artist, Heinrich Olivier (1783–1848), encapsulated in a small gouache the most retrospective extremes of art and politics east of the Rhine. It represents the imperial rulers of Prussia (Friedrich Wilhelm III), Austria (Franz I), and Russia (Alexander I) united in the so-called Holy Alliance, in which they swear to resurrect and, if need be, defend in battle a pre-Napoleonic world (fig. 106). Olivier had been in Paris between 1807 and 1811, and he had later fought against Napoleon, experiences that are both reflected in this neo-medieval and nationalistic work. If the patriotic and military fervor of these vows recalls the *Oath of the Horatii* (see fig. 16), as well as many other oaths of allegiance, the setting, costume, and miniaturist style recall the French Troubadour Style (see figs. 55 and 67) as well as the medieval art that was newly exhibited in Paris at the Musée des Monuments Français. But all

of this has now crossed the Rhine, relocated in what seems a newborn world of German medieval splendor, where, from Romanesque foundations, ornate Gothic vaults and stone carvings surge overhead in an emblem of national glory and military strength. It is the look of patriotic rebirth, rooted in venerable medieval traditions, found in many neo-Gothic architectural projects designed,

Fig. 106 **Heinrich Olivier**, *The Holy Alliance*, 1815. Gouache on paper, 17½ × 14″. Staatliche Galerie, Dessau.

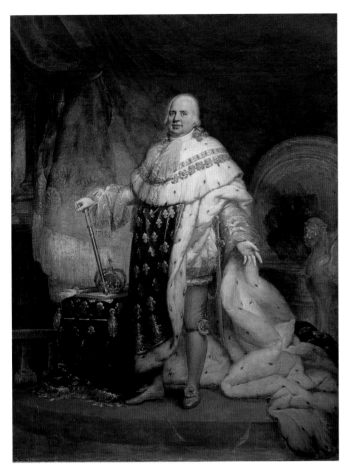

Fig. 107 **Paulin-Jean-Baptiste Guérin**, *Portrait of Louis XVIII*, Salon of 1819. Oil on canvas, 8' 10" × 6' 8". Musée National du Château de Versailles.

after 1815, by Karl Friedrich Schinkel and his German contemporaries.

This retrospective style, with its nationalistic associations, has many pictorial counterparts in France, which, after the final surprise of Napoleon's return for a hundred days in the spring of 1815, could at last settle back into a period of true Restoration. In the official paintings of the restored monarch Louis XVIII—a gouty brother of the unfortunate Louis XVI—the clock has again turned back to a prerevolutionary world, creating royalist illusions that, it was hoped, might convince French spectators that little, if anything, had happened between 1789 and 1815. Typical of such state portraits of Louis XVIII is that by Paulin-Jean-Baptiste Guérin (1783–1855) for the Salon of 1819 (fig. 107). Attempting to resurrect the great Baroque tradition of official portraits of Bourbon monarchs, Guérin mimics the look of Rigaud's state portraits of Louis XIV and Louis XV, offering Louis XVIII in what is presumably an uninterrupted sequence of royal images. But the stiffness of the posture, the specific truth of an old man's head, the hardened surfaces of ermine and velvet coronation robes are jarring intrusions in this feeble survivor from a

Baroque world, subtly undermining the propagandistic intention.

For Charles X, who in 1824 succeeded the short reign of his elder brother, Louis XVIII, these historical retrospections were even more elaborate, now reaching back to a medieval as well as a Baroque past. Following the traditions of his Bourbon ancestors, this "ultraroyalist" king arranged an elaborate coronation for himself on May 29, 1825, at the traditional medieval site for this sacred rite, Rheims Cathedral, thereby hoping to eradicate the memory of Napoleon's coronation at Notre-Dame in 1804, which David had transformed into a major icon of French history (see fig. 26). It was one of the many ironies of the chameleon politics of nineteenth-century artists that it was François Gérard (1770–1837), a student of David (and one who had earlier made art for both revolutionary and Napoleonic patrons), who was commissioned to paint this extravagant neo-medieval ceremony that would presumably provide a historical graft onto roots existing before 1789. In a huge canvas that was promised for the Salon of 1827 but not completed in time for view (fig. 108), Gérard matches Charles X himself in an effort to revive the combination of hallowed medieval traditions and Bourbon pageantry. The choir of Rheims Cathedral is meticulously rendered, with the hard, linear precision of many neo-Gothic projects of the period, but the flurry of excitement among the representatives of the reunited church and state (who are shown at the moment when all shouted "Vive le roi!") resurrects the grand and fluent Baroque rhythms of figural groups gracefully agitated by the impact of this exalted ceremony.

Although many artists such as Gérard and Olivier espoused in their work the mood of fervent and usually nationalistic retrospection, many others clearly felt the underlying contradictions of Europe as reconstructed by the Congress of Vienna. It was predictable that Goya, above all, would sense, as he so often did before 1815, the hollowness and hypocrisy of a modern world that preserved the pomp and circumstance of decadent traditions; and his work for the newly restored Bourbon king, Ferdinand VII, the son of Goya's former patron Charles IV, chillingly bears this out. In 1815, Goya was commissioned to commemorate a meeting of the junta of the Royal Company of the Philippines, then a Spanish colony. The result was one of the most subtly devastating comments ever made by an artist on officialdom, on the pompous gathering of authorities to determine the fate of others (fig. 109). In the dead center of the canvas, whose vast dimensions (more than thirteen feet wide) and sweeping one-point perspective suggest a virtual extension of the spectator's space into the council room, we see Ferdinand VII himself, a tiny figure seated haughtily against a round-back chair a trifle larger than those that fan out around him. But this foreboding image of power is so remote that it becomes a

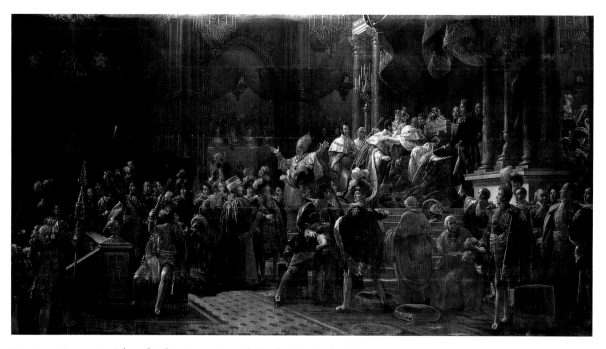

Fig. 108 **François Gérard**, *The Coronation of Charles X*, 1827. Oil on canvas, 16 × 32'.
Musée National du Château de Versailles.

Fig. 109 **Francisco de Goya y Lucientes**, *The Junta of the Philippines*, 1815. Oil on canvas, 10' 10¾" × 13' 10¾".
Musée Goya, Castres, France.

phantom of judicial authority. Moreover, the simple box space, evocative of the most stable and rational order, is invaded by engulfing shadows that contrast strangely with the disintegrating glare of sunlight from what seems an alien world outside. Inside, all is darkness and inertia. The figures on the two sides have barely the energy left to shift their legs as they squirm with boredom, and, in a grotesque mutation of the twelve disciples in the Last Supper, those on the dais look as if they may soon be absorbed into their chairs. The luminous, ample spaces of Velázquez's *Las Meninas*, so frequently echoed in Goya's work, have become suffocating here; and the fervent energy of David's *Tennis Court Oath* (see fig. 20), another image of a council meeting but one invested with the utopian hope and passion of the years following the Revolution, has vanished, to be replaced by a numbing but ominous lethargy. Literal in its portrayal of a group seen at a particular time and place, Goya's record of governmental proceedings becomes a deathly postscript to the terrifying, close-up vitality of his *Third of May 1808*, painted in the previous year (see fig. 34). Both immediate and distant, real and hallucinatory, this silent apocalypse captures a world of empty rituals at what seems the very moment of its extinction.

It is not surprising to find that, after this virtual annihilation of a public world of official commisions, Goya turned more and more inward to those private fantasies which he had often explored before in the more modest dimensions of prints and small cabinet pictures. The most dumbfounding and disquieting of these later excursions into a hermetic world was the series of paintings with which he decorated (if the word can be used here) a country estate near Madrid that he had bought in 1819. Within the walls of what was to be called popularly "La Quinta del Sordo" (The Deaf Man's House)—the name originally given, by ironic coincidence, to the house of his neighbor, who was also deaf—Goya created, between 1820 and 1823, a terrifying environment of fourteen paintings which often elude rational analysis, but always assail the emotions. Alternating between references to a public domain of symbols and myths and a completely personal world, they create frightening echoes of the themes that Goya had earlier culled from his observations of contemporary experience. In the bloodiest of them all, *Saturn Devouring His Children* (fig. 110), Goya turned to a familiar mythological subject in which the aged god, fearing a prophecy that one of his sons would usurp his power, devours his own children. Goya had already treated, in small paintings, the reports of cannibalism among North American Indians, and he also knew Rubens's interpretation of Saturn in the Prado; but none of these precedents prepares us for this nightmare. Shrouded in a sinister blackness (whose constant recurrence in these late works has earned them the label "las Pinturas Negras," the Black Paintings), this humanoid

giant bursts into a space that cannot contain him, looming before us with a sudden, hallucinatory assault that magnifies to nearly psychotic dimensions the bogeyman of *Los Caprichos* (see fig. 30). With panic-stricken eyes and voracious mouth, he attacks the flesh and blood of his own child, whom he clutches, like a crazed animal, in his pawlike hands. The degree of violence is so extreme here that we are tempted to locate it in a demented world of private fantasy, until we realize that Goya is only intensifying, now through the metaphors of mythology, the brutalities of war which he found necessary to record. Indeed, the very motif of cannibalism, of a parent tearing at and devouring its own child, becomes almost a symbol of the monstrous self-destruction of humans engaged in war. In *Saturn*, the barbaric military facts of the Napoleonic occupation of Spain have been turned into a sadistic fantasy that echoes through universal nightmares and myths.

In the Black Paintings, Goya totally rejected a rational world in which ordinary mortals occupy measurable spaces. When there are figures, they tower like giants, or huddle like frightened birds in nests; and in one of the paintings, there is not even a human being to guide us, or even a title to offer other than *A Dog* (fig. 111). Here the apocalyptic mood of Goya's later art reaches its most devastating extreme, a painting of nothing at all but a single survivor, a lost dog whose head alone is visible, the rest of his body perhaps struggling in an undefined element which might be earth, sand, or water. The mood here is grimly prophetic of the aftermath of a nuclear holocaust, a world in which all of matter has been pulverized by an uncanny light, a world in which nothing has been left but one desperate animal.

Although such works suggest that Goya had retreated into a fantasy life incomprehensible to spectators before the advent of late nineteenth-century masters like Redon and the Symbolists or their Surrealist heirs, he was nevertheless able, as before, to return from these inward journeys to the outside realities of public events and things seen. In 1824, he left the appalling political oppression of Spain in order to live out the four remaining years of his life in France. There, mainly in Bordeaux, he not only painted portraits of the people close to him, but also made countless rapid sketches of the sordid, miserable facts of the daily life around him—beggars, blind men, prisoners, lunatics. When he visited Paris in the summer of 1824, he was able to catch the opening of a momentous Salon, where Ingres, now the official champion of an ideal world of serene, timeless beauty, met in open pictorial conflict with the young Delacroix, a champion of that new movement, Romanticism, which would seek out truths of ugliness, passion, and suffering in an art of the fullest emotional freedom. In the work of Delacroix, who had, in fact, already made copies of most of *Los*

Fig. 110 **Francisco de Goya y Lucientes**, *Saturn Devouring His Children*, 1820–23. Mural transferred to canvas, 57⅛ × 32⅝". Prado, Madrid.

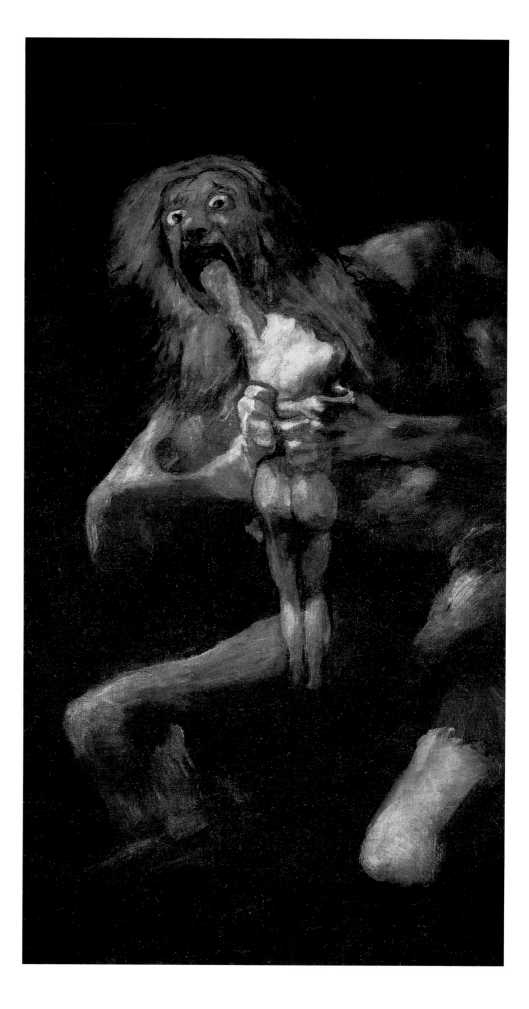

Fig. 111 **Francisco de Goya y Lucientes**, *A Dog*, 1820–23. Mural transferred to canvas, 53½ × 32″. Prado, Madrid.

Caprichos, and in the work of Géricault, who had just died before his thirty-third birthday, Goya might well have found in Paris two French painters who continued to explore those experiences of both the mundane and the irrational that were concealed behind the smug and conservative facades of the newly restored monarchies of Spain and France.

Théodore Géricault

No French painter who inherited the great traditions of David and the old masters so completely subverted their human and political messages as did Théodore Géricault (1791–1824). Thoroughly steeped in both the Neoclassical world of his teacher, Pierre-Narcisse Guérin, and in the grand images of those masters, from Titian to Rembrandt, whose works he copied at the Louvre, he early had at his command a resonant framework of grand-scale figural and landscape compositions. But by the end of the Napoleonic era, when one ideal after another was toppling, the conventional themes of these old masters could appear strangely out of joint with the disillusioning realities of modern experience. Géricault soon searched for, and found, a new kind of subject matter that usurped the place of Christ, of Hector, of Napoleon with anonymous figures culled from daily life, and that replaced the domain of reason and morality with a trip to human hells where, among his contemporaries, perhaps Goya alone would be no stranger.

Géricault's disruption of existing hierarchies can already be seen in a large panel painting of about 1814 which was intended to be nothing more important than the signboard of a nameless blacksmith (fig. 112). But instead of a predictably humble image of a common worker about to shoe a horse, we find a heroic descendant of a noble Western pedigree. Inevitably, such recent historical memories as David's own *Napoleon at St.-Bernard* (see fig. 22) are recalled in the dramatic interplay of a passionately rearing animal constrained by the tautest human discipline of mind and body. But the icy precision of David's art is suddenly thawed here in a molten brushwork that resurrects the traditions of Rubens. The paint itself has a creamy, agitated density that bestows upon everything—the horse's flowing mane and tail as well as the blacksmith's rolled-up shirt sleeves and open collar—an uncommonly vibrant warmth and vitality appropriate to a legendary theme. As for the grouping of horse and master, the linking in rhymed pairs of raised and lowered hooves and limbs dramatically silhouetted against the shed's simple arch conveys the ideal nobility of a long Western sculptural tradition of classical horse tamers. These might be found in Rome at the Quirinale, or in France, in the Baroque equestrian statues by Coysevox and Coustou that once decorated the seventeenth-century château at Marly and that, after 1795, reared up again in Géricault's Paris at the entrance to the Champs-Élysées.

But it is not only the replacing of Castor and Napoleon by a common worker that demands attention here. For one, the expression of the blacksmith is clouded by a strange mood, discernible in his furrowed brows and stunned gaze and echoed in the somber shadows that surround him. The horse itself rears with an alarming energy, his mane furiously windswept, his eyes bulging with unexplained excitement. From his youth, Géricault had been fascinated by horses (which, it should be recalled, were once as commonplace a sight in both city and country as automobiles would become in the twentieth century); and, like Gros before him, he often sensed in them a vehement strength that could become a metaphor for a suppressed human

Fig. 112 **Théodore Géricault**, *The Blacksmith's Signboard*, 1814. Oil on wood, 49¾ × 41″. Kunsthaus, Zurich.

Fig. 113 **Théodore Géricault**, *The Bull Market*, 1817–18. Oil on paper, pasted on canvas, 22¼ × 19″. Fogg Art Museum, Harvard University, Cambridge, Massachusetts.

potential. The blacksmith's horse is one of this Romantic breed, enlisting the spectator's emotions as it surges upward with the kind of passion formerly reserved for the heroic equestrian conflicts of Napoleonic battles or mythological hunts.

For Géricault, as for many other members of a disillusioned generation that had experienced the eclipse of Napoleon, a turbulent cargo of homeless emotions and grand pictorial rhetoric had to be discharged in unfamiliar subjects. During a year's sojourn in Italy, between 1816 and 1817, he not only studied the work of Raphael, Michelangelo, and antique sculptors, as so many French painters had done before him, but absorbed such experiences of contemporary Roman life as the thrilling annual Carnival race of Barbary horses, a scene of literally unbridled passion in which riderless horses thundered down the Corso, not to mention the more prosaic sights of Italian butchers and herdsmen. From these observations, he was inspired to dream of dramatizing such themes in vast canvases that might rival those of the Salons. Although he never fully realized these grandiose schemes, he did execute, both in Italy and after his return to France, small but heroically scaled paintings that articulated his ideas.

In one of these, *The Bull Market* of 1817–18 (**fig. 113**), Géricault telescoped a number of actual and fictional experiences, ranging from his observations of slaughterhouses in Rome and Paris to memories of mythological subjects that deal with the sacrifice of bulls. From these multiple sources, alternately brutal and heroic, classical and contemporary, Géricault fused an astonishing new whole, which translates the prosaic realities of butchers and cattle into a private poetry of such uncanny passion that we begin to read it as a symbolic drama from the domain of Hercules or Mithras, or perhaps even of Freud.

Against a Mediterranean setting that translates Poussin's vistas of a Greco-Roman countryside into the more common language of starkly simple rural architecture, we see a passionate struggle between man and beast. The stockyard is of an almost Neoclassic severity, defined by a rectilinear fence and cylindrical posts like column bases; but within these rational confines, an outbreak of animal energies erupts with volcanic violence. A nude man tries to separate a biting dog from a bull that has gotten out of line; another figure, half-draped, seizes a rearing bull by a horn; and still another figure, in colorful peasant costume, tries to control a bull which seems to be mounting another bull. But throughout, a rigorous structural discipline is imposed. With Davidian clarity, both figures and animals are pruned to essentials, their forces of rebellion and repression tautly locked in place. Similarly, the inclusion of nude and near-nude figures contributes to the evocation of a world that appears to have inherited the ideal language of a timeless classical tradition. Yet this lucid environment is now threatened by such irrational, brutal emotions that the equilibrium is feverishly strained. Before such a painting, it is difficult to avoid speculating on the degree to which Géricault's tormented amorous biography is reflected in these raging but straitjacketed emotions; but his genius as an artist assures that these personal projections are transformed into a language public enough to convey almost a new universal myth about the struggle between order and chaos, human reason and animal fury. Like Picasso, who would also use such richly evocative motifs as bull and minotaur, Géricault creates a symbolic narrative of human versus animal passions rich enough to rejuvenate the myths and legends of the past.

It is this capacity of reshaping a contemporary experience into an epic metaphor that helps to explain the enormous achievement of Géricault's most ambitious painting, *The Raft of the Medusa* (**fig. 114**). To be sure, many artists from West and Copley to David and Goya had already painted newsworthy events in the language of heroic tragedy, but the story here was of a different kind, one of scandal and horror rather than patriotic sacrifice. On July 2, 1816, a French frigate, the *Medusa*, carrying soldiers and settlers to the colony of Senegal, was wrecked on a reef off the African coast. The six lifeboats were inadequate to hold all the passengers, and three days later, one hundred and fifty people, including a woman, were left behind, forced to face a grim destiny on a jerry-built wooden raft. Two of the

Fig. 114 **Théodore Géricault**, *The Raft of the Medusa*, Salon of 1819. Oil on canvas, 16′ 1″ × 23′ 6″. Louvre, Paris.

GÉRICAULT AND *THE RAFT OF THE MEDUSA* ◆

A political furore greeted Théodore Géricault's picture (see fig. 114), which covers the horrible aftermath of a French frigate's shipwreck in 1816. But the artist had to weigh his reading of the documentary evidence against the need to focus his pictorial theme. At times, the survivors' accounts were made to yield to the need for visual drama.

The Medusa's surgeon described the painting's moment of drama:

Captain Dupont, casting his eye towards the horizon, perceived a ship, and announced it to us by a cry of joy: we perceived it to be a brig, but it was at a very great distance; we could only distinguish the top of its masts. The sight of this vessel spread amongst us a joy which it would be difficult to describe. Fears, however, soon mixed with our hopes; we began to perceive that our raft, having very little elevation above water, it was impossible to distinguish it at such a distance. We did all we could to make ourselves observed; we piled up our casks, at the top of which we fixed handkerchiefs of different colours. Unfortunately, in spite of all these

signals, the brig disappeared. From the delirium of joy we passed to that of dejection and grief.[24]

Miraculously, the brig reappeared two hours later. But Géricault took liberties with the appearance of the scene at the moment of rescue, as the modern art historian Lorenz Eitner has shown:

He had probably never intended to show the raft and the men on it as they actually appeared at the time of the rescue: the raft littered with strips of dried human flesh, the men emaciated, with matted hair and tangled beards, their bodies covered with wounds. Contemporary prints ... represented the raft in this way, but at no point in his work did he imitate their literalism. From first to last he gave his figures, the living and the dead, the appearance of athletes in vigorous health. His concern with the reality of the event centred throughout on what he regarded as its essential drama. To treat the scene in its detail of rags, wounds and haggard flesh would have meant giving it a picturesque-ness which was not

part of his plan—he wanted to paint history, not inflated genre.[25]

The public response to the painting differed depending on the politics of the beholder. Géricault was clearly angered by the slur of one right-wing journalist:

This year, our journalists have reached the heights of ridicule. They judge every painting according to the spirit in which it was composed. You will find a liberal article praising some work for its truly patriotic brush, its national stroke. The same work, judged by a rigorous conservative, turns out to be nothing less than a revolutionary composition, pervaded by a general tint of sedition ... I have been accused by a certain *Drapeau blanc* [an Ultra-Royalist paper] of having slandered the entire Ministry of the Navy by the expression of one of the heads in my picture. The wretches who write such nonsense have certainly never gone without food for two weeks on end, otherwise they would realize that neither poetry nor painting can ever do justice to the horror and anguish of the men on the Raft.[26]

fifteen survivors—an engineer, Alexandre Corréard, and a surgeon, Henri Savigny—published an account of the nightmare that followed, a period of thirteen days on a floating coffin, where insanity, mutiny, mutilation, famine, thirst, and cannibalism became commonplace. Compelling in itself as a true story of hell on earth, the narrative record was also political dynamite; for the captain of the *Medusa* was an incompetent seaman of noble birth, whose appointment depended on his connections with the Bourbon Restoration government, and whose haste to save himself and other senior officers while abandoning the lower ranks to the raft was a shocking indictment of aristocratic privilege. The story grew to scandalous proportions both in France and abroad, and quickly captured Géricault's imagination. Here was an event that turned upside down the Revolutionary and Napoleonic heritage of reason and of the nobility of death, and one that could expose the darkest side of human suffering.

In dozens of drawings and painted sketches, Géricault plotted out the huge canvas, whose subject, he finally

decided, should be the excruciatingly tense moment when, on the thirteenth day, July 17, the survivors sighted the brig *Argus*, a speck on the horizon, and frantically signaled it. (The rescue ship, in fact, disappeared, but then miraculously turned up again two hours later.) And even more than his predecessors in the painting of contemporary history, Géricault worked feverishly, like a journalist with a deadline, taking a trip to the Normandy coast to study the movement of water, arranging to have constructed in his studio a model of the raft with wax figures upon it, visiting hospitals and morgues to scrutinize the ravages of illness and death. But this accumulation of documentary details is completely absorbed in an epic construction of five corpses and fifteen survivors, who take their places in a desperate pyramid that becomes the human counterpart to the triangular volume of makeshift mast and rigging at the left. If the lucid geometry of this taut chain of figures recalls the ideal order of the French classical tradition, so too does the ascending rhetoric of emotions, which begins in the watery foreground with a

macabre quartet of corpses and then continues in a communal rush of hope that reaches its apex in the African who vigorously signals the distant ship with a windswept cloth and who inevitably evokes a burning contemporary issue that Géricault, in fact, had contemplated as the subject of a painting: the slave trade, officially outlawed in France in 1815, but nevertheless continued in a clandestine manner. Yet this academic language of ideal order is constantly subverted by the horror of the subject, which explores the most irrational depths of human experience, and turns inside out its noble prototypes in history painting. Thus, the group of an aged mourner numbly contemplating the nude corpse of a youth echoes ironically the martyrdom of military heroes or of the Pietà itself, and even alludes to the well-known accounts of cannibalism aboard the raft, since the grouping recalls illustrations to Dante's gruesome tale of the starving, imprisoned Count Ugolino, whose sons offer him their own flesh. Like Copley's *Watson and the Shark* (see fig. 4), *The Raft of the Medusa* phrases a contemporary event in the language of tradition; but the eccentric drama of the earlier cliff-hanger is here aggrandized to epic dimensions that translate the monumental gloom of the Deluge and the Last Judgment into a secularized symbol of human despair, momentarily aroused by a remote glimmer of salvation.

At the Salon of 1819, the title of the painting was changed to *A Shipwreck Scene* in order to avoid the politically inflammatory reference to the specific disaster whose cause lay in royal Bourbon favoritism; but this topical censorship did not violate the metaphorical spirit of the painting, whose allegorical potential was so great that the historian Jules Michelet, on the eve of the 1848 Revolution, could interpret it as France drifting into the darkness of political conservatism, whereas others might see it as a universal symbol of human misery on the order of Goya's prisons and madhouses. By conferring tragic status upon anonymous victims rather than upon classical or modern military heroes, by demonstrating that the human potential of terror and chaos was more compelling than that of reason and order, Géricault set out to destroy the premises of Davidian traditions, while nevertheless working within their language of ideal form. Indeed, like Goya's *Third of May 1808* (see fig. 34), painted only five years before, *The Raft of the Medusa* extinguishes the Age of Enlightenment, revealing the dark and terrifying truths that lie below the layer of reason. And in terms of French history painting, *The Medusa* offers the fullest contradiction of David's epic veneration of human will and heroic action.

For all its grandiose ambition, rivaling David's canvases in their own terms, the painting was not a sensation at the

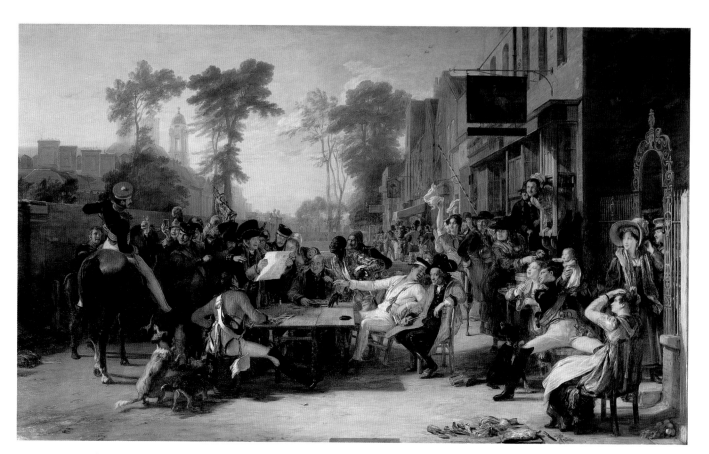

Fig. 115 **David Wilkie**, *Chelsea Pensioners Reading the Gazette of the Battle of Waterloo*, 1822. Oil on canvas, 36½ × 60½". Victoria and Albert Museum, London.

1819 Salon, and critics were perplexed by its newness, wondering who the hero was and in what public building it would be suitable for display. Disappointed by the response of the conservative Paris audience, Géricault welcomed the opportunity to have *The Raft of the Medusa* shown in London and Dublin in 1820–21 under the auspices of the kind of popular, commercial exhibition that Copley had arranged in the 1780s for his paintings of the dramatic deaths of Chatham and Peirson (see fig. 6). The gruesome and topical subject of *The Medusa* guaranteed its enormous commercial success in the British Isles, where it was viewed more as a morbid entertainment, like a wax museum's chamber of horrors, than as a landmark in the epic demise of Davidian painting. Accompanying his picture, Géricault spent almost two years in England, where new experiences of art and life affected him deeply. In the work of British painters, whose company he sought

out, he found a startling alternative to the grand French tradition in which even corpses on a life raft smack of the ideal anatomies of Michelangelo and Raphael. He looked with intense interest at such works then in progress as *Chelsea Pensioners Reading the Gazette of the Battle of Waterloo* (**fig. 115**), by the Scotsman David Wilkie (1785–1841), who had made his early reputation painting Scottish peasants not in the heroic mode of Géricault's *Blacksmith* but rather in a humble manner whose pedigree stemmed from seventeenth-century Holland and Flanders. Commissioned by the Duke of Wellington himself, Wilkie's *Chelsea Pensioners* recorded the repercussions of his victory at Waterloo in 1815 as experienced by an amiable and anonymous crowd of London military veterans, with attendant families of women and children. Géricault was struck by how this picture was "like nature itself"; for the poignant human drama of the left-hand group of figures intently

Fig. 116 **Théodore Géricault**, *The Piper*, 1821. Lithograph, 12⅜ × 9⅛″. Art Institute of Chicago.

searching the casualty list for the names of loved ones is in no way dramatized by, in his words, "fatally presaging lightnings," but seems rather a candid fragment of ordinary truths, in which terrible human pathos can be observed in an uneventful environment of pleasant skies, busy city streets, playful dogs, and cheerful holidaymakers. Such British paintings, with their rejection of French structural and dramatic rhetoric, helped to reveal to Géricault the possibilities of recording the most prosaic experiences in a simple, direct fashion.

The grime and poverty of early nineteenth-century London also arrested Géricault's attention, and he unpretentiously documented there the somber side of the modern city, whether the spectacle of a public hanging or of dray horses carrying their daily burdens under the Thamesside wharves. Working in the then new medium of lithography, whose thick and soft graphic patterns seemed appropriate to a melancholy aura of London fog and darkness, he published in 1821 a series of twelve prints, some of which, like

The Piper (fig. 116), seem to seize for the first time the heartbreaking commonplaces of nineteenth-century urban misery. Isolated by the rubble of a brick wall, beyond which we see a rooftop glimpse of slum dwellings, an impoverished old man plays his bagpipe for no visible audience. Were it not for his faithful pet dog, who seems as hopelessly inert as his master, he would be totally alone. Such a pitiful record of an aged dweller amid the rapidly expanding population of an industrialized city may belong, in part, to the candid insistence on "nature itself" that Géricault admired in Wilkie's work; but the Frenchman's genius for ennobling generalization is apparent even here, not only in the lucid, if dilapidated, architectural framework, but in the poignant dignity of the piper and dog themselves, who, viewed in calm profile, seem pathetic emblems of any outcast victims, whether in a legend like that of Belisarius (see fig. 15) or a modern world of grueling economic hardships. Géricault's grasp of the plight of the London urban poor was not rivaled until 1868, when another Frenchman,

Fig. 117 **Théodore Géricault**, *Portrait of an Insane Man (Mania of Military Command)*, 1822–23. Oil on canvas, 32½ × 26″. Collection Oskar Reinhart "Am Römerholz," Winterthur, Switzerland.

Gustave Doré, visited London and documented its industrial slums (see fig. 359).

After returning to Paris in December 1821, Géricault wavered between the pursuit of a more straightforward immediate record of empirical fact, bolstered by his English experience, and the more French, Salon-oriented goals of making epic canvases from such dramatic contemporary events as the horrors of the African slave trade. His vast new plans were never realized, but in his last months of activity, the winter of 1822–23, he was able to complete a series of ten unforgettable portraits of insane men and women, painted in association with a pioneer in the new field of psychiatry, the young Dr. Étienne Georget, who changed the treatment of the mentally ill from chains and jeering to a humane effort to understand the mysterious correlations between mind and body, especially as revealed in the disturbed physiognomies of his patients. It is not clear what practical function Géricault's paintings of these distressed countenances could have served—lecture demonstrations would be a better guess than textbook illustrations—but it may well be that, as in his earlier documentation of the dead and the dying from Paris morgues and hospitals, Géricault found through Dr. Georget yet another way to scrutinize the realm of human suffering. In one of the five extant portraits of these anonymous victims of mental disorder, a case described as an obsession with military command (fig. 117), the degree of Géricault's compassion and observation can be measured. Like Stubbs's recording with precision the zoological fact of a monkey (see fig. 37), Géricault also adheres to the intense truth of medical illustration. The patient's face, with its nervous yet severe gaze of mock authority, is so specific that we feel we could instantly single him out in a hospital ward. Yet these askew features, painted with an immediate, bravura swiftness that recalls the techniques of seventeenth-century Dutch realists such as Hals, are only the empirical component of documentary fact through which Géricault seems to explore, with the fullest empathy, a haunting domain of irrationality, in which an alienated soul, totally isolated against a dark, abstract ground, forces us to confront in the most individualized terms this frightening human potential. And for Géricault, this patient's particular delusion—military command—must have been especially ironic. The world of heroic Napoleonic officers, whose pictorial veneration before Waterloo was the breeding ground for Géricault's art, has now collapsed entirely in this pathetic charade of an old man wearing mock military gear—a black cap with a tassel and a medallion on a metal chain. Goya, who arrived in France only months after Géricault's death in January 1824, would have understood. He had already represented the madness of both asylums and battlefields, and, after 1824, he even made a series of sketches of different types of madmen. For both the younger and the older artist, the demon of irrationality had conquered.

Delacroix, Ingres, and the Romantic–Classic Conflict in France

Despite his premature death, Géricault left behind an enormous heritage for a younger generation. No artist seemed to put on his mantle more authoritatively than his junior by seven years Eugène Delacroix (1798–1863), who, with his close contemporaries in literature and music, Victor Hugo and Hector Berlioz, became one of the great trinity of French Romantics to reign even beyond the mid-century mark. Given the fact that he had posed (face down) for the central corpse in *The Raft of the Medusa*, it was predictable that the shadow of that maritime disaster would fall across the painting with which Delacroix would make his Salon debut in 1822, *The Bark of Dante* (fig. 118). The scene plunges us into the labyrinthine horrors of Dante's *Inferno* (Canto VIII), which, from the late eighteenth century on, had become a fertile source for those artists who wished to explore imaginative worlds of uncommon mystery and passion. Ferried across a tumultuous lake by the muscular oarsman Phlegyas, Dante and his companion, Vergil, recoil in horror at the hellish sights that surround them. Clustered in the foreground, the shades of the damned writhe in eternal contortions that convey acute physical and emotional suffering; some even try savagely to tear at the bark with gnawing teeth or grasping arms. At the left, the ever-blazing fires of the infernal city of Dis can be seen, casting their fearful light across the murky depths of hell. Throughout, this image of humanity reduced to animal desperation in an overwhelmingly malevolent environment echoes *The Medusa*; but Delacroix's originality is no less apparent. The choice of a literary text from the late Middle Ages rather than the journalistic truth of a contemporary shipwreck already marks Delacroix's preference for seeking inspiration from the highest flights of authors as diverse as Dante and Shakespeare, Goethe and Byron. Here, the rectilinear, almost Davidian tautness of *The Medusa* yields to churning, rounded rhythms that resonate in an unstable space. Recognizing genius, Adolphe Thiers, a journalist who was later to become President of France, claimed that the painting combined the virility of Michelangelo and the fecundity of Rubens. In fact, the doomed souls echo not only the monumental restlessness and heroic musculature of the Medici tombs but the corporeal energies of Rubens's most dynamic nudes. Next to the ethereal visions of Dante illustrated by Flaxman or Blake, Delacroix's painting seems startlingly sensuous and palpable, a fusion of warm Venetian color with the most immediate, tactile presence of struggling flesh.

For the next Salon, that of 1824, Delacroix turned temporarily from poetic fictions to a contemporary subject whose reported horrors rivaled those of the *Medusa* itself. For all of liberal Europe, the Greek revolt against the Turks was a theme of consuming interest. Its associative power—

Fig. 118 **Eugène Delacroix**, *The Bark of Dante*, Salon of 1822. Oil on canvas, 74 × 94⅞″. Louvre, Paris.

from a modern re-creation of an ancient conflict between classical and barbarian forces to a contemporary spectacle of exotic passions and brutality geared to the cause of liberty—was enormous, and already in 1821, after the outbreak of these wars, Delacroix contemplated a painting based on these conflicts remote in space but immediate in the Western European consciousness. An event of April 1822 helped to crystallize this ambition. To suppress again the Greeks, who had declared their independence in January, the sultan sent an army of ten thousand to the island of Chios, where some twenty thousand inhabitants were massacred, and countless women and children were taken into slavery to fill the markets of North Africa. Like Géricault for *The Medusa*, Delacroix consulted the published documentation and its eyewitness author, Colonel Vautier, in order to achieve a maximum of reportorial accuracy; and when he exhibited the painting, his lengthy title reflected these journalistic concerns: *Scenes from the Massacres at Chios; Greek Families Awaiting Death or*

Slavery, etc.—See Various Accounts and Contemporary Newspapers (fig. 119).

Even by the standards of 1819, as defined in *The Medusa*, the painting was a shocking assault on the great traditions of history painting, and Gros himself, whose *Pesthouse at Jaffa* (see fig. 53) prefigured these exotic horrors, could only quip, "It's the massacre of painting." For here, still more than *The Medusa*, was a painting not only without a hero, but even without a core. In the center, where we might expect a heroic climax, is a hollow rush of space that carries us across scorched plains, domestic rubble, and gloomy skies to a faraway combat, the death rattle of this brutal conquest. In the foreground, in a sudden shift of scale, is a display of human debris, forced close to our view by the imprisoning boundaries of a Turkish soldier holding a rifle and of a victorious horseman, whose head alone surmounts the horizon with an expression of chilling indifference to those below. The conquered Greeks, clinging to each other in pathetic family groups,

have fallen into a hopeless exhaustion and lassitude, made all the more poignant by the desperate, last-minute effort of a prisoner to attack the Turk who has tied a Greek woman to his horse. Below her writhing nude torso, destined for sexual slavery, is perhaps the grimmest of all displays—a dead mother, whose living infant still seeks milk at her breast. But for all the documentary accuracy in this morbid catalogue of contemporary barbarism, *The Massacres* still has a fictional quality. However tattered in defeat, the exotic costumes, of which Delacroix made close studies in Paris, lend an enchanted Arabian Nights atmosphere to the scene. Moreover, this flavor of Near Eastern sensuousness was further supported by Delacroix's study of Persian miniatures, whose flat and brilliant surfaces are reflected here in, among other things, the intense colors and the high horizon line that constricts many of the lower figures into sharply contoured patterns. This may be an artist-journalist's account of the human degradation reported in the

Greek War of Independence, but it is also an imagined adventure that wallows in an orgy of blood, bondage, and exotic gorgeousness.

At the Salon of 1824, many new directions, both French and foreign, converged for the first time in a clear historical focus. Not only was there a particularly rich display of British watercolors and paintings, including three Constables, whose vibrant, flecked surfaces inspired Delacroix, at the last minute, to retouch some of the foreground figures of *The Massacres*; but there was also a major new painting by Ingres, which could represent the stable voice of tradition against Delacroix's shocking veneration of horror and disorder. Like his earlier *Napoleon* or *Jupiter and Thetis* (see figs. 49 and 54), Ingres's *Vow of Louis XIII* (**fig. 120**) takes us to a remote and, in part, timeless realm. The commissioned subject was in itself an evocation of a lost historical epoch that the Bourbon Restoration authorities hoped to resurrect: Louis XIII is shown in February 1638 placing

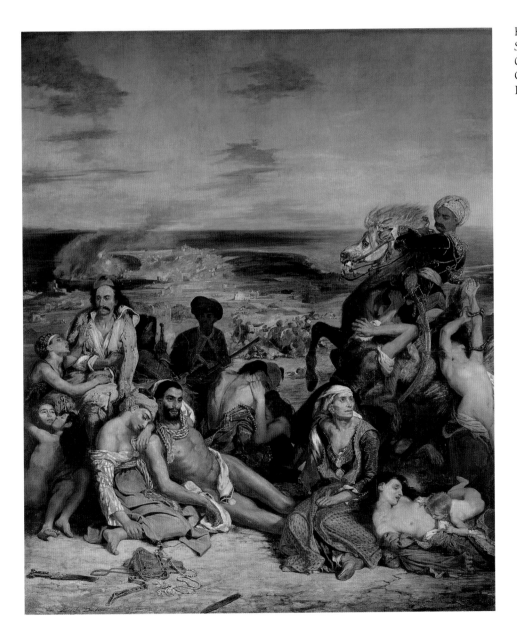

Fig. 119. **Eugène Delacroix**, *Scenes from the Massacres at Chios*, Salon of 1824. Oil on canvas, 13′ 8¼″ × 11′ 7⅜″. Louvre, Paris.

Fig. 120 **Jean-Auguste-Dominique Ingres**, *The Vow of Louis XIII*, Salon of 1824. Oil on canvas, 13' 9¾" × 8' 8⅛". Montauban Cathedral.

France under the protection of the Virgin of the Assumption. This fusion of church and state posed many problems for Ingres in its collision of natural and supernatural events; but he resolved the contradictions by presenting the scene in two zones, each painted in a different mode. Below, the Bourbon king is represented in the sharpest focus, his lace, velvet, and ermine robe as specific and palpable as his proffered crown and scepter. Suitable for a particular historical personage at a particular time, this materialistic style was unsuitable for the heavenly and eternal dramatis personae to whom he pledges his country. The apparition of the Virgin and Child, revealed in a glow of light behind symmetrically parted curtains, belongs rather to an ideal realm, that of the everlasting beauty of art and religion as defined by Raphael, whom Ingres venerated. Like the putti with the tablet below, the Madonna above is a close paraphrase of the Renaissance master's

inventions (here the *Sistine Madonna*), for Ingres believed that some of the eternal verities of art could at best only be respectfully restated, though with inevitable variations. Ingres's re-creation of Raphael's ideal harmonies and generalized surfaces has, in fact, a curious new flavor, not only in a certain hardening of form that reveals the materialist premises of this eclectic reconstruction of the past, but in the odd psychology of the Virgin and Child, whose imperious and almost sensual gaze on the earthling below recalls the image of supplication before a supreme authority defined in *Jupiter and Thetis*, an image almost more chilling than pious.

For all its strange undercurrents, Ingres's painting could easily have represented, at the Salon of 1824, a call to arms for the values of tradition, whether of art or of the *ancien régime*; and its simultaneous appearance with Delacroix's *Massacres* virtually elected the older master as preserver of time-honored beauty and stability against such youthful rebels as Géricault and Delacroix, who would propagate a cult of ugliness, violence, and disorder. In keeping with a long French tradition of polarizing aesthetic beliefs into enemy camps, such as the ancients versus the moderns, Rubens versus Poussin, or Shakespeare versus Racine, the Ingres-Delacroix confrontation at the 1824 Salon mobilized two adversaries who would fight under the rubrics Classic and Romantic, a black-and-white antagonism that ignored the many shades of gray we now see in historical retrospect.

As for Ingres's master and the father-figure of modern Classicism, Jacques-Louis David, this exiled regicide was also able to make a pictorial statement in Paris in 1824, the year before his death in Brussels. On May 26, three months before the opening of the Salon, a private exhibition of David's work was inaugurated that included not only old, prerevolutionary paintings still in his possession but a major new canvas, completed that year, which grandly perpetuated a belief in classical deities. *Mars Disarmed by Venus and the Three Graces* (**fig. 121**) was not only David's swansong, but an overt contradiction of the high moral seriousness and virile political engagement that marked his life and art before the fall of Napoleon. Here the god of war reverses his usual role; for instead of preparing for battle, he is seduced and disrobed by Venus herself, accompanied by her helpful son, Cupid, who removes his sandals, and by the Three Graces, who bring him nectar and deftly carry off his helmet and shield. On his already naked lap, inclined toward Venus' nearly supine torso, a pair of billing and cooing doves leaves no doubt about who has triumphed. This inversion of David's familiar ethos—be prepared for war, not love—is the surprising climax of a subterranean but recurrent impulse in his art, a chilly but voluptuous sensuality that could flower in Brussels, where the aging master was fully divorced from the political exigencies of Revolutionary and Napoleonic Paris. The *Mars and Venus*

Fig. 121 **Jacques-Louis David**, *Mars Disarmed by Venus and the Three Graces*, 1824. Oil on canvas, 10′ 3¼″ × 8′ 8¾″. Musées Royaux des Beaux-Arts/Koninklijke Musea voor Schone Kunsten, Brussels.

was in part inspired by a ballet production of this theme, and it was the *première danseuse* herself, Mlle. Lesueur, who posed for the sinuous anatomy of a Venus who belongs to the same race as many of Ingres's erotically entwining nudes. It is the theater, too, that one feels in this mythological fantasy; for despite the Olympian fiction, a material world of palpable stage sets and portrait-like faces is sensed throughout. The cloud puffs, which recall those at the base of Ingres's *Jupiter and Thetis* (see fig. 54) and which could not possibly support the weighty chaise longue and elaborate tetrastyle temple, are as mock as stage smoke; and the floral wreaths, bows and arrows, and metal arms resemble portable props that can be taken to and from the wings. A kind of *tableau vivant*, composed of the pinkest flesh and the whitest feathers, sheets, and marble, David's last history painting offers an intriguing collision of those two extremes—the empirical and the ideal—that alternated in his own art and in that of his greatest pupil, Ingres, a clash that verges here on a parody-like debunking of the purity and credibility of the classical world. Later nineteenth-century painters of an official cast, like

Bouguereau, would try to maintain these ideal fictions above their materialist foundations, whereas other, more innovative artists, like Daumier and Manet, would totally undermine these myths, as David had begun to do, by translating them into the language of observed modern facts.

To many younger eyes of 1824, the subject of David's painting seemed an anachronism. Moreover, its insistence on glossy surfaces, incisive contours, and local colors affirmed the source of Ingres's conservative opposition to Delacroix's impetuous brushwork and vibrant, broken hues. Yet these traditional techniques could also be freshly used for the most overtly Romantic themes. For instance, they could be seen at the Salon of 1824 in the *Ruins of Holyrood Chapel* (**fig. 122**) by Louis Daguerre (1787–1851), whose later fame as a pioneer photographer eclipsed his earlier importance as a painter. Related to the de Loutherbourg tradition of theatrical spectacles (see pages 75–76), Daguerre's painting restates with almost photographic clarity the thrilling and evocative dioramas he began to show to Paris audiences in 1822. Like Friedrich's Gothic

Fig. 122 **Louis Daguerre**, *Ruins of Holyrood Chapel*, Salon of 1824. Oil on canvas, 7′ ½″ × 8′ 6½″.
Walker Art Gallery, Liverpool.

Fig. 123 **Constant Desbordes**, *A Vaccination*, Salon of 1824. Oil on canvas, 43¾ × 54¾". Musée de Douai, France.

ruins (see fig. 72), these are haunting relics of a mysterious civilization viewed by moonlight; in this case, however, the associations are less spiritual and more historical, the site being that of the Scottish royal tombs as well as of the unfortunate Mary Stuart's two weddings. Such connections were frequent under the Bourbon Restoration, whose royal family had long ties with the Stuart dynasty, and Scottish as well as English themes began to proliferate throughout the arts, whether in the vogue for Sir Walter Scott or the operas based on his stories, or even in such fashionable events as the Duchess of Berry's Mary Stuart costume party of 1829. In fact, Daguerre's spooky Gothic vista belongs far more to the growing public world of Romantic entertainment than to the private religious tones of Friedrich's vision of medieval Christianity.

In yet another painting from the same Salon, more prosaic instincts reign. Continuing the tradition of Marguerite Gérard's neo-Dutch domestic scenes (see fig. 56), Constant Desbordes (1761–1827), in *A Vaccination* (fig. 123), modestly combines the homely virtues of child care with the triumphs of modern medicine. Working in the lacquered style of sharp-focus realism, Desbordes shows the still new methods of conquering smallpox introduced by Edward Jenner in the 1790s, with a glimpse, to the left, of the cows that provide the vaccine. So charming and anecdotal a scene of a doctor and a loving family is as remote from Delacroix's *Massacres*, with its tragic memories of plague scenes, as it is from Ingres's *Vow of Louis XIII*, with its perpetuation of timeless beauty. Desbordes's preference

for well-wrought prose rather than lofty poetry was to become typical of the less taxing narrative paintings of the nineteenth century, pictures that invoked no urgent aesthetic credo, but only quiet admiration for the skilled, painstaking handicraft of a painter who, like the little Dutch masters of the seventeenth century, could mirror an untroubled contemporary world.

It was inevitable, however, that the lion's share of public attention went to those rebellious young Frenchmen who, rallying under the flag of Romanticism, proposed a grand-scale liberation from moribund academic rules that would permit them an adventurous exploration of the domain of passion and imagination. At the Salon of 1827, the year of another major Ingres-Delacroix confrontation and of Victor Hugo's drama *Cromwell*, whose preface became a manifesto of literary Romanticism, one could see how many artists noisily joined this revolt. For one, there was Louis Boulanger (1806–67), who, age twenty-one, presented the enormous *Mazeppa* (fig. 124), a feverish scene of sex and sadism inspired, like so much other Romantic art and music, by the poetry of Lord Byron, in this case his account of the Polish legend of the page Mazeppa, who had become the lover of the Count Palatine's wife, Theresa. Upon discovering this, the count sternly ordered Mazeppa's brutal punishment: he was to be tied naked to a wild horse, which would then drag him through a nightmare cavalcade of wolves, ravens, and other forest terrors that would later be described by Romantic composers from Liszt to Tchaikovsky. In Boulanger's painting, the contemporary

Fig. 124 **Louis Boulanger**, *Mazeppa*, Salon of 1827. Oil on canvas, 17′ 6″ × 13′.
Musée des Beaux-Arts, Rouen.

horrors of Delacroix's *Massacres* have turned into a liter-
ary fantasy, but one of no less shocking fleshiness and
immediacy. The victim of his own sexual passion and the
count's cruel vengeance, Mazeppa makes explicit the
animal metaphors of Géricault's work, for his own nude
body is virtually to be identified with a wild, untamable
horse, whose windswept mane and terrified gaze become
extensions of the tragic hero's own agonies. The gloomy,

raven-filled night sky, the somber medieval castle, the
exotic costumes, all contribute, like operatic stage props, to
this extravagant tale. Boulanger's painting could immedi-
ately join the youthful ranks of Romantic rebellion. In fact,
it was soon to inspire directly literary works by Victor Hugo
and Alfred de Vigny.

Such wallowing in uncommon extremes of violence was
to become a commonplace at the Paris Salons, as it had

earlier been at the London Royal Academy. Another entry to the 1827 Salon, *The Suliot Women* (**fig. 125**) by the young Ary Scheffer (1795–1858), a painter of Dutch birth, extends the human misery of the survivors of the *Medusa* or of the prisoners at Chios to perhaps a worse extreme. His imagination aflame with reports of atrocities in the Greek War of Independence, Scheffer represented the hair-raising moment when the Greek island women, whose husbands had been killed by the pasha's troops, join desperate forces in a collective suicide by throwing themselves, like helpless lemmings, over a precipice. Again, as in Delacroix's work or Boulanger's *Mazeppa*, a full-scale Rubensian language of twisting, sensuous bodies is chosen for this rendering of corporeal and emotional suffering; and, once more, we are plunged into a world without the leadership of heroes or the control of reason.

Even when uncommon heroism could be found, it is pitted against such terrible odds that we fear the outcome. In *The Devotion of Captain Desse* (**fig. 126**), a cliff-hanger by the marine painter Théodore Gudin (1802–79), shown at the Salon of 1831, the nautical horrors of *The Medusa* are further intensified. The story is again a true one, for given the frequency of disastrous shipwrecks in the early nineteenth century, none had to be invented. In this case, the tale is of the noble French captain of the *Julia*, who, discovering the distress of a storm-tossed Dutch ship, the *Columbus*, resolved not to abandon it without saving its helpless crew. Although Captain Desse finally succeeded in this feat after five grueling days, Gudin preferred to record not the heroic resolution but the midstream terror of the narrative, when both the Dutch ship, its mast already smashed, and the French rescuer in the distance became ghostly pawns of a malevolent nature, battered mercilessly in a whirlpool of foaming energy where neither ruler nor compass can function, and where human beings are reduced to specks. More a spectacle of storm and sea than a theatrical arrangement, like Géricault's, of human figures acting out despair and hope, Gudin's painting foreshadows the most furious of Turner's late shipwreck dramas (see fig. 134).

The passionate rhetoric of such paintings may seem inflated and callow today, but, in the 1820s, it was exactly

Fig. 125 **Ary Scheffer**, *The Suliot Women*, Salon of 1827. Oil on canvas, 8′ 8½″ × 11′ 11¾″. Louvre, Paris.

Fig. 126 **Théodore Gudin**, *The Devotion of Captain Desse*, Salon of 1831. Oil on canvas, 7′ × 9′ 10″. Musée des Beaux-Arts, Bordeaux.

this epic turbulence that could provide for the younger generation a liberating catharsis from the conservative traditions established by David and perpetuated by Ingres. Delacroix, the greatest of these rebels, could even apply the excitement of an abstract poetic and pictorial ideal of liberty to the political actualities of the July Revolution of 1830, which immediately followed repressive legislation that raised taxes for the middle classes and curtailed freedom of the press and many voting privileges. Like his Romantic colleagues, Delacroix was usually more inflamed by literary fiction or exotic fact than by the realities of life in Paris: but the concept of liberty had an overwhelming poetic power for him, as it did for Byron, who, in 1824 at Missolonghi, had lost his life for it while crusading for Greek independence. Although Delacroix's own political and social leanings were clearly more aristocratic than proletarian, he was an excited eyewitness to the popular uprisings in Paris during the "three glorious days" of July 27–29, 1830, and determined to commemorate them in a painting that would resurrect the spirit of revolutionary idealism that had come to a halt with the Congress of Vienna (**fig. 127**). The Salon title itself, *July 28: Liberty Leading the People*, reflects the difficult mixture of contemporary historical fact

and poetic allegory that dominated Delacroix's conception. In front of the smoking barricade, almost at our own feet, is an unsparing record of the human sacrifices to liberty, a civilian and two soldiers, whose contemporary costume and brutal display of the ignoble facts of death give the scene the kind of journalistic truth familiar to the grisly foregrounds of so many Napoleonic history paintings by Gros and others (see fig. 52). But these literal facts are swiftly transcended as we continue to look upward with the wounded man who raises himself from the rubble to stare into a higher realm. There, accompanied still by the urban realities of, reading from the left, a vengeful worker brandishing a cutlass, a plug-hatted student armed with a musket, and a street child in a beret holding a pistol in each hand, is the reigning muse, a passionate female leader who can step across the debris of the barricades and wield a bayonet as well as ascend, with her tricolor flag, to the poetic heights of liberty with a capital L. This hybrid creature, both of Paris and of Olympus, brings with her a multitude of associations. Her simple headpiece recalls the Phrygian cap of liberty, and the vigorous striding motion of her bare-breasted torso evokes as well such classical references as the Victory of Samothrace. But she also conjures

up many actual accounts of the heroism of women during the street fighting, just as her youthful companion may also symbolize various tales of adolescent courage. This capacity to transform the particularities of a bloody revolution into a poetic hymn to French liberty continues in the glimpse at the right of the Île de la Cité and of Notre-Dame (from whose distant towers the tricolor flag, raised in revolutionary triumph, is just visible) and in the patriotic orchestration of color, in which red, white, and blue resonate throughout. In some ways, Delacroix's *Liberty* is only a late variation on the heroic street fighting recorded by Copley in the *Death of Major Peirson* (see fig. 6), but what makes it so original is its power to rekindle a revolutionary faith in an abstract deity after so many political gods had come and gone. The powerless, leaderless crew of the *Medusa*'s raft is suddenly resurrected here by Liberty, who, at the apex of a human pyramid of death and rebirth, strides forward into our space, her flag bursting across the upper frame.

How compelling Delacroix's pictorial and imaginative energies are may be measured by crossing the French border to Belgium, where, one month after the July Revolution in Paris, a popular revolution erupted against the Dutch government that had been forced upon the country at the Congress of Vienna. The most famous record of this nationalistic struggle was that by a young painter, Gustaaf Wappers (1803–74), who in fact had visited Paris in the late 1820s in time to see how the fleshy, dynamic style of his own countryman Rubens could be transformed into a passionate new kind of history painting. Thanks to David's exile in Brussels (1816–25), Belgian painting had been dominated by an icy Classicism; and the alternative of Rubens could mean for a young Belgian not only aesthetic but also national freedom. In the tradition of West and Copley, Wappers was able to shift from an earlier national past (most frequently the sixteenth and seventeenth centuries) to the immediacy of the national present, as in the case of his *Episode from the Belgian Revolution of*

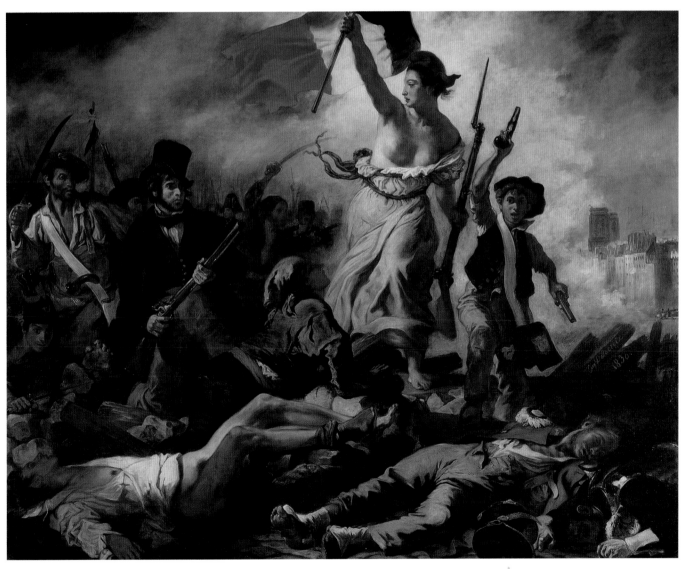

Fig. 127 **Eugène Delacroix**, *July 28: Liberty Leading the People*, 1830. Oil on canvas, 8′ 6⅜″ × 10′ 8″. Louvre, Paris.

1830 (fig. 128). Prepared for exhibition in Antwerp in 1835 and then shown triumphantly throughout the Continent, this twenty-two-foot-wide canvas commemorates the heroic resistance of the Brussels population against the Dutch troops who invaded the city on September 23, to be repelled three days later. Like Delacroix's *Liberty*, it pinpoints in the background a particular site of nationalistic resonance, here the Grand-Place, the late medieval city center of Brussels. Similarly, it telescopes the fullest range of civilian turmoil, patriotism, and sacrifice, from a prancing dog and drummer boy to heart-rending close-up views of one family mourning a dying son and another about to be rent asunder by the father who drags himself away from his wife and child with one arm raised in angry protest against the Prince of Orange's oppressive proclamation. But if the literally flag-waving nationalism of Wappers's painting parallels Delacroix's *Liberty*, its imaginative level does not. For here, the glorification of a popular revolution through such venerable echoes as a Pietà motif or paraphrases of Rubens's energetic groupings adds up only to a jingoistic prose account of an actual event. Wappers's interpretations of history had legions of successors, not only in Belgium, through his own role as professor and then

director of the Antwerp Academy, but in more general terms, throughout Europe and America, where comparable nationalistic needs guaranteed that artists would be constantly commissioned to paint or, better put, to manufacture idealized documents of historical events, past and present. For the most part, the results are equatable with textbook illustrations. After the demise of Napoleonic ideals in 1815, it took the greatest of painters—a Delacroix or a Manet (see fig. 280)—to accommodate this public demand to the highest demands of their own vision.

Indeed, after *Liberty* and several competition entries of 1831 to illustrate episodes from the French Revolution, Delacroix himself retreated from the painting of modern history, turning away from the realities of Paris life under the new citizen-king, Louis-Philippe, and toward the inspiration of the Bible, of the classics, of medieval history, and of literature from Shakespeare to Byron, as well as to the still accessible fantasies provided by the living experience of a four-month visit to Morocco in 1832. As the guest of the Count of Mornay, Delacroix was to help document a diplomatic trip, and he did so avidly in seven notebooks filled with drawings and watercolors, executed in what seems a frenzy of excitement. Such a fascination with the

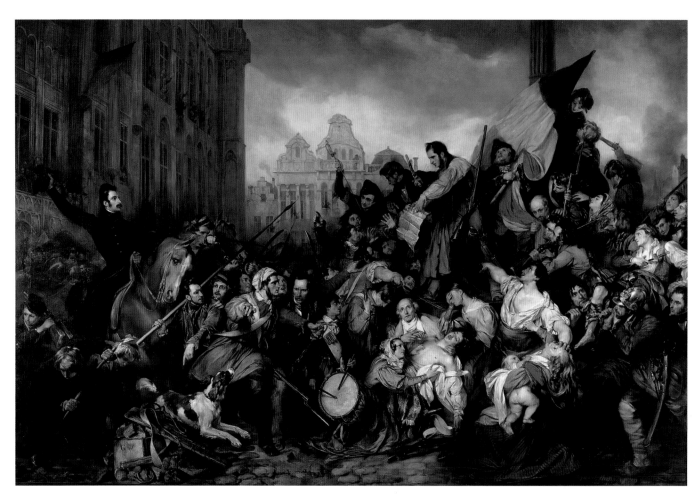

Fig. 128 **Gustaaf Wappers**, *Episode from the Belgian Revolution of 1830*, 1835. Oil on canvas, 14′ 9½″ × 22′. Musées Royaux des Beaux-Arts/Koninklijke Musea voor Schone Kunsten, Brussels.

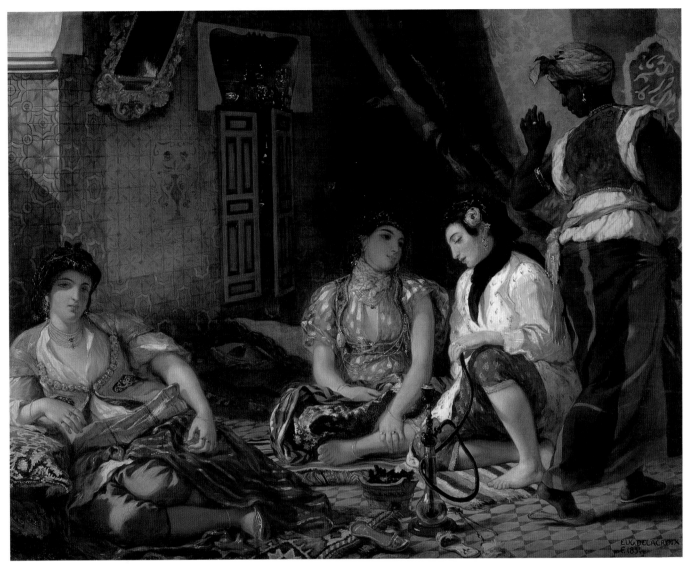

Fig. 129 **Eugène Delacroix**, *Women of Algiers*. Oil on canvas, 70⅞ × 90⅛". Louvre, Paris.

sensuous detail of an exotic world was already apparent in the 1820s, when Delacroix prepared paintings of Near Eastern subjects, but here was an opportunity to see an Islamic civilization first-hand. The intense documentary jottings he made there provided imaginative nourishment for the remainder of his long career, beginning with a major Salon entry of 1834, *Women of Algiers* (**fig. 129**). At the end of his North African sojourn, he was able to arrange access to a harem, and was enthralled there by what seemed to him a survival of the ancient Mediterranean world, as beautiful, he said, as in the time of Homer. What he saw was the preservation of a world inhabited exclusively by women, a voluptuous hothouse environment in which female flowers could flourish—beings dedicated solely to a life of pleasure, whether of the flesh, of the palate, or of the making of the gorgeous costumes that Delacroix constantly recorded. Renoir commented that when he got close to *Women of Algiers*, he could smell incense: the painting indeed exudes a narcotic atmosphere that permeates the

shadowy room, from the water-cooled smoke of the hookah, with its serpentine tube, to the postures of animal relaxation in a world whose timeless torpor is interrupted only by the just-visible gold watch hanging on the right breast of the woman in the center and by the quiet departure of the black servant. These cloistered creatures were a living incarnation of a recurrent nineteenth-century dream of Western male tourists and spectators, a dream of women as carnal beings adorned by flowers, fragrances, jewels, exquisite fabrics. Ironically, Delacroix in the same decade became a close friend of that Frenchwoman who had so urgently promoted woman's right to be man's social and intellectual equal, George Sand.

The pervasive eroticism of *Women of Algiers* was amplified by Delacroix's painting techniques, which attained such a resonant interweaving of dabs of intense hue that figures and ambience seem to merge in veils of warm, softly lambent color. But for many artists and critics, this loosening of contour and brushstroke, dependent as it was upon

the great traditions of Rubens and the Venetian masters, became the earmark of an undisciplined, rebellious style that even Delacroix's great defender Baudelaire would later characterize as painting with "a drunken broom." There was, in fact, abundant counterdemonstration of a more fettered approach to painting, even when dealing with the erotic abandon of a harem, and no one provided a sterner alternative than Ingres. From his earliest years, Ingres had been fascinated by the linear manipulation of the female form, making it bend and twist to demands that mixed the aesthetic and the erotic. His conception of women cut across many strata, whether in the classical guise of the nymph Thetis (see fig. 54) or the exotic motif of Near Eastern bathers and odalisques; and he constantly competed with Delacroix in his own harem territory, re-creating with the same documentary precision those perfumed gardens of a non-Western world that cultivated secluded spaces for the uninhibited display of feminine sensuality. In his *Odalisque with Slave* of 1839–40 (fig. 130), painted for the delectation of a private male patron, he drastically

lowered the temperature of Delacroix's *Women of Algiers*, chilling his colors and contours to a glacial inflexibility that is paradoxically at odds with the wanton theme. Gautier's later quip that Ingres was "a Chinese . . . lost in the streets of Athens" becomes intelligible before this complex fusion of classical and Oriental sensibilities: on the one hand, a reclining idealized nude whose ancestry evokes the great Venuses of Western painting as well as the marble Ariadnes of Greco-Roman antiquity; on the other, an obsession with an exotic world that relieves the restraint and drabness of nineteenth-century Western realities with a proliferation of Islamic ornamental surfaces, of exquisitely wrought artifacts (from the floor tiles and feather fan to the fountain and balusters), and even of different races (the standing black eunuch and the olive-skinned slave who plays the *tār*, an Oriental lute). As rigorous as his master David in his ability to interlock a multitude of rectilinear volumes and surfaces, Ingres nevertheless evokes here a feminine ambience of voluptuous relaxation and engulfing sensuousness. (The painting, in fact, has even been interpreted as an

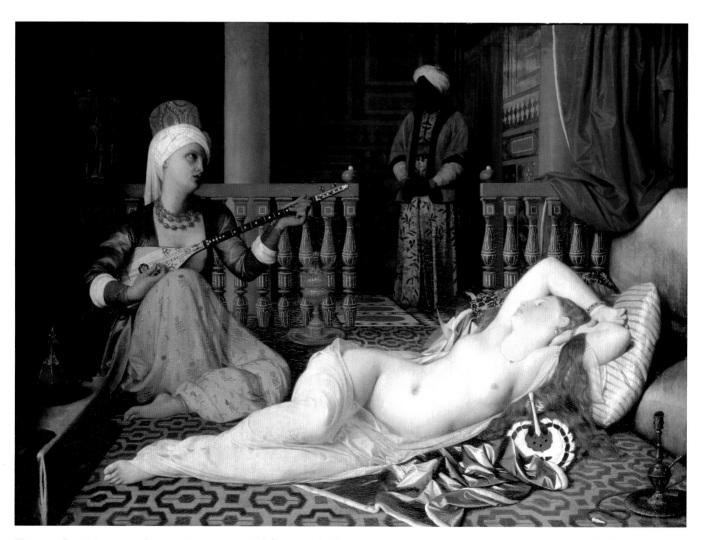

Fig. 130 **Jean-Auguste-Dominique Ingres**, *Odalisque with Slave*, 1839–40. Oil on canvas mounted on panel, 28¾ × 40″. Fogg Art Museum, Harvard University, Cambridge, Massachusetts.

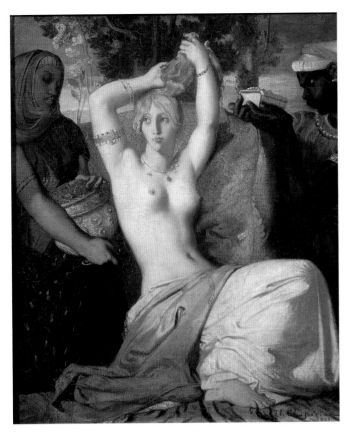

Fig. 131 **Théodore Chassériau**, *The Toilet of Esther*, 1841 (Salon of 1842). Oil on canvas, 18½ × 14⅛″. Louvre, Paris.

allegory of the five senses.) Like Delacroix, Ingres sees this world in the role of a Western voyeur, but imposes his own complex sensibility upon it. In place of smoldering colors and an almost steaming atmosphere, Ingres offers a crystal-clear space where icy local colors collide but never fuse, where skin textures seem both hard as marble and soft as wax, where what is so hedonistically displayed to the eye remains as frozen and untouchable in its patterned perfection as the Persian and Indian miniatures he marveled over.

Yet for all the visible and emotional antagonism between these two paintings, the black-and-white Ingres-Delacroix polarity obviously has many shades of gray, and at least one artist, Théodore Chassériau (1819–56), a student of Ingres, often achieved a fusion of what many considered to be these masters' mutually exclusive modes. His *Toilet of Esther* (fig. 131), shown at the Salon of 1842, translates Ingres's and Delacroix's Orientalism to the greater propriety of an Old Testament text, in which the beautiful Hebrew queen is seen adorning herself with the help of servants as exotic as those who could still be observed in nineteenth-century Morocco, Egypt, or Turkey. And his synthetic style keeps wavering between the flat, patterned effects of Ingres's sleek attenuations of the female figure and the resonant, comforting warmth of Delacroix's more shadowy, vibrant brushwork. But apart from such examples of the

peaceable coexistence of Ingres's and Delacroix's contrasting visual modes, these two giants constantly overlapped in their own achievements; for not only did Ingres intrude again and again upon the nominally Romantic territory of Oriental or medieval themes, but Delacroix referred no less often to Ingres's major deities, Raphael and Greco-Roman art, history, and legend. Even more, both artists strenuously attempted to maintain the subject hierarchies of the academic tradition, locating lofty, distant narrative and allegorical themes in a higher realm than the ephemeral, prosaic facts of contemporary life that, for younger artists, were becoming far more compelling than the remoteness of the Trojan Wars, the Crusades, or a harem.

Turner and Romantic Visionaries

For most French painters who wanted to explore the highest reaches of the Romantic imagination, it was the human figure that occupied center stage. But this anthropocentric view, nurtured by the traditions of David, was less common outside France, especially in England, where the phenomena of nature provided the richest metaphors for speculation about man's role in a grand, universal scheme. Already before 1815, Turner, in such pictures as *Hannibal and His Army Crossing the Alps* of 1812 (see fig. 74), had brought the late eighteenth-century fascination with the Sublime to a thrilling climax. For the next three decades, he continued to pursue even further reaches of the awesome experience of man before nature, achieving by the 1840s one of the most spectacular rejections of the material world in the annals of modern painting.

For all his originality and his passionate endeavors to record what he saw, Turner, no less than David, Géricault, or Delacroix, was constantly aware of the old masters; and, from his beginnings, he could work simultaneously in different pictorial modes that brought up to date not only the work of such immediate London predecessors as de Loutherbourg (see fig. 59), but such seventeenth-century Continental masters as the Dutch marine painter Willem van de Velde, or the French painter of luminous elegies Claude Lorrain. Turner venerated Claude, in particular, as much as Ingres did Raphael, and even published a collection of prints of his own work, the *Liber Studiorum*, in imitation of Claude's collection, the *Liber Veritatis*. In 1815, this homage was made explicit in *Dido Building Carthage* (or *The Rise of the Carthaginian Empire*; fig. 132), a painting shown at the Royal Academy. How consciously this attempted to resurrect Claude's achievement was made clear by Turner's stipulation in his will that the painting be left to the National Gallery, provided it was hung next to Claude's *Seaport: Embarkation of the Queen of Sheba*. The structure of Turner's work, in fact, resurrects Claude's many views of a classical harbor seen *contre-jour*, that is, against

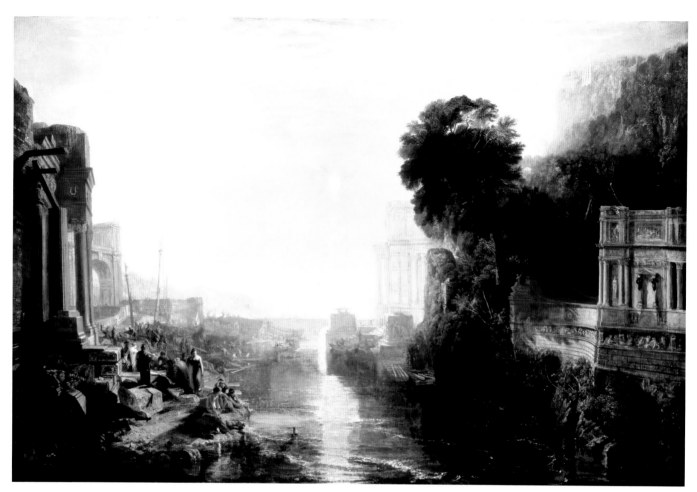

Fig. 132 **Joseph Mallord William Turner**, *Dido Building Carthage*, Royal Academy 1815. Oil on canvas, 61¼ × 91¼″. National Gallery, London.

a glowing, sunlit sky that casts a filtered golden haze across the signs of both nature and civilization in the foreground. But as in Ingres's paraphrases of Raphael, Turner's own mark is subtly apparent. The disk of the sun seems now to be a source of such quiet but absolute energy that the very proportion of light to matter seems to alter, as if the silhouetted tree, the sun-drenched figures, and even the high rocks and ornate architecture were ultimately to dissolve before this vital natural force. And even if the swiftly receding shoreline of the Carthaginian port gives us some anchoring in a measured, diminishing space, the foreground flood of water, shimmering with reflected sunlight, threatens this stability. Indeed, it is telling that Turner completed two years later a companion picture, *The Decline of the Carthaginian Empire*, a melancholy pictorial commentary on the familiar Romantic theme, so poignantly defined in Shelley's *Ozymandias*, that nature will be heir even to man's most noble achievements. If *Hannibal*, Turner's earlier meditation on Carthaginian history, presents nature's power as a whirlwind vortex, this one moves to an opposite extreme of uncanny stillness and luminosity in which, as in many of Friedrich's paintings, a dense and mysterious atmosphere quietly absorbs the world of matter.

But whether furiously or serenely pervasive, nature is presented as an intangible force, a bodiless energy that will ultimately conquer and destroy historical time on earth. Like many other Romantics, Turner evokes universal ultimates, whether those of creation or apocalypse, translating the imagery of the Book of Genesis or the Book of Revelation into the language of natural phenomena.

The epic sweep of Turner's imagination constantly merged past and present, the particular and the universal, so that even his most intense observations from on-the-spot experiences could absorb a distant memory or become a timeless symbol. When working in Venice, that city whose visual dissolution of matter almost fulfilled objectively his pictorial goals, Turner could occasionally include in the blurred crowds of tiny figures such historical personages as the eighteenth-century master Canaletto (from whose own Venetian scenes he had learned so much) or such fictional ones as Shakespeare's Juliet and her nurse. When he painted the maritime event of Nelson's old flagship, the *Téméraire*, being towed off to be scrapped in 1838, the result became a melancholy symbol of destiny, as potent as Friedrich's ships disappearing toward the remote horizon. And when he rapidly recorded, in small watercolor

sketches, the spectacular fire of October 16, 1834 that devastated the Palace of Westminster, he transformed them into paintings that, when exhibited in the following year, could almost have been mistaken for depictions of the end of the world.

In one of these (fig. 133), we see, to be sure, enough specific data to pinpoint the event in time and space—crowds of South Bank spectators in contemporary costumes, the rising and falling sweep of Westminster Bridge, the distant Gothic towers of Westminster Abbey. But these topographic facts have all been set ablaze in a pictorial furnace of cosmic dimensions. Before this sublime fusion of the four elements—fire, air, earth, and water—the throngs in the foreground disappear in ghostly, flickering shadows, as if they were watching an epic disaster, whether historical, like the Great Fire of London of 1666 or the catastrophe at Pompeii and Herculaneum in 79 A.D., or even biblical, like the destruction of Sodom and Gomorrah. Turner, in fact, had earlier painted both this Old Testament subject and an eruption of Vesuvius, as well as a host of other cataclysmic scenes; but his technique had never before reached this degree of fluidity, nor had his gyrating rhythms, even in *Hannibal*, ever approached such an overwhelming evocation of sheer, disembodied energy. The bridge itself becomes a weightless force that plunges us across phantom boats and water into an infernal pyre that confounds up and down, reality and reflection, the man-made and the natural. And from there, the golden flames and blue-black smoke rise and merge indissolubly with the clouds and stars of the night sky. By comparison with such earlier pictorial spectacles as de Loutherbourg's hellish furnaces at Coalbrookdale (see fig. 59), Turner's vision transcends empirical fact in a fluid world that captures nature's primal energies.

In the 1840s, his last decade, Turner achieved even more astonishing distillations of what seem the very forces behind creation. In *Snowstorm* (fig. 134), exhibited at the Royal Academy in 1842, he began, as he often did, with the immediacy of personal experience. In this case, his own legend had it that he actually had had himself lashed to the

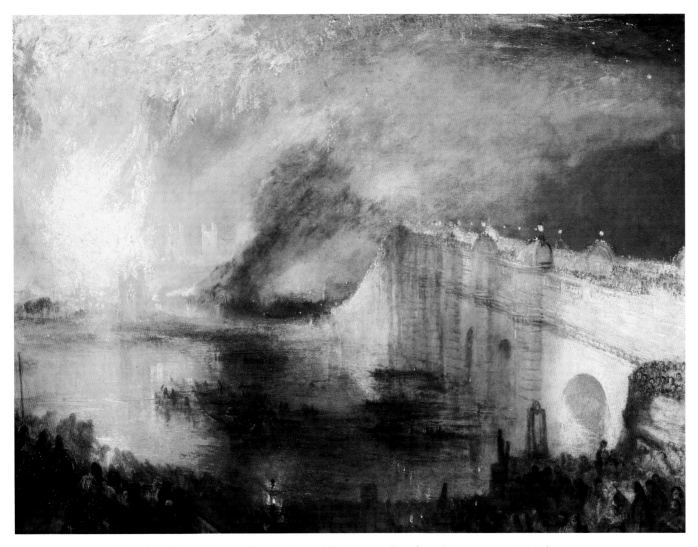

Fig. 133 **Joseph Mallord William Turner**, *The Burning of the House of Lords and Commons, 16 October, 1834*, exh. British Institution 1835. Oil on canvas, 36¼ × 48½". The Philadelphia Museum of Art, Pennsylvania.

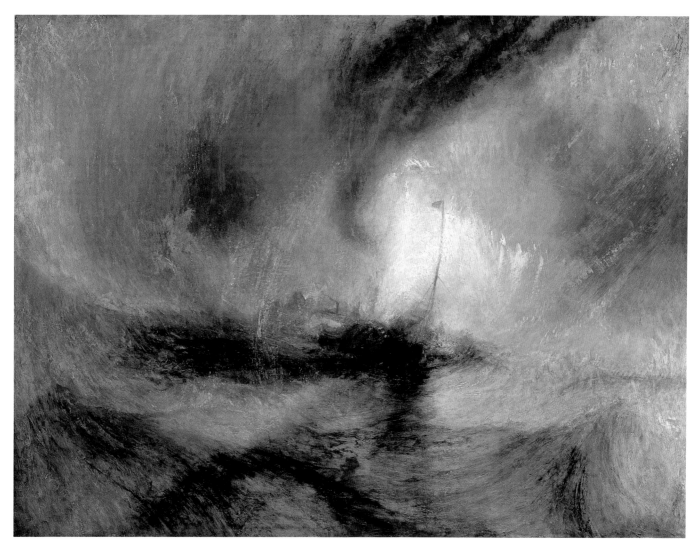

Fig. 134 **Joseph Mallord William Turner**, *Snowstorm, Steamboat Off a Harbour's Mouth*, Royal Academy 1842. Oil on canvas, 35½ × 47½". Tate Britain, London.

mast of the *Ariel* for four hours after the ship's departure from Harwich in a snowstorm, so that he might immerse himself totally in this whirling blizzard of snow, smoke, wind, and sea. The painted result, however, leaves far behind the popular realm of such Romantic maritime adventures as Gudin's *Devotion of Captain Desse* (see fig. 126), and approaches what might almost be the Deluge or a study of galactic explosions. A pitiful artifact of man, the boat becomes an insignificant specter absorbed in a vortex of cosmic energy that Turner seizes in its rawest, most terrifying aspects. Like so many other great paintings, *Snowstorm* seems both an end and a beginning. It brings to an overwhelming climax and conclusion themes that obsessed not only Turner but many of his Romantic contemporaries—the sublime power of nature, the poetic resonance of a distressed ship as a symbol of man's destiny. But in its revelation of a fluid pictorial language that completely annihilates matter, it also announces some of the most daring innovations of later modern painting, from Monet to Pollock, and like them, provoked both antagonistic

criticism ("soapsuds and whitewash") and fervent support (from Turner's greatest defender, John Ruskin). And in terms of nineteenth-century British painting, its freedom to transform nature into what appears to be almost an abstract pattern of subtly fused, luminous tones heralds Whistler's art of the 1870s. Depending on one's vantage point, Turner's final achievements can look either backward or forward.

Unique as Turner's genius was, his ambitions to depict the most grandiose extremes of natural and supernatural phenomena were shared by many of his contemporaries both at home and abroad. In England, such artists as John Martin (1789–1854) ascended to equally lofty peaks of fear and trembling in a vast repertory that could be associated with the period's many controversies about the reconcilability of new theories of geology with the Bible accounts of the origins of the universe. More technically conservative than Turner, Martin was more easily acceptable, and his many printed illustrations of the end and the beginning of the world had enormous currency on both sides of the

Channel and the Atlantic. In his *Fall of Babylon* (fig. 135), a mezzotint of 1831 that adds even greater melodrama to an earlier painted version of the subject exhibited in 1819, Martin offers the kind of extravaganza that made his international fame. To the ubiquitous Romantic themes of exotic pageantry, sublime catastrophe, and the rise and fall of a great and distant civilization, he adds here an up-to-date documentation of the legendary wonders of Near Eastern archaeology, attempting a reconstruction of such fabled monuments as the Tower of Babel (the stepped

TURNER AND HIS CHAMPION, JOHN RUSKIN:
THE *SNOWSTORM* AND THE OSCILLATING CRITIC

J.M.W. Turner's full title for the picture (see fig. 134) in London's Royal Academy catalogue of 1842 provides a clarity and specificity absent in the picture itself: "Snowstorm, Steamboat off a Harbour's Mouth making Signals in Shallow Water, and going by the Lead. The Author was in this Storm on the Night the Ariel left Harwich."

Turner's greatest supporter, the critic John Ruskin, wrote frequently about this painting over many years. While younger, he certainly viewed the work as one of Turner's greatest, but his opinion evolved over time.

Ruskin first mentioned the picture in Modern Painters, *Vol. I, published initially in 1843:*

... imagine ... the low rain-clouds brought down to the very level of the sea, as I have often seen them, whirling and flying in rags and fragments from wave to wave; and finally, conceive the surges themselves in their utmost pitch of power, velocity, vastness, and madness, lifting themselves in precipices and peaks, furrowed with their whirl of ascent, through all this chaos; and you will understand that there is indeed no distinction left between the sea and air; that no object, nor horizon, nor any landmark or natural evidence of position is left; that the heaven is all spray, and the ocean all cloud, and that you can see no farther in any direction than you could see through a cataract. Suppose the effect of the first sunbeam sent from above to show this annihilation to itself, and you have the sea picture of the Academy, 1842, the Snowstorm, one of the very grandest statements of sea-motion, mist, and

light, that has ever been put on canvas, even by Turner. Of course it was not understood; his finest works never are: but there was some apology for the public's not comprehending this, for few people have had the opportunity of seeing the sea at such a time, and when they have, cannot face it. To hold by a mast or a rock, and watch it, is a prolonged endurance of drowning which few people have courage to go through. To those who have, it is one of the noblest lessons of nature.[27]

In a subsequent revised edition of the same text he expanded on this idea in a passage that brilliantly illustrates Ruskin's near-poetic attention to the minutiae of nature:

The "yeasty waves" of Shakespeare have made the likeness familiar, and probably most readers take the expression as merely equivalent to "foamy;" but Shakespeare knew better. Sea-foam does not, under ordinary circumstances, last a moment after it is formed, but disappears ... in a mere white film. But the foam of a prolonged tempest is altogether different; it is "whipped" foam, thick, permanent, and, in a foul or discoloured sea, very ugly, especially in the way it hangs about the tops of the waves, and gathers into clotted concretions before the driving wind. The sea looks truly working or fermenting.[28]

Ruskin returned to the picture a decade later in Notes on the Turner Gallery at Marlborough House 1856. *Before sharing his revised opinion, he recalls the artist's anguished reaction to a critic's barb:*

It was characterized by some of the critics of the day as a mass of "soapsuds and whitewash." Turner was passing the evening at my father's house on the day this criticism came out: and after dinner, sitting in his arm-chair by the fire, I heard him muttering low to himself at intervals, "Soapsuds and whitewash!" again, and again, and again. At last I went to him, asking "why he minded what they said?" Then he burst out;—"Soapsuds and whitewash! What would they have? I wonder what they think the sea's like? I wish they'd been in it."

... Interesting, however, as this picture is, in marking how far the sense of foaming mystery, and blinding whiteness of surf and salt, now influenced Turner's conception of the sea, rather than the old theories of black clouds relieving terminated edges of waves, the sea is, however, even thus, not quite right: it is not yeasty *enough*: the linear wave-action is still too much dwelt upon, and confused with the true foam.[29]

Finally, in 1875, Ruskin qualified yet again the comments he had made in Modern Painters, *over thirty years earlier:*

The whole of this was written merely to show the meaning of Turner's picture of the steamer in distress, throwing up signals. It is a good study of wild weather; but, separate from its aim, utterly feeble in comparison to the few words by which any of the great poets will describe sea, when they have got to it.[30]

Fig. 135 **John Martin**, *The Fall of Babylon*, 1831. Mezzotint, 18½ × 28¾". British Museum, London.

pyramid across the river), Nebuchadnezzar's Palace with the Hanging Gardens (right foreground), and the vast bridge which spans the river without the use of the arch (a word which, as Martin explained, was never mentioned in such ancient sources for Babylonian history as Herodotus and the Bible). Next to Turner's mixtures of historical fact and imaginative terror (whether pertaining to *Hannibal and His Army Crossing the Alps* or *The Burning of the House of Lords and Commons*), Martin's visions of doom seem less like private meditations on history, man, and nature, and more like hair-raising theatrical spectacles geared to the largest of popular audiences. Martin's work could also seize the imaginations of such great Romantic poets as Keats, Hugo, and Heine, but it is less surprising to learn that the American director D. W. Griffith found inspiration in Martin's prints for his cinematic reconstruction of the fall of Babylon in *Intolerance* (1916).

The same extravagant effects were responsible for the making of another international reputation, that of Karl Briullov (1799–1852), the first Russian painter to become known throughout Europe, thanks to his enormous (twenty-one feet wide) *Last Day of Pompeii* (**fig. 136**). Like many other Romantics, from Delacroix to Turner, he was inspired both by actual experience (a visit to the ruins of Pompeii) and a rampant imagination (kindled here by reading Pliny and attending a performance of Pacini's opera about this classical catastrophe); and in 1833, after three years of work, he completed this theatrical extravaganza in which, before our very eyes, volcanic eruptions,

toppling statues and buildings destroy this helpless city as its most illustrious victim, Pliny the Elder, is carried off, dying of asphyxiation, in the foreground. Although Briullov's retention of heroic figural compositions recalls his long exposure to Italian painting, his dazzling effects of both lighting and lightning are closer to Turner and Martin at their most apocalyptic. The combination was, in any case, a success; for not only was the painting exhibited in both Rome and Milan, but it was also included in the Paris Salon of 1834, before being sent back to St. Petersburg for viewing. And among the crowds who admired it were not only such writers as Pushkin, Gogol, and Scott, all of whom commented on it in prose or verse, but also Sir Edward Bulwer-Lytton, whose *Last Days of Pompeii* (1834), one of the most widely read novels of the nineteenth century, was a direct response to this image of a historical disaster that seemed to fuse both classical and Christian epochs.

The opposite side of this calamitous coin, where havoc and pandemonium were the reigning deities, was a mood of uncommon stillness, with nature casting a spell of primordial purity. Like Turner, the Irish painter Francis Danby (1793–1861) alternated between these two extremes, for he was attracted not only to doomsday subjects, but also to landscapes of mythical calm. In *The Enchanted Castle—Sunset* (**fig. 137**), exhibited at the Royal Academy in 1841, he offers his own interpretation of that aspect of Claude Lorrain which had also fascinated Turner in works like *Dido Building Carthage* (see fig. 132): the head-on spectacle of a diffuse sunset whose hazy, golden beams wreak magic

Fig. 136. **Karl Pavlovich Briullov**, *The Last Day of Pompeii*, 1830–33. Oil on canvas, 15′ 2½″ × 21′ 8½″. Russian Museum, Leningrad.

Fig. 137 **Francis Danby**, *The Enchanted Castle—Sunset*, Royal Academy 1841. Oil on canvas, 33 × 46″. Victoria and Albert Museum, London.

upon everything they touch, whether shimmering bodies of water, near and far; silhouetted screens of uncommonly high and exotic trees; or vaporous, fairy-tale architecture glimpsed as through a stage scrim. Here Danby's homage to Claude even includes the theme, for the French master had also painted the melancholy story of the lonely Psyche, the prisoner of love's illusions in Cupid's magic palace. This work, in fact, had been retitled "The Enchanted Castle" in Romantic England; and in 1818, two years after its public exhibition in London, it was to inspire a poetic rumination by no less a contemporary of Danby than Keats. Like the great poet, who calls Claude's castle "a Merlin's hall, a dream," Danby in turn evokes an elegiac mood where art and myth, landscape and love fuse in an immaterial ambience that permits associative fantasies to wander at will. Isolated in the foreground, the unhappy Psyche echoes many earlier Romantic formats by providing a single point of emotional contact that wafts the spectator off to ever more distant realms.

The almost supernatural character of these excursions to territories charted only in the imagination could often, especially in Catholic countries, find support in more conventionally celestial themes, such as the Ascension and the Holy Trinity, both of which were essayed with spectacular effect by Domingos António de Sequeira (1768–1837). Exiled from his native Portugal for his participation in the liberal revolution of 1820–22, he went first to Paris and then Rome, where, in his last years, he painted cloud-borne visions of eternity that parallel, in Catholic terms, the ethereal congregations in John Martin's works. For all its dependence upon the dizzy altitudes of heaven depicted by Baroque artists in Catholic nations like his own, Sequeira's *Holy Trinity* (fig. 138) has a nineteenth-century visionary ring, in which contemporary terra firma is left far below in favor of a religious apparition of awesome symmetry, with infinite throngs of heavenly hierarchies ascending to an immutable truth. It was a structure of stunning simplicity and permanence that, in fact, characterized many

Fig. 138 **Domingos António de Sequeira**, *Holy Trinity*, c. 1830. Oil on canvas, 29¼ × 37½".
Museu Nacional de Arte Antiga, Lisbon.

Fig. 139 **Samuel Palmer**, *Rest on the Flight into Egypt*, c. 1825. Oil and tempera on panel, 12½ × 15½".
Ashmolean Museum, Oxford.

nineteenth-century efforts, in both private visions and public murals, to create at least the illusion of absolute truth for a period that constantly challenged traditional Christian views of the afterlife.

But heaven could be found on earth as well, especially by those Romantic masters of Northern Europe who, like Friedrich and Runge, often scrutinized the closest details of nature as miraculous evidence of a religious force. Few artists brought to this pantheistic vision a more passionate conviction than Samuel Palmer (1805–81), at least during the 1820s, when he fell under the potent spell of William Blake, whose woodcut illustrations to Vergil's *Eclogues* offered him the possibility of seeing nature in terms of an enchanted pastoral where shepherds and their flocks recalled an ancient world of rural innocence and purity. Palmer applied this vision of landscape to the English countryside, which became for him a haven of unpolluted

calm and mystery far from the grime and social unrest of London. Deeply religious, sensing within his own being the call of both Christ and Satan, Palmer was thrilled by his first views of prints and paintings by Northern fifteenth-century masters like Van Eyck and Dürer, whose art evoked for him, as it had for the Nazarenes, a distant religious epoch when every blade of grass and every incised line was a testimony of an all-pervasive faith in Christianity. Small wonder, then, that Palmer could succeed in transforming his perceptions of English landscape into an environment suitable for a traditional religious theme, the *Rest on the Flight into Egypt* (**fig.** 139), a panel painting of about 1825 whose tiny dimensions, as in the case of Blake, magnify the image's intensity. Here, nature's burgeoning vitality overwhelms the countryside, where gently rolling hills are bathed in a golden light that brings energy and life to the young trees and a fresh harvest of wheat, a

traditional symbol of Christ's earthly nature. So deeply felt is the supernatural aura of this rustic English vale (which includes the smoking chimney of a farmer's cottage) that it can suddenly become the Holy Land, where a palm tree on the right shades Mary, Joseph, and the Infant Christ, where a golden halo is almost camouflaged by gleaming, sunlit foliage, and where a grazing donkey is the very beast that bore the Holy Family. Palmer's fusion of the terrestrial and the divine was a goal of many Romantic masters, but one seldom achieved with such uncommon ardor. That his art, rediscovered in the mid-twentieth century, was so often compared to Van Gogh's is a tribute to his capacity to render through landscape a bursting, luminous energy whose origins seem more supernatural than natural.

Constable and Romantic Naturalism

For Palmer, as for Turner or Friedrich, the mystical component of landscape experience is often so pervasive that we feel elevated to an otherworldly realm. But many of their contemporaries saw nature less in transcendental than in empirical terms, attempting to record the simple truths of a vision unclouded by thoughts of eternity. Working in small oils or with the rapid notations of watercolor techniques, many British artists, for example Thomas Jones or John Cotman (see figs. 62 and 63), had occasionally seized candid and specific truths of nature, but few, if any, had reached in larger oils on canvas such a literal rendering of commonplace rural fact as did the precocious George Robert Lewis (1782–1871). For in 1816, he exhibited two paintings that the catalogue designated as having been "painted on the spot." *Hereford, Dynedor, and the Malvern Hills, from the Haywood Lodge, Harvest Scene, Afternoon* (fig. 140) has been convincingly identified as one of these records of daily life in a county known for agriculture. Neither Vergil nor the Bible comes to mind before this clear-eyed, matter-of-fact view of a specific site at a specific time; and no personal temperament seems to color this sharp-focus document of an uneventful harvest scene. Instead, Lewis has given us a record of prosaic farm life, in which the face, clothing, and posture of every farmhand relaxing in the afternoon sun are as particularized as every

Fig. 140 **George Robert Lewis**, *Hereford, Dynedor, and the Malvern Hills, from the Haywood Lodge, Harvest Scene, Afternoon*, Society of Painters in Oil & Water Colours 1816. Oil on canvas, 16⅓ × 23½". Tate Britain, London.

Fig. 141 **John Constable**, *The Hay Wain*, 1821. Oil on canvas, 51¼ × 73″. National Gallery, London.

blade of grass and stalk of wheat that covers the cultivated soil. Quietly insistent on nothing but the truth, Lewis's painting, in the context of the early nineteenth century, seems to lack both style and emotion; but its very objectivity, attempting an exact transcription of the artist's direct observation, heralds a major ambition not only of photography, but of many mid-nineteenth-century painters from the Pre-Raphaelites to Manet.

In words, the goals of John Constable (1776–1837), the most beloved laureate of British landscape painting, might sound similar to those of Lewis; for his work, too, gave priority to truth to nature, constantly sketching observable facts as he explored them in his native Suffolk and in a few other regions of England. But if Constable also pursued what might be described as objective natural data, the pictorial results remind us that he once claimed, "Painting is for me but another word for feeling." Traditionally, Constable has been set into polar opposition to his great contemporary Turner, the unadventurous, stay-at-home versus the Romantic wanderer; and his humble records of the particularities of wild flowers, elm trees, agricultural tools, canal boats, or farmers' cottages have often been

considered the pictorial counterpart of Wordsworth's quiet veneration of the simple felicities of the English countryside, a literary parallel that would locate Turner's extravagant imagination in the realm of Byron and Shelley. But such generalizations, for all their truth, have tended to limit Constable's achievement to that of a mere observer of rural landscape, as if emotion and idea were negligible factors in his work.

His most famous painting, known as *The Hay Wain* (fig. 141), but first exhibited at the Royal Academy of 1821 as *Landscape: Noon*, may suggest how much more he is than, in his own words, "a natural painter," for it offers in dimensions (here six feet wide) that rival Turner's history paintings a virtual universe that is no less complete for being based on the scrupulous record of the farm life that Constable knew intimately from the Stour Valley where he was born and raised. Unlike so many fictitious eighteenth-century pastorals, where shepherds, milkmaids, and feathery trees evoke a courtly ideal of rural charm and relaxation, *The Hay Wain* speaks the authentic language of firsthand experience. Although nothing more exciting is happening than a hay wain's untroubled fording of the

Stour River, the eye willing to accommodate itself to the slow tempo of a long and loving country walk can find here a multitude of those rustic pleasures which Constable himself articulated in words as well as images. Above, a typically British cloud-filled sky moves swiftly from storm to sunshine; below, in place of a human spectator, a black-and-white dog stops to notice the moving horses and wagon. At the right, a figure, hidden in the bushes, seems to be mooring a boat, while at the left, an old cottage with a smoking chimney is almost camouflaged by earth and trees. Sharper inspection will reveal farmers working in the noonday sun, and flying and swimming birds. Such homely details of the country could be found abundantly in many earlier landscapes, especially those of seventeenth-century Holland, from which Constable learned so much; but here, they seem freshly discovered, as if the artist had fallen in love again with these commonplace truths. Indeed, what we feel here belongs to that Romantic passion for nature as a metaphor for something true, pure, and simple, a timeless idyll that, from the vantage point of nineteenth-century London, could begin to take on the enchantment of the Garden of Eden or a Vergilian pastoral. It is worth noting that the cottage at the left, as real as everything else in the painting, belonged to a certain Willy Lott, a Suffolk farmer who impressed Constable by the fact that in the eighty-odd years of his life, he had spent only four nights away from this humble dwelling.

In achieving this unpretentious evocation of a benevolent, natural universe where man, animal, and landscape are joined in the most elemental harmony, Constable employed pictorial techniques that are well-nigh invisible to eyes used to the later innovations of Impressionism, but were startlingly conspicuous to contemporary arists and critics, especially those French artists, like Géricault, who had a chance to see *The Hay Wain* in London, or like Delacroix, who was dazzled by it and the other two Constables at the Salon of 1824 (see page 135). As the French critics themselves noticed, whether in praise or blame, Constable's color and brushwork were so flecked and vibrant that individual details were obscured. Instead, a dappled, moist luminosity seems to saturate the whole, fusing leaf and wood, sky and river, man and beast in a pulsating atmosphere that, as profoundly if less spectacularly as in Turner's work, threatens the world of matter. To achieve this goal, in fact, Constable often made both small and full-size oil sketches (as he did for *The Hay Wain*) that slurred over descriptive details in order to capture a shimmering, overall unity.

Many of Constable's oil sketches (which, in the twentieth century, were often preferred, in their ostensibly Impressionist spontaneity and abbreviation, to the finished, exhibited paintings) were also intended as documentary material, recording in small format the directly perceived truths of nature for which earlier landscape painters had substituted artificial academic formulas. Of these, none are more quietly thrilling than his on-the-spot studies of clouds, whose swift movements and variety are as predictable in England as the unpredictable weather conditions they generate. In 1821–22, Constable engaged in a virtual campaign of what he called "skying," seizing in small, oil-on-paper studies the empirical truths of these ever-changing wonders in an ethereal world above. His approach was both wide-eyed and learned. He studied and copied Alexander Cozens's own drawings of clouds (see fig. 61), and he also commented, usually critically, on earlier meteorological treatises; but he felt compelled to see and experience clouds firsthand, often even noting on the sketches the exact time and location. In a characteristic study of cirrus clouds (fig. 142), we might almost be airborne, so completely has Constable concentrated his vision within an uncharted region where there is no up or down, beginning or end. Instead, puffs and streaks of white rapidly move in all directions against an infinite blue ground. If we sense here the naturalist's dogged pursuit of meteorological data and the painter's skill in translating these cottony wisps into an intensely cohesive whole, we may also experience the poetic magic of this image of total, expansive freedom. It is no accident that many Romantic poets from Goethe to Shelley were drawn to clouds as a metaphor for everything from transience and loneliness to adventure and freedom. As so often happens in the work of Romantic artists eager to explore the truths of nature, science and poetry, natural fact and private emotion are one.

Constable's studies of clouds were often paralleled by other artists of his generation, both at home (Turner) and abroad. Friedrich himself was fascinated by comparable effects of enveloping fog and haze, but it was his Norwegian friend, Johan Christian Clausen Dahl (1788–1857), who most closely shared Constable's impulse to capture in paint these elusive wonders of the sky. In what was once thought to be an independent painting, but is now known to be one of three surviving fragments of a

Fig. 142 **John Constable**, *Cloud Study*, 1821–22. Oil on canvas, 11¾ × 19″. Victoria and Albert Museum, London.

Fig. 143 **Johan Christian Clausen Dahl**, *Waterfall in Norway* (detail: one of three remaining fragments), 1819. Oil on canvas, 32 × 22½". Staatliche Museen Kassel.

larger painting of a waterfall (**fig. 143**), Dahl has finally located us at the end of terra firma, where we reach the immaterial realm of darkening clouds, moving endlessly above the steadfast silhouettes of the evergreens crowning the mountain peak. Although lacking Friedrich's religious imagery, Dahl's painting also evokes, in the purely naturalistic terms of the ultimate meeting of earth and sky, the Romantic yearning for communion with the potentially supernatural mysteries found at the farther distances from a man-made world.

Dahl's clouds, like Constable's, may summon up Romantic dreams; but, in general, Constable's work might be seen as displaying so intense a surface effort to record things seen that later histories of modern painting could consider him a precursor of Impressionism. This at best partial view is drastically undermined by the work of his last decade, whose overtly tragic tenor may be a direct response to the death, in 1928, of his wife, Maria who had been suffering from tuberculosis. Their seventh child was not yet a year old. Of the many late paintings that seem dominated by a monumental gloom, one, in particular,

helps to make explicit the implicit drama of his earlier work—*Salisbury Cathedral, from the Meadows* (**fig. 144**). Exhibited at the Royal Academy in 1831, with a quotation from James Thomson's eighteenth-century poem *The Seasons* about how the rainbow offers a symbol of hope after a storm, this turbulent painting is almost an avowal of faith. The sweeping vista, which opens with reminiscences of *The Hay Wain* (including the watchful dog), takes us back to an oblique view of that Gothic cathedral which Constable, from 1811 on, had often sketched and painted in a more overtly objective manner for his friend and patron, Dr. John Fisher, the Bishop of Salisbury. The component parts may seem to restate Constable's earlier, more casual observations of a British country idyll, yet the effect of the whole demands not only a more passionate response but even invites a symbolic reading. Here, all of nature is immersed in the quaking drama of a storm, whose gusting winds seem momentarily to threaten the stability of even the aged tree at the left that frames this breathtaking panorama. Its arcing, windswept trunk is then countered by the arcing rainbow that announces the end of the storm and that encloses the lofty Gothic silhouette of the most steadfast element of the painting, the cathedral. Although its message is not as clearly emblematic as Friedrich's interpretations of Gothic architecture in nature (see fig. 72), it nevertheless conveys a sense of faith in this venerable monument of a Christian past that is part of, yet beyond, the changing natural phenomena that surround it. A vision of hope in a storm that is both meteorologically and psychologically authentic, this late work also offers a vibrant pictorial fusion of nature's discrete parts that can rival Turner's own destruction of matter. Earth and water, leaf and cloud, stone and sky dissolve in a moist and shimmering paint fabric that equates the dappled interweaving of pigment on canvas with the organic changes and continuities of nature.

Constable's faith that nature held the key to timeless truths and moral values was particularly shared by his contemporaries across the Atlantic, where the New World spectacle of, in Longfellow's words, the "forest primeval" was an even more powerful reminder of the contrast between human and natural history. Of the many early nineteenth-century American painters who attempted to record the beauties and sublimities of an ever-expanding virgin landscape, Thomas Cole (1801–48), who left his native England for America in 1819, offered the most profound meditations upon the philosophical meaning of an omnipotent nature that would reign both before and after the ephemeral works of man. In 1826, a year after he settled in New York, Cole painted the recently deceased pioneer Daniel Boone (**fig. 145**), whose legendary rejection of human society not only pushed him farther and farther west but also reached international fame in the 1820s when Byron, in *Don Juan*, romanticized him in verse as one who

Fig. 144 **John Constable**, *Salisbury Cathedral, from the Meadows*, exh. Royal Academy 1831. Oil on canvas, 59¾ × 74¾". National Gallery, London.

chose the company of trees rather than of men. Next to his rude log cabin (the American wilderness equivalent of Willy Lott's cottage in Constable's *Hay Wain*), the aged Boone is a notable inhabitant of primitive nature, with a dog for his companion and a slain deer behind him for sustenance. Beyond this secular hermit is a vista of the pristine waters of Great Osage Lake, Missouri, framed by rugged trees and rocks even more venerable than Boone himself and located beyond the reach of even the most adventurous human trespasser. Seated at this remote outpost of a newly explored continent, Boone might be the first or last man on earth; and indeed, the contrast of trees in the foreground, ranging from young saplings to a dead, blasted trunk, implies a commentary on the cycles of man and nature that Cole would amplify in such later, more overtly allegorical series-paintings as *The Course of Empire* and *The Voyage of Life*. Cole's Romantic symbolism has also a distinctly American inflection in its scrupulous documentation

of natural fact. Although Cole had not been to Missouri, he based his imaginary reconstruction of the site on his first-hand studies of the Hudson River Valley, recomposing in his studio such specifically observed landscape components as the thick underbrush, the craggy mountain heights, the luminous skies of infinite extension, the particularities of individual trees into which Cole, like Friedrich, so often projected human emotions. For his friends and disciples, including Asher B. Durand and Frederic Church (see pages 185–86 and 280–81), Cole left a double legacy: the exploration of the natural wonders of the New World, from the Catskill Mountains to the jungles of Central America, and the possibility of interpreting these empirical data as grave, even religious speculations on the role of man within the overwhelming grandeur and antiquity of a primordial landscape.

The exotic fauna of America, from the strange creatures—turkeys, iguanas, loggerhead turtles, first recorded

Fig. 145 **Thomas Cole**, *Daniel Boone and His Cabin at Great Osage Lake*, 1826. Oil on canvas, 38 × 42½". Mead Art Museum, Amherst College, Massachusetts.

by sixteenth-century expeditionary draftsmen—to the indigenous bison, whose rapidly dwindling herds so often symbolized for nineteenth-century painters the tragic destruction of American nature by the hand of man, could also inspire art that might be documentary, imaginative, or both. This fusion of science, art, and poetry is distilled in the work of John James Audubon (1785–1851), which, like that of George Stubbs (see pages 50–51), might be claimed simultaneously for both the history of zoology and the history of Romantic art. Audubon's most overwhelming achievement was his *Birds of America*, the fruit of a bird-watcher's firsthand observation of some 489 indigenous species. Audubon's goal was "to copy [nature] in her own way, alive and moving," so that the 435 hand-colored aquatint plates in the double-elephant folio that appeared in eighty-seven parts between 1827 and 1838 have the look not of the stuffed specimens he drew from but of an explorer's on-the-spot glimpse into a fabulous world unspoiled by human intervention. In *Barn Owl* of 1833 (fig. 146), a print based on the watercolor made the year before in New Jersey, he offers a silhouetted pattern whose linear clarity and exquisite descriptive detail support his probably spurious claim that, before leaving France for the States in 1803, he had studied drawing with David. But this

Fig. 146 **John James Audubon**, *Barn Owl* (from *The Birds of America*), 1833. Aquatint engraving, page size 39½ × 26½" before trimming. Library of Congress, Washington, D.C.

technical and aesthetic mastery also serves both ornithological education and an exploration of Romantic terror not far from such grim British animal fantasies as those by Reinagle (see fig. 38). Instructively displaying both the inside and outside of one spread wing, these two eerie night creatures are disputing their prey, a ground squirrel which has been carried to such dizzying heights that the panoramic landscape added to the original watercolor offers literally a bird's-eye view. The head-on confrontation with these owls, perched on leafless branches in a non-terrestrial world, is typical of that Romantic sense of scale which, rejecting human size and experience (here, even gravity) as a measure of all things, obliges the spectator to empathize fully with these strange phenomena of nature. Like Stubbs's monkey (see fig. 37), Audubon's owls can return our gaze, reminding us once again that nature has many mysteries that transcend man's understanding.

From History Painting to Biedermeier

The sense that a painting could far transcend prosaic fact, whether in its disclosure of latent mysteries in nature, of uncommon heroism in the deeds of men and women, or of an aesthetic realm remote from ordinary perception, dominated the work of the most ambitious artists who matured before 1830. But following that date, many prominent painters turned the poetics of earlier generations into a hard prose style that clung doggedly to a description of the material world. In France, one of the most successful artists to reflect this new orientation was Paul Delaroche (1797–1856), who, no less than Ingres and Delacroix, selected subjects from history, religion, and literature, but who, in works like *The Execution of Lady Jane Grey* (fig. 147), one of the great showstoppers of the Salon of 1834, drastically altered the look of these venerable stories.

Fig. 147 **Paul Delaroche**, *The Execution of Lady Jane Grey*, Salon of 1834. Oil on canvas, 8′ 1″ × 9′ 9″. National Gallery, London.

Continuing the vogue for themes culled from British history and literature, and exploring theatrical extremes of pity and terror, Delaroche has chosen a drama that could recall many comparable events in recent French history—bloody executions, religious conflict, and the usurpation of a throne. The scene depicts the Tower of London on February 12, 1554, at the moment of the beheading of the sixteen-year-old Jane Grey, who, caught in a web of power politics, reigned as Protestant queen for only nine days, was imprisoned by her Catholic enemy and successor, Queen Mary, and was then condemned to death. Delaroche fully exploits here the heart-rending range of responses to the blindfolded martyr, who, pathetic in the pure and pallid whiteness of her flesh and robe, reaches in confusion toward the executioner's block; and he underlines in every detail of Romanesque architecture and Tudor portraiture and costume his painstaking research. This emphasis on lucid stage rhetoric and historical accuracy may recall Davidian traditions, but what is unfamiliar is the overwhelming proportion of material fact to an ideal order. The painting seems, if possible, to have no style at all,

presenting the immediate illusion of a theatrical tableau enacted by costumed players in a crystal-clear space. Even the colors seem chosen not for the ends of an artful pictorial harmony but rather as the neutral, utilitarian means of rendering more literal the meticulous replication of the almost palpable surfaces of satin, fur, metal, hair, wood. Indeed, the sense of unaltered, unidealized reality is so intense here that, as Théophile Gautier observed, more than one spectator was tempted to pluck a blade of the straw intended to soak up the victim's blood.

In such a work, an analogy with the impersonal, objective data recorded by the photograph is inevitable; and it is telling that Delaroche brought to maturity this seemingly mechanical, brushless style of painting in the same decade, the 1830s, that witnessed the first inventions of photography and culminated in the public presentation of the daguerreotype in 1839. Delaroche, in fact, officially proclaimed in that year that photography could be an enormous aid to the painter by providing a dependably exact facsimile of reality. But the quasi-photographic style of Delaroche's painting is not to be construed as reflecting

Fig. 148 **Horace Vernet**, *Arab Chiefs Telling a Tale*, Salon of 1834. Oil on canvas, 39 × 54½". Musée Condé, Chantilly.

photography (which it actually precedes) but rather as a parallel manifestation in art of the direction of the 1830s toward an empirical vision that insisted on nothing but the literal truth, a reliance on the material world divested of the fancy rhetoric of art and imagination.

In France, Delaroche's position was referred to as the *juste milieu*, that is, a "golden mean" or sensible balance between the extremes of, in this case, the overly passionate "Romantiques" and the coolly abstract "Classiques." It was the middle-of-the-road view that not only reflected many of the compromises of the government of Louis-Philippe, who essayed a monarchy for the ever more powerful bourgeoisie, but that suited the taste of the rapidly growing throngs of Salon-goers who were still fascinated by the remote subjects of the schools of Ingres and Delacroix but who preferred to these artful styles a straightforward demonstration of the painter's skill at duplicating, as if in a two-dimensional waxwork, the tangible stuff of the real world.

The same may be said of the work of Horace Vernet (1789–1863), another popular master of the *juste milieu*. Like Delacroix, he visited Algeria, where, in 1833, he witnessed not only the French army's continuing efforts to occupy the country but also glimpsed an exotic civilization that would intrigue any Western tourist. His record of *Arab Chiefs Telling a Tale* (**fig. 148**) is a documentary statement of fact, especially vis-à-vis Delacroix's *Women of Algiers*, shown at the same Salon of 1834 (see fig. 129). The heat generated by Delacroix's molten brushwork and languorous odalisques has been cooled off to the descriptive language of a Baedeker. Everything from the dry landscape and picturesque domes to the burnooses and Arab horses has been accounted for in a painting that, like *The Execution of Lady Jane Grey*, remains as neutral as the camera eye. Neither the artist's hand nor feelings appear to intrude upon the task of reconstructing for home consumption this tourist souvenir of Arab life.

Such reconstructions could be made for any kind of subject, grave or trivial, historical or contemporary; and, from 1830 on, this sense of a painting being manufactured rather than hand-made dominated the look of the many canvases produced by the old and new academies whose ranks of masters and students swelled with the century's population growth. A parallel to Delaroche and Vernet may be seen, for instance, in the work of one of the most successful German painters of that generation, Carl Friedrich Lessing (1808–80), a leading figure of the Düsseldorf School, which until 1870 rivaled Paris in attracting students of painting all the way from Russia and the United States. In his *Hussite Sermon* of 1836 (**fig. 149**), the first of a series illustrating the life of Jan Hus, the Bohemian reformer burned as a heretic in 1415, Lessing re-creates in paint a historical episode that could well be reinterpreted in terms of modern problems. Here the scene takes us to the years following Hus's martyrdom, when his disciples

continued to fight for sacred and secular reforms within the Catholic church, and for the abolition of the feudal system in favor of a society without class or property. Like St. John the Baptist, the Hussite preacher seems to stir a new faith in the worshipful flock gathered about him, a faith that offered medieval remedies for the many German problems of state, church, and economy that preceded the 1848 Revolution. But this fervent page from a religious war is presented in the neutral manner of Delaroche and Vernet, in which the bark of the trees, the gleam of the metal chalice, the smoke rising from the burning cloisters behind, and the late medieval costume resemble a cinematic reincarnation of the event. Unlike the Nazarenes' reconstructions of Germanic history (see fig. 67), Lessing's makes no effort to evoke visually the archaizing simplicity of a style appropriate to the late Middle Ages. Here, the pervasive literalism of surface detail, the consistent display of that systematized knowledge of perspective, anatomy, and chiaroscuro propagated by the nineteenth-century academies offer no deception about the painting's date.

The collision between the ideal, authoritarian image of history and the materialist vision of many nineteenth-century artists is nowhere demonstrated more amply than in Delaroche's semicircular wall painting *Artists of All Ages* (**fig. 150**), commissioned in 1836, for the hemicycle in the very seat of the Paris art establishment, the École des Beaux-Arts. Completed in 1841, it still presides over the august amphitheater where, appropriate to its theme, annual prizes were distributed to the best students, who aspired someday to join the pantheon of artist-deities assembled on these walls. Elevated in the center like a tribunal, the immobile paragons of classical Greek architecture, painting, and sculpture—Ictinus, Apelles, and Phidias—sit facing us in a daunting, judgmental confrontation. Below, to their left and right, are paired female personifications of the four great periods of art history—Greek, Roman, Gothic, and Renaissance; and in front of them is a sleekly idealized personification of Glory, bearing laurel wreaths. But the main cast in this Olympian pageant is Delaroche's own selection of sixty-six postclassical painters, sculptors, and architects who range from the thirteenth to the nineteenth centuries, from Robert de Luzarches and Cimabue to Velázquez and Puget, a Hall of Fame which, unlike earlier pantheons in Western art, includes—relevant to the location—only artists rather than all venerable geniuses of literature, music, philosophy, science. In abrupt contrast to the abstract and otherworldly septet in the middle, who seem to reign for eternity in frozen symmetry, this encyclopedic anthology, with a stately Ionic colonnade for a backdrop, is surprisingly earthbound. For all the elegance of their posture and remoteness of their historical dress, the figures resemble contemporary actors at a costume ball caught in the most casual, oblique groupings as they chat, turn, and gesture.

Fig. 149 **Carl Friedrich Lessing**, *Hussite Sermon*, 1836. Oil on canvas, 7′ 8″ × 9′ 8″. Nationalgalerie, Staatliche Museen Preussischer Kulturbesitz, West Berlin (on extended loan to the Kunstmuseum, Düsseldorf).

Fig. 150 **Paul Delaroche**, *Artists of All Ages*, 1836–41. Encaustic, 12′ 9″ × 82′. Hemicycle, École des Beaux-Arts, Paris.

The truth to commonplace fact that dominates these historical worthies (as opposed to the chilling idealism of the classical authorities in dead center) provoked the Romantic sculptor David d'Angers (see pages 211–14) to comment that this was a "scholarly genre painting," a description that might well apply not only to many later assemblies of historical figures for public places but to the growing number of paintings that illustrated anecdotes, Vasari-like, from the lives of famous artists and other historical personages.

When Delaroche painted, say, Michelangelo and Titian in this pictorial dictionary of artists, he was sure to get the details of costumes and physiognomy right, yet he painted them not in the *styles* of Michelangelo and Titian but rather in his own impersonal, documentary manner. But other painters wished to make learned replicas—some would say counterfeits—of the styles as well as the events and characters of the past. Already in the late eighteenth and early nineteenth centuries, painters like West, David, Ingres, Turner could effectively re-create, when appropriate to their various subjects, the different looks of Rubens, Roman relief sculpture, Claude Lorrain, or the Flemish primitives, but this skill in replicating art-historical styles accelerated rapidly by mid-century, much as nineteenth-century architects grew ever more erudite in their expanding repertories of both Western and non-Western styles. Often, this art-historical self-consciousness was linked to the intensifying nationalism of the post-Napoleonic years, which could push painters to a zealous revival of the great styles of their own country's heritage. As early as 1815, Olivier's *Holy Alliance* (see fig. 106) imitated stylistically a German late medieval painting, an evocation consonant with its subject's anti-Napoleonic plea for a medieval unity of the church and state authorities, and such examples would multiply throughout Europe. Thus, in the Low Countries, the definitive split of Belgium and Holland after the Revolution of 1830 fomented an intense new awareness of each nation's artistic and historical traditions. By the 1840s, Dutch artists could make virtual facsimiles of work by their seventeenth-century ancestors. Looking at the *Choir of the Church of Our Lady in Breda* (fig. 151) by Johannes Bosboom (1817–91), the modern connoisseur might have more than a moment's pause about the painting's actual date, 1843. For in addition to providing seventeenth-century period costume for the Dutch burghers who have come to their Gothic church choir to pay their respects to the famous early sixteenth-century Italian tomb of Count Engelbert II of Nassau (a Dutch statesman under Emperor Maximilian), Bosboom precisely imitates the style of such seventeenth-century Dutch painters of architectural interiors as Saenredam and De Witte, who specialized in immaculately detailed oblique views rendered in miniaturist scale. Even in so small and unpretentious a painting, the grandeur of centuries of Dutch history and art history resonates.

On the other side of the border, in Belgium, where official art after the Restoration had been dominated by the Neoclassic mode of the French exile David, it was Rubens who offered a stylistic alternative of new patriotic inflections. Already in Wappers's record of the Belgian revolution (see fig. 128), the ghost of Rubens is visible, but it was to be fleshed out in far more passionate and megalomaniac terms by the eccentric Antoine Wiertz (1806–65), who, in 1841, published a fervent eulogy for his seventeenth-century compatriot. Although many of Wiertz's paintings reflect a macabre taste for gory, near-demented fantasy (premature burial, infanticide, cannibalism, guillotined heads, suicide, human torches), he also made huge paintings intended for a wider public, hoping that these would resurrect in style and subject, whether classical or Christian, the overpowering heritage of Rubens. In 1845, after exhibiting an immense *Patroclus* at the Brussels Salon, he took over a studio in a vacant factory and there worked for three years on the wildly ambitious *Triumph of Christ* (fig. 152), completed in time for the Salon of 1848. Anachronistic in both its Counter-Reformation religious message and its duplication of Rubens's heaven-and-hell visions of airborne angels and devils, it is nevertheless propelled by the febrile energy of its nineteenth-century

Fig. 151 **Johannes Bosboom**, *Choir of the Church of Our Lady in Breda with Tomb of Engelbert II of Nassau*, 1843. Oil on panel, 34¼ × 27⅛". Rijksmuseum, Amsterdam.

Fig. 152 **Antoine Wiertz**, *Triumph of Christ*, 1845–48. Oil on canvas, 20′ 9¼″ × 36′ 9½″. Wiertz Museum, Koninklijke Musea voor Schone Kunsten/Musées Royaux des Beaux-Arts, Brussels.

creator, who wished to materialize on canvas his optimistic belief that the luminous spiritual force of Catholicism could vanquish the thunderous swarms of demons led by a fleshy Lucifer, who, though fleeing, still dares to return Christ's incorporeal gaze. For many spectators and governments in 1848, when the Antichrist might be thought to have arrived via the *Communist Manifesto* and the snowballing revolutions, Wiertz's gargantuan spectacle— the canvas is almost thirty-seven feet wide—was a retrospective dream fulfilled. Despite the difficulty of access— the painting had to be exhibited separately in the factory-studio—crowds and critics came and praised it, and both the Russian and Prussian governments proposed enormous sums to buy it for propagandistic home use. Wiertz, however, refused to part with it, keeping it in his new, state-provided Brussels studio, where, together with other products of his bizarre and turbulent imagination, it may still be seen.

The artists of the international revival of Christian art in the mid-nineteenth century could look back to many venerable sources. For a Belgian like Wiertz, it was Rubens who best conveyed the conflict between airborne spirit and corporeal substance; for an Italian like Tommaso Minardi (1787–1871), however, such aesthetic and moral beauty could be found on equally nationalist soil in the work of the ever-revered Raphael. There had already been many foreign artists in Italy, including the Nazarenes and Ingres,

who in the first quarter of the century had worshiped at the shrine of the young Raphael. But for Minardi and for his Italian colleagues, such a revival also had nationalist implications, rekindling the great traditions of Italian art that, for many nineteenth-century spectators, had seemed dormant since the death of Raphael. Minardi's pious devotional image of 1840, *The Rosary around the Neck of the Lamb* (**fig. 153**), distills familiar Christian symbols to a would-be purity of statement and feeling, matched by the choice of the clearest compositional harmonies from Leonardo's and the young Raphael's variations upon the theme of the Madonna and Child with St. John. If anything, Minardi would push Raphael's sweetly lucid forms to an even greater simplicity, regressing to a more archaic moment. Like many of his contemporaries, he sought out the earliest, presumably least corrupt phases of the evolution of Italian art as the wellspring of aesthetic and religious purity. It was a viewpoint that, in Italy, was summed up in the *Manifesto del Purismo*, published by Antonio Bianchini in 1843, and signed by Minardi, an Italian sculptor Pietro Tenerani, and the Nazarene Overbeck. In its belief that art could be regenerated by rejecting the sophisticated illusionism and chiaroscuro techniques of later, decadent Western styles in favor of something simple, clean, and honest, *Purismo* belonged to a continuous tradition of nineteenth-century art and theory that hoped to unload what to many felt like the decadent burden of post-Renaissance art.

Fig. 153 **Tommaso Minardi**, *The Rosary around the Neck of the Lamb*, 1840. Oil on canvas, 43¼ × 32¾″. Galleria Nazionale d'Arte Moderna, Rome.

These venerable and, to modern eyes, often poignantly naïve roots of the great Italian tradition continued to appeal not only to native Italians but to countless foreign artists who would foster the resurrection of Christian art. For a devout Scotsman like William Dyce (1806–64), concerned with the revival not only of art but of music for the Anglican High Church, it was again the style of early Raphael that conjured up the most authentic expression of faith in the image of the Madonna and Child, an icon that, in the nineteenth century, often seemed an anthropological relic of another civilization. During his second visit to Italy in 1827, Dyce became acquainted with the Nazarenes in Rome and began to paint simple devotional images that he hoped would breathe new life into a lost world where art and faith were one, a goal that would be understood in England in the 1830s and 1840s by zealous religious reformers like Cardinal Newman, who led the Oxford Movement, or by Augustus Welby Pugin, who felt that the beauty of Gothic architecture reflected the moral probity of an integrated Christian society. In Dyce's *Madonna and Child* of 1838 (**fig. 154**), the imprint of the Raphael *Tempi Madonna* he had seen the year before in Munich is clear; but, as in Minardi's Raphaelesque painting, the direction is

toward an even greater simplicity, evidenced in the stiff profiling of the Madonna and the stark silhouetting of the figures against the limpid sky and landscape. Active as well in the revival of the fresco techniques of the early Italian masters, Dyce was involved in the 1840s in commissions for the mural decorations of major London civic buildings like the new Houses of Parliament, where British history and literature provided the appropriately nationalistic subject matter.

It was almost a predictable irony that in the very years— 1830 to 1848—that witnessed the rapid growth of the most miserable new realities of ninteenth-century life, whether the city slums or the hellish conditions of factory workers, the appeal of a remote artistic and religious past would take on increasing official sanction. During these decades, there was, in fact, a virtual revival of mural commissions that, like Delaroche's *Artists of All Ages* (see fig. 150), could remind nineteenth-century audiences of the authority of the past and, by hopeful implication, could avoid the threats of the present. In particular, mural paintings flourished throughout European churches, in both a Romanesque building like Paris's St.-Germain-des-Prés and a neo-Romanesque one like Munich's Ludwigskirche.

Fig. 154 **William Dyce**, *Madonna and Child*, 1838. Oil on plaster, 29¾ × 20½". Castle Museum, Nottingham.

In the former, Hippolyte-Jean Flandrin (1809–64), a devoted pupil and disciple of Ingres, began, in 1842, a series of frescoes that imitated not only the techniques of the Italian primitives but even their style and iconographic programs, in which Old and New Testament subjects were paralleled. A winner of the Prix de Rome in 1832, Flandrin found the Nazarenes inspiring models for his neo-Catholic pictorial goals, which often regressed far beyond early Raphael to a style that recalled Giotto or even Byzantine art. In the *Entry of Christ into Jerusalem* (**fig. 155**), there seems a confusion of tongues and centuries. The fairy-tale simplicity of the composition, with its leveled tiers of heads and bodies lined up in stiff, repetitive patterns; the gold background behind the building; the flat halo against which Christ's head is profiled—such devices would evoke the dawn of Christian fresco painting and mosaic, whereas the literal, palpable details of clothing, anatomy, physiognomy reveal the sophisticated illusionism and materialist viewpoint of official nineteenth-century art. The oil-and-water mixture of past and present resembles a

photograph of modern people acting out the naïve pageantry of a Giottoesque fresco, and pinpoints the precarious balance that threatened so many nineteenth-century commissions for official mural decorations in both sacred and secular places.

That same conflict may be sensed in the enormous fresco—more than sixty feet high—by Peter Cornelius (1783–1867) of the *Last Judgment* (1836–40; **fig. 156**), in the choir of the new Ludwigskirche, part of the vast building campaign launched in Munich by Ludwig I of Bavaria. Appropriate to the medieval revival style of the church (by Friedrich von Gärtner), this hieratic image of eternal salvation or damnation would rush us centuries backward to the mural permanence of a Christian art that, as resurrected in the 1830s, might also herald, in Cornelius's phrase, the "church of the future." Cornelius's mastery of the fresco medium was long in the making, first through his close association with the Nazarenes in their Roman fresco commissions and then through his work on the decorations for Munich's Neoclassic Glyptothek; and his faith in the art of

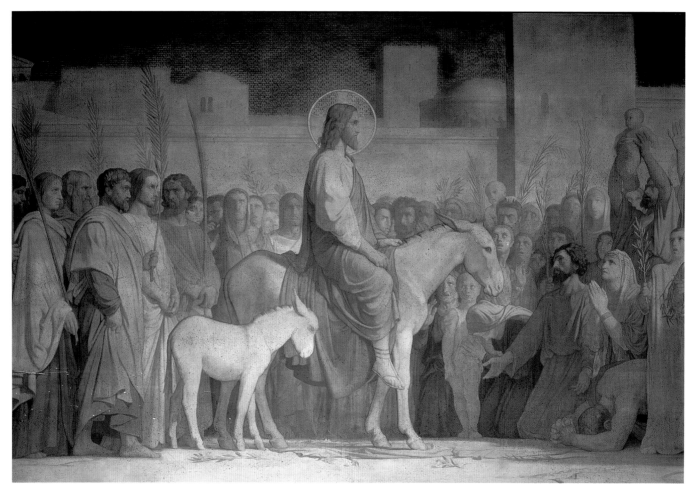

Fig. 155 **Hippolyte-Jean Flandrin**, *Entry of Christ into Jerusalem*, 1846. Fresco. St.-Germain-des-Prés, Paris.

the past was enforced by his position as director of first the Düsseldorf, and then the Munich, academies. Here he instantly recalls Michelangelo's *Last Judgment* in the Sistine Chapel, but at closer view, the style moves chronologically backward to the dry but agitated linearity of Dürer's apocalyptic visions and to the tiered structure and doll-like stiffness of Fra Angelico's heavenly choirs. Typically for so much official nineteenth-century art that would invoke remote, timeless authority, the structure is grandly symmetrical, ascending on a vertical axis from St. Michael, who separates the saved from the damned, through St. John the Evangelist, and finally to the rigid image of Christ, who, like the governing classical judges in Delaroche's *Artists of All Ages*, seems to reign from a remote realm. As a strange anachronism in this willful reconstruction of the mural glories of another civilization, Cornelius has included—just barely visible at the lower left—none other than his monarch-patron, Ludwig I, who stands in this heavenly company in a manner that imitates the frequent inclusion of donors in late medieval and Renaissance art. It was no surprise that, in the 1840s, a critical audience more in tune with a growingly earthbound view of an art that should exist in the present tense reacted against Cornelius's

monumental achievement, nor is it a surprise that, outside Germany, especially in France, Cornelius had many admirers—not least, Ingres and Delacroix—who respected his efforts to keep the ideal traditions of art unsullied by the prosaic facts, both mundane and frightening, of nineteenth-century life.

For those artists who would resist the pressures of these new facts, the difficulties became more and more evident, and often involved the invention of private allegories within the public domain of official art. One of the great successes of the Paris Salon of 1843 was the large painting titled *Evening* (and soon subtitled *Lost Illusions*) by the Swiss-born Charles Gleyre (1808–74; **fig. 157**), a work whose lacquered, quasi-photographic style recalls Delaroche (whose studio Gleyre took over that very year). But the bizarre components—a dejected old man, a radiant Nile sunset, an ancient Egyptian ship with classical passengers—yield a private, unreal environment that permits the spectator to daydream in the faraway realm of the subtitle's lost illusions. The characters and motifs are, in fact, culled from a repertory of traditional sources—the shipload of women is to be associated with the Parnassian muses; the melancholy man on the wharf, his lyre cast aside, refers to the

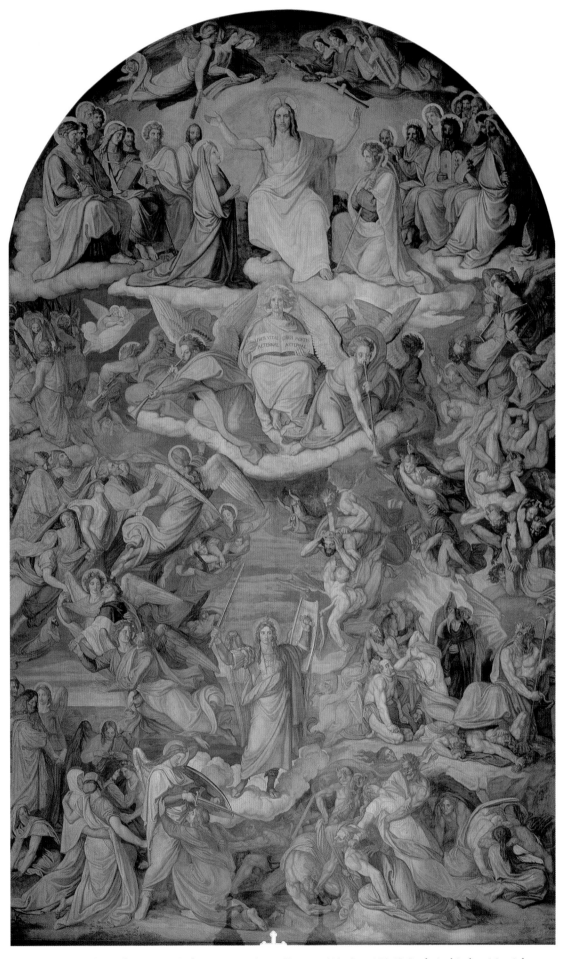

Fig. 156 **Peter Cornelius**, *Last Judgment*, 1836–40. Fresco, 60′ 5″ × 37′ 3″. Ludwigskirche, Munich.

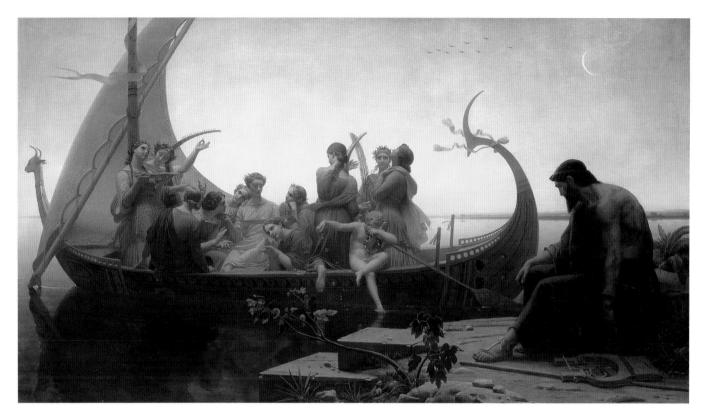

Fig. 157 **Charles Gleyre**, *Evening (Lost Illusions)*, Salon of 1843. Oil on canvas, 62½ × 95¼". Louvre, Paris.

blind bard Thamyris from Homer's *Iliad*; and the departing ship as an allegory of the voyage of life is a familiar symbol. But these disparate themes create an introverted, cryptic mood that almost functions as emotional autobiography. Indeed, the painting has been explained as a series of evocative metaphors that allude to the disappointment of Gleyre's own public and private life. (His vision, for example, had been gravely impaired during a trip to Egypt and the Near East with a patron from Boston; and the ship of muses speaks for the artist's unattainable aesthetic ambitions.) In earlier Romantic art, such as James Barry's self-portrait (see fig. 44), erudite classical themes might also be fused with intensely personal references, but here, the large official dimensions and impersonal style are surprising vehicles for goals of emotional self-disclosure. Although Gleyre's gloomy meditation on the transience of art and life may seem a last gasp of the Romantic spirit, it can also be looked at as prophetic of the haunting mysteries of late nineteenth-century Symbolism. More unexpectedly, Gleyre, as a teacher who underlined the importance of broadly painted, preliminary sketches, left his stamp on a group of younger pupils—Monet, Renoir, Bazille, and Sisley. These Impressionists-to-be were ironically to use their master's recommendation of rapid sketches not as a means to the polished, finished ends of official Salon painting, but as ends in themselves that might convey those immediate experiences of the here and now which Gleyre had banned from his repertory of timeless, ideal subject matter.

Another great Salon success of the 1840s, the *Romans of the Decadence* (**fig. 158**), by Thomas Couture (1815–79), also attempted, though less moodily than Gleyre's *Evening*, to uphold venerable traditions and evoke a hazy range of solemn thoughts. Approaching the imposing dimensions of Wiertz's contemporaneous *Triumph of Christ* (see fig. 152), it preaches a moral lesson while simultaneously depicting an unbuttoned display of sexual and alcoholic license that translates the sensuality of Ingres's and Delacroix's harems into the high-minded language of classical history and Renaissance art. Accompanied in the 1847 Salon catalogue by a quotation from Juvenal that comments on how it was not war that sapped the strength of ancient Rome but rather the vice that was later cultivated in years of peace, Couture's huge canvas (more than twenty-five feet wide) had the appeal of both a weighty philosophical statement and a rich succession of easy references to hallowed masterpieces of painting. Built upon the stable architectural foundations of grandiose symmetry, so familiar to the official art of the mid-nineteenth century, it seems to fuse the worlds of both Raphael's *School of Athens* and Veronese's *Marriage at Cana*, polar opposites in the Renaissance tradition that might represent intellect versus passion, line versus color—in short, the kind of theoretical contrast that forced Ingres and Delacroix into the leaderships of enemy camps. Here, the infiltration of Venetian warmth and sensuality into a Raphaelesque structure almost evokes in itself the feeling that an orgiastic decadence has corrupted

a once noble Roman world. To amplify this generalized sermon on virtue versus vice, Couture has inserted among the columns a sculpture gallery of Roman ancestral figures, with Germanicus in the middle. Like marble ghosts, they chillingly recall the moral probity of the Roman past and, in the case of the statue at the right, even seem to refuse a cup of wine proffered by a living, vice-ridden Roman. Moreover, at the extreme right, a pair of observers, identifiable as members of the alien Germanic civilization that will conquer Rome, seem to be pondering, along with the Salon spectator, this sad decline. With such broad symbolic contrasts, the *Romans of the Decadence*, like *The Raft of the Medusa*, was easily subjected to many metaphorical speculations in which the themes of Latin versus Germanic cultures, contemporary decadence versus ancient uprightness could be freely interpreted in a nineteenth-century context. After the 1848 Revolution, Couture himself would turn to subjects from modern French history, but the sheer size and persistent idealism of the *Romans of the Decadence* gave it an establishment position against which younger generations would have to take a stance. Couture's own French and foreign students could either pursue his official goals, as did Puvis de Chavannes and Feuerbach (see figs. 257 and 258), or reject them, as did Manet. As for the most ambitious and radical artist to emerge after the 1848 Revolution, Gustave Courbet, the *Romans of the Decadence*,

exhibited in 1847 on the eve of the deluge, must have represented the last major fortress to be attacked in his new war of Realism versus Idealism. When, at the Salon of 1850, he exhibited his *Burial at Ornans* (see fig. 228), a vast canvas committed to the coarse but true image of country life in the nineteenth century, he hoped to bury as well what seemed to many the false premises of Couture's monumental tribute to tradition.

The undermining of idealist traditions was by no means so abrupt as the collision of Couture and Courbet before and after 1848 might suggest. Already in the 1830s, Vernet, Lessing, and Delaroche (see figs. 148–50) could present historical, religious, or exotic subjects in a style that seemed more appropriate to photographic documentation than to the lofty abstractions of pure art. Such deflations of the ideal and the pompous accelerated in the 1830s and 1840s, offering a counterpart to the growing power of the middle classes throughout the West. Whether in Jacksonian America, in England after the Reform Bill of 1832, or in France under Louis-Philippe, new reflections of the ordinary, the workaday, the comfortable could be felt. Coined in Germany, the term Biedermeier (originally the name of vulgar lampoon characters in a Munich periodical) has come to refer to a middle-class outlook that pervaded all the arts of the Western world. Vienna, during the age of Metternich, was a perfect mirror of this social

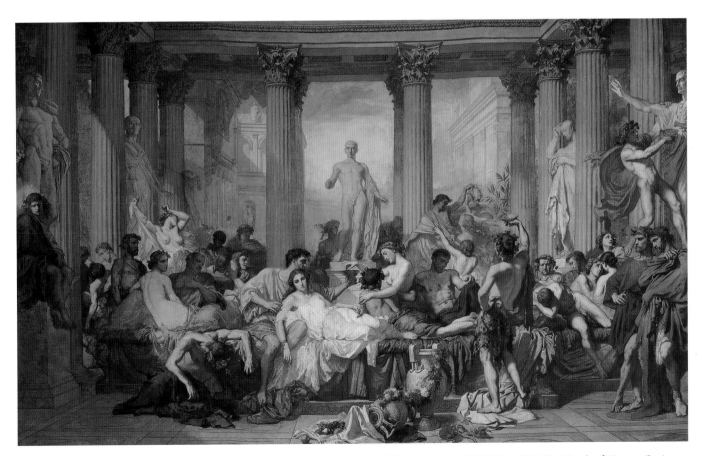

Fig. 158 **Thomas Couture**, *Romans of the Decadence*, Salon of 1847. Oil on canvas, 15′ 6½″ × 25′ 10″. Musée d'Orsay, Paris.

transformation, where an old aristocratic order crumbled and a more cozy, earthbound world replaced it. The state portrait of the first emperor of Austria, Franz I (and, as Franz II, last of the Holy Roman emperors), speaks volumes (**fig. 159**). Painted in 1832 by Vienna's most acclaimed portraitist, Friedrich von Amerling (1803–87), it pinpoints a frightening last gasp of a royal tradition even more moribund that in Paulin Guérin's portrait of Louis XVIII (see fig. 107). Having studied with Sir Thomas Lawrence (see fig. 43) in England, Amerling learned to master the bravura brushwork associated with aristocratic portraiture, but the crown, robes, and scepter here seem a desperate masquerade imposed upon the all-too-mortal and feeble reality of a sixty-four-year-old man painfully at odds with the material trappings of his imperial inheritance. Seldom after Goya was the conflict between monarchy and the modern world so poignantly mirrored.

At exactly the same time, another Viennese painter, Johann Peter Krafft (1780–1856), was depicting Franz I in completely different circumstances that locate us squarely in the Biedermeier culture of the 1830s. For the imperial

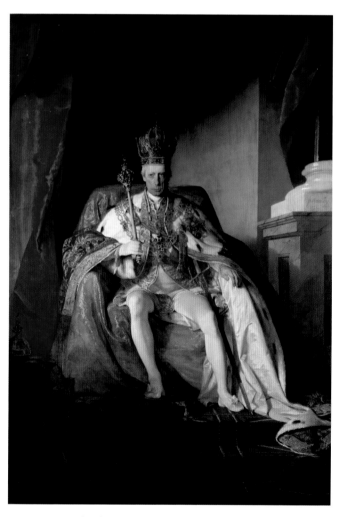

Fig. 159 **Friedrich von Amerling**, *Portrait of Emperor Franz I*, 1832. Oil on canvas, 8′ 8″ × 5′ 5½″. Hofburg, Vienna (on loan from the Kunsthistorisches Museum, Vienna).

chancellery, Krafft painted between 1828 and 1833 three huge murals illustrating worldly scenes from the emperor's life. In one of these (**fig. 160**), we see Franz I emerging in horse and carriage from the Hofburg (the royal residence) after a serious illness. Almost lost against the vista of the noble, ground-hugging Doric gateway (by the Neoclassic architect Peter von Nobile), the emperor is reduced to mortal dimensions. To see him, we must join the enthusiastic crowd of prancing dogs and middle-class spectators in their Sunday best, a crowd described inch by inch with the glossy, mechanical accuracy so typical of most official painting of the period.

Such earthbound representations of a nineteenth-century monarch became standard fare in the 1830s and 1840s, when the growing pressures of the lower and middle classes demanded a more accessible and realistic image of their countries' rulers. In England, the young Queen Victoria could still be represented in such traditional roles as a luminous, saintly creature at her coronation of 1837 or as the living heiress to the costumes of a royal medieval ancestor like Queen Philippa. But after her marriage to her cousin Prince Albert in 1840, she was ready to assume, for pictorial posterity, the posture of benevolent wife and mother, which image was recorded by Sir Edwin Landseer (1802–73), one of the most successful painters of the age. His *Windsor Castle in Modern Times*, completed in 1845 (**fig. 161**), shows Victoria in a role happily subservient not only to the seated Albert, next to whom she stands with head bowed, but to the Princess Royal and even a family of adorable and adoring dogs. This coziness is given a more manly dimension appropriate to Albert, who has brought back from the hunt both his boots, which he still wears, and an assortment of dead game birds, as immaculate as the carpet and furniture over which they are strewn for display. Through the window of the Green Drawing Room, one can just make out Victoria's mother, the Duchess of Kent, in her bath chair. In this happy, well-regulated world, all is family, sunshine, and good sport, arranged in a casual but polished and dustless order.

That same sense of tidiness, earthbound harmonies, and Sunday leisure pervaded many paintings of the 1830s that freshly documented the agreeable and often wondrous new facts of urban life which accommodated the rapid growth of city populations. One of the most arresting of such new pedestrian pleasures was an immense granite bowl that the Neoclassic architect Schinkel first planned to place inside his own brand-new art museum in Berlin in homage to the huge porphyry bowl from Nero's house in the Vatican Museum collection. His patron, King Friedrich Wilhelm III of Prussia, finally decided to locate this bowl outdoors in a pleasure garden framed by the museum, the Old Cathedral, and the City Palace; and in 1831, in a tour de force of modern engineering, it was set down on a high base for all Berliners to marvel at. It was a painter specializing in optics

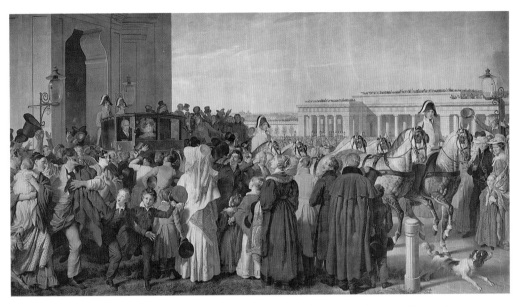

Fig. 160 **Johann Peter Krafft**, *Emperor Franz I Driving Out after a Serious Illness*, 1833.
Oil on canvas, 12′ 2″ × 19′ 7″. Audience Hall, Imperial Chancellery, Hofburg, Vienna.

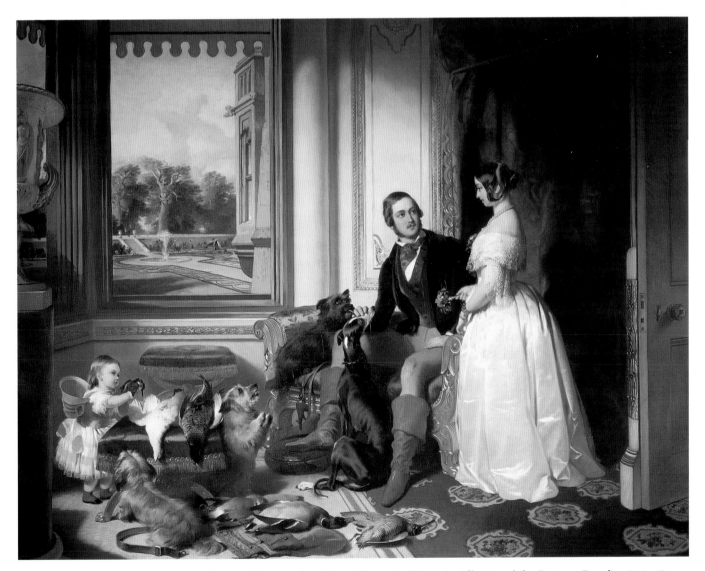

Fig. 161 **Sir Edwin Landseer**, *Windsor Castle in Modern Times (Portrait of Victoria, Albert, and the Princess Royal)*, 1841–45.
Oil on canvas, 44⅝ × 56⅞″. The Royal Collection, St. James's Palace, London.

Fig. 162 **Johann Erdmann Hummel**, *The Granite Bowl in the Lustgarten, Berlin*, 1832. Oil on canvas, 26½ × 35½".
Nationalgalerie, Berlin.

and perspective, Johann Erdmann Hummel (1769–1852), who recorded this urban wonder just after its installation (fig. 162). Belying its daunting weight, this gleaming pink-and-gray granite marvel appears as the most immaterial, highly polished surface, mirroring upside down and with bizarre optical distortions a 360-degree view of the immaculate cityscape around it. This spectacular equivalent of the popular dioramas and panoramas of the day is painted by Hummel with the precision of a lens grinder and an architectural draftsman at his trade, creating a world of pristine clarity where a magnifying glass can discern ever more minuscule details. The figures themselves (which include the king's building director, Cantian, at the left, and the artist's own two sons with an older female cousin, at the right) are casually distributed with the to-and-fro movements of well-heeled city folk enjoying a stroll in a public garden on a blue-skied day. But Hummel's miniaturist technique freezes them in their tracks in a way that, together with the bowl's strange reflections, inadvertently appeals to post-Surrealist eyes. Nevertheless, it is fact, not fantasy that dominates Hummel's vision, though the facts have the

utopian, drawing-board look of a new, middle-class dream of urban order and pleasure—not to mention hygiene.

Landscape no less than monarchs and townspeople was subject to this vision of cleanliness, informality, and comfort, and even the Alps, which for earlier painters like Wolf, Turner, and Friedrich had come to evoke Sublimity and overpowering destiny, could be housebroken for middle-class needs. So it is in the Alpine scenes of the Austrian Biedermeier master Ferdinand Georg Waldmüller (1793–1865), whose *View of the Halstattersee* of 1838 (fig. 163) puts one more in mind of summer vacations than of a Byronic contemplation of nature's majesties. Within a limpid, welcoming atmosphere, where the sun shines, where verdant meadows roll, and where the highest mountain peak and the nearest blade of grass are depicted with equally crystalline precision, a feeling of what in German is called *Gemütlichkeit* (a kind of agreeable coziness) prevails. In this tourist's dream of a ravishing mountain retreat that is nevertheless domesticated and accessible to the city dweller, the peasants, in pristine native costume, take their cheerful places among charmingly ramshackle cottages, as

Fig. 163 **Ferdinand Georg Waldmüller**, *View of the Halstattersee from Hütteneckalm*, 1838. Oil on canvas, 17¾ × 22¾″. Historisches Museum, Vienna.

if they were extras in a Viennese operetta. That Waldmüller's smiling mountain paradise fulfilled a common middle-class fantasy is amply borne out by the many later variations on its theme, from calendar art to *The Sound of Music*.

In genre painting as in landscape, the great Romantic themes were gradually sweetened and diluted by later generations for expanding popular consumption. Take the theme of the Voyage of Life from infancy to old age, which for such high-serious Romantic painters as Friedrich or Cole could be interpreted as a symbolic ship whose voyager is sent into transcendental waterways to reach, at last, death's port. By the 1830s, however, this imaginative theme could also be translated into more homely terms by the likes of the Irish genre painter William Mulready (1786–1863), whose *First Voyage* of 1833 (fig. 164) reduces this solemn meditation on the cycles of life to a rural game,

Fig. 164 **William Mulready**, *The First Voyage*, 1833. Oil on panel, 20½ × 25″. Bury Art Gallery, Lincolnshire.

Fig. 165 **Caspar David Friedrich**, *Woman by the Window*, 1822. Oil on canvas, 18⅜ × 14⅝″. Nationalgalerie, Berlin.

where a country boy launches a makeshift washtub-boat for his infant brother. The rustic characters and the brushy, casual landscape setting create a pleasant country ambience that shares the sunnier side of Constable's peaceful pastorals. In fact, it is only the slight inflection of anxiety in the baby's face and of deep concern in the parents' protective gestures that reminds us of the potentially grave, even religious connotations of this first human venture into the unknown.

Or take another genre theme, that of a woman by a window. For Friedrich, this seventeenth-century Dutch motif, as re-experienced by him in 1822 (**fig. 165**), could reach an unexpected peak of hushed, contemplative intensity that quickly transcended its domestic origins and aspired almost to the silent mysteries of his earlier *Monk by the Sea* (see fig. 71). Here, the juxtaposition of indoors and outdoors, of a restricting man-made world and the evocation of a hazy natural world of water and sky beyond is distilled to a statement of iconic, cruciform purity. The woman happens to be the artist's new wife, Caroline, but this biographical fact is rendered irrelevant by her posture.

Typically, Friedrich presents us with a back view that conceals the face and expression. The spectator is thereby permitted maximum empathy with this lonely contemplation of an unspecified mystery further enriched by the view of the mast of an invisible boat that prompts imaginary voyages. The shrinelike enclosure of walls and windows contributes to this abrupt and poignant contrast between near and far, between the earthbound and the imaginative in a way that again borders on the religious experience of prayer and contemplation. For a later German generation, however, that of Johann Peter Hasenclever (1810–53), a prominent member, like Lessing, of the Düsseldorf School, this Romantic genre image has become almost ludicrously explicit. In *The Sentimental Girl* of 1846 (**fig. 166**), we know all too well the mystery behind this domestic languor. In virtually a parody of the swooning feminine sensibilities that were cultivated from the late eighteenth century on, this young heroine is clearly lovesick. Pining away by the eerie light of both a candle and a Romantic full moon, and separated, like Friedrich's woman, from the outside world by a windowed wall, she is surrounded by portraits of a

CASPAR DAVID FRIEDRICH'S *WOMAN BY THE WINDOW*

When it was first exhibited at the Dresden Academy in August 1822, this picture of Caspar David Friedrich's wife Caroline (see fig. 165) was seen by one critic as being flawed for the very aspect that has made it of such interest to modern scholars:

A small picture, showing the artist's studio in its unusual simplicity, with its window offering a view of the Elbe and the poplars on the opposite bank in the center of the background, would be very true and charming if Friedrich had not once again followed his whim, namely his love of portraying people from the back. His wife stands at the window in such a pose, to some extent most unadvantageously in lighting and placement, and he repeats such figures, all of which look the same, much too often.[31]

In his recent study of the artist, Werner Hoffman has discussed the work at length, seeing it as an attempt to show how the spiritual and physical realms interpenetrate one another, and how religious symbol can be discerned even in a seemingly prosaic setting:

… Caroline has not invaded this bare room. Instead, her husband has integrated her into his holy of holies, his cell-like studio. But this is not a prison cell, as [earlier writers] believed, reading into the figure a longing for freedom and therefore interpreting the picture as representing a conflict between despair and hope. In my view, Friedrich's conception rests on the dialectics of picture and non-picture. The window plays an important role in this. … the interior frames and distances the exterior view. … all the horizontals and verticals in the room come together in the window. Its lower part is closed by wooden shutters, forming a triptych ("in disguise," as Panofsky says). The middle shutter is open, and the woman has a full view of what lies beyond, while we, the viewers, can see only a small segment: a river

with poplars and two sailing boats. We guess more than we actually see. The mast of the nearer boat extends into the upper part of the window, which is subdivided by window bars forming a cross. Such windows were often called "religious windows" in New England at that time. Why should not Friedrich, too, have spiritualized the formal analogy? … It is also conceivable that he associated the window and its shutters with a small folding altarpiece. In that case, the abstract symbol which contains and articulates the vastness of the sky would represent contrast to the lower part of the picture, which conveys empirical reality at its most transient. The woman takes an interest in what is happening outside and leans forward in a definite way, but she is standing inside the house, where the cross in the window lifts the spatial axes into a higher, dematerialized sensory region. The message in the picture appears to be the spiritual liberation which this symbol promises to those who can see it.[32]

Angelika Wesenberg recently highlighted the long tradition of such "window paintings" in northern European art, and showed how Friedrich gave his a particularly Romantic dimension:

"Window pictures" had been popular particularly in Dutch painting, and became so again in the nineteenth century. It was predominantly women who were depicted, women in their domestic environment. The juxtaposition of inside and outside, of internal and external worlds, was essential to such pictures. Generally the outside comes in, as light and movement, as life. Friedrich's *Woman at the Window* is characterised by a particularly stark opposition between the austere room and the open air. The window permits the entry of a slanting top light. Caroline looks through the open middle area of the lower window across the Elbe to the far bank lined

with poplar trees. There is traffic on the river, and we can discern the rigging of two sailing boats.

… for all the domesticity of [its] subject-matter … this work … was intended to convey a sense of yearning. Over and above the opposition between dark and light and limit and expanse, Friedrich's *Woman at the Window* expresses the soul's (Romantic) longing to escape from earthly confinement into the infinity of Nature—in a particularly impressive way. The river, the ship and the bank on the far side, for all their objective reality, are at the same time symbols, with existential and religious content.[33]

The strongly symbolic quality of these forms has been analyzed in concrete terms by Helmut Börsch-Supan:

The dark interior stands for the narrowness of the terrestrial world into which light only enters through the window, representing the opening to the supernatural world. The woman is gazing out over the river to the opposite bank which is a symbol of the life to come. The river, though not actually visible, signifies death. … The relation between [the] two masts creates a suggestion of movement across the river. The concept from antiquity of the River Styx across which Charon ferried the dead, is here reinterpreted in Christian terms. Because of the way they grow straight upwards poplars are an allusion to the Christian longing for death. Similarly, the thin cross shape formed by the glazing bars of the window is to be understood symbolically; the vertical would, if extended downwards, meet the mast of the ship in the background.[34]

Such a dialogue shows how in the Romantic era even a small, seemingly prosaic painting can contain within it a vast variety of meaning in its combination of the personal, the religious, the historical, the natural, and the transcendent.

Fig. 166 **Johann Peter Hasenclever**, *The Sentimental Girl*, 1846. Oil on canvas, 14½ × 12¼″. Kunstmuseum, Düsseldorf.

dashing hussar (on the wall to the right, and on the table behind her). And amid her still life of roses and forget-me-nots, her reading matter includes two classic German novels of Romantic passion, Goethe's *Sorrows of the Young Werther* and Clauren's *Mimili*, as well as a letter that begins: "Innigstgeliebte Fanny . . ." ("Most deeply beloved Fanny . . ."). By 1846, the intense and private longings of earlier Romantic generations could be circulated as common coin. The clash of changing generations is underscored by the fact that only two years later, in the great revolutionary year of 1848, Hasenclever represented for the first time in Western painting a scene of workers fighting for their rights before a municipal council.

The decades after 1830 abound in these popularized reinterpretations of potent Romantic themes. At the Paris Salon of 1830–31, for example, one could find an immediately tearful and appealing variation on the Romantic theme of malevolent nature and its human victims. In *A Neapolitan Woman Weeping over the Ruins of Her House* (fig. 167), by Léopold Robert (1794–1835), who was born in Switzerland, worked in Rome, and exhibited mainly in Paris, it is Vesuvius again that has taken its grim toll. But, unlike the epic scale and fearful orchestration of many Romantic paintings inspired by classical disaster victims at Pompeii and Herculaneum or by modern victims at Chios and Missolonghi, Robert's canvas, for all its miseries, is tamed for tourist consumption. Like a modern Madonna, this grieving Neapolitan, alone with her *bambino*, is left with only a cross for consolation. Framed by a ravishing

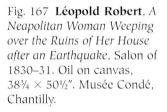

Fig. 167 **Léopold Robert**, *A Neapolitan Woman Weeping over the Ruins of Her House after an Earthquake*, Salon of 1830–31. Oil on canvas, 38¾ × 50½″. Musée Condé, Chantilly.

vista that includes a still smoking Vesuvius, she offers a bit of mournful local color to the foreign spectator who, up in Paris, could pity her affliction, but also enjoy the view, the folkloric costume, and the untroubled naïveté of a peasant's Christian faith.

Empirical Directions

For many artists between 1815 and 1848, the overtly Romantic rhetoric of such paintings as Robert's was an irrelevance. They might also paint foreign landscapes and picturesquely costumed peasants, but they would do so with a directness and modesty that avoided the theatrical in terms of the drama of nature or man. Already in the late eighteenth century a painter like Thomas Jones could record the plain facts of a Neapolitan window view as if he had never heard of Vesuvius (see fig. 62), and this quiet tradition was maintained, especially by Northern artists, well into the mid-nineteenth century. An unpretentious case in point stems from the Roman sojourn (1813–16) of a Danish painter, Christoffer Wilhelm Eckersberg (1783–1853), who had earlier been trained in ideal figural traditions by both his compatriot Abildgaard (see fig. 36) and Jacques-Louis David. In *View through the Colosseum Arcade* of c. 1815 (**fig. 168**), this high-minded education seems to be jettisoned in favor of a close-eyed look at the present topographical facts of the remains of ancient Rome. Ignoring the crushing scale, say, of Piranesi's famous prints of Roman ruins, Eckersberg seems simply to have sat down, brush and small-size canvas at hand, in front of this venerable monument, selecting as a framing motif a trio of Roman arches that moves the architectural setting of David's *Horatii* from background to foreground. Its noble associations as a theater backdrop for a classical tragedy are relocated in the empirical, here-and-now domain of modern tourists' views of the ruins of Rome, complete with weeds and rubble at their feet. To be sure, Eckersberg has carefully chosen his vantage point, using the triple arcade as a lucid modular screen to mark out what, in the work of a moody German landscape painter like Friedrich, would be a poignant contrast of the near and the far; but these adaptations of the spatial and emotional structures of an earlier generation seem in no way forced here, but rather part of what lay before the artist's eyes. The particularity of observation, whether of the transient, distant cloud movements or of the high-keyed Mediterranean light that irradiates sky, buildings, and earth, also belongs to a vision that

Fig. 168 **Christoffer Wilhelm Eckersberg**, *View through the Colosseum Arcade*, c. 1815. Oil on canvas, 12¾ × 19¾". Statens Museum for Kunst, Copenhagen.

Fig. 169 **Camille Corot**, *The Forum Seen from the Farnese Gardens*, 1826. Oil on paper mounted on canvas, 11 × 19⅝".
Louvre, Paris.

would accept the given facts of things seen. It is no surprise that after returning to his native Copenhagen and becoming a professor at the academy, he inaugurated, in 1820, a class in painting from nature out-of-doors. In this, he was one of the growing number of nineteenth-century painters who felt that a landscape recomposed in the artificial light of the studio was a falsification of nature, and that no pains should be spared to achieve the most immediate, truthful record of the luminous, transient facts of sunlight.

Later artists as disparate as the Pre-Raphaelites and the Impressionists would have understood this view, and so, too, would have the renowned Camille Corot (1796–1875), at least during the first half of his long career. From the beginning, he had been steeped in the venerable tradition of French landscape painters working in Rome, for his two masters, Achille-Etna Michallon and Victor Bertin, were in turn students of Pierre-Henri de Valenciennes, who alternated between more casual, on-the-spot sketches of Roman views and their reconstruction in more ideal historical paintings like *A Landscape of Ancient Greece* (see fig. 65). Corot himself inherited these two modes of landscape painting—one more immediate, often executed, at least at the inception, out-of-doors (or, to use the French phrase, *plein-air*); the other, a more official production geared to public view, and often including, along with smaller figures, biblical or classical subjects. (Valenciennes, in 1817, had been responsible for introducing a Prix de Rome in *paysage historique*, or historiated landscape.) During the first of his

three Italian sojourns, that of 1825–28, Corot painted about one hundred and fifty works, mostly of a small, sketchy kind that could provide a maximum of direct truth about how he perceived the sunbaked buildings and landscape in and around Rome. Like Eckersberg before him, he approached the Eternal City with seeming innocence and humility, unburdened by the weighty baggage of Greco-Roman erudition that most Paris-trained artists would have brought along.

In March 1826, six months after leaving Paris, Corot set for himself the modest task of painting three different views of Rome from the Farnese Gardens, which together would form a three-part cycle of the times of day—morning, noon, and evening. In the midday painting, that of *The Forum* (fig. 169), we see what at first looks like almost an arbitrary portion of a panoramic observatory view, in which any building that falls within the selected range of vision—whether as important as the Arch of Titus or as insignificant as the distant vernacular achitecture—is recorded with the same probity, like a documentary photograph from a hill above the city. But if Corot shares Eckersberg's respect for the data of Roman topography, he transcends his capacity to turn descriptive prose into poetry. Using a spatial ordering from which a less subtle Romantic artist might have extracted too obviously emotive a contrast, Corot locates his city view at an elusive distance, separated from us by a foreground barrier of softly dappled vegetation and submerged by an unusually low

horizon and a surprisingly unbroken expanse of blue Mediterranean sky that luminously covers half the painting. The effect is of something seen through a telescope, of an otherworldly remoteness that belies the particularities of time (March 1825) and place (the Farnese Gardens). Indeed, the buildings of Rome, steeped in the torpor of noon, look uninhabited, remnants of a deserted site from another epoch. To this unexpectedly haunting quality, so much more quietly suggestive than many of the period's florid meditations upon the passing of an ancient civilization, Corot has added an exquisite sense of pictorial order as unforced as his elegiac mood. Without a ground plan or a ruler, he has aligned, with almost unconscious subtlety, the sunstruck or shaded planes of these buildings in an orderly pattern of cubic and spherical geometries which gain further coherence by the restriction to a narrow range of creamy, beige, and terracotta tones. And if, at first glance, Corot seems to have accepted everything that was there, at second glance, his exclusion of countless details of fenestration or textural variation underlines his intuitive genius in respecting the demands of both truth and art. It is no surprise that twentieth-century taste, focusing less on the "truth" than the "art" side of this equation, singled out Corot's early Roman paintings as forerunners of an abstract constructive tradition that leapt decades ahead to Cézanne and early Cubism.

Corot was a constant traveler in Europe, and his views of both city and country evoke the contemplative detachment of a visitor who observes from outside. In particular, he painted throughout the provinces of France, savoring and recording with the same visual scruple and emotional reserve both such famous monuments of medieval architecture as Chartres Cathedral and the most ordinary village church. Like many of his contemporary landscape painters, he was attracted to a countryside that preserved those timeless qualities of man and nature that were increasingly threatened by the new roads and new agricultural methods of the nineteenth century.

As a part of France that, in twentieth-century language, began to be described as "unspoiled," that is, untouched by industrialization, Brittany was an inevitable stop in his wanderings, as it was later to be for such other refugees from nineteenth-century city life as Gauguin. When Corot visited the bleak coastal region near Le Croisic in 1840, he predictably paused to paint the people and landscape there. In *Breton Women at the Well* (**fig. 170**), the

Fig. 170 **Camille Corot**, *Breton Women at the Well*, c. 1840. Oil on canvas, 15½ × 22″. Louvre, Paris.

timelessness of his Roman views is again apparent. The local costumes of workers in the salt marshes blend inconspicuously into a rugged, elemental landscape, as if the figures and their environment were one. And the primitive ritual of gathering water in earthenware pots is consonant with the stark, almost crude structure. The blunt cubic form of the well dominates the foreground, and the figures are disposed in frontal and profile postures that evoke an archaic world, as if Homer or the Bible had been re-experienced through the peasant life of France's remote provinces. Too grave and monumental to be thought of as picturesque extras in a tourist's souvenir, these Breton women have a generalized, mythic quality, which would make them no strangers in the historiated landscapes, such as *Hagar in the Wilderness* or *Homer and the Shepherds*, which Corot submitted for public view at the Paris Salons. The quiet dignity of these peasants, evoking their elemental unity with the soil, was one that other artists would amplify to heroic, politically charged dimensions in the years after the 1848 Revolution. Contrariwise, Corot himself, in his works after 1848 (see fig. 268), seemed to accentuate the dreamlike potential of his early vision, softening his figures, earth, trees, and skies with a blurred, feathery touch that located them in the realm of distant, twilight reverie, light-years away from the harsh facts of the French countryside that Courbet and Millet would force upon the attention of Paris spectators.

In multiple guises, grave or picturesque, cheerful or pious, peasants abounded in nineteenth-century art, symbolizing for most urban viewers what they liked to imagine as the innocent felicities of country life, untroubled by the changing times. In Russia, where a feudal agricultural society was still in good part preserved, painters gravitated early to this international theme. The first to do so was Alexei Venetsianov (1780–1847), who, in 1819, moved from St. Petersburg to a country property in Safonkovo, where he dedicated himself to painting, often out-of-doors, the peasant life around him and where he cultivated art students who were mainly the children of serfs. This close contact with the tilled earth is quietly and luminously reflected in *Summer*, a painting of c. 1830 (fig. 171), whose record of rural experience is so distilled that it might do double service as an allegory of Mother Russia. The counterpart to a painting titled *Spring* (a scene of labor), *Summer* offers a serene image of a peasant mother and child, seated with almost Neoclassic timelessness on a wooden ledge and accompanied by that most emblematic of agricultural tools, a sickle. The unforced dignity of her right-angled posture cleanly outlined by sunlight against a vast expanse of wheatfields, the compositional candor of a tiered trio of planes that enforce the dominant horizon of the earth—such plain visual statements approach Corot's own frequent espousal of a direct and ingenuous style, closer to the language of folk art and popular imagery than to the inherited rhetorical conventions of the academy.

The venerable harmonies of a landscape inhabited by simple people who seem blessedly unaware that they are living in a century which would threaten their very existence were a constant inspiration for artists both at home and abroad. For a Berlin-trained landscape painter like Karl Blechen (1798–1840), an Italian voyage in 1828–29 prompted not only a need to record the beautiful and unfamiliar factors of Mediterranean nature, whether coastal views or inland forests, but also to envelop them in an aura of quiet reverie where mythical worlds might be evoked. In one of many painted versions Blechen continued to make of the gardens at Terni (later the Borghese Gardens) in Rome (fig. 172), we sense an Arcadian serenity. Here the sunlight dapples trees that shade a hidden watering spot and the figures are neither modern tourists nor local residents but a pair of female bathers, who, like the ghosts of classical nymphs in many of Corot's gentle woods, might not be out of place in an illustration to Vergil's pastorals. It is telling that in other versions of this landscape, Blechen replaced the distant bathers by a pair of monks, figures of comparable seclusion from the pressures of a modern world. Yet despite these poetic associations of timelessness, the

Fig. 171 **Alexei Gavrilovich Venetsianov**, *Summer*, c. 1830. Oil on canvas, 24 × 19⅓". Tretyakov Gallery, Moscow.

Fig. 172 **Karl Blechen**, *Women Bathing in the Gardens at Terni*, c. 1830. Oil on canvas, 39¾ × 22¼". Nationalgalerie, Berlin.

close-eyed observation of the forest setting suggests a particular time and place. In fact, Blechen's rapid, sketchy brushwork would seize the *plein-air* fugitive effects of sunlight on rustling leaves that would be emphasized by many later nineteenth-century painters who focused upon the most transient aspects of nature. And at other times, Blechen could even confront harsh, contemporary facts, painting, in the mid-1830s, a German rolling mill seen against a smoky Prussian landscape. It was a fusion of past and present, of enduring nature and nineteenth-century industrialization that the Impressionists themselves later attempted when they included the new factories and railroads in their glimpses of the French countryside's abiding beauties.

For those painters who sought in nature a mythical Eden, it was the North American continent that provided the most intensely polarized contrast of a rapidly changing man-made civilization and a natural paradise that was clocked not by nineteenth-century calendars but by biblical or geological time. As John Locke had put it, "In the beginning, all the world was America." In the 1820s, Thomas Cole had proposed images of nature that suggested a

surviving Eden (or, alternatively, the hellish sublimities of landscapes fit for Expulsions and Deluges), and it was predictable that he would gather many followers who, with youthful nationalistic pride, offered variations of the imaginative themes kindled by the new continent's overwhelmingly primeval landscape. The search on native grounds for these quasi-religious truths in nature was shared by a growing number of landscape painters who came to be known loosely as the Hudson River School, although the American landscapes they sketched and drew on the spot were far more geographically dispersed than the spectacular mountains, rivers, and valleys to be seen only hours away from New York or Boston. A painting of 1847 by Cole's long-lived contemporary and disciple (if not actual student) Asher B. Durand (1796–1886), *Landscape Composition: Hudson River, Looking toward the Catskills* (**fig. 173**), may exemplify the more idyllic, milk-and-honey aspect that American nature could offer its viewers. Grazing sheep and cows, a rowboat moored beside a gentle stream, fine old beech and birch trees silhouetted against the suffused glow of the sun—such a vision of green pastures, in which the

Fig. 173 **Asher B. Durand**, *Landscape Composition: Hudson River, Looking toward the Catskills*, 1847. Oil on canvas, 46 × 62″. Fenimore Art Museum, Cooperstown, New York.

cycles of humans and animals, days and seasons unroll serenely, struck profound chords in mid-nineteenth-century spectators who, like Thoreau and Emerson, so often found moral, even religious values in the phenomena of nature. The painting borrows heavily from the seventeenth-century landscape conventions of the Dutch and of Claude Lorrain, which Durand venerated but nevertheless found wanting in the fullest truth to the firsthand experience of nature. Yet he translated these European authorities into a more American idiom, recording the specific scenery of the Hudson River Valley and offering plainer, even more awkward dispositions of trees and cattle that smack of authentic observation rather than of studio formulas. But above all, it is the emphasis on light that produces a new inflection. As in Turner's work, a pervasive glow begins to threaten the balance between solid and void, substance and atmosphere, as if a hushed, almost mystical energy were slowly enveloping the terrestrial world. It was just this sense of natural light as the bearer of almost supernatural mysteries that was soon to dominate a

major mode of mid-century American landscape painting (see page 395).

Of the many groups of painters who found in landscape a rural paradise, it was the Barbizon School whose name became internationally synonymous with this nineteenth-century idyll of nature unpolluted by the grim facts of modern city life. Easily accessible to landscape painters whose careers were to be made within the context of the Paris art establishment of Salons, critics, and public and private patrons, the tiny village of Barbizon was located in the middle of the Forest of Fontainebleau, some thirty miles southeast of the capital. Beginning in the 1830s, it became the symbolic seat of those painters who, on long sojourns away from Paris, wished to immerse themselves in the commonplace, enduring truths of nature—tangles of weeds in marshes, the watering places of cattle, the reflections of a setting sun on thick foliage—truths that had already been passionately embraced in the paintings Constable had introduced to a wide-eyed Paris audience at the 1824 Salon. For the growing numbers of French landscape

painters who subscribed to this faith and who insisted on gathering directly on the spot, in small drawings and oil sketches, the data to be reworked into more ambitious paintings, these humble phenomena could be dense with associations of a meditative, historical cast. The most prominent member of the Barbizon School, Pierre-Étienne-Théodore Rousseau (1812–67), referred to the Fontainebleau Forest as Arcadia, and imagined that even "Homer and Vergil would not have minded sitting there and contemplating their poetry." Just as figures like Blechen's bathers and Corot's Breton peasants began to take on a mythical status, the landscapes of Rousseau and his colleagues resonate with a sense of reverie and remoteness, as if unspoiled nature in the mid-nineteenth century had already become, in the twentieth-century phrase, "an endangered species," to be cherished as a reminder of a long-lost world, whether of a biblical or Greco-Roman antiquity or, more prosaically, of a pre-industrial civilization of untroubled farmers and village peasants. A sturdy oak tree, as painted and experienced by Rousseau, was not only beautiful in itself, but grew from roots that might date back long before the French Revolution.

Like the Hudson River School, the Barbizon School was by no means restricted geographically to the region of its name, and Rousseau, like his occasional Barbizon companion Corot, traveled extensively in the French provinces to witness and to record firsthand the mountains of the Auvergne and the Jura, the swamps of the Vendée, the farmers' thatched cottages of Normandy. In 1842, after a dauntingly long series of rejections by the Paris Salon jury, which found most of his paintings ugly in their clotted, speckled brushwork and candid, unidealized compositions, Rousseau left, discouraged, for a seven-month sojourn in the Berry, a province that another Barbizon painter, Jules Dupré (1811–89), had recommended to him for its quiet, simple character. *Under the Birches* (fig. 174) is Rousseau's testimony to this experience. As in many of the more informal works of Cotman or Constable, Corot or Eckersberg, observed facts take priority over preconceived order. Each of the birches has an irregular, unique shape; and their overall configuration, while approaching the man-made symmetry of a paired bower on either side of a sunken country lane, refuses any geometric regimentation in favor of the specific truths of straight and crooked branches, of high and low trunks, of the shaggy contours of rustling autumn leaves. The foreground, too, records honestly the mass and density of actual rocks and underbrush, and the puffs of clouds above the distant horizon defy predictable

Fig. 174 **Pierre-Étienne-Théodore Rousseau**, *Under the Birches*, 1842–43. Oil on wood panel, 16⅝ × 25⅜".
Toledo Museum of Art, Ohio. Gift of Arthur J. Secor.

Fig. 175 **Jules Dupré**, *The Sluice (The Duckpond)*, c. 1845–48. Oil on canvas, 20½ × 27½". Musée d'Orsay, Paris.

patterns. Throughout, we feel that a particular time of day and year in a natural cycle has been pinpointed—the chill and russet coloration of autumn; the sparkle of a soft, late-afternoon light on trees that screen a darkening blue sky. And to complete this sense that a simple, fundamental rhythm of days and seasons has been captured, we see in the center, half-hidden by earth and tree, a country priest on his horse (hence the painting's nickname, *Le Curé*), whose passage through the birches suggests not some dramatic narrative but rather a daily event as comfortingly recurrent as the sunset.

In his experience of both the ephemeral and the permanent, Rousseau often combined what appears the most solid of pictorial structures—here, the elemental opposition of horizontal earth and vertical tree—with stippled paint surfaces that catch, as did Constable's white highlights, the effect of changing, flickering light. It was a technique shared by Dupré, who had also absorbed the lessons of Constable both in Paris and during a visit to England in 1834. In a typical Barbizon School subject, *The Sluice* of c. 1845–48 (**fig. 175**), Dupré selects the familiar point where humans, animals, and nature are almost fused in a symbolic whole, a rural translation of a primordial ooze, where, in an unruly growth of trees, brushstrokes camouflage a distant farmer, a ramshackle wooden dam, and a flock of ducks that are almost at one with their choppy reflections in the murky pond. Again, nothing is forced: the dense foliage, in particular, moves every which way, appearing to extend, like a cropped photograph, beyond the arbitrary confines of the picture.

In its later decades, the 1860s and 1870s, and in the work of its lesser masters, the Barbizon School could dilute many of these fresh insights into pallid formulas. But its initial audacity in recording the unedited truths of landscape was to permeate the goals of the Impressionists, who concentrated even more intensively on fidelity to observed fact and on translating, with ragged, broken brushwork, the scintillation of sunlight on land, sky, and water. Indeed, the Impressionists often repeated specific Barbizon motifs, so that Rousseau's screens of trees or Dupré's duckponds, for example, recur in the work of Monet and Renoir as polar extremes of ordered and random structures in landscape. But on a less exalted level, the vision of the Barbizon School rapidly proliferated and was debased by thousands

of commercial artists who, as in a Pavlovian reflex, could instantly remind urban audiences of the soothing magic in those sylvan retreats least touched by modern society. On both sides of the Atlantic, everything from calendar illustrations to hand-painted, gilt-framed oils repeated in beltlines the industrial age's longings for nature's Arcadian harmonies.

It was not only timeless nature and humble peasants, but also rural nineteenth-century people, going about their routine activities, who might be transformed into an art that, for urban audiences, could conjure up the serenity and purity of ordinary life. Of those Northern European artists who in the 1830s and 1840s could pinpoint the magic of the commonplace, both indoors and out, none surpasses the Dane Christen Købke (1810–48), whose student training under his compatriot Eckersberg (see fig. 168) intensified his respect for direct observation and sharpened his pictorial focus to a point that anticipates the camera lens. With crystalline precision, Købke records

what at first seem impersonal documents of the uneventful aspects of life he saw near his home in the Danish provinces just north of Copenhagen. In his *View of Lake Sortedamssøen (near Dosseringen)* of 1838 (**fig. 176**), specific local and national facts are immediately on view, most particularly the patriotic display of the red-and-white Danish flag, undramatically drooping at the height of a thin flagpole, a lone intruder in a breezeless, open sky. The sense of a bleak, underpopulated Scandinavian suburb is further underlined by the immobile pair of women who stand in isolation on the pier, waiting for the ferry to arrive. This prosaic glimpse of rural Danish waterways might be only documentary were it not for the chilly, austere spell cast by the bone-dry perpendicular grid of horizon, pier, and flagpole and the pervasive, cool light that captures in sky and water a pinkish reflection of a distant Scandinavian sun. Købke's special alchemy in translating the neutral fact of a ferry landing, with its scruffy lakeshore foliage and patiently waiting passengers, into an image of hushed, almost melancholic suspense is akin to the powers of

Fig. 176 **Christen Købke**, *View of Lake Sortedamssøen (near Dosseringen)*, 1838. Oil on canvas, 53 × 71½". Statens Museum for Kunst, Copenhagen.

earlier Romantic masters like Friedrich, whose fusion of intense, close-up detail and a veiled, hazy light could also transform the observed experience of the bleaker climes of Northern Europe into vehicles of inward meditation. Yet by contrast to Friedrich, and typical of a generation maturing in the 1830s and 1840s, Købke embraces far more of the accidents of reality. His axial grid, if spare, is off center; his cloud patterns, if still, are as irregular as the contours of the distant and near shores or the trail of smoke that rises higher than the windmills on the distant horizon; and the edges, as in Dupré's *Sluice*, seem cropped at an arbitrary point that suggests not a self-contained whole but an almost arbitrarily cut-off portion of a visual field that extends unpredictably in all directions. The Romantic light of some transcendental deity imagined by a Friedrich or a Turner becomes here the observed light of a particular time and place. The real has begun to usurp the symbolic; the natural, the supernatural. But if Købke's subject matter and literalism of detail may be associated with a Biedermeier sensibility, the mood he projects transcends it. An uncanny silence and expectancy, a sense that even palpable facts like wood and stone are rendered immaterial by a filtered light, maintain, in a new, earthbound context, the imaginative force of Romantic longings for something beyond the visible.

Købke's art, inspired by the experience of provinces remote from Europe's major capitals, was paralleled in the work of many painters in the United States who recorded, with growing literalness, the simple facts of rural or frontier life. Of these, the most typical and successful was George Caleb Bingham (1811–79), an almost exact contemporary of Købke and one who also could extract a haunting mood from what might otherwise be considered literal documents of the lives of those fur traders, raftsmen, and shipping hands who brought prosperity to the midwestern outposts of the rapidly expanding nation. Bingham, both an artist and a political figure, was a man of the Jacksonian age who, in the 1830s and 1840s, moved about from Missouri to Philadelphia, New York, Washington, and then back to the Midwest. And he could try his hand at everything from cabinetmaking and sign painting to campaigning for William Henry Harrison in the 1840 presidential election. European visitors to the States in these decades, from Alexis de Tocqueville to Mrs. Trollope, commented, with approval or discomfort, on the conspicuous absence of aristocratic traditions, the lack of unemployment, and above all, on the pervasive sense of human equality, where no one descended as low as the peasants of Europe or as high as the monarchs who governed them and where, as was almost literally the case with Bingham, anyone could become president. In Bingham's art, this egalitarian world is apparent. His subjects are culled from the boatmen whose work and, more often, leisure he observed on the Missouri River; yet these anonymous laborers are

presented within dignified figural structures earlier used in Europe for the gravest themes from Christianity or from Greco-Roman history and myth.

In *Raftsmen Playing Cards* of 1847 (fig. 177), a compositional order of almost archaic clarity is imposed upon a lowly genre theme, whose every detail, from the left-hand figure who looks at his injured foot to the surprising variety of frontier hats, is brought so close that the spectator can almost feel the raft boards below. But the grouping, with its cleanly calculated contours of profile and frontal views, and its assertive horizontal geometries of a rude wooden bench and planking, looks almost more appropriate to a Holy Family by Poussin than to what, in reality, would have been a boisterous and agitated card game. This American merging of a museum-tinged, old-master artiness with the contemporary facts of that pioneering life which made the wheels of commerce and territorial expansion turn faster was a huge success. Bingham's paintings of the 1840s were widely shown, commented on, and bought, especially through the American Art-Union in New York, a democratic combination of art and commerce that, founded in 1839 and inspired by the many German *Kunstvereine* in cities from Berlin to Düsseldorf, used everything from annual exhibitions to lotteries and subscriptions for engravings in order to propagate the nationalist cause of American art.

But Bingham's own paintings, at their best, transcend this populist, commercial network. His debts to European compositional formulas are more than repaid by the unexpected hush of silence and solemnity that he extracts from ostensibly trivial subjects. As in Købke's art, a strange loneliness and immobility prevail, as if the human intruders had been exiled in a remote natural environment of endlessly open, luminous spaces and ever more distant, irregular shores. Such experiences were particularly appropriate to the art of North America, where the collision between the material facts of nineteenth-century life and an awesomely vast wilderness was most acute. For finally, it is the filmy, all-encompassing light of the sky and the river which dominates the brightly lit, close-up grouping of six men who, barefoot or shod, idle or working, mirror that transient population of the 1840s which would soon reach even more remote regions of Texas and California.

For all its implicit poetry, the art of a Bingham or a Købke is predicated on observed fact in an everyday world, a factuality that, between 1815 and 1848, was becoming conspicuous on all levels of painting, in the historical dramas of Delaroche as well as the landscapes of Waldmüller. In the domain of portraiture, these changes are apparent not only in images of European monarchs, from the Emperor Franz I of Austria to Queen Victoria, but in less regal walks of life. Nowhere is that sense of a candid encounter with a particular person more unforgettably seized than in Ingres's renowned portrait of the sixty-six-

Fig. 177 **George Caleb Bingham**, *Raftsmen Playing Cards*, 1847. Oil on canvas, 28 × 36". City Art Museum, St. Louis.

year-old journalist and businessman Louis-François Bertin (fig. 178), which, painted in 1832 and shown at the 1833 Salon, has come to symbolize the no-nonsense, down-to-earth reign of the July Monarchy, which in fact was actively supported by the newspaper Bertin directed, the *Journal des Débats*. Manet's quip that this portrait was the "Buddha of the bourgeoisie" neatly sums up our response that, indeed, Bertin, in his imposing physical presence and leonine, head-on stare, is a deity of the powerful new middle classes, usurping Ingres's supernatural representations of the divinities of Napoleon or Jupiter with a tough, terrestrial man of action who evokes the authority of the supreme boss. Bertin's energy and aggressive potential are captured by Ingres as if by a lion tamer. Within the confines of a restless contour that displays Ingres's prodigious ability to spin out the tautest linear web, the huge bulk of the sitter is constricted in the most shallow of spaces, his arms and hands almost about to pounce.

That Ingres could paint such a picture at all, and in the same decade as his *Odalisque with Slave* (see fig. 130), is an indication of how the premises of intense, realistic observation underlay even his most abstract inventions. In this, he was heir to his master, David, whose portrait of Mr Cooper Penrose (see fig. 24) similarly coexisted with the more exalted, ideal subjects and styles demanded by high art and history. Here, Ingres's descriptive wizardry is so acute that, as in the case of so many other paintings of the 1830s, we feel this must follow rather than precede the invention of photography. And, as in the photographs to come, the tones themselves remain within a muted range of browns, grays, and blacks that exclude the artful luxury of color. Moreover, the rendering of optical truths is so intense that we find recorded not only every wrinkle of jowl, knuckle, and jacket, but even the reflections of a mullioned window in the high polish of the chair arm that momentarily contains the sitter. In both physical and psychological terms, Ingres's Bertin is so vivid a person that he almost ruptures the confines of art to impose himself as a living presence.

Although we reach for the word "photographic" to describe what appears to be so unedited a version of a palpable human fact, it should be stressed that it was a full

seven years after Ingres had painted this portrait that the invention of photography by Louis Daguerre, a man who himself had been a painter (see fig. 122), was officially announced during a meeting of two French academies, one of art, the other of science. And in the very same year, across the Channel, as if destiny had decreed that more than one person would finally invent a way to make a permanent record of the illusion of impersonal, optical truth, an Englishman, William Henry Fox Talbot, presented another method of seizing reality, this captured on paper rather than, as was the case with Daguerre, on a metal plate. In retrospect, the growingly factual, objective manner of painting pursued by so many painters in the 1830s makes the birth of photography seem inevitable. Thereafter, in fact, the history of photography can best be interpreted as a parallel development interwoven with the history of painting. The dialogue between photography and painting is not so much a question of priority or stronger influence, but rather that of a shared view of both public and private worlds. Clearly, the first photographers produced images dependent on the painted images they knew, and would continue to echo the hand-made art they saw around them.

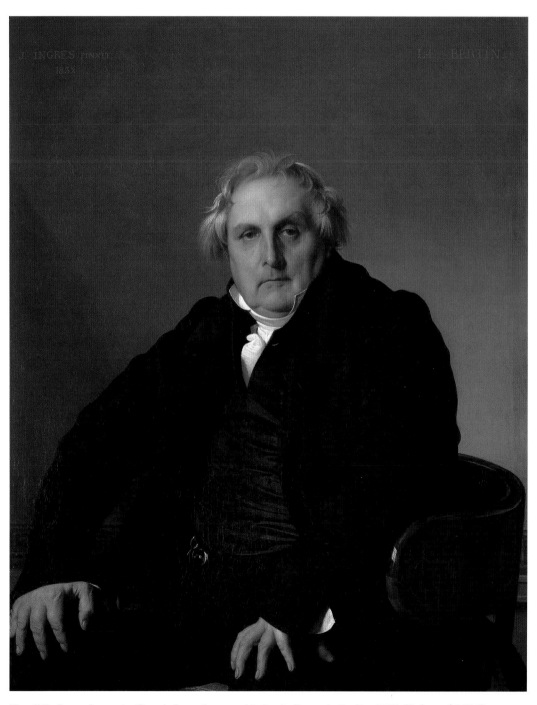

Fig. 178 **Jean-Auguste-Dominique Ingres**, *M. Louis-François Bertin*, 1832 (Salon of 1833). Oil on canvas, 46 × 37½″. Louvre, Paris.

Similarly, artists, in turn, lived in an environment that was saturated with photographic images, and could respond to them in countless different ways. Even painters like Delacroix and Cézanne, while intent on their personal visions, would use photographs as visual props. Other painters, such as the Russian Ivan Kramskoy (see fig. 376), were trained as professional photographers, a skill that shows in their canvases. And often, well-known painters such as Degas, Eakins, Vuillard, and Munch, were also amateur photographers, creating machine-made images whose authorship, on the basis of their hand-made art, we can instantly recognize. No less than painting, photography could be molded to individual temperaments or could be used for objective documentation; and in each medium, the possibilities are infinite. But the prevailing concept of photography in the nineteenth century was that of preserving objective truths, a commitment to the sharp-focus recording of the visible world that, in fact, was shared by the majority of the century's painters whose work, one might speculate, would have looked no less "photographic" had Daguerre's and Talbot's inventions been failures. But since they were successes, their progeny provides an inseparable complement to the history of painting. The chicken-or-egg question of which came first has prompted many historians, especially those whose primary concern is photography, to find examples of nineteenth-century painting presumably influenced by photography. The influences discerned are far and wide and often contradictory. On the one hand, we learn that photography could inspire painters to work with intensely sharp focus; on the other, that photography taught the Impressionists how to blur figures in motion. On the one hand, we hear that photography prompted painters to explore accidental croppings; on the other, that photography helped painters to fix an active scene with glassy permanence. It is much more useful, however, to think of this parallel history not in terms of priorities—who did what first?—but in terms of the way in which both photographers and painters responded together to the changing experiences of living in the nineteenth century. In fact, almost every feature of nineteenth-century painting that has been attributed to the influence of photography has ample visual precedents in paintings made long before 1839, just as most paintings made after 1839 can find their counterparts in any anthology of nineteenth-century photography.

Ingres's portrait of M. Bertin is a case in point. If we say it looks like a photograph (an anachronism, given its date, 1832), we really mean that it resembles the official portraiture made later by both painters and photographers. It is, in fact, a painting that would have fitted comfortably into an anthology of French celebrities, a series titled *Galerie contemporaine, littéraire, artistique* published from 1876 to 1884. For this compilation (a dignified preview of today's magazines that record the faces of royals and movie

Fig. 179 **Étienne Carjat**, *Victor Hugo* (from *Galerie Contemporaine*), 1876. Woodburytype. Private collection.

stars), various photographers contributed portraits of such famous Parisian men and women as Gustave Courbet and George Sand. In a typical plate, the photographer Étienne Carjat (1828–1906) provides for his contemporaries as well as for posterity an image of the internationally renowned Victor Hugo (**fig. 179**), a portrait probably made around 1870, as the writer approached his seventieth year, and published in 1876, nine years before his body was laid to rest in the Pantheon, Paris's Hall of Fame. Seen together with Ingres's portrait of a prominent public figure, the photograph of Hugo seems a branch off the same tree. It is not only the force of a similarly sobering confrontation with the huge presence of nineteenth-century secular authority, but also a matter of format and style, in which painstaking, mirror-like detail that guarantees a permanently truthful record of a prominent personality is contrasted with a blank, but slightly luminous background that evokes both a real and an abstract environment. There may be suggestions of light and depth behind these figures, but the absence of any specific setting gives them an iconic, daunting power. Moreover, both Bertin and Hugo are cropped at the knees, turning into pyramids of strength what in fact were only their heavy-set, full-bellied bodies, covered by the same kind of colorless, layered clothing that persisted in male wardrobes throughout the century. Were we to see the furniture legs that supported these men, their force would

Fig. 180 **Louis Ferdinand von Rayski**, *Portrait of Count Zech-Burkersroda*, 1841. Oil on canvas, 57¼ × 40¾".
Galerie Neue Meister, Dresden.

be vastly diminished. Whether painting or photograph, whether created before or after 1839, both portraits belong to a genealogical table that mirrors the middle decades of the century.

This welling insistence on what appeared to be unadorned truth, but was actually the product of endless choices, can be found throughout mid-century portraiture, even in the domain of court portraits, as practiced, for instance, by the Dresden artist Louis Ferdinand von Rayski (1806–90). In his record of the thirty-six-year-old Count Zech-Burkersroda of 1841 (**fig. 180**), Rayski chooses to represent the chamberlain of the Saxon king, Friedrich Augustus II, not within the context of aristocratic artifice, inherited from a prerevolutionary world, but rather as an unpretentiously dressed man who stands before a monochrome background that in no way deflects our attention from his honest, matter-of-fact presence. Rayski had visited Paris during 1834–35, and was particularly drawn there to the broad, creamy brushwork of Géricault, which he has adapted here. Yet unlike Géricault, Rayski makes no effort to probe the mysteries of the individual psyche, leaving us

a straightforward human document that is almost neutral in psychological character, a portrait whose very lack of artful, interpretative accents becomes a mark of a new, egalitarian realism, the equivalent of the many daguerreotype portraits of the 1840s.

Social Observers

In the eyes of many artists of the years 1830–48, the realities of particular people were quickly generalized to encompass a broader view of the new social strata that were taking shape. In this domain, it was Honoré Daumier (1808–79) whose spectrum of human and historical experience was the widest and whose contact with a mass audience was the most direct. Working within the medium of lithography as an illustrator for such new politically oriented periodicals as *La Caricature* and *Le Charivari* (founded, respectively, in 1830 and 1832) that chronicled the repressive activities of Louis-Philippe's government, Daumier drew everything there was to know about the facts of Parisian life, whether the corrupt and pompous behavior of judges and deputies, the public passions of women fighting for their emancipation in 1848, the laughable vanity of affluent Parisians posing for their daguerreotypes, or the tawdry spectacle of half-clad city dwellers in public baths. He flinched at nothing, even the brutal facts of war and death, but he could also laugh sympathetically at the foibles of his compatriots. A man of enormous moral conviction and one who, like David, was, in the French phrase, *engagé* (i.e., politically committed), he had actually been imprisoned in 1832 for six months for his mordant contributions to the growingly popular satirical imagery that could transform the new king into Gargantua, the monstrous glutton invented by Rabelais, or, in a more widely spread caricature (which even appeared in graffiti on Paris walls), a pear (which fruit the king's face resembled and which word, in French slang, also meant a dullard).

Even after release from jail, Daumier would not be censored. Labor conditions under the July Monarchy were no less wretched than elsewhere in Europe, especially among the silk weavers in Lyons, where a British investigator noted in 1834 that the average working day lasted sixteen to twenty hours. Already in 1831 in Lyons, the government suppressed, with twenty thousand troops, an armed uprising of workers who wanted to negotiate wage increases with their employers, after which a law of 1834 forbade any kind of unionization. The extensive week-long uprising that followed had the usual official repercussions in Paris (barricades were put up), as well as popular reprisals. On the night of April 14–15, a certain Lebrun kept shooting at soldiers from a window at 12 rue Transnonain and finally killed an officer. After this crime, soldiers forced their way into the building and, with bayonets and sabers, murdered

Fig. 181 **Honoré Daumier**, *Rue Transnonain, April 15, 1834*, 1834. Lithograph, 11½ ×17⅝″. Albertina, Vienna.

eight men, a woman, and a child. It was this event, or rather its deathly aftermath, which Daumier recorded in a lithograph that all of Paris crowded to see when it was finally exhibited in a shopwindow in October of that year (fig. 181).

With the on-the-spot eye of a reporter, Daumier, like Goya before him, thrusts the spectator into the scene of death, insisting on the chaotic data of an overturned chair, of a mattress and pillow that might momentarily fall to the floor, of the indignities of a corpse whose nightshirt covers a large belly but exposes the legs. Yet if the first effect is of unedited, flashbulb truth, the second is of Daumier's selective genius in ordering this disorder into a working-class Pietà. Just as David ennobled the murdered Marat (see fig. 21), so too does Daumier lend an unexpected rhetoric to this heap of nameless corpses. The father, propped up on the sheets of the matrimonial bed in a postion that bitterly echoes many images of the Lamentation of Christ, is singled out by a strong white light, which also illuminates the infant, whose skull, still bleeding, has been bashed in. This gruesome family tree is then subtly extended in the shadowed and cropped figures at the left and right, a mother and grandparent, so that three generations have been symbolically annihilated by impersonal murderers who are represented only by their bloody footprints on the floor. Daumier's power here, as always, was to take the particular and the accidental, and somehow to elevate them to a statement that might immediately function as a political protest for any violation of the rights of common men, women, and children. What at first has the ring of arbitrary, brutal fact—a preview of documentary war photography—is edited and dramatized by an intuitive sense of major and minor, and by chiaroscuro contrasts of symbolic resonance.

Daumier's genius in translating great Western themes into contemporary realities could be used for both tragic and comic effect. Inevitably, the ideal realm of Greco-Roman myth and history, still propagated by artistic

officialdom, would strike him as ever more ridiculous and anachronistic in the world of Louis-Philippe or Louis-François Bertin. Between 1841 and 1843 in *Le Charivari*, he published a series of fifty lithographs, *Histoire ancienne*, presenting hallowed classical themes updated to modern Paris. In one of these, *Penelope's Nights* (fig. 182), he shows us Homer's faithful wife at a handloom preposterously unlike those used by workers in France's industrial mills. Patiently weaving, night after night, in her gaslit tenement, and awaiting the return of her husband, Odysseus, she swoons like the heroine of a Romantic melodrama in a boulevard theater, inspired by the crude profile image of a helmeted head that recalls both classical legends about the primitive beginnings of the art of drawing and the childlike caricatural graffiti that so often carried obscene or politically inflammatory messages on Paris walls. All these brilliant disparities between official culture and the more sordid facts of modern life, between the ideal and the coarsely real, seem to be dashed off by Daumier with his usual economy, so that we end up relishing every detail, from the sandals to the voluptuously exposed shoulder, and registering every luminary contrast, from the white wall, with its minimal classical pilaster, to the gas flame that sputters against the blackest shadow. Not once, but hundreds of times, Daumier could pinpoint with the

Fig. 182 **Honoré Daumier**, *Penelope's Nights* (from *Histoire ancienne*), 1842. Lithograph, 9½ × 7½″. Bibliothèque Nationale, Paris.

swiftest strokes not only the tragic and comic ways in which the lofty heritage of Western civilization was at odds with the modern world, but also the full panorama of the individuals who composed the same new society that Balzac was describing in the novels of changing Parisian life he subsumed under the title *La Comédie humaine* (1842–48). In fact, the analogy between Daumier's perceptions of contemporary people and those of his fellow novelists extends even across the Channel, where the British illustrator Phiz used a Daumier print of a smug old sick nurse as a model for the character of a midwife in Dickens's *Martin Chuzzlewit* (1843). Luckily, Daumier lived beyond both the 1848 Revolution and the Franco-Prussian War of 1870, continuing to provide, as we shall see, eyewitness accounts that cut right to the core of the mid-nineteenth-century life around him (see figs. 242 and 334).

Daumier was hardly alone in his role as both artist and social observer in the years before 1848. Of the many other Paris illustrators, Paul Gavarni (the pseudonym of Guillaume-Sulpice Chevalier, 1804–66), was his most distinguished contemporary, and one who also moved from highlife to lowlife, from fashion plates and opera boxes to scenes of urban misery. Even before his 1847–51 sojourn in London, where he became acutely aware, like Géricault before him (see fig. 116), of the pathos and horror of the modern city, he could comment in Paris on the heartrending breach between the rich and the poor. Using the

Fig. 183 **Paul Gavarni**, *"Hunger? Laziness!"* (from *Baliverneries parisiennes*), 1847. Lithograph, 7¾ × 6⅞". Bibliothèque Nationale, Paris.

lithographic medium favored by Daumier, he offered in his *Baliverneries parisiennes* (Parisian Nonsense) of 1846–47 glimpses of momentarily restrained class struggle. In one plate, titled *"Hunger? Laziness!"* (fig. 183), we can read on into the caption the soliloquized rationale that prevents the wealthy Parisian, with his cocked stovepipe hat, from letting his conscience prick him as he passes the starving beggar: "He's hungry? I'm hungry, too, but I take the trouble to go to dinner." Almost as concisely as Daumier, but still falling under his shadow, Gavarni instantly symbolizes two opposing social classes seen against a rapidly drawn vista of a narrow, picturesque Paris street that becomes, as in many of Daumier's images, a sign for the endless labyrinth of the entire city.

For Daumier and Gavarni, lithographic illustration was the most effective medium to convey these social messages, and obviously the one that might achieve the widest distribution. But for other artists, in France and elsewhere, such comments on the burning questions of the times were phrased in more conventional pictorial language that smacked of the academy's rhetoric, a language that was by no means detrimental to the propagandistic effect. In *The Slave Trade* (fig. 184), a painting by Auguste-François Biard (1798–1882) that was shown at the 1835 Salon, the exoticism of Ingres's and Delacroix's voluptuous harem prisoners is transported to the shores of Africa, where we see an inventory of barbaric behavior by both black and white traders as they inspect, flog, chain, and brand their human merchandise. As an issue that could be as philosophical as Age of Enlightenment speculations on liberty or as venal as the insurance money collected by traders who lost human cargo at sea, slavery haunted the conscience of the nineteenth century; and many artists, from Blake and Girodet to Géricault and Turner, touched on this fearful moral theme. Biard's treatment of the subject has the flavor of neither a grandiose meditation on human iniquity nor a popular broadsheet against slavery. Instead, it combines the literal, documentary approach of its period with an old-master compositional order that would arrange this reportorial composite of horrifying truths into rhymed and interlocking figural groupings as graceful as those in Couture's *Romans of the Decadence* (see fig. 158). It was a formula that, since Copley's *Watson and the Shark* (see fig. 4), usually guaranteed success, and it is no surprise that the painting was later sent to London for viewing at the Royal Academy exhibition of 1840. As a British commentator of 1847 put it, Biard had "made the slave trade, by a single picture, more infamous than it had been depicted by a score of advocates for its suppression." Appropriately, Biard was later to celebrate, in a painting for the 1849 Salon, the official emancipation of the slaves by the law of the new French Republic of 1848.

The same mixture of journalistic awareness of the pressing social and economic problems that preceded the

Revolution of 1848 with a bow to the authority of academic pictorial conventions may be found in the work of a Düsseldorf painter of Biard's generation, Carl Wilhelm Hübner (1814–79). In *The Silesian Weavers* of 1844 (**fig. 185**), he takes on the theme of contemporary victims of the linen industry, handworkers who were being starved out by machine competition, and whose rebellion of 1844, like those of the Lyons weavers of the early 1830s, was suppressed by government troops. Their plight, which also inspired a protest poem by Heinrich Heine (1844) and, later, Gerhart Hauptmann's drama *The Weavers* (1892), is translated here into the language of theatrical rhetoric. On the left, the capitalistic profiteer imperiously rejects the fabric proffered by the handweavers as not being worth the price asked, leaving the weavers' families in despair. The gestures, the facial expressions, the figural groupings continue the kind of moral domestic dramas enacted in the 1770s on Greuze's pictorial stage (see fig. 11), where good and evil are pitted against each other in a turmoil of fierce glances, steadfast postures, upturned eyeballs, innocent children, and swooning women; but the context here is one of irreconcilable conflict between handicraft and factory

systems, capitalists and workers. *The Silesian Weavers*, like Biard's *Slave Trade*, communicated clearly its contemporary message. Friedrich Engels himself, who had surveyed the infernos of modern industrial life in England and Germany before collaborating with Karl Marx in writing the *Communist Manifesto*, said of Hübner's painting that it had helped to create a climate where new social ideas might be received. Indeed, Hübner could hardly have illustrated more forcefully what Marx and Engels conceived as the class struggle, although his use of an academic language may seem anachronistic, especially by contrast with, say, Gavarni's more casual treatment of the same economic polarities. But what is clear is that even before 1848, artists of the most varied style and talent felt compelled to record and to comment upon the pressing social realities that existed outside the fortresses of the academies or the imaginative realms charted by Romantic literature, opera, and ballet.

Yet there were other realities to be observed as well, and some no more consequential than momentary glimpses of what life looked and felt like within the privacy of one's own home. In Berlin in the 1840s, Adolph Friedrich

Fig. 184 **Auguste-François Biard**, *The Slave Trade*, Salon of 1835. Oil on canvas, 64 × 90″. Wilberforce House, Kingston upon Hull City Museum and Art Galleries.

Fig. 185 **Carl Wilhelm Hübner**, *The Silesian Weavers*, 1844. Oil on canvas, 30½ × 41⅛″. Kunstmuseum, Düsseldorf.

Erdmann von Menzel (1815–1905) turned from a successful commission to make four hundred engravings illustrating a published life of Frederick the Great to small-size oil paintings that recorded the modest facts of the domestic world around him. In *The Artist's Sister with Candle* of 1847 (fig. 186), we may still sense something of the coziness of a Biedermeier world; yet the candlelit atmosphere of shadow and quivering light evokes an unexpected, if unspecified mystery, and the paint is applied so sketchily that the straight edges of the doorways, walls, and framed pictures are as blurred as the material facts of furniture, costume, and still life. The young woman, we know, is the artist's sister, yet her appearance, en route from one room to another, with eyes turned toward something beyond our view, is so ephemeral that we can no more easily call this her portrait than we could call it the portait of the older woman seated at the far table. Menzel has caught here a world of private sensations that alternates between something objectively observed, available to anyone who was there at that time and place, and something so subjective that no one but the artist could have

selected and experienced it that way. The narrow, almost arbitrary visual range, with its startling croppings; the fusion of near and far in a vibrant continuum of muted color and light; the swiftness and fluidity of the brushwork that seizes only an instant of vision and feeling—such aspects of Menzel's unpretentious painting reveal an important subcurrent to the publicly oriented art of his generation, as if the page of an intimate domestic diary could begin to carry as much significance as a full-scale official statement. To be sure, many artists after 1848—Millet, Courbet, Daumier, the Pre-Raphaelites—would continue to locate their most ambitious works within a network of urgent social questions. But other masters, whether working under the banners of Realism or Impressionism, felt an equal conviction that their primary duty was to explore the point where their personal sensibility touched upon the immediately perceived experience of a world in which events might be no more enduring or consequential than a stroll on the beach, the lighting of a cigarette, the ripples of a boat on water, or the casting of a glance from one café table to another.

Fig. 186 **Adolph Friedrich Erdmann von Menzel**, *The Artist's Sister with Candle*, 1847.
Oil on canvas, 18⅛ × 12⅝″. Bayerische Staatsgemäldesammlungen, Munich.

Part 2:

❖

1815–1848

SCULPTURE

Introduction

We do not by any means wish to suggest that the history of sculpture between 1815 and 1848 was dominated by its social environment. Yet, to the extent that it was a public art, sculpture responded to the pressure of these forces, directly and indirectly, far more than did painting, and was shaped by them in varying degrees, depending on local circumstances. It seems appropriate, then, to begin our survey with the areas where the impact of political change on sculpture was least pronounced, and to conclude it with those where it was greatest.

The Mature Thorvaldsen

For all of Europe except France and the Iberian Peninsula, Bertel Thorvaldsen remained the model of sculptural perfection, more "truly Greek" than Canova, until the 1850s. After some lean early years (see page 113), Thorvaldsen quickly became Rome's most admired artist, and his studio, with its display of original plasters, was a pilgrimage goal for countless prominent visitors as well as aspiring artists. The Napoleonic wars in no way impeded Thorvaldsen's career. His only contact with the emperor was an indirect one: in preparation for Napoleon's visit to Rome, he was commissioned to model a huge relief frieze in plaster, *The Triumph of Alexander*, for the Palazzo Quirinale. When the visit was canceled, Napoleon ordered a marble version, but his fall prevented its delivery; it was acquired by an Italian collector, Count Sommariva, who installed it in his villa near Como. A painted view of Thorvaldsen's studio occasioned by the visit of Pope Leo XII on St. Luke's Day, October 18, 1826 (fig. 187), not only commemorates a unique honor but conveys the artist's role as the "reigning monarch of sculpture." The large enthroned figure next to the central doorway is Pope Pius VII, whose tomb in St.

Peter's had been commissioned from the staunchly Protestant Thorvaldsen in 1823. The sculptor himself, standing next to Leo XII in front of the papal monument, points to a colossal series of statues, the *Blessing Christ* and the *Twelve Apostles*, for the Protestant Church of Our Lady in Copenhagen. In the center is *Mercury about to Kill Argus* (1818), while another "modern classic," *The Three Graces*, appears in the right foreground behind a section of the Alexander frieze clearly inspired by the horsemen of the Parthenon frieze, which Thorvaldsen knew from reproductions, both casts and engravings (he never visited England, so did not see the originals in the British Museum). A longer portion of the Alexander frieze is dimly visible along the left-hand wall of the studio. The most conspicuous work in the picture is the huge equestrian statue of Prince Joseph Poniatowski, a commander of Polish troops in Napoleon's army, destined for Warsaw; the bronze cast, completed in 1832, could not be installed as a public monument because of Russian objections and remained in Russian exile until 1922. It is a "timeless" variant of the Marcus Aurelius in Rome, except for the portrait head and the extended right arm with its sword.

The sculptures in the painting do not include any hint of Thorvaldsen's most demanding project of the preceding decade, the restoration of the tympanum figures from the Temple of Aphaia at Aegina, which had been acquired, against Goethe's advice, by Crown Prince Ludwig of Bavaria in 1812. For a sculptor whose ideal was the classic Greek style from Phidias to Praxiteles, these Late Archaic fragments must have posed a special challenge; Thorvaldsen was justly proud of having matched them. His restorations, once a significant aspect of display at the Glyptotech in Munich, were removed when the sculptures were reinstalled in the 1960s.

In 1818, the Mayor of Lucerne approached Thorvaldsen with a proposal for a monument in the shape of a colossal dying lion to commemorate the members of the Royal

Fig. 187 **H. D. C. Martens**, *Pope Leo XII Visiting Thorvaldsen's Studio on St. Luke's Day, 1826*, 1830. Oil on canvas, 39½ × 54½″. Thorvaldsens Museum, Copenhagen (on loan from Statens Museum for Kunst).

Fig. 188 **Bertel Thorvaldsen**, *The Lion of Lucerne* (Monument to the Royal Swiss Guards of Louis XVI), 1819–21. Limestone (carved by Lukas Ahorn), length c. 30′. Lucerne.

Fig. 189 **Bertel Thorvaldsen**, *Lord Byron*, 1831. Original plaster, life-size. Thorvaldsens Museum, Copenhagen.

where, according to patriotic legend, the Swiss Confederation had originated more than five hundred years before. His opponents objected to the lion as a royalist symbol, saw no reason to honor (by implication) Louis XVI, and took little pride in the long Swiss tradition of military service as mercenaries in foreign lands. Thorvaldsen, unfamiliar with these arguments, thought of *The Lion of Lucerne* simply as an opportunity to project a sense of heroic pathos.

Thorvaldsen's indebtedness to Flaxman (see pages 97–98) is most clearly seen in his funerary reliefs for private patrons, which included many English admirers. One of them, Sir John Hobhouse, arranged the commission for the monument to Lord Byron, whom Thorvaldsen had portrayed from life in a bust in 1817. The committee expressed a preference for a seated statue, because of the "contemplative nature of poetry" and the poet's misshapen right foot. Thorvaldsen, who idolized famous literary figures despite his reputation of "never reading a book," relished the opportunity. His plaster model of 1831 (fig. 189) shows Byron perched on ancient ruins, with his right foot on the fragment of a Doric column, alluding to the poet's death in the Greek War of Independence. There is, however, nothing classically timeless about the monument: in modern dress, the poet looks like a secularized Evangelist receiving inspiration from on high, and the half-open mouth reinforces the impression that he has been caught at a moment when he is communicating with his muse. Because of Byron's "immoral character," it was banned from all public sites in London, and not until 1845 did it come to rest in the library of Trinity College, Cambridge.

England

Among the sculptors who came into prominence during the heyday of memorials to war heroes in St. Paul's between 1800 and 1815 (see pages 95–96 and 98–99), Francis Chantrey (1781–1841), who had executed a relief commemorating General Bowes, proved the most original. Unlike Westmacott, Chantrey was both too young and too poor to have gone to Italy before the onset of hostilities. The son of a tenant farmer, he served an apprenticeship with a woodcarver in Sheffield but was otherwise largely self-taught. Soon after 1805, he settled in London and married his cousin, whose sizable dowry helped him to launch a remarkably successful career. With the support of Nollekens (see page 94), Chantrey became a member of the Royal Academy in 1816, an unprecedented honor for a man of no formal artistic training.

Chantrey's greatest gift was for portraiture. His busts, the foundation of his fame, make few concessions to Neoclassical restraints; Chantrey always professed his admiration for François Roubiliac (see page 94), and work such as the

Swiss Guard, who had died trying to protect Louis XVI in 1792 during the storming of the Tuileries in Paris. The idea, including the dying lion and the site, a sheer wall of rock rising from a small pond just beyond the city limits of Lucerne, had been conceived and effectively promoted by Karl Pfyffer von Altishofen, former lieutenant in the Swiss Guards. Thorvaldsen consented, and within a year delivered the model, clearly based on Canova's mourning lion on the tomb of Maria Christina (see fig. 95); a local sculptor carved the monument itself (fig. 188). What attracted Thorvaldsen, surely, was the Romantic idea of a monument hewn into the living rock, rather than its political implications, which became the subject of a sharp public debate in Switzerland. Pfyffer von Altishofen, a Lucerne patrician of decidedly conservative, indeed reactionary, convictions, wanted the lion to honor not merely his dead comrades but, as the inscription proclaims, "The Loyalty and Virtue of the Swiss." He thought of it as a national monument, in a characteristically Swiss natural setting not far from the very spot

bust of his old friend the printmaker John Raphael Smith (fig. 190) clearly attests this renewed link with the Baroque tradition. Its ancestors are the *portraits en négligé*, the informal portraits with open-necked shirt derived from Bernini which Roubiliac had introduced into England. This is a "speaking likeness"—the sitter communicates frankly with the beholder: we note the turn of the head, the half-open mouth, the sensuous surface textures, the consistent avoidance of symmetry in the tilted cap and even in the features. Yet Chantrey's bust has a straightforward seriousness, a psychological acuity, and a realistic precision that differentiate it sharply from the Baroque. The same qualities also stand out in the best of Chantrey's grave monuments. In that of David Pike Watts (1817–26; fig. 191), the deceased is shown blessing his daughter and her children, a scene surely meant to evoke analogies with Old Testament

Fig. 191 **Francis Chantrey**, Monument to David Pike Watts, 1817–26. Marble, life-size. Ilam, Staffordshire.

Fig. 192 **Matthew Cotes Wyatt**, Monument to the Fifth Duchess of Rutland, unveiled 1828. Marble, height c. 20′. Belvoir Castle, Leicestershire.

patriarchs. There are echoes of Neoclassicism in the costumes of the daughter and the children, but the main figure wears a simple nightshirt. Although he shows no obvious marks of illness, his bearing, grave and gentle, movingly conveys his awareness of a final parting.

Matthew Cotes Wyatt (1777–1862), whose works were most in the public eye from the 1820s to the 1840s, was the very opposite of Chantrey. The son of a well-known architect, he went to Eton and soon became a favorite at court. He began his career as a painter, and his imagination was that of a theatrical designer rather than that of a sculptor. Wyatt's first great success, the cenotaph of Princess Charlotte August in St. George's Chapel, Windsor (1820–24),

with the princess's soul rising against a backdrop of endless yards of marble drapery, is indebted to Flaxman's Swedenborgian tombs (see fig. 78). The monument to the Fifth Duchess of Rutland at Belvoir Castle (**fig. 192**), unveiled in 1828, is simpler in design but equally theatrical. It, too, includes carefully contrived lighting by stained-glass windows. Within a proscenium of Romanesque columns and arches, the duchess soars from a medieval sarcophagus toward a Baroque heaven populated by four cherubs, the souls of her dead children. Historical references merge in a Romanticism more emotional than anything on the other side of the Channel at that time.

The United States

American colonial sculpture hardly existed aside from weather vanes, tombstone carvings, and cigar-store Indians. Public monuments, for example the lead statue of George III in New York, melted down for bullets during the Revolution, were few, and imported from England rather than produced at home. Thus the newborn republic had to look to Europe for a sculptor to immortalize its Founding Father (see pages 104–06). This may explain why William Rush (1756–1833), the earliest American sculptor of any ambition, had no more than a tangential relation to Neoclassicism, despite the fact that he helped to found and later directed the Pennsylvania Academy of the Fine Arts in Philadelphia. He was a woodcarver whose style has the playful charm of the Late Rococo.

Not until 1832, when Congress decided to commission a statue of Washington for the Capitol Rotunda, was a native-born sculptor ready for the task; on the advice of James Fenimore Cooper, it went to Horatio Greenough (1805–52). A Bostonian, Greenough had started modeling before he entered Harvard, and in 1825, barely twenty years of age, went to Rome to experience the ancient and modern classics. What he saw when he visited Thorvaldsen indicates what was to determine his own sculptural ambitions. Greenough settled in Florence, where he studied with Bartolini (see page 206) and remained until the year before his death. He set a pattern to be followed by a long line of American sculptors until the 1870s, when Paris began to displace Florence and Rome. Since these artists are habitually called "expatriates," we must understand that their behavior does not reflect upon their patriotism. They settled in Italy not in order to escape from America, but in order to measure themselves against the achievements of the Western sculptural tradition. Italy also offered the stimulating presence of other sculptors, as well as the finest marble and an ample supply of carvers. Significantly enough, neither Greenough nor his successors were eager to find European patrons. Their ambition was to receive monumental commissions in America, and even their

Fig. 193 **Horatio Greenough**, *George Washington*, 1832–41. Marble, height 10′ 6″. National Museum of American History, Smithsonian Institution, Washington, D.C.

private patrons were mainly Americans. They all kept in steady touch with friends and supporters at home; most of them, including Greenough, made repeated trips to the United States to further their projects. Without them, American sculpture would have remained hopelessly provincial.

Greenough's huge seated marble figure of Washington (fig. 193) was finished in 1841. Clearly, the artist wanted to create the most majestic and timeless image he could conceive; his *Washington*, nude to the waist, is derived from a classical Greek statue of Zeus. The subject is immediately recognizable, but the public refused to accept so remote and godlike an interpretation of the father figure familiar to all. And yet Greenough has labored strenuously to stretch the ideal of timelessness so as to relate the statue to the American experience: on one side of the throne, we find the infant Hercules strangling the snakes sent to attack him in his cradle while his brother hides his face in fear, a

reference to the political contrast between North and South America; the back of the throne is flanked by an Indian, in classical mourning pose, and Columbus contemplating a sphere. Even so, the work became a subject of heated controversy. After a brief time in its intended site, it stood outside the Capitol for many years, exposed to the rigors of the climate. Today, after further peregrinations, it is on display, somewhat incongruously, in the National Museum of American History.

Hiram Powers (1805–73), the first American sculptor to win international fame, followed Greenough's initiative. Born in Woodstock, Vermont, he spent his boyhood in Cincinnati. There he received instruction from a local artist and during his twenties did life-size wax figures for the Western Museum. Powers had meanwhile become an admirer of Greenough. In 1837, he went to Florence, where he remained for the rest of his life, concentrating his artistic

energies on marble statues of the female nude. By far the most famous of these, and the foundation of Powers's renown, is *The Greek Slave* (fig. 194) of 1843, known to us in the original plaster and six marble replicas. The figure was the star of the Crystal Palace Exhibition of 1851; the first marble was bought by a British nobleman, and some of the others toured the United States for years like the road companies of a successful play, admission being charged for viewing them (often with separate hours for men and women). It is difficult to imagine the intense emotional response evoked by *The Greek Slave*. For those old enough to remember, she brought back the pathetic tales of suffering that had circulated during the Greek War of Independence: a beautiful and virtuous Christian maiden—note the small cross among the tassels below the right hand—has

Fig. 194 **Hiram Powers**, *The Greek Slave*, after original plaster of 1843. Marble, height 65½". Yale University Art Gallery, New Haven, Connecticut.

been forcibly disrobed and is being offered for sale to some lustful Turk. For others, especially in America, where anti-slavery sentiment reached its peak in the decade before the Civil War, *The Greek Slave* conveyed the basic inhumanity of the "peculiar institution." But her appeal had a religious dimension as well. One critic, in 1847, wrote that "standing before this work, the beholder is not only spellbound by beauty, but awed by a solemn, ineffable feeling, and mysteriously drawn closer into the chastening presence of God." These words express the sculptor's own intention, for Powers was an active member of Swedenborg's New Church; like Flaxman, he believed that the soul was man's "spiritual body," and that "the nude statue should be an unveiled soul" in which the physical and the spiritual body coincide. His religious beliefs help us to understand his perfectionism, which included the materials he used—only a flawless piece of the purest white marble would do for him—and his concentration on a very limited number of types. More than any other nineteenth-century sculptor, he was concerned with the technique of marble carving and the sensuous, fleshlike surface he sought to achieve.

In characteristically American fashion, Powers combined his mystical faith with mechanical ingenuity. He became impatient with the traditional three-step process of his craft (clay model, original plaster, marble) and wanted to start by carving directly in plaster, but the existing sculptor's tools proved useless for this purpose. He invented his own, which came to be widely used by others.

Italy

Politically divided and in part under foreign rule, Italy between 1815 and 1830 was united, sculpturally speaking, by its reverence for Canova. Younger artists found it difficult to establish an identity of their own. The most notable and independent-minded among them, Lorenzo Bartolini (1777–1850), the son of a Tuscan blacksmith, went to Paris in 1797, where he was befriended by the young Ingres and became one of many Italians collaborating on the sculptural projects of Napoleon. In 1808, the emperor sent him to Carrara to establish a school for marble carvers. After the Congress of Vienna, Bartolini moved to Florence, but in this conservative environment he depended more on foreign patrons than on official commissions (he became a professor at the academy only in 1839). Theoretically, Bartolini was a fervent advocate of working from nature rather than from the ancient or modern classics; he even modeled a relief of a hunchback, symbolizing his claim that nature, despite all her shortcomings, must be the artist's supreme authority. The kneeling nude known as *Trust in God* (fig. 195) demonstrates that his practice, in general, was less radical than his pronouncements. The adolescent girl sits back on her heels with her hands folded in her lap. The

reclines on her deathbed, wearing a nightgown. She is rendered with a precise realism that is prophetic of *verismo* (the Italian term for the realistic style of the mid-century and after; see pages 334, 499–500).

The young Swiss-Italian sculptor Vincenzo Vela (1820–91), born in the small town of Ligornetto, a few miles north of the Lombard border, but trained at the Milan Academy, carried the challenge of *verismo* into the field of ancient subject matter with his *Spartacus* (fig. 196). The Thracian prince who led a slave revolt in republican Rome has here become a completely modern figure as he rushes down the steps in fury after breaking his fetters. His explosive physical and emotional energy led the Italian public, when the statue was first exhibited in 1850, to think of it not only as a revolutionary artistic achievement but to link it with the abortive revolt of the Milanese in 1848 against

Fig. 195 **Lorenzo Bartolini**, *Trust in God*, 1935. Marble, life-size. Museo Poldi-Pezzoli, Milan.

figure is not meant to be a personification of Faith, but rather a Christian entrusting herself to God. One senses that the artist has used a live model, even though the forms have been smoothed over and generalized. The nudity itself is symbolic of the spiritual message of the work—the Christian soul entrusting itself to the Lord. There is, then, a kinship here with the "unveiled soul" of Hiram Powers, who certainly knew Bartolini's work.

If a return to religion was part of the Romantic temper, so was the rediscovery of the Middle Ages (the "national past" as against the "universal past" represented by classical antiquity). Artistically, this included everything before the High Renaissance, so that Bartolini's interest in the fifteenth century made him a pioneer of Pre-Raphaelitism in sculpture. One of the most striking examples of this aspect of his work is the tomb of an exiled Polish aristocrat, Countess Zamoyska, of 1837–44 in Sta. Croce, in Florence. Set against an arched background panel of colored marble, it is a free adaptation of Early Renaissance tombs. The effigy itself, however, has little in common with its predecessors. Instead of lying in state as they do, the countess

Fig. 196 **Vincenzo Vela**, *Spartacus*, 1847. Original plaster, height 82″. Museo Vela, Ligornetto, Switzerland.

Fig. 197 **Carlo Marochetti**,
Monument to Duke
Emmanuel Philibert, 1833.
Bronze, height 14′ 5″
(without pedestal).
Piazza San Carlo, Turin.

the Austrians, a cause so dear to Vela's heart that he fought for it as a volunteer.

The only part of the north Italian plain not under Austrian domination was the westernmost area around the city of Turin, which belonged to the Kingdom of Sardinia. Politically and culturally, it had long been oriented toward France, where Carlo Marochetti (1805–67) had his early training. He went to Rome at his own expense for several years before his debut at the Salon of 1827. Nevertheless, he maintained a link with his native Turin, for which in 1833 he created his most original equestrian monument, honoring the sixteenth-century Duke Emmanuel Philibert (fig. 197). The statue was cast and exhibited in Paris before it reached its destination five years later, permitting conservative French critics to condemn it for its "theatricality." It is indeed a far cry from the classic model of Marcus Aurelius and the staid equestrian statues of French monarchs: the duke performs the symbolic gesture of sheathing his sword, a difficult feat on a prancing horse. Marochetti's emphasis on movement and drama, down to the wind-blown tassels on the horse's harness, has its sources in French Romanticism, especially Delacroix and Barye, but no one before him had dared to embody these qualities in a work of so monumental a scale.

After two active decades in France, Marochetti followed Louis-Philippe to England in 1848, where he spent another equally successful twenty years, favored by the court and the aristocracy.

Germany

During the years when Napoleon was at the height of his glory, Prussia maintained a precarious independence, although under heavy political pressure from France, which directly or indirectly dominated the rest of Germany. It was the emperor's disastrous Russian campaign of 1812 that made possible the German War of Liberation, under

Prussian leadership, which caused his downfall. While his defeats, from Leipzig to Waterloo, would have been impossible without the aid of Austria, Russia, and England, Prussia responded to victory with a sense of elation and national pride that had no counterpart among her allies, perhaps because they were, unlike Prussia, established great powers. In Berlin, this pride soon found visible expression in a series of monuments that made the city the sculptural center of Germany until the end of the century.

Johann Schadow (see pages 116–17) had laid a strong foundation. By 1815, however, leadership had passed to his most exceptional pupil, Christian Daniel Rauch (1777–1857). After several sojourns in Italy, where he admired Canova and especially Thorvaldsen, Rauch settled in Berlin in 1819. His first monumental task there, which he shared with other disciples of Schadow, was the Kreuzberg Monument (fig. 198), on a hill a few miles beyond the city limits—a war memorial as well as a celebration of the victorious war itself. War memorials (that is, monuments honoring the soldiers who died in action) were a Prussian invention dating from 1793. Subsequently, local war memorials of a modest sort began to be erected in Prussia even before the end of the War of Liberation. The Kreuzberg Monument was, however, more ambitious. As the inscription informs us, it is dedicated by the king to his people, who offered their possessions and their blood to the fatherland; in memory of those who died fighting; in praise of the living; and as a model for future generations. The glorification of patriotism, then, is the overarching theme. This explains why the king had ordered Karl Friedrich Schinkel (1781–1841), the foremost Berlin architect, to design the monument as a Gothic tower, in what had come to be regarded as the "national German style," regardless of its French origins, and in cast iron, the "patriotic material," rather than bronze. There are twelve niches, each holding a genius personifying a particular victory. The architectural framework was completed in 1820, within two years of the final design—a remarkable feat. In Schinkel's drawing, the statues resemble Gothic angels, but Rauch and his collaborators individualized them (fig. 199), using a strange mixture of ancient and medieval armor and weapons and introducing portrait heads of generals and members of the royal family. The two female geniuses are the only straightforward Neoclassical figures.

Even before the Kreuzberg Monument, Rauch had been busy with public statues of the principal Prussian generals, continuing the tradition started by Frederick the Great (see page 116). The most dramatic of these, completed in 1825, was that of Marshal Blücher (fig. 200). Since Blücher was famous as a particularly activist commander, Rauch shows him sword in hand, with one foot perched on the barrel of a cannon as if in mid-battle. The energetic movement and historically accurate uniform make this the least "timeless"

Fig. 198 **Karl Friedrich Schinkel**, Kreuzberg Monument, Berlin. Lithograph by Reiche, 1822, after Schinkel's drawing, 27 × 18″.

monument of its kind; only the great cloak, draped in a manner reminiscent of a toga, gives the statue a residual Roman air. The reliefs on the base, in contrast, still speak the language of Neoclassicism.

Meanwhile, the concept of the monument to genius had reached Germany from England and France, and soon after 1800, statues of Luther, Schiller, Goethe, Bach, Dürer, and Kant began to be erected in ever larger numbers. Rauch's most demanding task, which occupied him for over a decade, was the monument to Frederick the Great. While the project was initiated in 1787 (see page 116), not until 1836 was the dispute between timeless or historic costume resolved. Schadow's plan for an equestrian statue in historic costume had won out, but Rauch greatly elaborated the base. Statues of all of Frederick's generals on horseback were included at the four corners (fig. 201); one side was devoted to the cultural heroes of Frederick's reign,

Fig. 199 **Christian Daniel Rauch and assistants**, Kreuzberg Monument (detail), 1821–26 (statues), 1818–20 (architecture). Iron. Berlin.

Fig. 200 **Christian Daniel Rauch**, *Marshal Blücher*, 1824. Bronze, over life-size. Berlin.

Fig. 201 **Christian Daniel Rauch and assistants**, Monument to Frederick the Great, 1836–51. Bronze, over life-size. Unter den Linden, Berlin; photo c. 1935.

including Lessing and Kant. A second, narrower level, with seated allegories at the corners, displayed a frieze showing the manifold concerns of the king. The monument thus honored not only Frederick but the state that had grown to greatness under his guidance. It inspired many later monuments, equally rich but artistically less disciplined.

France

The fall of Napoleon, after a decade of imperial grandeur, left the French nation numb. For sculptors the problem of employment was grave, since the projects of the Empire were abandoned with the Restoration. To find work, whatever their political sympathies, they had to adapt to the demands of the new government, which chose to glorify royal history, rather than the singularly unimpressive present king. Under Louis XVIII, the revival of past French styles assumed the aura of patriotic duty, and the sculptors, having already experienced the revival of the antique, were prepared to handle these later revivals as well. During the Revolution, all equestrian monuments of royalty had been destroyed, and an effort was soon under way to replace them, such as the bronze statue of Henri IV (fig. 202), on the Pont Neuf, reconstituted in 1818 by François Lemot (1771–1827), approximating the original of 1614.

In the hands of a gifted artist, the retrospective orientation of state patronage under Louis XVIII could yield extraordinary results. The finest instance is the *Grand Condé* (fig. 203) by Pierre-Jean David d'Angers (1788–1856), one

Another government project, planned in 1815 and completed eleven years later, was the Chapelle Expiatoire, built on the spot where Louis XVI, Marie-Antoinette, and other members of the royal family guillotined during the Revolution were buried in a common grave with the Swiss Guards who had died in their defense. Its purpose was to purge the guilt of the French nation for having murdered their king-by-divine-right. The chief feature of the interior are two sculptural groups, *The Apotheosis of Louis XVI* by François-Joseph Bosio, and *Marie-Antoinette Succored by Religion* (fig. 204) by a younger sculptor, Jean-Pierre Cortot (1787–1843). The theme of the group was suggested by the queen's last letter, which is reproduced on the pedestal and which begins with the words, "I die in the Catholic apostolic and Roman religion. . . ." Here we find an odd dichotomy of style: Religion is a thoroughly Neoclassical figure while the queen displays the intense movement and emotion of the neo-Baroque. In historical costume with

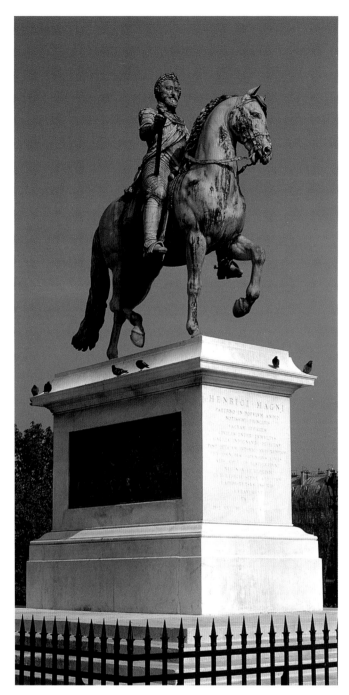

Fig. 202 **François Lemot**, *Henri IV*, 1818. Bronze, over life-size. Pont Neuf, Paris.

of a dozen colossal marble statues of heroes of the past on the bridge leading across the Seine from the Place de la Concorde, a repetition, on a grander scale, of the Great Men series (see pages 103–04). The fourteen-foot marble of Louis XIV's famous general, completed in 1827, no longer exists; its appearance is known from bronze casts of the maquette of 1817. David d'Angers chose the "significant moment" at Freiburg when the Grand Condé was about to hurl his baton at the enemy. He has achieved a paradigm of neo-Baroque dynamism more impressive than any members of the original series of Great Men.

Fig. 203 **Pierre-Jean David d'Angers**, *Grand Condé*. Bronze cast of sketch model of 1817, height 14″. Private collection.

streaming hair, she desperately clings to Religion, the lost crown at her feet. The contrast heightens the impact of the group, since it corresponds to two levels of reality—a living person and an allegory.

If the fifteen years of the Bourbon Restoration failed to gain the loyalty of the artists whose early careers fell within its time-span, it did not hinder their development. Four major sculptors whose most fruitful years fall after 1830—Rude, David d'Angers, Pradier, and Barye—shared a background of training in Napoleonic Neoclassicism at the École des Beaux-Arts. However individual their personalities, none of them repudiated this heritage, yet each in his own way absorbed Romantic ideas and attitudes.

Of the four, David d'Angers, who added the name of his home town to his own so as to avoid confusion with the painter Jacques-Louis David, whom he revered, serves as the most eloquent witness of the period. When David d'Angers undertook the *Grand Condé*, he had just returned from a five-year sojourn at the French Academy in Rome. He had an enormous range of friends and acquaintances, especially among the literary figures of his day (Victor Hugo wrote an *Ode to David* in 1828). A sensitive observer and skillful writer, he kept a diary that ranks with the journals of Delacroix.

For tomb sculpture, an important aspect of his work, David d'Angers preferred the "timeless" Neoclassical mode, such as the poetic memorial to Marco Botzaris, a hero of the Greek War of Independence, where a charming nude girl symbolizes the young Greek nation. His flexibility, however, is demonstrated in the striking monument to General Gobert of 1847 in the Père Lachaise Cemetery, which shows the mortally wounded general about to fall off his mount, a work undoubtedly influenced by Westmacott's Abercrombie monument (see fig. 81).

David's largest public commission was the sculpture for the pediment (1830–37) of the Pantheon, built as the Church of Ste.-Geneviève, but converted into a secular monument to the Great Men of France. Although the *Grand Condé* had assured his career during the Restoration, David remained a lifelong republican who keenly felt the supreme challenge of the Pantheon task. His solution—France flanked by Liberty and History, distributing laurel crowns to the great minds of art, science, and politics, as well as to men of action—made the pediment so crowded that its artistic merits proved a disappointment.

David d'Angers had a well-earned reputation as the greatest portrait sculptor of his time. Extraordinarily enough, the choice of sitter was entirely his own, determined by personal admiration and reflecting a characteristically Romantic view of the history-making hero. Profoundly convinced that physical appearance mirrors the soul, a brief reinforced by the then fashionable pseudo-science of physiognomy and phrenology, David d'Angers regarded his passion for portraiture as a moral and

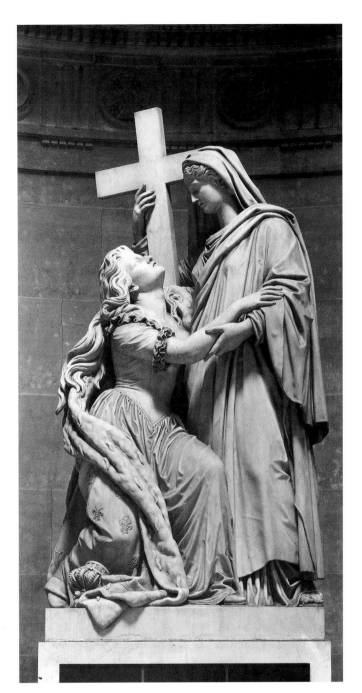

Fig. 204 **Jean-Pierre Cortot**, *Marie-Antoinette Succored by Religion*, c. 1825. Marble, over life-size. Chapelle Expiatoire, Paris.

aesthetic duty. To him each portrait was a monument to genius, destined to perpetuate examplars of greatness. His plaster bust of Victor Hugo (**fig. 205**) is austerely symmetrical and truncated in the manner of a Greek herm. The sculptor reserved this "timeless" format for a very limited number of "immortals" whom he honored with over life-size marble busts which he presented to the sitters, a generous form of homage unparalleled in the history of sculpture.

Bronze medallions, designed to take full advantage of the sheen of bronze, constitute by far the largest number

Fig. 205 **Pierre-Jean David d'Angers**, *Victor Hugo*, 1842. Original plaster, height 27″. Musée des Beaux-Arts, Angers.

1830s, Dantan's busts and statuettes reached such popularity that he sold reproductions of them commercially. To be caricatured by Dantan became a mark of distinction. Witty and inventive but never malevolent, Dantan deserved his peculiar fame, as a comparison of his bust of Victor Hugo (**fig. 207**) with David's will attest. Readers who know French might try to figure out how the author's name is "spelled" on the base.

During his tenure at the French Academy in Rome, James Pradier (1790–1852) must have known David d'Angers, and both became professors at the École des Beaux-Arts in 1828, Pradier taking the place of his former teacher Lemot. Otherwise, the two had little in common. A native of Geneva, Pradier spent his entire artistic career in France. He has often been labeled—and libeled—as the epitome of a dead-end phase of Neoclassicism. The conservatives accused him of too great a dependence on the Greeks ("he never invented anything") and an inability to understand the true nature of their art (his work lacks "chastity"), while Baudelaire, in his notorious essay of 1846, "Why Sculpture Is Boring," made Pradier the chief butt of his scorn, accusing him of misuse of "the noble crutch" of the Greeks to inflate the torsos of antique sculpture and fit them with the coiffures of kept women. Yet Pradier was a straightforward Neoclassicist only before the July Revolution. From 1830 on, he was part of the Romantic movement even when he dealt with classical subjects, except for a few solemn occasions such as the Victories he provided for Napoleon's tomb in Les Invalides. His life-size marble *Three Graces* has a robust sensuousness that would have embarrassed Thorvaldsen and would have been

(more than five hundred) of David d'Angers's portraits. Most of them are devoted to the artists and thinkers of his own time, done from life (David d'Angers made several trips abroad in order to portray foreign luminaries he admired, such as Goethe and Caspar David Friedrich). He reserved, however, a special niche in his pantheon of genius for the makers of the French Revolution, from Mirabeau to the young Napoleon. Most of them were long dead, so he had to reconstruct their features from whatever visual sources he could find. His three-quarter-view of Géricault (**fig. 206**), done six years after the subject's death, is the most impressive portrait there is of the painter.

The interest in sculptured portraits of celebrities which David d'Angers had helped to create had an unexpected but perhaps inevitable side effect: the sculpture caricature of the same individuals. Its inventor, Jean-Pierre Dantan (1800–1869), had been trained at the École des Beaux-Arts and also did serious, if conventional, sculpture. During the

Fig. 206 **Pierre-Jean David d'Angers**, *Théodore Géricault*, 1830. Bronze, diameter 6″. Bibliothèque Nationale, Paris.

Fig. 207 **Jean-Pierre Dantan**, *Victor Hugo*, 1832. Plaster, height 6¾″. Musée Carnavalet, Paris.

unthinkable for Canova. The Geneva *Rousseau* in his open-necked shirt owes more to Houdon's *Voltaire Seated* than to any classical statues of philosophers. As for the artist's much-maligned female nudes, the most successful of them, a life-size marble *Odalisque Seated* of 1841 (fig. 208), owes her inspiration to Ingres rather than the antique (compare fig. 130). Pradier's *Odalisque*, however, retains only a trace of Ingres's abstract sinuosity; she is far more natural, casual, and tangible. Something has attracted her attention, and she turns her head with a coolly appraising glance. More remarkable still is the fact that she has no principal view: her limbs are interlocked in such a way that we can read her pose only by looking at her from every possible angle.

Fig. 208 **James Pradier**, *Odalisque Seated*, 1841. Marble, life-size. Musée des Beaux-Arts, Lyons.

BAUDELAIRE AND THE CHALLENGE FOR SCULPTURE IN THE MID-NINETEENTH CENTURY

In the course of 1846, poet and critic Charles Baudelaire began to feel that the difficulty with sculpture lay in the nature of the medium—it was an art that had primitive origins and which lacked the sophistication of painting. Although effective at simulating physical reality, its three-dimensionality made it vague and vulnerable and it lacked a grounded, fixed viewpoint. For Baudelaire, sculpture should be considered subservient to other forms of aesthetics and it was the mediocre display at the Salon in 1846 that lay behind this analysis. In his view, the works were inconsistent and lacked scale because they were divorced from their proper role as architectural embellishment. For him the result was debasement and triviality:

As soon as sculpture consents to be seen from close at hand, the sculptor will risk all manner of trivial details and puerilities that triumphantly outstrip any pipes or fetishes. When sculpture has become a drawing-room or bedroom art, the Caribs of lace, like M. Gayrard, and the Caribs of the wrinkle, the hair and the wart, like M. David [d'Angers], at once appear. ... But it would be wrong to think that these artists lack knowledge of their art. They are as erudite as writers of vaudevilles and academicians; they plunder every period and art form; they scrape the barrel of every school. They would willingly make the tombs of Saint-Denis into cabinets for cigars or boxes for cashmere shawls, and all

the Florentine bronzes into penny pieces. ... The best proof of the pitiful state sculpture is in today lies in the fact that M. Pradier [see fig. 208] is its acknowledged master. At least he knows how to render flesh, and he has a peculiar delicacy of touch with his chisel; but he has neither the required imagination for large compositions nor the draughtsman's imagination. He is a cold academic talent. He has spent his life fattening up a few specimen torsos from antiquity, and adorning them with the hairstyles of kept women.[35]

By 1859 Baudelaire was seeing things differently and more poetically. He felt that in public places sculpture could shine, and could therefore trump painting in terms of its power. He argued that for sculpture to succeed it needed to reject the aims of painting. But he cautioned that as sculpture was becoming more modern, there was a temptation to overuse the previously rarified medium of marble. Advanced fabrication techniques made producing sculpture easier and more cost-effective, but removed its production from the creator's hand. As a consequence, he warned, the increased accessibility of sculpture for purchase by the middle classes would result in a dilution of quality, due to the purchasers' suspect tastes.[36]

Just as lyric poetry makes everything noble—even passion; so sculpture, true sculpture, makes everything

solemn—even movement.
Upon everything which is human it bestows something of eternity, which partakes of the hardness of the substance used. Anger becomes calm, tenderness severe, and the flickering and faceted dream of painting is transformed into a solid and stubborn meditation.[37]

Despite this promise of transcendence, the tone of much of Baudelaire's criticism is ironic and arch, and certainly the works do not measure up to his aspirations for the medium. He concludes his essay by arguing that sculpture continues to fall short of his ideals:

...the most ingenious and the most patient of talents can in no wise do duty for a taste for grandeur and the sacred frenzy of the imagination. ... whatever the *skill* that is annually displayed by our sculptors, nevertheless, since the death of David [d'Angers, in 1856], I look around me in vain for the ethereal pleasures which I have so often had from the tumultuous, even if fragmentary, *dreams* of Auguste Préault.[38]

Eighteen years would pass before a sculptor showed at the Salon who might have met Baudelaire's prescription for a grandly imaginative three-dimensional art—it was not until August 1877 that Auguste Rodin exhibited his Age of Brass *(see fig. 481). Baudelaire had died on the final day of August 1867.*

Many of Pradier's statues were offered to private collectors in bronze reductions. The artist also modeled a number of statuettes for the same market, and these reveal his diverse abilities. He pioneered in subjects taken from everyday life, such as *The Ironer* or *Woman Putting on Her Stocking*; at the same time he anticipated the Rococo revival of the 1860s with daringly risqué bacchantes and satyrs.

François Rude (1784–1855) won the Prix de Rome in 1812, but was prevented from taking up the award by a

shortage of funds. Disappointed, he returned to Dijon, his native city, where he zealously took Napoleon's side after the emperor's return from Elba. He thus had reasons to fear for his safety under Bourbon rule and sought refuge in Brussels, as had Jacques-Louis David. During his years in Belgium, Rude was far from idle as a sculptor, but when he returned to Paris, he struck out in new directions, evident in *Mercury Attaching His Winged Sandals*, shown at the Salon of 1827. Like Houdon's *Diana*, Rude's *Mercury* borrowed the movement of the *Flying Mercury* of

Giambologna but took its proportions from the French Renaissance tradition.

Rude exhibited the plaster model of the *Neapolitan Fisherboy*, more directly linked with the Romantic movement, at the Salon of 1830–31, and the marble two years later (fig. 209). The freshness and originality of Rude's choice of subject, observed directly from nature without any concessions to "beauty," have been largely obscured by its countless imitators. Having never been to Italy, Rude must have found the motif among paintings of Italian folk life, such as those by the Swiss Léopold Robert (see fig. 167), which were appealing to the Romantic taste for distant people and places. Rude was the first to isolate a figure from this repertory and make it the subject of a life-size marble, challenging a basic tenet of Neoclassicism that regarded scenes from everyday life as unworthy of the sculptor's art. Despite the mutterings of conservative critics, the work was a sensational success, bringing Rude the cross of the Legion of Honor.

By 1836, Rude had completed his masterpiece, *The Departure of the Volunteers of 1792*, commonly called *The Marseillaise* (fig. 210), for the triumphal arch of the Place de l'Étoile. The enormous arch, begun in 1806 as Napoleon's most conspicuous project of self-glorification, remained unfinished in 1815. During the Restoration, there were plans to convert it into a monument celebrating the reinstated Bourbon monarchy, but little was actually done. For Louis-Philippe and his energetic minister of the interior, Adolphe Thiers, it became an opportunity to demonstrate national reconciliation; the sculptural program had to offer something to every segment of the French political spectrum. Rude was lucky in getting a commission for one of the four groups that were to flank the opening. He raised his subject—the French people rallying to defend the Republic against attack from abroad—to the level of mythic splendor. The volunteers surge forth, some nude, others in classic armor, inspired by the great forward movement of the winged Genius of Liberty above them,

Fig. 209 **François Rude**, *Neapolitan Fisherboy*, 1831–33. Marble, height 30½". Louvre, Paris.

Fig. 210 **François Rude**,
The Marseillaise (The Departure of the Volunteers of 1792), 1833–36. Limestone, height c. 42'.
Arc de Triomphe de l'Étoile, Paris.

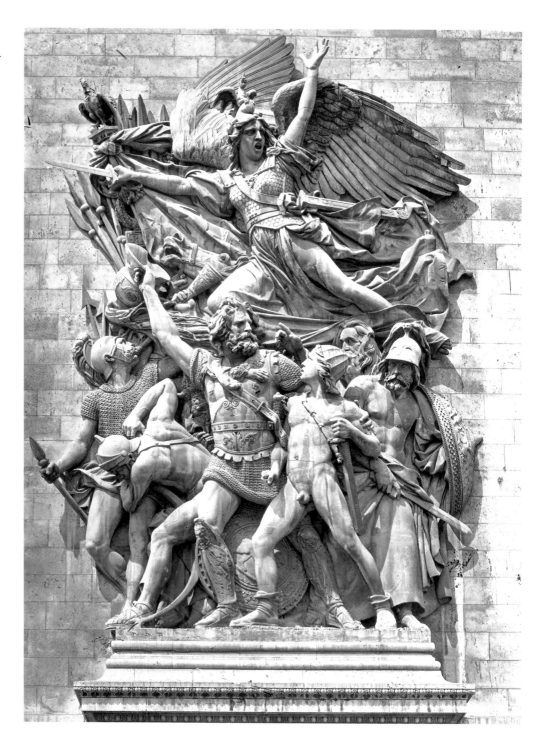

engendering an emotional response that made people identify it with the national anthem itself. The group had a deeply felt personal meaning for Rude: his father had been among those volunteers.

When the arch was officially unveiled in 1836, there was almost unanimous agreement that Rude's group made the other three pale into insignificance. Only the bold Genius of Liberty drew negative comments from conservatives. One critic called her "a fishwife" and even David d'Angers felt that there was "exaggerated passion" here. Despite its great public acclaim, *The Departure* failed to gain Rude the official honors he so clearly deserved, and he found himself

more and more in opposition to the regime. Indeed, his most important works between 1836 and 1848 were direct expressions of his political beliefs. In 1840, the remains of Napoleon were brought back from St. Helena and solemnly entombed in the Dôme des Invalides in Paris. This "return of the emperor" rekindled the enthusiasm of his admirers, who included both Rude and his friend Noisot, a wealthy vintner at Fixin near Dijon. Noisot, a former captain of grenadiers under Napoleon, conceived the extraordinary idea of putting up a monument to the emperor's glory on his own property at Fixin; Rude immediately agreed to provide the model free of charge. The result was *Napoleon*

Reawakening to Immortality (**fig. 211**). By 1847, the monument was in place on a wooded hillside above Noisot's vineyards. On a rock to which he had been chained like Prometheus, and above the dead eagle of empire, Napoleon is slowly coming back to life, his right arm lifting the shroud that covers him so that we see his shoulders and laurel-wreathed head. The work has a gentle, lyric air, completely devoid of the rhetoric of *The Departure*. In itself, the idea of a hero's "resurrection to glory" was not wholly new; but Rude succeeds in translating the concept of a symbolic reawakening into a compelling visual experience.

The Salon of 1831 also marked the first public success of Antoine-Louis Barye (1796–1875), who showed his *Tiger Devouring a Gavial of the Ganges* (**fig. 212**). The son of a goldsmith, Barye began his career as a metal engraver and die cutter. From 1812 to 1814, he served as a conscript in Napoleon's army. Two years later, he began to study with François-Joseph Bosio and the painter Antoine-Jean Gros (see pages 66–69), and in 1818 was admitted to the École des Beaux-Arts, where he tried unsuccessfully to win the Prix de Rome. Until 1831, he worked for a goldsmith, modeling small figures of animals to be used in jewelry. At the same time, he spent his free hours at the Jardin des Plantes (the Paris zoo), sketching live animals and studying their anatomy, interests he shared with his friend Delacroix. Thus the *Tiger* of 1831, Barye's first large-scale animal scene, displayed a realism based on thorough zoological knowledge. What really impressed critics and public alike, however, was the ferocity of the tiger, the pitiless display of "nature red in tooth and claw" so exciting to the Romantic imagination. Animal combats had a long tradition going back to classical antiquity, but Barye disregarded all such precedents. While he studied his exotic animals directly from nature, what mattered was not zoological plausibility but the expressive power of the group, intensified by its monumental compactness of design.

Barye's *Lion Crushing a Serpent* (**fig. 213**) electrified the Salon of 1833. The state ordered a bronze cast for the Tuileries Gardens, and the artist received the cross of the Legion of Honor on the same day as Rude. The impact of

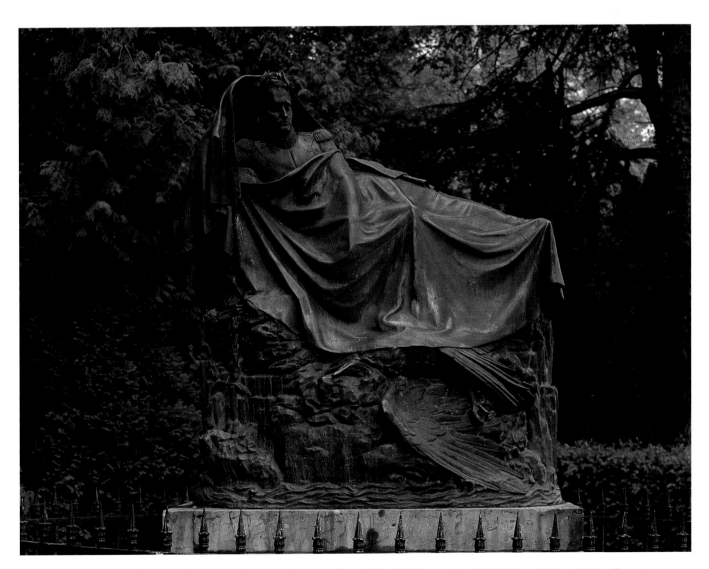

Fig. 211 **François Rude**, *Napoleon Reawakening to Immortality*, 1845–47. Bronze, length 99″. Parc Noisot, Fixin, France.

Fig. 212 **Antoine-Louis Barye**, *Tiger Devouring a Gavial of the Ganges*, 1831.
Bronze, length 39½". Louvre, Paris.

Fig. 213 **Antoine-Louis Barye**, *Lion Crushing a Serpent*, 1833. Bronze, length 70". Louvre, Paris.

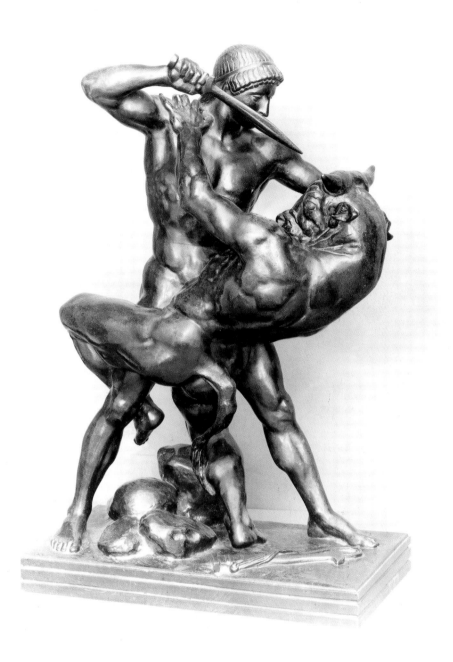

Fig. 214 **Antoine-Louis Barye**, *Theseus and the Minotaur*. 1840. Bronze, height 18¾". Ny Carlsberg Glyptotek, Copenhagen.

this group was even greater than that of the *Tiger* because the antagonists were more evenly matched: the snake might strike before the lion's grip succeeds in immobilizing it, while the gavial is a mere victim. Moreover, the group offered a tribute to the July Revolution (July is under the zodiacal sign of Leo), with the lion representing the power of the people and the snake the evil Bourbon dynasty.

As government patronage declined, Barye depended increasingly on the sale of small bronzes to private collectors. He established his own foundry, but went into debt and had to go into partnership with an entrepreneur, thereby losing control over the quality of the casts.

Although animal subjects predominate among Barye's small bronzes, they were by no means his exclusive concern. He also drew themes from history, literature, and classical mythology. *Theseus and the Minotaur* (fig. 214) represents the serious domain of classical myth, second only to biblical subjects in moral authority; it demands and receives monumental treatment, quite independently of its actual size. The bodies of the two antagonists are weighty, the anatomical detail simplified. Theseus' victory is preordained, so that the struggle assumes the quality of a ritual; the Minotaur, despite his superior strength, is terrified, while Theseus acts with the calm assurance of a god. The lack of expression on his face, his stylized hair, even his stance, with the body weight distributed evenly over both legs, hark back to Greek Archaic art. But the pose of Theseus also derives in part from Géricault's drawings of

British boxers, some of which Barye had copied. The group is prophetic of Barye's monumental sculpture after 1848 (see fig. 307).

August Préault (1809–79), the most interesting of the generation of sculptors too young to have experienced the Napoleonic era, was termed by one of his contemporaries "a genius without talent"; he may have been the first to earn this epithet, which in later years was applied to so many others (even Van Gogh) that it became a cliché. From all accounts, Préault was a fascinating conversationalist, widely acquainted among Romantic writers and artists. He studied briefly with David d'Angers, whom he regarded as a kind of father figure, with all the ambivalence implicit in that relationship.

Préault's ambitious relief titled *Tuerie* (*Slaughter*; **fig. 215**), sent to the Salon of 1834, suggests that his interest centred on extreme physical and emotional states. He submitted the panel as the fragment of a larger composition; but the design is quite self-contained, even though, except for the baby, every figure in it is a fragment. The style of *Tuerie* must be termed neo-Baroque, yet its violence far exceeds anything to be found in Baroque art, and its expressive distortions, its irrational space filled to bursting point with writhing shapes, evoke memories of Gothic sculpture. In fact, the helmeted knight's face next to that of the screaming mother hints that the subject itself is medieval: some dread apocalyptic event beyond man's control. As a radical attack on the rules of classical relief, *Tuerie* was acclaimed by avant-garde critics (what the others thought of it can easily be imagined). Its very extremism, however, condemned it to being a dead end; it established the sculptor's reputation as the archetypal Romantic sculptor but also barred him from the Salon until 1849. Préault showed the plaster again at the Salon of 1850 and soon after had a bronze cast made, which was bought by the state in 1859, twenty-five years after its creation.

Such belated recognition was shared by a good many other works regarded as too radical in the early 1830s.

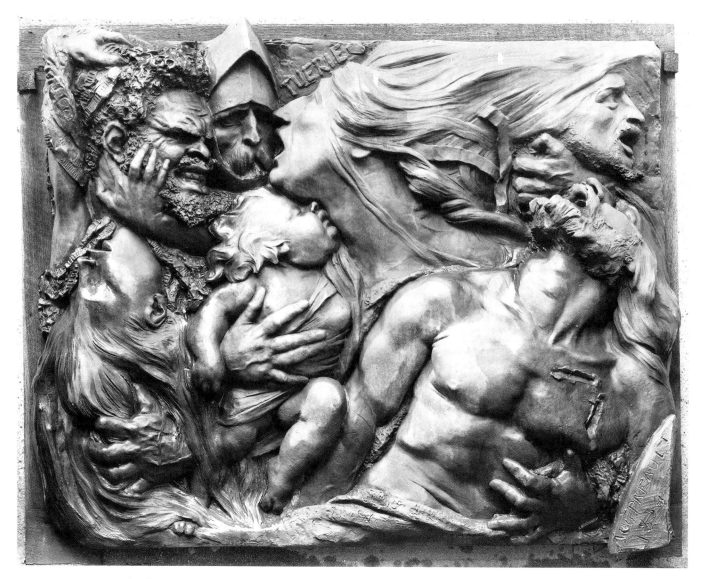

Fig. 215 **Auguste Préault**, *Tuerie (Slaughter)*, 1833–34. Bronze (1854), 43 × 55″. Musée des Beaux-Arts, Chartres.

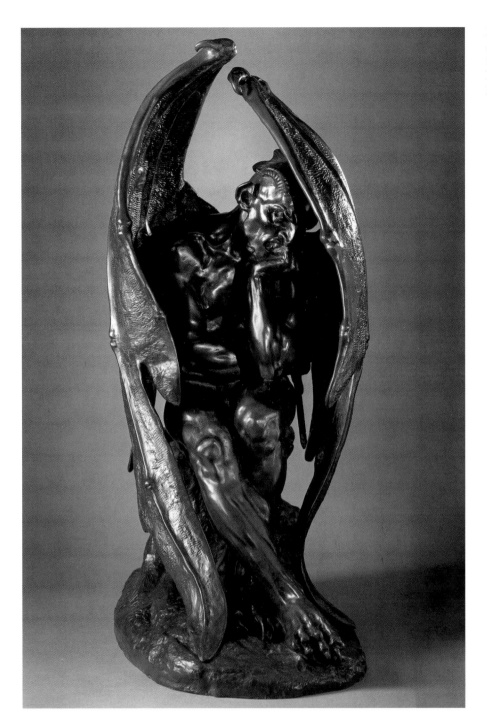

Fig. 216 **Jean-Jacques Feuchère**, *Satan*, 1834. Bronze enlargement (1850) of the original plaster, height 31″. Los Angeles County Museum of Art.

Meanwhile, the regime of Louis-Philippe did not treat Préault as an outcast; in the 1840s, he received three commissions from the state, and the state even paid him for a wooden *Crucifix* of 1840.

The revival of religious art promoted by both the Restoration and the government of Louis-Philippe gained its impetus from Romantic literature, even if the ultimate source of themes is biblical. The Romantic fascination with Evil made Cain and Satan favorite characters, and their isolation as "antiheroes" in sculpture was a novel development. As early as 1820, Barye submitted a statue of *Cain Accursed of God* (now lost) for the Prix de Rome, and it was the life-size group *Cain and His Race* of 1833 that

brought Antoine Étex a commission for two groups on the arch of the Étoile. As Cain's counterpart, the dead Abel became an equally popular subject for sculptors, although many of these prone bodies of beautiful nude youths are barely distinguishable from their Neoclassical predecessor, the dead Hyacinth (see fig. 46), and similarly statues of Eve may be hard to tell apart from those of Venus.

In the wake of Chateaubriand's translation of Milton's *Paradise Lost* in the 1829s, Satan, "the rebellious angel falling into the abyss," began his career as a sculptural subject. The most impressive example was the *Satan* by Jean-Jacques Feuchère (1807–52) at the Salon of 1834, enlarged in bronze in 1850 (**fig. 216**). Encased, as it were,

in his huge bat's wings, Satan broods over his defeat in the well-known pose of Melancholy derived from Dürer's engraving. Despite his goat's horns and taloned feet, Feuchère's figure is so nearly human as to enlist some measure of compassion.

Auguste Clésinger (1814–83) had a brief moment of glory the year before the Revolution of 1848. In his late teens, Clésinger was taken to Rome by his father, also a sculptor, in 1832. Then he spent the next dozen years moving about before settling in Paris. Vain and ambitious but unsteady, he exhibited at the Salon from 1843 on. He met with only indifferent success though he cultivated the critics assiduously in the hope of favorable notices. He finally achieved his goal in 1847 with the life-size marble of a *Woman Bitten by a Snake* (**fig. 217**), a sensuous nude writhing on the ground in mingled agony and ecstasy. Pradier had paved the way for Clésinger with similarly voluptuous female nudes (see fig. 208). Clésinger could easily have named his figure Eurydice or Cleopatra, but he ensured a *succès de scandale* by not doing so. The critics'

praise for the realism of the *Woman* was nourished by gossip that apparently had some foundation in fact: the model was said to be Mme. Sabatier, who had been the sculptor's mistress before she left him for her current lover. At the latter's request, Clésinger had made a plaster cast of Mme. Sabatier, and the *Woman* was no more than a slightly retouched version of this cast. The story was a journalist's dream, and it helped to make the *Woman* more famous than she deserved to be. Still, she holds a place in the history of sculpture as a step beyond Pradier in the direction of the Rococo revival of the Second Empire. Clésinger exploited his *Woman* by producing variants and reductions of her. Yet she could be said to have ruined his future, simply by overshadowing everything else he did. Even without her, however, Clésinger must be remembered as a masterly portraitist. His bust of the painter Thomas Couture (**fig. 218**), whose *Romans of the Decadence* (see fig. 158) had stunned the same Salon that held Clésinger's *Woman*, has a vital presence that was truly astonishing for 1848.

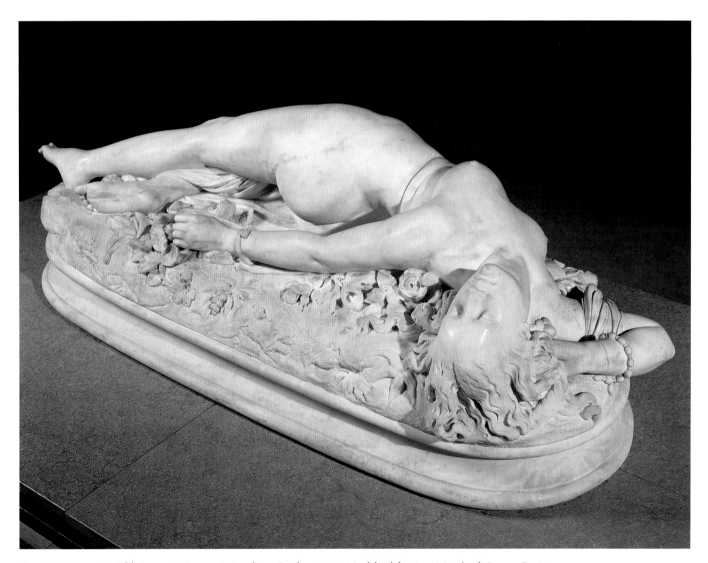

Fig. 217 **Auguste Clésinger**, *Woman Bitten by a Snake*, 1847. Marble, life-size. Musée d'Orsay, Paris.

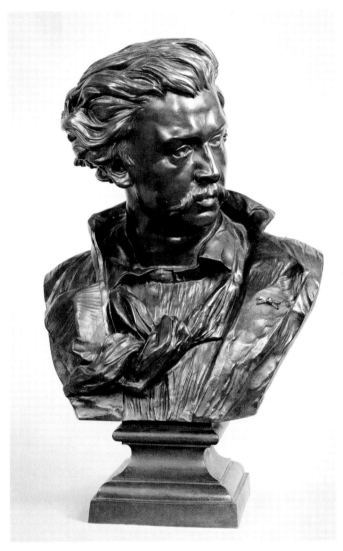

Fig. 218 **Auguste Clésinger**, *Thomas Couture*, 1848. Bronze, height 31″ (including base). Los Angeles County Museum of Art. Gift of Michael Hall in Honor of Kenneth Donahue.

The Romantic Theory of Sculpture

In contrast to the abundance of theoretical writings that accompanied Neoclassical sculpture, there exists, to my knowledge, only one piece of writing that sets forth a general theory of sculpture from the Romantic point of view: Baudelaire's essay of 1846 "Why Sculpture Is Boring," which occupies a few pages in his long review of the Salon of that year. The essay is mentioned above in the context of the poet's scathing comments on Pradier. Actually, Baudelaire was less concerned with the state of French

sculpture at that moment (which struck him as deplorable—the only sculptor he evidently respected was Préault, and he cited his opinions, not his works) than he was with the limitations of sculpture as an art form. If we take him at his word, there can be no such thing as Romantic sculpture, because, unlike the painter, the sculptor cannot control the beholder's view of his work. Baudelaire took it for granted that there is only one "correct" view for a given piece of sculpture, and thought it purely a matter of chance whether the beholder discovers it or not. Here he turned an old argument upside down: in the Renaissance literature on the *paragone*, the comparison of the arts, those who favored sculpture had maintained that while painting is only an illusion, sculpture is "real" because of its three-dimensionality and hence offers an infinity of views, whereas painting offers only one. For Baudelaire, the three-dimensionality of sculpture is evidence of its basically primitive nature. Every piece of sculpture to him is a "fetish" whose objective existence prevents the artist from making it a vehicle of his subjective view of the world, his personal sensibility. Lacking that precious quality, what is sculpture good for? Baudelaire claimed that it can rise above the "fetish" level only if it is in the service of architecture, enhancing a larger whole such as a Gothic cathedral or the palace of Versailles. As soon as sculpture detaches itself from this context, as soon as it invades the living room and the boudoir, it reverts to its primitive status as a "fetish." There is an implied historical perspective here that can be traced back to the end of the eighteenth century: it postulates that the three visual arts correspond to different levels of man's development and therefore reach their highest point of achievement at different times, the Age of Architecture preceding the Age of Sculpture, and the Age of Painting representing the most recent (and highest) stage. One almost gains the impression that Baudelaire started with the conviction that sculpture is an art inevitably passé and then looked around for arguments to prove his point. In principle, his attitude is not basically different from Winckelmann's, who had claimed that classic Greek sculpture represented the highest degree of perfection sculpture was capable of; Baudelaire simply shifted his emphasis from Greek temples to Gothic cathedrals and Baroque palaces. Fortunately, his theory was not taken at face value by either artists or patrons, but it does suggest the difficulty Romantic sculptors, or those sculptors who thought of themselves as part of the Romantic movement, had in establishing a self-image with which they could live.

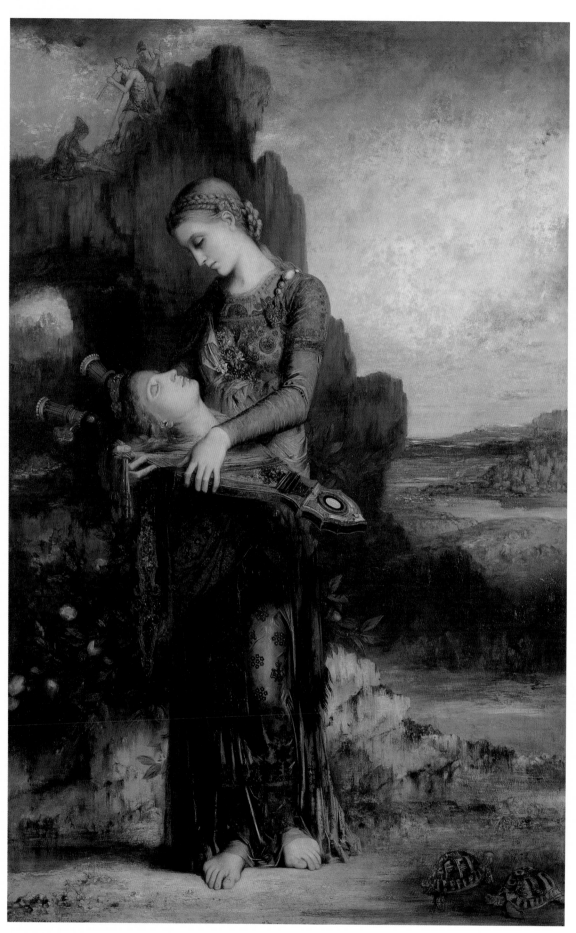

Gustave Moreau, *Orpheus*, 1865 (Salon of 1866). Oil on canvas, 61 × 39½″. Musée d'Orsay, Paris.

Part 3:
❖
1848–1870

Part 3:

❖

1848–1870

PAINTING

The 1848 Revolution: Some Pictorial Responses

When Delacroix, in 1830, painted the revolutionary July days as an allegory of *Liberty Leading the People* (see fig. 127), he was able to orchestrate in a convincing whole both the rhetorical, ideal symbol of liberty and a journalistic account of civilian streetfighters, dead and alive, in contemporary costume within a modern Paris environment. But by 1848, the year of revolutions not only in Paris, but throughout Europe, from Berlin to Palermo, this wedding of traditional allegory and reportorial document seemed rent apart, as if the overwhelming new facts of nineteenth-century experience had for ever banished the abstract language of timeless symbols into an anachronistic, vacuum-packed world where the air was so pure that it could no longer sustain life.

A perfect example of this rupture can be found in the responses of French painters of the same generation to the events, ranging from the uplifting to the grisly, that began in a startlingly swift three-day revolution, from February 22 to 24, 1848, and ended with Louis-Philippe's abdication. There followed a series of chaotic provisional governments that instituted welfare workshops to alleviate the drastic unemployment and then held an election in which, for the first time in European history, almost every male—if not female—adult was given the right to vote. (Some nine million Frenchmen went to the polls, whereas under the July Monarchy, suffrage was granted only to wealthy "stockholders" of the government.) But even before this election, the new Second Republic sought out a visual icon for its utopian resurrection of the First Republic's dreams of the 1790s, and on March 18, 1848, a competition was announced for a symbolic figure of the new regime. Although Daumier himself was one of the twenty finalists in the painting division, it was mainly artists of a more high-minded academic persuasion who aspired to this lofty task. Of these, Armand Cambon (1819–95), a student of

Ingres, is typical in his efforts to perpetuate the traditionally abstract language and style of allegory. With her frontal, immobilized posture, fixed beneath the perfect arch of a rainbow, his *Republic* (**fig. 219**) belongs to the dynasty of Ingres's *Napoleon* and *Jupiter* (see figs. 49 and 54). Her Olympian throne, whose base bears, in inscribed Roman

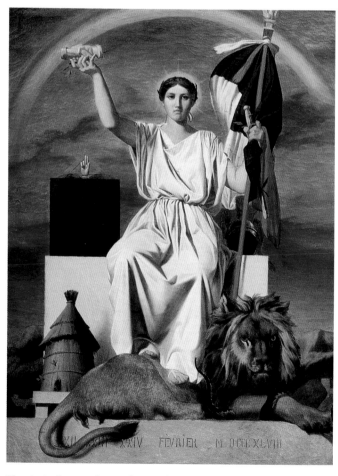

Fig. 219 **Armand Cambon**, *The Republic*, 1848.
Oil on canvas, 29¼ × 21¼″. Musée Ingres, Montauban.

numerals, the revolutionary dates, is as pure as a lesson in solid geometry; and her feet rest on a lion which symbolizes the power of the people (although in 1830, the symbolically flexible lion could refer, in astrological terms, to the new July Monarchy). Far above our earthly heads, she holds a flag and an oddly disembodied pair of clasping hands that stand for Fraternity. Among the other symbols, a beehive suggests, as it had under Napoleon, communal labor. This strange assortment of palpable, cleanly defined objects—nouns without verbs—has the abstruse quality of a rebus, although, for much later generations, its irrational scale, odd juxtapositions, and clear-eyed rendering of individual facts make it a precursor of Magritte's Surrealism. But however we respond to this bizarre dictionary of objects, the chill the image casts is remote and unpolluted. Her eyes averted from terrestrial events below, *The Republic* belongs to a serenely timeless realm, which in fact corresponded to the competition's premise that an icon of stability might magically affect the instabilities of the real world in 1848. When in October of that year the jury of statesmen and establishment artists finally scrutinized the submissions, it was decided to give no prize at all; for clearly, even to them, the results were hopelessly out-of-joint with the demands of history.

One of the jurors was an artist of Cambon's generation, Jean-Louis-Ernest Meissonier (1815–91), whose experience of 1848 could not have been more at odds with these still-born allegories. By June 1848, the makeshift improvements of the conditions of Paris workers had been so negated by governmental shifts to the right that full-scale riots broke out in the working districts, culminating in four bloody days (June 23–26), when the army, under General Cavaignac, was called in to suppress what seemed to be almost an immediate demonstration of the fratricidal class warfare Karl Marx and Friedrich Engels had discussed in their *Communist Manifesto*. Published in London in January 1848, the *Manifesto* urged an international proletarian revolution, and observed how the economic conflicts between freeman and slave, lord and serf had been transformed by the mid-nineteenth century into a struggle between capitalist and worker. Before 1848, Meissonier had painted agreeable eighteenth-century genre subjects with a miniaturist precision that lent an otherworldly distance and nostalgia to a prerevolutionary past. But during the "June days" of 1848, this master of what contemporaries often referred to as a Lilliputian style was called to duty as a captain in the National Guard. Before the Hôtel de Ville, which his troops were defending, he became an eyewitness at the barricades to the spectacle of, in his own words, "defenders slain, shot down, thrown from the windows, covering the ground with their corpses, the earth not yet having drunk up all the blood." When the mayor of Paris asked the Republican Guard whether all the victims were guilty, the answer was that, to be sure, not more than a quarter were innocent.

From this traumatic revelation of the moral and physical horror that accompanies any war, and especially civil war, Meissonier created a pictorial catharsis which he first submitted to the Salon of 1849 under the title *June*, and then decided to withdraw until the Salon on 1850–51, when it appeared under the title *Memory of Civil War* (**fig. 220**). Even the precedent of Goya's *Disasters of War* or Daumier's *Rue Transnonain* (see fig. 181) offers inadequate preparation for the close-up scrutiny of the facts of modern military death that Meissonier insists on here. Behind the stone rubble of the barricades, abruptly cropped at the right as in a narrow-range photograph, lies what a contemporary described as an "omelette of men," a black-humored metaphor that nevertheless captures the indiscriminate scramble of a slaughter. The ignoble truths of violated flesh and blood, of grotesque foreshortenings, and of ripped clothing are presented with the chilling veracity of a modern news photo that might document anything from the corpses of the Crimean War to those of a Nazi concentration camp. All the empyrean poetry of Delacroix's scene of the glorious July days of 1830 has vanished into thin air, leaving behind nothing but the terrible earthbound facts. Of course, all good artists, like all good photographers, edit their work, and Meissonier has chosen, for one, a patriotic palette that evokes, in red blood and blue and white clothing, the tricolor. Moreover, his increasingly blurred rendering of this street, the rue de l'Hôtel de Ville, as it funnels away from us, gives it the same generalized, imprisoning gloom often found in the abbreviated city backgrounds of Daumier's and Gavarni's lithographs, Such an effect was especially appropriate to this working-class street, which, in 1832, when it was called the Rue de la Mortellerie, was a prominent site of another urban apocalypse, a cholera plague. But most of all, Meissonier has tempered the shock of reality here by the surprisingly tiny dimensions of the canvas (less than a foot high) and by the jeweler's precision of his technique, both of which evoke the unreality of the miniaturist's art. Yet even relative to Daumier's view of civil massacres, documentary truths overwhelm artistic fictions here to a degree that brutally discloses the anachronism of Cambon's *Republic*, while proclaiming the possibility that art and reality might become one.

Meissonier's painting, in fact, was not only prophetic of other mid-century efforts, such as Winslow Homer's and Manet's, to document, with seeming objectivity, the facts of wars, uprisings, and executions on both sides of the Atlantic, but also of the new use of photography to record for history the human realities of war. Although photographs had been made of the Crimean War (1853–56), it was the American Civil War that prompted the fullest expansion of what would later be called photo-journalism. The successful photographer Matthew Brady, who, with his large display of daguerreotype portraits, won the top award at London's Great Exhibition of 1851, decided a decade

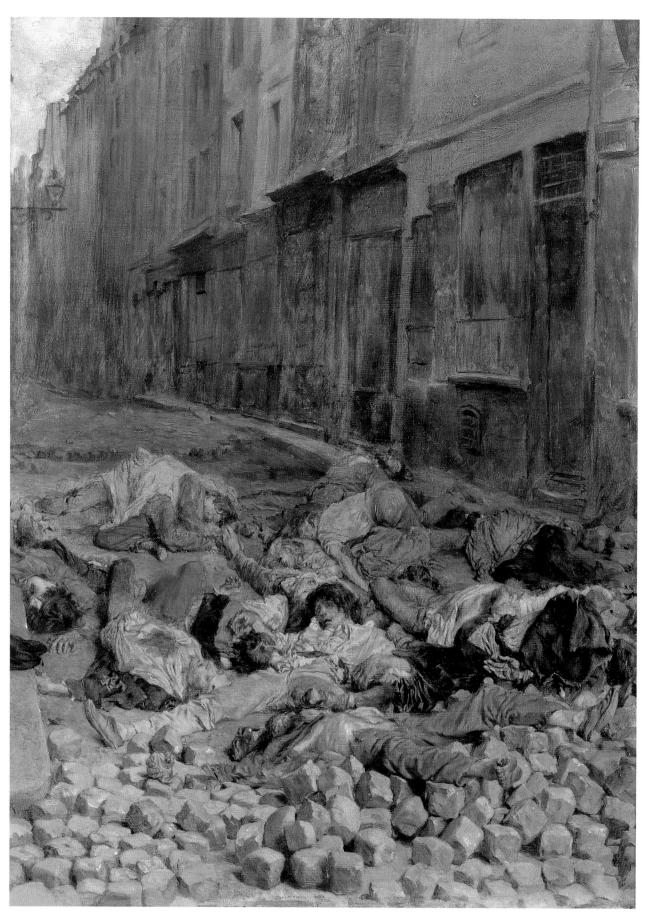

Fig. 220 **Jean-Louis-Ernest Meissonier**, *Memory of Civil War (The Barricades)*, 1849 (Salon of 1850–51).
Oil on canvas, 11½ × 8¾″. Louvre, Paris.

Fig. 221 **Timothy O'Sullivan**, *A Harvest of Death, Gettysburg, July 1863*. Albumen silver print. Library of Congress, Washington, D.C.

later, at the outbreak of the Civil War, to use his profession in the manner of a historian, recording with the truthful eye of the camera the traumatic events of 1861–65. For this ambitious project, Brady hired a team of some twenty photographers to cover the expanding zones of conflict, from South Carolina to Pennsylvania, with results that range from unforgettable images of the burned-out ruins of Richmond, Virginia, to the taking of prisoners. From these eyewitness accounts, which numbered about ten thousand, Brady and his colleagues also envisioned an expanding business enterprise that could be profitably marketed to a vast public: unless they had survived the battlefields themselves, most people had never before seen the shocking realities of modern warfare. Of these records, none are more devastating than the photographs taken by an Irish immigrant, Timothy O'Sullivan (1840–82), who, like Meissonier, did not flinch at the sight of a ground littered with soldiers' bodies. In the albumen print poetically titled *A Harvest of Death, Gettysburg, July 1863* (**fig. 221**), we find ourselves standing in front of a field of corpses that seems to continue forever toward a distant horizon and, thanks to the cropping, to both left and right. Like Goya's *Third of May 1808* (see fig. 34) or Daumier's *Rue Transnonain* (see fig. 181), this pinpoints a moment of nineteenth-century history and transforms it into a new kind of memento mori.

In O'Sullivan's head-on confrontation with the nameless victims of modern warfare, their former allegiance to the Confederacy or to the Union could hardly matter less.

Jean-François Millet and Peasant Painters

For a whole generation of artists who were young in the revolutionary year of 1848, the social realities of the everyday, whether in city or country, whether dramatic or commonplace, loomed large, leaving them with the problem of reconciling these newly observed facts with the traditions of high art. Of the countless major and minor artists who responded to these pressures, it was Jean-François Millet (1814–75) and Gustave Courbet (1819–77) who most conspicuously defined for the Paris public the kind of painting whose newness startled spectators in the decade following 1848, although their personalities and art are so different that they stretch even further the boundaries of the once inflammatory word Realism that is still used to describe them both. Born to a prospering family on the Normandy coast near Cherbourg, Millet from the beginning was steeped in an environment where he could see, and often participate in, the tilling of the soil, the shearing of sheep, the gathering of the harvest. Yet these humble origins did

not prevent him from being profoundly well educated not only in art, but in literature; and his lifelong concern with artists as diverse as Michelangelo, Poussin, and Fragonard was equaled by his familiarity with classical authors, especially those like Theocritus and Vergil who evoked bucolic idylls, as well as with modern ones like Robert Burns, who also captured the poetry of country life.

Peasants as subject matter had become popular decades before 1848; but their physical energies and their potential social force had been minimized in order to permit more Arcadian interpretations that, to urban eyes, like those which inspected the paintings of Corot or the Barbizon School, conjured up a nostalgic world of simplicity and innocence. Millet's own early works often perpetuated this mode. After 1845, however, when he moved to Paris, his art began to register more clearly the powerful tremors that introduced the year 1848. He could even record the violent, body-wrenching labor of those miserable itinerant workers from the country who were forced to construct the new railway lines in the Paris suburbs, and by the time the

Fig. 222 **Jean-François Millet**, *The Winnower*, Salon of 1848. Oil on canvas, 41¼ × 28½″. National Gallery, London.

month of revolution came, he was ready to exhibit at the Salon (which opened only weeks later, in March) a large painting that seemed to exemplify the emergence of the rude, terrifying power of ignorant laborers. *The Winnower* (fig. 222), which was rediscovered in 1972, dramatically singles out from the tranquil or charmingly picturesque peasants of earlier art one rugged worker who suddenly demands, so to speak, equal time. For Millet has bestowed upon this nameless peasant not only a full-scale monumental presence, but has given him an unexpectedly heroic grandeur that transforms the arduous physical marks of winnowing—the slightly squatting stance, the firmly bent wrist and grasping fingers—into titanic anatomies that would be recognized by critics as conveying "Michelangelesque energies." Millet did not avert his eyes from coarse, peasant detail—the pathetically worn shoes, the patches on the clothing, the brutalized expression, the powdery scattering of the grain. But as in even the more modest prints of Daumier's urban characters, a grand Western pedigree is sensed here, with broad patterns of light and shadow dramatizing this crude, almost primitive man, whose social power, after 1848, began to threaten the status quo. As usual, it was not only the question of class that could make the well-heeled Salon-goer uncomfortable before this painting, but also the question of style. Théophile Gautier, the most accurate and vivid of all nineteenth-century art crtitics, again pinpointed the matter when he described how Millet "trowels on top of his dishcloth of a canvas, without oil or turpentine, vast masonries of colored paint so dry that no varnish could quench its thirst." Even the vigor and coarseness of the paint application, so different from both the lacquered smoothness of Cambon's or the exquisitely fine detail of Meissonier's, underlined the image of grueling physical exertion.

We know nothing directly of Millet's own political sentiments, but he probably shared the Republican convictions of his friends and of the critics who hailed this work. Yet he was obviously happy to turn his back on the turmoil of Paris, where he had been conscripted during the "June days" of 1848. In 1849, he left for the serenity of Barbizon, where he remained until his death, in 1875. There, like other Barbizon masters, he could maintain close touch with the art network of Paris, while continuing to explore firsthand those facts of rural life that he would translate into many epic canvases for the Salon. Of these, *The Gleaners*, shown at the 1857 Salon (fig. 223), is so familiar that, as in the case of the equally famous *Angelus*, it takes considerable historical knowledge to understand exactly what is represented. Although it may first evoke a harmonious idyll of farm women gleaning the harvest as they might have in biblical times, it is also a comment on the economic hierarchies that by the 1850s were being rapidly established among the peasant classes. The three gleaners in the foreground are, in fact, separated from the rich and densely

Fig. 223 **Jean-François Millet**, *The Gleaners*, Salon of 1857. Oil on canvas, 33 × 44″. Louvre, Paris.

populated farm on the distant horizon. They belong to the lowest level of peasant society, those who are given permission to pick up the scant leftovers in the fields after the wealthy have harvested the crops, the rural equivalent of urban beggars who looked for crumbs and coins on the streets of Paris. Nevertheless, Millet transforms this scene of numbing, heart-breaking poverty and labor into an image of epic nobility, bearing out the belief of his champion, the critic Jules-Antoine Castagnary, that a new art had been born in which the artists "had gained the conviction that a beggar in a ray of sunshine is seen in truer circumstances of beauty than a king on his throne." So stark and so emblematic is this trio—two of whom move toward the meager pickings in a broad postural rhyming while the third, her back still arched from this exhausting labor, begins to move upward toward the horizon, but remains below it, as if eternally rooted to the earth—that a hostile critic could refer to them as "the Three Fates of pauperdom." Yet the very fact that they could resonate with such grand associations is a tribute to Millet's genius at distilling figures,

landscape, and architecture into a serene, interlocking organism that might rival Poussin's vision of antiquity. Even the haystacks and wagon on the left horizon echo the archaic clarity of the trio's A–A–B rhythm, and the gabled farm buildings have a comparably terrestrial firmness. Millet's sense of color, too, underlined this search for almost primitive truths. In general, his palette smacked of the duller, earthier tones of stone, of fields of grain, of the coarse gray-brown weaves of peasant costume; and in *The Gleaners* the parched yellow-browns of the tilled fields dominate the whole. Yet the three women are distinguished from each other by their colored caps, aprons, and sleeves, which offer an elemental trio of primary hues—blue, red, yellow—muted to tones appropriate for their lowly, utilitarian clothing. By bestowing such pictorial dignity on the most poverty-stricken rural population of France, Millet not only revitalized, in an agrarian translation, the inherited vocabulary of classicizing art, but also implied, to nervous upper-class spectators, that this population should be taken seriously as a welling force both inside and outside the Salon.

That force was often tempered and sweetened by other Salon painters of the 1850s, who, like Millet, magnified the peasant class to epic scale. Of these, Jules Breton (1827–1906) was, so to speak, Millet's milder-mannered understudy who could present France's vast agricultural population not as an image of raw, threatening power, but as a simple society of archaic harmony dominated by the serene, recurrent rhythms of daily labor and church ritual. Like Millet, Breton had lived most of his life in a rural, provincial community and could paint from firsthand experience such disasters as a fire in a haystack. Indeed, he even preceded Millet in representing, at the 1855 Salon, the labors of the poorest gleaners. Yet his view of peasant life generally censored out of sight the harsh facts of ragged clothing, hands like clubs, and faces like those of whipped animals. In 1857, at the same Salon as Millet's *Gleaners*, Breton presented the huge *Blessing of the Wheat in the Artois* (fig. 224), one of the many venerable Christian ceremonies he had observed near his native town of Courrières. His record of ethnographic detail, in fact, is scrupulous, presenting far more precise, sharp-focus descriptions of regional costume and individual people than are usually found in Millet. But these particular truths are filtered through rose-colored lenses, so that, finally, an entire rural population becomes as pious, content, and harmless as a peasant chorus in an opera like Gounod's *Faust* (1859). Bathed in a gently sparkling light and separated from us by kneeling worshipers, a harmonious procession of picturesque, devout, and ignorant people moves across the fields in solemn step, clergy first, peasants behind, recalling, in modern rural guise, the historicizing biblical processions of the faithful in such mid-nineteenth-century church frescoes as those by Flandrin (see fig. 155). The earth, to which they are all wedded, rises high above them to form a continuous horizon line punctuated only by the sacred

canopy and, at the right, the skyward thrust of the church steeple. There is much of Millet's sense here of the naïve beauties of peasant life and even reminiscences of Courbet's *Burial at Ornans* (see fig. 228), with its friezelike display of a whole society. But Breton's leap from reportorial fact to poetic fiction (or, some would say, to whitewashing) is so smoothly contrived that we understand how more complacent spectators of the 1850s might be convinced that the increasing multitudes of troublesome peasants outside Paris would in no way disturb their status quo. Small wonder that the painting was enthusiastically endorsed by the conservative director of the Museums of the Louvre, the Count of Nieuwerkerke, and bought by the state; whereas Millet's *Gleaners* at the same Salon antagonized and frightened a right-wing audience.

The same distancing from the grubby realities of farm life, whether of men, women, or beasts, characterized much of the work of Rosa Bonheur (1822–99), the most internationally renowned woman painter of the mid-nineteenth century and one whose professional and social independence was probably nurtured by her father's association with the Saint-Simonian Socialists, who proselytized for the equality of women. Indeed, that goal was assertively realized by Bonheur, who applied for and was regularly issued legal permits to wear men's clothing in public. At the Salons of the 1840s, she made a name for herself as an animal painter, replacing, however, the Romantic zoo—tigers, jaguars, herons, gavials—of an earlier generation, that of Delacroix and Barye (see pages 219–21), with the domesticated animals—horses, rabbits, sheep, goats, cows—of prosaic country life. A member of Courbet's and Millet's Realist generation, she, too, hit her stride by 1848, receiving that year a lucrative government commission which was exhibited at the next Salon, that of 1849. *Plowing in the Nivernais: The Dressing of Vines* turned

Fig. 224 **Jules Breton**, *Blessing of the Wheat in the Artois*, Salon of 1857. Oil on canvas, 4′ 3″ × 10′ 6″. Musée d'Orsay, Paris.

ROSA BONHEUR: PAINTING IN THE NIVERNAIS

At the Salon of 1848, Rosa Bonheur won a gold medal, a Sèvres vase, and on July 3, 1848 a 3,000-franc commission for Plowing in the Nivernais *(see fig. 225), which was shown at the Salon of 1849 in the Tuileries palace. Bonheur wrote of this period in her diary:*

I'll never forget my father's [the minor landscapist and portraitist Raymond Bonheur] joy at this double triumph. He felt that my success was truly his own. Hadn't he been my only teacher? Another thing added to his legitimate pride: he loved the government honoring his daughter, and its advent had nourished his dreams. ...

Alas! I cannot help feeling a twinge of pain whenever I think of my *Plowing in the Nivernais.* Although it really made my reputation, what gloomy memories it calls back. A few days before my father died, he made another proud inspection of my work. He embraced me and said: "You're right on the heels of Vigée-Lebrun. So it's not in vain that I made her your role model." Poor Father, despite his long and even worse suffering, he had no idea that the money I got for this painting was meant to pay for his funeral expenses. ...

I was twenty-seven when my father died. Two months later *Plowing in the Nivernais* was shown at the Salon. I had a hard time finding it in the catalog, since it was listed as *Boarding in the Nivernais, Sinking* [*L'Abordage nivernais, le sombrage*]. This made me momentarily cross, all the more because this mix-up raised lots of questions that I couldn't answer. Fortunately, people still liked it.[39]

In 1859 Emile Cantrel compared Bonheur to the novelist George Sand:

There is a most intimate relationship between the two talents. Mlle Bonheur often reads George Sand, her favorite author, and I would not be surprised if Mme Sand felt the same way about Rosa Bonheur's landscapes. George Sand has a special genius for landscapes; and in her paintings Rosa Bonheur gives song to the trees and eloquent speech to the animals, grass, and clouds. Both can understand the mute symphonies of creation and render them in the passionate, harmonious language of art: one, through descriptions drawn by a pen equal to Ruysdaël's brush and Lorrain's palette; the other, through stories told by a palette with all the genius, the masterful style, the vigorous color that have so rightly glorified the pen.

George Sand and Rosa Bonheur are two landscape artists in Jean-Jacques's [Rousseau] school, two superior women who are the envy of Europe, two serious and confident painters who will give France the right to bask in glory—two brother geniuses.[40]

Later writers invested the painting with political overtones that Bonheur herself might not initially have recognized. The painting inspired Adrien Dézamy to write a socialist poem published in 1880, "Labourage Nivernais," a reference to the popular print, Le Labourage, *made after the painting:*

Six huge Nivernais oxen, six huge white and red oxen,
Till a slope on an autumn morning,
And drag a heavy plough that scallops
And crawls with a clank of iron and nails.

While his holly-wood goad flies over their backs
To quicken their monotonous pace,
The driver intones in a falsetto voice
Some old song with a slow, sweet refrain.

The ploughshare opens up the flanks of the fertile earth...
To the trills of the birds fluttering around,
The ox team replies with a long bellow.

The sun is shining on this festive countryside:
And facing this painting that is so alive
I stop and hum one of old Pierre Dupont's refrains.[41]

[Pierre Dupont was a socialist poet and songwriter.]

out to be a huge success (fig. 225). Its concern with depicting specific agricultural activities (the dressing of vines in tilled soil) in a particular province (the Nivernais) was typical of the period's inquisitiveness about the regional variations of French rural society and, in this case, may have been inspired by a passage in *The Devil's Pool* (1846), George Sand's novel of rustic life. To this record of local truths—and it was Bonheur's custom to travel in the provinces for documentary material—is added, as in the case of Breton, a vision of Eden. The meticulous detail of the landscape, of the breed of cattle, all studied *in situ*, attest to the artist's firsthand experience, yet the stately movement of the beasts of burden and of the men who direct them across the soil is kept at a sufficient distance from the spectator to make sure that none of the harsh facts of country life—flies, manure, grinding poverty—offend the sense of sight, smell, or touch. The whole appears as remote and noble as the procession of oxen in ancient Egyptian reliefs, finally fulfilling the expectations of high art. Such a fusion of the real and the ideal, of modern fact and historic beauty quickly made Bonheur's reputation, not only at home, where she eventually became, in 1894, the first woman officer in the Legion of Honor, but particularly in the Anglo-American world, where patrons from Queen Victoria to Cornelius Vanderbilt lauded and bought her work.

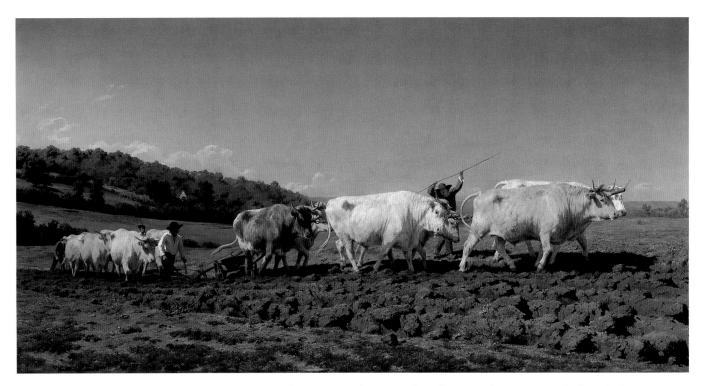

Fig. 225 **Rosa Bonheur**, *Plowing in the Nivernais: The Dressing of Vines*, Salon of 1849. Oil on canvas, 5′ 9″ × 8′ 8″. Musée National du Château de Fontainebleau.

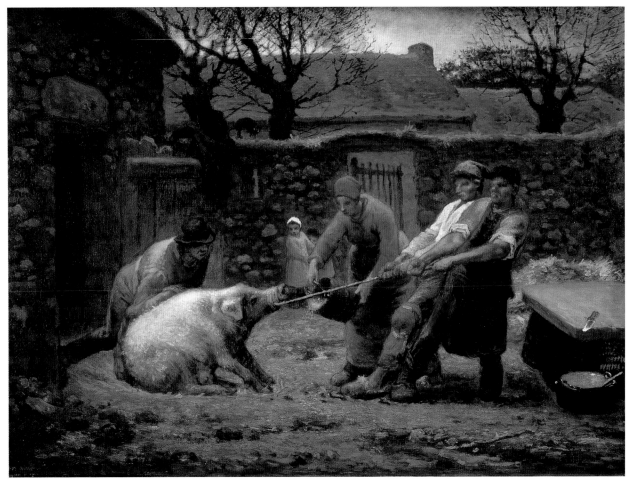

Fig. 226 **Jean-François Millet**, *Killing the Hog*, 1867–70. Oil on canvas, 28¾ × 36½″. National Gallery of Canada/Galerie Nationale du Canada, Ottawa.

Millet's reputation, too, expanded internationally, especially after the 1850s, when his art, like that of many other Barbizon masters, tended to take on an ever more remote, nostalgic look, his rural people and landscape often viewed through a veiled, crepuscular light that glowed with a halo of Romantic reverie. Nevertheless, his art never turned into formula, and he could continue to confront, with total honesty, even the most brutal truths of farm life, ranging from the *Man with a Hoe*, with its heroic record of a single fieldworker who seems to bear centuries of mind-dulling and back-breaking labor, to the routine murder of wild birds and farm animals. Of these latter works, *Killing the Hog* of 1867–70 (**fig. 226**) is both alarming and matter-of-fact in its subject matter, the commonplace exertions of farmhands to drag a recalcitrant hog to a low table where it will be slaughtered with a knife. Yet, in Millet's hands, this ordinary scene of farmyard noise, agitation, and violence is converted into a grave ritual act that evokes biblical sacrifices. The archaic lucidity of the planar composition, with its parallel layers of rude cottage and barnyard walls and its trio of leafless trees, is echoed in the solemn tug-of-war between man and beast, finally stalemated by the axial clarity of the triangular grouping. Even in family terms, Millet has extracted a primal image, including a pair of children in the background who quietly watch their elders act out, in a theatrical space, an ancient, cruel ritual which brings the specter of death into their life. That Millet's art could resonate so deeply into all kinds of mythic and psychological archetypes was testimony not only to his greatness but also to his ability to transcend the confines of the historical category, Social Realism, in which he is usually placed.

Gustave Courbet

That category, suggesting an artist who is primarily concerned with conveying the facts, and often bitter ones, about contemporary social issues, is one that suits many painters who matured with the experience of the 1848 revolutions, and who came to believe that the routine events of city and country life were the only vital source of artistic truth. It was Gustave Courbet (1819–77), far more than Millet, who represented the embodiment of this viewpoint, both through the revolutionary force of his paintings of the 1850s and through his appetite for arousing and enjoying public controversy. With gargantuan conceit, he not only thought that he was the most handsome and seductive of all men, but that he was a secular incarnation of a second coming of Christ, a messiah who would lead his disciples into new paths of truth and beauty that would finally crush Paris's infidel art and social establishment. Luckily for him and posterity, his estimate of his own importance was pretty accurate.

Like many other mid-century artists responsible for replacing Greek heroes or medieval kings with workers, Courbet himself came from the rural provinces, where he was raised with those physical and social facts of country life that, in his eyes, could undermine the arty, moribund traditions of Paris with the ring of coarse, grass-roots truth. He was born to a wealthy farming family in the town of Ornans in the Franche-Comté, a region of France near Switzerland where the landscape is rugged and rocky and where the locals are known for their hard-boiled pragmatism. The strength of these origins even extended to his early artistic training as a teenager under a certain Père Baud, a provincial student of Gros whose own paintings have the stiff, naïve character of folk art, which, like the crude, flat imagery of anonymous broadsheets, could inspire Courbet to create a style that was willfully popular in its avoidance of the compositional sophistications of Parisian high art. Yet, like most artists, revolutionary or conservative, Courbet needed Paris as the stage to act out his ambitions. In 1839, he arrived in the capital to continue his training and to study firsthand the old masters. Among these, his enthusiasms turned to those painters who insisted on recording the commonplace truths of city and country life—French masters like Chardin and the Le Nain brothers (whose dignified images of seventeenth-century peasants were the object of new excitement in the 1840s and 1850s) or Spanish masters like Ribera, Zurbarán, Murillo, and Velázquez (whose earthy vision was especially prominent in the 1840s in the so-called Musée Espagnol, a gallery of Spanish painting created under Louis-Philippe). Courbet's own early work, in large part rejected by the Salon juries from 1844 on, featured overwhelmingly narcissistic self-portraits, in which he scrutinized his own handsome features in mock-Romantic poses. It also included more straightforward portraits of friends and family, landscapes, and more fanciful subjects, like a guitar player in troubadour costume, which often seem to parody the apparatus of conventional Romanticism. For him, as for Millet, 1848 was a watershed; and in the words of his early champion, the novelist and Socialist Jules Champfleury, Courbet began to "exist" only in 1849, with *After Dinner at Ornans*, a painting which, like the novels of George Sand describing rural life, offered an accurate accounting of such uneventful truths as the indoor comforts of a chilly November day when the artist, his father, and two friends enjoyed a smoke, drink, and music after a meal. This chronicle of country life, even magnified to the life-size dimensions appropriate to more heroic history painting, was agreeable enough to be warmly received at the 1849 Salon, earning Courbet not only a state purchase but a medal that guaranteed him automatic acceptance at future Salons.

Ingres, who grudgingly recognized the unfamiliar talent of this painting, also worried that its example might be

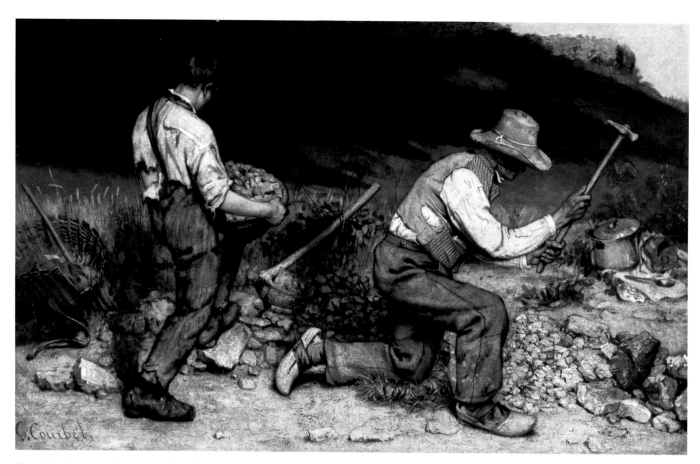

Fig. 227 **Gustave Courbet**, *The Stonebreakers*, 1849 (Salon of 1850–51). Oil on canvas, 5' 3" × 8' 6".
Formerly Gemäldegalerie, Dresden (destroyed 1945).

dangerous; and indeed it was. At the next Salon, Courbet himself presented a trio of paintings about rural life which scandalized the Paris audience. To generate these works, Courbet had returned to his native Ornans for the autumn of 1849, reimmersing himself in his rural origins for fresh inspiration. The episodes he chose were a local funeral, a pair of stonebreakers, and the return of a group of wealthy peasants from a country fair. Of these, *The Stonebreakers* and *A Burial at Ornans* instantly became the kind of manifesto paintings which, like the *Oath of the Horatii* (see fig. 16) at the 1785 Salon, announced a new world.

For posterity, *The Stonebreakers* (**fig. 227**) is almost more of a myth than a real painting. Because the work had been in Dresden since 1904 and was then destroyed there during the Second World War, its image has been conveyed mainly through reproductions in history books. There it became the very symbol of the proletariat invading the center stage of high art, the ideal visual parallel to 1848 and the *Communist Manifesto*. Controversial from the outset, the painting still inspires theoretical writings by Marxist critics. To measure something of how shocking it was to the Salon audience in the winter of 1850–51, it is best seen in the context of Millet's *Winnower* from the 1848 Salon, which in good part inspired it (see fig. 222). By contrast, Courbet seems coolly matter-of-fact, directly recording

what he described as an encounter on the road to Maizières with two stonebreakers whom he then had pose for him in his Ornans studio. Neither monumental gloom nor Michelangelesque energy ennobles or dramatizes their physical labors, and if their faces happen to bear, like those painted by Millet, the marks of physical stress or of the blunting of intellect through countless man-hours of sweat and toil, Courbet has chosen to avert the spectator's eyes from such emotionally charged evidence. Yet he provides all the clues to a life totally lost as a human beast of burden: the pairing of a young and old worker in a suggestion of the long, imprisoning cycle of a worker's existence; the upward strain of raising a basket of stones versus the downward exertion of hammering them to pieces; the pathetic marks of poverty in the clothing, from the sagging trousers and torn stocking heel to the grindingly worn shoes. Courbet puts this all down as sheer, unbiased fact, viewed in a clear flat light that permits only the shortest shadows to be cast and that evenly defines every detail from the disarray of crushed stones in the foreground to the working-class still life behind of bread, spoon, and metal soup-pot. This removal of any lingering veil of sentiment, this inclusion of all palpable facts, were as alarming in Paris as the dimensions accorded this lowly vignette of anonymous, unskilled workers paving the new roads of

provincial France. For indeed, this canvas occupied an area more than five by eight feet, outsizing countless noble subjects on the same Salon walls. And if it was impossible to get away from the sheer size of these workers, it was just as hard to get away from their material presence. Instead of being seen against a hazy background that makes them less threateningly near, they are pushed close to us against a steeply rising hill, a parched, gritty terrain that is abruptly cropped at the upper right. Abrasive, too, was the willful ingenuousness of the figural composition (or non-composition), which seemed as clumsy as the graceless movements it depicted. None of Millet's abstract rhymes generalize this pair, whose contours and surfaces bear the specific ring of ugly truth, the ragged clothing as unideal as the bodies it covers. And the paint surface, even more than Millet's, corresponds to Gautier's metaphor of troweled masonry.

Even though Courbet himself had referred to his subject as the "most complex expression of misery," his painting seems totally poker-faced. But to his close friend and compatriot from the Franche-Comté, the Socialist Pierre-Joseph Proudhon, *The Stonebreakers* became a heart-breaking indictment of capitalism, which he described with highly charged language in his rhetorical treatise *On the Principles of Art and Its Social Purposes*, not published until 1865. For Proudhon, the painting told as horrible a story of immoral greed and human degradation as the issue of slavery; yet the emotions and grand ideas the work generated for him seem more appropriate to the pictorial rhetoric of Biard's *Slave Trade* or Hübner's *Silesian Weavers* (see figs. 184 and 185). Finally, Courbet's art, for all its Socialist implications, was far more tight-lipped and dry-eyed than its propagandistic potential, meeting the demands of a new kind of painting based on the equality of all material facts even more than the demands of a new kind of society based on the social and financial equality of all people.

This visual, as well as social, democratization of art was seen in still more ambitious terms in the immense *A Burial at Ornans* (fig. 228). Like *The Stonebreakers* (whose title, as listed at the Salon, also included, between parentheses, the specific region, the Doubs, where the scene took place), *A Burial* transported a huge slice of rural truth into the urban sanctuary of the Paris Salon. Courbet's loyalty to the provinces was also borne out earlier in the year when, before the opening of the 1850 Salon (delayed until December 30), he showed *A Burial* and other works in one-man exhibitions at Ornans, Besançon, and Dijon, presumably reaching those less cultivated audiences which in turn had provided the raw material of his art.

Here, the rural truth—inspired, according to one legend, by the funeral of Courbet's own grandfather—encompassed a vast spectrum of human experience, from the commonplace but inherently tragic fact of Christian burial rites for a beloved family member to the inventory of a provincial community. And individuals they were! Courbet had dozens of local people come pose for him before clustering them together on canvas, side by side and almost fifty strong, in order to honor the deceased in the coffin, which, casually held by four pallbearers at the left, will soon be placed in the newly dug grave. This crass hole hollows out the bottom center of the canvas with a dull thud, invading the space of the spectator who, in imagination, joins the

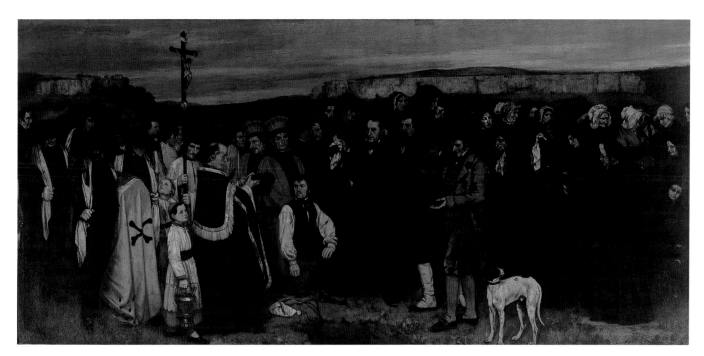

Fig. 228 **Gustave Courbet**, *A Burial at Ornans*, 1849 (Salon of 1850–51). Oil on canvas, 10′ 4″ × 21′ 9″. Musée d'Orsay, Paris.

mourners on the near side of the momentarily empty grave, just across from the kneeling gravedigger.

Although there are still some problems in identifying several people in this assembly, each one is so individualized that we feel a totally authentic, one-to-one confrontation with a complete cast of characters who compose the small community of Ornans—the sober, balding justice of the peace in the center, with the corpulent mayor behind him; the village priest in profile with his entourage of bored choirboys and craggy-faced beadles, each wearing a brilliant red toque and turning in opposite directions; the pair of aged villagers who wear, for this state occasion, costumes of the veterans of 1793; behind them, the trio of tearful women (modeled after Courbet's sisters, Juliette, Zoé, Zélie), each of whom responds differently—one half-concealing, the second totally concealing her face with a handkerchief, the third tilting her head pensively; and not least, the insouciant half-breed hunting dog in the foreground, whose presence is neither more nor less important than that of the human participants, and whose temporary distraction from the events is neither more nor less conspicuous than the indifference of many of the human mourners. Indeed, we feel a sense throughout of totally unedited truth, like the results of a photographer who snapped a large restless group before telling them to compose themselves in a less unruly way, with everyone standing straight and facing the camera. Courbet's genius lies here in, among other things, the consistency of his vision, which refuses to idealize, to compose, to ennoble according to any familiar conventions, even those of the most doggedly literal Spanish or Dutch seventeenth-century masters in whom he found a certain historical ancestry. So insistently anti-traditional is *A Burial* that the figural composition seems an anti-composition. We sense that the edges arbitrarily crop the line-up of mourners, some of whom may stand beyond the frame, just as we feel what has been called a democratization of structure, each figure having, as it were, the same number of pictorial votes as his or her neighbor, including the dog. There are, to be sure, strong prophecies of this new earthbound society of individuals in David's *Coronation of Napoleon* (see fig. 26), but Courbet has eliminated the traditional aura of supreme authority, leaving us with a social order that seems to exist only on the level of the most ordinary mortals and that, as such, is susceptible to change.

If Courbet's vast canvas at first seems self-consciously artless, it of course is not. His tendency to polarize tonal extremes of literally funereal black and startling passages of creamy white paint (the dog, the pallbearers' robes, the women's handkerchiefs and starched bonnets) creates a coherently flattened effect of silhouetted patterns compressed against the high, rocky horizon of Ornans's new burial grounds which enclose, from above and behind, these earthbound figures. And if these figures seem

disorderly in their democratic individuality (unlike, say, the more dignified choreography of rural multitudes in Breton's later *Blessing of the Wheat*; see fig. 224), they are more subtly ordered in a loose but pervasive structure that gives the left third to the clerics, the center third to prominent secular figures, and the right third to a chorus of grieving women and children. The whole composes a visual trio that reflects social facts as well as providing a solemn, wavelike rhythm of figures who weave from front to back around the grave. The epic dignity that emerges makes us understand how artists like Mary Cassatt could later recognize in Courbet's rural burial an artistic pedigree that went back to Greek sarcophagus reliefs.

But in these funerary terms, too, the painting was initially heretical. Not only did it challenge the noble with the vulgar in terms of sheer size (its dimensions approaching Couture's *Romans of the Decadence*, from the Salon that preceded the 1848 Revolution; see fig. 158), but it also challenged Christian ideas of the transcendental passage from life to death. On a visit to the Low Countries in 1847, Courbet apparently saw under way in Brussels the famous new *Triumph of Christ* by Wiertz (see fig. 152), whose gigantic apotheosis of a supernatural cast of airborne angels, archangels, and of Christ himself may have impressed Courbet as a prerevolutionary pendant to his postrevolutionary world of material facts that would extend even to a Christian afterlife. "Show me an angel and I will paint it" was one of Courbet's most quoted quips, and doubtless, such a creature could not survive a moment on Courbet's Christian soil. Christ exists only as an artifact held high above the horizon by a provincial clergyman (Colard, by name), and the soul goes to eternity in a freshly dug ditch. Far from being blasphemous, which is how it appeared to most conventionally pious eyes in 1851, Courbet's *Burial* locates the falsehoods of earlier heavens in the terrestrial truths of the nineteenth century. He records the rude facts of modern Christian ritual with such dedication and seriousness that they are finally transformed into an experience no less dignified and harmonious than a Baroque representation of a saint's apotheosis.

With *A Burial* and *The Stonebreakers* at the Salon of 1850–51, Courbet achieved a *succès de scandale*, his name suddenly a household word for everything that attacked social and artistic hierarchies through a cult of deliberate ugliness. At the next Salon, in 1852, his assault was through a painting about women and cows, originally bearing the long title *The Young Ladies of the Village Giving Alms to a Cowherd in a Valley of Ornans* (**fig. 229**). Although at first glance, it had enough superficial pastoral charm to have been purchased before the Salon opening by the Count de Morny, a major figure in the establishment of the Second Empire, that charm was immediately discerned by the Salon audience as veiling a multitude of heresies. Three young women fancily dressed for the kind of country outing

Fig. 229 **Gustave Courbet**, *The Young Ladies of the Village Giving Alms to a Cowherd in a Valley of Ornans*, Salon of 1852. Oil on canvas, 6' 4¾" × 8' 6¾". The Metropolitan Museum of Art, New York.

familiar from Rococo pastorals pause in an upland pasture to offer a farm girl what seems to be a piece of cake, while their dog stops to observe a pair of cows grazing on the far side of the valley. This ostensibly innocuous image of rural charity, however, produced outraged responses. The three "ladies" of the village, or in the French word, "demoiselles," were, by Parisian standards, anything but that; for their coarse, ruddy features and hands, their pretentious, but provincially out-of-style costume, their lifted-pinkie demeanor of affected grace immediately made it clear that these were vulgar rural women who were not only artistically offensive in their almost parody-like reference to the classical group of the Three Graces, but socially so. For in 1852, it was apparent that these "demoiselles" were on their way up the ladder of economic mobility, to so high a point, in fact, that they were grandly separated, like eighteenth-century aristocrats, from the lowly cowherd, whose origins were very much their own. Millet's peasants had begun, as it were, to take on city airs. Again, Courbet told the whole truth. The women were modeled after the

Fig. 230 **The Young Ladies of the Village** (caricature from *Le journal pour rire*, April 16, 1852). Lithograph. Bibliothèque Nationale, Paris.

same three sisters he had used as mourners in *A Burial* and were no less gross by urban standards of beauty. Even their dog, quickly recognized as a mongrel, seemed to belong to that insolent breed of the country nouveau-riche whose growing strength would make many a socially and financially secure Parisian cough nervously.

The awkward structure of the painting was equally offensive in its violation of hallowed traditions, and we may learn something of this from one of the many caricatures made of Courbet's works after the exhibition (fig. 230). To eyes of 1852, the figures had a wooden, doll-like stiffness (they are propped up gracelessly like scarecrows or mannequins on crude bases) that reeked not of the old masters but rather of the naïve figures in popular imagery which Courbet had explored as the visual counterpart to his rural subject. And the spatial ordering also seemed childishly inept. As in *The Stonebreakers* and *A Burial*, the conventions of perspective and atmospheric depth are flouted: the rear side of the figures almost touches the distant valley, which rises behind them, high above their heads; and even odder, the two cows, which should be located on the far side of a break in the terrain, if only to explain their diminutive size, appear to be in the foreground, a visual paradox that is further exaggerated in the caricature, which pushes these peasant's toys on wheels almost in front of the plane of the figures and dog. Courbet's greedy sense of capturing material facts with the palpable stuff of pigment made everything he recorded feel as if it were accessible to the touch, its reality verifiable in the most primitive, tactile way. Unlike the spatially remote barnyard idylls of Rosa Bonheur, Courbet's painting got uncomfortably close, imposing its coarse truths on the viewer. There were coarse truths, too, in Courbet's palette, which, as in many of Millet's peasant paintings of the 1850s, veered here toward earthy, simple colors, those of cattle, of sunbaked earth and stone, of slightly parched grass and trees, colors that set into instant opposition the blatant luxury and artifice of the hues favored by artists of more noble subject matter. And the brushwork again conveys the look of manual labor, the broad patches of gray-browns that define the background rocks almost palpably creating in thick pigment the density of the stony landscape around Ornans.

Fig. 231 **Alfred Dehodencq**, *A Bullfight in Spain*, Salon of 1850–51. Oil on canvas, 4′ 11½″ 6′ 11¼″. Musée des Beaux-Arts, Pau.

Although Courbet was the most conspicuous public force in this breakdown of pictorial conventions after 1848, he was hardly unique, witness *A Bullfight in Spain* (fig. 231), a painting at the 1850–51 Salon by a minor contemporary, Alfred Dehodencq (1822–82). Wounded during the revolutionary days of June 1848, Dehodencq recuperated with the help of the Spanish sun, under which he witnessed, in September 1849, a provincial version of the national sport in the village of El Escorial, which he then used as the motif for a government commission. The painting shows us not the pageantry of the Madrid bullring, but rather a more humble, rural variant, the equivalent of Courbet's funeral rites in Ornans vis-à-vis the pomp of a stately burial in Paris. Dehodencq also preferred this naïve regional truth, which he recorded with a willful compositional awkwardness that parallels Courbet's. Not only is the dramatic narrative focus on the bull diffused by the equal importance given to the participants and spectators on the sides; but the space, as in *The Young Ladies of the Village*, compresses near and far, with the ground plane tilting upward at so steep an angle that the mountain, the ruins of an arch, and the vernacular houses of the background seem almost as flatly and directly accessible in the foreground as the bullfighter, whose back faces us. Moreover, as in Courbet's work, the loose-jointed composition gains a kind of patterned coherence through the strong silhouetting of dark and light patches in the bright, even light of the sun. Not only in his subject matter, but in the candid scattering of figures and events, Dehodencq continues a long dialogue between French painters and Spain, and one that would reach greater complexities in the 1860s through Manet's reinterpretation of Spanish themes in a style of snapshot truth and immediacy that the mid-nineteenth century associated with Spanish painting from Velázquez to Goya.

Materialism versus Idealism

Even without the support of such lesser artists as Dehodencq, Courbet's art of the 1850s separated itself irrevocably from the official styles of painters in Paris who would perpetuate an ideal art based on continued faith in the mythologies of the Greco-Roman world or of aristocratic social hierarchies. At the 1853 Salon, an exact contemporary of Courbet's, Charles-François Jalabert (1819–1901), exhibited a painting that, like so many of the other hundreds on the Salon walls, would shield the viewer from the ugly, nouveau-riche girls of peasant origin—Courbet's own sisters—who had crashed the 1852 Salon. His *Nymphs Listening to the Songs of Orpheus*(fig. 232) is positively dreamlike, a mirage of a forest glen in which a rapt audience of half-veiled nymphs seems almost to waft upward in the direction of the magic sounds of Orpheus's lyre. The hazy

light and mellifluous movement of powdery soft flesh and wispy draperies transport us almost literally from a gravity-bound world to the imaginative flights inspired by music and the dance, creating the kind of phantom, eyes-closed ambience that would mesmerize Parisians who attended Adolphe Adam's popular new ballet *Giselle* (1841) or those new operas of Wagner that featured siren choruses of mythical maidens who resided in Venusberg (*Tannhäuser*, 1843–44) or in the Rhine (*Das Rheingold*, 1853–54). Although Jalabert's painting stubbornly adheres to the values posited in earlier nineteenth-century paintings of Greco-Roman myth, such as Broc's *Death of Hyacinth* (see fig. 46), its new inflection of what is almost a period style, that of the then one-year-old Second Empire of Napoleon III, is unmistakable. For here, the academic conventions of marmoreal flesh and drapery have softened and multiplied into a florid hothouse that evokes a pastel world of luxurious surfeit and erotic plenty, a nostalgic whiff of the style and civilization of Rococo France.

This conspicuous consumption, so evident in the official architecture of the Second Empire (of which Charles Garnier's Paris Opera would become an international symbol), reached a pictorial height at the Salon of 1855 in the huge group portrait of the new empress of France, Eugénie, surrounded by her ladies-in-waiting (fig. 233). The artist, Franz Xaver Winterhalter (1805?–73), although born and trained in Germany, was practically a subject of other European monarchs, whether Victoria, Louis-Philippe, or Napoleon III; for, like a mid-nineteenth-century Rubens, he frequented international courts and painted state portraits in a way that applauded the pomp and circumstance of royalty. Eugénie de Montijo, a Spanish countess, had married Napoleon III barely two months after his stately entrance, on December 2, 1851, from St.-Cloud into Paris as the new emperor of France; and one year later, Winterhalter reappeared in Paris, from London, to become once again an official court painter. His connections with Eugénie were particularly close, and he supported pictorially her historical fantasies by representing her, for example, in the eighteenth-century costume of Marie-Antoinette or of those French queens whose genealogical table she hoped to extend, grace, and honor. By the time of the 1855 Salon, he had completed the grandiloquent portrait of the new empress, seated in a stage-set fantasy of a woodsy retreat with an imperial assortment of one princess, one duchess, one countess, one viscountess, two baronesses, and two marchionesses. The group portrait was apparently commissioned and paid for by the empress herself, who quietly reigns over this aristocratic octet, and holds a bunch of imperial violets whose color is discreetly echoed in the trim on her dress. Like Jalabert's wood nymphs, these *grandes dames* create a powder-room ambience of billowing flesh and fabric. The cumbersome crinolines, which had just become

Fig. 232 **Charles-François Jalabert**, *Nymphs Listening to the Songs of Orpheus*, 1853.
Oil on canvas, 40¾ × 36¾". The Walters Art Museum, Baltimore.

fashionable and which actually needed a concealed metal cage to support their concentric hoops and petticoats, now seem the vehicles of gauzy, airborne flutter, like the costumes of the ballet. Even the expressions, haughtily pensive and grave, have a mock-theatrical quality. Such an image of total artifice, where the iridescent pastel colors have never seen the light of day and where the tumbling floral bouquets might come from a pastry tube, aspired to nothing less than the resurrection of the gorgeous fictions and bravura brushwork of the court painters of eighteenth-century France, as if the ghost of Boucher had been

summoned up and magnified to gargantuan dimensions in order to accommodate the ambitions of the new empire. For in that same year, 1855, Paris would not only see its railway line extended to the Mediterranean, but would play host to the first of its own long series of great world's fairs as well as to the state visit of Queen Victoria and Prince Albert, who in 1851 had inaugurated the tradition of international exhibitions at the Crystal Palace. At the Salon of 1855, which opened on May 15 as part of the Exposition Universelle, Winterhalter's painting occupied a place of imperial honor and must have been seen by many of the

over five million visitors to the fair. Its critical reception was, in fact, poor, if polite, given the identity of the sitters; but it seems that exactly those meretricious qualities which marred the painting for serious observers were those which made it a beloved popular incarnation of everything that was nostalgically, if preposterously, anachronistic about the mid-century's efforts to relive in a fantasy world another century's idea of extravagance and grace. The authentic traditions of prerevolutionary monarchy have been re-created as a pictorial operetta, both lovable and silly.

For the likes of Courbet, of course, such a painting was an evil falsehood, even though his vulgar village ladies might soon have aspired to these imperial pretensions; and, in 1855, he made publicly clear the unbridgeable gulf between an official art of historical pipe dreams and his own insistence on nothing but the most coarse, physical truth, whether of slightly soiled double chins or an ugly scattering of crushed stones. Of the group of old and new paintings he wanted to show at the official Salon, two had been refused by the selection committee, *A Burial at Ornans* and an even larger new work, *The Painter's Studio*. Courbet seized this occasion to show them in a supplementary private exhibition of forty paintings and four drawings that opened six weeks after the fair, on June 28, and that gave both French and foreign visitors an opportunity to see his doctrine of Realism with a capital *R*. Indeed, the exhibition space, off the Champs-Elysées, was identified with a big sign: DU RÉALISME (that is, "about" or "concerning Realism").

Before Courbet, establishment artists like Copley, West, and David had privately sponsored the exhibition of important new paintings to paying customers, and Géricault had shown *The Raft of the Medusa* to curious Londoners and Dubliners. Moreover, rebellious anti-establishment artists like Carstens and Blake had made efforts to find an audience by holding one-man shows in alternate spaces far from academic territory. But Courbet's enterprise combined all these traditions—official, commercial, and messianic—insofar as he was powerful enough to work inside the establishment, being well represented at the 1855 Salon, and to undermine it simultaneously with a personally sponsored display of his own revolutionary art. As his friend Champfleury wrote to George Sand in 1855, "A painter whose name has made an explosion since the February

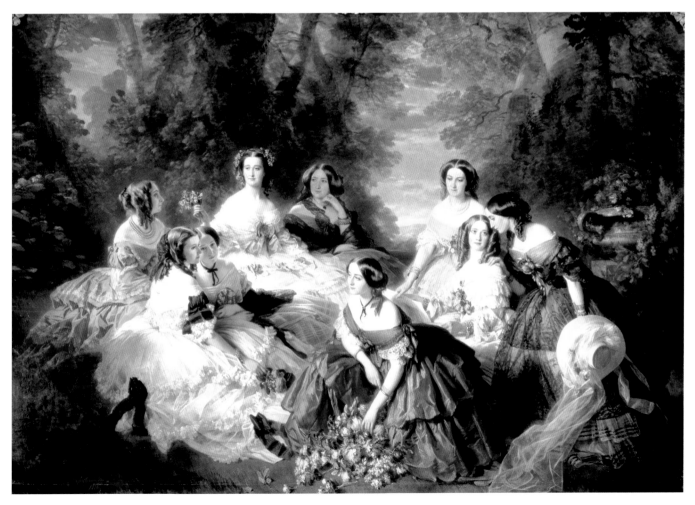

Fig. 233 **Franz Xaver Winterhalter**, *Empress Eugénie Surrounded by Her Maids of Honor*, 1855. Oil on canvas, 10 × 14'. Musée National du Château de Compiègne.

Fig. 234 **Gustave Courbet**, *The Painter's Studio*, 1854–55. Oil on canvas, 11′ 10″ × 19′ 8″. Musée d'Orsay, Paris.

Revolution has chosen the most significant of his works and has had a studio constructed. It is an incredibly audacious act; it is the subversion of all institutions associated with the jury; it is a direct appeal to the public; it is liberty." Inside, the visitor was able to buy for ten centimes a catalogue that included a brief manifesto of Realism, initialed by Courbet, but probably ghostwritten by Champfleury. In it, the artist complained rightly that the name Realist had been imposed upon him and was meaningless without the works, which were what mattered. But he summed up his goals clearly: "To be in a position to translate the customs, the ideas, the appearance of my epoch according to my own estimation; to be not only a painter, but a man as well, in short, to create living art—this is my goal."

This combination of exalting the artist's own ego and of claiming, at the same time, to record the impersonal, shared realities of the world around him is monumentally reflected in Courbet's largest and most enigmatic painting, whose full title—*The Painter's Studio: A Real Allegory Summing Up Seven Years of My Life as an Artist* (**fig. 234**)— already suggests its autobiographical ambitions as well as its efforts to achieve symbolic ends through Realist means. *The Painter's Studio* dominated the one-man show not only in size (almost twenty feet wide) but also in subject; for here, at center stage, is Courbet himself, replacing the classical deities who, as in Delaroche's *Artists of All Ages*

(see fig. 150), had earlier marked the apex of these pictorial pantheons. On both sides of his own ample space, the great artist-hero-revolutionary has materialized a crowded cast of characters to pay homage within the amphitheatrical sanctuary of his studio.

In a letter to Champfleury of fall 1854, Courbet wrote an indispensable description of the as yet untitled painting, identifying the figures and offering clues to the general meaning. In this tripartite structure, which reflects that of *A Burial at Ornans*, the left-hand group is composed of figures representing commonplace reality outside the studio—a Jew and an Irish beggarwoman Courbet claimed to have seen in London, a hunter, a priest, a rag merchant, a Chinese clown, and many other types who provided the raw, Realist stuff of his art. On the right, another gathering represents Courbet's audience, a circle of patrons and friends who supported his pictorial achievements and political beliefs (including Champfleury, Proudhon, and, seated at the extreme right, Baudelaire) as well as a grandly dressed society lady and her male companion, whom Courbet referred to as art lovers. In the middle, tilting what he called his "Assyrian profile" at its most flattering, rakish angle and nonchalantly ignoring the vast assembly he has summoned up, as in a séance, is the great man himself, painting a landscape. Behind him stands a half-naked model, whose clothing has fallen in a heap, whereas in the

COURBET, *THE PAINTER'S STUDIO* AND THE *PAVILLON DU RÉALISME* IN 1855

Gustave Courbet wrote to his supporter, the writer Champfleury, at the end of 1854, outlining his ambitious plans for The Painter's Studio (see fig. 234):

Even though I am turning into a melancholic, here I am [Ornans], taking on an immense painting, twenty feet long and twelve feet high, perhaps larger than the *Burial*, which will show that I am not dead yet, nor is Realism, for there is Realism in it. It is the moral and physical tale of my atelier. First part: these are the people who serve me, support me in my ideas, and take part in my actions. These are the people who live off of life and off of death; it is society at its highest, its lowest, and its average; in a word, it is how I see society with its concerns and its passions; it is the world that comes to me to be painted.[42]

In April 1855, as the Exposition Universelle (the official Salon) neared, Courbet wrote in a panic to his faithful patron in Montpellier, Alfred Bruyas:

I am at my wits' end! Terrible things are happening to me. They [the jury] have just refused my *Burial* and my latest painting, the *Atelier*, together with the *Portrait of Champfleury*. They have made it clear that at any cost my tendencies in art must be stopped as they are disastrous for French art. Eleven of my paintings have been accepted. *The Meeting* [owned by Bruyas] barely got by. They found it too personal and too pretentious. Everyone is urging me to have a private show and I have given in. I will organize another exhibition of twenty-seven of my new and old paintings, saying that I am taking advantage of the boost the government has given me by receiving eleven paintings in its exhibition. ... What is odd is that the site is enclosed within the very building of their exhibition.[43]

Six weeks after the Salon opened, then, Courbet mounted his private exhibition.

The Pavillon du Réalisme, within sight of the Exposition itself, housed thirty-nine oils and four drawings.[44] The Painter's Studio was number one in the catalogue, which contained this preface, probably written by Champfleury:

The title "realist" has been imposed on me in the same way as the title "romantic" was imposed on the men of 1830. Titles have never given the right idea of things; if they did, works would be unnecessary.

Without going into the question as to the rightness or wrongness of a label which, let us hope, no one is expected to understand fully, I would only offer a few words of explanation which may avert misconception.

I have studied the art of the ancients and the moderns without any dogmatic or preconceived ideas. I have not tried to imitate the former or to copy the latter, nor have I addressed myself to the pointless objective of 'art for art's sake'. No—all I have tried to do is to derive, from a complete knowledge of tradition, a reasoned sense of my own independence and individuality.

To achieve skill through knowledge—that has been my purpose. To read the manners, ideas and aspects of the age as I myself saw them—to be a man as well as a painter, in short to create living art—that is my aim.[45]

As Linda Nochlin showed, although The Painter's Studio can be read as going against the grain of the social and political assumptions of the period, it was also shrewdly commercial:

Courbet, by representing himself in his own painting surrounded by his past and present pictorial production, has created an allegory of his beneficent role as a producer of valuable cultural goods. The real allegory then, in the context of the Exposition Universelle of 1855, may be read as Courbet's production of himself as a countercommodity—a

free and self-determined man producing objects of genuine value—for a new and relatively unfamiliar public. ... in the context of the year in which it was created, 1855, and the place for which it was intended, the French section of the [Salon], [it] may be conceived of as a kind of miniature "universal exhibition" in its own right, in which the artist displays his wares to an interested public in much the same way as Napoleon III displayed his nation's commodities to would-be buyers and investors.[46]

This plan, if plan it was, was thwarted by the rejection of the picture. Eugène Delacroix visited the private exhibit and wrote of it in his journal:

... I went to the Courbet exhibition. He has reduced the price of admission to ten sous. I stayed there alone for nearly an hour and discovered a masterpiece in the picture which they rejected; I could scarcely bear to tear myself away. He has made enormous strides ... the planes are well understood, there is atmosphere, and in some passages the execution is really remarkable, especially the thighs and hips of the nude model and the breasts—also the woman in the foreground with the shawl. The only fault is that the picture, as he has painted it, seems to contain an ambiguity. It looks as though there were a *real sky* in the middle of the painting. They have rejected one of the most remarkable works of our time, but Courbet is not the man to be discouraged by a little thing like that.[47]

At the close of the display, in December, Courbet wrote to Bruyas: "My exhibition has gone perfectly and it has given me an enormous importance: things are going well." In early 1856, seeking to capitalize, Courbet painted The Young Ladies of the Banks of the Seine (Summer) (see fig. 235). The scandal this caused at the Salon of 1857 did not deter the authorities from awarding him a medal.[48]

shadows behind the easel is a naked male model, who has awkwardly assumed the pose of Christ or of a saint in martyrdom. Next to a playing cat, a young boy, member of a future generation, looks up at the mature genius; and on the floor at the right, another child is studiously drawing a figure. All of this and much, much more have inevitably tempted historians to decipher the allegorical message promised in the subtitle, *A Real Allegory*; and both the parts and the whole have been seen as a kind of rebus. In fact, everything invites symbolic speculation. Is the left foreground still life of cloak, dagger, and guitar an allusion to the outworn trappings of Romanticism? Could the background trio of men with a gun, a fur hat, and a scythe represent the leaders of revolutionary insurrections in Italy, Hungary, and Poland? Could the scribbling child be Courbet's own illegitimate son, whom he taught to paint? Could the lay model posing as a Christian martyr signify not only Courbet's debunking of ideal, supernatural subject matter but his own role as a new secular messiah who replaces these false traditions? As to the whole, it has been interpreted as a gigantic cryptogram that, in one reading might be decoded in relation to the utopian doctrine of Fourier or, in another, as decipherable only in the context of the esoteric rituals and symbols of freemasonry, which would mean that Courbet himself had been initiated into the Masonic Temple.

But whatever new objective readings may seem most plausible, it is the subjective genius of this painting that endures. For, amazingly, Courbet has now taken over the largest pictorial arena imaginable in order to offer, among other things, a new model of an artistic and social universe of which he is the center and the sole creator. The "seven years" referred to in the title would begin with the revolutionary year, 1848, so that the artist has envisioned a statement in which public and private worlds are fused. And he has also employed a language both real and allegorical, in which the representation of gravity-bound material facts, whether people, animals, or clothing, can suddenly be transformed into fictions and ideas. The coarse-fleshed, half-clad model can become a new, Realist muse; the

Fig. 235 **Gustave Courbet**, *The Young Ladies of the Banks of the Seine (Summer)*, Salon of 1857. Oil on canvas, 68⅛ × 81⅛". Musée du Petit Palais, Paris.

canvas the master is painting, no more than a palpable studio object partly covered above by a theatrical curl of drapery, can suddenly be unveiled as a luminous vista of earth, tree, and sky; and the vast shadowy spaces of the studio, more than twice the height of the figures below, can become a dreamlike stage, in which the artist's combative public life, his own paintings and aesthetic doctrines merge with more private memories. In attempting to reconcile these extremes of the objective and the subjective, of fact and idea, Courbet not only confirmed his generation's welling belief that, in his own words of 1861, "the art of painting can only consist of the representation of objects which are visible and tangible for the artist," but also proved exactly the opposite, namely, that these objects could be symbols and that the artist might even have the license to invent elaborate iconographic programs that would no longer be intelligible to a public unwilling to go beyond the first step of recognizing what was depicted. No less a genius of Realism than Manet would pose the same problems, though in more ironic and elusive terms.

In fact, the critical reception and public attendance of Courbet's one-man show were disappointingly slight, especially vis-à-vis the fuller response to his works at the official Salon, where he was in the company not only of such masters as Delacroix and Ingres, who were honored by large retrospectives, but of an international anthology of painters from both sides of the Atlantic, from Peru to Norway, who displayed their wares alongside those of booming mid-century industries. Courbet's ego and ambitions seem to have been deflated in this year of exhibitions, and his work thereafter lost some of its polemical, revolutionary character, if not its pictorial genius. For at his next Salon, that of 1857, he showed *The Young Ladies of the Banks of the Seine (Summer)* (**fig. 235**), which, if not as historically or personally pivotal as *The Stonebreakers* or *The Painter's Studio*, is no less a masterpiece. Again, the subject was shocking, though this time in urban rather than rural terms. The two "demoiselles" of the French title, enjoying the leisure of a Paris summer, are hardly "proper" young ladies at all, but rather members of a rapidly growing class of city women whose nests were feathered and bank accounts enriched by wealthy middle-class gentlemen who, on formal occasions, would have been shocked by tales of loose moral standards. In a period when prostitution was rampant and could extend socially and financially from the miseries of the sidewalk to the urban palaces of the great courtesans of the Second Empire, Courbet chose the equivalents of *The Young Ladies of the Village*, namely, upwardly mobile, nouveau-riche women whose combination of grossness and opulence satirically mirrored the fancy imperial display of Winterhalter's group portrait. The near *demoiselle*, in her rush to find relief from the exertions of a hot summer day on the Seine, has taken off her hat, removed her dress, flopped down upon it, and revealed her

elaborate chemise and petticoat, while still wearing her fanciest gloves. Her companion, whose underclothing for the moment is concealed, is equally blowsy and vacant in her sodden torpor. Both of them seem to have fallen clumsily to the earth in stiff, supine postures that were immediately caricatured as toppled wooden dolls and that also reflected the young ladies' sexual vocation, which might escalate, in the phrase of the time, to that of a *grande horizontale* (a "renowned horizontal lady"). And, as if these breaches of decorum in clothing and posture were not vulgar enough, the outstretched bower of hands and arms of the near *demoiselle* echoes the elegant movements of the ballet, whereas her friend puts gloved hand to fat rouged cheek in a way that recalls the conventional antique pose of serious meditation, ubiquitous in nineteenth-century classicizing art and high-minded portraiture. But these parodies, far from being thin-blooded, are vitalized by Courbet's epic sense of things physical and earthy. Against the high horizon of the Seine, a cornucopian abundance is crammed toward the spectator—the multiple layers of cashmeres and corsets, the inside and out of Second Empire dress; the bouquet of wildflowers that rounds out a lap; the sunhat suspended on a branch at the right; and filling in any hollows, a dense tapestry of grass, trees, leaves burgeoning in the summer heat. Yet, beyond this corporeality, a strange mood of reverie and daydream overtakes the painting, not only in the postures of groggy abandon, but through the distant, unfocused gaze of half-closed eyes that both seek out and avoid the spectator's notice.

If Courbet's veneration of a wealth of palpable stuff belongs to his unique flavor as an artist, it should not be forgotten that this materialism was also part of a period style that, in France, is generally associated with the Second Empire and, in the Anglo-American world, with the Victorian age. There, as elsewhere, a kind of *horror vacui* and a love of ostentatious display began to prevail in the 1850s. It can even be discerned in the late work of the noble septuagenarian Ingres, the guardian of ideal beauty who in 1855 vied for public attention with the apostle of ugliness, Courbet. Yet viewed through the lenses of period style, Ingres's portrait *Mme. Inès Moitessier* of 1856 (**fig. 236**) is hardly alien to Courbet's Seine-side *demoiselles*. Both paintings make us wallow in a plum-pudding richness of textures, materials, patterns that aspire to an airless density. Mme. Moitessier, of course, is a model of cool propriety in her wealthy Paris interior, and her posture alludes to classical prototypes; but she and Ingres clearly revel in her sumptuous inventory of possessions: the gilt console, the tufted damask sofa, the Chinese vase, the peacock-feathered fan, the bracelets and brooch with their enormous gems, and above all the full cascade of the rose-patterned silk dress with its embellishments of fringes and ribbons. But Ingres, like Courbet, transcends the Second Empire period look through his own genius, which

here ennobles the sitter not only with the abstract, yet sensual linear circuits that command the undulant shapes of fingers, shoulders, and arms, but through an adaptation of the common antique pose of contemplative head-on-hand that Courbet was soon to spoof. Mme. Moitessier's oracular mysteries even parallel Courbet's in their suggestion of a more concealed introspective world, the other side of this materialistic coin. For her gaze, too, is elusive and remote, and her profile reflection in the mirrored background adds an even more distant layer of unreality to the graspable facts accessible to the spectator. It is telling that Picasso was to be infatuated by both these paintings, and made variations upon them. Perhaps he intuited, as their contemporaries did not, how Ingres and Courbet, starting at the opposite theoretical premises of Idealism and

Realism, could often meet halfway in works that cast a spell of meditative stillness upon a mid-nineteenth-century world of the crassest material facts.

Poverty and Piety

Courbet's and Millet's need, after 1848, to transform new social realities into art was shared by countless painters of their generation who also felt that common men and women should replace kings and gods. Often, the results achieved a kind of compromise between the conventions of the past and the innovations of the present, a fusion that may be seen, for instance, in *The Fire* (fig. 237), a painting by Jean-Pierre-Alexandre Antigna (1817–78) shown at the

Salon of 1850–51 with Courbet's *Stonebreakers* and *Burial*. This large canvas (almost nine feet square) extracts a journalistic commonplace from the miseries of city life and aggrandizes it through the noble language of high art. Antigna had not only been a student of Delaroche in Paris but had also lived on the Ile St.-Louis in the Seine, where a growing colony of artists and writers (including Baudelaire) lived side by side with working-class families in crowded tenements. The theme of poverty had attracted him before 1848, but after that date the time had truly come to render the urban tragedies he knew firsthand in the dramatic, or better said, melodramatic vocabulary he had learned from many of Delaroche's history paintings. In *The Fire*, a worker's family is pruned down to its essential human components—a father who desperately looks out of a smoke-filled window into the dark city streets below; a mother who opens a rude wooden door to find a sheet of flames just behind it; and a trio of children ranging from a helpless infant and a terrified young girl to an older boy alert enough to bundle up quickly some paltry possessions. The sudden panic of this trapped family is nevertheless distilled into a figural structure that rings with old-master authority, the grouping of the mother and her brood establishing almost a rulebook idea of an academic pyramid. The expressions, too, reflect the heroic rhetoric of the grandest history painting, perhaps transmitted in part through Greuze's domestic

Fig. 237 **Jean-Pierre-Alexandre Antigna**, *The Fire*, Salon of 1850–51. Oil on canvas, 8′ 7¾″ × 9′ 3⅞″. Musée des Beaux-Arts, Orléans.

versions of the style. Even the drama of intense light and shadow, so appropriate to the theme, creates an atmosphere of high tragedy that might help convince a Salon audience to respect its working classes and sympathize with their fearful hazards. Antigna's idealized composition and chiaroscuro, his theatrical gestures and expressions may seem very old-fashioned when measured by the radical innovations of Courbet's flattened, hard-boiled account of the facts of life, work, sex, and death; but his efforts to adapt the means of traditional art to the ends of social realism were nevertheless typical of the strategies of many of his contemporaries.

Across the Channel, the same approach could be found in *The Irish Famine*, a painting of 1849–50 (**fig. 238**) by a British artist, George Frederic Watts (1817–1904), who had lived the life of art in Italy until 1847, but who then, returning home, was deeply troubled by the miseries of the poor who confronted him there. Of these, few were as humanly catastrophic as the failure of the potato crop and other harvests all over Europe, which resulted in the economic collapse and finally the starvation of entire working-class populations on the Continent and, most devastatingly, in Ireland. For Watts, this modern tragedy, which included not only starvation but desperate migrations, especially to

the United States, had to be painted; but the language available to him, as to Antigna, was steeped in old-master traditions. Here, a starving Irish family, homeless and displaced in a gloomy no-man's land, takes on the iconographic resonance of the Holy Family or, even more, given the migratory subject, the Rest on the Flight into Egypt. And there may be grimly appropriate allusions as well to Romantic illustrations of Dante's Ugolino (see page 130) in the *Tower of Starvation*. For all the harsh truth of proletarian misery in the lines of the father's face, or the unkempt hair of the pallid mother, the painting smacks of the grandiose figural rhythms and chromatic warmth that Watts had studied in the art of Michelangelo and Titian and that he aspired to throughout his career, which, in fact, moved quickly away from the timely problems of 1848 to timeless allegories.

In Belgium, whose industrialization followed rapidly behind England's, especially in the production of coal, and where, as in Ireland, crop failures in the 1840s made famine an ordinary fact, the plight of the poor was also a compelling theme. Charles de Groux (1825–70) was one of many who, around 1848, turned from history painting to the compassionate record of the suffering urban and rural poor, who might be seen warming themselves in the

Fig. 238 **George Frederic Watts**, *The Irish Famine*, 1849–50. Oil on canvas, 71 × 78″. The Watts Gallery, Compton, Guildford, Surrey.

Fig. 239 **Charles de Groux**, *Saying Grace*, 1861. Oil on canvas, 31½ × 60⅝". Musées Royaux des Beaux-Arts/ Koninklijke Musea voor Schone Kunsten, Brussels.

freezing streets of Brussels or partaking of a sparse meal in a country hovel. In *Saying Grace* of 1861 (**fig. 239**), De Groux offers a powerfully stark interpretation of a familiar nineteenth-century sugarcoating, that the poor, especially in the country, are fortified by their unshaken faith in Christianity, which bathes them in a saintly aura and permits their survival even in the hardest times. This comforting fiction, exploited, for instance, in Breton's *Blessing of the Wheat* (see fig. 224), is looked at more sternly here, where the dignity of daily Christian ritual—in this case, saying grace before even the most meager of peasants' repasts— helps to give these toughened faces a sacramental nobility, and where the bluntly symmetrical composition and stiff postures are appropriate not only to the style of a more naïve folk art but to representations of the Last Supper by Flemish primitives. That Courbet's *Stonebreakers* was exhibited to a scandalized Brussels in 1851 may partly account for the rugged, close-up truths of this worker's family (which conspicuously includes, in the Courbet manner, a working-class mongrel in the foreground). For even though these peasants are pious, they are also real— as real, in fact, as the potato eaters Van Gogh would paint in Holland in 1885 (see fig. 413)—and their grave, full-scale presence grants them a force absent from most mid-nineteenth-century views of peasant life, which often turned this threatening social specter into otherworldly quaintness. Such is the case in an exquisitely tiny and detailed watercolor of 1853 by the Viennese Rudolf von Alt (1812–1905), which offers a peephole view of a peasant's

room in the Austrian village of Seebenstein (**fig. 240**), a belated extension of a smiling Biedermeier trip from Vienna to the nearby countryside. Here the simplest human virtues are extolled without even the appearance of the room's invisible occupant: a miniature stage set that tells us that the peasants are pious—witness the large sculpted crucifix over the chest of drawers—and therefore harmless, and that their homes, bathed in the cheerful light of the landscape beyond the open windows, are as tidy, clean, and humble as a monastery cell. One of Courbet's peasants would be an unthinkable intruder here, in terms of griminess, gruffness, or sheer physical size; for Alt has looked at peasant life through a reducing glass that distances it to the dollhouse-charm of the birdcage on the window ledge.

That it was blessed to be poor, especially if the poor in question shared this belief, was a message that could reach the loftiest heights when elevated by William-Adolphe Bouguereau (1825–1905), whose name both during and after his long life became synonymous with the archetypal, right-wing academician who upheld faith in the timeless beauties of the classical tradition in the face of one youthful challenge after another. But even he paused before the issues of social realism, though in a roundabout way. His *Indigent Family* (**fig. 241**), at the 1865 Salon, belongs to that familiar type which, like Watts's *Irish Famine*, ennobles contemporary misery by association with venerable compositions of the Holy Family. But here, Bouguereau has kept these social truths far beyond arm's length. His poverty-stricken, homeless mother with her sad brood of

Fig. 240 **Rudolf von Alt**,
*Peasant's Room in
Seebenstein*, 1853.
Watercolor and pencil on
paper, 7 × 9".
Kunstmuseum, Düsseldorf.

three children is found in a composite of two cities. She begs on the steps of the Church of the Madeleine in Paris, but the view at her left is of the Campidoglio in Rome, where the artist, under the protection of the French Academy, lived from 1850 to 1854, immersing himself in the ideal harmonies of High Renaissance art at exactly the same time that his compatriots in Paris were challenging them with the genuine disharmonies of modern social problems. Seated, like Poussin's *Madonna of the Steps*, on the threshold of a Neoclassical building, Bouguereau's vagrant, with her quietly upturned eyes crowning a perfect human pyramid, becomes a modern Madonna of Mercy in whose veins runs the blood of Raphael. The air is limpid, and even the unshod feet of the mother and her beggar children seem unsullied. A fatherless, destitute family could hardly have a nobler pedigree, aspiring to a far higher lineage than the clean and pious, but still folkloric peasants and gypsies who populated so many earlier Salon paintings (see fig. 167).

Bouguereau's explicit demonstration of how the allocation of the most hallowed style and Christian theme could keep even modern paupers locked up in the ivory tower of art was paralleled implicitly in many of Daumier's works, especially in the oil paintings that, in the 1840s, he began to make as a more ambitious supplement to his lithographs. His submissions to the Salon were few and far between, and with one exception, his paintings are undated and almost always, by Second Empire standards, unfinished. Yet many of them unselfconsciously achieve what Bouguereau the academician set out to do: to translate the

experience of the modern urban poor into the resonant language of the museums. From the time of the inauguration of the first important French railway line (Paris–Orléans) in 1843, Daumier had been attracted to this new phenomenon of mid-nineteenth-century life, which for so many contemporary artists and writers, from Turner and Monet to Dickens and Tolstoy, could become everything from a Romantic symbol of energy, travel, or destiny to a prosaic fact reflecting the crowds and hubbub of the expanding city. Like his friend the sketch writer and cartoonist Henri Monnier, whose satiric *Les Diseurs de Rien* (1855) contains vivid descriptions of life on the French railways, Daumier had a passenger's-eye view of the "iron horse," and captured many glimpses of his compatriots in rapid transit. Of these, the weightiest are found in the series of three painted interpretations of third-class carriages. In what is probably the last of this sequence (fig. 242), whose date, c. 1862, is, as usual with Daumier's paintings, a rough conjecture, we are virtually seated opposite a wooden bench of passengers on one of the many new lines that brought the poor of Paris to and from their jobs or, on rarer occasions, to public places of leisure and history, like the park at Versailles. The family before us is, like Bouguereau's, fatherless and itinerant—we do not know where they bought their tickets, where they will get off, or what they have been doing—but we do know that they belong to a modern urban world of flux and anonymity, unlike the rural world of Millet's peasants, who seem to have been in their fields and churches since the beginning of time. Against a crowded background of Parisian men and women, unknown to us or to each

other, three generations of the same family stake out a claim of permanence and dignity in a new environment of to-and-fro movement and change. In the center, the weary but steadfast grandmother presides, the apex of a figural structure as grand and grave as any in the annals of Renaissance art. One older grandson leans toward her on the right, while her own daughter, nursing an infant, gently seeks her support at the left. Cropped off just at the knees, with the immediacy of encounter familiar to Daumier's lithographs, the grouping nevertheless resonates with museum authority, recalling, for one, the traditional Christian image of the Madonna and Child that includes the Virgin's mother, St. Anne. And the broad treatment of faces and

clothing, of even the humble wicker basket held as firmly in the grandmother's lap as the attribute of a saint, contributes to our willingness to accept Daumier's version of brandnew modern facts within the context of the deepest archetypes of human experience and artistic order. Daumier's painting also raises the vexing and perhaps unanswerable question of how to define Realism in its broadest sense. Bouguereau would surely have shuddered at the vulgarity of the gutter types represented here and at the Realist candor and confusion of what might seem an arbitrary slice of a direct perception; yet Daumier, whose figures seem generalized enough to become, like Millet's, symbols rather than individuals, would probably have shuddered, too, at

Fig. 241 **William-Adolphe Bouguereau**, *Indigent Family*, Salon of 1865. Oil on canvas, 48 × 60″. Birmingham Museums and Art Gallery, England.

Fig. 242 **Honoré Daumier**, *The Third-Class Carriage*, c. 1862. Oil on canvas, 25¾ × 35½".
National Gallery of Canada/Galerie Nationale du Canada, Ottawa.

the mechanically even detail of stone, drapery, and flesh in Bouguereau's painting, which, for all its high-minded structure and classical references, is rendered in the most literal, quasi-photographic way. Paradoxically, Daumier, the rapid, on-the-spot observer of modern Paris life, takes us further away from the material facts of perception than Bouguereau, the keeper of the academic flame.

The Pre-Raphaelite Brotherhood

The wide verbal umbrella of Realism could also shelter most of the early works of the Pre-Raphaelite Brotherhood, an ardent society formed in London in September 1848 by three artists whose ages ranged from nineteen to twenty-one and whose adolescent passion for sweeping artistic and moral reform directly echoed the revolutionary earthquakes resonating from the other side of the Channel. William Holman Hunt, John Everett Millais, and Dante Gabriel Rossetti, who were then rapidly joined by four less consequential figures, all shared the belief that British art, as they found it in the 1840s, was suffering from a terminal disease, the last ugly gasp of a decadence that had begun

in the later work of Raphael, especially the *Transfiguration*, where abbreviated artificial formulas for rendering graceful contours, broad rhythms, and murky chiaroscuro patterns marked a turn away from truth with a capital *T*. The latter quality they found mostly in fifteenth-century painting before Raphael, whether in Italy or in the Low Countries, where artists with wide eyes and pious hearts seemed to record every perceived detail, from a blade of grass to the irregular wrinkle of a doublet, never indulging in the deceitful shortcuts that, in post-Raphaelite painting, concealed the truths of nature and the visible world. By 1848, such zeal for an archaic pictorial past had, in fact, a long tradition. Individual artists like Flaxman, Blake, Runge, Dyce; artistic fraternities like the French Primitifs, the German Nazarenes, the Italian Purists—all of these had felt that the art of their immediate inheritance was corrupt and could be regenerated only by a return to the infancy of art, to a kind of naïve fidelity to the variegated surfaces and textures of the seen world or to a sharp, incisive outline that seemed equally truthful in seizing the essence of an image. Within this archaizing tradition, where simplicity and honesty would have the power to exorcise the evils of modern civilization, it is the Nazarenes who offer the closest

antecedent to the British Pre-Raphaelites, not only in their double allegiance to the art of the Netherlandish and the Italian primitives, but in their formation of a youthful artistic brotherhood, a kind of monastic order where fervent vows were taken to destroy the falsehoods of the modern artistic establishment by espousing ancient truths. But of course, living in Vienna or Rome around 1810 was different from living in London around 1848, and the work of the PRB, to use the cryptic initials they hoped would add a mysterious aura to their fraternity, belongs not only to the long history of the primitivist impulse in modern art but to the outlook of the generation of 1848. In short, William Holman Hunt (1827–1910), the member of the PRB who remained most loyal to its founding principles, has as much to do with, say, Courbet as with Overbeck.

Shrouded in secrecy and exuding contempt for the authority and practice of the Royal Academy in which they studied, the PRB first liberated itself in private manifestoes, such as a long and astonishing list of "Immortals" in history, from Jesus Christ and the author of Job to Fra Angelico, Giovanni Bellini, George Washington, and Edgar Allan Poe, whom they graded by a star system (none to four) matching their student-like enthusiasms. Then, after

quickly evolving what was to be a communal style of revolutionary force, they burst upon the scene at the Free Society and Royal Academy exhibitions of 1849 with a trio of works by the founding members. Hunt's contribution (fig. 243) paid tribute to one of the "Immortals," the fourteenth-century Roman patriot Rienzi, in a painting illustrating an episode in the historical novel *Rienzi, the Last of the Tribunes* (1835), by Bulwer-Lytton, whose *Last Days of Pompeii* had also sparked so many pictorial imaginations (see fig. 136). Hunt's full title made the story and the message clear to an audience who might not have read the novel or attended the opera by Wagner (1840) which also treated the theme: *Rienzi Vowing to Obtain Justice for the Death of His Younger Brother, Slain in a Skirmish between the Colonna and the Orsini Factions*. Hunt himself later explained that he had chosen this subject in 1848, because "like most young men, I was stirred by the spirit of freedom of the passing revolutionary time." Moreover, through his Pre-Raphaelite Brother Rossetti, the son of an Italian immigrant, he had contact with political exiles from the revolutionary upheavals in Italy in 1848–49. The story of Rienzi, in any case, showed again how an event from remote history could suddenly be resurrected as relevant to

Fig. 243 **William Holman Hunt**, *Rienzi*, Royal Academy 1849. Oil on canvas, 32½ × 47½″. Private collection.

CROSS-CULTURAL REACTIONS TO THE PRE-RAPHAELITES: JOHN RUSKIN AND EUGÈNE DELACROIX

Unlike later avant-garde movements, the Pre-Raphaelite Brotherhood did not compose one grand manifesto to accompany their radical pictorial agenda. However, in 1895 the least artistic member of the seven brethren, William Michael Rossetti, the younger brother of Dante Gabriel Rossetti and the group's secretary, looked back in a memoir to the aims of the movement:

That the Præraphaelites valued moral and spiritual ideas as an important section of the ideas germane to fine art is most true, and not one of them was in the least inclined to do any work of a gross, lascivious, or sensual description; but neither did they limit the province of art to the spiritual or the moral. I will therefore take it upon me to say that the bond of union among the Members of the Brotherhood was really and simply this—1, To have genuine ideas to express; 2, to study Nature attentively, so as to know how to express them; 3, to sympathise with what is direct and serious and heartfelt in previous art, to the exclusion of what is conventional and self-parading and learned by rote; and 4, and most indispensable of all, to produce thoroughly good pictures and statues.[49]

In May 1851, the critic John Ruskin wrote to The Times *to defend the group's works, a public rebuttal of the overwhelmingly negative criticism they had received. The intervention helped to turn their fortunes. He identified, in particular, their fidelity to "stern facts," but, at the same time, their commitment to advances in technique, regardless of conventional artistic rules:*

… the mere labour bestowed on those works, and their fidelity to a certain order of truth (labour and fidelity which are altogether indisputable), ought at once to have placed them above the level of mere contempt; and, secondly, because I believe these young artists to be at a most critical period of their career—at a turning point, from which they may either sink into nothingness or rise to very real greatness; and I believe also, that whether they choose the upward or downward path may in no small degree depend upon the character of the criticism which their works have to sustain.

… These pre-Raphaelites (I cannot compliment them on common sense in choice of a *nom de guerre*) do *not* desire nor pretend in any way to imitate antique painting, as such. They know little of ancient paintings who suppose the works of these young artists to resemble them. As far as I can judge of their aim—for, as I said, I do not know the men themselves—the pre-Raphaelites intend to surrender no advantage which the knowledge or inventions of the present time can afford to their art. They intend to return to early days in this one point only— that, as far as in them lies, they will draw either what they see, or what they suppose might have been the actual facts of the scene they desire to represent, irrespective of any conventional rules of picture making; and they have chosen their unfortunate though not inaccurate name because all artists did this before Raphael's time, and after Raphael's time did *not* this, but sought to paint fair pictures rather than represent stern facts, of which the consequence has been that from Raphael's time to this day historical art has been in acknowledged decadence.[50]

Eugène Delacroix visited the Exposition Universelle in Paris and wrote in his journal on June 17, 1855 of the effect that the Pre-Raphaelites had had on him, one quite similar to Ruskin's response. He contrasted the truth of this English "Dry School" of painting favorably against the French tradition of the Primitifs (see page 59):

What sincerity they have managed to get into their would-be imitations of old pictures! For example, compare the "Order of Release", by Hunt or Millais (I've forgotten which), with our primitives and Byzantines, who are so obstinately engrossed by questions of style that they keep their eyes rigidly fixed on the images of another age and extract from them nothing but their stiffness, without adding new qualities of their own. The crowd of hopeless mediocrities is enormous. There is not one who shows a vestige of truth, the truth that comes from the heart, not one painting like this child asleep in its mother's arms, whose silky baby hair and sleeping state are so truthful (in every particular, even down to the redness of the legs and feet), and are expressed with such remarkable observation and, above all, with feeling.

30 June 1855
… Stayed there until midday looking at the paintings by those Englishmen whom I admire so much. I am really astounded by Hunt's sheep.[51]

Delacroix, like Ruskin in 1851, understood the novel nature of the Pre-Raphaelites' approach, the radical aspect of their practice that broke with art since the Renaissance and sought to depict the wider world, and its deeper truths, in a penetratingly precise and modern manner.

contemporary issues. Already in Milan, in the 1840s, Verdi's operas, from *The Lombards* to *Macbeth*, dealt with themes of nationalistic liberation that set prerevolutionary Italian audiences ablaze.

In a way, Hunt's *Rienzi* is an Italian medieval (or better said, Pre-Raphaelite) version of that vengeful patriotic theme of oath taking so common before and after the revolutionary year of 1789 in the work of David and his

contemporaries. But here, the distance and idealization of that classicizing style which ennobled the *Horatii* or *The Tennis Court Oath* (see figs. 16 and 20) are rejected in favor of an impassioned pursuit of "truth to nature," the core of the PRB credo. Each head, for instance, is so obviously individualized that we are hardly surprised to learn that the fervent Rienzi, with eyes and clenched fist raised to the sky as he cries out "Justice, justice," is modeled after the swarthy Rossetti himself, whereas the more Anglo-Saxon features of the young knight Adrian di Costello, who responds with inward pathos to the slain corpse of Rienzi's younger brother, belong to the third PRB founder, Millais. For the PRB, "truth to nature" was akin to Courbet's ground-hugging empiricism, although in pursuing such truths, it often went to fanatical extremes, assuring that every detail was painstakingly accurate. For *Rienzi*, Hunt had not only to study medieval shields and spears in the Tower of London, but, even more important, he had vowed to capture the look of brilliant white sunlight, "abjuring altogether brown foliage, smoky clouds, and dark corners." That description might well apply to the goals of later *plein-air* painters like Monet, who in the 1860s also moved his canvases outdoors in order to achieve on-the-spot truth. Thus, the fig tree on the left was painted by Hunt in a friend's garden directly onto the canvas, and was described by him as having "its leaves and branches in full sunlight, with what was then unprecedented exactness." To achieve this luminous dazzle, so harsh to eyes accustomed to the blurry chiaroscuro and dark varnish of post-Raphaelite painting, the PRB revived, as a shared secret, the techniques of the Flemish primitives, meticulously painting, like medieval craftsmen, layer after layer of thin translucent colors on a brilliant white ground.

As conspicuously "true to nature" was the obsessively sharp-focus rendering of every detail, from the dandelion puff, the hovering butterfly, the gravel and pebbles in the foreground to the cloud banks and Gothic fortifications in the remote distance. Such equalizing acuity of vision produces, as in many of Courbet's paintings of the 1850s, a contraction of near and far that does violence to conventional illusions of atmospheric depth. And this sense of true, palpable fact, whether distant or close, pertains as well to the ungainly postures, which smack of clumsy reality rather than of the rounded, artificial rhythms that fused figures in British paintings of the previous decade, such as Mulready's *First Voyage* (see fig. 164).

Rienzi was received with considerable enthusiasm (including that of Bulwer-Lytton himself); but the presence of the cryptic initials PRB on this canvas raised suspicions of a subversive society. After January 1850, when the PRB published the first of four issues of its house magazine (whose title, *The Germ*, expressed the recurrent modern hope for regeneration), its identity and that of its members were made public. A paranoid fear of youthful conspiracy

within the sanctuary of the academy provoked a head-on assault on the PRB's contributions to the 1850 exhibition, where critical outrage paralleled that which greeted Courbet at the Paris Salon of 1850–51.

The main scapegoat was *Christ in the House of His Parents* (fig. 244) by John Everett Millais (1829–96), an audacious attempt to resurrect, in a PRB spirit, not only the naïve realism but even the intricate symbolic thinking of a late medieval painting. Inspired by a passage in Zechariah (13:6), the subject is fraught with grave prophecy. The young Christ, in the shop of his carpenter father, Joseph, has been wounded in his left hand, an event that casts a sudden spell of sacred awe and mystery amid this secular environment. And secular it is, for almost every detail, from the scrubbed, worried faces to the disorderly profusion of wood shavings on the floor, reflects the most close-eyed observations of the facts of Victorian life. It is no surprise to learn that Millais had actually been to a carpenter's shop (on Oxford Street) to get all the background tools right; that the exposed arms of Joseph (if not his head, which is that of Millais's father) were modeled after those of a real carpenter in order to secure maximum veracity of muscle structure; or that two real sheep heads had been bought from a butcher to use as models for the waiting flock in the left background. Of course, many artists before Millais had gone to such pains to assure truth (Géricault, for one, in *The Raft of the Medusa*), but seldom, if ever, had artists presented what seemed such an unedited and unelevated profusion of literal detail in which the grains of a plank of wood are seen with the same clarity as the spare hairs that grow on a bald pate. And that this was not a Victorian genre scene, but rather a sacred painting, of course, made it all the more offensive, propagating, as it did, a new mid-nineteenth-century positivism that challenged the divine truth of the Bible, not only through the scientific discoveries of Lyell and Darwin, but through the earthbound views of such historians as David Friedrich Strauss and Ernest Renan, who published lives of Christ that treated Him with a lower-case *h*.

Millais's painting enraged many people, most notably Dickens, who railed against it in his weekly journal *Household Words*. He found Christ to be "a hideous, wry-necked, blubbering, red-headed boy, in a bed-gown" and Mary to be "so horrible in her ugliness that . . . she would stand out from the rest of the company as a Monster, in the vilest cabaret in France, or the lowest ginshop in England." If these outrages sound similar to critical attacks on Courbet, so too were the complaints about such literal truth being a regressive artistic force. Hunt's submission to the 1850 exhibition—a historical reconstruction of Druidic persecution of the first British converts to Christianity—which hung next to Millais's, was charged with displaying "the objectionable peculiarities of the infancy of art." By this was meant the insistence on absolute fidelity to even

Fig. 244 **John Everett Millais**, *Christ in the House of His Parents*, 1850. Oil on canvas, 33½ × 54″. Tate Britain, London.

the coarsest detail, untouched by the refinements of a modern artistic education, which would slur over the irrelevances of wrinkles in face or in clothing with varnish and shadows and which would order a figural grouping in terms of fluent harmonies, not clumsy, real-life angularities.

Even in the later twentieth century, Millais's painting, like many other Pre-Raphaelite works, retains the power to shock, as well as to touch and to awe the spectator. To post-Surrealist eyes in particular, the obsessively close-up detail has an almost magical quality, as if every surface of the seen world were as precious and fascinating as when viewed through a microscope. The Christian content, too, seems miraculously to work, not only through the spell-bound hush that translates the trivial fact of a wounded hand into the most ominously significant prefiguration of the Crucifixion, but through the pervasive symbolism that Millais has invented with a virtually neo-medieval empathy into the mystical meaning of the commonplace: the carpenter's tools which foreshadow the rude construction of the cross; the uncommon pathos of Mary's face as she comforts her wounded son; the tentative steps of the bare-chested John as he holds a bowl of what will one day be baptismal water; the anxious crowding of spectator-like sheep that await a new leader under a brilliantly sunlit sky.

In essaying a rejuvenation of the potency of Christian painting, Millais was joined by Dante Gabriel Rossetti (1828–82), whose *Ecce Ancilla Domini!* (later retitled *The Annunciation* to quiet charges of popery; **fig. 245**) was shown in 1850, not at the Royal Academy but at an exhibition sponsored by the more liberal National Institution. Rossetti, whose given names were Gabriele Charles Dante and who was called Dante Gabriel in reference to his life-long veneration of the medieval writer, was the son of an Italian poet and professor of languages who had settled in London in 1824 and had steeped his children in a bilingual literary ambience. Following the tradition of Blake, Rossetti found both poetry and art necessary and interrelated vehicles of expression, and saturated both his words and his images with a sultry passion and anxiety that we recognize as belonging more to the psychology of the modern world than to the Dantesque Middle Ages. Here his interpretation of the hallowed theme of the Annunciation introduces a complex emotional charge that seems half-sexual, half-mystical. The blond angel Gabriel, his feet floating on heavenly fire, invades the Virgin's white bed-chamber, whereas she in turn recoils, registering in both her averted gaze and her cringing physical withdrawal that the innocence and purity of her mind and body are somehow to be violated. Without the Christian attributes—the lilies, the gold

haloes, the dove—the Virgin might almost be interchangeable with a Victorian maiden troubled by the stirrings of puberty, a common theme in many contemporary genre paintings that dealt with the ardors and rituals of proper and improper courtships.

In Hunt's and Millais's paintings from the first years of the PRB, the style seems to revive the hyperrealism of such fifteenth-century Flemish primitives as Van Eyck and Memling, but in Rossetti's painting, these pictorial archaisms—appropriate to his national heritage—revert more to the Italian quattrocento. Rossetti's vision is crystal-clear in passages like the embroidery frame and the Virgin's head. She, in fact, was modeled closely after the artist's twenty-year-old sister, Christina, herself a poet of great distinction and the author of introspective verses ("I lock my

Fig. 245 **Dante Gabriel Rossetti**, *Ecce Ancilla Domini! (The Annunciation)*, 1850. Canvas mounted on wood, 28½ × 16½". Tate Britain, London.

door upon myself . . .") that correspond to her expression here and that inspired the narcissistic moods of such later Symbolist painters as Khnopff (see fig. 438). In this head, Rossetti has recorded every strand of red hair as well as the very Victorian contrast between pallid skin and ruby-red mouth. Yet elsewhere the painting evokes rather the aura of pious naïveté associated with Fra Angelico. The perspective is innocently askew, with the ground plane rising at so steep an angle that it joins the plane of the wall and almost catapults the very corporeal Virgin from her pallet bed. And the overall tone of a chalky whiteness is redolent not only of Christian and sexual purity but of the look of those Italian fresco paintings Rossetti admired. The mix of past and present here is, however, an odd one, parallel to that in Flandrin's contemporary fresco cycles in Paris (see fig. 155), which in fact had thrilled Rossetti when he saw them with Hunt in 1849. The search for a medieval spirituality that can lift angels off the floor and compel one's belief in flat gold haloes is constantly at war with the modern materialism of cast shadows and the pull of gravity; and the sense of complex sexual repressions again feels more at home in London, 1850, than in Florence, 1450. Fascinating as *The Annunciation* may be as cultural collision, it is less coherent visually and emotionally than Rossetti's later work, where both a fuller sensuality and spirituality reign together (see fig. 260).

The turbulent conflict between sexual innocence and experience which glimmered here metaphorically through the holiest of Christian narratives often became the explicit subject of paintings that dealt with Victorian moral warfare. Of these, the most urgent and strife-ridden is surely Holman Hunt's *Awakening Conscience* of 1853 (**fig. 246**), shown at the Royal Academy in 1854 to spectators who had trouble reading its narrative. But as a critic usefully explained, "It represents the momentary remorse of a kept mistress, whose thoughts of lost virtue, guilt, father, mother, and home, have been roused by a chance strain of music." Hunt, like Rossetti, had come to feel that his evangelical messages could be conveyed not only through subjects from history, literature, and the Bible, but also through flagrantly contemporary issues. Inspired by a passage in *David Copperfield* where Dickens describes Mr. Peggotty's search for his runaway Emily, Hunt treats this common motif of mid-nineteenth-century art and life, the miserable lot of those young women who, instead of pursuing the moral road that led to marriage, family, and propriety, yielded to immoral pressures that led to adultery, prostitution, and eventually suicide or a lonely pauper's death. In the 1850s, Courbet himself, in his *Young Ladies of the Banks of the Seine* (see fig. 235), would deal robustly and candidly, with this growing stratum of society; but Hunt, characteristically, presents a fallen woman not as a relaxed *fait accompli*, but in terms of a passionate moral crisis that is projected by so agonized a facial expression that, in

Fig. 246 **William Holman Hunt**, *The Awakening Conscience*, 1853. Oil on canvas, 29½ × 22".
Tate Britain, London.

1856, the painting's original owner requested Hunt to alter the features so that they would be less painful to look at. Indeed, Hunt's anonymous heroine is seen at the moment of making a moral choice as demanding as those in George Eliot's novels of Victorian life. Seated in the lap of the man who owns her out of wedlock, she is suddenly stirred by some words in the song he is singing, "Oft in the Stilly Night." Illustrating almost literally the biblical text from Proverbs inscribed in Gothic letters on the frame ("As he that taketh away a garment in cold weather, so is he that sings songs to a heavy heart"), she rises with a slow, but burning revelation that she has been trapped in a material world of moral evil.

The most informative and passionate defense of the painting was made by John Ruskin, who had earlier espoused the cause of Turner's truth to nature and who in the 1850s found similar qualities in the Pre-Raphaelites. On May 25, 1854, in a letter to *The Times*, Ruskin explained how meticulously thought out every detail was in Hunt's painting. The print above the piano shows the biblical image of the woman taken in adultery (whose posture reflects the Victorian heroine's); a bird under the table is tormented by a cat (whose outstretched paw rhymes with the gentleman's outstretched and enclosing right arm); the rosewood furniture itself has a look of harsh, gleaming newness (inimical to the warmth and use of a family home). Indeed, no matter where we look, the prosaic facts of a Victorian interior become as charged with symbolic meaning as in, say, a painting by Jan van Eyck, whose *Arnolfini Wedding Portrait* had in fact entered the London National Gallery in 1842 and had clearly provided inspiration to Hunt not only in its uncanny realism but in the sense that every object in its domestic interior conveyed a symbolic message related to the couple here united in holy matrimony. For Hunt, even the time of day contributes to the moral point: the clock in the bell jar over the piano tells us that high noon is swiftly approaching, a fact that coincides with the luminous mirror reflection of an open window that leads to a verdant, sunlit world of nature and freedom. Uplifted in mind, spirit, and body, the hand-wringing heroine seems magnetically drawn to this noontime vision in a desperate act of salvation. In a famous pendant to this painting, *The Light of the World*, Hunt made the same point in Christian terms: the Savior, a lantern in hand to guide him through the darkest night above, knocks on the door of an untended cottage, bringing the possibility of moral revelation to a benighted soul.

The fervent Victorian sermon preached in *The Awakening Conscience* has its moral corollary in the PRB goal of absolute truth to nature, here carried to such obsessive extremes—from the unraveled embroidery in the right-hand corner to the hard, brassy gilding of the mirror, window, and picture frames, both real and reflected in the background—that the painting seems to burst with visual

fact, as if every kind of texture, material, pattern were crammed into the most congested space, and as if every color, natural or synthetic, in the Victorian rainbow were vying for our attention. Such descriptive detail of absolutely everything near and far, major and minor, produces a kind of grating, visual harshness that may look ugly by most conventions of what is beautiful. But as in the case of parallels in Victorian architecture, and most particularly in church buildings by William Butterfield, this shrill, collisive style seems motivated by an evangelical zeal that can communicate the fever of its conviction even to spectators whose values are totally alien to those espoused by these British moral crusaders.

Hunt's compelling intensity of vision and emotion may be partly measured by considering a French painting of a related mid-century theme. In *The Abandoned Woman* of 1852 (**fig. 247**), Octave Tassaert (1800–74) narrates the social melodrama of a pregnant young woman who swoons against a column in the side aisle of a church while stealthily observing in the center aisle her lover's wedding to someone else. Her dreaded position as unmarried mother-to-be is underscored by the way in which, at her left and right, a young boy and a mother and infant recoil from her presence, dissociating themselves from this morally and socially unworthy creature. But for all of Tassaert's empathy with such modern problems—he

Fig. 247 **Octave Tassaert**, *The Abandoned Woman*, 1852. Oil on canvas, 18½ × 14¾". Musée Fabre, Montpellier.

Fig. 248 **Arthur Hughes**, *The Long Engagement*, 1859.
Oil on canvas, 41½ × 20½". Birmingham Museums and Art
Gallery, England.

men, women, and children, and so too would many other
Victorian painters who elevated the traditions of genre
painting to more dramatic and passionate heights. Of these,
Arthur Hughes (1832–1915) created especially heart-
rending images of sexual and moral turmoil. Although not
actually a member of the PRB, he was converted to their
ideals by 1850, and, like them, could alternate between lit-
erary and contemporary themes. *The Long Engagement* of
1859 (**fig. 248**) began as an illustration to *As You Like It*,
showing Orlando carving Rosalind's name on a tree in the
forest of Arden; but it was then changed to a love scene that
projected the true-life ardors and frustrations of a Victorian
couple who, unlike the protagonists of *The Awakening Con-
science*, have elected to wait for the sacrament of marriage.
With eyes heavenward, as in a fervent oath, and with
hands desperately clasped in maximum physical contact,
they convey so authentic a blend of Victorian passion and
repression that their poignant emotions still register today.
In a typically Pre-Raphaelite manner, Hughes elaborated
the theme symbolically. Following the original Shake-
spearean subject, the tree also bears a lover's carved
inscription, here AMY, though the name is already covered
by clinging ivy, evoking, with the dog, the attribute of stead-
fastness and fidelity over a long and clearly difficult period.
Pre-Raphaelite, too, is the fanatical pursuit of truth to
nature, in which bark, fern, petal, branch are rendered with
such close-up precision that we feel a botany lesson could
be given from a microscopic examination of any passage. A
letter by Hughes offers testimony to how stressful his out-
of-doors researches could be. At one time, a bee attacked
him as he worked; at another, a rainstorm obliged him to
seek shelter for three hours under a beech tree in a morass
of dead roots and leaves. Such painful means, the stuff of
absolute dedication to an ideal, seemed to assure the moral
beauty of the ends, a parallel with the theme of the paint-
ing itself. When Hughes exhibited *The Long Engagement* at
the Royal Academy in 1859, he included a quotation from
Chaucer:

> For how myght sweetness ever hav be known
> To hym that never tastyd bittnernesse.

The ethic of hard work, whether applied to the tasks of
an artist, a thinker, a factory hand, or a stonebreaker,
loomed large in the mid-nineteenth century, when industry
of all kinds seemed a moral activity. Nowhere was this
belief expressed more ambitiously than in the large paint-
ing that bears the blunt title *Work* (**fig. 249**), completed by
Ford Madox Brown (1821–93) in 1865, after more than a
dozen years of hard pictorial and intellectual labor and at a
time when the initial concerted energies of the PRB had
been dissipated or redirected. Brown, like Hughes, was not
actually a member of the PRB, but shared its beliefs in an
art that would be absolutely truthful to observed, natural
fact and morally edifying. *Work* would attempt this lofty

painted many images of starving, poverty-stricken families,
unwed mothers, and the suicides that had become a grim
commonplace—the results would have been found tepid
and artificial by the likes of Hunt, who would have loathed
the slurring of visual detail, the muted tones, the graceful
theatrical gestures. Such an old-fashioned style, which
earned Tassaert the epithet "the Correggio of misery," testi-
fies to the fact that Tassaert was born in 1800, a full gener-
ation before Hunt, never mind Courbet.

Hunt, of course, would have understood Tassaert's
concern with the economic and moral distress of modern

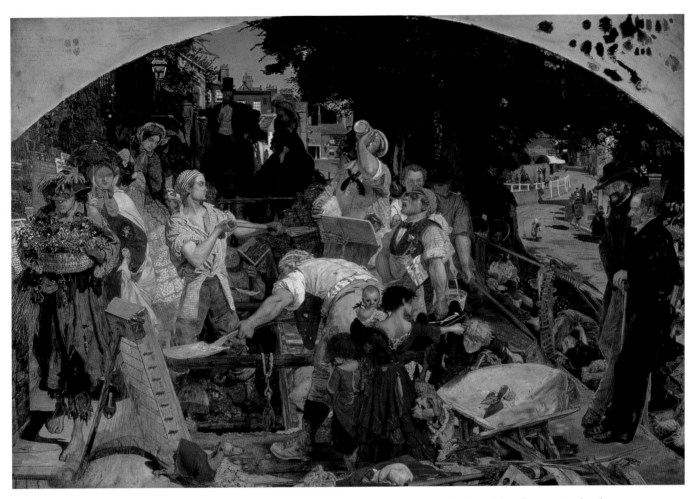

Fig. 249 **Ford Madox Brown**, *Work*, 1852–65. Oil on canvas, 54 × 77¾". City Art Gallery, Manchester, England.

goal in every way, and Brown himself, in a lengthy descriptive text, explained what he had done. Like Courbet's *Painter's Studio* (see fig. 234), *Work* is a "real allegory," insofar as it uses the stuff of real people and real life to compose a complex statement, a panoramic cross-section of work in the many manifestations evident to a zealous Victorian who believed that the work of any man could counter the work of the devil.

The setting is a hot July day overlooking Heath Street at Hampstead, near Brown's home, where a complete spectrum of suburban Londoners displays not only the range of activities subsumed under the concept of "work," but the range of modern social classes which, after 1848, were to become so conspicuous a motif in art as in life. In the center of this theater of labor is a group of "navvies" (the British colloquial word for ditchdiggers), who, unlike their counterparts in Courbet's *Stonebreakers* (see fig. 227), perform their grueling physical labors with noble, heroic movements and who wear what Brown called "manly and picturesque costumes." In Brown's eyes, these workers were no less worthy of the painter's brush than the folkloric Italian peasants and fishermen so often depicted by his contemporaries. The polar opposite of these navvies is the

pair of standing observers at the right, identified as the Reverend John Frederick Denison Maurice, whose philanthropic achievements included helping to found, in 1848, Queen's College for the education of women and, in 1854, the Working Men's College (where Brown himself was later to teach), as well as propagating the Christian Socialist Movement; and behind him, Thomas Carlyle, whose leftist views on the French Revolution and on the evils of modern social structure Brown had thoroughly absorbed. These prominent Victorians represent brain workers, whose minds labor to interpret contemporary problems and assist in improving human lives through religion, education, politics. An economic hierarchy appears, too, beginning on top with the dark distant silhouettes of a colonel and his daughter on horseback, accompanied by a hunting dog (the wealthy, leisured class), through the middle-class Victorian women at the left (one of them distributes Temperance tracts rather than devoting herself, like her companion, to beauty and idleness), down to the unruly group of children in the foreground, where a young girl in a torn, hand-me-down dress (Brown tells us she is no older than ten and probably abandoned by a drunkard father) must now look after her mischievous brother, a more docile sister, and an

Fig. 250 **William Frith**, *The Derby Day*, Royal Academy 1858. Oil on canvas, 40 × 80″. Tate Britain, London.

infant. Even the dogs in the foreground symbolize these social strata. The navvies' bull pup and the orphans' mongrel suspiciously eye the red-jacketed whippet that approaches them from the moneyed classes at the left.

Only a magnifying glass and Brown's own account of this Dickensian fusion of contemporary fact and fiction can help the spectator to find the myriad details embedded in this microcosm of modern city life—a policeman who pushes an orange girl's fruit basket off her arm; a procession of sandwich men promoting a campaign for a corrupt politician who has made his fortune with horsemeat sausages; posters informing pedestrians about a Boys' Home and a reward for a robbery; and countless other incidents that may make the spectator's experience of the painting a labor as exhausting as its conception and execution. To add to these all-encompassing social goals, Brown attempted another truth, the pictorial facsimile of brilliant summer sunlight, which here, as in other paintings of the 1850s, he observed and recorded out-of-doors as much as was humanly possible. Even in a black-and-white reproduction, the brilliance of white sunlight flickers crisply throughout, providing an overall luminous dazzle that alleviates the suffocating congestion of figures and of details whose focus is no less intense in the bricks of the Georgian house facades in the distance than in the petals of the flowers borne by the barefoot street peddler in the left foreground. And in a typically sermonizing PRB manner, the visual unity of the painting is hopefully confirmed by the moral unity of purpose, defined in biblical quotations inscribed in the frame (e.g., "In the sweat of thy face shalt thou eat bread").

Brown's novelistic techniques in *Work*, especially in displaying a rich variety of commonplaces of modern life, were shared by many contemporary artists with less fervent moral conviction or with none at all beyond their own commercial profit. One of the latter breed, William Frith (1819–1909), who wanted to be an auctioneer but whose father pushed him into a London art school, is exemplary. A contemporary and enemy of the Pre-Raphaelites, Frith also could look at what he called "the infinite variety of everyday life"; but his goal, far from being evangelical, was like that of a popular Victorian novelist who could delight modern audiences with a reflection of their own prosaic image rather than straining their morality or intellect. In the 1840s, in fact, he had illustrated Dickens's *Barnaby Rudge*. Frith's first great success, at the 1854 Royal Academy exhibition—a view of crowds at Ramsgate Sands, a seaside resort on the Channel—was followed in 1858 by *The Derby Day* (fig. 250), which was greeted by such eager crowds that a railing had to be put up to protect it, an honor before accorded only to Wilkie's *Chelsea Pensioners* (see fig. 115). Sold, with copyright and exhibition rights, at record prices for the work of a living artist, *The Derby Day* then went on tour, from 1859 to 1865, not only to Europe but to faraway America and Australia. Such global and financial success—the equivalent of a record-breaking popular movie—was the product of Frith's directorial deftness in mirroring the crowds milling about a modern racetrack and then, within sweeping dimensions (almost seven feet wide), offering to closer view a multitude of delightful or poignant anecdotal details.

Rich and poor are common polarities in Frith's painting. The undoubtedly hungry child acrobat in the foreground is so heart-breakingly riveted by the luxurious picnic of lobster and game being spread out behind him that, for the moment, he cannot perform for his entreating acrobat

father. At the extreme right, a barefoot beggar girl tries to sell flowers to a dissipated, indifferent dandy; at the extreme left, a distressed wife implores her husband to stay away from the shell game that is emptying visitors' pockets. Such vignettes, multiplied by the dozens, were the product of Frith's empirical labors in compiling, between 1856 and 1858, not only drawings of individuals and groups to be used in the finished painting, but even photographs of crowds and the grandstand at the Derby. The final effect fuses the episodic and casual nature of a multitude of real-life incidents with a wide-screen vista, creating a theatrical illusion of being in the midst of these anonymous crowds. *The Derby Day* shares its unfocused, democratic composition and its awareness of modern social hierarchies with many other ambitious paintings of the 1850s, from *Work* to Courbet's *A Burial at Ornans* (see fig. 228); but its rendering of observed facts and its moral and aesthetic seriousness are of another order. Frith's adherence to more conventional academic techniques of chiaroscuro modeling, of atmospheric blurring in the distant views, of mechanically regularized perspective recession is at odds with Courbet's or Brown's daring explorations of new compositional systems that equate near and far, and of new painting techniques that refuse to temper unvarnished truths with the softening of glazes and warm shadows. No reformer, Frith, in Ruskin's assessment, worked in an "entirely popular manner" that was necessarily "stooping and restricted," combining "a dash of daguerreotype here and there and some pretty seasoning with Dickens's sentiment." Yet Frith's very choice of a slice of modern life experienced in locales where all of society could be represented—seaside resorts, racetracks, railroad stations—was an important prophecy of a direction that far greater painters (Manet, Monet, Degas) would take. However innovative the styles of these masters would be, their subjects of ordinary modern leisure activities, in which nameless crowds come and go in city or suburb, were rooted in the kind of popular image which Frith had first mastered and exhibited as large-scale paintings within the sanctuary of the Royal Academy. In France, there were countless counterparts, especially in the more plebeian domain of printed illustrations and photographs, whose production, by mid-century, was accelerating as rapidly as the census figures of the Western world.

History Painting

By the 1850s, the casual, episodic flavor of Frith's *Derby Day* had penetrated not only the painting of contemporary events but past ones as well, so that the boundaries between genre and history painting became ever more blurred. In Germany, in the 1840s, Adolph von Menzel had already experimented with the most informal pictorial observations of rooms and people (see fig. 186), and also produced over four hundred wood-engraved illustrations for Franz Kugler's history of Frederick the Great (1839–42), in which he not only drew from earlier popular imagery but rendered the episodes from the eighteenth-century Prussian king's life with such unfamiliar candor and spontaneity that the biographer described them as "daguerreotypical reality." This metaphor in photography might apply as well to Menzel's paintings of the 1850s which transformed these small book illustrations into large canvases. In *The Flute Concert* of 1850–52 (fig. 251), we see one of the two contrary facets of Frederick the Great which could be venerated by the nineteenth century: his role in the liberal intellectual life of the Age of Enlightenment, as opposed to his forging of an iron-fisted Prussian empire, an image more popular after 1848, in the age of Bismarck. The year is 1750, the setting is a candlelit Rococo interior at Sanssouci in Potsdam, and the event is a concert in which the king, himself an accomplished flutist and composer, performs, accompanied by a small chamber orchestra with Carl Philipp Emanuel Bach at the harpsichord. Yet this individually identifiable cast of characters is rendered as in a momentary glimpse: Frederick is caught between breaths; his audience comfortably twists and turns; and the whole scene is perceived in the flickering ambience provided by the chandeliers above and the single candles that illuminate the musicians' scores. In a split second, what we see and what we hear will have changed. Even though Frederick the Great could be aggrandized by nineteenth-century German historians as a Prussian hero to rival Napoleon himself, Menzel could also depict him in an instantaneous flash excerpted from a continuum of royal domestic events as agreeable and witty as those recorded in another of this series, the king's dinner conversation with Voltaire.

Menzel's painted vignette of Frederick's life not only conforms to the growing genre character of mid-nineteenth-century history painting, but also alludes, in its restless, delicate movements and shimmering brushwork, to the Rococo style which the artist had used in his design for the frame (now lost) and which Frederick himself had so strongly favored. This conjunction of historic subject and style, already apparent in the late eighteenth century, was still more common (and more historically sophisticated) in Menzel's generation, and often had nationalistic implications. In Belgium, Baron Hendrik Leys (1815–69) had, by the 1850s, also evolved a way of painting national history that partook of the genre character that dominated so much ambitious art after 1848. Moreover, he resurrected an art-historical style appropriate to the sixteenth-century Netherlandish subjects in which he specialized. In his *Publication of the Edicts of Charles V* (fig. 252), first shown in 1861 in his native Antwerp and then in London (1862) and Paris (1867), the dense frieze of townspeople may at first make it as difficult to recognize the solemn subject as in

Fig. 251 **Adolph von Menzel**, *The Flute Concert*, 1850–52. Oil on canvas, 56¾ × 82″. Nationalgalerie, Berlin.

Courbet's *A Burial at Ornans*; yet the individual expressions of inward distress lead us finally to the narrative focus, the envoy of the emperor reading aloud one of the eleven grim decrees that, between 1520 and 1550, established the Inquisition in the Low Countries and made the practice of Protestantism a crime punishable by death. The setting, costumes, and decor seem scrupulous reconstructions of a crowded sixteenth-century town square, suggestive of Antwerp, and the pictorial style seems a learned compilation of quotations from such contemporary Netherlandish and German painters as Bruegel, Massys, and Holbein, whose incisive line, crystal-clear description, steady light, and archaically contracted spaces are invoked here as a visual milieu no less appropriate to a scene of Netherlandish religious history than the Rococo was for Menzel's page from the musical life of Frederick the Great. Even the expressions in Leys's painting appear psychologically appropriate to the Protestant mood of serious introspection, and contribute as well to the sense of a more democratic world made up, like the mourners in Courbet's *Burial*, of distinctive individuals. Before 1848, a history painter might have shown us Charles V himself proclaiming his edicts at court; but Leys shows us, instead, their

effect upon a cross-section of the population. Already in 1855, when Leys exhibited at the Paris Exposition Universelle, the Goncourt brothers wrote how, in reconstructing the Middle Ages, this Belgian painter "exhumes and resurrects the Bourgeois, that great unknown actor of the time."

The location of venerable historic events within the space-time co-ordinates of commonplace experience rather than in some remote ideal realm could characterize even the depiction of high tragedy in the classical world. A student of Delaroche, and then of Gleyre, Jean-Léon Gérôme (1824–1904) followed and refined the former's ability to re-create, in terms of a theatrical tableau, what appear almost as flashbulb records of famous moments in history. Before the *Death of Caesar* (**fig. 253**), one of Gérôme's variations on a theme he worked on between 1859 and 1867, the spectator becomes an eyewitness to the Ides of March, 44 B.C. The conspiratorial band of assassins (the last holding the lethal sword) is caught in a breathless, centrifugal exit that drastically undermines the structural principles of, say, Couture's 1847 *Romans of the Decadence* (see fig. 158), with its static, enduring harmonies of classical figures and setting. In seconds, the vast colonnaded

MENZEL, MODERNITY AND REALISM IN GERMANY

Adolph von Menzel, whose personal motto was Nulla dies sine linea *(not a day without drawing), was an artist with a fierce desire to comprehend the visible world; he produced over 10,000 drawings. At all times he carried sketchbooks of various sizes with him in eight pockets specially sewn into his coat. He was only 4 ft 7 in tall and died a bachelor. In 1855 Menzel went to the Exposition Universelle in Paris and visited Courbet's* Pavillon du Réalisme *(see page 247). At the Paris Exposition in 1867, he saw Courbet's work again and remained unimpressed. But it was there that he met Ernest Meissonier, an artist more suited to his ideas, and who pursued a broadly similar naturalist approach to history painting.*

In Michael Fried's recent study of Menzel, he pointed out that in France advanced history painting was suffering a slow decline. By contrast, it was resuscitated in Germany by Menzel, whose historical works are modern, in the sense of being alive to the realm of human experience. In particular, Fried addressed

the problem of knowing what to make of Menzel's passionate interest in the life and deeds of Frederick the Great and more broadly his affinity for scenes set in earlier times, with personages wearing the costumes of the period. ... the contrast with French modernism and its supposed indifference to considerations of subject matter could hardly be more glaring, even if artists such as Delacroix and Ingres, not to mention Meissonier and Delaroche, did not hesitate to depict subjects taken from the past. Or perhaps the French parallel is exactly to the point: by 1861 ... only academic painters continued to exploit historical subject matter. (Two seeming exceptions, the young Degas and the young Tissot, quickly turned away from the past to contemporary life.) But Menzel's historicism ... has almost nothing in common with the French variety,

which inevitably was viewed as a clearcut alternative to an art of conspicuous and programmatic modernity (such as Courbet's, Manet's, the Impressionists'). In contrast, Menzel's historical works take up exactly the same stance toward the perceived world, toward the realm of human experience, as do his self-evidently modern ones, so that for all intents and purposes there is no meaningful opposition between them.[52]

For Fried, a key to Menzel's realism and modernity is his emphasis on multi-sensory experience in his paintings, as in The Flute Concert *(see fig. 251):*

Modern commentators have stressed the liberal political implications of this representation of the enlightened monarch who was at once a military genius and a patron and practitioner of the arts. But what has not been recognized are the lengths to which Menzel went in order to combine a particular *visual* impression, that of nocturnal illumination by means of candles refracted by a crystal chandelier and reflected in wall mirrors (also by the polished marble floor), with the evocation of something *heard*, Frederick's flute solo (note the quiet composure with which the other musicians, led by C.P.E. Bach at the harpsichord, wait to resume playing once the solo is done). ... the low nocturnal illumination forces us to gaze intently into the picture, and indeed to approach the canvas closely in order to perceive exactly what is going on, the evocation of Frederick's flute solo requires that we "listen" closely as well, resisting the natural inclination to shut our eyes, so to speak. In other words, candlelight and the flute solo place looking and listening under equal strain, making us aware of both as acts of willed attention. (One vivifying detail that only intent looking discovers: the standing string player farthest into the picture is

turning a page of music on his music stand with his right hand; we do not actually see the hand, but we glimpse the turning page, which catches the light, and the angle of his bow can be explained in no other way.)[53]

Another modern writer, Jason Gaiger, argues that Menzel's pursuit of history painting in this period is patently not a conservative gambit. Frederick the Great is seen as the standard-bearer of Enlightenment values:

... it was in the years following the failure of the 1848 revolution that Menzel commenced work on the large Friedrich paintings. Far from glorifying the exercise of Prussian military and economic power, it can be argued that Menzel sought to sustain an image of enlightened rule that stood in deliberate contrast to the reactionary policies of Friedrich Wilhelm IV [r. 1840–61]. ... Menzel's Friedrich paintings found little favour at court and did not enter the national collection until after 1871, when they were reinterpreted in the context of a vigorous Prussian nationalism.[54]

For his part, Menzel expressed ambivalence about this picture in his old age, as the modern art historian Claude Keisch has shown:

As soon as it became known this picture established itself as Menzel's most popular work. Soon it was also pressed into service to support the official myth of Prussia, and reproduced thousands of times, though without the artist's involvement; in his old age he tended, on the contrary, to regard it with grumpy self-criticism: "The king stands there like a shop assistant piping a tune to mothers on a Sunday ... In fact I only painted it for the sake of the chandelier ... Sometimes I regret having painted it; but, anyway, half my life is made up of regrets, one way or another."[55]

Fig. 252 **Hendrik Leys**, *Publication of the Edicts of Charles V*, exh. Antwerp 1861. Oil on canvas, 4' 6" × 8'. The Walters Art Museum, Baltimore.

Fig. 253 **Jean-Léon Gérôme**, *Death of Caesar*, 1859. Oil on canvas, 33⅝ × 57¼". The Walters Art Museum, Baltimore.

Fig. 254 **Karl von Piloty**, *Seni before Wallenstein's Corpse*, 1855. Oil on canvas, 10′ 5″ × 12′ 2″.
Neue Pinakothek, Munich.

spaces of the curia at Pompey's Theater (seen only as a cropped fragment) will become a poignantly silent and near-empty void populated only by the foreshortened corpse of Caesar himself (whose throne has been over-turned in the struggle and whose bloodstained hands have left their traces on the base of the statute of his enemy Pompey) and, at the far right, a drowsy old senator who has apparently slept through the whole thing. This multi-focused staging around a narrative and spatial void is exe-cuted with cool grisaille tonalities and a glossy, brushless surface that evoke the marmoreal chill of classical Rome, much as Leys had evoked Northern sixteenth-century painting for a scene set in that period or Menzel, Rococo painting for the life of an eighteenth-century monarch. Yet if all three paintings learnedly reconstruct both the histori-cal and the art-historical past, they all display as well the new sense of the earthbound, the immediate, and the frag-mentary that we find in so many paintings of contemporary life of the 1850s, whether by Courbet or Frith. Just as Menzel's illustrations of Frederick the Great's biography had been called "daguerreotypical," Gautier, always astute,

could write of Gérôme's painting: "If photography had existed in Caesar's day, one could believe that the picture was painted from a photograph taken on the spot at the very moment of the catastrophe." Often, mid-century viewers would turn to the metaphor of photographic truth to empirical fact as a way of describing the radical changes that were also bracketed under the category of Realism.

Even on the loftiest and most ambitious levels of official mid-century history painting, this emphasis on the verifi-able facts of history and perception became the primary goal, and one that also guaranteed popular success with audiences used to seeing historical dramas sung and acted by living people on the contemporary stage. So it was with Karl von Piloty (1826–86), a Munich artist who, like Gérôme, followed the lead of Delaroche in history painting, but who inflated his images to melodramatic heights more reminiscent of grand opera than photography. His *Seni before Wallenstein's Corpse* of 1855 (**fig. 254**) defined this new style, whose gravity-bound, theatrical character swiftly replaced the airborne idealism that had dominated Munich's official painting under the earlier direction of

Fig. 255 **Johan Fredrik Höckert**, *The Fire in the Royal Palace, Stockholm, May 7, 1697*, 1862–66. Oil on canvas, 7′ × 9′ 4″. Nationalmuseum, Stockholm.

Cornelius (see fig. 156). The scene takes place in February 1634, and makes us virtually on-the-spot witnesses of the treacherous murder of the imperial general Wallenstein, one of the main protagonists of the Thirty Years' War. Like Gérôme's *Death of Caesar*, it also depends on Delaroche's historical reconstructions of bloody assassinations, including the chaos of a broken door, dragged bed linens, scattered carpets, and a dropped servant's bell. The tone, however, is one of high solemnity set by Wallenstein's astrologer, Seni, who had foreseen in the stars this unhappy destiny (as indicated by the celestial globe) and who now stands, hat in hands, meditating upon the tragic death of a hero.

Like Menzel's Frederick the Great, Piloty's Wallenstein belongs to the growing pantheon of historical figures who recalled the high moments of German national history. In this case, the German pedigree is further enriched by allusions to Schiller's dramatic trilogy *Wallenstein* (1798–99), from whose text, however, Piloty deviates. The mood is

clearly one of a theatrical finale, the pictorial parallel to a dramatic fusion of sight and sound in an opera by Verdi, who also could transform literary accounts of national history into the illusionistic immediacy of the stage. *Wallenstein* immediately set the standard for a new kind of Realist history painting; in the following year, 1856, Piloty became a professor at the Munich Academy, inspiring disciples from both sides of the Atlantic. His achievement, like that of the many heroes he painted, enlarged Germany's sense of national power, which found its first full artistic statement in Munich in 1858 at the "All-German Historical Exhibition." Here, in clear emulation of the prominent French and British schools, was a survey of modern German art from the anti-nationalist Carstens (see fig. 41) to Piloty, who marked the triumph of both Realism and nationalism and therefore provided an artistic equivalent for what the period of Bismarck called *Realpolitik*, that is, reality, not theory in politics—the use of practical means of any kind that would increase the state's power.

In an age of welling nationalism, Piloty's viewpoint dominated the grand-scale pictorial efforts that were sent about from one international exhibition to another as a kind of aesthetic counterpart to the industrial displays with which Belgium might rival England, or Germany, France. It was an attitude that extended as far as Sweden, as exemplified in the work of an exact contemporary of Piloty, Johan Fredrik Höckert (1826–66), who learned his craft in Munich and Paris, but who turned to his country's own life and history in both genre paintings of Lapland and scenes of epic moments in Swedish history. His *Fire in the Royal Palace, Stockholm* (fig. 255), displayed at the 1867 Paris Exposition Universelle with works by his compatriots that also stressed national subject matter, takes us (the catalogue explained) to 2:00 A.M., May 7, 1697, when we are meant to be frightened spectators before the flight of the Swedish royal family down the palace staircase already cloudy with smoke. The new fourteen-year-old king, Charles XII, behaves bravely, helping the terrified dowager queen, his grandmother, down the stairs, while in the murky upper reaches, the as yet unburied corpse of his father, Charles XI, is carried along, behind this desperate evacuation. A whole genealogical table (including, in the foreground, the king's younger sister, who is busy saving her dogs) is spread out before us in a split second of fiery

light and fleeting movement. Even though the cast of characters here is royal and historical, Höckert's *Fire* seems even more realistic as an illusion that invades our space than does its low-class counterpart Antigna's *Fire* (see fig. 237), where the figures are disposed according to more idealized conventions.

Our sense that these paintings of history are only realistic records of modern costume dramas is confirmed in a charming charade of a painting by Gustave Boulanger (1824–88), which elegantly documents *The Rehearsal of "The Flute Player" and "The Wife of Diomedes" in the Atrium of the Pompeian House of Prince Napoleon, Avenue Montaigne* (fig. 256). Shown at the Salon of 1861, it offered a glimpse of the cultural refinements inside the imperial prince's new Paris home designed meticulously in the Pompeian style, right down to its wall paintings by Gérôme. The characters are identifiable portraits, including the prince himself and Gautier, as well as prominent actors and actresses from the Comédie Française. Dressed in classical robes, they are shown rehearsing dramas inspired by Pompeian paintings. The whole is rendered in a style of chiseled and lacquered perfection that corresponds to the ivory-tower literary aesthetic of the Parnassian poets to which Gautier adhered and to the pictorial aesthetic that Gautier had dubbed "Neo-Greek" or "Neo-Pompeian" in the works

Fig. 256 **Gustave Boulanger**, *The Rehearsal of "The Flute Player" and "The Wife of Diomedes" in the Atrium of the Pompeian House of Prince Napoleon, Avenue Montaigne*, 1861. Oil on canvas, 33¼ × 52″. Musée National du Château de Versailles.

of Gérôme, Boulanger, and others, works which looked like tinted photographs of exquisitely detailed Greco-Roman costumes and interiors. Boulanger's painting records a historical fantasy world made of real materials and of real people who act out their antique dreams in the middle of Paris in 1861. But just outside the door lay the new boulevards, the new railway stations, the new urban crowds of rich and poor which so many artists found far more compelling truths than those of the historical past.

Escapist Modes in Figure and Landscape Painting

It was possible as well to avert one's eyes from the documentable realities of the past and present and to create instead mythical, dreamlike realms that afforded images of serenity or mystery completely alien to the ordinary experience of mid-century life. Even in the domain of public decoration inspired by deeply ingrained classical traditions, this goal might be reached, as it often was by the nineteenth century's most internationally renowned muralist, Pierre Puvis de Chavannes (1824–98), whose work and

influence were eventually to spread as far afield as Boston. His instantly recognizable style was first defined in the 1860s in mural schemes for new provincial French art museums at Amiens (1861–65) and Marseilles (1867–69). For the latter city, so rich in classical Mediterranean memories, Puvis was commissioned to paint two staircase murals of Pagan and Christian Marseilles, which he interpreted in terms of imaginative coastal views of *Massilia, Greek Colony* (fig. 257)—using the Latin name for the city—and *Marseilles, Gateway to the Orient*, which was probably inspired by the completion of the Suez Canal in 1869 and suggested the historical role of the city as a great seaport. In the former painting, the closely documented classical world of Gérôme or Boulanger is cast aside for an image of archaic amplitude, order, serenity, and quiet, in which the unspoiled expanses of earth, sea, and sky create a harmonious environment for this provincial Greek community. The activities range from the grilling of fish in the foreground to the construction, at the upper left, of a classical temple; but whether lofty or mundane, all these episodes that define the microcosm of a city take place not within the hubbub and confusion that characterize paintings of modern life in Paris or London, but rather within a

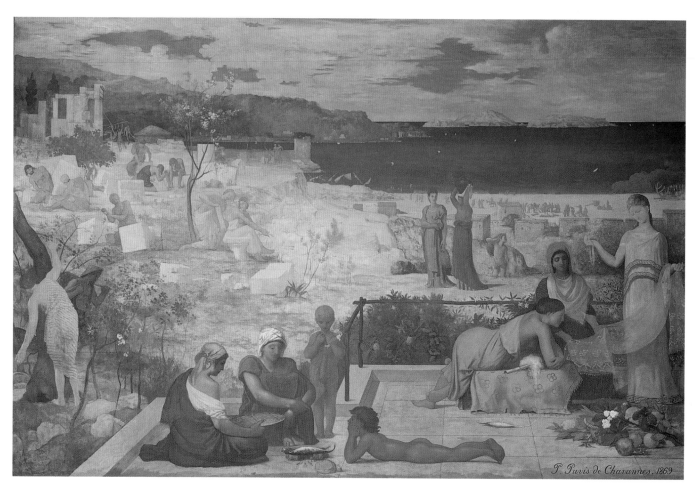

Fig. 257 **Pierre Puvis de Chavannes**, *Massilia, Greek Colony*, Salon of 1869. Oil on canvas, 14′ × 18′ 8″. Musée des Beaux-Arts, Marseilles.

Fig. 258 **Anselm Feuerbach**, *Iphigenia*, 1862. Oil on canvas, 98⅜ × 68⅞". Hessisches Landesmuseum, Darmstadt.

willfully primitive structure that locks quietly into place with the timelessness of an ancient myth or a narrative from the Bible. Conforming to an earlier pictorial idea of decorative flatness, as found in classical wall paintings or the Italian primitives, Puvis contracts his vast spaces by raising the ground plane so steeply that the figures all seem silhouetted against it. Their dispositions also evoke an archaic figural style, with even the two children in the foreground maintaining rigorous profile and frontal postures. Moreover, the colors have a subdued, chalky quality, more redolent of ancient fresco than of the modern oil paint which was actually used.

Critics who first saw this work at the 1869 Salon, before its installation in Marseilles, were generally hostile, making fun of Puvis's penchant for "the anachronistic, the monochromatic, the planiform." But these stylistic archaisms, already seen in paintings and public decorations by Ingres and Flandrin, could also seem exactly appropriate to their pre-Christian subject, and could quickly become the visual vehicle of a nostalgia for a long-lost Arcadian world untroubled by industry, poverty, ugliness, and the threat of constant change. Puvis's panacea for all modern ills would seize the eye and imagination of countless later spectators. That roster includes Seurat, Gauguin, and Munch, who, in various ways, would find in his work an inspiration for a monumental public art that spoke of eternal truths buried in civilizations remote from the nineteenth century.

For other artists of Puvis's generation, the abiding fascination of venerable themes in history, myth, and legend

could be thoroughly divorced from the public purposes which supported Puvis's career and could turn inward to more personal fantasies. His German contemporary Anselm Feuerbach (1829–80), who had studied in Paris with Couture, perpetuated the classical subject matter of his training, but often cast upon it a spell of strange longing, silence, and melancholy that becomes the private side of Puvis's more publicly oriented vision. A resident of Italy between 1856 and 1872, Feuerbach lived mainly in Rome, where he continued a tradition of German writers and artists—Carstens, the Nazarenes—who left their homeland for Italy in an effort to immerse themselves in the alien beauty of a Mediterranean civilization.

In 1862, Feuerbach painted the first version of a theme that obsessed him, *Iphigenia* (fig. 258), whose legend had already inspired two dramas by Goethe which the artist had read in 1860. Here the heroine is seen in the land of the Tauri, exiled from her native Greece, which she seems to be dreaming of at the edge of these distant shores. The

Fig. 259 **Gustave Moreau**, *Orpheus*, 1865 (Salon of 1866). Oil on canvas, 61 × 39½″. Musée d'Orsay, Paris.

mood is one of lonely reverie, whose inwardness permits many interpretations. Radiating the aura of a person displaced in time and space, Iphigenia may well reflect the feelings of Feuerbach and other foreigners who went to modern Rome to seek out the relics of a remote and beautiful classical civilization. Moreover, the painting venerates a particular woman who was, in fact, the artist's own Roman model and mistress, Nanna Risi, and who must have embodied in real life the German artist's classicizing dreams. So generalized, in fact, is this interpretation of a Greek myth that in a later version of the 1870s, Feuerbach changed the title to *By the Sea*, transforming Friedrich's fogbound images of religious meditation on the water's edge to an unspecified nostalgia for a Mediterranean world.

However personal and introspective Feuerbach's interpretation of classical myth may be, it seems tepid by comparison with the heated visions of Gustave Moreau (1826–98), who in the 1860s began to view the legends of antiquity, as well as the Bible, through such eccentric, misty lenses that the results seem more like drug-inspired hallucinations than illustrations of a shared Western heritage. His *Orpheus* of 1865 (fig. 259) was exhibited at the Salon of 1866 with a title that explained Moreau's own fantasy upon the Orpheus theme: "A young girl reverently recovers Orpheus's head and lyre, carried by the waters of the Hebrus to the shores of Thrace." This macabre and meditative postscript to the legend of the Thracian women (who tore Orpheus's body to shreds and flung his head and lyre, still singing and playing, into a stream) becomes a weird conglomerate of sex, art, and death that turns Jalabert's *Orpheus* of 1853 (see fig. 232) into the most innocent pipe dream. The disembodied head of the legendary poet, who had rejected the love of women, is now held helpless, but still wedded to its lyre, within the embrace of an exotically garbed maiden who seems totally transfixed by the possession of this morbid trophy of undying artistic creativity. At the upper left, almost part of the cloudscape, a group of music-making shepherds perpetuates Orpheus's invention, while at the lower right, a pair of tortoises alludes to the legend that their shells were used for the first lyre. The blurred landscape, reminiscent of the mysterious rocks and valleys behind the enigmatic *Mona Lisa*, wafts us to a mirage-like world that would vanish under the clear Mediterranean light and stony modeling of Feuerbach's *Iphigenia*. Despite its bizarre character, *Orpheus* was a critical success and was immediately purchased by the state. But if it appealed to the escapist impulses of the 1860s, it also fascinated later spectators. *Orpheus*, in fact, established a kind of eyes-closed vision that would find a fuller fruition in Symbolist art of the 1890s, when the theme of Orpheus itself, not to mention the *femme fatale* so beloved by Moreau, would reach its heyday. The writers Joris-Karl Huysmans and Marcel Proust found a kindred spirit in Moreau, and still later, the founder of Surrealism, André

Fig. 260 **Dante Gabriel Rossetti**, *Beata Beatrix*, c. 1863. Oil on canvas, 34 × 26″.
Tate Britain, London.

Breton, who wanted art to dwell in the unconscious, vener- ated Moreau's "somnambulistic world."

Across the Channel, one of the founders of the PRB, Ros- setti, also moved in Moreau's direction in the 1860s, turning from his reformist spirit of 1848 to personal fan- tasies that carry us to dreamworlds as morbid and eroti- cized as those of his French contemporary. His *Annunciation* of 1850 (see fig. 245) already bore a high sexual charge, despite its venerable holy theme. Soon after,

his art became even more sultry, the vehicle of private visions and passions. In 1862, his young and ailing wife, Elizabeth Siddal, whom he had drawn and painted in countless guises, died of an overdose of laudanum. The fol- lowing year, he began to transform such a portrait into a pictorial catharsis of this tragic event, *Beata Beatrix* (**fig. 260**), inspired by Dante's interpretation of the death of his own beloved Beatrice in *La Vita Nuova*. Bearing the thickly voluptuous red hair and full, sensual features of Rossetti's

dead wife, Beatrice appears in a state of trance as she moves from earth to heaven. A haloed bird, reversing the theme of the dove in *The Annunciation*, drops the poppy of sleep and death into her hands; a sundial points to nine, the hour of her passing; and in the filmy background, Dante and Love walk through the desolate streets of Florence, recognizing the omen of Beatrice's death. The most personal of funerary monuments, *Beata Beatrix* seems to exude a dense atmosphere of ether that almost drugs the spectator, as it did its victim, in a fantasy of swooning, erotic transport from this life to another. The evocation here of a mixture of the most intangible and mysterious of experiences, love and death, offers a visual parallel with Wagner's famous "Liebestod" in *Tristan und Isolde*, first produced in 1865 and the object of growing enthusiasm in the later nineteenth century. Far more than Puvis or Feuerbach, Rossetti and Moreau were capable of taking time-honored legends from the Bible, from classical or medieval literature and, through intensely private alchemy, transforming them into a never-never world that sealed itself off from the pressures and material facts of public life. As Moreau said, "I believe only in what I do not see and solely in what I feel."

Already in the 1860s, keen practitioners of the twenty-year-old art of photography could share such a faith, turning their sights from commercial portraiture to the themes that characterized the loftiest domains of painting. A pioneer in this marriage of photography to more hallowed subjects was Julia Margaret Cameron (1815–79). Her stated goal was "to ennoble photography," an ambition fortified by her close acquaintance with the painter George Frederic Watts (see fig. 238), whose blurred contours and murky use of shadows must have helped point the way to her soft-focus images. In these, even particular people could be transformed into soulful, introspective beings, so that her portraits of, say, Thomas Carlyle or Henry Wadsworth Longfellow make the sitters look more like saints or prophets than like living Victorians. Her art was clearly defined in the early 1860s, at the same time that another woman photographer, Clementina Hawarden, was reinterpreting fashion-plate photography as a sequestered world of feminine self-reflection (see fig. 286). Unafraid to tackle Tennyson's *Idylls of the King* through the medium of photography, Cameron also attempted to depict the more universal image of maternity in the manner of a saintly icon. In *Divine Love* of 1865 (**fig. 261**), as small and precious as a devotional image, she used once more her servant, Mary Hillier, who often served as the most convenient model for her re-creation, through photography, of such unlikely subjects for the camera as Sappho or St. Agnes. Here, Cameron offers a complement to Rossetti's *Beata Beatrix* (see fig. 260), concentrating now not on the ineffable mysteries of the passage from life to death but rather on the no less mysterious interchange of love between mother and child.

Fig. 261 **Julia Margaret Cameron**, *Divine Love*, 1865. Silver print, 9¾ × 7¾". Private collection.

Through her exploration of soft-focus techniques, as well as through the Raphaelesque garment the mother wears, Cameron manages to persuade us that maternal devotion, even in the contemporary world, has deep roots in the sanctity of the Madonna and Child. And, as in Rossetti's painting, there is a curious mixture of something that seems at once sensual and divine, as naked flesh and protective clothing fuse into a maternal kiss on the forehead of a little girl, Kate Keown, whose portrait was also made by Cameron. Yet this child, like the Christ child himself, seems strangely prescient, aware of an indefinable destiny. In terms of nineteenth-century cultural myths, Cameron's maternity also provides one side of a two-faced coin. Here, divine, Christian motherhood is venerated as the highest role for women. But the other side is its evil opposite, the childless, sexualized woman whose satanic wiles could doom the male of the species – in short, the *femme fatale* whose reign was ever more terrifying by the end of the century. Cameron's achievement, though thoroughly rooted in Victorian values, was enormous, providing, among other things, a basis for such later excursions in the realm of spiritualized photography as those by F. Holland Day (see fig. 443). And she would later become a major figure in feminist studies, so that it seems appropriate that she was the great-aunt of Virginia Woolf. Nevertheless, Victorian

Fig. 262 **Richard Dadd**, *The Fairy Feller's Masterstroke*, c. 1858–64. Oil on canvas, 21¼ × 15¼". Tate Britain, London.

attitudes still clung to the title of the 1926 anthology of Cameron's portraits for which Woolf would write an introduction: *Victorian Photographs of Famous Men and Fair Women.*

The escapist fantasies that accelerated in the mid-century could even reach clinical extremes, as revealed in the odd case of Richard Dadd (1817–86), who was a student with Frith at the Royal Academy. He exhibited there until 1843, when he began to believe that devils were persecuting him, and then murdered his father. He was incarcerated in Bethlehem Hospital, whose familiar name, "Bedlam," still is synonymous with lunatic chaos. In 1843, the art press referred to him as "the late Richard Dadd," but in fact, during forty-three years of hospitalization with the criminally insane, he continued to paint and draw in a way that intensified the hyperrealist style and gossamer subject matter (fairy revels, illustrations to *A Midsummer Night's Dream*) which, in his early years, he shared with many sane artists. Despite its diminutive size (less than two feet high), his best-known work, *The Fairy Feller's Masterstroke* (**fig. 262**) was the maniacally painstaking product of at least six years' labor (c. 1858–64), presumably painted for a hospital warden who may have given him fairy poetry written by a friend. Next to Fuseli's *Titania and Bottom* (see fig. 35), this seems like genuine rather than feigned delirium, a hallucinatory, sharp-focus world in which large and small, near and far, major and minor rush simultaneously to the eye and mind, preventing the viewer from grasping clearly the narrative, the scale, or the congested spaces. The central event of the title refers to the woodchopper dressed in leather who attempts to split a hazelnut with one stroke of his ax (central foreground). This strange feat is attended breathlessly by a bewildering cast of fairy-tale characters, from Titania and Oberon and assorted winged elves and sprites to a grasshopper-like insect at the upper left which ceremonially trumpets this event. Even odder, if possible, is the screen of long, thin timothy grass through which we are obliged to peer at this camouflaged Lilliputian spectacle. This gives us, in effect, an insect's-eye view, inspired perhaps by a contemporary poem about a grasshopper which can glimpse "fairy folk the stalks between." Like Lewis Carroll's Alice, Dadd's painting takes us through the looking glass of Victoran Realism into an irrational domain. The same fanatical truth to material fact that characterized the compilation of public experience in Brown's *Work* (see fig. 249) is here turned inside out to reveal yet another version of the welling countercurrents of mid-nineteenth-century art that, in defiance of the demands of Realism, constructed ever more private realms ruled by the artist alone.

By mid-century, landscape, too, could carry viewers to the farthest reaches of the globe and the imagination, presenting spectacles that revealed nature as a fearful, primordial power which, in a century of accelerating triumphs of industry and engineering, could often evoke symbolic messages about whose victory, God's or man's, would be final. Such ideas, explored first by several generations of Romantic artists, reached their most theatrical climax in the work of Frederic Edwin Church (1826–1900), an American pupil of Thomas Cole (see fig. 145). First investigating New England as a source of sublime landscape, Church then turned to South America in 1853 and 1857, recording first-hand the breathtaking and unfamiliar sites of Ecuador and Colombia that paralleled such North American marvels as Niagara Falls, which he had visited and sketched in 1856. In this he followed in the footsteps of the German scientist Alexander von Humboldt, who had been to the Ecuadorian volcano Cotopaxi as part of a five-year field trip (1799–1804) during which he studied natural history and its effects upon the human inhabitants of this planet. In fact, in his five-volume synthetic treatise, *Cosmos* (1845–62), whose English translation had an especially wide readership in the United States, Humboldt had specifically recommended that landscape painters turn from the Mediterranean and penetrate instead the interiors of tropical countries. Church's own voyages produced final results like *Cotopaxi* of 1862 (**fig. 263**), shown the following year to huge crowds at the New York branch of Goupil's, a commercial gallery in Paris. Aggrandizing yet further the apocalyptic extremes of the generation of Turner and John Martin (see figs. 134 and 135), Church places the spectator on the brink of a verdant precipice, surveying a numbingly expansive panorama of sulfurous radiance that dramatically pits against each other two awesome natural forces: the volcano, which disgorges its black clouds, and the rising sun, which casts a cruciform reflection across the waters that eventually reach the foreground plateau. From this vantage point, we observe what in the 1860s appeared to be a cosmic struggle of such epic and mythic protagonists that interpretations could bear allusions not only to the Book of Genesis or the timeless combat between heaven and hell or light and darkness, but even to such contemporary issues as the Civil War and the belief in Manifest Destiny, according to which America (the newly risen sun) would inevitably conquer the New World. Such lofty readings permitted Church's contemporaries to refer to him as "the Michelangelo of landscape art," a phrase that neatly pinpoints how common it was for nineteenth-century landscape painting to bear heroic, quasi-religious messages which reminded audiences of their roots in nature, whether the nature of Darwin or Humboldt or the nature of "In the beginning. . . ." Moreover, Church's investigation of the New World as a subject for landscape painting gave him a national flavor that was quickly recognized abroad. When his *Niagara* was shown at the Paris Exposition Universelle of 1867, it received a gold medal and was admired by Gérôme, who found in it the origins of an

Fig. 263 **Frederic Edwin Church**, *Cotopaxi*, 1862. Oil on canvas, 48 × 85″. Detroit Institute of Arts.

American tradition. Church's actual voyages, however, expanded far beyond the New World, not only to the Alps and to such shrines of Western civilization as Jerusalem and the Parthenon, but to uncharted Arctic territories where intrepid voyagers could be dazzled by the aurora borealis or threatened by icebergs.

It was precisely such remote, almost extraterrestrial regions that also could trigger the imagination of Sir Edwin Landseer, whose subjects were usually Anglocentric, beginning with Victoria and Albert themselves (see fig. 161), and extending to the domestic and wild animals of Britain and the more dramatic landscapes of Scotland. In 1857, twelve years after Sir John Franklin had set off with two ships to find the Northwest Passage, an expedition finally discovered the remains of this Arctic tragedy. It was this sensational news that provided the starting point for Landseer's bizarre memento mori *Man Proposes, God Disposes* (fig. 264), which chilled viewers at the 1864 Royal Academy exhibition. The familiar Romantic motif of the triumph of nature over human aspirations is expanded here to the topical theme of Arctic exploration and verbally supported by the title, which restates a biblical proverb. The wreck of a ship and its crew—a Navy coat, a telescope, a sail wrapped around a mast—are discovered by two polar bears which maul these pathetic vestiges of man's ambitious intrusion into nature's no-man's-land, represented by an unnavigable, uninhabitable panorama of glacial mountains

that might as easily belong to another planet. As an especially gruesome touch (and one which may have recalled reports of cannibalism that occurred here, as in the shipwreck of the *Medusa* which inspired Géricault to similarly grisly allusions; see fig. 114), one bear is seen chewing the remnants of a human rib cage. Continuing earlier traditions of Romantic animal painting, Landseer, the most famous of nineteenth-century animal painters, tried not only for zoological accuracy (he probably modeled the polar bears from those at the London Zoo), but for a kind of psychological projection into the life and world of his subjects, which, unlike the human invaders, are here at home in what to us is so alien an environment. And as with Church's *Cotopaxi*, there may be topical references, too, in this case to the triumphs and the tragedies of British imperialism, the painting becoming, as it were, a generalized monument to those who died in their efforts to keep the sun from ever setting on the British Empire.

Mid-century landscape painting became more and more a surrogate adventure for spectators who wanted to glimpse the Arctic or the tropics, or who wanted to see barely accessible Western sites where venerable traditions still reigned and where local inhabitants seemed utterly unaware that the year was 1855 or 1867. At the Paris world's fairs of those years, when many nations displayed their art as well as their industrial products, it was to be expected that artists from Sweden or the United States or Switzerland

FREDERIC EDWIN CHURCH, *COTOPAXI*, AND THE AMERICAN SUBLIME

Recent writing on landscape painting in the United States has developed the idea that particular images, even if not of U.S. soil, could reflect the political realities of a nation in turmoil in the 1860s. Angela Miller wrote that

... between 1853 and 1859, when [Frederic Edwin] Church had exhibited a series of brilliant South American landscapes, the story of the tropics had inspired not profound sadness but an expansive new sense of spiritual and national possibilities. No longer evoking a New World Eden, *Cotopaxi* [see fig. 263] dramatized a nature that was, like the nation, at war with itself. ... the metaphor of a natural conflict embodied the artistic response to contemporary events.

Cotopaxi returned to an older "theatrical sublime" of volcanoes and earth-shaking tumult, in a manner that echoed the confrontational rhetoric of the early Civil War period.[56]

Another modern art historian, Andrew Wilton, commented on Church's increasingly dark vision in the 1860s of nature as an arena of apocalyptic conflict, and suggested J.M.W. Turner as a likely influence:

Church painted several views of Cotopaxi after his first visit to South America in 1853, and he saw the volcano again during his second tour in 1857. At 18,858 feet ... it is perhaps the most impressive of the South American volcanoes, and its cone was considered particularly perfect and beautiful. It became for Church an important image of the workings of nature in an equatorial region. His early views show it in repose, the focus of a landscape embodying tropical luxuriance and harmony. In 1861 the New York collector James Lenox commissioned

this very different account of the mountain. By that date the Civil War had begun, and Church's choice of a more violent motif has been interpreted as a direct reflection on the tragic turn of events. The picture has also been recognised as one of the most theatrical, even "operatic" of Church's works ... it is hard to imagine an artist, steeped in Biblical lore as Church was, not intending an allusion, in the plume of smoke from the volcano, to the pillar of cloud that accompanied the Israelites in the desert. The connection between an epic journey across inimical terrain and an obscured sun also recalls Turner's famous *Snow Storm. Hannibal and his Army Crossing the Alps* of 1812 [see fig. 74], which [Thomas] Cole had seen in the original and admired for its sublimity, and which would have been known to Church through the engraving in the widely disseminated collection known as *The Turner Gallery* (1859–61). Church may well have thought of himself (and of Humboldt before him) as a conqueror of natural difficulties in the mould of Turner's Hannibal. But a connection with Turner may have been in his mind for other reasons: the picture was painted at the instigation of Colonel James Lenox, the New York collector who first brought oil paintings by Turner to America: he owned *Fort Vimieux* of 1831 and *Staffa, Fingal's Cave* of 1832.[57]

Finally, Tim Barringer has recently discussed the centrality of Cotopaxi *in Church's body of work, seeing it as one of the great landscapes of the century:*

Although the concept of a "national" landscape had been contested throughout the nineteenth century, the outbreak of the Civil War in

1861 marked its collapse. After a generation of uneasy compromise, war proved to be the inevitable result of the profound disparity which had grown up between the North, with its new urban cultures largely populated by a proletarian workforce of free labourers, and the South, whose economy still relied heavily upon slavery to fulfil the massive demand for cotton. As divisions widened between North and South, the question of the morality of slavery, and whether the newly acquired territories in the West should become slave or free states, ignited the final crisis. *Twilight in the Wilderness* [Cleveland Museum of Art], exhibited in 1860, seemed to presage an American apocalypse such as Church's Puritan ancestors had prophesied. When war came, new weapon technologies led to terrible bloodshed: Americans slaughtered Americans in the hundreds of thousands and photographers, draughtsmen and journalists recorded the carnage. As the Civil War raged, Church himself, deeply committed to the Unionist cause, was caught up in what his friend and pastor Horace Bushnell described (in Evangelical language) as "This immense enthusiasm, bursting forth spontaneous ... I know of nothing at all in the whole compass of human history at all comparable to it in sublimity." One of Church's finest achievements, *Cotopaxi*, reflects this political, military and ideological "sublimity"; the destructive energies of the volcano (surely emblematic of the Civil War) are balanced by a premonition of the "newly risen sun," the resurgent American nation (perhaps even a pun on the "son of God"), which pierces the gloomy cloud of smoke and ash.[58]

Fig. 264 **Sir Edwin Landseer**, *Man Proposes, God Disposes*, 1863–64. Oil on canvas, 36 × 96".
Collection Royal Holloway College, University of London, Egham, Surrey.

would emphasize the natural wonders of their own countries, creating a kind of *National Geographic* in painting. So it was with the Spanish painter J. Pérez Villaamil (1807–54), who specialized in spectactular, tourist's-eye records of not only the most thrilling mountains and valleys of the Iberian Peninsula, but also the most extravagantly ornate monuments of medieval Christianity, such as those in Toledo or Valladolid. Like other artist-voyagers, he also ventured abroad, spending three years working in Puerto Rico (1830–33) and then, back in Europe, seeking out for subject matter the Gothic architecture of northern France and the Low Countries. He lived and exhibited in Paris during the 1840s, when he attracted the attention of Baudelaire, and it was inevitable that in 1855, the year after his death, his work be included in the Spanish section of the Exposition Universelle. One of the paintings shown there, *Procession to the Chapel of the Holy Virgin in Covadonga* of 1850–51 (**fig. 265**), is typical in its fusion of a tourist's dream of mountain grandeur (a wildly tortuous pass in Asturias) and a patriotic recall of the history of Spanish church and state. For the site is famous for the eighth-century Battle of Covadonga, which marked the defeat of the Moors and the origins of the Spanish monarchy. Here, still, on September 8, 1850 (the annual pilgrimage day and the date inscribed on the painting), what seems an infinitely long procession of believers winds its way through the spectacular cliffs and gorges to pay ritual homage to a medieval shrine of both sacred and nationalistic significance. We view this scene like modern Gullivers, looking down upon a microcosm of minuscule worshipers almost camouflaged by the labyrinthine passes that lead to the monastery. Ironically, another of Villaamil's paintings included in the group at the 1855 fair represented not an almost science-fiction fantasy of a remote civilization

still miraculously preserved in the Iberian rocks, but rather the inauguration by Queen Isabella II of a new railway train as it enters the city of Gijón, whose citizens crowd about this spectacle as they might to watch a religious procession.

The accelerating tempo of change in urban and industrial life meant that what had once seemed an eternal landscape was often literally invaded and threatened by railways, factories, paved roads, or suburban sprawl. Artists could respond by seeking out ever more pure or remote landscapes as precious reminders of a vanishing world, or at times could confront directly these modern facts. There are few clearer examples of these cultural collisons than *The Lackawanna Valley* (**fig. 266**), a painting of 1855 by George Inness (1825–94). A man of strong religious conviction who eventually converted to the mystical beliefs of Swedenborgianism, Inness perpetuated in his early works the traditions of his native Hudson River School, though two visits to Europe between 1850 and 1855 redirected his landscape vision to something more universal in tone. When he was commissioned by the Delaware, Lackawanna & Western Railroad to depict its proliferating transportation network, the result pinpointed an irreconcilable conflict between the breathtaking changes of the nineteenth century and a serene vision of nature's grandeur. Constructed, like the works of Durand (see fig. 173) upon European landscape formulas, it opposes the sturdy silhouetted form of a tree in the foreground to an expansive and peaceful vista of a deep, horizontal terrain that stretches back to the hills; and it also includes a seated foreground figure who enforces a mood of reverie. Yet within this Garden of Eden there is a startling intruder, a railway train that puffs toward us from the distant roundhouse in a tangle of four or five tracks that, in fact, were

Fig. 265 **Pérez Villaamil**, *Procession to the Chapel of the Holy Virgin in Covadonga*, 1850–51. Oil on canvas, 60⅝ × 71⅝″. Patrimonio Nacional, Madrid.

Fig. 266 **George Inness**, *The Lackawanna Valley*, 1855. Oil on canvas, 33⅞ × 50⅛″. National Gallery of Art, Washington, D.C.

inserted at the request of the company's president as a prophecy of the future growth of what was actually, in 1855, only a single track. For a landscape painter like Inness, this commissioned image must have been a distressing reminder of the nineteenth century's swift industrial course, and his subsequent landscapes tend to censor out entirely such references to the modern world, becoming ever more idyllic and hazy.

It was light and atmosphere that bore, for many mid-century landscape painters, a mystical content, as if the material facts of the nineteenth-century world could be countered by concentrating on the most immaterial experiences of landscape. In the United States, an almost eerie stillness and luminosity reign over so many paintings of American land and water that the term "Luminism" was eventually coined in 1954 to describe this phenomenon. Whether or not it is indigenous to American painting and therefore a uniquely American contribution to Western art may be controversial, since European landscape painting offers many precedents and parallels (Friedrich and Købke, among others). There is, however, no doubt that this Luminist mode corresponded in the United States to a mid-century penchant for seeking out those aspects of nature that may elevate us to an awareness of the almost supernatural mysteries which Ralph Waldo Emerson had described in *Nature* (1836) as transforming him into "a transparent eyeball," his head "bathed by the blithe air, and uplifted into infinite space," his spirit vibrating with "the currents of the Universal Being." This pantheistic communion reverberates in such an exemplary Luminist

painter as Martin Johnson Heade (1819–1904), who, like Church, explored not only the farthest reaches of North America, from Maine to British Columbia, but also traveled to Central and South America to experience and record the marvels of landscape as well as of such exotic flora and fauna as orchids and hummingbirds. Marshes were among his favorite natural sites, whether the swampy ones of Florida, still harboring memories of prehistory, or cultivated ones with their stacks of hay, found on Long Island or along the New England coast. It is the latter type—in this case, at Newburyport, Massachusetts—which he depicts in *Sunrise on the Marshes* of 1863 (**fig. 267**), where a diminutive rowboat with fishermen in the foreground still accommodates popular taste for country genre. But beyond is a glowing, otherworldly calm. If the haystacks first locate a near distance accessible by foot, they soon evaporate into the all-encompassing radiance of the morning sun. Veiled by clouds, this source of life is discernible as being in the very center of the painting, illuminating a flat marshland that seems to extend beyond sight and to reach in all directions. The sun's centrality, the tug of horizontal axes on all sides, the dominance of light over substance immobilize us before nature's quiet grandeur as if we were standing before an altarpiece. Friedrich's archetypal meditation upon nature's mysteries, the *Monk by the Sea* (see fig. 71), still had issue a half-century later in a nation that constantly turned to nature, not only for clues to its own historical origins and the prehistorical ones that scientists were discovering, but for clues to what might be experienced firsthand as a testimony of the truths of religion.

Fig. 267 **Martin Johnson Heade**, *Sunrise on the Marshes*, 1863. Oil on canvas, 26½ × 51″. Flint Institute of Arts, Michigan.

Fig. 268 **Camille Corot**, *Memory of Mortefontaine*, Salon of 1864. Oil on canvas, 26 × 35½″. Louvre, Paris.

Fig. 269 **Gustave Courbet**, *The Shaded Stream (Le Puits Noir)*, Salon of 1865. Oil on canvas, 37½ × 54″. Musée d'Orsay, Paris.

Even the landscapes of Corot—whose earlier views of Italy and provincial France (see figs. 169 and 170) affirmed palpable stone and earth—moved in this immaterial direction, creating in the 1850s and 1860s a twilight world that seems more dreamed than observed. In his *Memory of Mortefontaine* (**fig. 268**), shown at the 1864 Salon, Corot recalls, as if with half-closed eyes, the mood of the venerable park, some twenty miles north of Paris, where Watteau himself had painted in the early eighteenth century. Indeed, something of the spirit of a Rococo *fête galante* haunts what appears to be an enchanted site. The movement is restricted to the gathering of flowers and the gentlest rustle of branches; and the sturdy, stable structure of tree and earth that marked Corot's earlier, classicizing landscapes is transformed into a tremulous web of leaves and branches painted with such feathery brushstrokes that the foreground becomes a blurring scrim. The far shores, reflected in the still pond, are an even more dreamlike never-never land. As in so many other mid-century paintings, there are premonitions here of the Symbolist aesthetic. Corot's late landscapes, in fact, were to provide a departure for the crepuscular mood of many nature paintings of the 1890s, on both sides of the Atlantic.

That sense of nostalgic escape in nature, as if it had become a retreat from the material assault of the nineteenth century, is found even in the work of an artist as vigorously hardheaded as Courbet about the facts of life after 1848. In *The Shaded Stream (Le Puits Noir*; **fig. 269**), first shown at the 1865 Salon and then again, with forty-seven other scenes of sea, snow, and verdure, at his retrospective that coincided with the 1867 Exposition Universelle, Courbet recorded a site near his birthplace, Ornans, which he had first painted in 1855 and then often returned to, with many variations that carry us through different seasons and times of day. The original Salon title pinpoints the site as the Puits Noir (black well) and describes the effect as that of twilight, an effect made all the more mysterious in a place where the vegetation was so dense that this turn in the river received hardly any direct sunlight. If Courbet's sense of coarse physical fact is still apparent in the trowel-like paint strokes of the foreground rocks and the unbeautiful depiction of this untidy, jungle-like landscape, the mood is nevertheless more veiled and secret, as if we had penetrated the uninhabited heart of the forest where the subtlest changes of nature's cycles might be experienced in an oasis of tranquility far from the social realities that preoccupied Courbet, the public man.

It is a mood, in fact, also captured by many mid-century photographers who followed the footsteps of painters into the secluded forests within easy reach of Paris. Courbet's junior by one year, Gustave Le Gray (1820–84), like Louis Daguerre, began as a painter. First studying with Delaroche (see fig. 147), he then turned to the new challenges of photography, a profession that also promised him quicker commercial success, a goal soon materialized with the opening of his own studio on the Boulevard des Capucines, where

Fig. 270 **Gustave Le Gray**, *Tree Study in the Forest of Fontainebleau*, 1856. Photograph. Metropolitan Museum of Art, New York.

Nadar also had his studio (see pages 350–52 and fig. 339). His repertory of subjects to be photographed was wide, ranging from architecture to portraiture, but he defined himself best by focusing his camera on nature, both woods and sea, with results that often parallel Courbet's own landscape and marine paintings. Like many painters, Le Gray was partial to the forest of Fontainebleau, which by the mid-1850s had taken on the status of what in the United States would come to be called a National Park, a protected, unspoiled area where visitors from the modern world, often following recommended trails, could escape into the cleansing purity and picturesque disorder of primeval nature. In a photograph of 1856 (fig. 270), Le Gray finds a perfect spot, harder to come by near Paris than in the landscape of the Jura mountains where, at the same time, Courbet had begun to explore similar retreats hidden inside the density of the nearby forests. Although Le Gray believed that the art of photography should be essentially different from the art of painting, his depiction of the Fontainebleau forest seems almost the work of a painter who has learned the skills of layered spatial mysteries by manipulating contrasts of intensely dark shadow and engulfing light, of objects perceived in crystalline detail and similar objects blurred into a hazy distance. In black-and-white reproduction, in fact, Courbet's landscape paintings might almost be mistaken for the hand-made counterparts of Le Gray's photographs, yet another indication of the way in which painters and photographers so often shared the visual languages of their time.

The 1860s: Manet and Painting in Paris

It was an artist of a younger generation, Édouard Manet (1832–83), who, among his countless other roles, would wipe out the vestiges of Romantic mystery, timelessness, and contemplation that still clung to works by even so avowed a Realist as Courbet. And it was Manet, too, who played most completely the role of a public man and artist determined to record in a seemingly detached, uninvolved way the onslaught of new urban and suburban experiences that greeted any Parisian who was young, alert, and observant during the heyday of the Second Empire. The timing could not have been better, for the eighteen-year-old Manet, the son of well-to-do parents in governmental positions, had entered the studio of Couture in 1850, the year before Louis Napoleon's coup d'état; and the maturation of his art and life thereby coincided closely with the changes that followed the new regime. But, if Manet's art may be interpreted as a marvelously accurate mirror of the world around him—the boulevards, the parks, the newspaper headlines, the cafés, the racetracks, the fashionable ladies and gentlemen, the well-to-do prostitutes—it also poses problems of interpretation that have intrigued one

generation after another, with results that offer a welter of contradictions. For some, Manet was the purest painter who ever lived, totally uninterested in his subjects except as neutral excuses for a light-dark contrast or a patch of lilac or lemon-yellow. For others, Manet constructed symbolic cryptograms, in which everything, from an orchid or a crane to a captive balloon, could be deciphered in a private but intelligible way. For some, Manet was the first genuinely modern painter, who liberated art from its mimetic chores and asserted the primacy of flattened pattern and color. For others, Manet was essentially the last great "old master," rooted in a multitude of art-historical references. For some, Manet was a technically defective painter, incapable of compositional and spatial coherence. For others, it was exactly these "defects" that made up his intentional contribution to drastic redirections of pictorial structure. As is often the case with a genius of Manet's stature, almost all of these contradictory points can be plausibly argued, the only certainty being that future generations will put forward quite different opinions.

What, to begin with, can be made of the *Concert in the Tuileries* (fig. 271), completed in 1862? As a painting representing a crowd of city people enjoying the leisure of what seems the cheeriest of Sunday afternoons, it belongs squarely to a type already established in such works as Hummel's painting of Berliners strolling in a pleasure garden (see fig. 162) or Frith's of Londoners enjoying an outing at the races (see fig. 250). But unlike these earlier works, Manet's appears uncalculated to the point of accident. Garden chairs and children in the foreground turn this way and that; the heads of elegant top-hatted gentlemen peer in and out at the edges; standing crowds extend backward, sideward, forward, every which way. For the instant, each figure is an individual, willfully ignoring, perhaps even parodying, the compositional rules that dominated the multi-figured *Romans of the Decadence* by Manet's master Couture (see fig. 158) or that could even be sensed in the stable congregations of humanity Courbet assembled in *A Burial at Ornans* (see fig. 228) or *The Painter's Studio* (see fig. 234). Manet's touch is here rapid and fluid, a far cry from the density of Courbet's almost weighty paint surfaces and at opposite extremes from the meticulous descriptive surfaces of Frith. We feel, instead, a perfect correspondence between a scene that captures a moment of agreeable confusion and a technique that swiftly slurs over details, reducing, say, the foreground parasol to an almost paper-flat scalloped pattern of gray and beige, or fusing, at the right, the elaborate bonnets, ribbons, and shawls of Second Empire clothing to a confetti-like sprinkle of sharp-hued pigments. Initially illegible, many such passages suddenly reveal more information than one expected—yet another parasol, or bobbing top hat, or restless child, or, more surprisingly, even a patch of light blue sky that aerates the verdant density of the trees,

Fig. 271 **Édouard Manet**, *Concert in the Tuileries*, 1860–62. Oil on canvas, 30 × 46½″. National Gallery, London.

which refuse to line up in any kind of regimented order. In this flickering sea of light and shadow, inky blacks and starchy whites supply the equivalent of a candid snapshot, which misses not only the main event (the concert that is being overheard) but even the main characters, should there be any.

But here, Manet displayed his usual elusive wit; for the painting, in addition to mirroring the elegant communal pleasures of Paris (which were often illustrated in popular magazines and newspapers and usually in journalistic styles as abbreviated and sketchy as Manet's), also provides, here and there among the anonymous crowds, a portrait gallery of Manet's friends and family, an updated, infinitely more breezy, outdoor equivalent of the personal universe Courbet presented so pretentiously in his *Painter's Studio*. The overall tone, in fact, is not that of the rugged, breast-beating radical from the country, but of a sophisticated city dweller, a gentleman who conforms closely to that nineteenth-century concept of the dandy which was written about and imitated on both sides of the Channel: an aloof observer, of impeccable dress and refinement, who watches from a poised distance the spectacle around him and who finds it vulgar to display either emotional or physical exertion. The cast of characters in Manet's *Concert* includes a roster of Second Empire celebrities—among them composer Jacques Offenbach (whose operatic spoofs of classical legends bear analogy with Manet's own

pictorial parodies), Gautier (who had early written about Manet's talents and his affinities with Spanish art), Baudelaire (who had also figured in Courbet's entourage), Baron Taylor (who had helped select Louis-Philippe's Musée Espagnol—see page 237)—and it also includes, at the extreme left, the artist himself, a dapper, bearded, frock-coated gentleman who is both part of and separate from the crowd and who holds in his gloved hand what is perhaps a walking stick but is tilted at an angle that suggests the brush of an artist who, as if before an easel, records what he sees of this chic Parisian society. Here, occasionally recognizable portraits are jostled by the anonymous faces and backs of the ambient crowds, a modern social phenomenon ever more apparent in the growing throngs of people who moved about the streets and parks of the capitals of Europe.

Already in 1845, Baudelaire, in his account of the Salon, had begun to recognize the need for artists who could seize what he found to be the epic, heroic qualities of modern life, of the dignity and beauty of contemporary clothing, especially the black hats, coats, and boots worn by gentlemen. In 1859, he wrote *The Painter of Modern Life*, in which he discussed earlier Realists like Daumier and Gavarni (see figs. 181–83) as approaching such goals, but not realizing them as fully as did Constantin Guys (1805–92). A kind of artist-journalist who had even covered the Crimean War for the *Illustrated London News*, Guys was best known for his

rapidly sketched drawings and watercolors of the elegant promenades of well-to-do Parisians and their horse-drawn carriages along the new boulevards and parks of Second Empire Paris (fig. 272). For Baudelaire, these vignettes of fashionable modern city life, which were totally unrelated to the official art world of the Salon (Guys was even self-taught), escalated in importance to fulfill his abstract ideal of a painter who at last fully reflected contemporary society; but by the time Baudelaire's essay was published, in 1863, Manet's *Concert in the Tuileries* could well have prophesied, even realized, the art Baudelaire had dreamed of. Far from being the dashing work of a successful illustrator, the *Concert*, for all its ostensible directness of observation, is rich with art-historical references, not only to the austere tonalities of black, gray, and white and the virtuoso brush-work which were so conspicuous in the paintings of Veláz-quez and other Spanish masters who were inspiring many younger French artists, but to those magically loose-jointed and hedonistic scenes of communal leisure in Arcadian parks painted by Watteau and other French Rococo masters whose stars had been rising through the 1850s and 1860s.

Such allusions to the art of the museums became far more explicit in Manet's most notorious painting, the *Déjeuner sur l'Herbe* (translatable as *The Picnic*; fig. 273). Along with two of his other paintings, the *Déjeuner* was rejected by the jury for the Salon of 1863, which had been particularly restrictive that year, refusing more than half of the five thousand submissions. As discontent welled among the twenty-eight hundred artists excluded, the government and art establishment appeased them by offering an exhibition space in the Palais des Champs-Élysées where the public could examine their work. Napoleon III himself, having seen samples of the rejects, could find little

difference between them and those selected for the official Salon, and the temporary exhibition space seemed a happy compromise. This so-called Salon des Refusés, however, immediately took on the stature of a counter-establishment manifestation, where artists at war with authority could be seen and where the public could go either to jeer or to enlarge their ideas of what a work of art could be. The counter-Salon opened on May 15, two weeks after the opening of the official Salon, and immediately attracted hordes of Parisians, who numbered as many as four thousand on a Sunday, when admission was free.

The focus of artistic innovation and public outrage was Manet's *Déjeuner sur l'Herbe*, which the artist had originally titled *Le Bain (The Bath)*. As in the *Concert in the Tuileries*, it was contemporary experience that challenged him, in this case the sight of bathers in the Seine near the suburban village of Argenteuil. But again, he would rephrase this modern scene in the language of the old masters, at once competing with them as well as underlining the vast differ-ence beetween life in Paris in the 1860s and life in, say, six-teenth-century Italy. The subject of country leisure, with picnicking, wading, and swimming, was already deeply rooted in Western art and letters, and seemed especially topical at a time when escape from city life—to the seashore or the woods—became mandatory for those who could afford it. Both in popular illustration and high art, such images abounded. A picnic scene by Auguste-Barthélémy Glaize (1807–93), painted c. 1850 (fig. 274), may exemplify an earlier vision of the nineteenth-century weekender's Garden of Eden, a graceful and prettified view, in modern costume, of decorous courtship rituals in an updated version of the Rococo *fête champêtre*, a party in a country setting. Even Courbet in his *Young Ladies of the*

Banks of the Seine (see fig. 235) offered his own low-class variation upon this essentially urban theme, as practiced by vulgar Parisian prostitutes. But Manet's painting is of another order, disconcerting in the immediacy of its glaring confrontation.

Refusing to look anywhere but at the spectator, the prominent nude (who was Manet's model Victorine Meurent) immediately establishes an insolently unblinking eye contact that forces the viewer to continue exploring the scene for some explanation. Her companions are two completely dressed gentlemen (identifiable as one of Manet's brothers, probably Gustave, his hand extended in a rhetorical gesture of discourse, and as his brother-in-law-to-be, Ferdinand Leenhoff, who seems quite distracted from the others) and a woman in a shift, who wades in the background. The shock of total female nakedness (her clothing has been tossed in a heap with the picnic still life) side by side with proper male attire was an instant assault on Second Empire propriety, baldly displaying licentious

behavior in the country that would be unthinkable, say, in the city confines of the *Concert in the Tuileries*.

But Manet had several cards up his sleeve. Like every other art student and Louvre visitor, he was aware of (and had actually copied) Giorgione's *Concert Champêtre*, a pastoral concert which depicts a similar country outing of clad men and unclad women but which, because of its venerability, caused no raised eyebrows. Why couldn't this Venetian scene be translated into the language of modern Paris? Moreover, the composition itself was derived from a most respectable model, a grouping of river gods in an engraving after Raphael's *Judgment of Paris*. Manet's references to such Renaissance authority gave the *Déjeuner* a demonstrably learned pedigree; but they also gave the effect of an irreverent take-off, like Offenbach's comic operas based upon such noble classical themes as Orpheus (1858) or Helen of Troy (1864). The spirit is that of a Beaux-Arts ball, with students acting out famous paintings in modern dress, thereby giving a sense of both the humor and the irretrievability of

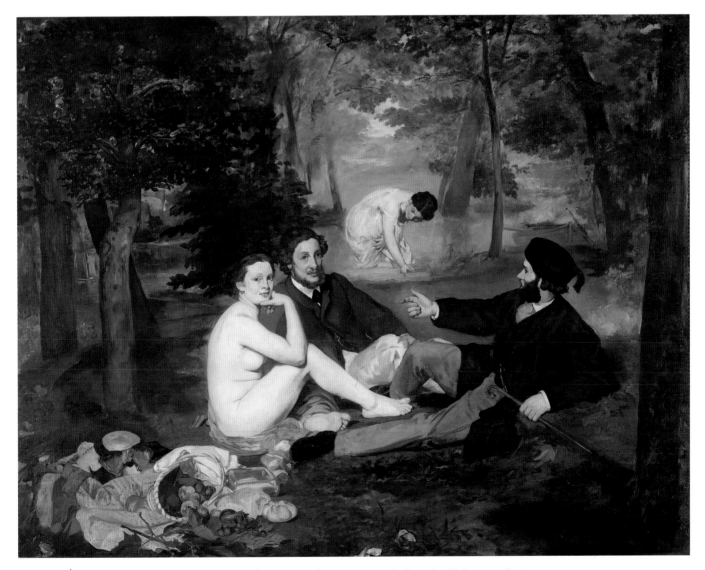

Fig. 273 **Édouard Manet**, *Déjeuner sur l'Herbe*, 1863. Oil on canvas, 6′ 9″ × 8′ 10″. Louvre, Paris.

Fig. 274 **Auguste-Barthélémy Glaize**, *The Picnic*, c. 1850. Oil on canvas, 18 × 45½". Musée Fabre, Montpellier.

the distance that lay between the modern world and the one enshrined in the museums and the academies.

Manet's inspired impudence would have been less apparent had his style not been equally daring. As in the *Concert in the Tuileries*, he imposed on the scene his aesthetic preference for intense contrasts of light and dark, a contrast wittily telescoped in the pairing of Victorine's unshod and his brother's shod foot and one that produces silhouetted patterns that rupture conventional illusions of fully modeled forms in receding spaces. The profiled expanse of Victorine's flesh seems summarily modeled, lacking middle tones that would round it, and asserting a sharpened edge. And as a hostile critic, Castagnary, put it: "No detail is in its final, precise, and rigorous form. . . . I

see fingers without bones and heads without skulls. I see sideburns painted like two strips of black cloth glued on the cheeks." Moreover, the space behind the foreground figures appears to move toward us, so that the diminutive wading figure at the top of the stable compositional triangle seems almost to be reaching down to touch an outstretched hand in the foreground. In fact, the more we look at this painting, the more the implied coherence of its sources falls apart. For all the unity of the grouping, each figure is a separate entity, engrossed in his or her own gaze, thought, or activity, so that no narrative connections can explain this grand ensemble. And this sense of breakdown, as if the very structure of the old masters, of intelligible sequences of events had crumbled before our eyes, pertains as well to

the cornucopian still life of a fruit-laden picnic basket and discarded clothing, which almost seems to belong to a separate painting, its cool color and profusion of tumbled objects constantly distracting us from the human players. Slowly, the *Déjeuner* seems to disintegrate into a kind of collage of disparate parts—still life, a female nude, male figures in modern city dress, a bathing figure, landscape—only momentarily held together by the borrowed semblance of Renaissance harmonies, and finally breaking every traditional hierarchy.

With the collapse of inherited order, the sympathetic viewer inevitably wishes to find here a new kind of order, which, for many later generations, was of a purely aesthetic kind, that is, the savoring of Manet's painted surfaces, with their velvety blacks set against the chill of pale flesh or their muted variations on green provided by a shaded landscape. In this, Manet's position parallels that of the novelist Gustave Flaubert. Both might be put in the Realist category for their insistence on telling the disjointed, graceless, amoral facts of modern life; but both are preoccupied with viewing such data through the highly refined screen of personal style, which imposes the dandy-like barrier of art and polished elegance upon dull, commonplace truths. As Flaubert has been considered the writer's writer, in his exquisite craft, Manet has equally been considered the painter's painter. In this respect, it is revealing that both Émile Zola, whose novels insisted on journalistic reportage of modern life in Paris, and Stéphane Mallarmé, whose ivory-tower poetry extracted from words the most evocative, exquisite nuances, were, for almost contrary reasons, passionate admirers and friends of Manet.

Still, a purely aestheticized approach to Manet has been found more and more inadequate, and recent scholarship has sought out internal systems of symbolic interpretation that, in the case of the *Déjeuner*, have even seized upon the bullfinch, fluttering over the group like the Holy Ghost, as conveying its traditional meaning of lewdness, or upon the frog, concealed in the lower left-hand corner, as an allusion to one in a famous painting of a young bull by Paulus Potter, a paragon of Dutch seventeenth-century realism. Moreover, with sometimes strained agility, Manet scholars have attempted to disclose more complex allegorical meanings in the painting, such as its referring to a new Judgment of Paris, Paris being the modern city, and the victor being Victorine. Yet Manet always remained close-mouthed about such cryptic readings, leaving it to future spectators to construct their own sense from the jigsaw-puzzle pieces of fact that he assembled in such enigmatic juxtapositions.

This curious sense of decomposition, of the possibility of a painting having no traditional structure of form or subject, was most explicitly demonstrated in a work accepted for the Salon of 1864, the *Incident in the Bullring*, which now exists only in two fragments (**figs. 275 and 276**) but can be reconstructed with the aid of verbal descriptions

and a contemporary caricature by Cham (**fig. 277**). The original painting depicted the drama of death in the afternoon, an enraged bull with his bullfighter victim stretched out dead in the foreground, sword and cape still in hand. As such, it conformed to the mid-century French taste for almost everything Spanish: the troupes of Spanish dancers whom both Courbet and Manet painted; Gautier's account of Spanish tourism (1843); or the enthusiasm for those painters from Velázquez to Goya who seemed to prophesy the goals of Realism; and not least, the new Empress from Spain, Eugénie de Montijo, who in 1853 had urged the introduction of bullfighting in France. Dehodencq's *Bullfight in Spain* (see fig. 231), from the Salon of 1850–51, may already move in Manet's direction, insofar as the narrative components are diffuse and the space of the makeshift arena oddly contracted; but Manet leaps ahead to something that must originally have been as baffling in its whole as it still is in its two surviving parts. As one critic described it, "On waking up, a bullfighter sees a bull some six miles away; undisturbed, he turns over and heroically falls asleep once more." The caricature makes clearer this odd disjunction of space and narrative drama, with the bull seemingly located in another spatial system (like the cows in the lampoon of Courbet's *Young Ladies of the Village*; see fig. 229) and the dead bullfighter ironically aloof from the danger. Within months after its exhibition, Manet cut the painting into two fragments (something he had done before, and would do later with other paintings), both of which seem to make as much (or as little) narrative and pictorial sense as the whole. The very fact that he could do this suggests his indifference to, and reversal of, the conventional procedures of picture-making, which lead from the parts to the whole and not the other way around. *The Dead Toreador* now exists as an enigmatically pathos-less corpse, whose fresh bloodstains seem to add more aesthetic delight (a touch of red against the somber blacks) than gory drama. His foreshortened posture, possibly derived in part from the just-assassinated Caesar in one of Gérôme's versions of this classical drama (see fig. 253), as well as from a painting then attributed to Velázquez, gives him the casualness of any inanimate object lying on the floor; and the curious spacelessness of the ground plane creates a kind of mid-air suspension where detached objects simply exist as floating facts without a context. In the preserved upper fragment (see fig. 275), the other bullfighters seem no less detached from the drama than the victim, their costumes, like the heads of the crowd peering over the wall, providing a decorative splatter of paint that serves as a foil to the huge black silhouette of the charging bull. For Manet, even the spectacle of a fatal goring, now thought to document a fatal drama that actually took place in a bullfight held in Paris, could be broken down into parts of an aesthetic continuum in which the trivial and the momentous are of equal importance and in which the

Fig. 275 **Édouard Manet**,
The Bullfight, 1864.
Oil on canvas, 18⅞ × 42⅞".
The Frick Collection,
New York.

Fig. 276 **Édouard Manet**,
The Dead Toreador, 1864.
Oil on canvas, 28⅞ × 60⅜".
National Gallery of Art,
Washington, D.C.

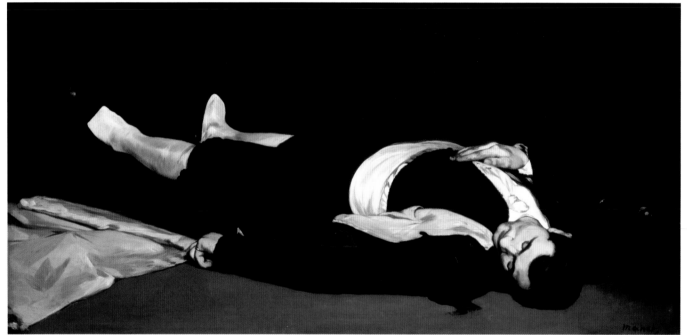

Fig. 277 **Cham**, *Incident in the Bullring* (caricature from
Le Charivari, May 22, 1864). Bibliothèque Nationale, Paris.

picture's rectangular field is the equivalent of a camera's viewfinder picking its image at random.

Yet the effect of the accidental, especially for an artist deeply rooted in old-master painting, involved as many careful decisions and calculated rejections of order as the effect of the planned. (Flaubert himself had complained how endlessly difficult it was to capture in his novels the character of ordinary, meaningless conversation.) Manet constantly balanced, especially in the 1860s, the inherited order of the past with experiments in the disorder of modern life. Thus, for many of his early masterpieces, like the *Déjeuner*, he alluded to tradition by way of offering a measurement of the distance between a familiar sense of pictorial structure and what artists and writers began to sense as something exciting and drastically new. *Olympia*, painted in 1863, but not exhibited until the Salon of 1865, is one of these works (fig. 278), even bolder than the *Déjeuner* in its parody of a Renaissance masterpiece and in its flagrant display of modern sexual mores. Based closely on Titian's *Venus of Urbino*, which Manet had copied in Florence in 1853,

it replaces a Venetian goddess of love and beauty with a high-class Parisian prostitute of a cast far more worldly and elegant than Courbet's gross young women on the banks of the Seine (see fig. 235). Moreover, the model is again recognizable as Victorine from the *Déjeuner*. Totally unabashed by her nakedness, indeed, proud of it, she once more stares down the spectator, as if it were he who offered the flowers held by the black servant (a model named Laure) but grandly ignored by Olympia herself. To underline the easy identification of her profession, her name, Olympia, had instant associations for a Parisian audience, being a common name for prostitutes of the period, of whom the most famous was Marguerite's rival in *La Dame aux Camélias* (1848–52), a popular novel and play by Dumas *fils*. And to add to this onslaught of the facts of modern sexual life, Manet replaced the lapdog in Titian's *Venus* with, at Olympia's feet, a velvety, foreshortened blot of a black cat, whose back is arched, whose tail is raised, and whose presence evokes not only a hissing animal in heat, but a stream of erotic associations especially close to the cat imagery in Baudelaire's poetry.

As in the *Déjeuner*, it was not only the subject—which here is not far from moderately pornographic photographs of the period—but the style which alarmed the Salon-goers. Even Courbet, who claimed not to flinch at reality, found the pressing closeness of *Olympia* disquieting, commenting that it was flat and unmodeled, that "it looks like a Queen of Spades getting out of the bath." Although meant negatively, this nevertheless helps us to see how daring Manet's challenges to conventional modeling and perspective were in 1865. The lighting is a head-on glare, which minimizes the illusion of roundness and maximizes a brash, almost heraldic pattern of lights and darks which at first could seem as crude as Courbet's playing card. Yet, on inspection, these extremes reveal a bravura subtlety worthy of the masterpieces of Velázquez so admired by Manet. In each polarity, black and white, there are exquisite refinements—within the dark values, the servant's head and the black cat against the deep green curtain; within the light values, the distinctions made among the sheets, pillows, skin, shawl, servant's dress, and wrapping paper. And if, for 1865, everything seems jammed flat into the foreground, like the figures, chairs, toys, and parasol that bluntly delimit the bottom of the *Concert in the Tuileries*, the screenlike recession of layered planes, from the bed linen hanging over a glimpse of upholstery to a view behind a parted curtain, is

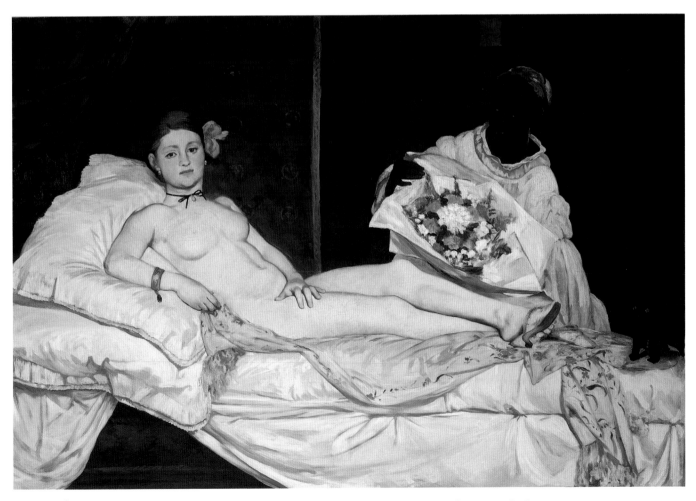

Fig. 278 **Édouard Manet**, *Olympia*, 1863 (Salon of 1865). Oil on canvas, 51 × 74¾". Louvre, Paris.

of an amazing spatial complexity that moves from the overt to the concealed.

It is conventional, and still informative, to contrast *Olympia*, scoffed at by the Salon audiences as ugly and incompetent, with the kind of Second Empire nude which won official favor, such as *The Birth of Venus* (fig. 279) by Alexandre Cabanel (1823–89), one of three paintings of Venus at the 1863 Salon and one which was singled out for purchase by Napoleon III himself. Olympia's ribbon necklace, gold bracelet, and informal footwear (one mule on, the other off) are as unthinkable in this pearly seashore idyll as would be Cabanel's airborne cupids floating over this modern goddess of commercial love and announcing her birth by blowing conch shells. Yet as Manet's friend and champion Zola was to put it in 1866, Olympia would have been presentable had Manet borrowed Cabanel's rice-powder puff for her cheeks and breasts. As for double standards of erotic propriety, Cabanel's Venus, seemingly born depilated and powdered, twists herself backward in a pose of professionally voluptuous abandon dependent upon Ingres's odalisques (see fig. 130), a pose that simply turns Manet's aggressive modern female into a passive receptacle of the male spectator's sexual wishes. Even in terms of upsetting the balance of male–female power, Manet's prostitute, so coolly and toughly holding her own, posed a threat to the status quo.

Cabanel's efforts to perpetuate inherited beliefs, not only in the timeless beauty of classical legend but in the function of the painted female nude as a fantasy of easy sexual conquest, pertain as well to his style. As described by Castagnary, who maligned the *Déjeuner* in the same year: "From the depths of the canvas, the procession comes toward us." This measured movement from distant illusion to the foreground produces exactly the opposite effect of Manet's paintings, in which near and far cling so stubbornly to the surface that everything becomes an insistent confrontation. Cabanel's circuitously modeled anatomy conveys the illusion of a totally carved and palpable marble, just turned into pink Rococo flesh, whereas Manet's prostitute seems, like many of Ingres's nudes, modeled as a cameo, all projected surface, with the invisible other side simply annihilated in the imagination. Even Manet's edges contribute to this flattening crispness, for Olympia's contours, unlike Venus's, are occasionally emphasized with a rapid dark outline that underlines the two-dimensional effect. The remote and the ideal have become harshly immediate facts of modern life; and venerable systems of picture-making yield to the artist's right to construct private aesthetic worlds that, when necessary, will jettison all conventions of perspective, of chiaroscuro modeling, of focused narrative or composition.

Manet's polarized position between an art that was at once reportorial, bringing contemporary truths from outside the Salon into its sacred precinct, and aesthetic, seeking out new kinds of visual coherence that would satisfy his unique sensibility, was apparent not only in his records of

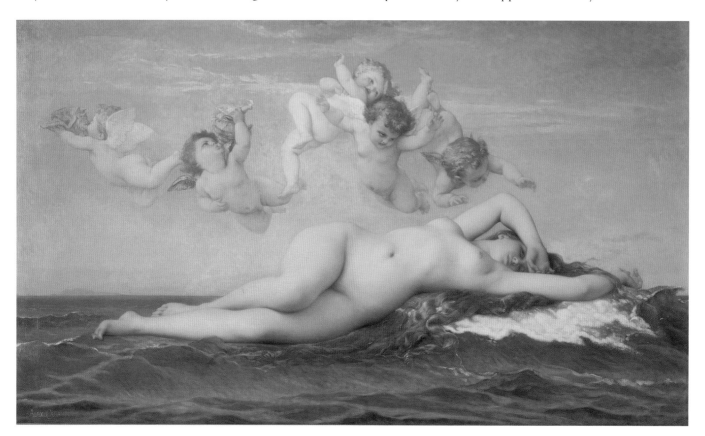

Fig. 279 **Alexandre Cabanel**, *The Birth of Venus*, Salon of 1863. Oil on canvas, 52 × 90″. Musée d'Orsay, Paris.

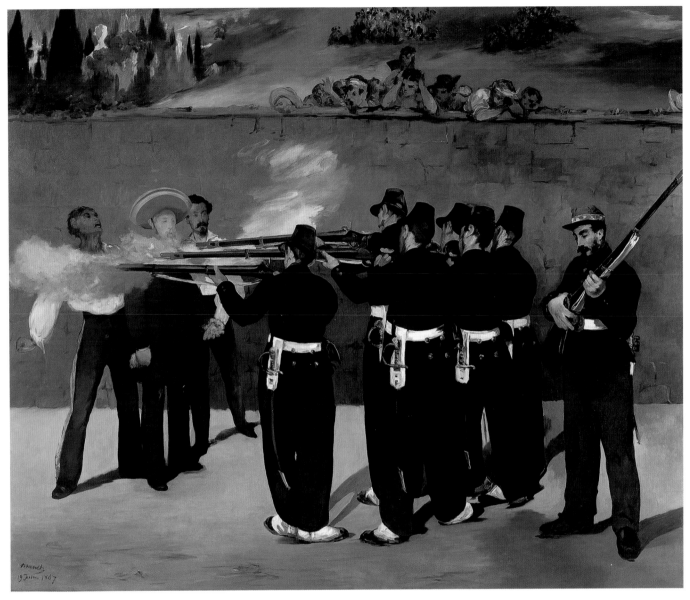

Fig. 280 **Édouard Manet**, *The Execution of the Emperor Maximilian*, 1868. Oil on canvas, 8′ 3″ × 10′. Städtische Kunsthalle, Mannheim.

modern morality but even in his major contributions to the imagery of dramatic military and political events of the day. These included an American Civil War episode of naval combat between a Union and a Confederate ship off the coast of Cherbourg in 1864 as well as one of the great mid-century affronts to Western standards of diplomacy and morality, the execution in 1867 of the Austrian Archduke Maximilian, the Hapsburg who had been transported and placed on the throne of Mexico in 1864 (fig. 280). After the departure of Napoleon III's troops, which had first supported his puppet government, Maximilian was left to face the welling native opposition led by Juárez, which brought him to trial and death at Querétaro. This shooting of a European monarch on remote, godforsaken soil was considered an act of chilling barbarism and one which Napoleon III and his court officially mourned,

despite the considerable responsibility of the French for the tragedy.

Manet found here the stuff of modern history and battle painting, in the tradition not only of Napoleonic, but even of Anglo-American reportage. He must have seen Copley's *Death of Major Peirson* (see fig. 6) when it was shown by his Paris dealer, Martinet, in 1863, and, far more timely, paintings that documented the American Civil War by the Bostonian Winslow Homer (1836–1910), who was trained as a journalistic illustrator and sent to the front in this capacity by *Harper's Weekly*. Visiting Paris in 1866, Homer submitted two Civil War paintings to the Exposition Universelle of 1867. One of these, *Prisoners from the Front* (fig. 281), which had first been shown with great success at New York's National Academy of Design in 1866, almost matches Manet's coolly documentary

Fig. 281 **Winslow Homer**, *Prisoners from the Front*, 1866. Oil on canvas, 24 × 38″. The Metropolitan Museum of Art, New York.

detachment, recording here not the rhetorical splendor or tragedy of battle, but rather the commonplace confrontation by an almost dandy-like Union officer with a group of Confederate prisoners, one of whom, the officer, retains his dapper bearing even in defeat, while the others present a sorry cross-section of bedraggled enlisted men, from young to very old, standing before two surrendered rifles. Homer's highly descriptive style may tell us more per square inch than Manet's, but his stance of a quiet observer before even the facts of war and his candidly loose-jointed composition of figures silhouetted against a high ground plane parallel what Manet was soon to do with his highly charged subject.

As before, Manet chose a famous painting to be his point of departure for translating the expired values of the past into the amoral language of the present, in this case Goya's *The Third of May 1808* (see fig. 34), a comparison which immediately underlines what appears to be Manet's almost chillingly dandified detachment in the face of an event still more gruesome and infinitely more consequential than the death of a bullfighter. Goya's sense of outrage, of a moral structure turned inside out, of individual despair versus collective brutality, of black and white as conveyors of good and evil, life and death have all been obliterated here in favor of what seems the most inappropriate mix of

shattering subject matter and aesthetic refinement. The streaks of gunpowder smoke and the uniforms of the firing squad (which mixed both French and Mexican elements, and for which Parisian soldiers posed) are marvels of those black and white silhouettes Manet explored; and the cursorily described coarse brick wall of the enclosure provides a flattened screen against which these opaque patterns, both chic and funereal, can best be savored. Most startling as a symptom of this ostensible indifference to manslaughter is the casual posture of the officer at the right who reloads his gun, an inclusion which, for contemporaries, had especially shocking connotations since it was well known that Maximilian was not killed immediately, but had to be given, as a final degradation, the *coup de grâce* close up as he lay squirming on the ground. Again, conventional perspective has collapsed: the trio of victims appears both too close to and too far from the line of fire, hovering instead in a spatial limbo between the wall and the steeply tilted ground plane.

Was Manet totally unaffected by this grim official murder, painting it as he would the fashionable assembly of black-costumed gentlemen in the Tuileries, or was he perhaps proposing for the first time that the hierarchy of moral values associated with life and death had totally crumbled? No longer a miniature vignette like Meissonier's

view of corpses on the barricades (see fig. 220), *The Execution of Maximilian* is a grand-scale statement of a willfully impersonal, quasi-documentary approach even to such chilling subject matter, the equivalent of photographic reportage. Moral readings, responses of horror are left to the beholder, with Manet remaining as poker-faced as the contemporary newscaster who recounts world disasters on a television screen. The inscribed date of the event in the lower left-hand corner, June 19, 1867, emphasizes this goal, as it does in the title of Goya's painting, and contributes to the function of the painting as an accurate image of what really happened. In fact, *The Execution*, which was politically inflammatory in France as a reminder of Napoleon III's disastrous foreign policy, was censored from public view, and seen in 1879–80 only in New York and Boston, where some critics found in it much of the drama and tragedy which later spectators have often found puzzlingly absent. Manet's seeming casualness about his subject may be borne out by the fact that he cut other versions he had made of the theme into fragments, as he had done with the *Incident in the Bullring*; but why, if he were so callous, would he have selected such a subject to begin with? The complex mechanisms of irony, of the contradictions between art and life, are prominent issues here, and seem to have fascinated Manet as they still do us. Could he even have been making subtle symbolic comments about this tragedy by offering allusions to other kinds of martyrdom: to the crucifixion of Christ (Maximilian's halo-like sombrero surrounded by the good and bad thieves in the guise of his generals Mejía and Miramón) or to the spectacle of the bullring suggested by the Goya-like crowd of low-class spectators, who, as in the *Incident in the Bullring*, peer over the barrier at the ritualized death below?

Although we may never know the definitive answers to the questions Manet's paintings continue to pose for us, we at least always sense the full-scale conviction behind his work, an integrity that he himself once articulated in words. In 1867, at the time of Paris's second Exposition Universelle, Manet, instead of showing at the Salon, followed Courbet's example of 1855 and arranged, at his own expense, a pavilion where he presented some fifty paintings. In the catalogue preface, possibly written with the help of Zola, Manet writes of himself with predictable detachment in the third person, and explains in a matter-of-fact way that the contemporary artist does not wish to protest, but that "it is sincerity that gives the work the character of a protest, whereas the painter only wanted to render his own impression." And he explains, too, that the most important thing for an artist is to exhibit, for "after looking at something for a while, one becomes familiar with what was once surprising or even shocking." With such comments, Manet quietly defined the predicament that was to face so many painters of the nineteenth and twentieth centuries who experienced something new, felt compelled

to depict it in an unfamiliar way that grated against accepted conventions, and often discovered, years or decades later, that their art, initially unintelligible, would be absorbed into comprehensible traditions. At the Salon of 1881, even the ultra-conservative Cabanel would recognize Manet's genius officially by awarding him the second-class medal.

For his innovations of the 1860s, Manet had the written support of Zola, who, in his role as an art critic for the weekly *L'Événement*, began in 1866 to herald Manet as the outsider who would revitalize French art, claiming the *Déjeuner* and *Olympia* as masterpieces, defending Manet's right to follow his own visual and intellectual instincts however much they defied academic rules, and challenging the concept of beauty as an absolute, universal standard. Zola's public support of Manet's art and his right to make it was soon reciprocated in the winter of 1867–68, when Manet painted Zola's portrait (**fig. 282**), which generally displeased or puzzled spectators at the Salon of 1868. As the painter Odilon Redon expressed it, the portrait "is more of a still life . . . than the expression of a human being," and it is true that attention to Zola's almost profiled head (a position which minimizes emotional probing) is largely deflected by the complex clutter of still-life objects that surround the writer at his desk. The tumble of bound books and the casual stacking of pamphlets (of which the foremost is Zola's on Manet, whose printed title wittily serves as the painter's signature) is especially conspicuous amid the rectilinear rigidity of a Japanese screen and a framed pinboard that encloses three overlapping works of art. The image of Zola, with his dapper clothing and cool composure, almost projects more of Manet's self-image as a dandy than of Zola's earthy and forceful personality; but the peacock feather just visible behind the pinboard and over Zola's head refers more specifically to the writer, evoking a crowning laurel that symbolically complements the quill pen of his writing tools. Typically for Manet, what may be seen as an accidental decorative accessory may also make sense as part of an allegorical program.

On this level, it is the seemingly casual inclusion of diverse works of art that begins to evoke a coherent personal avowal, a veritable inventory of sources that supported Manet's achievements. In the foreground, the black-and-white photograph of *Olympia* not only corresponds to his taste for composing with abrupt contrasts of colorless light and dark, but perhaps alludes as well to the importance for him of the ubiquitous new imagery purveyed by photography, whether of vulgar nudes, of press photos of the execution of Maximilian, or of the portraits of famous people taken by Manet's friend Nadar—all materials which helped to root his acutely personal sensibility in the public visual world around him. Less than half visible behind this photographic reproduction of his own painting is another kind of reproduction, Goya's etching after Velázquez's *Drinkers*, a pairing of Spanish masters, old and modern,

Fig. 282 **Édouard Manet**, *Portrait of Émile Zola*, Salon of 1868. Oil on canvas, 57 × 45″.
Musée d'Orsay, Paris.

that suggests Manet's awareness of his own pedigree in the Spanish tradition. Many lesser French painters of the 1860s were similarly attracted to Spanish art, as was Courbet in the 1850s; but, in general, their admiration was of a more overtly historicizing kind in both style and subject. Thus, at the Salon of 1867, Théodule Ribot (1823–91) exhibited *The Torture of Alonso Cano* (**fig. 283**), representing, in the popular nineteenth-century category of Vasari-like episodes from the lives of famous artists, the

ordeal of this seventeenth-century painter, who, falsely accused of murdering his wife, was interrogated by torture, which he withstood. Its style, appropriately, also resurrects that of the period depicted, suggesting a reprise of the Christian martyrs of Ribera. But Manet's absorption of Spanish style was of a far subtler order, transporting the somber blacks, grays, and whites or the bravura brushwork of, say, Velázquez's court portraits into the modern realm of contemporary costume and faces.

Fig. 283 **Théodule Ribot**, *The Torture of Alonso Cano*, Salon of 1867. Oil on canvas, 59 × 82¼″. Musée des Beaux-Arts, Rouen.

Fig. 284 **Alfred Stevens**, *The Visit*, Paris Exposition Universelle, 1867. Oil on canvas, 25⅜ × 18⁹⁄₁₆″. Sterling and Francine Clark Art Institute, Williamstown, Massachusetts.

As for the Japanese components, the screen at the left and the print of a wrestler (by Kuniaki II) next to the Goya were again common enthusiasms of the period. Ever since 1853, when Commodore Matthew Perry first sailed into Tokyo Bay and demanded that ports be opened to foreign trade, Japanese painting, sculpture, decorative arts, and even architectural specimens quickly infiltrated the West. Japanese ambassadors themselves arrived at Marseilles in 1863, bound for that year's International Exhibition in London, which featured a Japanese courtyard where Westerners marveled at the beauty and craftsmanship of even the most ordinary household objects displayed. Japanese decor was an immediate success in fashionable circles, as may be seen in *The Visit* (**fig. 284**), a painting shown at the 1867 Exposition Universelle by the Paris-based Belgian Alfred Stevens (1823–1906). Mirroring the same elegant society frequented by Manet, whose friend he was, Stevens here depicts two chic Paris women, one of whom sits idly by her easel, an unseen painting in progress, as the other pays a call. An early admirer of Japanese arts and crafts, Stevens includes in this wealthy Second Empire interior a vase, screen, and fan of a kind common in Manet's work, yet such exotic artifacts in no way permeate Stevens's pictorial style, which belongs to Meissonier's mode of highly detailed miniaturist description (see fig. 220). In the Zola portrait, however, the

style of the Japanese screen and print seem profoundly absorbed and freshly re-created by Manet. The contrast between the screen's delicately brushed bird on the flowered branch and the print's spaceless, dark–light heraldry becomes immediately apparent in Manet's own alternations between swift, dappled brushwork and flat, playing-card silhouettes, a combination which undermined inherited Western laws of gravity and perspective with an Eastern awareness of surface as a kind of exquisite skin that is all art and no illusion.

It was not only Manet, but other adventurous painters of modern life in the 1860s who found that Japanese art could spark off visual ideas that far transcended the question of up-to-date taste in interior decoration. Of these, the American-born expatriate James Abbott McNeill Whistler (1834–1903), a close friend of Manet's, was among the most dandified in life and inventive in art. Turning his back on the United States in 1855, Whistler soon lived a tale of two cities, studying with Gleyre in Paris, befriending Courbet, but also maintaining close relations with London, to which he moved in 1859.

In the 1860s, this cosmopolitan *bon vivant* alarmed jurors and public at both the Royal Academy and the Paris Salon, and exhibited at the Salon des Refusés a picture of a girl in a white dress standing against a white curtain, an effect of tonal nuances that he would continue to refine. He was later to call this painting *Symphony in White No. I: The White Girl*, a title and an idea probably inspired by Gautier's ivory-tower poem "Symphonie en blanc majeur" ("Symphony in White Major"), which proposes, with analogies to the abstract character of music, the possibility of the most delicate verbal network of white images. In 1864, Whistler painted another variation of the same theme, *Symphony in White No. II: The Little White Girl* (fig. 285), in which his *japonisme* (the French term for the fashion for things Japanese) is evident in both superficial and consequential ways. As in Stevens's paintings, Japanese decor is included, from the blue-and-white porcelain vase and the painted fan to the cherry blossoms; but these accessories, as in Manet's work, are also reflected in Whistler's daring departures from accepted Western style. The off-center, cropped placement of the figure, whose body seems to vanish under the flattening white silhouette of her dress; the no less surprising intrusion of the leaves and blossoms at the lower right, a shimmering fragment unsupported by stem or vase; the spare, screenlike rectilinear divisions measured by the vertical and horizontal patterns of the mirror, fireplace, and reflected picture frames—all of this moves toward new asymmetrical compositional systems that make us look as hard at the corners as at the center. We sense, too, that we have penetrated a precious, surface-oriented oasis of beauty and refinement as remote and untroubled as the arts of Japan must have seemed to Westerners in the 1860s.

Nevertheless, the *Symphony in White No. II* is thoroughly a Western painting of that decade, in both its Realism and its mood. The "little white girl" is as much a portrait as is Manet's *Zola*; being the artist's mistress, Joanna Heffernan, an Irish girl called "Jo," whom Courbet also used as a model. Moreover, the interior is as documentable as that of Whistler's own London house. But this record of real people and things is complicated by a sensual, introspective mood. Jo's abundant fall of red hair and her dreamy gaze and mirror reflection parallel, in a muted way, the sultry ideals of femininity in the works of Rossetti (see fig. 260), a friend of Whistler's. They inspired, too, a poem by Algernon Charles Swinburne, "Before the Mirror: Verses under a Picture," which Whistler liked so much that he pasted it (printed on gold paper) upon the picture's frame. Swinburne's imagery—"Art thou the ghost, my sister / White sister there / Am I the ghost, who knows?"—emphasized the languid mysteries of contemplation and of the mirror as fact and fiction, pictorial motifs that Whistler could have found in such portraits as Ingres's *Mme. Moitessier* (see fig. 236). It was a theme that often appeared in photography as well, especially in the work of the many British and American women who, from the 1850s on, began to practice a medium whose aura of laboratory work and chemicals might at first have seemed alien to what was deemed a proper artistic outlet for mid-nineteenth-century ladies. Nevertheless, one of the finest photographers to explore the mixture of feminine fashion and solitude was, in fact, a Scottish viscountess, Clementina Hawarden (1822–65). Using mainly her daughters as models, she was particularly productive in 1863–64, when she exhibited with the Photographic Society of London, which, two years running, awarded her a silver medal. In a characteristic albumen print (fig. 286), probably from 1861, the same year as Whistler's *Symphony in White*, she sets up a dramatic tableau of a fashionably dressed young Victorian woman, whose billowing dress and flowing hair may be examined, as in a fashion plate, from two sides: a back view and a near-profile in a mirror. Although she half-faces the window view of a public world outside her domestic confines, she also turns to contemplate her own reflected image in a cheval glass, a full-length mirror that could be tilted on a swivel, so that a woman might scrutinize herself from changing angles. Also called a "Psyche," as if it could be a mirror of the soul, this indispensable item for women of fashion could become a vehicle of introspection, a metaphor that extended most famously to Picasso's *Girl before a Mirror* (1932). Hawarden's photograph may belong to the enormous body of mid-century images that present women as a kind of still life of clothing, hair, facial beauty, and graceful demeanor—Alfred Stevens's *The Visit* (see fig. 284) is a perfect example—but it also begins to plumb more private, meditative depths relatively new to photography. Whistler's painting, however, pushes this

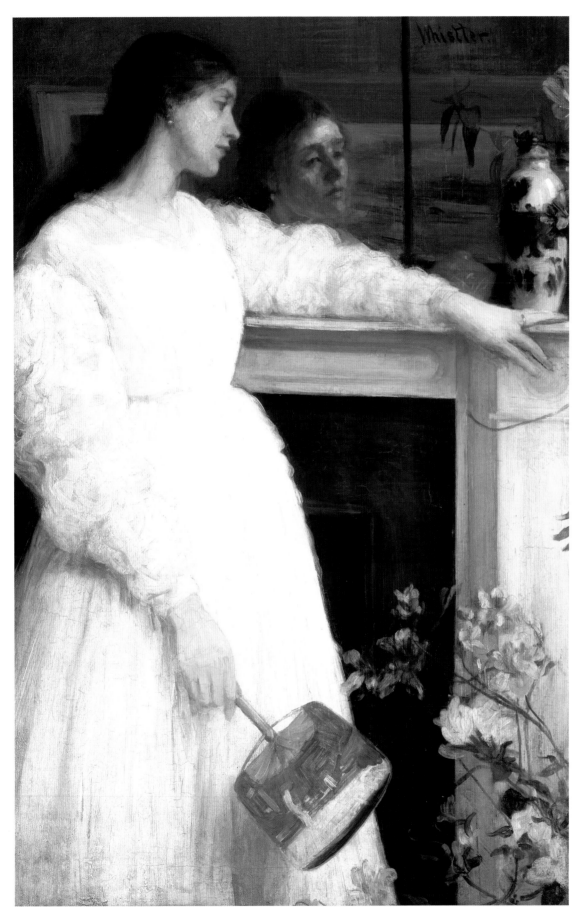

Fig. 285 **James Abbott McNeill Whistler**, *Symphony in White No. II: The Little White Girl*, 1864. Oil on canvas, 30⅛ × 20⅛″. Tate Britain, London.

Fig. 286 **Lady Hawarden**, *Clementina Before a Mirror in her Underwear*, c. 1861. Albumen print. Victoria and Albert Museum, London.

mood further. Its phantom-like frailty, in which the real world is perceived with such exquisite selectivity that it seems deprived of any coarseness or substance, is very much the artist's own and very much an avowal of his belief in the purity and sanctity of art. What became a virtual religion was subscribed to by growing numbers of artists and writers and was constantly nurtured by non-Western art that seemed, to Western eyes, liberated from earthbound realities. Indeed, in Whistler's case, this faith in art for art's sake would later reach public notoriety in 1878, at his trial (see page 370).

In the 1860s, both Whistler and Manet could be described as Realists, insofar as their vision was premised on recording the facts of contemporary life (although these facts, in Whistler's case, were often selected from interior environments that were already rarefied works of art). Nevertheless, they could also be described as aesthetes who believed that art represented a highly personal order distinct from the shared, inherited order of the Western past

that was still preached by the academies and that could be challenged by such new systems of decorative coherence as those found in Japanese art. This seemingly contradictory fusion of Realism and art for art's sake was similarly attained by a friend of Whistler's and Manet's, Hilaire-Germain-Edgar Degas (1834–1917), who also defined his unforgettably personal viewpoint in the early 1860s. As dandified as his friends, he was, if anything, a more oddly detached and acerbic spectator of the world around him, a world which, like Manet's, included both the private and public facets of Paris life, from aristocratic portraits and laundresses to cafés and brothels. And for all his willful contemporaneity, his art, like Manet's no less than Whistler's, has deep and self-conscious roots in the old masters, whom he studied assiduously first as a pupil of Louis Lamothe, a disciple of Ingres and Flandrin, and thereafter as a lifelong copyist of venerable painters from Mantegna and Poussin to David and Lawrence and even such contemporaries as Menzel. Thus, when he painted

horses at the racetrack, there was something of the Parthenon horses in their pedigree; and when he painted the rhythms of contemporary ballet, the measured rhymes of Poussin's figural order can be sensed.

Degas's daring rejection, however, of the overt structure of traditional art is immediately more conspicuous than his subtle immersion in history. In the *Woman with Chrysanthemums* (**fig. 287**), completed in 1865, we can trace this audacity. The painting was originally painted in 1858 as a still life, but was then fully repainted in 1865 with the addition of a figure, clearly a portrait, but one not yet identified with certainty. But is this then a portrait? If so, the amount of attention given to the sitter is perplexingly peripheral, since she not only looks anxiously away from the spectator and toward something unseen outside the painting, but she even becomes part of an inanimate still-life composition, her bent elbow symmetrically balancing the glass pitcher on the other side of the flower still life. Is this just a genre

scene, with a figure in an interior? If so, the face is far too specific and even inexplicably troubled, and the still life far too prominent. And of course, by the same token, it cannot be accepted merely as a still life. To measure something of Degas's startling breakdown of these inherited subject categories, other works of the early 1860s may be mustered, such as Courbet's *The Trellis* of 1863 (**fig. 288**), which also features a young woman and a copious still life, but connects them in a narrative way by having her arrange the flowers rather than turn her back on them. As for flower paintings per se, there were remarkably fine examples by Degas's friend Henri Fantin-Latour (1836–1904), who painted subjects ranging from sober portraits to vaporous evocations of Wagner's operas, but whose success, in both France and England, was associated with his floral still lifes. In one of 1862, he painstakingly records with serene centrality and absolutely no other visual distractions, the botanical detail, petal by petal, of an elegantly disheveled,

Fig. 287 **Hilaire-Germain-Edgar Degas**, *A Woman with Chrysanthemums*, 1865. Oil on canvas, 29 × 36½″. The Metropolitan Museum of Art, New York.

Fig. 288 **Gustave Courbet**, *The Trellis*,
1863. Oil on canvas, 43¼ × 53¼".
Toledo Museum of Art, Ohio.

autumnal bouquet of chrysanthemums (fig.
289), whose intricate silhouette against a cool
monochrome ground was to become his visual
signature.

But in the context of Courbet and Fantin-
Latour, Degas's painting proposes a new and
intensely modern world, where the eye seesaws
from an unruly profusion of flowers to a woman
who nervously looks sideways, with both com-
peting for equal visual time and reaching a stale-
mate. Moreover, Degas's flowers, far from being
painted with either the robust concreteness of
Courbet's or the miniaturist accuracy of Fantin-
Latour's, are seized in a swift, brushy way that
almost merges them with the artificial flower
pattern of the wallpaper behind, and that differ-
entiates them as well from the more finished

Fig. 289 **Henri Fantin-Latour**, *Chrysanthemums*, 1862.
Oil on canvas, 18⅛ × 22". The Philadelphia Museum of Art.

detail of the woman's head (if not of her broadly sketched-in clothing). We seem here to have captured an unedited glimpse of a corner of a French interior and its occupant. The still life, for all its centrality, becomes almost as arbitrary in its inclusion as the tan gloves that seem so casually strewn on the tabletop. What we see, as in many of Manet's paintings, has the character of an accidental frame in a view-finder, though even more contracted in its visual range; and, as a corollary, what we see suggests an instant in time, with fingers twitching, eyes darting, and reflected window light glimmering off the pitcher. If Manet's *Zola* or Whistler's *Little White Girl* presents a variety of still-life components that compete with the human presence, Degas's painting is even more startling in its willingness to equate the human figure with its surroundings, as if, for the purposes of art, neither had more or less importance.

In both public and private spaces, Degas continued to explore these surprising fragments of the visual spectacle around him, extending, in many ways, the journalist's view offered by Daumier and lesser illustrators who rapidly depicted cross-sections of Paris's cafés, streets, and entertainments, but elevating this mode to an unfamiliar level

of razor-sharp construction and psychological irony. At the theater, for instance, his vision was willfully eccentric, avoiding the head-on view of the stage and choosing, instead, what look like random frames that crop images mercilessly top, bottom, left, and right. In *The Orchestra of the Paris Opera* of 1868–69 (**fig. 290**), we are thrust into the middle of a ballet performance, with the musicians in full swing. But what are we to look at? The dancers above, their gauzy tutus illuminated by gaslight, are seen only in one small corner of the vast stage, their feet, as it were, amputated by the edge of the footlights and their heads guillotined by the upper edge of the canvas. As for the musicians, they comprise only a small part of a large orchestra, although, unlike the headless dancers, each one is so specific that we might think of this as a group portrait of the orchestra, were so many members not excluded. Indeed, it is hardly a surprise to find that the painting began as a kind of occupational portrait of the bassoonist, Désiré Dihau, who ended up being only one part of a multi-focused whole that even includes, at the extreme left, in a box, the composer Emmanuel Chabrier, who sees this spectacle from an even more oblique and close-up

Fig. 290 **Hilaire-Germain-Edgar Degas**, *The Orchestra of the Paris Opera*, 1868–69. Oil on canvas, 22 × 18″. Louvre, Paris.

view than we do. At first, this may look like undifferentiated disorder, the product of the blinking of an eye as we move to find our central and stationary places; but then we discern the calculations of Degas's art, in which a network of abstract lucidity is imposed upon what may seem sheer visual happenstance. Unlike Manet, whose vision of the random emphasizes a kind of loose-jointed, flexible relationship among all things, Degas insists upon clockwork precision. A broad and taut pattern of diagonal axes is marked out by the front and rear enclosures of the orchestra pit against the rigid angles of the harp, cello, bassoon, and bass; and within this linear skeleton, countless smaller rhymes, from the violin bows to the repeated movements of the dancers' arms and legs, are regimented into abstract place.

Fig. 291 **Édouard Manet**, *Still Life with Salmon*, 1866–69. Oil on canvas, 29½ × 37½". Shelburne Museum, Vermont.

Fig. 292 **François Bonvin**, *Still Life with Lemon and Oysters*, 1858. Oil on canvas, 30 × 33½". Private collection.

As in Manet's paintings, the close and the distant are telescoped in a continuously decorative surface: the luminous frieze of decapitated dancers above appears to be almost on the same plane as the darkly silhouetted scroll of the bass viol held by the musician in the right foreground. Up and down, near and far are confounded in what appears to be both a candid camera record of public Parisian fact and a totally artificial construction that proclaims the rights of artists to invent the rules of their own aesthetic domain. Dealing with things that anyone with eyes could verify, Degas, like Manet, nevertheless translated these objective commonplaces into the subjective world of art. This was a polarity that was, in fact, to become still more intense in the later work of Degas and his contemporaries, and that would reach its peak in the 1870s in a kind of painting that would be called Impressionism.

Yet throughout these innovations, the tug of tradition could also be felt. In Degas's split-second glimpse of the Paris Opera orchestra, the musicians, unlike the dancers, are rendered with a clarity and suppleness of contour that could pass muster as the work of an Ingres student. In still-life painting as well, these ghosts of the past continue to hover, as in Manet's *Still Life with Salmon* of 1866–69 (fig. 291). Here, the ostensibly serene and timeless display of food and drink upon a heavy white cloth, turned up to reveal a wooden buffet and metal keyhole, evokes similar arrangements by Chardin, whose still-life and genre painting were an especially fruitful inspiration in mid-nineteenth-century France. Chardin's ghost, in fact, was often resurrected in Manet's lifetime, as in the works of François Bonvin (1817–87), whose *Still Life with Lemon and Oysters* of 1858 (fig. 292) prefigures many aspects of Manet's own Chardinesque still lifes of the 1860s, including even the strong dark–light contrasts or the cooling color accent of a single lemon. Yet next to Bonvin's inventory of the ritual bounty and elegance of a French table, Manet's strikes a subtly different note that reveals even here the newness of his art. Rather than an inviolate, static arrangement like Bonvin's, Manet's introduces a curious element of the momentary and the casual, with the lemon half-peeled, the cloth disheveled, and a knife and fork precariously poised in the foreground, as if the dinner guest presented with the salmon, lemon, and wine had just left the table. And spatial relations also begin to move in restless ways. The bowl at the right is tipped off axis, and the tabletop is tilted too high for the laws of gravity to work without effort. Even here, in a set piece so close to traditional still-life painting, Manet's modernity can be felt.

That modernity could, at the same time, be aired far more openly in other paintings of the late 1860s which seem to have left the art of the museums to another premodern era. Even seen beside the *Concert in the Tuileries* of 1862 (see fig. 271), Manet's *Departure of the Folkestone*

Fig. 293 **Édouard Manet**, *Departure of the Folkestone Boat*, 1869. Oil on canvas, 23½ × 28⅞″.
The Philadelphia Museum of Art, Pennsylvania.

Boat of 1869 (**fig. 293**) conveys a liberating acceptance of an outdoor world of cheerful hustle and bustle that has never known an old-master rule to obey. During the summer of 1869, Manet, on vacation with his family, stayed in a second-floor room in the Hôtel Folkestone at Boulogne, that Channel port which, like its English counterpart, Folkestone, saw the comings and goings of so many international travelers, including, for a two-day visit to London in summer 1868, Manet himself. There he observed the movement of holiday tourist crowds on the pier, amid the constantly shifting spectacle of puffs of smoke, passing clouds, waving flags, and bobbing maritime movement. The painted result is of a breathtaking openness and freedom, far from the rigorous axial alignments of Degas. Even the machinery of the steamboat's parallel smokestacks and side wheels is camouflaged by the agreeable confusion of a summery mood, where all is dappled

sunlight and where the pageant of ladies and gentlemen in their holiday best is dissolved into a flurry of speckled paint that, typically for Manet, moves abruptly and unpredictably from opaque blacks to dazzling whites countered by rapid touches of the coolest hues. That the fashionable couple on the dock at the left may be identifiable as Manet's wife and her ostensible younger brother (but probably Manet's own illegitimate son), Léon Leenhoff, hardly seems to matter in a crowd whose faces are as undefined as the cargo at the lower left. Moreover, the pair stand with their heads turned away from us, glancing toward the shipside animation. There are perhaps distant memories here of Watteau's Rococo vision of lovers embarking from the Isle of Cythera, a painting whose magic was especially potent in the 1860s, when the Goncourt brothers were writing their re-evaluation of French eighteenth-century painting; but in general, we sense that Manet's willful

allusions to the indoor art of the museums have been cast aside in favor of a luminous new outdoor world that, for him and his contemporaries, presented in the 1860s a fresh range of rejuvenating experiences to be savored in life and recaptured in art.

Painting Out-of-Doors: Toward Impressionism

The idea of painting out-of-doors, of achieving an immediate, one-to-one response between what is observed and what is recorded has a long history whose roots go back to the eighteenth century, if not before. Most artists concerned with landscape painting made drawings, watercolors, or oil sketches on the spot. Constable's small studies of changing English skies (see fig. 142), the countless painted notations after nature made in the Forest of Fontainebleau, the Hudson River Valley, or the Roman Campagna are reminders that artists before 1848 valued the possibility of a small painting providing a kind of stenographic record of unedited, documentary experience. But it was only beginning in the 1850s that the pursuit of maximum truth to the look of nature became a full-scale obsession; and only in the 1860s that painters would start to value these often arduous confrontations with the outdoors not as means to more calculated works of art to be finished in the studio but as complete ends in themselves. Constable, for instance, would make rapid oil sketches, usually *in situ*, for compositions that would then be elaborated and enlarged for public exhibition; but whether he himself thought of these swift, painted jottings as self-sufficient works of art (as was claimed by later viewers, trained after the heyday of Impressionism and valuing spontaneity over finish) is debatable. In any case, the issues here are at least twofold. There is, for one, the fervent search after 1848 for optimum fidelity to empirical experience, which includes the truths of landscape that might be transcribed either in meticulous detail or as a momentary overall impression. And there is, for another, the growing awareness of the possibility that a small, painted sketch (completed in hours, perhaps minutes, rather than days and weeks) might begin to rival in aesthetic importance, as could a drawing or a watercolor, a larger painting that was a long sequence of refinements and choices. Already in 1816, the École des Beaux-Arts established an annual competition and prize for a painted sketch (though these were conceived as shorthand versions of works to be properly finished); but it was not really until the late 1860s and 1870s, with the maturation of a group of artists whose style was to be dubbed Impressionism in 1874, that this idea finally triumphed and challenged the assumptions of what was necessary for aesthetic and empirical completeness.

It was clearly within the Pre-Raphaelite circle of the 1850s that the most painstaking and zealous efforts were made to replicate with paint on canvas the fullest optical truths of landscape. Already in narrative compositions like Hunt's *Rienzi* (see fig. 243) or Brown's *Work* (see fig. 249), the outdoor settings are exactly rendered under the glare of actual sunlight; and such goals continued to inspire many British painters working at home and abroad. A typical case is that of John Brett (1831–1902), who, following in the footsteps of countless artists and tourists, first visited and painted the Alps in 1856 and then returned, in 1858. Under the aegis of Ruskin, who was in Turin that summer, Brett painted the *Val d'Aosta* (fig. 294), a Shangri-La vista of a sun-flooded, mountain-crowned valley in the Piedmontese Alps. The fidelity to nature that Ruskin admired as the foundation of artists as different in their results as Turner and the Pre-Raphaelites was extended here to so accurate a record of a particular spot that, when the *Val d'Aosta* was exhibited at the Royal Academy in 1859, Ruskin could claim that through this painting, "for the first time in history, we have . . . the power of visiting a place, reasoning about it, knowing it, just as if we were there, except that we cannot stir from our place, nor look behind us." We do, in fact, seem perched on the edge of a rock, a mountain goat and a sleeping peasant girl precariously located just below us. Beyond this, a vertiginous bird's-eye view takes in everything from the wooden Alpine cottages and cultivated fields that mark a human presence in this sunlit haven to the atmospheric mix of clouds and mountains in the remote heights. The brusque croppings of trees, rocks, and earth at the sides and the bottom suggest that accidental slice of unadulterated fact so often sought after in the 1850s and 1860s by Realist artists as unlike Brett as Manet, but the sharp-focus rendering of every vine leaf, chestnut tree, or vein of rock in what is actually a panorama some twelve miles deep pertains to the obsessive search for quasi-scientific truth in the art of landscape, a truth infinitely more microscopic and accurate here than in, say, such a relaxed, earlier view of an Alpine valley as that by Waldmüller (see fig. 163). Ruskin had written of "historical landscape," by which he meant a kind of natural history, a record of the present truths of nature in which could be read (as in geology or botany) the past and the future of what, in the mid-century, seemed a landscape whose life was being drastically altered by industrial change. Brett's faithful transcription of this sunlit fragment of a wondrous and unpolluted mountain site does indeed convey a sense of serious purpose that could inspire, without the rhetoric of Church's *Cotopaxi* (see fig. 263), grand thoughts about man and nature. Ruskin was finally unsatisfied with Brett's painting. He called it "Mirror's Work, not Man's," feeling that it lacked, especially in the soft, distant blurring of clouds and mountains, the emotional force that elevated Turner's landscapes to a higher plane; yet the *Val d'Aosta* can still make us marvel at the degree of truth to landscape that artists could attain so

Fig. 294 **John Brett**, *Val d'Aosta*, 1858. Oil on canvas, 34½ × 26⅞". Collection of Lord Lloyd-Webber.

laboriously and could control as well through the unifying phenomena of light and atmosphere.

The fanatical detail of Brett's painting and its breathtaking fusion of the telescopic and the microscopic were often rivaled by other British landscape painters of his generation, many of whom were disinclined to bathe nature with the aerating luminosity of the *Val d'Aosta*. In what seems almost a maniacal competition for unedited landscape truth, a special prize might be awarded to Daniel Alexander Williamson (1823–1903), who was born in Liverpool, the most important provincial center for the display and influence of Pre-Raphaelite paintings, but who lived in London

from 1847 to 1861, and then retreated to a village in Lancashire. There, he painted such astonishing works as *Spring: Arnside Knot and Coniston Range of Hills from Warton Crag* of 1863 (**fig. 295**), a feat of on-the-spot observation (from the exact site given in the title) all the more incredible when one realizes that the canvas is only sixteen inches wide. The abrupt leap from the smoky blue tones of the overcast sky to the riot of prismatic colors on the earth below intensifies the already eye-boggling variety of the clearest hues defining the infinite detail that extends from the yellow gorse and orange bracken of the foreground to the green, blue, and purple of the remote hills. Williamson's

Fig. 295 **Daniel A. Williamson**, *Spring: Arnside Knot and Coniston Range of Hills from Warton Crag*, 1863. Oil on canvas, 10⅝ × 16″. Walker Art Gallery, Liverpool.

perpetually keen eye has even caught a distant flock of birds on the wing and a rabbit, which seems to have been just spotted in the foreground. The immediate impact is of a total lack of selectivity by any familiar standards (even Brett's) of landscape coherence, with the colors, in particular, being shrilly dissonant in their hairbreadth juxtapositions of the artist's complete repertory of unmodulated rainbow pigments. Yet if Williamson's little oil painting totally defies the kind of muted, instant unity achieved by many mid-century landscape sketches that blur the parts in an all-embracing tonality, it is memorable for different reasons. For here, the replication of the teeming chromatic, botanical, and geological profusion of a landscape at the peak of springtime burgeoning is seized with a passionate empathy that transcends a mere mirror image, conveying the marvels of a nature both timeless and timebound. Changing by the second and the season, these unruly, bursting tangles of rocks and vegetation also reflect, as Ruskin recognized, that the history of landscape is a far more ancient and enduring one than that of the human race.

There were other ways, however, of grasping these empirical facts, ways that, instead of re-creating, leaf by leaf, color by color, every minuscule component of sunlit landscape, chose rather the swift, momentary effect, as in the blinking of eyes yet to be focused. Such a vision was captured early by Eugène Boudin (1824–98), who spent most of his life as an artist on his native Normandy coast, where, around the shores of Le Havre, Trouville, and Honfleur, he could watch the ever-changing skies and atmosphere of the often windy beaches on the Channel, and the movements of clouds, people, boats, and water. In his own words, "Everything painted on the spot always has a strength, a power, a vividness of touch that is not to be found again in the studio." Boudin practiced very much what he preached, and in his painted oil sketches, like the *Beach at Trouville* of 1863 (**fig. 296**), a wood panel barely over a foot wide, we glimpse what appears to be a split-second record of sea breezes that gently sweep across the little painting, left to right, in a path made almost visible by the movement of the brushstrokes in the high and wide sky. The tilt of sails and smoke on the water, of parasols and blowing veils and ribbons on the shore powerfully conveys an instant response to these airborne pressures in a world that seems exhilaratingly open and fluid. Such a work radiates an unpretentious but authentic effort to depict the ephemeral sensations provided by nature and by the holiday intruders—men, women, children, dogs—who, by mid-century, came in growing numbers to the Channel coasts from Paris and London to enjoy the salubrious sea air. In so rapid an account of these coastal scenes, Boudin could use only the broadest strokes of paint, which

Fig. 296 **Eugène Boudin**, *Beach at Trouville*, 1863. Oil on panel, 7 × 13¾". Phillips Collection, Washington, D.C.

Fig. 297 **Claude Monet**, *The Coastline at Ste.-Adresse*, June 1864. Oil on canvas, 15¾ × 28¾". Minneapolis Institute of Arts, Minnesota.

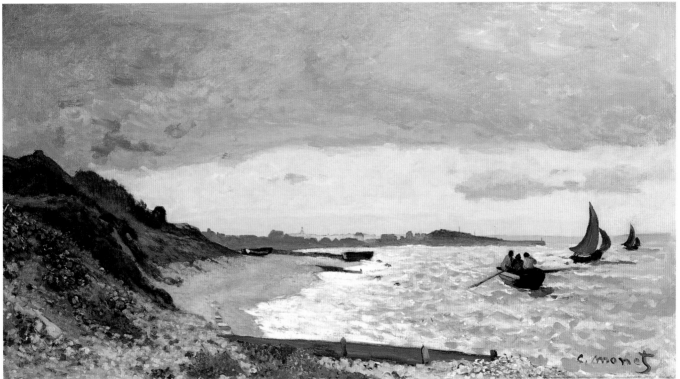

inevitably blurred the identity of even the royal visitors—for example, the Empress Eugénie herself—whom he painted enjoying the leisure of these fashionable resorts. By implication, the figure for him was neither more nor less important than any other element in this continuum of light and atmosphere, and a face deserved no more detail than the arc of a sunlit parasol.

From the time of their first showing at the Salon of 1859, when Baudelaire praised them, Boudin's beach scenes were well received by the public, which found his abbreviated, sketchy technique appropriate to the small-scale charm and modesty of these works. Yet this same approach, amplified to full-scale ambitions, could become far more threatening to acceptable canons of picture-making, which is exactly what was to happen in the work of Claude Monet (1840–1926), the painter whose name was later to become synonymous in the public view with the most consistent pursuit and capture of an instantaneous perception of the

visible world. Monet's initial revelations of the possibilities of painting directly from nature sprung from his first contact with Boudin, his senior by sixteen years, whom he met in Le Havre in 1858 and with whom he went on excursions in the open country and on the coast to paint, with minimal time and brushwork, nature seen firsthand. As Monet was later to write about this teenage conversion, "A veil was ripped from my eyes, and in a flash, I saw what painting was about." After two years of military service in Algeria, he returned, in 1862, to Boudin and the Normandy coast; and then, back in Paris, entered Gleyre's studio, where he was to befriend a group of younger painters of his generation (Renoir, Sisley, Bazille) who were soon to share many of his goals. Visits to Le Havre, where Monet spent most of his youth, were frequent, and prompted in the mid-1860s a number of marine paintings that seem to pick up where Boudin left off. In *The Coastline at Ste.-Adresse*, painted in June 1864 (**fig. 297**), the wide format, the insistent

awareness of barometric pressure, the dominant sky, and the stenographic brushstroke all suggest Boudin's own sketches of this coastal region; but already a greater ambition and more intense refinement of perception can be savored. That it is more than twice the width of Boudin's sketch literally expands its pictorial ambitions; and the subtle changes of brushstroke that distinguish among choppy waves, streaky sky, mottled earth, and translucent sails convey an infinitely more probing effort to find the exact equivalent in paint for a panorama of different perceptions that range from filmy distant shores to grainy foreground, from the agitation of water to the movement of low-lying clouds.

Unlike Boudin, the young Monet was not content to remain within the agreeable and, to the public, still palatable confines of a sketchy marine painting; and like all great painters, he quickly set his sights at the top, wishing soon to vie with the most exciting new achievements of his generation, works which treated large figures in a landscape in a language of startling contemporaneity. Between 1865 and 1867, he worked first on a huge updating of Manet's scandalous *Déjeuner sur l'Herbe*, creating his own version (almost twenty feet wide and therefore rivaling the most imposing Salon masterpieces), which was finally dismembered and exists only in fragments and a smaller replica. Then he worked on another large painting with life-size

Fig. 298 **Claude Monet**, *Women in the Garden*, 1866–67. Oil on canvas, 8′ 4½″ × 6′ 9″. Musée d'Orsay, Paris.

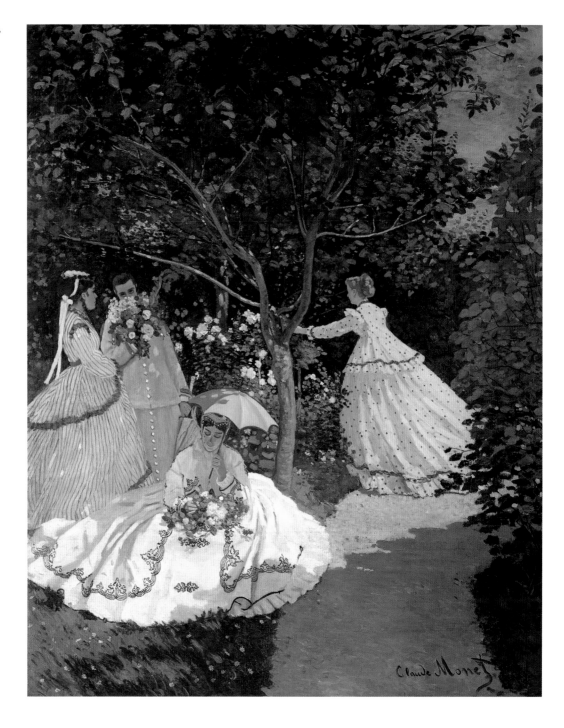

figures, *Women in the Garden* (fig. 298), which he prepared for the Salon of 1867, where it was rejected. The lessons of painting small works out-of-doors were here magnified to imposing dimensions, which, among other things, made the labors involved in attaining fidelity to perceived experience worthy of a Pre-Raphaelite's most intrepid exposure to the elements. In the garden of a rented house at Ville d'Avray, Monet dug a large trench, so that the painting could be raised and lowered on pulleys in order to make the top portions of the canvas quickly accessible to the reach of arm and brush. When the sun came out, Monet had to make sure that the marvel of the whitest light on the greenest leaves could be caught instantly, a scruple which his friend Courbet, who could paint his landscapes in the comfort of his studio, found puzzling. But Monet clearly believed in a Realism different from Courbet's, or even Manet's, one that was less concerned with the new facts of modern society than with achieving a kind of visual *tabula rasa*, in which the immediate perceptions of the seen world could be seized in all their freshness and purity, a kind of innocent child's-eye view that could wonder at the most commonplace pleasures of sunlight and shadow, of clear hues unmuddled by conventional chiaroscuro modeling, of the sparkling excitement of the most contracted here and now, of a transient moment caught on the wing.

In *Women in the Garden*, such goals are aggrandized from the world of a painted sketch to the size of ambitious history painting. The product of months of work in 1866–67, it is meant to deceive us into thinking that we are savoring the fragrance of a moment. Four women, each modeled after Monet's mistress, Camille Doncieux, enjoy the pleasures of a summer day while displaying variations upon four crinolines whose starchy whiteness, even by Manet's standards, was such a glaring affront that eyes used to traditional tonal modulations might almost demand sunglasses. The more vigorous, outdoor equivalent to Whistler's muted indoor variations on the theme of white on white, Monet's women were also highly aestheticized creatures, who sit and move with studied, but casual grace and who, for activity, do nothing more than turn around a tree or whiff a bouquet of freshly picked flowers. Yet, however artificial this Arcadia of modern leisure may seem in costume and gesture, the garden setting is of a stunning visual veracity, the dappled paint spots fully achieving the months-long labors of Monet to re-create in pigment on canvas the blaze, both harsh and gentle, of sunlight as it speckles leaves and lawns or casts irregular shadow patterns diagonally across the garden path. As almost always turns out to be the case in art that seems so willfully to reject both high and low art in favor of an unadulterated response to the real world, *Women in the Garden* may, in fact, reflect a variety of old and new imagery, including the popular fashion illustrations of the Second Empire. Far more venerable, however, the mood of elegant hedonism

seems a modern translation of the artificial Rococo gardens of Watteau or Fragonard into the language of nineteenth-century Positivism, which insisted on the direct accumulation of empirical data as the means to verifiable truths. How rigorous Monet's belief was in this outer structure of objectivity is suggested by the fact that his personal life in 1867–68 went from bad to worse. The birth of his illegitimate son, Jean, in 1867, occurred under such dire financial circumstances that, during a particularly brutal siege of poverty and hunger in 1868, Monet attempted suicide, an event that seems extraordinarily concealed from and irrelevant to his art.

If Monet had ample reason to despair in 1867–68, when the gulf between his most labored paintings and official acceptance seemed unbridgeable, at least he had friends who supported him such as Renoir, who actually stole bread for the Monet family, or another fellow student at Gleyre's academy, the wealthy Bazille, who bought the *Women in the Garden* (but was slow to pay for it) and tried, usually without success, to sell Monet's other work. Frédéric Bazille (1841–70), who was killed before his thirtieth birthday in the Franco-Prussian War, had worked side by side with Monet both in the forests near Paris and on the Normandy coast, between 1862 and 1865, often seeming to mimic closely the paintings of his friend and mentor. But he was soon to give his art a personal inflection, derived in good part from his continual contacts with the countryside of southwestern France, near his birthplace, Montpellier, where he would summer with his family. His *View of the Village* of 1868 (fig. 299) offers, as it were, a more southern version of Monet's northern outdoor figure pieces of 1865–67, and one that radiates the sense of sturdy rock, tree, and earth familiar to a gravity-bound, sunbaked, blue-skied scenery at odds with the more evanescent nature of Monet's Normandy coasts and Paris suburbs. The model here is the daughter of the family gardener at the Bazille country estate; and, like the women in Monet's garden painting, she is seen relaxing in a sun-shot, verdant landscape. Yet the effect is one of an almost archaic rigidity, with the figure, flowers in hand, seated stiffly in the perpendicular frame of a vertical foreground tree countered by a serene horizon that caps the beige and tan geometries of the distant village of Castelnau. More obviously composed (there were, in fact, many preparatory drawings for the figure) and more conventionally modeled than Monet's *Women in the Garden*, the painting was accepted at the 1869 Salon, where its surprisingly high horizon, which produces a tapestry-like effect upon the landscape vista, elicited many jokes centering upon the idea that the figure was seated in front of a flat and coarsely executed picture rather than a real view. But it could also be admired, not only by Puvis de Chavannes, who must have recognized here a variant of his own archaizing structure, but, for quite opposite reasons, by Berthe Morisot, a painter

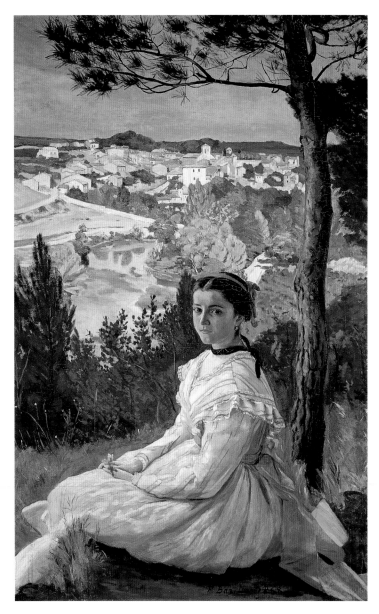

Fig. 299 **Frédéric Bazille**, *View of the Village*, 1868 (Salon of 1869). Oil on canvas, 51⅛ × 35″. Musée Fabre, Montpellier.

in Bazille's and Manet's circle, who found in it the light and sunshine, the fusion of a figure in an outdoor environment that so many artists, herself included, were seeking in the 1860s.

These were goals, for instance, sought by many younger Italian painters who, inspired by the movements to unify their country, also felt the need to band together in a distinctive national group, an urge that was officially recognized in Florence in 1861. There, the brand-new king of Italy, Victor Emmanuel II, inaugurated the first national exhibition, a patriotic display not only of Italian agriculture and industry but of art, a category reviewed by critics from Paris and London who were eager to tell their readers about the artistic aspects of the Risorgimento. Although the exhibition included Italian artists of the earlier nineteenth century who espoused Neoclassical and Purist styles, the cutting edge belonged to a post-1848 generation that was loosely referred to as the "Macchiaioli," because of their common exploration of the possibilities of the *macchia*, translatable as a spot or patch of color. Such broadly applied strokes of dark and light hues could create a continuous weave that fused figure and ground and that evoked, without conventional perspective techniques, a vibrant movement in a space charged with atmosphere. This patterned and simplified brushwork was used by a diverse group of artists who could even apply it tentatively to religious or historical subjects; but, by the 1860s, the freshest adaptation of this technique of color patches was in the domain of casual scenes of outdoor life, the kind of subject to which many painters of the 1860s were attracted and which seemed particularly appropriate to unpretentious little oil sketches. Such sketches were made by Giovanni Fattori (1825–1908), who, as a veteran of the Revolution of 1848, was well equipped to paint, in 1861, such a nationalist military subject as the *Italian Camp after the Battle of Magenta*, but who, between 1861

Fig. 300 **Giovanni Fattori**, *Silvestro Lega Painting*, c. 1866. Oil on canvas, 4¾ × 11¼″. Private collection.

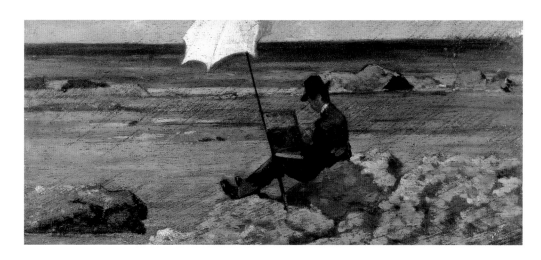

and 1867, in long visits to his birthplace, the seaport of Livorno, executed many on-the-spot records, often on small wooden panels, of the uneventful comings and goings of the people he saw on the coast or in the nearby countryside. He even painted one of his fellow Macchiaioli, Silvestro Lega (1826–95), in the act of doing what he himself so often did, painting a small picture directly in front of the motif, in this case, what seems a breezy seaside at Livorno (fig. 300). At first, all seems as casual as the beach scenes of Boudin—the artist at work seems unaware he is being observed, the tilted parasol is cropped, the horizontal tiers of sky, water, sand, and rock suggest endless extension sideways. But the use of the broad techniques of the *macchia* imposes on this candor a highly selective dark–light patterning, a crisp effect that fuses near and far or different objects (the little canvas almost merging with the dark line of the parasol handle) in vibrant visual rhymes that seem more art than nature, eliminating all detail in favor of an abstract mosaic of painted patches.

These refined nuggets of visual experience could be pieced together by the Macchiaioli in larger and more intricate paintings as well, the equivalents of Monet's *Women in the Garden*. Such parallels are particularly vivid in *The Pergola* of 1868 (fig. 301) by Lega himself, who, like Fattori, had also painted religious and historical subjects and experienced firsthand the battles of 1848. By the 1860s, he had retired to the Tuscan countryside, to observe there, with other Italian artists, the quiet ritual pleasures of a life untroubled by political and urban turmoil. In *The Pergola*, which was originally titled *After Lunch* when shown in Florence in 1868 at the Società Promotrice (dedicated to the promotion of artistic activities, and more lenient and progressive in its standards than the academy), Lega permits us to glimpse a ceremonial moment in a summer afternoon, when a servant brings coffee to a group of elegant women and a young girl, all dressed in their country best and enjoying the cool shade of a pergola. In a sympathetic review of Lega's and Fattori's work, another

Fig. 301 **Silvestro Lega**, *The Pergola*, 1868. Oil on canvas, 30 × 37½". Pinacoteca di Brera, Milan.

◆ ──────────── SILVESTRO LEGA AND THE MACCHIAIOLI ──────────── ◆

The painter Telemaco Signorini (1835–1901), who had met the English artist Frederic Leighton in Venice in 1856 and first pledged his allegiance to the macchia *("patch of color") style in 1858, traveled to Paris to see the Salon of 1861 and, along with Odoardo Borrani (1832–1905) and Silvestro Lega, subsequently formed the school of Piagentina, in a rural region outside Florence. He wrote of the French paintings he had seen in 1861, and the older Lega, who had fought as a Tuscan volunteer in the battle to unify Italy in 1848–49:*

Lega, former pupil of Luigi Mussini, was opposed to this artistic revolution [Realism] because it came to us from France, whose failure to fight in Rome in 1849 for the defense of the Republic greatly angered him.

And when, with the advent of the art of Courbet, the tendency toward realism began to prevail, Lega became even more enraged, as though he feared that this realism from France would bring along with it some king to be served.[59]

Lega, like many artists of the period across Europe, insisted on il vero, *"truth," also meaning "nature," as the presiding principle in his art, commenting that "a work which is not done from nature … cannot be good."[60] And Signorini saw Lega's revivalist style as being both modern and*

faithful to his program of producing an art in which the interpretation of nature [*il vero reale*] might return without pre-Raphaelite plagiarism to our quattrocento artists and continue their wholesome tradition, not with the religious feelings of their period but with the human ones of our own …[61]

The Pergola (see fig. 301) was painted in Piagentina, where Lega lived with the family of Spirito Batelli, whose fortune came from a family publishing business. Lega became particularly close to, and may have been intimate with, Batelli's

eldest daughter, Virginia, probably the third figure from the left in the picture. *His many paintings of the Batelli villa, its inhabitants, and the family's friends in the surrounding countryside reveal his affection for the quiet domesticity of his living situation. Signorini described these works as*

… painted in a very light and luminous tonal range, where the different feelings of women of all age groups were sensitively analyzed, in all of their passions and social conditions, observed directly in the many young, adult and elderly women in the Batelli family among whom he lived, as well as in the many, rustically beautiful women in the family of Gieppe, the farmer who lived next door.[62]

Recently, Albert Boime has read them as indicative of social divisions in the countryside. In particular, the sun and shade of The Pergola *becomes a visual metaphor for service versus privilege, labor versus leisure:*

The pergola was the symbolic focus of villa life, the symbol of leisure; the real labor in the sun was left to the peasants. The dynamic between work and leisure is the dominant motif in Lega's painting. The central figure under the arbor turns her head at the approach of the young female servant who strides in from the right carrying a pot of coffee. More precisely she carries *una caffettiera napoletana*, a favorite utensil of the period and part of the daily ritual of the leisure class. The mistress's abrupt reaction to the servant is emphasized by the profile silhouette of her body and frontally turned head. This establishes an unusual tension, reinforced by the arrangement of the trellises and the low wall on which the central woman sits. The composition follows a step-like pattern, echoed by the disposition of the women. The tension between the hostess and her domestic is as much social as it is

formal; a gap is established between the classes. The upper-class woman's facial expression, with its mingled expectation and self-consciousness, is countered by the confident and self-contained look and posture of the servant. Indeed, the servant's bearing is as regal as that of her mistress, and Lega carefully aligns their heads at the same level.[63]

Another modern art historian, Norma Broude, has summed up Lega's production of the 1860s and 1870s in a manner that reflects similar critical reactions to the work of Gauguin in Brittany and Van Gogh in Arles in the 1880s—that it is fueled by a need to escape from modern life:

… Lega, the newly converted Macchiaiolo and realist, was painting intimate scenes of romanticized middle-class life, replete with descriptive detail and often sentimental and idyllic in mood. The taste for the anecdotal which sometimes threatens to intrude in these pictures is countered and controlled by a delicacy of feeling and poetic restraint that are characteristic of the best of Lega's work, as well as by an impressive sensitivity on the artist's part to the sensibilities and the social and domestic values of his female subjects. Lega's view of middle-class rural Tuscan life, however, was as nostalgic as it was "real." … the quiet and traditional life of the villas was already on the verge of disappearing even as the Macchiaioli were painting it. Within this context, their attraction during the 1860s, not only to Pergentina [Piagentina], but also to places like Castiglioncello, can be understood, at least in part, as a desire to reaffirm these traditional values and retreat from some of the disorienting change and disruptive expansion that were being forced upon their region, and particularly Florence because of its new role as the nation's capital.[64]

Fig. 302 **Winslow Homer**, *Croquet Players*, 1865. Oil on canvas, 16 × 26". Albright-Knox Art Gallery, Buffalo, N.Y.

Macchiaiolo painter, Telemaco Signorini, commented that these artists had not "painted the background for the figures or the figures for the background," an astute observation that would hold equally for Monet's *Women in the Garden*. Here, too, the fusion of figures, light, shadow, flowers, and vegetation is so complete that we can no more separate the component parts than we can in Monet's figures in a landscape. But if Lega may share some of Monet's goals and can also make us blink at the brilliant rendering of dappled sunlight, or delight in the irregular patterns of shadow that complicate the ground, his painting has a distinctive character that one is tempted to call Italian. Like the southern French Bazille, whose figures in outdoor settings share none of Monet's liberty of movement, Lega imposes a kind of archaic rectilinear network upon the entire scene, the grids of the trellis and rough stone pavement creating a tidy perspective box that fixes the figures in rigid postures. It is not surprising to learn that Lega, like many of his Italian colleagues, admired certain painters of the quattrocento whose lucid geometries and simple love of nature are surprisingly secularized here in the kind of pure and measured garden enclosure that was once the sacred precinct of the Virgin Mary. Nominally a scene of modern leisure and relaxation, and one which shimmers with the most audacious mottling of bright green and yellow brushstrokes, *The Pergola* also resonates back to a venerable Italian pictorial tradition, just as Monet's *Women in the Garden* recalls the pastoral artifices of French Rococo painting. Even when seeking the Positivist goals of truth to nature, artists inevitably carry with them earlier traditions of seeing and composing which often evoke their cultural heritage.

In the 1860s, the freshness of outdoor facts began to inspire painters as far afield as Hungary and the United States. Already before his visit to Paris in 1866–67, the American Winslow Homer started to paint open-air scenes of fashionable leisure whose spirit, like that of many of Manet's and Monet's depictions of city and country pleasures, is close to the popular imagery of the day. Indeed, Homer himself provided just such illustrations for *Harper's Weekly*, reportorial glimpses of modern life that could then be translated into oil on canvas. A modish motif that appealed to him, as it did to many French painters, was the game of croquet, which offered not only the possibility of representing ladies and gentlemen strolling about in elegant summer garb, but also, in compositional terms, the quality of unhurried accidental movement, as the figures drift casually from one point in the game to another. In *Croquet Players* of 1865 (**fig. 302**), the players are located in a verdant environment where the strong sunlight bleaches the costumes into crisp white patterns and highlights the croquet balls and wickets in an unpredictable order which demands that our gaze constantly shift. Although it preserves a more conventional sense of figures in depth, Homer's painting parallels closely Monet's outdoor scenes of the mid-1860s as well as the work of the Macchiaioli. Yet it also bears what is often discerned as a specifically American inflection, not only in the harshness of the light, but in its flavor of spareness, almost puritanical next to the sensuous fragrance of Monet's *Women in the Garden*. Unsurprisingly, Homer's excursions to these domains of outdoor leisure included, as they did for his French contemporaries, seaside resorts. In 1869, he went to Long Branch, New Jersey (then referred to as "the American

Fig. 303 **Pál Szinyei-Merse**, *Drying Laundry*, 1869. Oil on canvas, 15³/₁₆ × 13³/₈". Magyar Nemzeti Galéria, Budapest.

emphasize the narrative potential of the situation seems secondary to what is, in effect, a visual fusion of figures, landscape, and white laundry, in which the whole dissolves the sum of the parts. Such rapidly painted sketches hover between works of art sufficient in themselves (but still generally incomprehensible to contemporary audiences) and preparatory studies for larger paintings on the same theme, an ambiguity which posed no special problem in earlier decades and centuries, when highly improvisatory drawings, for example, could be prized as well as the finished painted product. But this began to raise perplexing issues in the 1860s, when so many artists found that the sheer intensity and immediacy of a small oil sketch executed on the spot might in fact be even more honest as art and experience than a similar work in which all the t's were crossed and the i's dotted.

This shift of value from the calculated to the spontaneous can be seen most memorably in painted sketches that Monet executed alongside his fellow student at the Gleyre studio Pierre-Auguste Renoir (1841–1919). In the summer of 1869, the two artists sketched together at one of the flourishing new recreation centers of the Paris suburbs near Bougival, La Grenouillère (The Frog Pond). There, countless Parisians arriving by rail or carriage on a sunny weekend could enjoy boating, swimming, picnicking, and conversing in an outdoor environment that brought Watteau's Isle of Cythera or Fragonard's pleasure gardens up to Second-Empire date. It even figured in a short story about romantic intrigue by Guy de Maupassant, *Paul's Wife*. The results of Monet's and Renoir's visual explorations (**figs. 304 and 305**) are of a dazzling newness even by such advanced standards as Manet's *Departure of the Folkestone Boat* (see fig. 293), also of 1869. Here, all seems at first an almost illegible confusion of the most varied brushstrokes—broad horizontal slashes for the water, rapid speckles for the leaves of the foreground trees, soft dapples for those on the far shore—and the most intense unmodulated pigments of yellows, blues, greens, whites that seem to come right out of the tube. It is impossible to get one's bearings here, for the spectator seems half-suspended over a watery ground plane as choppy and unstable as the cropped rowboats that bob up and down in the foreground. Near and far now merge into a shimmering surface of often almost palpable pigment, carrying to a new extreme the disintegration of perspective illusion that had begun with Courbet and Manet. Yet this at first bewildering, unanchored world of varied, pulsating sensations is clearly predicated on objective fact, for both Monet and Renoir have documented on the spot precisely the same data, from the heads and chests of the bathers in the Seine at the far left to the footpaths over the water that lead to the central island (referred to as the "Camembert," because of its cheese shape) to the words of the sign on the pavilion cut off on the right: LOCATI[ON] CANOTS (Boats for Hire). What

Boulogne"), where he drew and painted for *Harper's* the windswept costumes and parasols of the ladies who, like those in Boudin's or Monet's resort scenes, enjoy a decorous confrontation with sand and sea breezes.

Homer, like the Macchiaioli, apparently developed a technique to record the intense glare of outdoor light independently of Monet and his circle, and so, too, did a Hungarian painter, Pál Szinyei-Merse (1845–1920), who was trained not in Paris, but in Munich, finishing his studies under Piloty in 1868. The following year, that of Munich's International Art Exhibition, which brought Courbet himself and his paintings to the capital of Bavaria, Szinyei-Merse began to make sketchy, outdoor paintings that moved far past Courbet's Realism or even that of the early Manet (some of whose work was also seen in Munich). Like Monet and other French contemporaries, he often chose subjects that, as scenes of carefree, springtime leisure—figures enjoying garden swings or picnics—recall Rococo traditions revisited in the contemporary world. His *Drying Laundry* of 1869 (**fig. 303**), signed and dated boldly for so small an oil study, is one of these, transporting to the modern countryside a familiar Fragonard theme of cheerful laundresses hanging the wash on a line, while a dapper gentleman and his dog look on. The painting, in fact, was originally titled *Monsieur*, but this verbal effort to

may at first seem amazing here is that two different artists of two different personal and aesthetic temperaments achieved so similar and so objective a result, the equivalent of two photographers recording the same site from the same place at the same time. Yet what seems no less remarkable is that these presumably objective facts of fleeting, fragmentary impressions of the movement of light, nature, and people reveal, on subtler examination, the work of two very different artistic temperaments. Renoir's colors have a more pastel, Rococo flavor than Monet's, and his touch similarly seems softer and gentler. Monet's vacationers have a crude, stick-figure quality that yields, in Renoir's case, to a more convivial warmth of paired couples who seem almost to be conversing rather than disappearing, as do Monet's, into the more jagged patterns of the ambient brushstrokes. Renoir, typically, includes some family dogs, invariably excluded from Monet's depictions of Parisian society. Even the atmosphere varies, with Renoir's casting a more balmy, hazy spell and Monet's creating a more silvery, limpid tone. But however much we view these works as products of separate temperaments, we may also marvel at the common impulse

which, by the 1860s, could result in such a convergence of result that at least two artists in Paris could make us feel that Western painting has been rejuvenated and that we have suddenly been forced to rediscover what children perhaps always know, that the most immediate spectacle of light, color, and movement, perceived before the brain can sort out other kinds of order, is a tonic, joyous experience.

Again, the question of whether paintings like *La Grenouillère* should be regarded as self-sufficient works of art is a slippery one. Later spectators, accustomed to much greater kinds of spontaneity in painting, have learned to accept them easily as such. Yet we also know that Monet himself thought of this study as a means to a more complex end, a larger painting of this popular resort that could be submitted to the Salon as a more modern vision of earlier depictions of the same popular locale by lesser artists. But from what we know and will see of his later development, such a preparatory oil sketch, even if broadly rooted in the academic traditions of making small, cursorily painted studies for larger works, began to seem not only totally adequate as a work of art, but the most authentic pictorial

Fig. 304 **Claude Monet**, *La Grenouillère*, 1869. Oil on canvas, 29⅜ × 39¼″. The Metropolitan Museum of Art, New York.

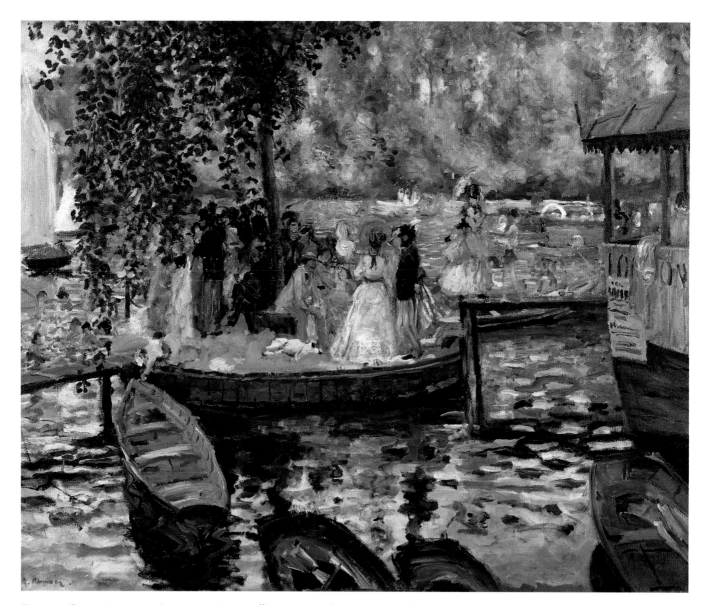

Fig. 305 **Pierre-Auguste Renoir**, *La Grenouillère*, 1869. Oil on canvas, 26½ × 32½″. Nationalmuseum, Stockholm.

equivalent of what for many artists of Monet's generation was to become the only thing that mattered: the individual search for that most wonderful and most primitive of aesthetic phenomena, the seen world as primary, unedited sensation. Even though these artists carried with them an intricate complex of artistic traditions and of varying emotional responses, they tried to act as if all this might be discarded by using their eyes as innocent but refined reflectors of a moment of perception. They ignored, among countless other things that had to do with the world they lived in, the welling national rivalries that at the Munich International Art Exhibition of 1869 provoked a French critic, Eugène Müntz, to comment that "the artistic battle of the Munich Glass Palace [built in emulation of the London Crystal Palace of 1851] is essentially nothing but a duel between the Germans and the French." And they ignored in their art, if not in their life, the political storm clouds that could prophesy how, within a year, this artistic duel would take on another kind of reality when the imperialist ambitions of Bismarck and a growingly patriotic and unified Germany would provoke France into declaring war against Prussia on July 19, 1870.

Part 3:

❖

1848–1870

SCULPTURE

France

The Second Republic fared little better than the First in leaving sculptural monuments behind for posterity. It did initiate one public monument, only to abandon it for political reasons: a statue honoring Marshal Ney, the most loyal of Napoleon's generals and the only one executed under the Bourbon regime. François Rude, who had received the commission, modeled a maquette showing Ney the moment before his execution as a "martyr of the Restoration" rather than as a military hero, but even that was deemed too much of an encouragement to Bonapartism. The project was resumed after Napoleon III had become emperor and finished late in 1853. Rude's second design revives the "significant moment" tradition of the Great Men of France series (see figs. 86 and 203) and gives free rein to his worship of the First Empire (fig. 306)—Ney storms forward, shouting to his troops, in a dynamic pose reminiscent of the Genius of Liberty on the Arch of Triumph (see fig. 210) but, of course, in historically correct uniform.

When Rude died two years later, he was at work on a marble *Christ* without precedent in the history of sculpture, for it is a purposely truncated figure, a self-contained fragment of monumental scale. When the work was shown posthumously at the Salon, it had to be classified as a bust; the term "torso," which fits it rather better, was then applicable only to classical statues that had lost their extremities.

Of the other French sculptors of Rude's generation, only Barye survived and remained active throughout the Second Empire. His animal bronzes, which were represented in both the fine arts and the industrial sections, brought him great honors at the Paris Exposition Universelle of 1855, and he produced a number of major pieces of monumental sculpture between 1854 and 1860 for the exterior of the new portions of the Louvre then under construction. Chief among these are two pairs of limestone groups, *War* and *Peace*, *Force* and *Order*; these have badly deteriorated, but

Fig. 306 **François Rude**, Monument to Marshal Ney, 1853. Bronze, height 8′ 9″. Paris.

Fig. 307 **Antoine-Louis Barye**, *Force*, 1855. Patinated plaster, height 39½". Musée d'Orsay, Paris.

the plaster models, although on a far smaller scale, convey their power and dignity. That for *Force* (**fig. 307**) has the same basic structure as the rest: a classical nude youth of Herculean build, accompanied by a child, sitting on an animal appropriate to the concept represented—in this case a lion. We recognize the main figure as a descendant of the Greek hero type formulated earlier in Barye's *Theseus* (see fig. 214), only he is completely at rest now, except for the small protective gesture toward the child. Did Barye, we wonder, know Canova's *Theseus* of 1781–83 (see fig. 94)?

Préault rarely lived up to his early promise. Although he often showed at the Salon after 1848, most of his entries were far from memorable—the great exception being the life-size relief of the dead *Ophelia* floating in the stream. A surprisingly large number of Préault's works, most of them portrait roundels, are to be found in Paris cemeteries. The most moving of these is on the grave of the great actor Philibert Rouvière, done in 1866 (**fig. 308**). Beautifully composed within the circular frame, it shows Rouvière at the moment of death, great suffering etched into his features, in poignant contrast with the actor's mask that has fallen from his face.

Fig. 308 **Auguste Préault**, *Philibert Rouvière*, 1866. Bronze, life-size. Montparnasse Cemetery, Paris.

Fig. 309 **Charles-Henri-Joseph Cordier**, *Jewess of Algiers*, 1863. Bronze, enamel, gilt, onyx, life-size. Collection of M. Rejaee, New York.

Three major sculptors established their renown in the Second Empire: Carpeaux, the greatest and best known; Carrier-Belleuse; and Cordier. They are discussed here in the order of their appearance on the stage of art history. Charles-Henry-Joseph Cordier (1827–1905) attended the École des Beaux-Arts in 1846–47, then became a pupil of Rude, and made his Salon debut in 1848. The piece he exhibited, a bust of *Said Abdala of the Mayac Tribe*, established his fascination with ethnology and anthropology, which he was to pursue for the rest of his long career, although not to the exclusion of more conventional themes. Romanticism encouraged the vogue for foreign cultures, witnessed in Delacroix's enthusiasm for the Arab world of North Africa, and Cordier fell heir to this lure of the exotic. What makes his work different and impressive is his insistence on ethnographic precision. His busts could serve as scientific exhibits in the Natural History Museum in Paris and at the same time be admired as works of art. In 1854

and 1856, Cordier spent the better part of a year in Algeria, with government support, studying "from the point of view of art the different types of the native human race." He even collected photographs of his subjects to ensure accuracy. The richness and variety of local costumes enthralled him no less than the ethnic types themselves. To render them more fully, he became a pioneer in polychrome sculpture. Neoclassicism had banished color from sculpture until the 1850s, when Cordier was the boldest and most imaginative in exploiting its possibilities. His *Jewess of Algiers* (**fig. 309**) is a marvel of technical intricacy in the service of sumptuously rich contrasts of color and texture: the noble face of dark bronze, with pupils of translucent semiprecious stone, is framed by a gilt and enameled headdress held in place by jeweled brooches and the richly embroidered facing of her onyx dress. Despite the misgivings of conservative critics, who denounced them as "distracting" or "commercial," Cordier's polychrome busts

Fig. 310 **Albert-Ernest Carrier-Belleuse**, *Angelica Chained to the Rock* (portion). Terracotta, after marble of 1866, height 30″. Private collection.

became an important part of the Second Empire neo-Baroque.

Albert-Ernest Carrier-Belleuse (1824–87), the most prolific and versatile sculptor of his time, is often termed neo-Rococo, but the label fits only one of the many aspects of his work and even there must be employed with caution. As a teenager, he worked for a goldsmith, then briefly attended the École des Beaux-Arts. During the 1840s, he gathered considerable experience in the decorative arts, working for various employers. After a very modest Salon debut in 1850, he went to England for several years as chief designer for the Minton china manufactory, so his career in France began only after his return in 1855. At that time, he specialized in small bronzes such as the statuettes of *Michelangelo* and *Raphael*, for which there had been a ready market since the 1830s (see page 221).

Although Carrier-Belleuse regularly showed at the Salon from 1857 on, his first great success came to him only in 1863, when the emperor bought his marble group of a *Bacchante with a Herm of Dionysus* for the Tuileries Gardens. The equally successful *Angelica Chained to the Rock* entered the Paris Exposition Universelle of 1867. The life-size marble is lost but its appearance has been preserved in terracotta reductions (fig. 310), which Carrier-Belleuse and his workshop produced for sale to private collectors. *Angelica* is frankly sensuous, displaying herself against the rock in a way designed to convince Roger that rescuing her will really be worth his while. The *Bacchante* and *Angelica* presuppose Clésinger's *Woman Bitten by a Snake* (see fig. 217), but Clésinger himself was unable to work in the more graceful and coquettish vein that earned Carrier-Belleuse the title "the Clodion of the nineteenth century." Yet the

resemblance is more apparent than real; these are not the adolescent nymphs of the Rococo but fully developed women reflecting the study of live models. The solid strain of Realism in Carrier-Belleuse is evident in his numerous portrait busts, such as that of Honoré Daumier (**fig. 311**), a sober and incisive likeness without any attempt to aggrandize his friend.

Throughout his career, Carrier-Belleuse designed a vast amount of decorative sculpture ranging from jewelry to fireplaces and large architectural ornamentation. His most ambitious, and certainly best-known, works of this kind are the two splendid *torchères* in the grand staircase of the Paris Opera, commissioned by its architect, Charles Garnier, in the late 1860s but not completed until after the Franco-Prussian War. Standing figures, most often women, holding candelabra were a standard part of the interior decor of palaces and other ambitious structures, and Carrier-Belleuse had designed some of the usual, static kind before. For the Opera staircase, he combined a seated and a standing figure on either side (the left-hand pair appears in **fig. 312**) who give the impression of just having landed on their perches for the visitor's special benefit. Here, as in many other decorative designs of his, Carrier-Belleuse harks back to the elegantly elongated figures and formal poses of the

Fig. 312 **Albert-Ernest Carrier-Belleuse**, Torchère, c. 1874. Bronze (zinc cast), from model of c. 1869, height c. 7'. L'Opéra, Paris.

Fig. 311 **Albert-Ernest Carrier-Belleuse**, *Honoré Daumier*, c. 1865–70. Patinated plaster, life-size. Musée National du Château de Versailles.

Fontainebleau style. These light-bearers hold up their burdens without the least sign of effort. In fact, the groups themselves are not nearly as heavy as they seem, since they are zinc casts—the earliest in France of so large a size.

Born in Valenciennes, Jean-Baptiste Carpeaux (1827–75) made his way to Paris in 1842, where he studied for a while with Rude, who advised him to go to Francisque Duret, a more conservative sculptor, who "won't teach you anything but will be useful in your getting the Prix de Rome." It was to be a slow road for Carpeaux; he finally won the prize in 1854, a decade after entering the École des Beaux-Arts. He was far from a model fellow at the French Academy in Rome. In 1858, he sent to Paris a work that complied with the rules of the academy only to the extent that it was a nude figure: the *Fisherboy Listening to a Seashell*, a graceful bow in the direction of his teacher's *Neapolitan Fisherboy* (see fig. 209).

Carpeaux's final academy project, *Count Ugolino and His Sons*, was another unorthodox subject for which he gained approval only with difficulty. The tragic tale, from Dante's *Inferno*, of the count who was immured in a tower

with his sons to die of starvation and who devoured his children, had been illustrated pictorially but not as a free-standing sculptural group. We do not know what moved Carpeaux to undertake this challenging task, only that he arrived at his choice after a trip to Florence, where he was tremendously impressed with Michelangelo. It may have been this experience that made him decide to show the figures nude, even though, as a historical subject, they should have worn appropriate period costume. An early maquette (fig. 313a) of 1858 already displays the basic composition of the final over life-size group (fig. 313b). Built up of small pellets of clay, the maquette is more concerned with the formal coherence of the group; the direct visual antecedents of the group, however, are to be found in recent French sculpture, including Feuchère's *Satan* (see fig. 216). On one level, *Ugolino and His Sons* can be viewed as a virtuoso academic exercise, consciously planned to ensure its success before the conservative judges who would have to pass on its merits in Paris; it parades Carpeaux's mastery of the nude, and the carefully studied expressions of the five heads recall the *têtes d'expression* (heads displaying

a variety of emotions) that every student had to practice at the École des Beaux-Arts. It is a tribute to Carpeaux's genius that we are not tempted to take the group apart, that it forms a single, breathtaking whole. By leaving his figures "unhistorically" nude, Carpeaux has endowed the work with a universality he could not have achieved otherwise. It speaks to us as an enduring vision of hell on earth, whether or not we happen to know its literary source.

After its acquisition in bronze by the state and the award of a first-class medal at the Salon of 1863, *Ugolino* proved so popular that Carpeaux arranged for a reduction to be produced that same year, as well as casts of two maquettes available in bronze and terracotta. That the latter found a ready market indicates an important shift of taste, in which the public came to appreciate the immediacy of the maquette free of the meticulous detail hitherto expected of small sculpture, blurring the distinction between the "finished" and the "unfinished."

Carpeaux produced his masterpiece of Second Empire neo-Baroque when Garnier entrusted him with one of the four sculptural groups across the facade of the new Opera.

Fig. 313a **Jean-Baptiste Carpeaux**, *Count Ugolino and His Sons*. Terracotta, from plaster of 1858, height 21″. Musée des Beaux-Arts, Valenciennes.

Fig. 313b **Jean-Baptiste Carpeaux**, *Count Ugolino and His Sons*. Marble, height 77″. The Metropolitan Museum of Art, New York.

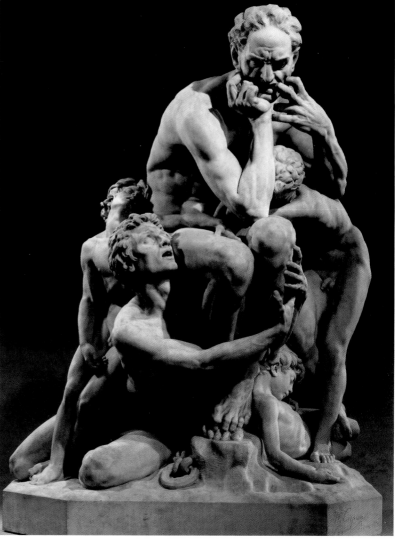

Fig. 314 **Jean-Baptiste Carpeaux**, *The Dance*, 1867–68. Plaster, height c. 15′. Musée de l'Opéra, Paris.

The Dance (fig. 314) was unveiled in 1869. Despite the fact that Carpeaux ignored the architect's stipulations (that he limit himself to "three figures and accessories"), Garnier not only accepted *The Dance* (although he complained that Carpeaux was "the terror of architects"), he loyally defended the group during the scandal in which the nude bacchantes dancing around the winged male genius were denounced as drunk, vulgar, and indecent. Public opinion insisted that it be replaced, but the outbreak of the war with Germany brought a halt to work on the proposed substitute. After peace had returned, the old complaints were forgotten and *The Dance* was as widely acclaimed as it had been reviled.

The circular movement of the dancers recurs, in more restrained form, in the third of the large decorative commissions Carpeaux received, the centerpiece of a fountain for the Luxembourg Gardens near the Observatory. The latter may have suggested Carpeaux's subject—the Four Continents sustaining a celestial sphere with the signs of the zodiac surrounding a terrestrial globe (fig. 315). Carpeaux worked on it from 1867 until the outbreak of the war in 1870, by which time he had almost finished the final plaster model. He showed it at the Salon of 1872, and two years later, the fountain was unveiled. Stimulated by the busts of Cordier, Carpeaux undertook careful ethnographic studies for at least two of the four female nudes: *Africa*,

◆ – CARPEAUX AND *LA DANSE*: THE TRIBULATIONS OF PUBLIC ART – ◆

Jean-Baptiste Carpeaux's monumental group on the facade of the new Paris Opéra triggered a debate about the propriety of public art in the Second Empire. The furore foreshadowed twentieth-century scuffles over politicized sculptural works as varied as Richard Serra's Tiled Arc *(1981) in New York City and Maya Lin's* Vietnam Veterans' Memorial *in Washington, D.C.*

Anne Middleton Wagner covered the reception of The Dance *(La Danse) in her modern monograph on the sculptor:*

… Carpeaux's group was one of the most controversial sculptures of the nineteenth century, with the brouhaha that greeted it equalled only by the controversy touched off by Rodin's *Balzac* in 1898. Both were lampooned, defended, caricatured, and praised. But there are important differences … When *La Danse* was unveiled on July 26, 1869, it became public property. … And it was not seen in the relative privacy and obvious impermanence of the Salon, but from the street, as part of a building already being called as characteristic of its age as the cathedrals are of theirs. So when judgement was passed on *La Danse*—as it soon was—the verdict seemed to have special weight because the public weal was somehow at stake.[65]

Charles Garnier, architect of the Opéra, explained the subject of the commission to Carpeaux as something between "Bacchic Dance and Amorous Dance, or some other kind of dance entirely, and Comedy and Drama. … We absolutely don't need three stick-straight little guys all in a row." Garnier enthused about the finished piece as "vivid and coloristic."[66]

The modernity of the sculpture consists in its use of form for meaning and its denial of time-worn modes of allegory and symbolic attributes, as Wagner has revealed:

… initially there *are* no attributes, just bodies a-rhythmically rendered, all caught mid-step, mid-movement. … Only … through the latticework

of legs, do we spot anything at all that has the status of attribute. Happily waving his jester's wand, a putto hides beneath the dancers' feet. A faun's head is almost completely lost in darkness. …

Because *La Danse* displaces or swallows its attributes, it does not follow that … no meaning is secured. Meaning is evident in Carpeaux's sculpture: this is dance, not because of a label or scroll, or even the putto and faun, but because stone bodies take the poses of people caught in motion—because they are dancing. It is difficult to be not deceived by the quickness of surface here, and easy to slip into metaphors that make stone flesh quiver or dancers circle and sway (contemporary critics saw them sweating). We might call these effects realistic, but what we would really be saying is that this is a way of sculpting which locates meaning squarely in its rendering of the human body, and therefore goes to great lengths to achieve the necessary illusion of physicality and substance. This is the realism of *Ugolin et ses fils* [see fig. 313], its exaggerations tamed but its disorders emphasized, so that the inward tensions of the earlier group here explode as movement.[67]

One month after its unveiling, the sculpture faced a barrage of hostility. A vandal threw a bottle of ink that exploded on the torsos of the two women on the left; and subsequently, caustic journal critics and caricaturists used printed ink to express their outrage. Georges Lafenestre of the Moniteur Universel *caught the mood: Carpeaux's sculpture had more affinity with the wild can-cans of the public* bals *than with the elevated rigor of the ballet.*

La Danse is a bacchanale, the most violent, unbridled, impetuous bacchanale ever to have shattered a voluptuous night of an antique summer. … Standing on a rock, a nude man, tambourine in hand,

quivers frenetically, arousing the circle of howling dishevelled maenads which boils around him. Shivering, feverish, exhausted, these drunken women whirl at random, smiling with a lascivious, dazed air. As if at the point of exhaustion, holding one another by the hand or on the flank, they collapse into each other, ready to roll in the dust, while already under their cruel feet a little putto writhes. Ah, if only these lost dancers were Greek women with their splendid bodily attitudes and forms. But no, no, look at those hard faces which provoke the passerby with their furious rictus. Look at those tired, sagging legs, those flaccid and deformed torsos, and admit it, we are in the midst of the 19th century, in the midst of a diseased and undressed Paris, in the midst of realism. This realism is ardent, passionate, strong. I admit it readily—but it has absolutely no place on the facade of a monument consecrated to the arts.[68]

This opinion was not ubiquitous. Some writers, among them Émile Zola, wrote enthusiastically about the work, and employed it in the service of critiques of the Second Empire of Napoléon III. Indeed, Wagner underlines how anxiety about public life and sexuality intersected in the reaction to the group:

In the end what is striking about *La Danse* is the chain of associations it produced and the way they circled around the issues of woman, sexuality, and the state. *La Danse* was free, it was alive, it was sexualized, it was seditious, it was corrupting. All these words could equally well be applied to Woman in 1869, and were, with a usage resulting from the longstanding habit, in western culture, of making its own peculiar uses of the female body. In that body's pleasures— and their repression—were found metaphors for value and debasement in general. They were terms which allowed for description and control.[69]

court. As the perceptive critic Théophile Thoré-Burger remarked at the Salon of 1868, her bust (fig. 317) emulates French Baroque portrait busts, obscuring the truncation in such a way that the bust seems to float above its pedestal.

After the fall of the empire, Carpeaux's own circumstances—financial and physical—deteriorated as the illness that caused his premature death began to undermine his energies.

Among Carpeaux's admirers was the Duchess of Castiglione-Colonna (1836–79), who became the finest woman sculptor of the century. In 1861, when Carpeaux was exhibiting the plaster of his *Ugolino* at the French Academy in Rome, she remarked: "Nobody since Michelangelo has done anything like this; it seems that his spirit has entered into you!" Born Adèle d'Affry, near Fribourg in Switzerland, she came from a noble family that had long served the kings of France before the Revolution. When she was barely eighteen, she began to study sculpture in Rome; at twenty, she married the Duke of Castiglione-Colonna, who died six months later of typhoid fever. Adèle settled in Paris in 1859. Beautiful, titled, and charming, she soon made important friends, including Delacroix, and gained entry to

Fig. 315 **Jean-Baptiste Carpeaux**, *The Four Continents*. Bronze, from plaster of 1867–72, over life-size. Luxembourg Gardens, Paris.

represented by a black (fig. 316), and *Asia*, represented by a Chinese (he used a young male Chinese whose head he then grafted onto a female body; apparently he could not find a Chinese female model willing to pose for him). America is identified only by her Indian headdress, presumably because no American Indians were available to the artist. The issue of slavery was still sufficiently alive in the late 1860s for Carpeaux to attach a leg iron to *Africa*. The sculptor marketed the head of *Africa* as a bust, bound with ropes, inscribed, "Pourquoi naître esclave?" ("Why was I born a slave?").

Carpeaux served as the unofficial court sculptor and among his diverse range of portraits are many members of the imperial family and their circle. At twenty-six, the Duchess of Mouchy was among the famous beauties of the

Fig. 316 **Jean-Baptiste Carpeaux**, *Africa* (detail of *The Four Continents*), 1867–72. Patinated plaster, over life-size. Louvre, Paris.

Fig. 317 **Jean-Baptiste Carpeaux**, *The Duchess of Mouchy*, 1867. Patinated plaster, height 37½″. Ny Carlsberg Glyptotek, Copenhagen.

the imperial court. Nevertheless, she pursued her professional career with the utmost seriousness, even obtaining permission to attend dissections. From 1863 on, she successfully exhibited at the Salon, under the pseudonym Marcello.

Marcello's early and impressive bust of Bianca Capello, a *femme fatale* of the sixteenth century, bespeaks the sculptor's admiration for Michelangelo; one cannot escape a suspicion that Marcello identified to some degree with Bianca. The superwomen of myth and history held an enduring fascination for her—Helen of Troy, Ananke (the personification of Fate), Hecate, the Gorgon. Of this last, Marcello created a bust in 1866 which she developed into the compelling *Pythia* (fig. 318), a statue depicting the oracle at the sanctuary of Apollo at Delphi, who, perched on a tripod, transmitted the god's messages. Garnier, who saw it at the 1870 Salon, immediately acquired it for the Opera, where the statue occupies a niche in the Grand Foyer. The sibyl's exalted, visionary state can be sensed in every part of her body: the wild-eyed prophetess, violently twisting on her stool, recalls the expressiveness of Carpeaux's *Ugolino*. Here again the artist seems to have identified with her subject, for she made life casts of her own shoulders and of

her left hand as aids in modeling the figure. Carpeaux had become a close friend, and Marcello portrayed him less than a year before his death, when he was already very ill. Perhaps at that time Marcello herself had felt the first signs of the tuberculosis that was to kill her four years later.

This discussion of the Second Empire concludes with two sculptors born between 1830 and 1840 who were to dominate the last three decades of the century but who did their earliest significant work before 1870. Alexandre Falguière (1831–1900) rose through the established channels of the École des Beaux-Arts to obtain the Prix de Rome in 1859. Although his *Winner of the Cockfight* was well received in 1864, it was his *Tarcisius* three years later (fig. 319) that established his reputation. The state bought the plaster to be executed in marble and it received the Medal of Honor at the following Salon. Falguière had read about Tarcisius, the Christian boy martyr, in a popular religious novel, *Fabiola*, by Cardinal Wiseman, while he was at the French Academy in Rome, and may well have started work on the figure shortly before he returned to Paris in 1865.

Fig. 318 **Marcello (Adèle d'Affry, Duchess of Castiglione-Colonna)**, *Pythia*, 1870. Bronze, height 9′ 6″. L'Opéra, Paris.

Fig. 319 **Alexandre Falguière**, *Tarcisius*, 1867. Marble, life-size. Musée d'Orsay, Paris.

Tarcisius, dying, clutches the sacred host to his chest and thus offers a religious parallel to a well-known "martyr of the Revolution," the young Bara, who died clutching the tricolor; Falguière must have known David's painting of that subject as well as the sculpture by David d'Angers. He chose as his model an emaciated boy who reminded him of the sons in Carpeaux's *Ugolino* group, which he greatly admired. Still another visual source was Stefano Maderno's *St. Cecilia*, a key monument of Roman Baroque sculpture widely known and reproduced. Falguière's *Tarcisius* was thus bound to appeal to the public's emotions on so many different levels that its success was a foregone conclusion.

No such success—indeed, no success of any kind—was granted to the youngest and by far the most important member of this generation, August Rodin (1840–1917). Refused admission to the École des Beaux-Arts, he studied at the so-called Petite École, intended primarily for the training of craftsmen; he followed the course in anatomical drawing taught by Barye at the Natural History Museum; and he worked as one of many assistants in the studio of Carrier-Belleuse. The only piece he sent to the Salon during the Second Empire, *The Man with the Broken Nose*, was rejected as an unfinished fragment. For Rodin, however, it represented a revolutionary insight: what matters in sculpture is not whether it is "finished" or "complete" but whether it conveys to the beholder the way it grew—the miracle of dead matter coming to life in the artist's hands. *The Man with the Broken Nose* certainly does, and that is

Fig. 320 **Auguste Rodin**, *Mignon* (Rose Beuret), c. 1865–70. Original plaster, height 15¾". Musée Rodin, Paris.

why Rodin later said of it: "That mask determined all my future work."

That same year, 1864, Rodin met Rose Beuret, who was to remain his companion for the rest of his life (he married her shortly before his death). Some time between 1865 and 1870, he modeled a bust of her (fig. 320), which he exhibited as *Mignon*, following Carrier-Belleuse's practice of "depersonalizing" titles for busts of beautiful women that might be portraits. *Mignon* is not a fragment, and far more nearly "finished" than *The Man with the Broken Nose*, but a comparison with Carpeaux (see fig. 317) at once reveals that Rodin had now achieved greater spontaneity of handling and passionate intensity of expression. This, clearly, is not the work of a professional portraitist but a statement of the artist's emotional relationship to his model.

During the war, Rodin briefly served in the National Guard. After the defeat, unable to find work, he went to Brussels (see page 489).

Italy

The Second Empire was, for Italy, the age in which the Risorgimento—the drive for the reunification of the country—came to fruition; the age of Cavour, Garibaldi, and Victor Emmanuel II. Its center was Turin, where Vincenzo Vela, although Swiss by birth, spent eleven years

Fig. 321 **Vincenzo Vela**, Monument to Count Camillo Cavour, 1862–63. Original plaster, height 71″. Museo Vela, Ligornetto, Switzerland.

(1856–67) teaching at the Academy of Fine Arts and knew all the leading personalities. A master portraitist, he recorded them more strikingly, and truthfully, than any other sculptor of his day. In the late 1840s, he had become a leader of *verismo* (see page 000). In Italian, the term has a special coloration because of its derivation from *il vero*, which means both "truth" and "nature." *Verismo* was, on the one hand, a rejection of the "timeless" Canovian ideal and, on the other, the rediscovery of the realistic aspects of Baroque portraiture.

Vela portrayed Cavour, the architect of Italian unity, from life, and he was the author of the earliest monument to the great statesman, commissioned only three weeks after Cavour's death in June 1861. The marble statue, in the Genoa Commodity Exchange, was heavily damaged by bombardment in 1942, but the plaster is preserved at Ligornetto, Vela's birthplace. Cavour did not have the look of a commanding personality; short, squat, and soft-featured, he was difficult to "monumentalize." Vela chose to show him sitting at ease on an upholstered chair, pen and paper in hand, in pensive mood (fig. 321). For an indoor setting, this intimate "true-to-life" image was a happy choice which conveys Cavour's intellectual authority as the wise counselor.

Vela's chief rival, Giovanni Duprè (1817–82), who had studied at the academy in Florence when Bartolini taught there, produced a life-size *Dead Abel* in 1842, but abandoned its pioneering *verismo* style after the middle of the century. He was regarded as the greatest Italian sculptor of his day, although his reputation faded rapidly after the unfortunate monument in Turin to Cavour, swathed in a Roman toga with a semi-nude Italia. His retrospective style, mingling a Romantic Neoclassicism with Early Renaissance elements, made him particularly suitable for religious and funerary monuments. His tomb of Fiorella Favard (fig. 322) offers a variant of the Swedenborgian concept represented by Flaxman's Cromwell Memorial (see fig. 78); a heavenly messenger receives the young woman's soul from her pseudo-fifteenth-century sarcophagus. A gentle rhythmic grace recalls the English sculptor, who would have marveled, too, at the technical skill with which the hovering angel has been carved in three dimensions.

Raffaele Monti (1818–81), who like Vela studied in Milan and participated in the 1848 revolt, was a precocious talent who by that time had already worked in Vienna, Budapest, and London. After the failure of the revolt he settled in London for the rest of his life, but artistically remained Italian. Monti was a virtuoso marble carver who specialized in transparently veiled nude women, reviving an invention of the Italian Late Baroque. His most spectacular performance, much admired at the London International Exhibition of 1862, was *The Sleep of Sorrow and the Dream of Joy* (fig. 323); it was intended as an allegory of the Risorgimento, although no one could gather this from

looking at the group. Its closest relatives are the soaring
angels of Italian cemetery art (see fig. 322), and like these,
Monti's group is designed for frontal viewing only—a relief
without a background, as it were.

Of the sculptors born between 1830 and 1840, only one
emerged before 1870 as a distinctive personality. He also
was the wittiest of them all during his short career. Adriano
Cecioni (1838–86) studied at the conservative Florence
Academy during the 1850s and fought in the war against
Austria in 1859. In 1863, he won a traveling fellowship
from the academy and went to Naples, where he remained
until 1868. His last work done under the terms of his fel-
lowship is *The Suicide* (**fig. 324**), a life-size figure he
modeled in Naples and sent to Florence in 1867 for
approval by the professors at the academy, who refused to
authorize its execution in marble. The academy acquired
the plaster only after the artist's death. It was not the style
of the figure that the academicians found objectionable—
there is nothing unconventional in either the anatomy or
the drapery—but the strange subject. Had Cecioni chosen
to represent a specific suicide from history or mythology, all
would have been well. But the lightly clad, horror-stricken
youth gazing at the dagger in his hand as he leans for
support against an ivy-covered tree trunk is meant to
represent suicide as such, or, more precisely, the emotional

occasioned by the deaths of important public personalities, that of the Duke of Wellington in 1852 and that of Prince Albert, Queen Victoria's consort, nine years later.

The Duke of Wellington, last of the heroes on either side of the Napoleonic wars, was to receive a monument inside St. Paul's for which a worldwide competition was held. As a result of circumstances too complex to go into here, the commission was awarded in 1856 to Alfred Stevens (1817–75). Stevens was a man of many talents, which included the visual arts as well as poetry and music. He had spent nine years, 1833–42, in Italy, and had worked mostly in the provinces during the following decade. The Wellington monument, his only major sculptural project, consists of a marble canopy supported by Corinthian columns and enclosing the sarcophagus and bronze effigy of the duke; at either end there is a colossal marble group, *Truth and Falsehood* and *Valor and Cowardice* (fig. 325), reminiscent of Michelangelo. The two groups show considerable powers of invention, and one cannot deny them a

Fig. 324 **Adriano Cecioni**, *The Suicide*, 1865–67. Plaster, height 6′ 11″. Galleria d'Arte Moderna, Florence.

state leading to suicide. Cecioni himself commented on his intention by pointing out that nature, by endowing man with the ability to destroy himself, has made him the master of his own fate, the only being that can voluntarily put an end to a life of misery. The statue, Cecioni's goodbye to the academic tradition, is meant to be a monument to this unique human privilege.

England

In the 1850s and 1860s, often referred to as the "High Victorian" period, it is the monuments rather than the sculptors, that stand out. There are two very ambitious ones, both

Fig. 325 **Alfred Stevens**, *Valor and Cowardice*, 1857. Original plaster, over life-size. Victoria and Albert Museum, London.

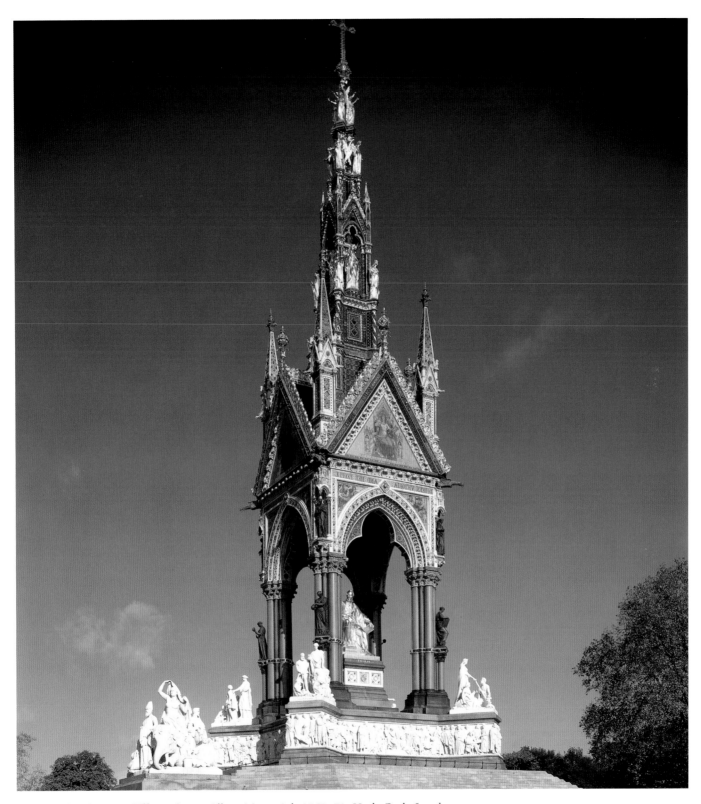

Fig. 326 **Sir George Gilbert Scott**, Albert Memorial, 1863–72. Hyde Park, London.

certain grandeur. The canopy to which they are attached was to be crowned by an equestrian statue of the duke, which was, however, not executed until long after Stevens's death.

The Albert Memorial, envisioned from the beginning as an outdoor structure impressive enough to be one of the landmarks of London (fig. 326), was primarily an architectural project, into which the sculpture had to be fitted once the basic design was decided upon. Characteristically, the style chosen was Gothic, the "national" style, rather than the "timeless" classical. As planned by Sir George Gilbert Scott in 1863 and completed nine years

later, the memorial consists of an elaborate neo-Gothic tabernacle for the prince's bronze statue, enhanced with sculpture, mosaics, and colored marble inlays. The tabernacle rises on a platform that allows for marble groups at the corners representing Industry, Commerce, Agriculture, and Science. Below them is a continuous frieze portraying the greatest poets, composers, painters, architects, and sculptors. Each of the corners of the wrought-iron fence that surrounds the memorial has a marble group of one of the Four Continents.

The Albert Memorial was by far the largest monument dedicated to an individual up to that time. It is, in fact, not so much a memorial to Prince Albert, as a celebration of the Age of Victoria, of the British Empire, and of the civilization that sustained and justified it. The various artists to whom the sculptural parts were entrusted all had the right credentials from the Royal Academy, which explains the homogeneity of their collaboration; they were all members of the same school, subordinating their personalities to a common purpose. The two most important were John Henry Foley (1818–74) and Henry Hugh Armstead (1828–1905). Foley, an Irishman who settled in London at sixteen, did the colossal figure of the seated prince and the group *Asia*, which like the other three continents has a characteristic animal as its central feature.

Armstead's frieze around the base of the memorial consists of one hundred and sixty-nine figures, drawn from antiquity to his own time. Both artists had gone to considerable trouble to find authentic likenesses, either for ethnographic realism or historical accuracy.

The United States

The earliest American sculptors able to compete with Europeans, Greenough and Powers, had settled in Italy in the belief that only there could they hope to achieve "modern classics" (see pages 204–06). Looking at their successors, we find an astonishing increase in number. The majority continued the pattern set by Greenough and Powers, although none reached the same level of distinction; but there were now also some who succeeded in becoming sculptors while staying at home.

Among the expatriates, Randolph Rogers (1825–92), born in upstate New York, spent his youth at Ann Arbor, Michigan, then little more than a pioneer village, which he regarded as his home town. At the end of his life, he donated all his original plasters to the University of Michigan museum, where, unfortunately, they perished through neglect. He had started modeling on his own while clerking in a New York store; his employee was so impressed that he sent him to Italy for training. After studying with Bartolini, Rogers settled in Rome in 1851. Within a few years, he produced *Nydia the Blind Girl* (fig. 327), a character from *The*

Last Days of Pompeii by Edward Bulwer-Lytton (see pages 152 and 257). The figure, acclaimed as an image of the human soul, was so popular that Rogers filled orders for scores of marble replicas—a success comparable with that of *The Greek Slave* (see fig. 194) some fifteen years earlier. The staggering, uncertain movement of *Nydia* suggests that Rogers had profited from some aspects of the neo-Baroque, in spite of his fundamental Classicism. Rogers's later fame stemmed from his numerous Civil War memorials.

Harriet Hosmer (1830–1908) was the leader of a large group of women sculptors working in Rome; Henry James patronizingly referred to them as "the white, marmorean flock." Born in Watertown, Massachusetts, the daughter of a physician who supported his daughter's ambitions, Hosmer left for Rome in 1852, where she worked with English Neoclassical sculptor John Gibson. Tough-minded and capable of competing in the male-dominated world of sculpture, she was the first American to be commissioned to design a funerary monument for a Roman church, the monument to Judith Falconnet in S. Andrea delle Fratte

Fig. 327 **Randolph Rogers**, *Nydia the Blind Girl*. Marble, from model of 1858, height 55″. The Metropolitan Museum of Art, New York.

Fig. 328 **Harriet Hosmer**, *Puck*, 1856. Marble, height 30⅞″. Chrysler Museum of Art, Norfolk, Virginia.

(1857). She established an international reputation for her numerous large-scale figurative works. One of her most playful and popular conceptions, *Puck* (**fig. 328**), brought her enormous financial success. Hosmer's ability to run a busy studio and the notoriety she gained throughout her long career inspired the many American women who struggled to break into the world of sculpture.

Of those who became sculptors without going abroad, some aspired to the Neoclassical ideal. The self-trained Erastus Palmer (1817–1904) intended his *White Captive* as a response to *The Greek Slave*, balancing observation of a live model against an idealizing tradition, to present an American alternative.

The one truly outstanding American sculptor of his generation, William Rimmer (1816–79), was also self-trained, but pursued his own powerfully expressive style. Born in Liverpool, England, he moved to the United States as a child. After an unsuccessful attempt to make a living as a painter, he became a physician, thus acquiring a thorough knowledge of anatomy. He did not turn to sculpture until 1861, when he modeled *The Falling Gladiator*, whose collapse is dramatized by his Herculean build. Ten years later, Rimmer modeled a *Dying Centaur* (**fig. 329**), equally bold in conception, with the added challenge of the truncated arms, which look so eminently right to eyes schooled in the works of Rodin but must have seemed incomprehensible to

Fig. 329 **William Rimmer**, *Dying Centaur*, 1871. Plaster, height 21½″. Museum of Fine Arts, Boston.

American audiences in 1871. These two pieces raise a host of questions to which answers are not readily found. What was the scope of Rimmer's visual acquaintance with European art past and present? On what resources available in Boston and New York around 1860—plaster casts, prints, magazine illustrations, copies, and so on—could he have drawn in training himself? Why was he obsessed with defeat and death? Is it sheer coincidence that he did *The Falling Gladiator* at the outbreak of the Civil War? Whether or not any of these questions can be resolved, Rimmer remains an astonishing phenomenon. His career was a constant struggle for recognition that kept eluding him; the only way he could make a living in art was as a drawing

teacher. Yet he was a man of genius: flawed and unfulfilled, but genius nevertheless. How else could he have created, in isolation, two works that bring to mind the achievements of Rodin fifteen years later?

Germany and Austria

There is an odd irony in the fact that Austria, which during the third quarter of the century repeatedly suffered both loss of territory and military defeat, produced more ambitious public monuments than Prussia, whose spectacular successes destined it to become the leader of a united

Fig. 330 **Anton Dominik Fernkorn**, Monument to Charles, Archduke of Austria, 1853–59. Bronze, height of statue 29′. Heldenplatz, Vienna.

Germany in 1871; and a further irony in the fact that the most successful makers of these monuments were German-born and German-trained. This was the case with Anton Dominik Fernkorn (1813–78), who received his training in Munich under Ludwig Schwanthaler, a follower of Thorvaldsen. In 1840, he settled in Vienna, where an even older (and staler) Neoclassical tradition derived from Zauner held sway. Fernkorn reacted to it by rediscovering Baroque sculpture, possibly under the stimulus of the French. Between 1853 and 1859 he carried out a colossal bronze of an earlier model for the equestrian statue of Charles, Archduke of Austria (fig. 330). Charles had led the Austrian armies at the battle of Aspern in 1809, one of Napoleon's few defeats before the Russian campaign. Fernkorn shows him on a rearing horse, a windblown flag in his raised right hand and his face turned back toward the troops he leads, more dynamically in action than Marochetti's *Emmanuel Philibert* of 1833 (see fig. 197) and yielding a more jagged and picturesque silhouette. It is also a remarkable feat of casting (which Fernkorn did himself), since the entire weight of the monument rests on the hooves of the horse's hind legs (for contrast, see Falconet's *Peter the Great*, fig. 84). By the time his second monument, to Prince Eugene of Savoy, was unveiled in 1865, Fernkorn had become incurably mentally ill.

Meanwhile, former students of Christian Daniel Rauch (see pages 209–11) were busily producing monuments to local heroes from Munich to Hamburg. Rauch's name, which means "smoke" in German, inspired a good many bons mots. It might be said, then, that a "pall of smoke" hung over the public monument in what was to become Germany. The sculptor who did most to dispel it was Reinhold Begas (1831–1911), a precocious talent who entered the Berlin Academy at the age of twelve to study first under the half-forgotten Schadow (see pages 116–17), then under Rauch. He went to Rome in 1856 on a fellowship from the Berlin Academy, and his style underwent a decisive change when he discovered Michelangelo and Bernini. Even more important was his friendship with the Swiss painter Arnold Böcklin (see pages 348–49), whose sensuously realistic interpretation of classical mythology made a lasting impression on the slightly younger Begas. The group *Pan Comforting Psyche* (fig. 331), modeled in 1857, laid the foundation of Begas's fame. Psyche still retains traces of Schadow's Neoclassicism, while the mighty figure of Pan already belongs to the neo-Baroque, an embodiment of animal masculinity that is the sculptural counterpart of a "Rubens done from nature." Begas was to become the official sculptor of the newly founded German Empire (see page 504).

Fig. 331 **Reinhold Begas**, *Pan Comforting Psyche*. Marble, from plaster of 1857, life-size. Nationalgalerie, Berlin.

Giovanni Boldini, *Lady in the Studio of the Artist*, c. 1888. Oil on canvas, 32¼ × 25⅝″.
Galleria Civica d'Arte Moderna, Ferrara.

Part 4:

❖

1870–1900

Part 4:

❖

1870–1900

PAINTING

Reflections of the Franco-Prussian War

In the year bracketed by the summers of 1870 and 1871, the French in general and the Parisians in particular underwent a series of shattering upheavals that began with a declaration of war against Prussia, whose new chancellor, Otto von Bismarck, followed the principles not of political idealism but of forceful, pragmatic *Realpolitik*. Bismarck had wanted a war with France in order to consolidate the German nation and assert its prowess, and by July 19, 1870, through the machinations of diplomatic insults to the French, he successfully reached this goal. For the French, disasters followed rapidly. Two months later, Napoleon III and his armies were defeated in Sedan, in northeast France. By late September, the war was extended into a lengthy siege of Paris, which was cut off from the rest of the country. And as a grim finale, in the spring of 1871, a civil war broke out in Paris between the forces of a newly established left-wing Commune and the official government of the Third Republic, headed by its new president, Adolphe Thiers. During these catastrophic months, France had endured not only the eclipse of the high life of the Second Empire, but the national trauma of defeat by the Germans and the loss of Alsace-Lorraine as reparation. And in Paris, the bitter cold winter of 1870–71 was accompanied not only by the constant pressure of encircling Prussian armies but by starvation conditions that forced citizens to eat local rats, cats, and dogs, and even the exotic animals at the zoo. By May, the second siege had come, this time not of Germans, but of official government armies against fellow Frenchmen who supported the Commune (which, under the official artistic leadership of Courbet, had managed to knock down the Vendôme Column, a symbol for them of imperial, Bonapartist aggression). The city of boulevards, cafés, carriages, and dandies had turned into a spectacle of barricades, executions, corpses, street fighting, and imprisonments that in terrifying scope far exceeded the

revolutionary conflicts of the June days of 1848, and that in its death toll (over twenty thousand) far exceeded the Reign of Terror that followed the 1789 Revolution.

Many French painters fled from the catastrophes of 1870, some to London (Monet, Bonvin, Pissarro), others to Brussels (Boudin). Manet, however, remained in Paris, as did his friend Degas, and enlisted in the artillery, where he served as a lieutenant in the headquarters of the National Guard and seems to have been fascinated, in his characteristically dandified way, with the varieties of military uniform which he had earlier painted in *The Execution of Maximilian* but could now try on himself. After Paris officially surrendered to the Prussians on January 28, 1871, Manet left for the south to rejoin his family, and then returned to the capital in May to be greeted by the bloodiest climax of the civil war raging there. In a group of etchings and lithographs, he recorded some of these commonplace sights with the kind of aristocratic aloofness that also characterizes the remarkable journal entries in which Edmond de Goncourt described firsthand what Paris was like during that grim year. Again, Manet chose scenes that one would expect to elicit the artist's emotional responses but that instead trigger off the detachment of a voyeur who sees the world through aesthetic lenses, combining the seeming artlessness of reportorial illustration with a wealth of references to other works of art. He recorded, for one, a line of women under umbrellas waiting in front of a butcher shop guarded by a soldier with a bayonet—a scene that could evoke the pathos of wartime starvation and military regimen but that looks instead like an elegant arrangement of parasols in a Japanese print. And when he recorded the facts of death on the streets, as in the lithograph of 1871 titled, with intentional generalization, *Civil War* (fig. 332), the corpses are strewn before the barricades with the casualness of figures who might be resting in the Paris parks, a theme that the artist could explore for its intense dark–light

Fig. 332 **Édouard Manet**, *Civil War*, 1871. Lithograph on Japan paper (first state), 15⅜ × 20″. Fogg Art Museum, Harvard University, Cambridge, Massachusetts.

contrasts. Yet this presumed lack of either feeling or editing bears with it an enormous visual culture; for the print and its counterpart (a street execution) not only allude to Manet's own earlier work, the *Incident in the Bullring* (see figs. 275 and 276) and *The Execution of Maximilian* (see fig. 280), but to multiple sources by other artists for this lethal imagery. There are resonances here of such earlier Paris massacres as Meissonier's recall of 1848 (see fig. 220), Daumier's of 1834 (see fig. 181), or Delacroix's of 1830 (see fig. 127), as well as of Goya's own documentary and equally generalized account of civilian bloodshed in his print series, the *Disasters of War*. Thus, even this rapidly drawn lithograph, with its rough indication of the stones of the barricade and its human debris scattered in and out of the frame, affirms, in a subtle way, long traditions both of the artist's own work and of his visual sources, while espousing a belief in the Realist doctrine of truth to empirical experience.

How else could artists respond to the disasters of 1870–71? Meissonier, not only a painter of the Paris barricades of 1848, but also an official recorder of the military triumphs of Napoleon III and his predecessor, Napoleon I, was a natural contestant for this difficult task. During the siege of Paris, he served as a colonel in the National Guard (ironically, the superior officer to Manet, who had often made caustic remarks about the mechanical execution of Meissonier's military canvases), and quickly recorded the Parisian resistance, which he felt had saved France's honor. The result, a detailed painted sketch of 1870 (**fig. 333**) intended to be used someday for a larger painting, offers a curious change in view from his youthful interpretation of 1848. There is, once again, a crystalline, miniaturist precision in describing the dead and the dying which even permits the exact identification of the military heroes who lie on laurel branches (a symbol of victory) in the foreground. (One, Neverley, is caught in a Realist moment of

excruciating pain, his leg crushed under a writhing horse.) Yet this empirical concept suddenly switches to one of traditional allegory, not only in the dominant female figure (a personification of the City of Paris, who, bellicose in her lion's-head helmet, stands silhouetted against a windswept tricolor), but also in the murky skies, where a figure of famine, accompanied by the Prussian eagle, hovers menacingly over the earthbound battle. Such a mixture of conventional symbols and journalistic fact may still have worked in Delacroix's vision of a female emblem of Liberty on the barricades of 1830. By 1870, however, these two worlds, one inherited, one modern, seem irrevocably rent asunder, the airborne figures appearing especially contradictory in a language that approximates the effects of the sharpest-focus camera lens.

Daumier himself, though associated with a Realist viewpoint, was more consistent in creating an image of France surviving these catastrophes. Although he had drawn tragicomic vignettes of life in 1870–71 as a regimented line-up of Parisians scouting the gutters for rats to be eaten, he also summed up these months more rhetorically in an illustration for the issue of *Le Charivari* dated January 11, 1871. Titled *Horrified by the Inheritance* (**fig. 334**), it envisions a giantess who seems to represent the newly resurrected France. Like a skeletal mourner in a shroud, she surveys a flat, infinitely vast terrain covered with corpses. Unlike Manet and Meissonier, Daumier gives no hints of costume to suggest contemporaneity, nor does the cemetery-like site offer a specific locale. Indeed, were it not for the year, 1871, palely inscribed in a barren sky, this could be an allegory of war or death in any time or place. Paradoxically, Daumier the Realist reporter translates the historical facts of the Franco-Prussian War and the Commune into a symbolic statement of universal implications.

On the other side of the Rhine, responses to the events of 1870–71 were no less diverse in style and conception. It

Fig. 333 **Ernest Meissonier**, *The Siege of Paris*, 1870.
Oil on canvas, 11⅜ × 8⅝″. Musée d'Orsay, Paris.

Fig. 334 **Honoré Daumier**, *Horrified by the Inheritance*
(from *Le Charivari*, January 11, 1871). Lithograph, 9¼ × 7¼″.
Bibliothèque Nationale, Paris.

was inevitable that the Berlin-based Menzel, who, like Manet, switched easily from history painting to scenes of modern public and private life, would essay this theme. During brief visits to Paris in 1855, 1867, and 1868, he not only got to know his contemporaries Meissonier and Courbet, but also took as his subject the streets, the theaters, and the gardens of Paris, painting them in a way that parallels the French search for a style which could capture the teeming crowds and constant movement of mid-century life. Back in Berlin after 1868, he was to witness the events of the Franco-Prussian War from a safer distance than his French colleagues, and was commissioned by a local collector to depict the military pageant of July 31, 1870 that accompanied the departure of the Prussian king, Wilhelm I, for the front. It was an event that would lead soon not only to victory over Napoleon III, but to the unification of all the German states

under Wilhelm's new title, Emperor of Germany, a title declared, with bitter irony for the French, in the Hall of Mirrors at Versailles. But Menzel's view of the king's departure (fig. 335), completed in 1871, in full knowledge of the political consequences of that fateful day, is that of a Parisian crowd-watcher who enjoys not only the parade but the people who attend it. The nominal center of attention, the royal carriage of the king, who salutes the unruly crowd, and his queen, whose face is concealed by a handkerchief, is almost swallowed up at the far left by the pedestrian confusion of men, women, and children in their Sunday best, milling about the Berlin equivalent of the Champs-Élysées, Unter den Linden, in an agreeable flutter of activity that carries us up to the flapping of flags (both Prussian and German, in a symbol of growing unification), and to the couple (viewed from an oblique angle worthy of Degas) who are perched on the near balcony and are actually portraits of the patron's daughter and son-in-law. Menzel does not camouflage entirely all the clues to the historical import of this day. A newsboy in the foreground prominently holds a special edition of the paper which is being excitedly read by the group at the left, and even the colors of the crowds tend to reverberate with the black, white, and red national colors of the German flags above. The immediate effect, however, is of the uneventful and agreeable confusion of city leisure that Manet, for instance, had caught in his *Concert in the Tuileries* (see fig. 271). Yet Menzel's technique, for all its adaptations of the flecked and mottled brushstrokes of the French, remains more minutely descriptive, producing finally a more illustrative, detailed effect in which the particularized interest of the parts is at odds with the outdoor fusion of a sunlit whole, as if the styles of Meissonier and Manet had been uneasily joined. As a response to these momentous political events, Menzel's painting offers only an empirical document of city spectators swarming around a colorful military procession.

Fig. 335 **Adolph von Menzel**, *Departure of King Wilhelm I for the Army on July 31, 1870*, 1871. Oil on canvas, 25¼ × 31¼″. Nationalgalerie, Berlin.

No interpretation (or non-interpretation) of the events of 1870–71 could be less like Menzel's than that of one of the most prominent painters of the German-speaking world, the Swiss-born Arnold Böcklin (1827–1901). Like his contemporary and friend Feuerbach, he, too, headed for Italy, where, with many other Northerners, he was to spend many years in Rome and Tuscany, as near as possible to a classical and Renaissance world remote from the German and Swiss cities that constantly commissioned and honored his work. Böcklin's feelings were those of his friend Jacob Burckhardt, the great Swiss historian of the Italian Renaissance, who had written, "I want to get away from all of them, from the radicals, the Communists, the industrialists, the intellectuals . . ., the philosophers, the sophists, the state fanatics, the idealists, from every kind of 'ist' and 'ism.' " Unlike his Realist contemporaries, Böcklin believed he could resurrect, with an intensely personal inflection, a mythical world that, for many artists of his generation—Moreau, Feuerbach, Rossetti, Puvis de Chavannes—seemed tinged with a melancholic nostalgia for a lost faith and civilization. For Böcklin, Venus and Pan, satyrs and nereids could be conjured up as living presences in the Italian sea and earth; but these deities and hybrid creatures often bore personal messages that might elude the spectator who thought of them only as illustrations to classical mythology.

In his birthplace, Basel, where, at the time of the Franco-Prussian War, Böcklin and his Italian wife could sometimes hear the roar of distant cannons, he was moved to comment, in the language of antiquity, on this contemporary disaster. He began to explore the theme of centaurs and Lapiths in combat, finally focusing on a battle of centaurs alone. In the large painting completed in 1873 that sums up, from Böcklin's vantage point of neutral Switzerland, these meditations upon modern barbarism (**fig. 336**), we are taken to a primitive landscape, where centaurs—half human, half horse—attempt to destroy each other in a triumph of their part-bestial nature. The subject per se is a narrative invention of Böcklin's, in which these creatures are now entirely overcome by brutal forces, as they hurl rocks, tear at each other's hair and eyes, and fall to the ground in violent contortions. A community of senseless physical struggle, they permit a wide range of speculations upon the human condition, from a commentary on the war itself (which had been concluded two years before the completion of the painting, but whose Northern European locale is still evoked here by the snowy ground, so unexpected for centaur territory) to the vaguer terrain of such contemporary philosophical viewpoints as that of Schopenhauer about the endless conflict that lies at the core of existence. Although Böcklin, in a way, was doing what Goya had done in his *Saturn* (see fig. 110) and what Picasso would be doing in *Guernica*—using venerable myths as metaphors for a private interpretation of both a modern historical event and of universal truths—his vision of primordial struggle and evil is strangely factual by comparison. As in Meissonier's *Siege of Paris*, we sense a pervasive literalness that runs counter to the idealist message. The human heads and torsos and the equine rumps seem made of the same materialistic flesh and hide that one finds in many battle paintings of the 1870s—only man and horse have

Fig. 336 **Arnold Böcklin**, *The Battle of the Centaurs*, 1873. Tempera on canvas, 42 × 78″. Kunstmuseum, Basel.

Fig. 337 **Vassilii Vassilievich Vereshchagin**, *The Apotheosis of War*, 1871. Oil on canvas, 50 × 77½″. Tretyakov Gallery, Moscow.

here been joined in what, to modern eyes, may look more like a photographer's trick than an imaginative re-creation of the mythic centaur. In Böcklin's art, as in that of many of his contemporaries who, in the heyday of Realism, clung to timeless, symbolic themes, the sense of observed, palpable facts—studio models, real animals, specific landscape sites—pervades the abstract climate of myth and allegory, often creating an odd clash of old and new worlds.

One of the most bizarre fusions of photographic reportage and high moral outrage about war can be found in the work of the Russian Vassilii Vereshchagin (1842–1904), who studied first in St. Petersburg, and then with Gérôme, whose technique he extended to the domain of journalistic documentation of war. From the Turkestan wars of 1867–70 to the Russo-Japanese War of 1904–05 (during which he died at Port Arthur on a sinking battleship), he was a recorder of international wartime atrocities—both Western and Eastern—which he hoped to protest publicly through his accurate eyewitness depictions. Vereshchagin, an extreme case of that classic psychological syndrome of being morbidly attracted to what one presumes to hate, created his most unforgettable image, *The Apotheosis of War* (fig. 337), in 1871. Like Daumier's vision of that year, it might almost symbolize human barbarism at any time

and place. Coincident with the trauma of the Franco-Prussian War, the painting represents, however, not Western brutality, but a grim memento of the Turkestan wars. A pyramid of human skulls, left for crows to feed on in a desolate landscape, remains as a testimony of the victorious army, a tradition that went back to the days of the four-teenth-century Mongol despot Tamerlane. The inscribed dedication on the frame underlines the moralizing message of the title—"To all great conquerors—past, present, and future"—although the painting also exists as a quasi-photographic record of a time-honored sadistic ritual in Central Asia. Vereshchagin's grandly humanitarian message is essentially no different from that of Böcklin's battling centaurs; but Vereshchagin substitutes for the traditional symbols of classical mythology a modern ethnographic document that, especially to Western eyes, expanded knowledge of exotic customs of life and death, and could thus be gruesomely instructive as well as morally uplifting.

1874: The First Impressionist Exhibition

For many French painters of the 1870s, the trauma of war, whether international or civil, was virtually censored out of

their art, though it could not be from their lives. Some decided to flee Paris for the provinces or other countries; others entered military service which, in one case, Bazille's, was fatal. Although Manet recorded poignant or tragic vignettes of the Commune in small prints, most of his younger contemporaries (Degas, Monet, Renoir) who had been pursuing in the late 1860s the goals of truth to rapid, casual perceptions had always tended to avoid problematic subject matter and could hardly have considered grappling with a theme as grave as war. By the end of 1871, they were back in Paris again and, like most people after a war, tried to resume their earlier life and work as quickly and as uninterruptedly as possible, continuing to paint with ever greater refinement the fleeting pleasures and spectacles of city and country.

For these painters, alienation from the official Salon system and the public was rapidly increasing. In 1873, in order to accommodate the growing number of artists whose viewpoint clashed with the conservative Salon juries, a new Salon des Refusés was created, though one that compromised the artists' freedom by imposing another jury to select works from the rejected group. What was needed, Monet and many younger artists felt, was an exhibition space where one did not have to compromise with authority, a place where many kinds of fresh and audacious painting could be shown to the public, work made not by artists who had been voted out of the Salon establishment, but by artists who wished to turn their backs on it entirely. On December 27, 1873, a group of artists drew up a charter, comparable with that of a business corporation, and called itself the "Société Anonyme des artistes peintres, sculpteurs, graveurs, etc. . . .". Only months later, on April 15, 1874 (two weeks before the official Salon), their first exhibition opened to the public in the vacated studio of the photographer Nadar, on the second floor of a building that faced the Boulevard des Capucines, one of the city's most bustling thoroughfares. Unlike the Salon, where many tiers of paintings on high walls meant that younger and unfavored artists were fated to be "skied," that is, shown at the very top and hence virtually invisible, this democratic group showed paintings in only two rows, the smaller pictures below.

Of the thirty artists who showed one hundred and sixty-five works, most have been forgotten. (Who has ever seen a painting by Pierre Bureau or Émilien Mulot-Durivage?) But a small group of artists attained there a public notoriety that immediately demanded a strong critical response, if only one of outrage and condemnation, as well as a name. In a review that appeared only ten days after the opening, Louis Leroy, a critic known for spoofing, coined the name "Impressionists" to describe the offending artists. Four days later, the new name was reiterated in a more sympathetic account by Jules Castagnary, who had often supported Millet, Courbet, and Manet in the 1860s and

who was able, quite correctly, to recognize that the viewpoint of the Impressionists was somehow an extension of the premises of Realism, perceiving that their overt lack of finish had to do with their wish "not to render a landscape but the sensation produced by a landscape."

Of what in retrospect seems a very diverse group of paintings, it was this willful sketchiness, this satisfaction with a moment's perception that was the most overtly startling and unifying characteristic. And it was clearly the work of Monet that pushed this intense abbreviation of art and experience to the most radical extremes. For one of the five canvases he showed there, a sunrise at Le Havre painted from a window, he chose the title *Impression, Sunrise*, realizing that to call it a view of Le Havre would arouse expectations of conventional description. He might also have called an "Impression" the now famous *Boulevard des Capucines, Paris* (**fig. 338**), which he painted in 1873 from the windows of the very studio, Nadar's, on whose walls it now hung for the public and critics to jeer or to wonder at. Like his sketch of *La Grenouillère* of 1869 (see fig. 304), the *Boulevard des Capucines* may at first seem an illegible confusion of blotchy, random movement. Yet again, each brushstroke has a corollary in something observed, whether the dark silhouettes at the extreme right which correspond to top-hatted figures on a balcony looking down, as we do, at the boulevard below; the streaks of white on the leafless trees that suggest a thin coating of the snow that covers the ground; or the almost indecipherable pink blobs at the lower right which describe a cluster of toy balloons freely floating in this pulsating world of perpetual motion. In fact, the sensation of airborne weightlessness, of viewing the familiar trees, buildings, crowds, and carriages as an unfamiliar aesthetic spectacle, could hardly be more appropriate to the locale of the first Impressionist exhibition.

Nadar's studio had become a meeting place for artists and writers who were at odds with the political and artistic establishment. And more to the point, Nadar, the nickname of Gaspard-Félix Tournachon (1820–1910), was not only a successful portraitist who immortalized such famous Parisians as Charles Baudelaire and Sarah Bernhardt, but a pioneer in the domain of aerial photography, ascending the skies over Paris in his own balloon, *Le Géant* (The Giant), and documenting what lay below. Perilously suspended in the balloon's passenger basket, he began in 1858 to invent a wholly new way of seeing in tune with the technological innovations that, like railways, anaesthesia, or photography itself, supported the mid-century's optimistic vision of scientific progress. (It is no surprise that artists who were eager to keep up with Parisian headlines—Daumier, Manet, among others—depicted Nadar's airborne marvel.) And apart from providing the unfamiliar thrill of bird's-eye views from a height that, with the advent of the airplane, would become a commonplace, his aerial

Fig. 338 **Claude Monet**, *Boulevard des Capucines, Paris*, 1873. Oil on canvas, 31¾ × 23½″. Nelson Gallery—Atkins Museum, Kansas City, Missouri.

photographs also made clearly visible the new geometric order of the city as reconstructed during the Second Empire under the direction of Napoleon III's prefect, Baron Hauss- mann. In one of the most complex of what he called "pho- tographies aérostatiques," taken in July 1868 (fig. 339), we see not one photograph of the new urban axes that radiate from the Arc de Triomphe, but eight of them, a com- posite of different views that methodically document an orderly sequence of events in time and space. In this, Nadar was not only a pathbreaker in the annals of aerial photography, but a prophet of the goals of many photogra- phers of the 1880s who, like Marey (see fig. 405), tried to

depict accurately, as in scientific diagrams, the split-second physiological changes of human and animal bodies in motion.

Monet's *Boulevard des Capucines* belongs to this new concept of discovering the excitement of unfamiliar sights born in a modern world. Many photographers, more earth- bound than Nadar, had also been recording overhead views (some stereoscopic) of Paris, and Monet's painted spectacle of one of the city's busy new thoroughfares as seen from a balcony is part of this growingly popular vantage point. In fact, exploring the spectacle of urban theater below as seen from the window or balcony of a private residence, it was

Fig. 339 **Nadar (Gaspard-Félix Tournachon)**, *The Arc de Triomphe and the Grand Boulevards, Paris, from a Balloon*, 1868. Modern gelatin silver print from the original negative. Caisse Nationale des Monuments Historiques et des Sites, Paris.

to become a familiar part of the Impressionist repertory. Innovative, too, was Monet's changing attitude toward the role of immediacy and finish. Unlike *La Grenouillère* (see fig. 304), which he conceived as only a rough painted notation for a larger painting to be submitted to the 1870 Salon, the *Boulevard des Capucines* was conceived and exhibited as an end in itself, satisfying to the artist and his colleagues, but clearly an affront to inherited standards of finish. For example, Leroy, who had inadvertently baptized Impressionism, derisively commented on the "black tongue-lickings" in the lower part of the painting, adding what a joke it was that these crude scratches could represent people. Had Menzel's *Departure of Wilhelm I* (see fig. 335) been exhibited there, it probably would not have elicited such scorn, since despite its similarity to the Monet (including the viewers looking over the second-floor balcony and the puffy painting of the trees that line the avenue), the description of the figures in the foreground, if

not the background, is precise enough to record details of costume and even of facial expression. But Monet has taken these urban components and dissolved them into a fluid, open world of such constant interchange and blurred movement that the stovepipe hats and black coats of the gentlemen seem indistinguishable in shape and substance from the dark frames of the horse-drawn carriages. The weave of brushwork is now so intricate a mesh of varied, rapid strokes that the substance of things seems totally annihilated. Even the building facades, with their swift, vertical strokes for windows, fuse and evaporate before our eyes.

For shocked viewers in 1874, the most obvious cause of this dematerialized world was the broken, seemingly spontaneous brushstrokes that marked so many Impressionist canvases. They not only upset the sense of a stable, measured order in which near and far, up and down, discrete objects and fixed colors could be counted on, but they also implied an impudent rejection of the officially learned craft

Fig. 340 **Berthe Morisot**, *Hide-and-Seek*, 1873. Oil on canvas, 17¾ × 21¾″. Private collection.

of painting, substituting what looked like childishly incompetent daubs of bright colored pigment. Such offences could be found at the Impressionist exhibition even in what seems to us today as innocuous a work as *Hide-and-Seek* of 1873 (fig. 340) by Berthe Morisot (1841–95), an intimate member of Manet's circle, who often posed for him and who, later in 1874, was to marry his brother Eugène. Morisot, who had earlier commented on how successfully Bazille had merged sunlit figure and landscape in his 1868

View of the Village (see fig. 299), pushed this fusion even further here. Choosing again the mother-and-child theme that was so often considered appropriate in the nineteenth century to the repertory of women painters, Morisot virtually camouflages the mother, daughter, and parasol in what then seemed a recklessly incompetent tangle of few and ragged brushstrokes. For most viewers, it was almost impossible to sort out grass from dress, hat from distant houses, hiding child from the tree that hides her. As Leroy mockingly put it, "That young lady [Morisot] isn't interested in trifling details. When she has to paint a hand, she makes exactly as many lengthwise brushstrokes as there are fingers, and it's done. Stupid people who are fussy about the drawing of a hand don't understand a thing about Impressionism."

The same kind of response greeted the five works submitted by Camille Pissarro (1830–1903), the senior figure of the Impressionist group. In his long artistic career, Pissarro reflected closely the major changes of approach to landscape and cityscape that marked the evolution of French painting from the 1860s to the end of the century, from the reign of Corot to that of Seurat; and his generous, paternal nature made him the natural protector and tutor of younger artists who, like Cézanne and later Gauguin and Van Gogh, wished to absorb what seemed the most advanced development of contemporary art, Impressionism. Painted in 1873, his seemingly on-the-spot record of, as the title pinpointed it, *Hoarfrost: The Old Road to Ennery, Pontoise* (fig. 341), elicited the usual scorn in Leroy's imaginary dialogue with a traditional landscape painter confronted with these

Fig. 341 **Camille Pissarro**, *Hoarfrost: The Old Road to Ennery, Pontoise*, 1873. Oil on canvas, 25⅝ × 36⅝″. Musée d'Orsay, Paris.

Impressionist heresies. The old master rubs his eyeglasses, thinking them dirty, and comments on how the hoarfrost on the plowed furrows looks like palette scrapings on a dirty canvas, and how the painting as a whole has neither top nor bottom, front nor back. Here, indeed, Pissarro's efforts to record the veiled effect of frost over roughly striated earth produce elusive, blurred patterns that are made even more immaterial as a result of the surprisingly original intrusion of diagonal shadows cast across the earth, from lower right to center, by invisible trees whose actual presence is presumed to be outside the spectator's field of vision. The world, as Leroy's outraged viewer complained, seems unanchored, the high horizon flattening both shadow and substance, earth and filmy frost, into a muffled tapestry of ragged brushstrokes that seem to have far more physical presence than the landscape illusions they presumably create.

Despite all this newness, the critic Castagnary recognized that the motif of the old farmer, with the bundle of faggots on his back, recalled the work of Millet, whose fusion of peasant figures within rugged French landscapes, like this wintry one near Pontoise, where Pissarro spent long periods away from Paris, provided a traditional source for what at first seemed so unconventional an image. Nevertheless, Pissarro was very much a man of the modern, industrial era. He was attracted to such specifically new subjects as the railroads and factories he could see in France, as well as in England at the time he fled the Franco-Prussian War; and, in the 1880s, he was to espouse many of the radical anarchist ideas shared by younger artists like Seurat. Yet this Impressionist painting resonates with an almost Romantic sense of the ancient ties between man and nature, whether in times of summer's bounty or winter's rigor. From the 1870s on, Pissarro's paintings register sensitively the ever-widening contrast between the traditional rhythms of rural life and the new ones of an urban society with bustling pedestrians and with clouds that must now merge with factory smoke.

As is usually the case when a new and startling kind of art appears as a group phenomenon, the public and the critics tended to lump these diverse artists together in a communal whole. To this day, the word Impressionist conjures up a shared, impersonal style. Obviously, the side-by-side painting campaigns of, say, Monet and Renoir contribute to this idea of artists sacrificing their individuality for some objective goal. Yet what is no less amazing is how, already at the first Imprssionist exhibition of 1874, each major figure also presented distinctively individual contours. For instance, there is no mistaking for a moment the aesthetic and emotional personality of Renoir in his *Loge* (fig. 342). He had also shown a scene of harvesters, a more sunny, loose-jointed version than Pissarro's of a Millet theme, but we immediately feel him more at home in this image of agreeable human relations and activities, here

a well-dressed couple in an opera box, posed for by a new model, Nini Lopez, and the artist's brother. On principle, conservative spectators might have scoffed at the smudges of black and white paint that make indeterminate boundaries between the lady's and gentleman's evening attire and the fan that floats in a cottony lap, or at the flecks of pigment that do stenographic service for seven strands of pearls and a corsage. And they might also have found perplexing the odd cropping of elbow and armrest, or the double focus upon first the lady and then the gentleman, whose upraised opera glasses carry us way beyond the constructed field of this small painting. Nevertheless, despite such innovative technical and compositional devices that Renoir shared with Monet, Degas, and Manet, *The Loge* was a popular success, emanating the human warmth and conviviality that came to typify Renoir's art and life. Even the brushstrokes, like the choice of textures, have a pillowy softness that invites rather than wards off the spectator. And we may even note again that this presumably contemporary subject of an elegant modern theater audience carries with it the hedonistic flavor and opalescent tones that Renoir had studied and admired in the paintings of Boucher and Fragonard at the Louvre.

Next to Renoir's couple, enjoying Parisian entertainments, Degas's submissions—ten paintings, drawings, and pastels of dancers, laundresses, and the racetrack—were knotty with the psychological and spatial complexities that had always marked his work. Of these, *A Carriage at the Races* of 1870–72 (fig. 343), which, with other Impressionist works, was first shown in 1872 at the London branch of the Paris dealer Paul Durand-Ruel, is a marvel of intricate plotting, all the more amazing for its small dimensions (less than two feet wide), characteristic of the unpretentious, sketchlike size of most Impressionist paintings. Once more, the public would be bewildered by the very idea of exhibiting this as a finished picture. The carefully tended grass of the racecourse seems a thin sheet of opaque pale green that rises flatly more than it recedes to the distant tents; and the accents of white that stand for a horse's rump, the light on a carriage wheel, or a baby's clothing are so flat and glaring that no detail can be discerned. But, beyond these surface matters, there is Degas's clockwork balancing of shape and narrative, a pictorial juggling act that, for all the effect of instantaneous motion, is locked forever in place. The victoria that weighs down the right foreground and encroaches upon the spectator's space contains, of all unlikely things, a portrait group. Perched on the top of the driver's seat next to his pet pug is Paul Valpinçon, whose family had befriended Degas in his childhood and put him up in their country estate during the worst of the Commune. He looks down momentarily at his infant son, Henri, held in the nursemaid's lap, while his wife also pauses, parasol in hand, to cast an eye on her baby. But this family group, the subject of so many other artists' sentimental variations, is

Fig. 342 **Pierre-Auguste Renoir**, *The Loge*, 1874. Oil on canvas, 31 × 25″. Courtauld Institute Galleries, London.

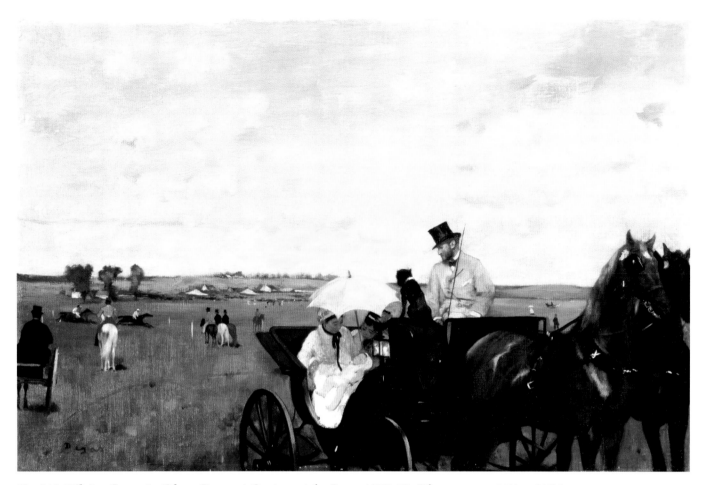

Fig. 343 **Hilaire-Germain-Edgar Degas**, *A Carriage at the Races*, 1870–72. Oil on canvas, 14⅛ × 21⅝″. Museum of Fine Arts, Boston.

here caught on the wing, momentarily capturing our attention, but then losing it, as we notice the startling cropping of the paired horses' legs and heads in the right corner, or the completely different spectacle of jockeys running a distant course while spectators on horses and in carriages, their backs in full or three-quarter view, casually observe these maneuvers. Moreover, more than half the little painting is dominated by an overcast, cloudy sky that bathes the entire scene in a grayish, filtered light.

Is this a depiction of the fashionable races outside Paris at Longchamp, is it a family portrait, is it principally a landscape, with people and horses accidentally intruding upon the clean sweep of turf, or is it all of these and more, an artful compilation of the unexpected multiplicity of modern experience in which spectator and spectacle, known people and strangers, the ordered and the random are constantly competing for our attention? Typically, Degas imposes the tyranny of his art upon this slice of elegant life, skewering every horse and rider, wheel and carriage, hat and harness in an invisible network of axial alignments that discipline these ostensibly accidental placements in a system of parallels, perpendiculars, and diagonals as orderly as the spokes on the carriage wheels or the marking posts of the racetrack. And if this incisive, abstract structure

distinguishes Degas from his fellow exhibitors, so too does his clean, sharp drawing. The father of the most prominent sitter (if he may be called that) in this portrait was Édouard Valpinçon, the owner of paintings and drawings by Ingres which had constantly inspired Degas. Indeed, in 1855, the elder Valpinçon had arranged a meeting between the twenty-one-year-old Degas and the venerable old master, who advised him to "draw lines, young man, many lines; from memory or from nature; and it is in this way that you will become a good artist." Ingres's advice can still be felt here, in the sharply contoured, but supple silhouettes, even though Ingres himself would have been distressed by the painting's modernity of subject and compositional heresies. It is no surprise that Degas objected to the word Impressionism, which had stuck to this group; for his art is the polar opposite of the informal and the improvised, even though his arrangements of the panoramic theater of modern life he saw around him emphasize the sense of the momentary and the random.

Another painter who showed at the 1874 exhibition was even more remote from the collective goals of the Impressionist group—Paul Cézanne (1839–1906). A member of the Impressionist generation, five years younger than Degas and only some two years older than Monet and

Renoir, Cézanne had always been and would continue to be something of a misfit and an alien in the Parisian world. A provincial from Aix-en-Provence, he moved to Paris in 1861 to study painting. The butt of jokes by his fellow students at the Atelier Suisse, he was awkward and tormented in life as in art; and the first decade of his work may well be the most crude (if also the most strenuously compelling) of any artist who attained such stature. As if he had been wearing blinders to both the official and the rebellious art of the 1860s, he explored the dark and morbid recesses of his own turbulent psyche, creating brutally clumsy images of violence and sexuality. In *The Murder* (**fig.** 344), probably completed around 1870, and clearly unexhibitable in even the most tolerant of public or private salons, his imagination plays out a sadistic charade. Probably inspired by some lurid episode in nineteenth-century criminal fact or romantic fiction, the drama—a female victim held down by a heavy-set woman while a man is about to stab her—presents the stuff of yellow journalism, yet the details have all vanished in the coarse modeling of the figures who, with maximum physical stress, enact their crime in the bleakest of landscapes and under the stormiest of skies. As a childhood friend of Cézanne's once commented, "It seemed as if he wished to avenge himself for some secret injury."

But by the early 1870s, these belated eruptions of adolescent turmoil began to be harnessed to the communal goals of other artists, particularly those of the kind and paternal Camille Pissarro, who took Cézanne under his wing and taught him to externalize his art by sketching out-of-doors in the practice that was soon to be dubbed Impressionism. It was Pissarro who insisted that this strange young artist be included with his other friends at the 1874 Impressionist exhibition. In addition to two landscapes executed under Pissarro's tutelage at Auvers, in the environs of Paris, Cézanne showed for him what was a relatively light-spirited painting that, in its subject as in its title, *A Modern Olympia* (**fig.** 345), alluded to Manet's candid vision of a prostitute in modern Paris. Cézanne's updated version moved from the oppressive darkness of his early work to a lightness of hue and tone not totally out of place with his colleagues' paintings; and the aggressively rapid and broken brushwork, although chaotic by the svelte standards of Monet's waves of pigment, was somewhat at home in Nadar's studio. But the odd charade enacted here was of a complex erotic fantasy totally alien to the empirical orientation of the other artists who espoused the Impressionist variant of the Realist viewpoint. A black servant, the offspring of Olympia's maid, dramatically rips a white sheet off a nude Olympia, who crouches in a coarse, fetal posture before an admiring client. This gentleman, fully clothed, his top hat peculiarly isolated at the right as a black pendant to the pet dog at the foot of Olympia's vast bed, suggests a psychological projection of the artist himself, gazing at an erotic offering which is rendered with an anatomy so faulty that its gross errors of foreshortening and crudely hacked flesh could only be vindicated by an artist who happened to be a genius. Although with hindsight we can recognize here the early manifestations of that genius, it is no surprise

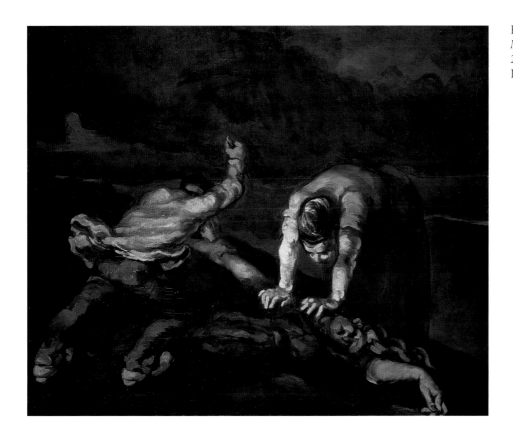

Fig. 344 **Paul Cézanne**, *The Murder*, c. 1867–70. Oil on canvas, 25¾ × 31½″. Walker Art Gallery, Liverpool.

Fig. 345 **Paul Cézanne**, *A Modern Olympia*, 1872–73. Oil on canvas, 18 × 21½″. Musée d'Orsay, Paris.

that the critics in 1874 found Cézanne "a kind of madman who paints in delirium tremens," and found in this painting "weird shapes generated by hashish, taken from a swarm of lascivious dreams," thereby pinpointing both the near-psychotic fantasy of this work and its reckless adaptation of Impressionist brushstrokes. Even within the rebellious context of the first Impressionist exhibition, Cézanne clearly stood apart, already projecting a pictorial world whose privacy and intensity demand separate treatment (see pages 396–407).

1874: At the Paris Salon and the Royal Academy

In 1874, even at the official Salon, traditional expectations could be assaulted by a painting which looked more like a rapid, sketchy notation of a random image than a stable structure with finished surfaces. Within the ceiling-to-floor confusion of the nearly two thousand paintings shown that year, Manet's *Railroad* (**fig. 346**) must have been conspicuous as a work that belonged more to the world of Monet, Degas, Morisot, and Pissarro than to a Salon that had been almost entirely depleted of adventurous young painters. Only slightly older than the artists who had exhibited just months before at Nadar's studio, Manet could easily have been included with his Impressionist friends, who had always thought of him as a guiding light. Yet he himself, now in his forties, preferred to remain within the arena of the establishment, where he had battled throughout the 1860s and could now feel the beginnings of his triumph as an older master. In fact, he would even be nominated in 1881 to the Legion of Honor, whose artistic ranks included predominantly those conservative artists, such as Cabanel and Bouguereau, who represented values he had set out to

undermine. As a statement of modernity and freedom, Manet's *Railroad* could hardly oppose more freshly and youthfully the standards of the venerable jury which surprisingly permitted it to hang on the Salon walls. Following the lead of Monet's *Women in the Garden* of 1866–67 (see fig. 298), Manet executed most of this large figure painting out-of-doors, in a friend's garden, from which could be seen the new railway cut leading into the Gare St.-Lazare as well as, on the right, a glimpse of the Pont de l'Europe, the pedestrian bridge that crosses the tracks. Yet despite such topographical exactitude, the painting offers what seems the most arbitrary confusion of sunlit glare, of a mix of people, things, and events accidentally observed during a leisure moment of a blue-skied Paris day. The spatial structure is no less disconcerting than the narrative structure. The plane of the picture is defined with almost geometric insistence by the parallels and perpendiculars of an iron grating, the kind of grid whose potentially decorative, flattening character was explored in the bamboo window screens depicted in many Japanese prints known to Manet; but what we are to look at is a pair of bewildering fragments located both in front of and behind this rigid barrier. If the foreground scene is considered a portrait of a chicly dressed woman (mother, nurse, or stranger?) and child, why should we be deprived of the daughter's face? If our interest, like the child's, lies on the other side of the grating, then what we are to look at has already disappeared, the

railroad engine having left as a trace only a cloud of white smoke that momentarily prevents our seeing the details of the urban background of new apartment houses, tracks, and railroad signals. Such an ephemeral spectacle is supported, in turn, by the dashing swiftness of Manet's brushwork which can even camouflage, for the moment, such foreground objects as the bunch of grapes on the bench at the right, or the snoozing puppy whose white fur almost disappears in the starchy white ambience of the pages of a paperback book and the pleats of two elaborate cuffs. Such ostensibly slapdash brushmarks were inevitably considered by critics and the general audience gross technical defects, defying standards of finish. Similarly, the modeling of the two figures appeared so inadequate that the crisp silhouettes of dark on dark and white on white could be described by an American reviewer as "cut out of sheet-tin." Probably most disconcerting, however, was the way in which the figures seemed excluded, as if behind bars, from the painting itself, intruding instead both psychologically and physically (down to the imagined extension of their cropped legs) upon the space of the viewer's real world. The offensive aspects of *The Railroad*—whether the minimal modeling, the maximal whiteness, the multiplicity of narrative focus, or the illegible brushwork—could all be duplicated in most of the works officially designated Impressionist in 1874; but Manet's own personality emanates no less strongly from this canvas than Degas's and Monet's do from

Fig. 346 **Édouard Manet**, *The Railroad*, 1873 (Salon of 1874). Oil on canvas, 36¾ × 45⅛″. National Gallery of Art, Washington, D.C.

Fig. 347 **Jan Matejko**, *Stephen Báthory after the Battle of Pskov*, 1872 (Salon of 1874). Oil on canvas, 10′ 9″ × 8′ 2″. Muzeum Narodowe, Warsaw.

theirs. It is not only a question again of elegantly irregular silhouettes, the sensibility to the coolest extremes of dark and light, the polarization of what appears to be a totally controlled aesthetic choice with a totally random and fragmentary inventory of urban events, people, and objects; but also of the aloof and enigmatic emotional tone, which is here concentrated in the recognizable stare of Manet's model, Victorine Meurent, who, perpetuating her role some ten years earlier in the *Déjeuner sur l'Herbe* and *Olympia* (see figs. 273 and 278), ruptures the pictorial illusion by seeming to have looked up from her books in order to establish a steady eye contact with the viewer. Such an extraordinary fusion of two worlds—that of the painting and that of the spectator—was to reach, as we shall see, an even richer complexity in Manet's last masterpiece, *The Bar at the Folies-Bergère* (see fig. 364).

Especially in the context of officially lauded and prize-winning Salon painting, it is easy to think of *The Railroad* as a renegade voice of modernity in a wilderness of moribund traditions. To enforce this black-and-white polarity, one need only look at the entry for the 1874 Salon from a painter of Manet's generation, the Polish nationalist Jan Matejko (1838–93), who had won a medal in Paris at the 1867 Exposition Universelle and had been elected to the Legion of Honor in 1870. This time, he sent from his native Cracow, whose academy he directed, a gigantic painting of 1872, *Stephen Báthory after the Battle of Pskov* (fig. 347),

which depicted a triumphant episode in Polish history that might inspire fervent nineteenth-century Polish patriots to continue their struggles against the domination of Russia, Austria, and Prussia. The year is 1582, and we see the final victory of the Polish king over his enemy Ivan the Terrible, whose envoys, bearing the symbolic bread and salt of submission, bring with them the papal ambassador, Antonio Possevini, sent by the Russian czar as a symbol of his willingness to embrace, with his people, the Catholic faith. This retrospective vision of the fusion of the power of the international church with the power of a nation freed from an invader's shackles is presented by Matejko as a Slavic operatic spectacle like Moussorgsky's *Boris Godunov* (1868–72), displayed behind the imaginary proscenium of the picture frame. Victor and vanquished, major and minor characters, historical costumes and historical props are all spelled out in a pictorial language that translates the poetry of Rubens's grandly turbulent and sumptuous style (deemed appropriate to a late sixteenth-century subject of triumphant church and state) to the earthbound prose of an unusually congested theatrical reconstruction. It is hard to believe that Manet's *Railroad* hung on the same walls.

Yet other admired historical paintings from the 1874 Salon introduce shades of gray in a blindingly black-and-white comparison. Consider a submission from Gérôme, the master whose *Death of Caesar* (see fig. 253) had already proposed startlingly modern narrative constructions that

intersected Manet's own concerns of the 1860s. In *L'Émi-nence Grise* (fig. 348), a painting whose modest dimensions correspond to those of many Impressionist paintings, Gérôme offers a split-second slice of life, although the life is that of the early seventeenth-century world of Cardinal Richelieu, whose château's staircase is here pictorially reconstructed as the correct setting for a famous personage in his court. The "gray eminence" of the title is the Capuchin monk Father Joseph, who had become Riche-lieu's intimate and powerful confidant in policy matters of church and state, much to the jealousy of higher-ranking courtiers. Here Gérôme gives us a snapshot of this Baroque world of pomp and intrigue, an effect of the instantaneous and the fragmentary that, beneath the historical trappings, is not alien to the vision of Manet or Degas. The field of vision appears to be caught in an accidental way, with the stairs cut off at the right, the immense column cut off at the upper left and, as a subtle suggestion of extension into our world, an attenuated patch of brilliant sunlight that passes through an unseen window on our side of the canvas and creeps obliquely up the staircase. The cast of characters is directed with a comparable sense of the open, multiple, and even conflicting events of an arbitrary fragment. The

gray monk, his head buried in a breviary and his figure momentarily and wittily framed by Richelieu's huge and florid coat of arms, seems just to be taking another diminu-tive step down the grand staircase, in teetering balance with the balletic court sycophants who don their hats in tandem, while another group challenges the primary narra-tive focus by departing in an upward direction to the left, casting scornful gazes at these obsequious performers. The cropped framing of the scene, the ricocheting of opposing directional movements and narrative focuses create a vision of history that, unlike Matejko's, reflects the mid-nineteenth century's keen pursuit of the here and now, as if what we see were the extension of the living confusions and complexities of our own world.

Gérôme's reconstruction of seventeenth-century France is painted with the precision of a jeweler, in minuscule and invisible brushstrokes that oppose the rapid, dashing facture of a Manet; but both achieve, on different levels, the illusion of an immediately seized truth about the empirical world. Moreover, this shared Realist goal is filtered through a highly selective range of aesthetic choices. If Manet's colors, spaces, and shapes immediately evoke his personal authorship, so, too, do Gérôme's. Despite what looks like a

Fig. 348 **Jean-Léon Gérôme**, *L'Éminence Grise*, Salon of 1874. Oil on canvas, 25¾ × 38¾". Museum of Fine Arts, Boston.

Fig. 349 **James-Jacques-Joseph Tissot**, *London Visitors*, Royal Academy 1874. Oil on canvas, 63 × 45″. Toledo Museum of Art, Ohio.

mechanically glassy rendering indistinguishable from a photograph, Gérôme, no less than a highly individual photographer, inevitably imposes his own aesthetic temperament. His colors, for one, are as characteristic as Manet's, revealing here, in the narrow range of salmon pinks and silky blues on a beige-gray ground, a familiar preference for exquisitely tinted hues chilled by marmoreal textures and mirror-like paint surfaces. And Gérôme's subtle networks of axial movement in open, multi-directional spaces, akin to Degas's, also reveal his ability to stamp his aesthetic contours upon a quasi-photographic style too easily assumed to suppress artistic freedom.

The growing parallelism between the rebellious view of Manet and the Impressionists and that of a whole group of artists who shared many of their concerns beneath painted surfaces of glossy finish and immaculate detail can again be seen in a painting by the Anglo-French artist James-Jacques-Joseph Tissot (1836–1902). Born in Nantes and a resident of Paris until 1871, Tissot absorbed not only the miniaturist techniques of the Belgian Leys (see fig. 252), but was totally conversant with the Realist directions taken by his friends and contemporaries Whistler, Degas, and Manet. In 1871, fearing the repercussions of his ardent participation in the Commune, he moved to London, where he continued to exhibit at the Royal Academy as he had at the Paris Salon. There, in 1874, he showed *London Visitors* (fig. 349), a fusion of the overtly antagonistic but ultimately complementary styles of, on the one hand, Degas and Manet and, on the other, Gérôme and Meissonier. Here we are instantly asked to extend the painting's fiction to our own real world, which appears for the instant to be a tourist's casual ascent up the steps of London's National Gallery, from which we can view, in surprisingly cropped segments, the sober Greek Revival portico of the museum, and, in the distance, an even more surprisingly bisected vista of St. Martin-in-the-Fields, whose steeple is just lost from sight. At the top, a fashionably dressed lady just catches our eye, in a more discreet variation of Victorine Meurent's penetrating gaze outward. Within this roving tourist's context, which turns noble architecture into picturesque fragments, ostensibly random groupings of visitors take their momentary places to observe the London scene. Two schoolboys, wearing the uniform of Christ's Hospital School, act as tourist guides, mingling, front and back, with expensively dressed adults; but their loose-jointed disposition makes it impossible to discern whether their relationships are those of friends, family, or total strangers. To add to the agreeable flux of an urban world, this disparate quintet seems to be temporarily distracted by the to us invisible spectacle of Trafalgar Square at the right, to which a pair of eyes, an outstretched hand, and the sharpest of umbrella tips are for the moment directed. Even city litter—the thin cigar butt on the steps at the left—contributes to Tissot's refined sense of the attenuated and the

accidental in a well-heeled social world whose haughty posturing and aristocratic demeanor belong in a Henry James novel.

Tissot shares with Gérôme a preference for high-gloss finish, whose relationship to photography is further borne out here by the almost total restriction to cool gray tones that can create both stony solidity in the near steps and columns and a mirage-like phantom in the far vista of the church. But again, as with Gérôme, the ostensible objectivity of camera vision can be the vehicle of a strong personal temperament. Tissot's chromatic preference is even icier and more understated than Gérôme's, prompting a critic to complain here of an "arctic frigidity." Within these grisaille tonalities, which capture the look of an overcast London day, only the mustard yellow stockings of the boys' uniforms provide a tart color accent, the counterpart to the effect Manet often achieved by placing a lemon in the midst of a dominance of black-and-white patterns. And Tissot's sensibility to human behavior is no less apparent here, revealing, despite his French origins, an Anglo-Saxon reserve and decorum that could and did make itself quickly at home in the art world of London, where he was to remain a vital force.

The 1870s: From Realism to Aestheticism

In the 1870s, whether in the rebellious domain of Manet and the Impressionists or in the more officially acceptable style of Tissot and Gérôme, the sense that painting could seize a prosaic instant of time and fragment of space was intensified to split-second precision. In this search, no artist was more probing than the American Thomas Eakins (1844–1916), who insisted on fusing the art of painting with a scrupulous study of anatomy, light, mathematics, and perspective, and who believed, with so many of his contemporaries, that the medium of photography, which he had also mastered and often used as a blueprint for his paintings, provided objective truths to support the artist's painstaking reconstructions of the visible world. In 1866, Eakins temporarily left his native Philadelphia for Paris, where he began his studies with Gérôme at the École des Beaux-Arts. After returning home in 1870, he translated some of the would-be poetry of the French master's historical scenes or exotic travelogues into a down-to-earth prose that can still produce, more than a century later, the effect of unedited truth to observed experience. Back in Philadelphia, Eakins looked at and recorded, among other things, the sporting events on the Schuylkill River, as it flowed through Fairmount Park, and even sent one of these works to Gérôme for criticism. An oarsman himself, Eakins was drawn to the sculls which animated the water in clement weather, offering an American counterpart to those Impressionist scenes of Seine-side boating which Manet, Monet,

Fig. 350 **Thomas Eakins**, *The Biglen Brothers Turning the Stake*, 1873. Oil on canvas, 40¼ × 60¼".
The Cleveland Museum of Art.

and Renoir so often painted at the Paris suburb of Argenteuil. But Eakins's version of this leisurely motif conveys not the casual, relaxed mood of urban vacationers at rest, but rather a sober, almost scientific intensity of visual research aimed at nothing less than the absolutely truthful documentaton of the seen world.

For a painting like *The Biglen Brothers Turning the Stake* of 1873 (fig. 350), even the light-shot surface of Philadelphia's river was studied as a mathematical problem in perspective rather than as a freely pulsating screen of Impressionist light. In the phrase of Eakins's own advice to his students, the brain should be strained more than the eye. Of course, a painting by Monet always implies that the specific space-time co-ordinates of the recorded observation are knowable beneath the more intuitive, spontaneous application of paint; but in Eakins's case, his scientific accuracy was so refined that in an earlier version of the Biglen brothers sculling it has been possible to determine from the angle of the sun's rays the very day and minute of 1872 at which the scene was viewed. In the painting of 1873, we see the same men, John and Barney Biglen, maneuvering their oars to turn the foreground stake marked by a blue flag. In the left background, near the distant red flag, Eakins himself, diminished to near invisibility by the

swift recession of the perspective grid that determines the precise size of every object on the river, holds up the starter's pistol in his right hand. On the right, an anonymous pair of scullers row by in the opposite direction. The water itself is a marvel of optical truth, including even the incisive splash that follows the cut of the oar's blade into the water. And on the distant riverbank, which most painters would have slurred over, scrupulous looking can discern a minute inventory of casual waterside activity—riverboats, rows of spectators—beneath the shrubbery, whose filmy greens, dulled by the distant atmosphere, contrast to the intense blues of the foreground flag and scullers' caps.

Yet what purports to be total objectivity ends up as revealing not only a particular artist's temperament, but even a particular national tradition. The all-encompassing intensity of Eakins's own concentration on truth to the minutiae of the seen world is reflected even in the facial expressions and bodies of the scullers, whose display of stern mental and physical control distills in a frozen moment an image of rigorous discipline. The mood, in fact, is not one of weekend pleasure but of a solemn, clockwork ticking of the orderly rules that unite the men with nature and that make the tiniest details of Eakins's painting an

essential part of his overall vision. Beyond that, this view of the Schuylkill conveys again a look of luminously barren, open spaces akin to the river environment of even the jolliest of Bingham's Mississippi boatmen (see fig. 177) or to the coastal meditations of Heade (see fig. 267). For all their paired athletic prowess, John and Barney Biglen, one looking up, the other down, seem separated both from each other and from the world around them. They project an aura of strange stillness and loneliness in the most empty of spaces that pervades not only many of Eakins's own figure paintings, but a tradition of American art that persists well into the twentieth century, beyond Hopper and Wyeth.

Despite its American inflection, *The Biglen Brothers* could find many counterparts across the Atlantic, especially in the growing number of paintings that documented, as with a camera lens, tandem pairs of figures caught in the midst of a variety of occupational movements, whether that of building construction or of ballet practice. One of the most remarkable contributions to this type was *The Floorscrapers* of 1875 (**fig. 351**), by a painter of Eakins's generation, the short-lived Gustave Caillebotte (1848–94). Wealthy and generous enough to support his Impressionist

friends by buying their work (and ultimately bequeathing his great collection to the state), Caillebotte also exhibited his own paintings with them. In 1875, wishing to make his public debut, he submitted a painting to the Salon jury, which rejected it. That work was probably *The Floorscrapers*, which Caillebotte then decided to exhibit in a more hospitable environment, that of the second Impressionist group exhibition of 1876, which was to open in April at the Durand-Ruel Gallery and which was to lose, among its original members, many artists who now felt it too risky to be exposed to the public with the likes of Monet, Degas, or Renoir. Caillebotte hardly shared this fear, and his *Floorscrapers*, in fact, was no less audacious in its modern subject and in its tilted, fragmented spaces than many works of Degas. But, unlike most Impressionist paintings, it was executed with a tight brushwork which Zola, Manet's great champion and a novelist who himself described the lives of Parisian workers, found "bourgeois" in character, that is, photographic in its tidy, conventional description of rounded volumes and sharp details and therefore anti-artistic in its suppression of the painter's individual touch. Zola might have leveled the same complaint against Tissot or Eakins.

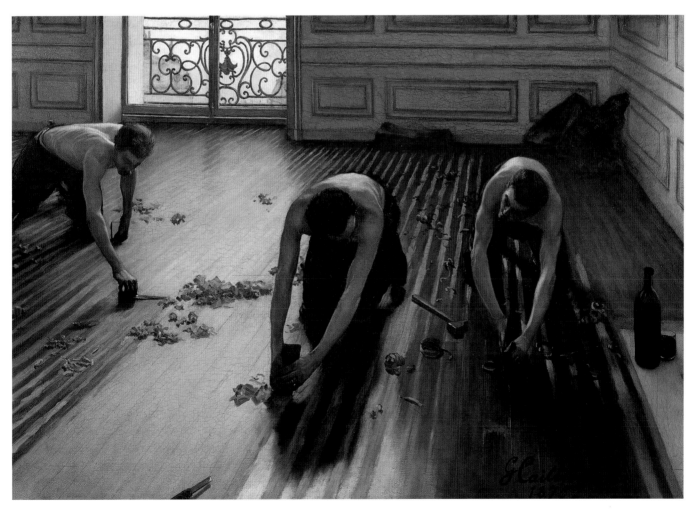

Fig. 351 **Gustave Caillebotte**, *The Floorscrapers*, 1875. Oil on canvas, 40⅛ × 57⅝". Musée d'Orsay, Paris.

Like those painters, Caillebotte also pursues an instant of vision, recording it with a fullness of truthful detail that here includes the close anatomical study of bare-chested workers, a one-point perspective rendering of the corner of a room whose floor is lucidly defined by the insistent parallels of wooden stripes, and a strewing of wood shavings whose seemingly accidental distribution counters the razor-sharp ordering of everything else, from the contrast between rectilinear and curvilinear patterns in the wall paneling and balcony grill to the tense placement of the three workers on a floor which rises so steeply at the right that their wine bottle and glass seem to hover above the ground plane. Within an ostensibly objective, Realist framework of vision, Caillebotte's eccentric sensibility to mechanically repetitive patterns and to oddly angled spaces, at once deep and shallow, begins to assert itself.

As a subject, *The Floorscrapers* belongs to a Realist tradition which would yield center stage to workers, whether in city or country. In fact, Caillebotte's trio of laborers can be seen as a modern translation of the back-breaking toil ennobled by Millet in his *Gleaners* of 1857 (see fig. 223), whose agricultural theme, by the mid-1870s, had become almost mythically remote by comparison with the topic of Paris workers putting the finishing touches on the artist's new studio. The grand, rhyming movements of Millet's three peasant women are now updated in contemporary urban terms, which here focus upon the specifics of this communal labor, while preserving Millet's idea of keeping the workers' heads facing downward below the horizon, at the bottom of a human hierarchy in which an upright standing posture would evoke individuality and freedom. In other ways, however, Caillebotte's approach to manual labor shares the more objective, detached attitude of his contemporary Eakins, who would also have been fascinated with the documentary inventory here of specialized tools for floorscraping, a carpenter's still life of files, planes, and blades. Moreover, both artists are attracted to figures paired in rhyming motions that virtually diagram a sequence of highly disciplined physical activities associated with a particular skill. The sense is close to the step-by-step, scientific explorations of modern photography, which Eakins himself had begun to investigate with such professional skill that in 1879 he was able to recommend his own techniques to the most famous practitioner of this new field, Eadweard Muybridge.

In the 1870s, Degas, too, began to explore and diagram what appear to be the clockwork mechanisms of human motion, creating an odd psychological distance from human subjects who are viewed as automatons. When Edmond de Goncourt visited Degas's studio in 1874, he was intrigued to find him working on two subjects of modern life, laundresses and ballet dancers, aggressively Realist subjects which, however, Degas could also aestheticize into his personal world of the strictest abstract order.

Himself a photographer, he would pinpoint in a pictorial flash the highly disciplined motion of young dancers' bodies, singly or in unison, as they revealed, like robots, the ability to manipulate their limbs, heads, and torsos in patterns of sharply regimented artifice. *The Rehearsal* of c. 1878 (fig. 352), a work shown at the fourth Impressionist exhibition of 1879, is typical of his many variations of behind-the-scenes views of ballet dancers practicing in studios or moving on or off stage at actual performances. Cropped to a triangular pattern in the left corner, the violinist, his bow a taut vertical axis, seems totally detached from the tense interlocking of four dancers, who have sacrificed their individuality to create rigid patterns of right-angled anatomies practicing difficult variations within the classical ballet's "second position" of outstreched arms. Everything clicks into place, from the triple beat of the light-flooded windows (which almost obey an imaginary ¾-time signature of the musician) to the trio of visible heads which, despite individual variations, share blankly impersonal expressions. Characteristically, what we see is only an angled corner of a room which spills over in every direction to the real space of the spectator. Most disconcerting is the appearance of nothing more than one extended leg and arched foot at the right, which rhymes grotesquely with the leg of her partner (the foot having been amputated, as it were, by the frame) and which identifies not only a fourth dancer, but implies perhaps many more dancers continuing these exercises outside our field of vision. As in Caillebotte's *Floorscrapers*, the floor plane shoots up and back at a vertiginous speed, fixing the viewer's vision at an odd, but absolutely specific angle, which appears as arbitrary as what might be seen by quickly turning one's head upward or downward, left or right.

What Degas and many of his colleagues were doing was, in fact, articulated clearly by his friend Edmond Duranty, who in 1876 published a pamphlet, *La Nouvelle Peinture* (The New Painting), which tried to define the goals of the Impressionists who showed at that year's group exhibition. He not only indicated that these painters extended the premises of those Realists like Courbet, Millet, and Manet whom he had earlier defended, but explained clearly how "views of people and things have a thousand ways of being unexpected in reality," how our viewpoint is "not always in the center of a room with the side walls receding toward the rear wall," or how "from inside, we communicate with the outside through a window"; and how "that window is the frame that endlessly accompanies us . . . cutting off the external view in the most unexpected, changing ways, achieving the endless variety and surprise that is one of reality's great pleasures." As for how people appeared within this constantly shifting window of vision we each carry about, Duranty vividly described Degas's special penchant for cropping a figure, which "is never in the center of the canvas, or of the setting . . . not always seen

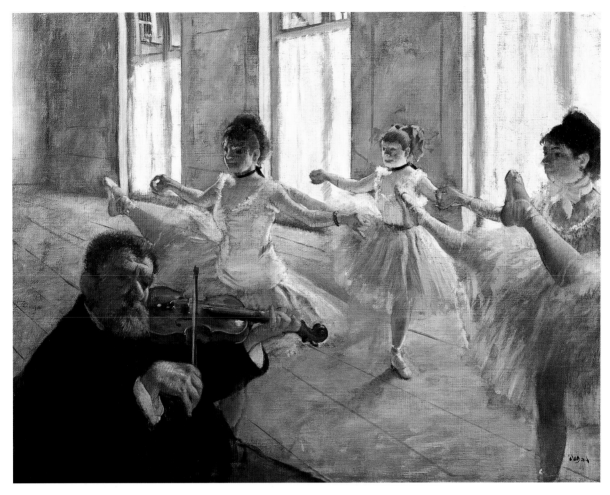

Fig. 352 **Hilaire-Germain-Edgar Degas**, *The Rehearsal*, c. 1878. Oil on canvas, 18¾ × 24″.
The Frick Collection, New York.

as a whole, and sometimes appears cut off at mid-leg, half-length, or longitudinally." So closely did these remarks correspond to Degas's art that it has even been proposed, incorrectly, that Degas, not Duranty, was the author. In fact, Duranty's explanation of how Impressionist painters insisted on recording the often surprising fragmentary images that momentarily met their shifting fields of vision could well apply not only to Renoir and Monet, but to Eakins, Tissot, or Caillebotte, whose tightly painted surfaces, however, parted company with the more brushy facture of the Impressionists.

For instance, Duranty's emphasis upon the window of vision through which each of us sees the outside world with surprisingly fluid variety was made no less explicit at the time of his writing in the work of Monet, who in 1876–77 painted a series of ten views both inside and outside Paris's Gare St.-Lazare, the terminus for the train that puffed through Manet's *Railroad* (see fig. 346), leaving only smoke behind. At the third Impressionist exhibition, that of 1877, Monet showed eight of these paintings that documented, from as many different vantage points, not the social and psychological drama that Daumier had found in railway travel, but rather the station's constantly changing

spectacle of locomotives coming and going, of the blurred movement of faceless passengers and workers on and around the tracks. By renting a nearby apartment and obtaining official permission to work inside the station, Monet was more easily able to ascertain the kind of truth to immediate experience that he before had so often pursued in landscape or coastal settings. In a typical view, dated 1877 (**fig. 353**), a railroad worker is seen abruptly cut off at mid-leg in front of a pulsating spectacle in which we can begin to sort out, in a billowing sea of vaporous blue paint, the half-enclosed foreground spaces of the train shed and a more distant, open vista of apartment houses and railroad bridge. Usurping the domain of Romantic cloud studies, such as Constable's (see fig. 142), Monet here examines how the smoke from the engines condenses in rounded puffs under the pointed roof of the glass-and-iron shed. Like Les Halles, the vast new marketplace built during the Second Empire, the train station would become for many mid-nineteenth-century Parisians a thrilling symbol of modernity, a secularized Gothic cathedral whose vast luminous spaces, supported by the thinnest of umbrella-like skeletons, seemed to dissolve into the ambient atmosphere of the sky and streets of an industrialized city.

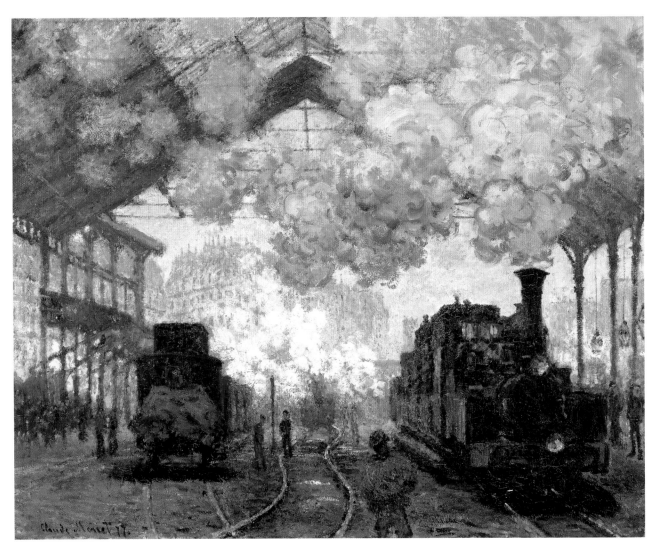

Fig. 353 **Claude Monet**, *Gare St.-Lazare, Paris*, 1877. Oil on canvas, 32¾ × 40½".
Fogg Art Museum, Harvard University. Cambridge, Massachusetts.

For Monet, this nucleus of modern urban life, a world of constant flux created by the dynamic rhythms of mechanical power and the rapid movement of thousands of people by public transportation, presented to him an environment so charged with multiple, changing energies that one painting alone could barely encompass it. What he needed to do, rather, was to make a series of paintings of the diverse spectacles provided by the station, each one of which could offer only a partial glimpse of an infinitely complex continuum. Instead of using each of these studies as an idea later to be recomposed as a grand pictorial synthesis that would be larger than the sum of its parts, he let the component parts speak for themselves, offering as they did a greater intensity of truth to immediate perceptions. In attempting to seize the realities of the perceived world through a series of views of the same motif, Monet paralleled the contemporary investigations of stop-action photography, in which the movement of humans or animals would be documented in stepwise, second-by-second series as in Marey's photography (see page 419). Yet Monet's art, at times describable

as quasi-scientific in approach, keeps crossing the threshold between extremes of objectivity and subjectivity. For finally, by intensifying the uniqueness of the artist-observer as the only source of visual truth about the external world, Monet tells us as much about the growingly refined nuances of his own perceptions, so attuned to the dissolution of the material world in a vibrant fabric of colored atmosphere, as he does about the documentable facts of a bustling railroad station. What begins here as public reportorial truth can end up almost as a private visual fantasy, a judgment more easily weighed by comparison with other paintings of railway stations, such as one by Angelo Morbelli (1853–1919), a painter who often depicted modern life in Milan, the most industrialized of Italian cities. In 1889, he recorded the inside of the train shed of the new Central Station, including, as did Monet, a cross-section of locomotives, carriages, passengers, workers, and indoor and outdoor spaces filled with smoke and daylight (**fig.** 354). Yet Morbelli's view, with its running figure, its lateral croppings of engine and porters, appears to be a plausibly

impersonal, split-second document of a public fact, detailed enough in its description of distant passengers to define their period costume and objective enough in the description of this vast interior space to employ a one-point perspective system that literally demonstrates the diagrammatic phenomenon of parallel railway tracks converging on the horizon. Next to this, Monet's on-the-spot view seems a pre-rational mirage, a filmy vision captured before shapes and spaces can be sorted out and categorized by the learned constructs of the mind.

When described abstractly, such a passionate dedication to the instant perception of moving light and color implies both a denial of interest in the motif depicted and a refusal to alter the data of vision to accommodate purely aesthetic preferences. But in fact, revised interpretations of Monet have indicated that even he, the archetypal Impressionist, could never attain the theoretical purity of an art that was completely subservient to the seen moment. It has become perfectly clear, for instance, that his choice of subject matter was anything but arbitrary; and the very fact that in the 1870s he was drawn to themes like the new Paris boulevards, railroad stations, and growing suburbs indicates his intense awareness of the changing world around him and his willingness to turn his back temporarily on the timeless phenomena of landscape that would later preoccupy him more fully. Moreover, we now know that even his rapid, shorthand technique and narrowed

field of vision are pictorial devices partly inspired by popular illustrations in contemporary magazines, just as we now know, too, that far from executing all of his paintings entirely on the spot, he was quite capable of reworking them in his studio in order to create more satisfying aesthetic wholes, even at the expense of an impersonal snapshot veracity. In short, Cézanne's famous quip about Monet's genius and its limitations—"He was only an eye, but what an eye"—no longer corresponds to our understanding of the complexities of his painting. Especially in the 1870s, when he worked with a group of artists with related goals, he could pursue simultaneously the world of modern life, in documentary records of the here and now, and the world of art, in subjective structures of beauty and coherence that replaced familiar concepts of order and clarity.

The equation of Realism and aestheticism was a precarious one, and many of Monet's contemporaries stressed more emphatically one or the other of these possibilities. In the case of the Anglo-American Whistler, who in the 1860s in Paris espoused the Realist cause with Courbet and Manet, the aesthetic component became intensified in the 1870s in London, where he painted many views of the Thames veiled in mysterious gray-blue fogs that would transform the grimy facts of industrial pollution into muted fantasies of Japanese refinement, and that would soon inspire no less nuanced poems by the young Oscar Wilde.

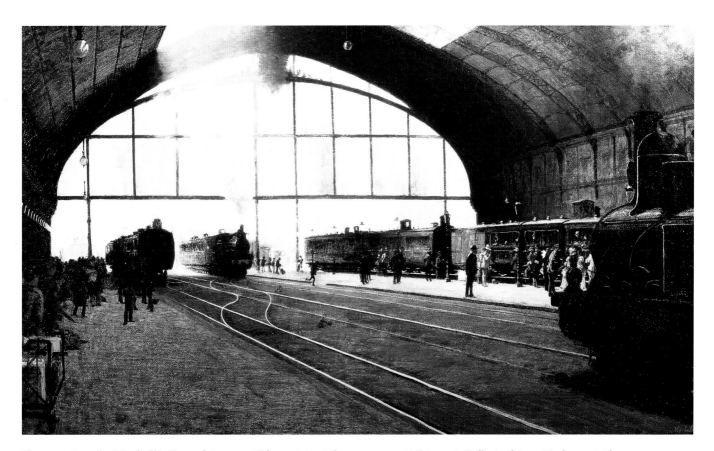

Fig. 354 **Angelo Morbelli**, *Central Station, Milan*, 1889. Oil on canvas, 23¼ × 40″. Galleria d'Arte Moderna, Milan.

These works, with their rapid, abbreviated facture and their sense of an acute sensibility to the ephemera of perception, might have hung on the walls of the Impressionist exhibitions in Paris as compatibly as on the walls of the London galleries where, in 1877, they would create a public scandal comparable with that provoked by Monet and his colleagues in 1874. The most notorious of them was the *Nocturne in Black and Gold: The Falling Rocket* of 1875 (fig. 355), whose primary title continued Whistler's tradition of emphasizing, as in his *Symphony in White No. II: The Little White Girl* of 1864 (see fig. 285), the musical, poetic, and aesthetic aspects of his paintings, rather than the description of the motif. Still working within the broad framework of a Realist premise, in which what was painted corresponded to something actually observed, Whistler chose here the most evanescent of motifs, the nocturnal spectacle of fireworks falling over Cremorne Gardens, a popular entertainment center in Chelsea, on the banks of the Thames. Such an ephemeral phenomenon of twinkling and disappearing colored light in a night sky demanded, for its capture in paint on canvas, the talent of an artist who could seize a rapid impression of gossamer subtlety, an effect Whistler achieved with a confetti-like sprinkle of paint dabs

Fig. 355 **James Abbott McNeill Whistler**, *Nocturne in Black and Gold: The Falling Rocket*, 1875. Oil on canvas, 23¾ × 18¾″. Detroit Institute of Arts, Michigan.

on a dark ground. (It is telling that fireworks later provided the theme for comparably brief and evocative fantasies by Debussy and Stravinsky, working in Impressionist musical modes.)

Yet without knowledge of the literal subject, the painting might look like an unintelligible chaos of random paint flecks and dark washes, an incompetent insult to the traditions of craftsmanship and the demands of verisimilitude. This, in fact, is how it appeared to the formidable and aging John Ruskin, who had earlier defended passionately both Turner's and the Pre-Raphaelites' different kinds of truth to nature (see pages 151 and 258). In 1877, when Whistler exhibited this and seven other paintings at the new Grosvenor Gallery in London—which was to promote an art-for-art's-sake view—Ruskin published an attack accusing Whistler of impudently asking "two hundred guineas for flinging a pot of paint in the public's face." Fearful of his reputation and forced to defend his belief in nothing less than the artist's freedom to create beauty by his own standards and not those of nature, Whistler then sued Ruskin for libel. In 1878, at the end of lengthy and often farcical court proceedings (the offending painting, for instance, was accidentally shown to the jurors upside down), and after the testimony of many British artists as to whether the painting was a legitimate, competent work of art, Whistler won a token victory of a farthing in damages, hardly compensation for the enormous expense of the trial. Nevertheless, the immense theoretical issue of art versus nature, of the right of the painter to alter objective truth to conform to subjective standards of beauty was at least brought to public attention and aired at exactly the time, the 1870s, when the double allegiance of art—to represent recognizable public truths and to create a private aesthetic order—began to present an irreconcilable conflict.

When, in 1878, Whistler published a pamphlet on the trial, *Whistler v. Ruskin, Art & Art Critics*, the dedication was to Albert Moore (1841–93), a painter who had been a friend of Whistler's since 1865 and whose own art, rooted in idealist rather than Realist traditions, was nonetheless totally compatible with Whistler's in its stress upon art's necessity to create an exclusively aesthetic domain. As a theme for these explorations in a realm of beauty untainted by the ugly world outside the gallery walls, Moore usually chose calmly poised, indolent women, dressed in splendid robes and frozen in a discreetly sumptuous environment of decorative motifs—flowers, inlaid floors, vases, fans—that often seem to combine the remote refinements of both Japan and classical Greece. In *Sapphires* (fig. 356), exhibited, like Whistler's scandalous paintings, at the Grosvenor Gallery in 1877, no complaint could be made of lack of finish or technical inadequacy, and the reference to the anatomical equilibrium and drapery patterns of classical Greek sculpture provides the authority of tradition. Yet Moore's message was very much the same as Whistler's.

Already in 1868, the poet Swinburne had discussed the two artists in comparable terms, writing of Moore's painting that it was "the faultless and serene expression of an exclusive worship of things formally beautiful," that "the melody of color, the symphony of form is complete." He recognized, too, analogies with Gautier's poetry, which also aspired to the purity of music, a goal which would become still more passionate in the thought and work of such early twentieth-century pioneers of abstract art as Kandinsky. A work like *Sapphires*, in fact, with its nuanced selection of icy blue tones that radiate from the pearl and sapphire necklace and with its immaculate ordering of the most delicate textures of marble, flowers, and patterned fabrics, belongs fully to Whistler's art-for-art's-sake world, alluding here even to the *W*-shaped butterfly which Whistler used as a monogram signature. Such shrines of beauty—the pictorial equivalents of the arts of interior decoration, high fashion, or Oriental flower arrangement—were to become, especially in England, the manifestations of an almost religious cult which would provide a place of refuge where elite audiences, educated in the mysteries of art, might feel protected from the philistine taste of the masses, who by and large preferred paintings which straightforwardly mirrored the visible world and which also might tell stories that anyone could understand.

The Grosvenor Gallery, in particular, became a sanctuary of artiness, and one so well known to the public that it could even be lampooned in Gilbert and Sullivan's *Patience* (1881). Of the artists it showed, Sir Edward Burne-Jones (1833–98) pushed even beyond Moore and Whistler in the direction of a dreamy languor totally remote in mood and setting from commonplace experience. Often considered the typical Pre-Raphaelite in his creation of a chaste, yet sensual feminine beauty that seemed almost too fragile to survive the pressures of reality, Burne-Jones was in fact too young to be a member of the original movement and pursued an art totally alien to the PRB's quest for truth to nature and for themes, whether contemporary or historical, of immediate moral import. He is better considered a disciple of Rossetti, with whom he studied in 1855–56 and who himself had moved from Pre-Raphaelite hard truth to a never-never world of myth and dream (see fig. 260). What excited Burne-Jones in art before Raphael was not so much the naturalistic details which inspired Hunt and Millais, but rather the atmosphere of tapestry-like richness and attenuated linear refinement found in such masters as Botticelli.

In 1878, at the Grosvenor Gallery, he showed his *Laus Veneris (Praise of Venus)* (**fig. 357**), which replaces the serene inertia of Moore's *Sapphires* with somnolent

Fig. 356 **Albert Joseph Moore**, *Sapphires*, c. 1877. Oil on canvas, 61 × 21½". Birmingham Museums and Art Gallery.

Fig. 357 **Sir Edward Burne-Jones**, *Laus Veneris*, 1873–78. Oil on canvas, 48¾ × 73¼".
Laing Art Gallery, Newcastle-upon-Tyne.

reverie. The theme is based on the legend of Tannhäuser, the minnesinger whose escape from the lair of Venus and subsequent repentance inspired an opera by Wagner and a poem by Swinburne and contributed to the myth of the *femme fatale*, which reached its peak in the 1890s. Here we see the goddess of Love herself, being praised in a song by a music-making retinue of maidens whom Henry James described as "pale, sickly, and wan, in the manner of all Mr. Burne-Jones's young people." The fully clad Venus also shares this pallor, creating an image of longing and frustration that reflects the sense of erotic repression so common to Victorian art and life. The sexuality of Venus's domain seems a literary pipe dream, more spirit than flesh. The knights dimly visible through the tiled window frame are phantoms; and the adventures of Venus that cover the wall are distanced through the medium of tapestry, whose gorgeously ornate surfaces transform physical desire into decorative sensuousness. More and more, the refined pleasures of art and the farthest reaches of the imagination were to become hermetically sealed from the facts of modern life. Already in the 1860s, painters like Rossetti and Moreau (see fig. 259) had pointed the way to Burne-Jones's escapist aesthetic. By the 1890s, as we shall see, many

more artists, working under the banner of Symbolism, would inhabit this twilight realm.

Neverthless, throughout the 1870s and 1880s, the Realist impulse to record the facts of a here-and-now world continued to dominate painters working both in the most adventurous styles of Impressionism and in the more conservative modes taught by the academies. And the range of subject matter, from miserable city slums to fashionable boulevards, from the regimented activities of schools and sweatshops to the leisurely movements of cafés and wealthy drawing rooms, also expanded to match the complexities of nineteenth-century life. Artists who wished to sress the legibility of their subjects avoided the path of Whistler or Monet, who often muffled detail in blurred pictorial effects of exquisitely woven tones and textures, and chose, instead, a language of more literal descriptiveness that permitted the viewer to pay as much attention to the contemporary reality depicted as to the way in which it had been filtered through a personal aesthetic temperament.

Of the experience most central to the changing world of the 1870s—the new streets and buildings that defined the geometric networks, the rhythms, the social mixes and

segregations of the modern city—no painting offers a more monumental statement than Caillebotte's headline-titled *Paris Street: Rainy Weather* (**fig. 358**), shown first in 1877 at the third Impressionist exhibition. Many Impressionist masters had painted the axial streets and boulevards of modern Paris teeming with pedestrians; but typically, as in Monet's *Boulevard des Capucines* (see fig. 338), they conveyed an impression, a rapid glimpse in which details are lost in an unfocused mesh of pulsating parts. Caillebotte's view of a complex intersection of radial streets near the Gare St.-Lazare shares, in some part, the Impressionists' sense of the moment, as well as of a cropped field of vision, which may catch just half of a gentleman's back or the rear wheels of a carriage, or may miss the very top of the lamppost that slices this complex thoroughfare in half. Still more prominent is the sense of a preordained order, in which the spectacle of upper-middle-class pedestrians, shielding themselves with umbrellas as they stroll under the rain so predictable in Paris, is transformed into an almost

mechanized image of clockwork movement, dictated by the insistent parallel, perpendicular, and diagonal axes of the city plan, as further emphasized by the most rigorous perspective grid. Against the lucid cruciform pattern defined by the vertical lamppost with its watery shadow and by the high horizon line (which seems to level off every head, near and far), each component, large and small, contributes to the feeling of an all-controlling system. The Paris that was constructed under Napoleon III's prefect, Baron Haussmann, seems here a utopian blueprint for a city of the future, dominating both the residents and their environment. The paving stones that fill the lower left quadrant of the painting are marvels of hygiene and of machine-belt regularity, a far cry from the muddy streets of old Paris, and a descendant, in terms of urban tidiness and order, of Hummel's view of the Berlin pleasure gardens (see fig. 162). As for the arm-in-arm bourgeois couple at the right, who appear to be walking out of the painting into the viewer's space, they turn their heads in tandem, with the precision

Fig. 358 **Gustave Caillebotte**, *Paris Street: Rainy Weather*, 1877. Oil on canvas, 6′ 11½″ × 9′ ¾″. Art Institute of Chicago. Charles H. and Mary F. S. Worcester Collection.

of automatons, and establish a modular human form repeated throughout the swiftly diminishing spaces.

Even more than in his earlier *Floorscrapers* of 1875 (see fig. 351), Caillebotte achieves here an extraordinary fusion of opposites, in which both literal description and the most inflexibly abstract regimentation appear to be joined effortlessly. Here, the documentation is so ample that it could well provide the data for a movie-set reconstruction of an elegant Paris street scene of the 1870s, from the veil worn by the lady in the foreground to the tidy rows of chimneys on the mansarded apartment houses that funnel our gaze back to unseen streets in the microcosm of the city. And even the sense of particular weather conditions, underscored by the title, is conspicuous in the blue-gray tonality that casts a chilly pall over a scene of such pervasive wetness that streets, buildings, and umbrellas create an overall image of damp, reflective surfaces. Yet, at the same time, this painting of a photographic, split-second truth quickly reveals a commanding skeleton of such austerely calculated geometries, both in the patterns of surface and depth, that we feel we are only a step away from that even more monumental and overtly artful construction of a cross-section of anonymous Parisians, Seurat's *A Sunday on the Grande-Jatte* (see fig. 399), where Caillebotte's indissoluble merger of art and reality is unbalanced in clear favor of art. And more surprisingly, Caillebotte's most imposing and important painting can be thought of as resurrecting, with modern subject matter, David's great

Neoclassic tradition, as in *Belisarius* and the *Horatii* (see figs. 15 and 16), of locking figures and architectural settings together in a taut, immutable order.

If Caillebotte's image of Paris appears to be one of ideal harmony, of a nineteenth-century optimism about social progress, his contemporaries often found in modern cities a strange, alien world that could, at times, become a hell on earth. The most dramatic vision of nineteenth-century urban misery might well be found in the work of the French painter and illustrator Gustave Doré (1832–83). A frequent traveler who often assumed the role of artist-journalist, Doré, between 1868 and 1872, made regular visits to London, where his literary illustrations were already well known in English editions. There, he and his friend the writer Blanchard Jerrold planned together a volume called *London: A Pilgrimage*, in which they would join visual and literary forces in a sweeping description of the totality of modern London life, from the racetracks to the factories, from the markets to the docks. Of Doré's many illustrations to this huge and weighty travelogue, published in 1872, few are so shattering as those which descend to the lower depths of working-class neighborhoods. Unlike Géricault, who in his heart-breaking lithographs of London life fixed on the plight of individuals (see fig. 116), Doré presents a panoramic, devil's-eye view of an infernal, yet man-made world that turns the Industrial Revolution upside down, mocking the idea of progress. In one of the most epically gloomy of these prints, *Over London—By Rail* (**fig. 359**), we

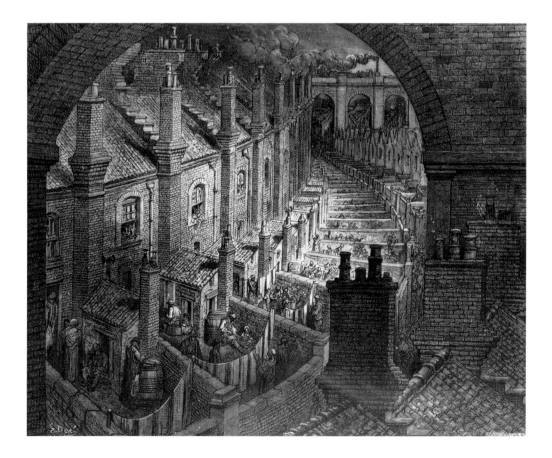

Fig. 359 **Gustave Doré**, *Over London—By Rail* (from Gustave Doré and Blanchard Jerrold, *London: A Pilgrimage*), 1872. Engraving, 8 × 10″. British Library, London.

Fig. 360 **John Atkinson Grimshaw**, *Liverpool Quay by Moonlight*, 1887. Oil on canvas, 24 × 36″. Tate Britain, London.

look down from the dizzy heights of railroad bridges into the abyss of a London slum, where workers' houses, as mechanically ordered as the rows of new apartment houses of Caillebotte's Paris, are crammed with countless, hopeless souls, clustered in family groups within the imprisoning confines of chimneys, clotheslines, and cramped backyards where the sun seems never to have shone. In the distance, a railway train, as dwarfed as the figures by the terrifyingly sublime scale of the curve of row houses, belches dark smoke into the benighted sky. That Doré's vision, partly true, partly imaginary, has the character of a descent to hell is no accident. Already in 1861, he had published illustrations to Dante's *Inferno*. In effect, the London views of 1872 translated a medieval Christian image of eternal damnation into the facts of nineteenth-century slum life. It is no surprise that a younger artist concerned both with religion and the plight of the poor—Vincent van Gogh—would admire to the point of imitation Doré's theatrical visions of the terrestrial infernos in a post-Christian era.

Another kind of urban gloom, more documentary than nightmarish, was mirrored in the work of an odd provincial artist, John Atkinson Grimshaw (1836–93). A policeman's son and a clerk who worked for the Great Northern Railway, Grimshaw knew firsthand the damp and dreary melancholy of those British cities—Liverpool, Hull, or his birthplace, Leeds—that flourished in the heyday of nineteenth-century factories and commerce. At first painting in his spare time, he began to achieve by the 1860s ever greater success with his closely descriptive renderings of the familiar streets of these economically thriving centers. In a typical painting, *Liverpool Quay by Moonlight* of 1887

(fig. 360), art and photography seem to overlap, as they often do in the work of Eakins and Caillebotte; and, like them, Grimshaw used photographs to assure the accuracy of his views. But just as photography can encompass subjective responses, so too do Grimshaw's paintings. A far cry from Caillebotte's immaculate and optimistic view of the new Paris, Grimshaw's account of Liverpool captures the overwhelming bleakness of countless modern cities, where the funneling perspectives of axial streets alternate with rows of stores, warehouses, and urban dwellings, and where the artificial yellow light of shop fronts displaying their wares dimly pierces the fog which veils the pedestrians and carriages moving along the wet pavements. The mood approaches that of many of Whistler's own twilight views of the Thames, and Whistler once even quipped, "I considered myself the inventor of nocturnes until I saw Grimmy's moonlit pictures." Yet Grimshaw, unlike Whistler, practiced a minuscule fidelity to things observed. Here, the viewer can scrutinize everything for sale in the jeweler's window at the right, or can read every last word on the wall of billboards that intrudes at the left, where such ordinary household products as Pears' soap are advertised. As such, Grimshaw's paintings reflect many new kinds of urban fact and feeling that began to proliferate in the late nineteenth and early twentieth centuries, whether in the anxiety-laden cityscapes of Munch and, later, the German Expressionists, or in the dominance of the printed, commercial words that extended from the art posters of the 1890s through the collages of Picasso and Braque.

The facts of modern life—grim or cheerful, rich or poor, public or private, urban or rural—continued to preoccupy painters in the 1870s and 1880s who turned to ever more

Fig. 361 **Hubert von Herkomer**, *Eventide—A Scene in the Westminster Union*, 1878. Oil on canvas, 44¼ × 59½".
Walker Art Gallery, Liverpool.

particularized subjects. In England, in particular, urban misery became an increasingly popular theme, not only in printed illustrations for magazines like *The Graphic*, but in more imposing painted counterparts that documented the sufferings of anonymous city dwellers faced with unemployment, illness, strikes, or penniless old age, and that mitigated these pressing human truths through the distancing lens of art. A master of this genre was the German-born Sir Hubert von Herkomer (1849–1914), who as a child went to England, where his artistic fame eventually earned him a knighthood shortly after his native country added a "von" to his name. Lower-class by birth, he became prominent in London with works like *Eventide—A Scene in the Westminster Union* of 1878 (fig. 361), a depressing glimpse of a London workhouse for aged women, who, in their last pathetic years, earn their keep through the menial, manual chores depicted in the foreground. Although deleting the more sordid aspects of workhouse life in Victorian London, Herkomer clearly registers not only compassion for this anonymous cross-section of lonely old women (who, even huddled together around a table, seem isolated from each other), but also an all-encompassing mood of imprisoning hopelessness. Although Herkomer was still working within the restrictions of a Realist, documentary style, his presentation of a corner of a vast, barren room, with the floor tilting upward at a swift and uncomfortably steep angle, is emotionally charged, rushing us from the large foreground

figures to the small and distant pair of women silhouetted, as if on the brink of death, against the somber twilight that penetrates the window. The spatial construction surprisingly resembles that in many more overtly modern paintings by Degas or Caillebotte, but instead of appearing to be an elegant exercise in oblique, asymmetrical patterns, contributes rather to the tragic sense of an entrapping, no-exit situation. Small wonder that Van Gogh, already an admirer of Doré's *London*, would also find inspiration in prints after Herkomer's work, which offered him not only truthful images of that social misery he hoped to alleviate but even schemes of restlessly contracted spaces, whose telescoping of near and far would find far more extreme and urgent echoes in his own paintings of such interiors as *The Night Café at Arles* (see fig. 420).

Other artists of Herkomer's generation, such as the German Max Liebermann (1847–1935), also painted in the 1870s many documents of modern social fact, although generally choosing scenes of a more optimistic, tidy character that suggested not individual misery but communal harmony and social progress. This was less difficult to do in Holland than in Victorian England; and Liebermann, in fact, frequently visited Amsterdam in the mid-1870s, recording there Dutch systems of what seemed models of public welfare, as exemplified in well-run orphanages or homes for the aged. Although responsive to a tradition of social realism in Dutch painting, Liebermann, during his

Paris sojourn of 1873–78, also adopted the youthful look of the Impressionist masters' more rapid brushstroke and high-keyed color. In his *Dutch Sewing School* of 1876 (**fig. 362**), the lugubrious tones of Herkomer's ward for the aged have been replaced by a sun-flooded schoolroom, where potentially sentimental details of the faces of the orphan girls and their belt-line learning of handicraft skills are partly obscured by a dappled paint surface that would not look out of place in the Impressionist exhibitions of the 1870s. The oblique angle of vision, too, with its cropping of windows and figures, is paralleled in many works by Degas, who also turned frequently to subjects of rhythmic, communal labor, like that of laundresses or ballet dancers. Of course, by French standards, Liebermann, who is generally considered the harbinger of Impressionism in Germany, seems timid, his croppings and oblique angles of vision being far less audacious than those of Degas, and his intermittent use of flecked brushwork and white accents producing finally a muted, grayed-out tonality. His compromises were typical of countless later nineteenth-century painters working in a diluted Impressionist mode more immediately accessible to a public who wanted to see simultaneously what was a recognizable account of the facts of modern life as well as a fresh pictorial style that looked up-to-date, but that finally remained unthreatening

to the pictorial conventions that Monet or Degas were undermining.

Even within the context of the Impressionist exhibitions in Paris, the tug-of-war became more acute between subject matter of topical interest and a private aesthetic order which might at first be incomprehensible to the viewer. A vote for reality over art was emphatically cast by Jean-François Raffaëlli (1850–1924), who was first excluded from the Impressionist group exhibitions but then, in 1880 and 1881, thanks to the pressures exerted by his friend Degas, was represented by dozens of pictures that offered almost a sociologist's view of the seamier sides of Parisian lower-class life. Around 1878, Raffaëlli moved to Asnières, an industrial suburb typical of the wastelands which the French call *terrains vagues*, peripheries, neither rural nor urban, that mark the expanding boundaries of modern cities. There he could observe firsthand the tramps, the rag-pickers, the derelicts whom he considered the proper subjects of an art that would record the new scope of humanity spawned by the later nineteenth century. In *The Absinthe Drinkers* (**fig. 363**), shown in 1881 at the sixth Impressionist exhibition, he scrutinizes a commonplace of modern life, a pair of tattered, dirty men at the bottom of the social ladder who are addicted to the absinthe which, located in dead center of this large, square composition, dominates

Fig. 362 **Max Liebermann**, *Dutch Sewing School*, 1876. Oil on canvas, 25¾ × 32½". Von der Heydt Museum, Wuppertal.

their inert and desperate lives, as it did those of so many men and women that finally the French government outlawed its sale in 1915. Bleakness, poverty are everywhere, from the railroad shack at the upper left to the sign that advertises VINS DE BOURGOGNE (Burgundy Wines) over a faded bunch of painted grapes that seem to have withered in this desolate environment. Insisting on such documentary facts, Raffaëlli called himself a "Naturalist," a term more familiarly applied to the novels and short stories of Zola, the Goncourt brothers, Huysmans, and Maupassant, writers who were determined to explore the physical and psychological facts of blighted urban lives. But the category of Naturalism, although generally implying a record, even an exposé, of the darker facts of the human condition in the later nineteenth century, is often used interchangeably with the category of Realism, not only by the painters, writers, and critics of the 1870s and 1880s, but by later historians. If such a distinction can serve any purpose at all, in the midst of the semantic confusion surrounding an umbrella word like Realism, it might be used to define the branch of Realism that concentrates on the reportorial account of lower-class life in a more literal style, as opposed to the branch of Realism that became known as Impressionism, which, in its pursuit of a more ephemeral and subjective experience of the seen world, evolved a style that tended to transform the slice of life selected by the painter into something that was more clearly art than social documentation.

Raffaëlli's style borrows much from Manet's own earlier versions of Realism, not only in the contracted spaces marked out here by the foreground plane of the ramshackle fence and the background plane of a dirty wall, but in the silhouettes of the derelicts projected as irregular, dark patterns against a light ground. By the late 1870s, however, Manet himself had fully adopted the broken, flickering brushstrokes of the younger Impressionists, which, in his last great work, *A Bar at the Folies-Bergère* of 1881–82 (fig. 364), he was able to synthesize with the more stable, lucid presentation of the commonplace truths of Parisian life that dominated his art of the 1860s. Eager to aggrandize his vision of modernity from that of an easel painter to that of a public muralist, Manet, in 1879, had proposed to the president of the Municipal Council a scheme for decorating

Fig. 363 **Jean-François Raffaëlli**, *The Absinthe Drinkers*, 1881. Oil on canvas, 43⅜ × 43⅜". Collection Mr. and Mrs. Raymond Klein (on loan to The Philadelphia Museum of Art, Pennsylvania).

Fig. 364 **Édouard Manet**, *A Bar at the Folies-Bergère*, 1881–82. Oil on canvas, 37½ × 51″. Courtauld Institute Galleries, London.

Paris's new Hôtel de Ville (City Hall) with scenes of the city's public and commercial life—its markets, railroads, bridges, underground structures, racetracks, gardens. As he put it, he wanted "to paint the life of Paris in the house of Paris," but his request went unheeded. Such grand-scale ambitions, however, seem redirected to *A Bar at the Folies-Bergère*, which, exhibited at the Salon of 1882, the year before Manet's untimely death, stands as his last will and testament. The subject chosen, anonymous crowds in a place of public entertainment, was a familiar one for the period, and attracted other artists, like Degas, and other writers, like Huysmans. Manet, however, transformed this Paris commonplace into an image of haunting contradictions that have never stopped intriguing spectators. For one, the painting at first proposes an almost Raphaelesque compositional clarity, with the blonde barmaid (posed for by a certain Suzon, who actually was a barmaid at the Folies-Bergère) usurping the traditional role of a frontal, centralized Madonna. Yet this surprising symmetry of the foreground—the very buttons of her bodice bisect the

painting—is immediately denied by everything around and behind the barmaid, who suddenly seems to stand totally alone in a world of such shimmer and confusion that it might almost be a mirage. Indeed, this ambient reality is in fact a mirrored surface in which we must read indirect clues to the reality which lies in the imaginary space behind us and which would be seen by the barmaid herself, were she to cast her eyes outward.

From the 1860s on, Manet redirected the illusions of painting from inside to outside the canvas, seeking the fullest involvement with the space of the viewer. The climax is reached here, as we realize that the entire rear plane of the painting, through its glassy reflection, obliges us to read the painted images as occurring on our side of the canvas. Of these surprising reflections, perhaps the most disconcerting and enigmatic is the top-hatted gentleman at the upper right, whose position apparently corresponds to that of the spectator who stands before the painting, forcing us to see ourselves mirrored irrationally as another person, a dapper Parisian who holds a walking stick and is possibly

propositioning the recalcitrant barmaid. At the upper left, this ostensibly stable composition becomes still more centrifugal, as we glimpse only the lower extremities of a pair of dangling legs that belong to a trapeze artist performing above the picture frame and over our heads. Further reflections include the lady at the balcony railing who peers through opera glasses at something invisible to us or, less momentary, the mesmerizing pair of globe lights that frame the barmaid's head and introduce a floating element of geometric order in the confusion of the reflected distance. Psychologically, too, the mood remains endlessly fascinating; for the barmaid's expression of loneliness or apathy completely denies the ambience of communal

pleasure and bustle, as if Manet had pinpointed definitively what was later to become a sociological cliché about the alienation of the individual in the modern city.

Marvelous, too, is the exploration not only of these multiple emotional realities, but of visual ones as well. The foreground still life of champagne bottles, roses, oranges, ales, and liqueurs is, like the barmaid, "real," but this "reality," already mitigated by the dissolving shimmer of reflected light on the bottles, glass, and crystal, must be measured against the oblique mirror image of the same still life as partially viewed behind the barmaid's right arm. And, typically for Manet, even though this painting at first conveys the unedited immediacy of a direct and casual

Fig. 365 **Thomas Eakins**, *The Gross Clinic*, 1875. Oil on canvas, 96 × 78″. Jefferson Medical College, Philadelphia, Pennsylvania.

encounter, it also evokes the selective and hermetic world of art, with its reference to the most famous old-master painting of the magic of a mirror which reflects figures on the spectator's side of the canvas, Velázquez's *Las Meninas*. Moreover, Manet asserts his own aesthetic choices, especially a chromatic sensibility which here translates Velázquez's silvery tones and dark shadows into a language of bold silhouettes countered by an abundance of the most delicate pastel hues—lilac, pink, gold, icy blue—that seem to have filtered out of the spectrum any suggestion of the brash and vulgar colors one might expect in a palace of Parisian night life of the 1880s. The world of art and the world of modern Paris; the juggling of fact and illusion, of a continuous plane of interwoven brushstrokes and a complex layering of near and far on both sides of the canvas; the simultaneous tug of the centralized and the peripheral, of the focused and the diffused—such are the many contradictions that Manet has wedded here in a masterpiece that summarizes not only his career, but the concerns of many of his contemporaries, be they called Realists, Naturalists, or Impressionists.

Thomas Eakins himself paralleled many of these ambitions in a notorious painting, *The Gross Clinic* of 1875 (fig. 365), which, on a heroic scale, documented the achievements of modern medicine as demonstrated in an eyewitness account of a living anatomy lesson. Although the work may reach back to Rembrandt's own venerable depictions of doctors dissecting corpses, it belongs no less fully to the new realm of documentary photography that could record for the public at large the triumphs of modern medicine, especially the use of ether as an anaesthetic. This miracle first occurred on October 16, 1846, at the Massachusetts General Hospital, where a new savior, in the form of William Thomas Green Morton, launched this procedure. Its wonders and blessings, ultimately commemorated in an allegorical public sculpture in Boston, were quickly recorded by the new photographic partnership of Southworth & Hawes (Albert Sands Southworth, 1811–94; Josiah Johnson Hawes, 1808–1901), both of whom had had scientific training as well as lessons in the daguerreotype process. To record the realities of this thrilling step in human progress, Southworth & Hawes, in fact, had to restage, like a painter, the medical scene, setting up for posterity an overhead view of a prostrate female patient surrounded by the learned doctors (fig. 366). It was a similar mix of pictorial theater and nineteenth-century faith in scientific advancement that informed Eakins's startling painting. In part, an occupational portrait of an illustrious surgeon, Dr. Samuel David Gross, in part a naturalist's record of the facts of anatomy and modern surgery as learned by students in the amphitheater of Philadelphia's Jefferson Medical College, *The Gross Clinic* insisted on the harsh truths of reality: the brusquely foreshortened view of the anaesthetized patient's buttock and dissected thigh, the

Fig. 366 **Albert Sands Southworth** and **Josiah Johnson Hawes**, *Operation under Ether*, 1847. Whole plate daguerreotype, 5⅞ × 7⅞". Fogg Art Museum, Harvard University, Cambridge, Massachusetts.

conspicuous smears of blood on the doctor's hand, and the accurate foreground still life of medical instruments that further document the scene. Eakins's approach here, in fact, continues his belief in the convergence of the truths of art and the truths of science that he had already revealed in his scenes of sculling (see fig. 350). But here, the confrontation with the facts of modern medicine was so unpalatable that the painting was generally thought offensive. At the Philadelphia Centennial Exhibition of 1876, it was included not with the other works of art, but was shown separately at the United States Army Post Hospital display. Yet, no less than Manet's documents of modern life, Eakins's huge canvas alludes to old-master traditions (from Rembrandt's *Anatomy Lesson* to mid-nineteenth-century French paintings of surgical demonstrations), as well as providing its own complex artistic orchestrations, which here include the emotional contrast between the cringing woman at the left (probably the patient's mother, an obligatory witness for medical charity cases) and the coolly impassive members of the medical profession; the rich variety of intellectual and manual concentration; the shadowy, Velázquez-like spaces that carry us from spectacle to spectators (one of whom, at the right, is Eakins himself); the superb highlight on Dr. Gross's forehead that singles him out as the mind behind this grave event.

Something of Eakins's genius, in fact, may be quickly measured by comparing *The Gross Clinic* with a later French version of an almost identical theme, *Before the Operation: Dr. Péan Explaining the Use of Hemostatic Clamps* (fig. 367), a painting by Henri Gervex (1852–1929) shown at the 1887 Salon. The blood, the female nudity, the medical still life belong to Eakins's realm of documentary candor and fidelity, and the cropping and fortuitous

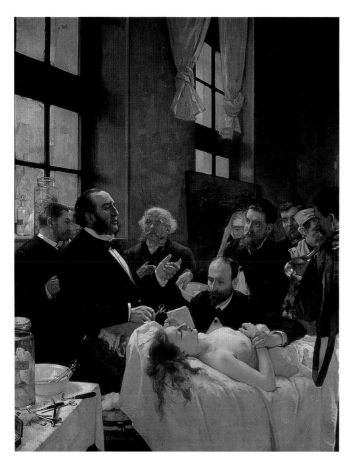

Fig. 367 **Henri Gervex**, *Before the Operation: Dr. Péan Explaining the Use of Hemostatic Clamps*, Salon of 1887. Oil on canvas, 95¼ × 74″. Musée de l'Assistance Publique, Paris.

disposition of the figures who watch and assist with the demonstration are also part of this empirical realm. Yet, next to the monumental seriousness and probity of Eakins's painting, Gervex's medical demonstration seems a neutral statement of a pedestrian fact, a reminder for the Paris Salon audiences that medicine participated in the march of scientific progress which was recorded not only at the international exhibitions but at the Salon itself.

Interiors: Domestic and Erotic

As a counterpoint to these paintings of public themes, many artists continued to offer intimate glimpses of domestic interiors, peephole views that captured ordinary moments in the lives of the wealthy, the middle class, or the poor. Such was the case in many works by the Scottish painter Sir William Quiller Orchardson (1832–1910), who, mirroring the course of nineteenth-century drama, gradually turned from his costumed episodes inspired by history and imaginative literature to accounts of contemporary upper-class life. In his *"Mariage de Convenance"* of 1883 (**fig. 368**), shown the next year at the Royal Academy, he follows a long tradition of British social commentary that goes back to Hogarth, presenting us here with the familiar story of a wealthy old man and, at the very far end of the table, a bored, distracted young wife, while a somber butler pours the wine. Hardly as fraught in emotional or moral terms as Hunt's *Awakening Conscience* (see fig. 246) and painted in a loose, brushy manner that underlines the

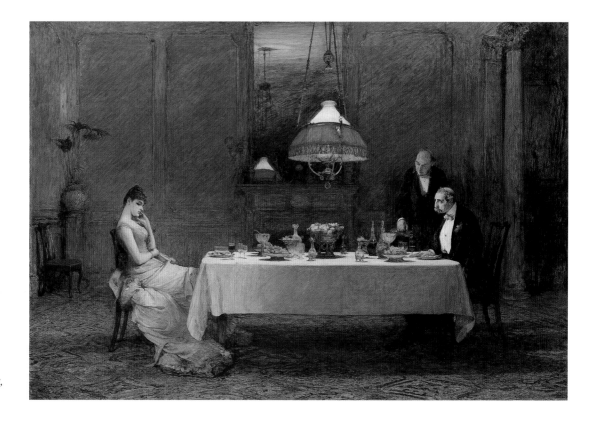

Fig. 368 **Sir William Quiller Orchardson**, *"Mariage de Convenance,"* 1883. Oil on canvas, 41¼ × 60¾″. Glasgow Art Gallery, Scotland.

shadowy lamplit spaces separating this mismatched couple, Orchardson's painting provides a rather lightweight, charming comment on human foibles. It won the artist such immense success that it was inevitably followed by its narrative sequel, *"Mariage de Convenance"—After!*, which represented the same husband alone, after the inevitable departure of his pretty young wife.

For Orchardson and many Victorian artists, the conventions of painting often coincided with those of modern social drama: the spectator was to be presented with a head-on view of a pregnant narrative moment enacted behind an imaginary proscenium. For more adventurous taste, however, especially in the Parisian orbit of the Impressionists, such an interpretation of the Realist facts of modern domestic life looked stale, to be replaced by more unexpected glimpses of events no more important than the reading of a daily newspaper, or the raising of a teacup. Of those artists who captured the telling, if dramatically uneventful, moments in upper-class Parisian life, few could rival Mary Cassatt (1845–1926), who, born of wealthy parents in Pittsburgh and educated at the Pennsylvania Academy, crossed the ocean in 1866 to become, like Whistler, an American expatriate completely in tune

with the most advanced interpretations of Realism proposed in Paris, and one also responsible for the enthusiastic acquisition of Impressionist paintings by wealthy American collectors. A friend of Degas, Cassatt exhibited with the Impressionists from 1879 to 1886, generally choosing scenes of women and children caught in moments of aristocratic leisure. Her painting, however, was too audacious for more official taste, and when she tried to show in the American section at the Paris Exposition Universelle of 1878, the jury refused her entry. The painting in question was *The Blue Room* (**fig. 369**), which offers a startlingly cropped, overhead view of a wealthy Paris interior where a little girl, elegantly dressed in white with contrasting tartan sash and stockings, is caught sprawling in a posture of almost sensual abandon that destroys any lingering veils of sentiment associated with the depiction of children. To add to this witty candor, her tiny puppy also relaxes on an overstuffed chair at the left, underscoring the curious confusion of scale created by a room crowded with commodiously upholstered furniture but occupied temporarily by an undersized girl and dog. Following Degas, Cassatt confirms the casual instantaneity of her vision by an oddly angled view that cuts off top, bottom, and sides of the three

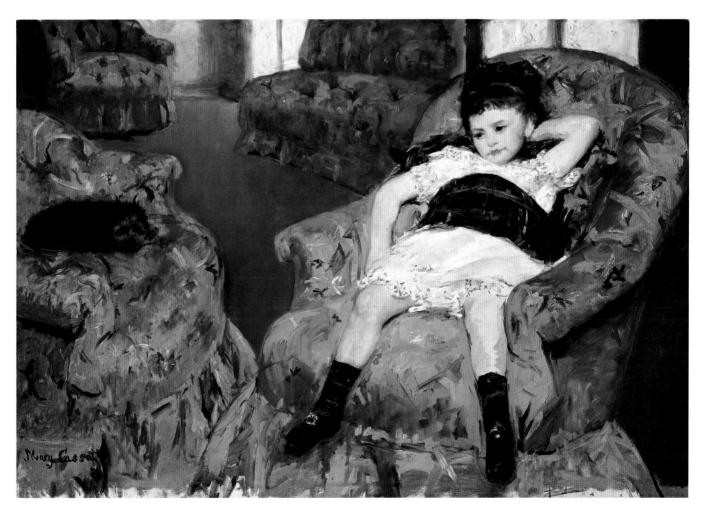

Fig. 369 **Mary Cassatt**, *The Blue Room*, 1878. Oil on canvas, 35 × 51″. National Gallery of Art, Washington, D.C.

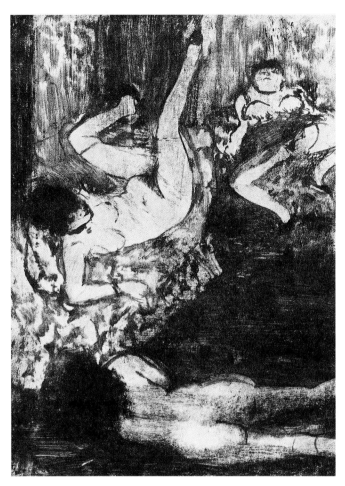

Fig. 370 **Hilaire-Germain-Edgar Degas**, *Repose*, c. 1879–80. Monotype in black ink on china paper, 6¼ × 4¾". Private collection.

chairs and the settee, and thrusts the spectator directly into the space of the room, rather than imitating, as did Orchardson, the separation of the audience from the pictorial stage.

While Cassatt was working within the proprieties of Paris's best drawing rooms, her friend Degas could widen his account of Parisian life by exploring the clandestine interiors of brothels, a theme common to such masters of the naturalistic novel as Huysmans. In a series of monotypes of c. 1879–80, whose grossly erotic candor kept their reputation subterranean until the more sexually liberated 1960s, Degas recorded this world. There he told the unabashed truths about the coarse postures, the crass displays of flesh greeting the male purchaser who frequented the houses of prostitution which so often provided homes and sustenance for women who could not survive working in the sweatshops that Degas also painted in the 1870s and 1880s. In a typical view, sardonically titled *Repose* (fig. 370), Degas offers an extreme statement of the degradation of the body that turns the hallowed traditions of the female nude upside down and provides, unwittingly or not, an ironic counterpoint to such discreet glimpses of female

abandon as recorded in works like Cassatt's *Blue Room*. Seen from a vertiginous vantage point that mirrors a male's overhead view of sexual conquest, the three almost faceless whores are flattened against floor and furniture in a carnal exposure of their bodies, as they scratch, stretch, and relax in the leisure moments between their sexual labors. So blatant and so confrontational an image of female sexuality was alarming even by nineteenth-century standards of pornographic imagery, and may reflect the perversities of Degas's own attitudes toward women, a topic which has provided later commentators with many opportunities for psychoanalytic speculations about his misogyny or his sexual abstinence. While Degas's images of these prostitutes may be seen as acutely personal interpretations, they could nevertheless spark the imagination of Picasso himself, who owned several of these monotypes and further explored their contracted spaces and their imagery of sexual immediacy and menace in his renowned painting of a brothel parlor, *Les Demoiselles d'Avignon* (1907).

In general, however, Degas's harsh erotic truths about the inspection and sale of female flesh in modern houses of prostitution were sugarcoated and bowdlerized. Following such early nineteenth-century traditions as the harem scenes explored by Delacroix and Ingres (see figs. 129 and 130), many of Degas's lesser contemporaries offered surrogate bordellos made respectable through the trappings of exoticism or history. At the 1873 Salon, for example, one could see *La Toilette Japonaise* (fig. 371) by Marie-François-Firmin Girard (1838–1921), a student, like Monet and Renoir, of Gleyre's. Indeed, like them, Girard was attracted to Japanese art, costume, and decor, and here he even offered a moderate variation of the oblique angle of

Fig. 371 **Marie-François-Firmin Girard**, *La Toilette Japonaise*, 1873. Oil on canvas, 21¼ × 25¾". Museo de Arte, Fundación Luis A. Ferré, Ponce, Puerto Rico.

Fig. 372 **Mariano Fortuny y Marsal**, *The Choice of a Model*, 1874. Oil on canvas, 21 × 32½″. The Corcoran Gallery of Art, Washington, D.C. The William A. Clark Collection.

vision which so excited the Impressionists in Japanese prints. But more conspicuous than such spatial innovations is the bric-a-brac he crammed into this painted reconstruction of a Far Eastern world that would offer visual and erotic refinements simular to those of classical antiquity or the Near East. A trio of geishas become a Japanese equivalent of the Three Graces, who take artful postures as they go about the sensual business of coiffing and feeding one of their group, who, having just bathed, is seen stark naked, as she idly fingers a Japanese variant of the mandolin, the samisen, and assumes an academic posture dependent on Ingres's own Near Eastern bathers and odalisques. Here, the passion for things Japanese, already so conspicuous in the 1860s in works by Whistler and Stevens (see figs. 285 and 284), is further complicated by the erotic motif, transforming this dense inventory of Japanese artifacts, from lanterns and screens to dolls and obis, into a sexual travelogue for the more refined Parisian male consumers.

If the remoteness of Japan could give a proper veneer to Girard's excursion to the sensualized women's spaces of the Far East, the respectability of Western art and history could disguise other scenes where female flesh is marketed among men. This theme, especially familiar in Gérôme's paintings of female slave markets in the Near East, could

be relocated in eighteenth-century Rome in a dazzling painting by the Spaniard Mariano Fortuny (1838–74), whose success was enormous not only in his native country, but in Italy, France, and the United States. Completed in the last year of his short life, *The Choice of a Model* (**fig. 372**) takes us to the light-filled saloon of the Palazzo Colonna in Rome, which is as crammed with Rococo ornament, furniture, and costume as Girard's scene is with Japanese bibelots. In the background, to add further dignity and art-historical resonance to the scene, we glimpse the venerable old-master collection of the Colonna family. The main narrative point, however, is the assembly of gentlemen connoisseurs of art and flesh—nine academicians of St. Luke dressed in Louis XV costume—who select a model by scrutinizing a nude woman posed on top of a marble table as if she were an inanimate sculptural object to be savored by the male viewers, one of whom approaches her with a lorgnette for closer examination. The erotic point is further underscored by the pair of gilded satyrs who crouch on the floor, framing the heap of clothing discarded by the model. Such surrogate painted versions of sexual barter were commonplace in the nineteenth century, but what was uncommon and what assured Fortuny's fame was the miniaturist sparkle of his technique, which, completely

appropriate here to the eighteenth-century subject, resurrects the most bravura aspects of Rococo style in a painting whose modest size further underscores the preciosity and refinement of this jewel-like world. Marble and porphyry columns, gilded furniture, floating cherubs, iridescent pastel colors that dare combinations of pink flesh on pink silk: in a coruscating shimmer of paint, these create the historicizing and, to the public, more immediately accessible counterpart of the flecked brushstrokes and vibrant luminosity in Monet's paintings that startled audiences at the Impressionist exhibitions.

Changes in History Painting and Portraiture

Despite his swift and glittering touch, the mark of a dashing personal calligraphy, Fortuny's paintings are clearly based on the same Realist premises as the more glossy, brushless descriptions of fact by Gérôme, Meissonier, and other contemporaries who, in the 1870s and 1880s, could push a sharp-focus truth in painting to a point that rivaled the medium of photography. At the Salon of 1880, for example, one could find paintings of historical and biblical subject matter that resembled photographs of models enacting dramatic roles. Such is the case in *The Late Empire: Honorius* (fig. 373) by Jean-Paul Laurens (1838–1921), who specialized in reconstructions of events taken from the more obscure pages of medieval history. Here he transports us to the crumbling Roman Empire of 395 A.D. when, on the death of Theodosius, it was divided into two parts, with the eleven-year-old Honorius ruling the West. Laurens, in effect, puts the spectator face to face with this swarthy child who poses stiffly for his coronation portrait, grasping with both hands the inherited symbols of imperial power, but still too young for his feet to touch the footstool on the ground. Huysmans, then a champion of Naturalism, applauded the verisimilitude of this sitter, who looked to him like an ordinary ruffian from the streets of Paris. In fact, this conspicuous clash between the historical pomp of the imperial throne and the literal facts of a coarse and mindless child added special poignancy to the image of the total collapse of Rome in the face of the barbarians. Laurens's erudition and respect for truth extended as well to art history, for the hieratic rigidity and the starkly frontal view of the enthroned emperor allude to that change of style, from Roman Naturalism to the more abstract heraldic modes of early Christian art, that corresponds to the depicted historical moment. In this, Laurens brings into ever more erudite focus the nineteenth-century tradition of synchronizing style and subject in the reconstruction of history.

Even more extreme as a quasi-photographic rendering of a figure existing only in imagination is *Job* (fig. 374), a painting shown at the same salon by Léon Bonnat

(1833–1923). Born in Bayonne, near the Spanish border, Bonnat was raised in Spain, where, like many French painters of his generation, he was attracted to the somber naturalism of Velázquez and Ribera, especially as applied to biblical themes. His *Job*, in fact, is a descendant of Ribera's tenebrist saints, but truth to fact here reaches so extreme a degree that we may find the painting more convincing as a naturalist's account of a specimen in the study of geriatrics than as a re-creation of that biblical symbol of endurance through untold affliction which is the nominal subject. Every wrinkle, blood vessel, strand of white beard or inch of sagging, emaciated flesh is so painfully detailed that the sheer physical fact of a specific and extraordinarily aged model striking a pose of lonely desperation makes the biblical reference almost an afterthought, a theatrical charade obscured by the role he plays, much as Laurens's Honorius may look more like a Parisian urchin than a child emperor of Rome.

This intensive scrutiny of the visible world, the painter's counterpart to the empirical, documentary impulses of photography, had been a potent goal even before the official proclamation of Daguerre's invention in 1839, and reached

Fig. 373 **Jean-Paul Laurens**, *The Late Empire: Honorius*, 1880. Oil on canvas, 42½ × 60½″. Chrysler Museum of Art, Norfolk, Virginia.

Fig. 374 **Léon Bonnat**, *Job*, Salon of 1880. Oil on canvas, 63¾ × 51⅛". Musée Bonnat, Bayonne.

ever greater extremes in later decades when photography could provide images that appeared to be completely objective as well as all-inclusive in detail. This look, often referred to broadly as Academic Realism, but perhaps more accurately described as Photorealism, could be applied to anything from the reconstruction of history to contemporary facts, whether of portraiture or genre. In Russia, for example, it dominated the work of a refractory group of thirteen artists who rebelled not against the style promoted by the St. Petersburg Academy but rather against the subjects which, veering toward the traditional Western repertory of mythological and biblical themes, appeared irrelevant to the pressing realities of life in nineteenth-century Russia. In 1870, they formed a society for traveling art exhibitions, which they hoped would bring their paintings to audiences far wider than the elite circles of St. Petersburg and Moscow, and became known as the Peredvizhniki, or Travelers. Their most famous member, Ilya Repin (1844–1930), turned from the gods of Olympus or Valhalla to the dramatic events of Russian history itself, which might be used to sharpen the social consciousness of the Russian people to the evils of the despotic, czarist tradition maintained under Alexander II and III. Coincident with the accession of the latter czar in 1881, Repin began to work on *Ivan the Terrible and His Son* (**fig. 375**), a huge

painting not completed until 1888. Here the spectator is plunged into the very room where, in November 1580, the most notorious of all czars, in a fit of rage, murdered his eldest surviving son and heir, Ivan. Then, swiftly overcome by remorse, he attempted to succor him back to life. Following the tradition of such national history painting as Piloty's *Wallenstein* (see fig. 254), *Ivan the Terrible* may also reflect the dramatic immediacy of obliquely angled views that Repin could have noted in the work of both Gérôme and Degas during his visits to Paris of 1871 and 1883. Under the somewhat softened brushstrokes, which add to the tenebrist gloom of the scene and may adapt Impressionist techniques, the same Realist premises obtain as if we were watching a moment in an opera or costume drama as reconstructed on the nineteenth-century stage. The long lance which, from a distance, struck the prince's head has dropped at our feet on this tilted ground plane; the czar's chair at the left has been knocked over in what must have been a violent lunge; the bloodstained rug is crumpled from the scuffle; and the expiring prince tries to free himself from the guilty embrace of his crazed father, who, after this deed, wished to abdicate since he no longer felt worthy to reign. Whether this painting was more effective as sheer, on-the-spot horror or as the anti-czarist propaganda Repin hoped to promote is a matter of conjecture; but its insistent truth to the facts of history, setting, costume, and even psychology characterized a growingly popular mode of painting that would find further fruition in the official styles of postrevolutionary Russia.

Repin's close-eyed Realism could find even more remarkable extremes in the portraiture of Ivan Nikolaevich Kramskoy (1837–87), the major spokesman for the Travelers. In 1880, he painted another member of the group, the landscape painter Ivan Shishkin (**fig. 376**), who, hands in pockets, confronts us with such seemingly indiscriminate completeness of detail, from every last strand of unruly hair to the gleaming links of the watch chain, that, as in a wax museum, we have the uncanny sense of looking at an exact facsimile of a living, breathing person. Already in 1832, before photography, Ingres had approached such meticulous Realism in his portrait of M. Bertin (see fig. 178), but Kramskoy so totally eliminates the abstract components of Ingres's portraiture, where a taut and fluent line dominates the whole, that we are left merely to marvel at the magic of a mirror image caught in paint on canvas, an experience comparable to the delight and shock with which audiences greeted mid-nineteenth-century portrait photography. Indeed, the dominant black-and-white tones of Kramskoy's portrait, in which the pink of the cheeks seems almost a tinted addition, directly reflect the look of photography. It is hardly a surprise, then, to learn that Kramskoy, in his youth, worked as a retoucher with a traveling photographer. Both the ancient medium of painting and the modern one of photography have always

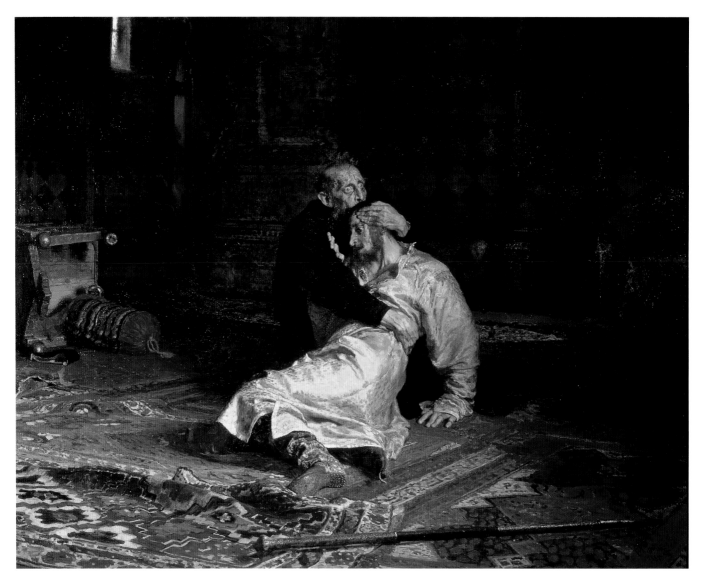

Fig. 375 **Ilya Efimovich Repin**, *Ivan the Terrible and His Son*, 1881–85. Oil on canvas, 6′ 7″ × 8′ 4″.
Tretyakov Gallery, Moscow.

had the potential of a seemingly objective, impersonal Realism (as well as an infinite number of other, more overtly subjective possibilities). Here the two techniques of imitation—one mechanical, the other hand-made—seem to merge in a painting that looks almost indistinguishable from a photograph.

Although many late nineteenth-century portraitists, Bonnat included, were content with such literally superficial accounts of their sitters, others chose to penetrate outer surfaces in order to disclose a more mysterious inner domain of emotions. One of the most haunting testimonies of this tentative redirection from exterior description to interior feeling can be seen in the *Sick Girl* of 1880–81 (fig. 377), by the Norwegian Christian Krohg (1852–1925). Influenced by such writers as Zola who wished to explore the physical and mental sufferings of individuals, especially in the lower strata of the nineteenth-century social order, Krohg turned away from the picturesque nationalism

of many of his Scandinavian colleagues in favor of particularized human truths. Here, we are inescapably confronted with a young victim of tuberculosis who, though nameless, is clearly a specific child recorded so exactly that, as in the case of Kramskoy's portraiture, we feel we could instantly recognize the sitter in real life. But this Realist description of physiognomy, as well as of the blanket, chair, bedclothes, and pillow, is secondary to the emotional revelation of a frail human being whose slow physical expiration we are forced to watch, as Krohg himself had watched his own sister die of tuberculosis in 1868. Such compassion is elicited not only by the head-on gaze, impossible to avoid, but by the spatial constriction, which demands our empathy into what life might be like were we, too, propped up in the imprisoning confines of a coffin-like armchair. Krohg's pictorial sensibilities reflect the styles of Manet and Whistler, whose nuanced patterns of white on white are restated here. Yet these effects, far

Fig. 376 **Ivan Nikolaevich Kramskoy**, *Ivan I. Shishkin*, 1880. Oil on canvas, 46 × 33½″.
Russian Museum, Leningrad.

Fig. 377 **Christian Krohg**,
Sick Girl, 1880–81.
Oil on canvas, 40¾ × 23½″.
Nasjonalgalleriet, Oslo.

from conveying an aestheticized elegance, contribute to the pall of doom that permeates the whole image. Like the withering rose in her lap whose leaves have begun to fall, the subtle tones of pink and white underscore the wanness of the sitter's face and the sense that life is being drained from her young, but feeble body. In the early 1880s, such a move from the description of fact to that of feeling, from a language of art for art's sake to one of art for life's sake was a significant one. No less a genius than Krohg's compatriot Edvard Munch (see pages 466–69) would soon follow in these footsteps, exploring, in a style that would finally abandon Realism entirely, the psychic truths of illness, death, anxiety, lust, as experienced in the modern world.

A comparable direction in the 1880s can be found in the portraiture of the Austrian Anton Romako (1832–89), who began as a student of the Biedermeier landscape and genre painter Waldmüller (see fig. 163), but soon rejected this even-tempered, sunlit world in favor of more sinister glimpses into human personality which shocked a Viennese audience used to society portraiture that flattered the

sitter's face and choice of clothing and jewelry. Such conventions are turned inside out in Romako's *Portrait of Isabella Reisser* of 1885 (**fig. 378**), which may provide the traditional inventory of fashionable accoutrements—the ruffles, the wasp waist, the bustle, the snake bracelet, the fan—but which also startles us when we reach the sitter's face, which, like her body, is flattened into an awkward silhouette, more grotesque than graceful. The sharp eyebrows, the staring eyes, the lipsticked mouth and row of sharp teeth all give her a menacing, almost demonic character, more of a spiritualist, devil doll, or *femme fatale* than an 1880s fashion plate. Adverse critics in Vienna could call Romako "the sick man of art," and the tragedies that struck his family, including mental illness and suicide, might be considered adequate explanation of his unveiling of the more disquieting, bizarre aspects of a human presence. But in fact, his eccentricity was part of a general direction in the 1880s to peer below the materialist surfaces and restricting social conventions of nineteenth-century men and women and to find there a dark and disturbing world that another Viennese, the young Sigmund Freud, would soon explain as the true foundation of adult behavior.

Even the more dashing society portraitists of the 1880s could offer on occasion glimmers into more mysterious psychological domains. So it was in the imposing, seven-foot-square group portrait of *The Daughters of Edward Darley Boit* (**fig. 379**), which the American expatriate John Singer Sargent (1856–1925) executed in Paris in 1882 for exhibition at the following year's Salon. Like Cassatt, Sargent was part of a well-heeled society of Americans in Paris, and painted this cosmopolitan world, so accurately mirrored in Henry James's novels, with a bravura touch and aristocratic elegance that seemed to bring the court portraiture of Velázquez up to date. Although later critics accused Sargent of being merely a shallow virtuoso who frequented and flattered the rich, his paintings often probe beneath appearances in their evocation of the quiet psychological drama of domestic life. In the case of the four daughters of his friend the painter Boit, seen in their Paris apartment, Sargent disposes them not as a familiarly harmonious quartet of adorable girls, big and little, but as unexpected intruders within the vast, shadowy spaces of an interior whose complexities, including a mirror, recall *Las Meninas*. Three of the children stare out at us as if diverted from their activities, while the fourth turns her back to lean against one of the pair of Japanese vases that asymmetrically complicate the cropped network of oblique, Degas-like axes and that, by rising to the height of an adult, underline our sense of the scale and intimacy of a world of children. But rather than being merely fortuitous, there is something unsaid and withdrawn here, as if a subtle and private psychological network among the four girls was about to be revealed. Henry James commented, in his enthusiastic account of this portrait for *Harper's Magazine*, on "the

Fig. 378 **Anton Romako**, *Portrait of Isabella Reisser*, 1885. Oil on canvas, 51½ × 38″. Leopold Collection, Vienna.

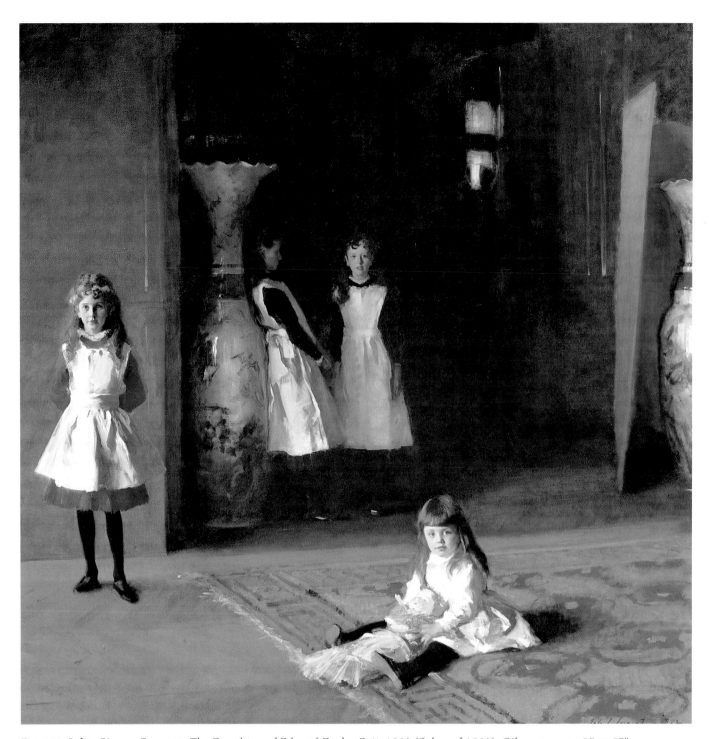

Fig. 379 **John Singer Sargent**, *The Daughters of Edward Darley Boit*, 1882 (Salon of 1883). Oil on canvas, 87 × 87″.
Museum of Fine Arts, Boston.

sense it gives us as of assimilated secrets," and praised as well the masterly painting of the white pinafores and the dazzling ease of figural disposition which produces "a comprehensive impression." He may well have recognized a kinship with his own literary goals in Sargent's brilliant description not only of the material contents and luminary complexities of an upper-class domestic interior, but of the psychological nuances disclosed in the characters whose lives unfold within the walls, both open and confining, of a space that recalls a stage set.

No less fashionable and successful as an international portraitist of the very chic and the very rich was the Italian Giovanni Boldini (1845–1931), who, after a brief stint in London, gravitated in the 1870s to the high society of Paris, which also patronized Sargent. A modern version of a court portraitist, Boldini developed so dashing a style that his swift, crackling brushstrokes look like the marks of an expert fencer or, in prophetic terms, like the rapid calligraphy of many Abstract Expressionists of the 1950s. Although there seemed little room for psychological

SARGENT'S "BROKEN REALISM": THE BOIT SISTERS

John Singer Sargent's The Daughters of Edward Darley Boit *(see fig. 379) has long been seen as radically unconventional in its composition, if not in its subject, for, unlike his Realist and Impressionist contemporaries in France, Sargent ignored the variegated social life of Paris streets and suburban parks, instead concentrating on the domestic and professional milieux of the wealthy. But in suggestively reimagining old-master painting and with the most innately athletic brush of the period, Sargent rendered cosmopolitan life in Paris and London in a manner that vividly captured his age.*

The portrait of the Boit sisters resonates with a sense of psychological isolation that is eerily reflected in the fortunes of the girls. From left to right they are Mary Louisa, Florence, Jane, and little Julia Boit. Florence, the eldest, is shown in shadow. Julia was born in 1878 and the picture was completed in 1882. None of the sitters ever married and the two eldest, Florence and Jane, ended up mentally ill or emotionally disturbed. Julia became an accomplished water-colorist.[70] In this sense, the image of four girls under the age of fifteen has a suitably mysterious air.

As Elizabeth Prettejohn recently showed, the painting

actually violates the basic requirement for recognizable likeness, since the face of one of the daughters is almost totally obscured. Moreover, two of the four are removed to a

background as shadowy as that of *El Jaleo* [1882, Isabella Stewart Gardner Museum, Boston], and the four sitters collectively occupy a startlingly small proportion of the total surface area. The composition sacrifices individual likeness to the evocation of a childhood world; it is a subject picture as much as a group portrait. The vast scale of the whole picture, of the strangely empty room, and of the blue-and-white vases emphasises the childish smallness of the figures. The canvas is square, an unusual format for either a portrait or a subject picture. The critic for the *Revue des deux mondes* stressed its oddness, saying that it was "composed after new rules: the rules of the game of four corners." Perhaps the comment also refers to the curious disposition of the figures, dispersed as if they are playing a childhood game whose rules are unfathomable to adults. One aspect of this mysterious ritual is growing up. The sisters in their white pinafores appear at successive stages of child development, zigzagging back through the picturespace from the infant in the foreground through the middle child on the left to the near-adolescent pair behind. Do the encroaching shadows of the background allude to their impending loss of innocence?[71]

Painted in the family residence at 32, Avenue de Friedland, Paris, the

portrait carries strong echoes of Velázquez's royal portrait Las Meninas, *which Sargent had seen and copied during a tour of Spain three years earlier. For Prettejohn, Sargent's reference to that painting is as complex as Goya's in the* Family of Charles IV *(see fig. 32):*

The conspicuous reference to the prototype provides a context, above all, for the unsentimental characterisations of the children. The Spanish precedent motivates a significant departure from the preciousness that surrendered the sitters, in much nineteenth-century child portraiture, to adult delectation. The American children of Edward Darley Boit ... retain an enigmatic quality, not quite accessible to adult rationality or available for adult pleasure.[72]

In this way, and with an unmatched brilliance in the brushwork, a kind of "broken realism" that rejected the finish of academicism (the slash of white on the large Japanese vase, the encrusted highlights on the doll and toddler in the foreground, the feathery fringe of the carpet), Sargent demonstrated the continuing viability of portraiture, even in the service of representing the supposedly debased world of the bourgeoisie.

In 1919, the four daughters of Edward Darley Boit donated this picture to the Museum of Fine Arts, Boston, in memory of their father.

exploration beneath such flamboyant paint surfaces, even Boldini could respond, in the 1880s, to the pressures of a more interiorized mystery. In his *Lady in the Studio of the Artist* of c. 1888 (fig. 380), the explosion of brushwork finally congeals into a haunting image of multiple realities, in which we see, swiftly telescoped in a rush of near and far, the tiny distant figure of the artist, the large foreground silhouette of a fashionable lady's back, and in the middle, a largely concealed view of one of Boldini's most famous portraits (known as the *White Pastel*), whose elegant, oval head stares out at us over the dark pattern of the hat of the visitor, who may even be the sitter herself contemplating

her painted image. Like Sargent in *The Daughters of Edward Darley Boit*, Boldini alludes here to the complex interior spaces of Velázquez's *Las Meninas*, and offers as well a restatement of that masterpiece's complex interactions of fact and illusion, artist and spectator. Here, artists, art, and sitter are shuffled, with the painted face on the canvas finally gaining ascendancy as almost an alter ego of the woman in the foreground who permits us to see not her face, but only her back. Ultimately working within the premises of a Realist viewpoint, in which what is painted corresponds to an observable phenomenon, even Boldini could stretch these confines enough to make us question

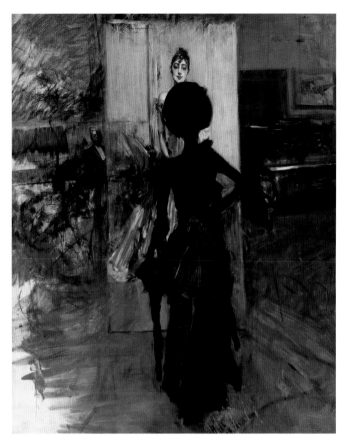

Fig. 380 **Giovanni Boldini**, *Lady in the Studio of the Artist*, c. 1888. Oil on canvas, 32¼ × 25⅝".
Galleria Civica d'Arte Moderna, Ferrara.

whether the truth of appearances was not less important than those other truths of art, of psychology, of the imagination which so many great painters—among them, Cézanne, Seurat, Van Gogh, and Gauguin—would fervently pursue in the 1880s.

National Landscape

Nevertheless, the pull of documentation, of recording the visible facts of people, places, social life persisted throughout the later nineteenth century, not only in the proliferating commerce of easily legible paintings for a growing middle-class audience, but in the more high-minded domain of creating a nationalist art that would reflect not the generalized truths of a pan-European tradition but the specific experiences of a Western world that now spread over five continents. In Russia, the Travelers provided one response to this need in their concern with painting Russian life and history. Another kind of response was found in the expansion of landscape painting to accommodate what was to become a global urge to record the geographic facts and beauties of those countries which were eager to be counted in a growing community of Western nations.

Before the 1860s, the United States already had a strong landscape tradition of such artists as Cole, Heade, and Church who explored the New World. By the 1870s, Canada and Mexico had also begun to add distinctive images to this repertory. Born in Upper Canada, Lucius R.

Fig. 381 **Lucius R. O'Brien**, *Sunrise on the Saguenay*, 1880.
Oil on canvas,
34½ × 49½".
National Gallery of Canada/Galerie Nationale du Canada, Ottawa.

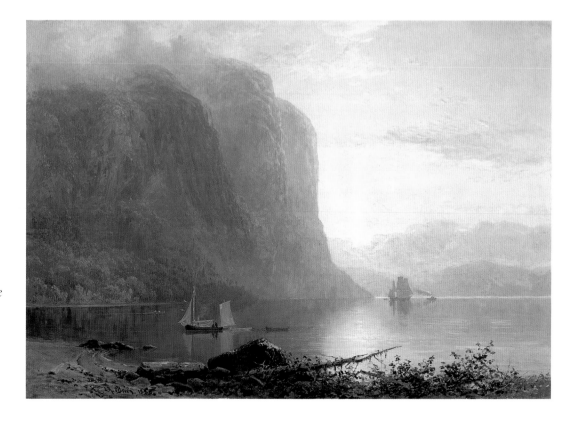

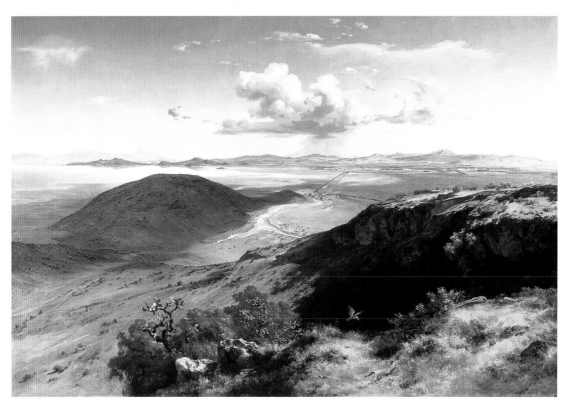

Fig. 382 **José María Velasco**, *Mexico*, 1877. Oil on canvas, 61 × 88½". Museo de Arte Moderno, Instituto Nacional de Bellas Artes, Mexico City.

O'Brien (1832–99) first worked as a draftsman-surveyor who, together with North American landscape photographers, documented his country and continent. When he decided to become a painter, he used this material as the basis of a more poeticized art that follows North American landscape traditions. In 1880, as the first president of the Royal Canadian Academy of Art, O'Brien inevitably chose an indigenous subject to submit as his diploma piece for the first exhibition. *Sunrise on the Saguenay* of that year (**fig. 381**) transports us to a Garden of Eden dawn on a tributary of the St. Lawrence River, where only a few boats intrude upon this belated Romantic vision of nature's primeval grandeur and purity freshly discovered by man. Like Heade's view of New England marshes (see fig. 267), O'Brien's painting of mountains and water seems more light than substance, another variation upon that Luminist mode which conveyed a sense of almost supernatural presence in a remote landscape that, like most of Canada and the western United States in the 1870s, had not yet been absorbed into the space-time co-ordinates of Western civilization. With nationalist pride, O'Brien contributed an engraving after this painting, as well as many other illustrations, to a publication, *Picturesque Canada*, which began to appear in serial form in 1882 as a document, at once patriotic, artistic, and topographic, which could display to both a Canadian and a foreign audience the natural wonders of that country. In this enterprise, he was joined by an artist from across the border, the American Thomas

Moran, who, like O'Brien, specialized in the pictorial record of North American nature, particularly the sublimities of the Rocky Mountains.

Across yet another North American border, the Mexican painter José María Velasco (1840–1912) also adapted the traditions of Romantic landscape painting into a vehicle for expressing his love of his native country, especially as exemplified in his views of the Valley of Mexico, whose panoramic vistas and potent memories of pre-Columbian civilizations he painted again and again, with variations including at times that familiar nineteenth-century symbol of progress, the railway line, which, in this case, connected Mexico City to Vera Cruz. In one of the most luminous and airy of the series, *Mexico* of 1877 (**fig. 382**), Velasco seems to have broken from the compositional conventions of Western landscape in order to offer almost an eagle's-eye view of this thrilling amplitude of nature and history, whose infinite extension is emphasized by the abrupt cropping at all four edges. In the remote distance, the silhouettes of volcanic mountains under the vast sweep of clouds echo the ancient forms of the great Aztec pyramids and, in the foreground, the cactus and the eagle which momentarily soars downward to the sunbaked earth record not only the local flora and fauna but also invoke, as in a nationalist allegory, the traditional symbols of Mexico. As hymns to the cradle of Mexican civilization and the renewed power of the Mexican nation in the late nineteenth century, Velasco's paintings had great international success, gaining him

Fig. 383 **Sir Arthur Streeton**, *Fire's On, Lapstone Tunnel*, 1891. Oil on canvas, 72⅜ × 48¼". Art Gallery of New South Wales, Sydney.

Athens in 1896. Like Velasco or O'Brien, the Australian Sir Arthur Streeton (1867–1943) was intent on depicting the local facts of his country, but he was no less eager to absorb the pictorial modernity of Impressionism. He combined both goals in works like *Fire's On, Lapstone Tunnel* of 1891 (**fig. 383**), a record of both Australian scenery and national progress. Choosing the theme of a railway cutting through a virgin landscape, a motif especially common in the farther reaches of the Western world, he recorded the thunderous moment when a gang of workers in the Blue Mountains of New South Wales shout "Fire's on!" to warn of the imminent explosion used in excavating a tunnel. But this shattering conquest of man over nature almost seems subordinate to Streeton's intense concern with the luminary and chromatic dazzle of what he called the "broiling sun" of Australia, which beat down from the clear blue sky onto the fractured stone. He in fact had been an eyewitness and rapid sketcher of these ear-splitting spectacles and was fascinated, too, by the social life of the railroad workers; but his letter about this expedition is also filled with the kind of visual detail that a Monet would have caught: "the rock is a perfect blazing glory of white, orange, cream, and blue streaks here and there where the blast has worked its force." Functioning simultaneously as a documentary statement of Australian pride in pioneering expansion and as an Impressionist tour de force that, with subtly nuanced, angular brushstrokes, captures the splintered grain of rock under a sunlit glare, Streeton's painting precariously balances a double allegiance to the demands of art and those of popular nationalist identity. For most Western artists, working within already established national traditions, the choice was easier. It was art that won.

Paul Cézanne

In the case of Paul Cézanne, the impulse to construct a pictorial world that corresponded not to public, but to private needs was so powerful that for posterity he has become the holy patriarch of modern painting, the first great master who appeared to reject inherited and shared systems of perspective, of modeling in darks and lights, of anatomical truth, in order to create a visual order that was satisfactory to him and, if necessary, to him alone. His solitude and often tormented introspection were already apparent in such early works as *The Murder* (see fig. 344); and even in 1874, in such revolutionary company as the first Impressionist exhibition, his *Modern Olympia* (see fig. 345) seemed the odd product of a unique, perhaps aberrant sensibility. By the mid-1870s, however, these morbid, erotic imaginings were suppressed in favor of more objective goals, the painting of things seen rather than things dreamed, an ambition largely encouraged by Pissarro. Just as Monet and Renoir would go out-of-doors together to

prizes and retrospectives at one international exhibition after another in both the New and the Old worlds—the Philadelphia Centennial of 1876, the Exposition Universelle of 1889, the Chicago World's Columbian Exposition of 1893. And in his native Mexico, Velasco easily became a national hero, fostering a school of landscape painters who would follow his patriotic lead.

Velasco's intense sensibility to the specifics of light and topography in his own country underscored the sense of a venerable, enduring landscape of breathtaking scope, a vision alien to the Impressionist mode. But in other Westernized countries far more remote from Europe than the New World, even Impressionism could be adapted to mirror the nationalist impulses that burgeoned in the later nineteenth century. Such was the case in Australia, where, by the 1880s, Impressionism became a symbol of advanced international pictorial taste that could nevertheless be reconciled with the need to reflect local pride and the growing national rivalries everywhere, from world's fair displays to the inauguration of the International Olympic Games in

paint the same site, Pissarro would take Cézanne with him to study the landscape of Pontoise and Auvers, rural communities in the valley of the Oise near Paris.

For Cézanne, this reversal of direction from interior fantasies to exterior perception was so pivotal that even in his later years he would refer to himself in a printed catalogue as Pissarro's pupil. But, already in the 1870s, when so many French painters shared common goals, his monumental force and density distinguished him from all others. In *A Farmyard at Auvers* (**fig. 384**), whose putative dating by scholars, 1879–82, reflects the way Cézanne's paintings seem the product of slow and uncertain accretion over weeks, months, and years rather than the immediate response to a perceived moment, the subject appears as impersonal as his earlier subjects appear fraught with personal demons. A humble farmhouse nestled in a landscape

and framed by two nondescript buildings is a motif that would turn up countless times in the work of the Barbizon School, let alone the Impressionists; yet Cézanne transforms this uneventful rural scene into a vehicle for composing a private order that slowly but drastically remolds the language of Impressionism which had provided him with a point of departure. The windswept clusters of ragged brushstrokes that define the earth and the rough, blocky textures that describe the farmhouse's roof and wall may reflect in an awkward, but sturdy way the more felicitous dapplings of a Monet or a Pissarro; yet such passages are immediately contradicted by the weight-bearing vertical and horizontal planes of the buildings, a broad network that imposes a constricting and more enduring order upon what might be a casual scene of light shimmering over the corner of a farmyard. The more one looks, the more such

Fig. 384 **Paul Cézanne**, *A Farmyard at Auvers*, 1879–82. Oil on canvas, 25⅝ × 21¼". Louvre, Paris.

contradictions one finds, as if Cézanne were grappling simultaneously with contrary ambitions. For one, the sunlit, mottled surfaces convey the Impressionists' sense of a moment; yet the imprisoning clarity of the architecture resists the ephemeral. For another, the flickering mesh of brushstrokes, almost palpable in character, creates, as in Impressionist painting, a continuous weave; yet the paired vertical planes in the foreground (the one on the right appearing to be so large and so close to the viewer that the unidentifiable building to which it belongs is cropped top, bottom, and side) imply the framing of a deeper vista, with the trees and farmhouse distant elements. Cézanne here seems to be trying at once to preserve the Impressionists' luminous surface, a network of vibrant paint strokes that dissolves our sense of weight and matter, while at the same time restituting a pre-Impressionist world of gravity-bound, solid forms that can measure out a terrain from near to far. If uniting these antithetical desires seems foolhardy, Cézanne nevertheless espoused them with a long-term energy and dedication that can often feel so passionate that we sense, to use the language of psychoanalysis, that the overwhelming emotions of his belated adolescence have been sublimated to different goals. So it is that, in this image of a strict and stable order, nothing stands still. The stark planes at right and left are defined not by ruler-sharp straight lines but by irregular, slightly tilted edges that exert almost physical pressures upon each other. And the farmhouse, which we know from its size to be distant from these foreground planes and which is clearly located behind a fully modeled tree, joins this strangely animate construct of planar forces by breaking spatial rank. Jamming directly onto the foreground plane at an angle that subtly defies the predictability of a perpendicular axis, this ground-hugging building, which we gradually approach at the left across a stretch of light-filled earth, is suddenly attached to the foreground plane in a head-on collision that obliterates the ground and the space below.

Insofar as he felt that the vibrant surfaces of Impressionism were inadequate to the expression of a more overtly calculated compositional order of regularized and stable volumes and patterns, Cézanne was certainly not alone. Even outside France, artists who were first drawn to the freshness and immediacy of Impressionism in the 1870s began to search for ways to impose more lucid structures within a pulsating screen of paint. For instance, during a long Roman sojourn (1873–79), the Pole Aleksander Gierymski (1850–1901) made many paintings out of doors. But when he tried to synthesize these works in a large painting, *The Arbor*, he was so dissatisfied with the result, which he felt had not attained the proper fusion of light and color, that he destroyed it. Back in Warsaw in 1880, he renewed his efforts in a study for a new version, which ended up being a self-sufficient work (**fig. 385**). Fascinated with the dissolution of light in a natural setting,

Fig. 385 **Aleksander Gierymski**, *The Arbor (Study with Top Hat)*, c. 1880–82. Oil on canvas, 23¼ × 16½". Muzeum Narodowe, Warsaw.

Gierymski nevertheless regiments this Impressionist effect with the diagonal latticework grid of the arbor, which imposes a sievelike grid across the entire background and sorts out the sparkle of green, yellow, and white with mechanical regularity. The sense of geometric lucidity conveyed by this screen of diamond patterns is underscored by the equally lucid statement of solid geometry provided by the perfect cylinder of a gentleman's top hat on a flat plane aligned in tandem with the garden bench. From the light-flooded confusion of plein-air surfaces, Gierymski has surprisingly extracted a preordained structure of measured spaces and volumes.

Cézanne's work, too, has often been associated with the general drive to resurrect the clarity of basic geometric forms after the Impressionists had annihilated these symbols of preconceived order. One of his most often quoted statements, the advice given in a letter of 1904 to the younger painter Émile Bernard that he "treat nature through the cylinder, the sphere, the cone," a familiar precept of the art academies that has often been cited to underline his search in nature for what sound like Platonic

ideals of solid geometry. Yet the evidence of Cézanne's paintings instantly contradicts such generalizations. No contour, no plane, no volume in Cézanne is equatable with any such abstract purities. In the *Farmyard*, for instance, even the presumably straight edges of the buildings quiver, expand, and contract; and parallels, like perpendiculars, are defied by warping shifts of axes that convey not the preconceived forms of geometry or of any inherited perspective system but rather a sense of living, breathing experience in which each shape responds unpredictably to the pressures of its neighbors. Far from being a lesson in geometric rigor, the *Farmyard* creates an indissoluble network of forms that register both the ephemeral sense of changing light and a no less animated, underlying density, as if a complex muscular structure were concealed beneath a membranous surface.

How potent this projection of almost organic forces can be is seen in a small still life of nothing but seven apples on a tabletop (fig. 386), a work again impossible to date with certainty—it is probably from the mid-1870s—and that again seems inevitably incomplete, as if that were the most authentic way Cézanne could express the sense of change, of conflicting impulses with which he wrestled. In attempting to describe such a painting, one is invariably forced into paradoxical assertions, a mirror of the artist's own struggles. If we first sense that each of these apples is individually characterized in terms of bright hues that range from the cool of yellow and green to the warmth of orange and red and in terms of shifting positions that give each one a unique axis and configuration, we may also feel a tug to convey a more generalized assembly of spherical volumes that subordinates the parts to a grander whole. And if we begin to think of pure spheres, we must instantly recognize, too, that no compass could ever create such irregularly rounded, quivering contours as these, the product of long and cumulative contemplations. In looking at the background, which is left so nondescript that we can only guess whether it is bare wood or cloth, we see a plane so vertically flattened that it is contiguous with the picture surface; yet the seven apples, far from being flattened silhouettes, are modeled with such density and weight that they can cast shadows and dent the intractable surface on which they hover so restlessly. As for this modeling, the patches of dark shadow convey a more conventional system of projecting roundness, whereas this effect is simultaneously achieved by another system of modeling in color, dependent on Impressionism, with adjacent patches of unmodulated hues and yellow highlights producing a different structure of protrusion and recession. And if the effect of a sturdy, graspable form is partly achieved, in which each apple seems to be located behind or in front of its neighbor, this illusion is then partly canceled by the insistent continuities of a subtle but powerful sweep of diagonal brushstrokes that, as in Impressionist painting, call our attention to the tangible layer of pigment on the surface and thereby deny our perception of depth. As a result, these apples appear to be pushing forward and backward, competing with each other for prominence as part of a cohesive fabric of broadly brushed paint that works both for and against the illusion of volumes projected in space.

Perhaps the most extraordinary thing in this endlessly complex pictorial world is the strange discrepancy between the subject of the painting and its impact on the viewer. Nothing could be less consequential than these seven

Fig. 386 **Paul Cézanne**, *Still Life with Apples*, c. 1875–77. Oil on canvas, 7½ × 10¾″. The Provost and Fellows of King's College, Cambridge, England. The Keynes Collection.

apples, which are not even arranged according to the conventions of earlier still lifes that offer the spectator a more intricate table setting of varied edibles and utensils. Yet we feel that Cézanne has exerted as much concentration upon this virtual non-subject as an earlier artist might have given to a Madonna and Child. Cézanne, in fact, seems to have constructed in one small painting an entire universe, almost the equivalent of a private solar system in which the seven apples, like planets, exist in an active and external state of magnetic attraction and repulsion. The most turbulent physical and emotional energies have somehow been channeled into what, for another artist, would have been a modest, throwaway painted study.

Such energies, disconcerting in a still life, may appear more appropriate to figural compositions, where facial expressions and the torsions of bone, muscle, and flesh are the more familiar vehicles of the drama of body and emotion. A lifelong copyist of the old masters, Cézanne, in fact, had absorbed a vast heritage of interpretations of the nude, from the sculpture of Michelangelo and Puget to the painting of Poussin and Rubens; and when he himself essayed the venerable Western theme of bathing figures in

a landscape, his images reverberated with echoes of these ancestors. In his *Five Bathers* of 1885–87 (**fig. 387**), we feel both the presence and the loss of earlier narrative traditions, as if the myths of Diana or Venus were distant, elusive presences. In fact, this strange quintet conjures up, without spelling out, an unclear dramatic situation initiated by the emphatically pointed finger of the nude at the left who seems to intrude upon her companions with a message. It might be possible at first to consider Cézanne's group as belonging to a common type of official painting practiced by his contemporaries, a narrativeless assembly of naked bathers in a forest glen whose erotic display of a variety of twisting and turning poses is given a certain propriety by depilating and pumicing their flesh to the perfection of idealized art and by alluding to the repertory of noble postures that descend from classical statuary through the nudes of Titian, Poussin, and Ingres. *Nymphs Bathing* (**fig. 388**), a painting submitted by the esteemed academician William Bouguereau to the 1878 Paris Exposition Universelle, may characterize this popular mode, which here offers a cornucopia of voluptuous nudes who do nothing but swing, wade, bend, crawl, and relax in

Fig. 387 **Paul Cézanne**,
Five Bathers, 1885–87.
Oil on canvas, 25¾ × 25¾″.
Kunstmuseum, Basel.

Fig. 388 **William-Adolphe Bouguereau**, *Nymphs Bathing*, 1878. Oil on canvas, 56½ × 82″. Haggin Museum, Stockton, California.

supine positions before the spectator, presumably male, whose sexual appetite may be diluted here by the strong memories of high art.

Cézanne's nudes echo, at a strange, warped distance, these familiar images of respectable nudity in the 1870s and 1880s; but their troubled and troubling presences belong to another world of form and emotion. One can only guess at the darker meanings of this unclear drama, which resonates with the kind of awkward and disquieting sexual confrontation that Cézanne had earlier explored in *A Modern Olympia* (see fig. 345) or in more traditional themes such as the Temptation of St. Anthony. But this erotic undertow also seems harnessed to other goals that would mold the rounded flesh of these five bathers into a study, at once abstract and emotionally charged, of the physical deadlock achieved, as in the case of the seven apples, by forms of uncommon energy that set up internal dialogues of thrust and counterthrust. Heads turn toward and away from each other as if responding to an unnamed event; classical memories of the newborn Venus are arduously re-enacted by the straining, convoluted gestures of the central figure; anatomies swell and withdraw with the pressures of adjacent forms, whether trees, drapery, or other bodies. The resulting figural distortions would be monstrous by any normative, public standards but appear inevitable within the living network of nude flesh which, as malleable as putty, is constantly reshaped to conform to the dictates of the master's will. Like the seven apples, these five nudes create an utterly private universe, whose bizarre anatomies, suppressed narrative structure, and compacted mergings of figures and landscape would be grotesque and

incomprehensible were it not for the astonishing energy and conviction that emanate from this painting, as from every work by Cézanne, and that force us to re-experience with the artist what feels like the necessary internal logic of a new pictorial world. Some twenty years later, in *Les Demoiselles d'Avignon*, a comparable scene of sexual confrontation, Picasso could use Cézanne's imagery as support for his even more devastating assault on classical canons of beauty and on the conventions of a measured perspective space that could keep the female nude at a safe, unthreatening distance from the viewer. In his very choice of subject—five nude bathers of a mythological pedigree—and in his very choice of structure—an awkward, but powerful suggestion of a monumental pyramid of figures and trees—Cézanne turned his back upon the lessons of Pissarro and other Impressionists, rejecting the empirical world of momentary observation in favor of an art that would resurrect the studied complexities of the old masters. In his impulse, as he put it, "to make out of Impressionism something enduring and solid like the art of the museums," Cézanne was hardly alone.

In the 1880s, Renoir, too, attempted to revive the art of the museums in a large painting, *Bathers* (fig. 389), which he worked on not for the short period of time implied by an Impressionist motif, but for almost four years, between 1884 and 1887. Already in 1881, he had visited not only Algiers, where he could experience firsthand the luxuriance of flesh and color that had earlier excited Delacroix, but more to the art-historical point, Venice, Florence, Rome, Naples, where a venerable Italian tradition, from the frescoes of Pompeii to the Madonnas and nudes of Raphael,

Fig. 389 **Pierre-Auguste Renoir**, *Bathers*, 1884–87. Oil on canvas, 45½ × 67″.
The Philadelphia Museum of Art, Pennsylvania.

inspired him to absorb the achievements of the past. In 1884, he even turned to theory, writing a proposal to found a new "Society of Irregularists" for artists of all kinds, from painters to goldsmiths, who, like Renoir, believed that art, to be beautiful, must deviate, like nature, from any absolute geometries, and must reject the machine-made, regularized forms of the industrial world in favor of overtly hand-made, irregular forms that reflected the infinite variety and complexity of nature. In the *Bathers*, many of these new goals are apparent. The subject itself belongs to the domain of Bouguereau's *Nymphs Bathing*: a display of female nudes who splash and frolic in and out of the water in a forest that looks so remote from the particularity of a landscape in the Paris suburbs that, as in Corot's late landscapes, nymphs might be found dwelling there. Moreover, Renoir adapted the figural composition from a relief structure at Versailles by the seventeenth-century master Girardon, offering, as it were, a point of comparison for his 1880s updating of tradition.

His synthetic ambitions are, in fact, clearly apparent in the abrupt discrepancy of styles within the painting. The nudes, unlike his cottony figures of the 1870s (see fig. 342), seem to be chiseled by contours firm enough to pass muster

in Ingres's academy; and their paint surfaces have a dry, bleached quality that evokes the look of the Pompeian and Renaissance frescoes Renoir admired in Italy. The landscape filling, however, has a spongy, impalpable texture that consolidates the warm chromatic fusions of his Impressionist brushwork. Analogous to Cézanne's *Bathers*, the spatial effects are also contradictory, implying great distance in the swift diminution of the wading, swimming figures at the right, but also creating, as in the seventeenth-century source, a cameo-like sense of relief modeling in which the figures appear embedded in a shallow background. Furthermore, these bathers also suggest the loss of a mythical subject that might identify them as, say, the nymphs of Diana or the nereids of Amphitrite and that might explain their gestures. Nevertheless, Renoir's *Bathers*, unlike Cézanne's, conveys an aura of direct, almost carnal sensuality that extends to their rounded young faces which, in this idealized environment, have a surprisingly contemporary cast. Their Parisian charm is utterly remote from the blunted, incomplete faces of Cézanne's bathers, whose features are brutally effaced by the directional energies of his rhythmic brushstrokes. Renoir's painting, in fact, was well received by the public, if

not all the critics, when it was exhibited in Paris at Georges Petit's gallery in 1887; for it offered a comforting affirmation of the possibility of being both modern and traditional. Cézanne, who had been rejected by the Salon throughout the 1880s, might well have wanted to show his *Bathers* to a Paris public, too; but even were a gallery courageous enough to show his work, it would have undoubtedly been greeted with puzzlement and outrage. His efforts to resurrect the great constructive tradition of the ideal nude within the new fabric of Impressionist pigment produced a tortuous, if heroic world, whose compelling integrity and strength were first recognized only by a small, but growing, circle of artists and writers.

Outside France as well, there were aspirations to revive the monumental nude during the 1880s. The most conspicuous example was in the work of Cézanne's German contemporary Hans von Marées (1837–87), who, after serving in the Franco-Prussian War, was called to Naples in 1873 for a decorative commission in the German Marine Zoological Station and then remained in Italy until his death. Like Feuerbach and Böcklin (see figs. 258 and 336), he became a symbol of a German longing for a classical, Mediterranean world; and the three painters were, in fact, later categorized as "German Romans." As German art

historians have often seen it, Marées also offers important parallels to Cézanne, attempting as he did to give new life to the old masters' noble images of idealized human forms in a landscape that evokes a remote, Arcadian setting. But compared with Cézanne, his ambitions were more public and literal in character. In *The Hesperides* (**fig. 390**), a huge triptych more than fifteen feet wide which occupied Marées between 1884 and 1887, the structure, like the subject, is more overtly intelligible than in any of Cézanne's figural compositions. Here, the format of a triptych over a painted socle establishes a hierarchic order familiar to Western art, both sacred and secular, and the elemental alignment of lucid parallel and perpendicular rhythms in the trees, figures, and earth, also establishes, as in the work of Puvis de Chavannes (see fig. 257), a sense of archaic simplicity and harmony. The central subject, too, is legible in its depiction of the garden of the Hesperides, where three beautiful maidens guard the golden apples that, as symbols of love and fertility, were the gift of Earth to Hera on the occasion of her marriage to Zeus and would figure in many classical myths.

In the side panels, an evocation of the Golden Age, the classical counterpart to the Garden of Eden, is offered. Marées's technique also conjures up a nostalgic realm of

Fig. 390 **Hans von Marées**, *The Hesperides*, 1884–87. Oil and tempera on wood, 11′ 2″ × 15′ 10″. Neue Pinakothek, Bayerische Staatsgemäldesammlungen, Munich.

remote beauty, for he imitated old-master techniques of multiple layers of oil paint (here on a tempera ground), which, in the traditions of Venetian painting, blur contours and bathe the scene in a warm, resonant glow. As in Cézanne's work, clarity of detail disappears behind dense and vibrant paint surfaces that create a sense of slow, quiet growth over a long period of contemplation; yet Marées's evocation of the mysteries surrounding a distant myth of classical serenity is, by Cézanne's standards, accessible and untroubled, a public reverie upon a lost paradise rather than a personal struggle to assimilate the great traditions of Western art and myth within a private world that would obey the dictates of both intense perception and disturbing emotions.

For Cézanne, the nude figure, which he generally painted and drew from photographs and earlier works of art rather than from the living model, bore weighty and clandestine psychological burdens; but his ambition to synthesize Impressionism with the art of the old masters was usually attained with less overt strain in the realm of landscape. As a native of Aix-en-Provence, where, apart from

extended visits to Paris, he lived in seclusion on his family estate, he was more at home with the blue skies, mountainous terrain, and broad vistas of sea and earth in this Mediterranean climate than with the more fugitive, one might say Impressionist, weather of northern France. Like many other painters of the region, he was attracted to one of its great sites, the Montagne Ste.-Victoire, a nearby mountain fraught with ancient memories of Gallic nationalism, for it was there, in 102 B.C., that the Roman general Caius Marius defeated the invading Teutons. Cézanne, in fact, was to depict the mountain's majestic presence more than sixty times in drawings, watercolors, and oils from the 1880s until his death in 1906. Like Monet, who, as in the Gare St.-Lazare series of 1877 (see fig. 353), would choose a motif and paint it at different moments in time and often from changing vantage points, Cézanne was also drawn to the idea of serial paintings as a way of recording what seemed a world of constant flux. However, the tempo of change in his art is slow and meditative, and each account of this great mountain seems not the record of a moment, but the long-term observation of processes of growth and

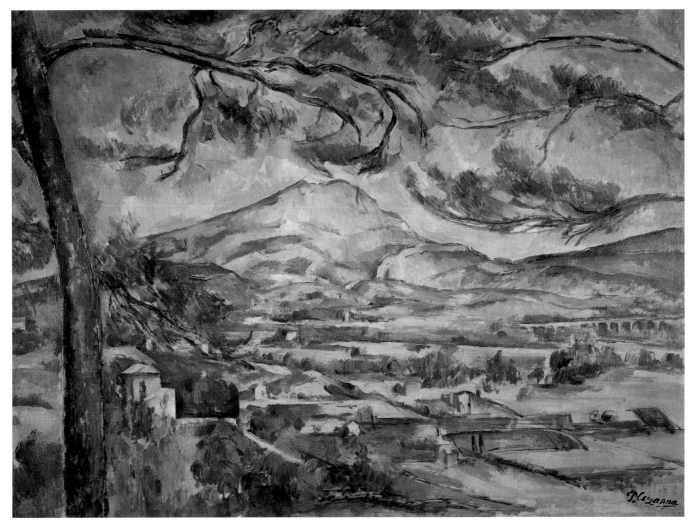

Fig. 391 **Paul Cézanne**, *Montagne Ste.-Victoire*, c. 1885–87. Oil on canvas, 26⅜ × 36¼″. Courtauld Institute Galleries, London.

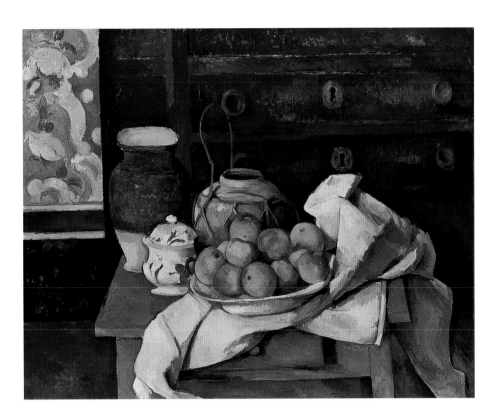

Fig. 392 **Paul Cézanne**, *Still Life*, c. 1883–87. Oil on canvas, 29½ × 34¾″. Neue Pinakothek, Bayerische Staatsgemälde-sammlungen, Munich.

change that pertain to the realms of both psychology and biology.

In one of the most overtly ordered and stable of this series, a version of *c.* 1885–87 (fig. 391), which he must have worked on simultaneously with the *Bathers* and many other oils of the mid-1880s, we feel at once the amplitude and grandeur of a panoramic vista of nature that, framed by a pair of trees, carries us from a foreground hill across a low valley to the distant heights of the mountain range, a construction common to earlier nineteenth-century images of the scene by local painters in Provence. But this exalting expansiveness then begins, bellows-like, to expand and contract, as if the objective facts of measured space were conforming to the subjective facts of an individual scrutiny of the sensations that interlock both the smallest perceptions of changing, luminous detail and the broadest, dominant rhythms of the whole. The warm, sunbaked colors of the Provençal landscape first affirm this illusion of traversing a vast valley, for the deep green hues of the foreground gradually fade and soften into the smoky blue mountain range. Once this remoteness is attained by the mind's eye, however, it ambiguously fuses with landscape elements presumably at arm's reach. The sturdy vertical of the tree trunk at the left, whose cropping, top and bottom, contributes to the sense of breathtaking scale, is painted in softer, bluish tones analogous to the mountain, and the irregular patches of green-leaved branches that extend from it perplexingly merge with the dappled green foothills at the mountain's base. Similarly, the craggy, curving contours of the mountain silhouette are echoed in the no less irregular pattern of the branches that frame our view at the right, so

that extremities of near and far seem merged in a surface design that cancels the traditional illusions of systematic perspective and that transforms voids into animate planes that, like a web, connect all spatial points in a continuous network.

Yet nowhere do we feel that Cézanne has imposed a formula upon nature. Each brushstroke, whether it refers to the earth-colored planes of the tilled soil, to the walls and roofs of the cubic houses, or to the changing luminosity of a sky that seems to vibrate in response to the near branches above it, appears the result of both an intense, on-the-spot perception and the adjustment of this experience to accommodate an overriding order that belongs both to nature and to art. And even the broken touch of these brushstrokes, the inheritance of Impressionism, conveys not only a sense of the physical weave of pigment that unites these disparate elements of landscape in an intermeshed whole, but also a truthful record of a response to nature that must necessarily be left unfinished in order to register the quality of endlessly subtle changes within the more enduring verities of earth, rock, and sky.

The luminous atmosphere of Cézannes's landscape paintings often veiled the turbulent energies that are more overtly visible in the still-life paintings of the 1880s. Constricted within the shallower space of a room, the densities of the inanimate studio props that the master would arrange in an ostensibly stable order would reveal more emphatically the marks of the perpetual struggle to appease so many simultaneous demands of art and experience. To the innocent eye, a typical still life of *c.* 1883–87 (fig. 392) may be a model of simplistic art-school ideas of equilibrium,

with its hierarchic clarity in the placement of the rounded ceramics, from the high vase and squat ginger pot (which figures in so many of Cézanne's still lifes) to the low dish filled with apples, and with its calculated interplay between these rounded, spherical forms and the flat planes of the background and crudely centralized table. Yet, within this seemingly naïve symmetry and balance, the objects begin to strain against one another and within themselves in a manner that turns this static arrangement into a field of muscular, pliant forces. Against the restricting rectilinear patterns of the rear plane, with its perpendicular alignments of a strip of wallpaper and the drawers of a large chest, the still-life objects appear almost to squirm and reshape themselves. The lips of both the vase and the ginger pot, rather than appearing elliptical, as they would by conventional perspective laws, are flattened into oblong shapes, as if reacting to the pressures of this grand,

rectilinear design; and the tabletop itself, which begins at the left with the head-on view of a centralized perspective scheme, re-emerges under the tumble of apples and cloth on the right at a different, subtly oblique angle, as if it had been slowly wrenched away from the static laws of rational measurement into the dynamic realm of subjective experience. Here, the angle of vision slowly shifts to the right in a painful, but inevitable rejection of systems of perspective construction shared by Western artists since the Renaissance. What begins as an almost inertly stable structure ends by registering a subliminal earthquake of multiple forces that dare to warp and bend spaces and volumes to conform to the truths of Cézanne's, and no one else's, perceptions. It is hardly a surprise that these difficulties could be so insurmountable to his contemporaries that the state refused to accept the Cézannes included in the Caillebotte bequest of 1894; and that it was only in the following year

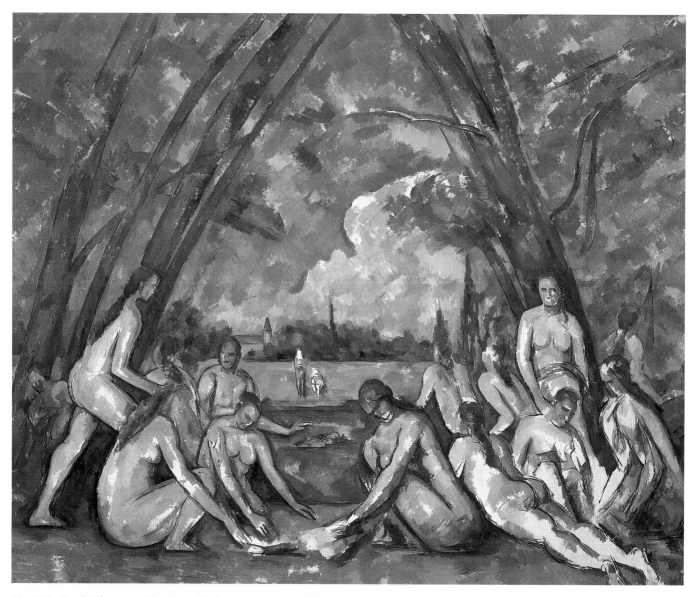

Fig. 393 **Paul Cézanne**, *The Large Bathers*, 1898–1905. Oil on canvas, 82 × 98″. The Philadelphia Museum of Art, Pennsylvania.

that the brilliant Parisian art dealer Ambroise Vollard would have the audacity to give this strange genius his first one-man show, an exposure that marked the begining of the deification of Cézanne by a younger generation of artists who felt liberated by the master's courage in creating the most private, yet monumental of pictorial universes.

Cézanne's intense introspection, however, was never deflected by the growing public recognition of his work, which was even included in the survey of French art shown at the 1900 Paris Exposition Universelle. In the 1890s and until his death in 1906, his art, like his life, became more hermetic, probing further into earlier themes of landscape, still life, and the nude which he had slowly defined for himself in the 1870s and 1880s. He would often, for instance, restudy the Montagne Ste.-Victoire, as Monet, in the 1890s, would re-examine the same motif—grainstacks, poplars, a cathedral facade—and he would return again and again to the theme of nude bathers with which he had struggled throughout the 1880s. In the last decade of his career, it was this theme that corresponded to his most exalted ambitions and he worked simultaneously upon it in two major canvases, one of which, begun in 1898 and still under way the year before his death, was to be the largest painting of his entire career (fig. 393). In a Proustian recall of life and art, this final triumph resonates deeply, its crammed abundance of female nudes at the water's edge evoking the more overtly awkward and erotically charged bathers of the 1880s (see fig. 387), and its ascendant vaults of trees even restating the pairs of chestnut trees that lined the approach to his family estate at Aix. And just as the grandly pyramidal symmetries perpetuate here the author-ity of old-master compositions, so, too, do certain elusive passages—a pointed finger above a swimmer, the rapt con-centration of the central group upon some illegible object or activity—remind one of a distant pictorial heritage in which dramatic events might unfold. Yet these public and private memories are finally absorbed by an overwhelming ampli-tude of visual order. Here, the arcing trees, like the nave of a Gothic cathedral, carry so broad and so forceful an upward thrust that their energies not only continue above the frame but carry with them the bathers' bodies, which must twist, merge, and strain to conform to these dominant rhythms. Yet the underlying tumult of Cézanne's earlier art at last seems resolved, for figures and landscape, light and substance are fused in an indissoluble whole, whose almost translucent, shimmering surfaces of softly fractured planes resurrect the goals of Impressionism without sacri-ficing the master's ongoing pursuit of a graver, denser struc-ture of major and minor forms.

Such a transcendent visual order could even conquer, in Cézanne's late work, the forces of death, as symbolized by the paintings and watercolors of the skulls which he scruti-nized in the studio he built outside Aix after the death of his mother in 1897 and the consequent sale of the family

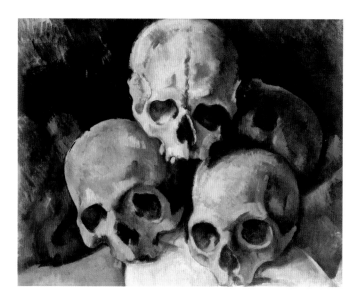

Fig. 394 **Paul Cézanne**, *Three Skulls*, 1898–1900. Oil on canvas, 14⅝ × 17⅞". Private collection.

estate. Whether he chose to focus upon the bald presence of one, two, or three skulls, the results, as in a painting of 1898–1900 (**fig. 394**), produce a surprising synthesis of opposites: a disturbing image which might have had the gruesome impact of, say, Vereshchagin's allegorical pyramid of skulls (see fig. 337), and a search for a visual coherence so intense that these traditional associations are almost suppressed. Though this simple trio of skulls may well have had a personal significance for the master in what were to be the last years of his life, this allusion to death, like the allusions to sexuality in the nudes or, more obliquely, as has been suggested, in the apples, is finally subordinated to the dictates of perception and of art. Here, the spherical protrusions and hollows of these grisly human relics are swallowed up in a dense, but luminous agitation of flickering surfaces that merge with their neutral setting as if they were only a trio of bowls or rounded fruit that the artist had used for abstract ends. This, indeed, was the interpretation of Cézanne's work that would mythologize him as the first modern painter and that would liberate many twentieth-century artists to fracture further his apples, nudes, or mountains, or to distill them into Platonic ideals of form. Yet, if Cézanne, like all great artists, could nurture future generations, he was nonetheless an artist of his own century, sharing with many of his contemporaries a belief that painting should record faithfully his own per-ception of the seen world, while attempting to wed these truths to the weighty traditions of the old masters.

Georges Seurat and Neo-Impressionism

Such ambitions, of course, might apply to many nineteenth-century painters, from Constable and Turner to Millet and

Manet, but the impulse to return to tradition was particularly urgent in the 1880s, when so many artists felt that Impressionism, while offering an exhilarating freshness of visual truth, finally obliterated more than it restored, denying, so it seemed, the values of a more timeless, calculated order that could encompass far more than the instantaneous experience recorded with the blinking of an eye. Of those artists who wished to graft Impressionism onto the tree of old-master tradition, none was so systematic and so immediately successful as the short-lived Georges Seurat (1859–91), who, dying before his thirty-second birthday, neverthless left a decade's work whose monumental achievement can rival even Cézanne's.

Precocious from the beginning, Seurat was his own master by 1880. In 1878–79, he had studied at the École des Beaux-Arts with an Ingres disciple, Henri Lehmann, who trained him in classicizing figural traditions; but then, in 1879–80, during a year of military service, he quickly turned to the world around him, making drawings of maritime life in Brest, the Breton coastal city where he was stationed. Like many other Parisian artists, he painted scenes of both city and country, and his first small painted sketches and drawings of 1880–83 oscillate beween these polarities. In *Farm Women at Work* (fig. 395), an oil sketch

of c. 1882, his unique stamp can already be felt. The subject itself belongs broadly to those images of agricultural labor that became so common after 1848; but more specifically, it is Millet's *Gleaners* (see fig. 223) that provides a point of departure. Although this working-class subject, like the stonebreakers Seurat painted at the same time, may still evoke the social issues so conspicuous in paintings of the 1850s, the emphasis here is upon an almost diagrammatic reduction of Millet's broadly rhymed peasants, their backs even more firmly arched toward the earth. More like robots than people, Seurat's farm women are at one with their landscape, which is similarly schematized into broad horizontal striations of sunlit grass and shadowy furrows.

Such strict, mechanized patterns and movements announce Seurat's mature pictorial ambitions. Moreover, the calculated regularity of the brushstroke, which resembles what has been described as "chopped straw," becomes an ally in his equally methodical exploration of scientific ways to capture in pigment on canvas the blaze of natural light and color which the Impressionists had sought intuitively through rapidly applied, irregular dabs of high-keyed hues. In his effort to find a rational basis for achieving such goals, he had read, for instance, Ogden Rood's *Modern*

Fig. 395 **Georges Seurat**, *Farm Women at Work*, c. 1882. Oil on canvas, 15⅛ × 18¼".
Solomon R. Guggenheim Museum, New York.

Fig. 396 **Georges Seurat**, *Place de la Concorde, Winter*, c. 1882–83. Conté crayon and chalk, 9⅛ × 12¹/₁₆″. Solomon R. Guggenheim Museum, New York.

Chromatics in a French translation of 1881, as well as treatises by the Frenchmen Charles Blanc and Eugène Chevreul, which also treated the question of how light could be broken down into component colors and how our sensations of color were heightened by the simultaneous presence of a complementary hue (orange, for example, intensifying the effect of blue). From such texts, he began to evolve his own system of disciplining Impressionist techniques into more predictable results, determining, for instance, how a local color should contain certain proportions of other colors (such as the orange and yellow of sunlight, or the reflections of adjacent colors). These meticulously measured recipes could theoretically be calculated in advance and would presumably produce more intense optical vibrations by using ever more regularized and minuscule brushstrokes.

In his black-and-white drawings, too, this fascination with the phenomena of light and this search for a stabilizing structure are no less apparent. In what at first seems the most casual drawing of the *Place de la Concorde* (**fig. 396**), probably executed in the winter of 1882–83, the strong sunlight he hoped to replicate with pigments is replaced by the gloomy effects of twilight on a snowy day, with results that parallel Whistler's refined perceptions of the veiled atmosphere of London at dusk. Yet, despite what seem the irregular scratchings of a velvety conté crayon that convey the

murky darkness enshrouding the fountain at the left or the scribble-like marks left by carriages on the snow, an ordered, rhythmic beat begins to dominate. The lampposts, in tandem with the horizontal strata of this vast Parisian traffic hub, measure out a network of rigorous parallels and perpendiculars that surprisingly create a strange melancholy, as the lone carriage moves out of our view and leaves these grandly ordered spaces empty and abandoned in the snow and gas-lit haze. Already in so modest a drawing, Seurat's urban poetry, often ignored in favor of his conspicuous adaptation of quasi-scientific methods, can be savored.

His aspirations, however, were rapidly scaled to the masterpieces of Western painting and to the walls of the Salon, which in 1883 accepted two of his small portrait drawings and which he hoped would accept, the following year, a huge painting (some ten feet wide) that he was preparing with a large battery of drawings and small oil sketches, *A Bathing Place (Asnières)* (**fig. 397**). In many ways, these preparations were for Seurat a rapid course in Impressionism, for he chose an outdoor theme, the banks of the Seine in a Paris suburb, and made on-the-spot studies which recorded the immediacy of the movement of figures, boats, water. But these individual studies, which for an Impressionist might have been the pictorial ends, were for Seurat only the means to grander goals. With infinite calculation,

Fig. 397 **Georges Seurat**, *A Bathing Place (Asnières)*, exh. Salon des Indépendants 1884. Oil on canvas, 6′ 7″ × 9′ 11½″. National Gallery, London.

he synthesized these observed fragments of experience into a composite whole that appears, in every last detail, the final, inevitable distillation of countless possibilities. In this, he reaffirmed the meticulous, intellectualized working methods of such masters of the French classicizing tradition as Poussin, David, and Ingres, deities whose noble structural order Seurat so often invoked in contemporary terms.

This pedigree, however, was not obvious enough to the 1884 Salon jury, which rejected Seurat's canvas, whose museumworthy ambitions, like those of Renoir's *Bathers* (see fig. 389), clearly called for a large public audience. The timing was nevertheless fortunate; for in the same year, in response to the Salon's conservative taste, a large group of rejected artists formed a Société des Artistes Indépendants, which, following the Impressionist group, would sponsor regular exhibitions, uncensored by a jury and therefore open to greater innovation. Althogh it was poorly displayed (it was hung in the bar), *A Bathing Place (Asnières)* could at least be included at the first Salon des Indépendants, which opened on May 15, 1884 and which included works by four hundred and one artists whose names, with the fewest of exceptions (Seurat, Signac, Redon), were soon forgotten.

In one way, everything about this painting was topical and contemporary; for it represents a specific site on the Seine in the growingly industrial suburb of Asnières, where Raffaëlli had also found themes from working-class life (see fig. 363). The background, with its view of a railway bridge and the factories at Clichy (whose smoke is visibly polluting the air), could hardly be more specific; and the seeming casualness of the men and boys who relax in or by the river, while sailboats, a sculler, and a small ferryboat go by, contributes to the effect of a random cross-section of a sweltering summer day, where physical exertion is minimized to near inertia. Yet the disposition of not only the figures, but every last smokestack, sail, or tree, is so willfully controlled and interrelated that this slice of working-class leisure is miraculously transformed into a remote idyll. One of Seurat's contemporaries, in fact, called the work "a fake Puvis," recognizing the rapport with Puvis de Chavannes's images of elemental harmony and serenity in some archaic, classical world (see fig. 257), and the point was apt in many ways. Seurat, like any artist of the 1880s, was aware of Puvis's ubiquitous mural decorations in France, and he seemed to re-create these dreams of terrestrial paradise in contemporary terms, finding inspiration as well in Puvis's

lucid compositional order which would align figures and landscape in the simplest relationships of parallels and perpendiculars, of profile and frontal views. These basic geometries, which also evoke the archaizing clarity of that quattrocento master Piero della Francesca, whose work had become known through copies at the École des Beaux-Arts, were explored and refined by Seurat in what finally becomes an enclosed system of clockwork intricacy. The incisively contoured arcs of the backs, for instance, carry one's eye, as in a theme and variations, from foreground to background and from water to shore; the absolutely vertical configuration of the white sailboat at the right is then varied by the form of the adjacent tree, which obligingly tilts inward to bring us back to center stage; the seemingly irregular contours of the discarded clothing in the foreground rhyme with the neighboring contours of the supine man who tidily fills the triangular corner at the lower left (mirrored in turn by the triangulation of his watchful dog); and so on, in a myriad of permutations and combinations. Despite these calculations of related planar and modeled shapes, the painting surprisingly conveys a luminous amplitude of outdoor sunlight and atmosphere, in which the heat, the languor, the glare of a summer day are as instantly present as in many Impressionist canvases. Yet Seurat's efforts to systematize the techniques of Impressionism are already evident in the brushwork of the greenery, the sky, the water. The grass of the riverbank, with its mixtures of yellow, orange, green, blue, and white hues, is as neatly shredded as the contents of a lawn mower; and the surfaces of the water, which catch reflections of everything from the blocky, utilitarian geometries of the factories to the furled French tricolor in the ferryboat, are applied with so regularized a white, blue, and green horizontal stipple that they look more like a product of the textile industry rather than the hand-stitching of an Impressionist weave of paint.

In many ways, Seurat's goals paralleled Cézanne's in the 1880s; for both artists were trying to perpetuate the gains of Impressionism while reviving pre-Impressionist goals of carving out images of depth where figures could be arranged in an interlocking order. And in the case of both artists, the rejection of inherited perspective systems meant the creation of new private systems to conjure up illusions of depth while maintaining the Impressionist inheritance of

Fig. 398 **Thomas P. Anshutz**, *Ironworkers: Noontime*, 1881. Oil on canvas, 17 × 24″. The Fine Arts Museums of San Francisco, California.

an insistent surface pattern in which visible brushstrokes play a material role. As in Cézanne's landscapes and bathers of the 1880s (see figs. 384 and 387), near and far are simultaneously evoked and contradicted. Here, for instance, the figures diminish swiftly in size along the receding riverbank, and the colors of the factory complex seem softened in the hazy distance; yet the flat white silhouettes of distant sailboats and houses connect visually with foreground shapes and light values, and the horizon is so high that the major forms below it become flattened patterns. Indeed, these figures, many of whom echo the postures and sleek surfaces of the ideal nudes propagated by Ingres and his disciples, seem modeled as shallow reliefs. Their obverse sides, even when suggested by, for example, the halo of white light around the central seated figure, are finally denied the rounded volume created by traditional modeling and perspective systems. Yet for all the parallels one can draw between Seurat's and Cézanne's efforts in the 1880s to reconstruct, upon Impressionist foundations, a monumental art, their visual and psychological temperaments separate them irrevocably. Already in his first major painting, Seurat, too, created a uniquely personal universe of form, an intricate, but finally serene harmony that seems

the product of a master chess player who has thought out every move. But here, as always, Seurat's quasi-scientific faith that art can be created through rational systems of color, geometry, even emotion—a faith so unlike Cézanne's lonely dependence on the truths of his own sensations before nature—is tempered by a strange poetry, an uncanny, even melancholic stillness and silence that totally transcend the prosaic modern subject.

It is worth noting that even on less lofty levels of achievement, there were comparable attempts in the 1880s to transform essentially working-class themes into figural groupings of almost systematic rigor. So it is in what has become a famous American painting, *Ironworkers: Noontime*, by Thomas P. Anshutz (1851–1912; fig. 398), a student of Eakins (see figs. 350 and fig. 365). Like *A Bathing Place*, it offers an industrial scene with factories and anonymous figures who are seen washing up for their noontime lunch break. Yet far from being only a document of working-class life, the painting proposes an almost abstract compositional order. Anshutz, like his master, was a scrupulous student of anatomy, and in 1880, when he was in Wheeling, West Virginia, he made many studies of workers from an iron foundry. However, in the painting,

Fig. 399 **Georges Seurat**, *A Sunday on the Grande-Jatte—1884*, 1884–86. Oil on canvas, 6′ 9″ × 10′.
Art Institute of Chicago, Illinois.

SEURAT AND POINTILLISM: THE DOT AS MARXIST MATRIX

Can a method of applying paint in itself be political? This is an issue that was debated in Georges Seurat's time and has been since. It is well known that Camille Pissarro was an active member of anarchist movements in France in the period and that Seurat hovered on their periphery. The debates first launched about Courbet's realism in the 1840s and 1850s resurfaced in this period. Seurat was developing a practice far removed from the polish of academicism, the crudeness of Realism, and the elegant if broken brushwork of Impressionism. At the same time, he was depicting subjects of seeming inconsequence on a grand scale. Do these features amount to a radical political agenda?

Seurat's contemporary, Paul Signac (1863–1935), alluded to this agenda in the publication La Révolte *in June 1891, shortly after Seurat's death:*

...[artists] by the synthetic represen-
tation of the pleasures of decadence
(*bals, chahuts*, circuses) in the manner
of Seurat (who felt so acutely the
degeneracy of our age of transition)
... will bring their testimony to the
great social trial that is underway
between the workers and capital.[73]

Stephen Eisenman has built upon this conception of Seurat's practice. The technique of Pointillism divorces the painter from his work just as factory work divorces the laborer from the fruits of his creation:

Indeed, for Seurat and the Neo-
impressionists, as for few other
artists of the time, the division
between the physical creation and
intellectual cognition of the artwork
was nearly absolute. Painted in
discrete dots of color, applied
according to a preconceived system,
Neoimpressionist pictures are a kind
of exaggeration or parody of the very
type of industrial and alienated labor
then expanding in France, in which
workers see no relationship between
their individual work-gesture and the
final product. To what, then, can be
attributed the sense of alienation and
isolation perceived by contemporary
and subsequent critics of the *Grand
Jatte* [see fig. 399]? Precisely this:
that it was a picture which sought to
discover and employ a rationalized,
esthetic formula for the represent-
ation of idleness, quietness, and
pleasure. Short of a revolution in

daily life and labor, these two halves
could not make a whole; the result
was parody.[74]

Finally, the contemporary art historian T.J. Clark has well summed up the radical, incendiary power of the dot:

What the dot seemed to promise,
at least for a while, was a truly naive
visualization of the singular and
uniform as the same thing. The dot
exploded the opposition. And this
was wonderful. It planted a bomb
in the middle of the bourgeois idea
of freedom – and order, and
individuality, and Art-ness, and taste
and "touch," intuition, variety,
expressiveness. All the aesthetic
categories of the nineteenth century,
including most of the modernist
ones, disappeared down the black
hole of Seurat's technique.[75]

For Clark, Seurat's pointillist technique, which the artist saw as a new, pseudo-scientific artistic principle, in the end was nothing of the kind, but a purifying, almost mechanical, approach to making art that presaged aspects of twentieth-century modernism and abstraction.

completed in 1881, these individual poses are locked together in a tautly rectilinear network of profile and frontal postures that are starkly consonant with the bare, hard-edged geometries of the factory buildings which dominate the funneling space. Unlike Seurat, Anshutz, following Eakins, espouses traditional systems of modeling and perspective; yet even within these Renaissance conventions, so thoroughly annihilated by the Impressionist generation in France, the impulse toward a new kind of constructive order, at one with the functional, modular forms of the industrial age, can be felt.

The most awesome construction that would mirror in art this growing sense of belt-line, machine-made regularity is also Seurat's most famous painting, which Parisians first saw in May 1886, at the eighth and last Impressionist exhibition, under the title *A Sunday on the Grande-Jatte—1884* (fig. 399), the date referring to the year Seurat began work on this canvas, whose imposing dimensions—about seven by ten feet—almost exactly duplicate those of *A Bathing Place*. In fact, the painting, executed in two long campaigns

between 1884 and 1886, may well be thought of as a successor, even a pendant, to the earlier masterpiece, reflecting similar paintings that contrast upper- and lower-class leisure shown at earlier salons. The title specifies another time of leisure, Sunday, and another place on the Seine, a sliver of an island whose tip is visible at the upper right of *A Bathing Place*. As if we had moved along the river from this industrial suburb to another social layer of Paris, this second masterpiece shows us not workers and factories, but a cross-section of elegant Parisians who, like tailors' dummies in the city's booming new department stores, display their Sunday best. Manet and Monet, among others, had already been inspired by contemporary fashion illustrations when painting figures in chic modern clothing, and Seurat followed their lead, insisting here on the artificially stiff and protuberant silhouettes popularized by the corsets and bustles of the 1880s. Yet Seurat's recognition of the time-bound modes of nineteenth-century costume is countered by a figural order of such timeless abstraction and immobility that many of the preclassical antiquities of

the Louvre—from the archaic Greek Hera of Samos to the statues and reliefs of Egypt and Mesopotamia—appear magically reincarnated in the unlikely environment of a Paris Sunday of 1884. For some viewers, then as now, what was most prominent in the *Grande-Jatte* was exactly this imperturbable, archaizing order. For others, among them Seurat's friend the critic Félix Fénéon (see page 421), what was no less important was the full-scale demonstration of new, quasi-scientific theories of painting, which explored what Seurat called Divisionism, by which colors would be divided, or broken down, into their separate component parts, as well as the technique of Pointillism, that is, the application of pigment in atomic dots, or points, of paint, almost microscopic units from which the vast whole would be constructed.

It was, in fact, Seurat's unique genius to be able to synthesize both the most distant dreams of a hierarchic, yet harmonious society, with a no less acute sense of a modern scientific world of industry and progress, as a result of which the *Grande-Jatte* reverberates in countless directions, past and present. If on the one hand, it looks back to the nineteenth century's countless utopian images of the Golden Age, a land of milk and honey, it also summarizes countless Realist efforts, from Ford Madox Brown's *Work* (see fig. 249) to Manet's *Concert in the Tuileries* (see fig. 271), to present a cross-section of modern society, right down, in Seurat's case as in Brown's, to the dogs in the foreground which, mongrel and pug, symbolize different social classes. Similarly, the monkey on the leash may be associated with a traditional symbol of licentiousness, a reference perhaps to the demi-monde origins of its now ramrod-backed mistress who, accompanied by her top-hatted cigar-smoking gentleman friend, dominates this upper stratum of middle-class society like a royal spectator on a day of official pageantry.

These sociological details, the heritage of the Realist and Impressionist generations, are nevertheless metamorphosed into a new image of humanity, society, and nature, which now has science and the machine as its presiding muses. Flattened into frontal and profile silhouettes against the steep ascent of the land, the water, and the distant riverbank, these park visitors look like an army of robots manufactured from geometric, modular parts which, like the arcs of the bustles, the umbrellas, and the sailboat, almost seem interchangeable. Caillebotte, in his *Paris Street: Rainy Weather* (see fig. 358), captured these rhythms of an industrial society, but even his Parisians, though regimented, are made of flesh and blood. In Seurat's inorganic world, even the grass looks like Astroturf, as if the dappled greenery recorded so exuberantly by the Impressionists had been synthesized by modern chemistry and machinery to provide a landscape environment suitable for these toylike automatons. The trees, too, contribute to this strange, dollhouse scale and imagery, their thin, leafless

trunks creating a weightless, decorative screen of vertical accents that belie the monumental gravity implied by the foreground figures. Within this mechanized republic, every citizen, from the pipe-smoking, bare-armed boatsman in the lower left corner to the parents who fondle their white-clad infant in the right distance, is subject to the tyranny of Seurat's laws, which increasingly polarize options—parallel or perpendicular, straight or curved, standing or seated, single or paired. Far more intricately and rigorously ordered than *A Bathing Place*, which, in comparative terms, still conveys the openness and freedom of nature, this new universe ticks like a Swiss watch, an immaculate image of modular precision consonant with the decade's faith in technological progress. Like a machine, Seurat himself, being able to determine in advance the exact chromatic components of all portions of the canvas, could work almost mindlessly into the night, by artificial light, thereby rejecting totally the Impressionist principle of the artist's immediate, instinctive response to the perceived world.

Seurat's faith in the rational methods of the Industrial Age makes the *Grande-Jatte* a kind of Eiffel Tower of painting, and it is telling that when that monument was erected on the occasion of the 1889 Exposition Universelle, Seurat rushed to make a small picture of it, even before its completion (while defenders of traditional beauty bewailed it as a monstrous eyesore that defiled their city). As such, the *Grande-Jatte*'s vision of a mechanized utopia could inspire many twentieth-century dreams of Brave New Worlds, most conspicuously those by Léger. Yet Seurat's more covert mystery can also wreak its irrational spell here in the stillness and hush that are so at odds with Sunday crowds, or in the patterns of long, dark shadows on the grass (Fénéon described the scene as occurring at 4:00 P.M.), which, together with the single running figure (the little girl who races toward the stove at the right, probably to buy a hot crepe or waffle), already propose the dreamlike spaces and frozen motion that would later excite the imagination of de Chirico and the Surrealists.

Like all great art, the *Grande-Jatte* looks far into the past and into the future; but in the context of its own time, its public debut in 1886, at what was to be the last Impressionist group show, gave it virtually the character of a manifesto which both repudiated and revised the premises of that movement and for which a new word, "Neo-Impressionism," as coined by Fénéon that year, seemed mandatory. Seurat's position vis-à-vis Impressionism in the *Grande-Jatte* is so complex as synthesis and rejection that it is probably more easily observed in the less ambitious landscapes and seascapes that he painted on the English Channel during the same years, 1884–86. In a view of the dramatic bluff called Le Bec du Hoc at Grandcamp, painted in the summer of 1885 (**fig. 400**), he offers almost a modernized, corrected version of the Normandy coast scenes that Monet had also been painting in the 1880s, such as

Fig. 400 **Georges Seurat**, *Le Bec du Hoc, Grandcamp*, 1885. Oil on canvas, 25¾ × 32″. Tate Britain, London.

Fig. 401 **Claude Monet**, *The Cliff Walk*, 1882. Oil on canvas, 25¾ × 32″. Art Institute of Chicago, Illinois.

The Cliff Walk of 1882 (**fig. 401**), which locates us on a comparable promontory near Dieppe. Typical of the 1880s' growing sensibility to silhouetted patterns, both paintings pit the craggy irregularity of a high headland against a flattened ground plane of water and sky divided by an almost unbroken horizon line, a format in good part inspired by such Japanese woodcuts as Hokusai's views of surging waves. Yet Seurat imposes upon this Romantic motif of jutting rock and breathtaking expanse of sea the tidiest order of the whole and the parts. Monet's choppy, erratic brushwork is replaced by a facture that would mimic the inhuman perfection of a sewing machine; and an abstract

border of colored dots, like the one Seurat would later add to the *Grande-Jatte*, puts into actual practice the theoretical preaching about intensifying painted colors by placing them next to contrasting colors. Even the birds here fly in a military formation that almost prophesies an air-force display, a far cry from Monet's gently windswept, uncontoured clouds. In short, the older master's immediate, almost sensuous capture of the pleasures of this breezy Channel site is replaced by the Neo-Impressionist's translation of nature into an artistic discipline that might be equatable with the impersonal application of a scientific theory, were it not for the many marks of personal genius. For here, as in the *Grande-Jatte*, Seurat juggles and fuses a scale both monumental and diminutive, and projects a horizontally tiered space that at once evokes immense depth and a jigsaw-puzzle tautness of flat patterning. Moreover, the master's strange poetry can again be savored in this image of such rapt immobility that even the flight of birds and the bobbing movement of the tiny sailboats seem fixed forever in a fairy-tale world.

In no major figure painting by Seurat is the mood more haunting than in the one titled *Une Parade de Cirque*, in English usage generally simplified to *La Parade*, a French

word that refers to the outdoor come-on meant to attract customers to the indoor circus performance (**fig. 402**). First shown to Parisians in 1888 at the fourth Salon des Indépendants, it was mainly executed in the autumn and winter of 1887–88, when Seurat turned away from the summery, sun-drenched landscapes of Paris suburbs and Normandy coastlines in favor of the kind of wintry, urban scene illuminated by the light of gas jets which Seurat had earlier recorded in drawings (see fig. 396) and which would also fascinate Whistler, whose lecture on the painting of artificial light Mallarmé would publish in a French translation in 1888. As usual, the stimulus was real, not imaginary, a particular circus identifiable as the Cirque Corvi. But also as usual, a mundane Parisian fact—here, a pedestrian's glimpse of popular entertainment on the boulevards—is transformed by Seurat into a scene of such ritualistic solemnity that we might also expect an Egyptian tribunal, with the most terrifying of proclamations, to appear after this brassy fanfare being played by a trombonist in a magician's costume on the center platform and four accompanying musicians behind the railing. Even more than in the *Grande-Jatte*, the figures of the performers have an iconic rigidity, and their implied solid geometries bear

Fig. 402 **Georges Seurat**, *La Parade*, exh. Salon des Indépendants 1888. Oil on canvas, 39¾ × 59⅛″. The Metropolitan Museum of Art, New York.

Fig. 403 **Fernand Pelez**, *Grimaces and Misery*, Salon of 1888. Oil on canvas, 7' 4" × 21'.
Ville de Paris, Musée du Petit Palais, Paris.

out Cézanne's remark about cylinders, spheres, and cones far better than does any work by Cézanne himself. Yet the modeling in the yellowish haze of the gaslights is now so filmy that the figures' profile and frontal postures almost dissolve into the tight, two-dimensional network of curved and rectangular patterns that define the props of the background, from the canvas curtain with its probably gaudy, but almost invisible, circus paintings within oval frames, and the zeros that refer to the second digit of the price of tickets (30 and 40 centimes), over to the cagelike window at the right which separates the cashier from the ticket buyers with whom we stand and watch. Locked into place by a preordained geometric system that follows the proportional principles of the Golden Section (an academic theory that here imposes an approximately 3:5 ratio on both the horizontal and vertical divisions of the painting), this razor-sharp backdrop is at once lucid and ambiguous, the exact sequence of planes constantly eliding and shifting places in the foggy, granular light.

But if the painting can look as remote as Egypt and as abstract as Euclid, its appearance is also rooted in the popular imagery of Seurat's day, an imagery fully appropriate to the subject. At the bottom and right-hand edges, the silhouetted heads of the prospective audience provide a casual, agitated movement at odds with the stark immobility of the players. Approaching the art of the caricaturist, Seurat seizes the salient features of hats, physiognomy, posture to define the vivacious diversity of the crowd, which includes the strange exception of a solitary figure in a bowler hat viewed from behind, a projection perhaps of the artist himself as witness to this spectacle. It is known that Seurat, like Courbet, Manet, and the Impressionists, often borrowed ideas from the posters or popular illustrations of his time, which frequently represented people in flattened, cartoon-like ways. Moreover, the Divisionist technique used here, in which even the most palpable of

forms dissolve in an infinity of regularized dots of color, coincides closely with the look of some of the new techniques of cheap color reproduction explored by printers in the 1880s. In this, Seurat's hand-made images would become ever more consonant with the machine-made color illustrations that were rolling off the printing presses and would, as such, prophesy such later aesthetic adaptations of commercial printing techniques as Lichtenstein's Pop Art use of benday dots in the 1960s.

Seurat's firm roots in the art and experience of the 1880s can be further borne out if we turn to an exactly contemporary painting of the same circus subject, *Grimaces and Misery* (fig. 403), a work by Fernand Pelez (1843–1913) accepted at the Salon of 1888, which opened its doors on May 1, two days before the closing of the Salon des Indépendants, where *La Parade* was to be seen. Working within the conventions of the meticulously descriptive Realist technique he had learned from such academic masters as Cabanel, Pelez also places us before a Paris circus come-on, with young acrobats, clown, barker, and musicians lined up as in a shooting gallery. The bittersweet contrast of a scene of rousing fun with the transparent poverty and dreariness of these performers' lives offered a segment of the urban misery which Pelez, following Hugo's *Les Misérables* (1862), made into a pictorial specialty at the Salons of the 1880s. The coincidences between this work and Seurat's are legion, from the leafless tree at the left and the posted prices of tickets to the carefully contrived network of parallels and perpendiculars that define this shallow, friezelike space (which in both cases is sharply cropped at the bottom and the sides, suggesting the continuing horizontal spectacle that greets the city stroller); yet they are undoubtedly the result of a common source in popular imagery rather than an instance of plagiarism. As such, they permit us all the more easily to measure not only the visual genius of Seurat, which here miraculously fuses

veils of ghostly light with a flat design of immaculate clarity, but also his hypnotic peotry, which Seurat scholars have found analogous to the verse and imagery of such French Symbolist writers as Jules Laforgue and Arthur Rimbaud, who could also translate the gas-lit crowds of Parisian entertainment seekers into resonant metaphors of the timeless drama of human folly and loneliness, or of the mysterious confrontation of spectator and spectacle.

If, by 1888, Seurat's art was nuanced and elusive enough to be compatible with the subjective efforts of the Symbolist aesthetic of the 1880s to evoke a shadowy realm of feeling and imagination beyond empirical experience, it also revealed an even stricter program to conform to objective systems that would guarantee predictable artistic

results and responses. In this, Seurat followed ideas proposed in 1885 in a treatise, *A Scientific Aesthetic*, by the then much talked about Charles Henry, who claimed that effects of sadness, serenity, and gaiety could be attained through the pictorial means of color and compositional direction (e.g., bright colors such as yellow and lines rising from the horizon evoke cheer; dark colors such as blue and lines descending from the horizon evoke gloom). Already in *La Parade* such theories are put into practice, and they become still more conspicuous in a later image of popular entertainment, *Le Chahut*, which Seurat showed at the 1890 Salon des Indépendants (**fig. 404**). Here, the spectator is abruptly thrust in front of a café act of frenzied hilarity, with a quartet of dancers performing the "chahut," a

Fig. 404 **Georges Seurat**, *Le Chahut*, 1889–90. Oil on canvas, 66½ × 54¾". Rijksmuseum Kröller-Müller, Otterlo.

kind of cancan that had already become popular in France under Louis-Philippe. Again, the place and the event were real—a nightclub close to Seurat's studio called the Concert de l'Ancien Monde—and the high-kicking dancers themselves can be named; but these documentary details are metamorphosed into what becomes a frozen tableau of such repetitive geometric patterning that we might be looking at an Egyptian relief of dancers at a pharaoh's court. Henry's theories are evident throughout, from the large and small V-shaped patterns that crackle upward from the lower frame to the more intricate arabesques that decorate everything from the abstracted foliate shapes of the gas lamps to the curling ribbons and bows that fly up from shoes, shoulder straps, skirts, and mustaches. Yet so rigid are these emblems of giddy, popular entertainment that the performers become mechanical wind-up toys, almost diabolical in their mimicking of such human activities as music-making and dancing. As for the spectators, from the solitary man with a cane at the lower right to the figures who peer up from the other side of the stage, they respond in a no less automatized way, prophets of the recorded laughter that now punctuates radio and television comedies. Prophetic, too, is the chevron-like fracturing of light and shadow marked by the regular beat of the four pointed shoes that pierce the stage light, a passage that would be at home in the equally mechanized splinterings of light and motion explored by Futurist painters before the First World War. And here again, Seurat's art overlaps with the scientific concerns of his own time, for the split-second capture of this dancing quartet parallels the concern of photographers in the 1880s to document in a scientific fashion the actual movements of humans and animals in motion, step by step, hoof by hoof. It is telling that the painter Thomas Eakins was involved in these discoveries which would blur the boundaries between art and science; but the most sustained efforts to depict sequential motion were made by two photographers, the Anglo-American Eadweard Muybridge and the Frenchman Étienne-Jules Marey (1830–1904). A doctor who wished to expand his many published studies of physiology with more precise knowledge about the movements of muscles and bones,

Marey observed not only human beings, but dogs, donkeys, horses, and birds, as if they were the flesh-and-bone counterparts to the mechanical marvels that visitors would be awed by in the Galerie des Machines at the Exposition Universelle of 1889, the year of Marey's first exhibition in Paris. His discoveries and innovations are clear in his "chronophotographs," the word he invented for his new process in which film and an electric photographic gun could record twelve images per second. In a characteristic example of 1886 (fig. 405), a uniformed French cadet runs past Marey's invention, spelling out, like Seurat's clockwork dancers, the regimented motion of his arms and legs. Never was the equation of the body and the machine made more clear; and, perhaps more important, never had the visual experience of the fusion of time and motion been diagrammed with such clarity. The consequences of this kind of scientific vision were enormous for art. The entire enterprise of the Italian Futurists, with their goals of depicting people, animals, and machines in rapid, sequential motion, was based on these photographic premises.

If Seurat's *Chahut* reflects the fascination with the mechanical body that fired the imagination of so many photographers in the 1880s, it also can be looked at as a late entry in a tradition best known through Degas's café and theater scenes. Both the foreground silhouette of the bass player and the odd corner segment of a flutist's hands are ideas compatible with the older master's vision. Yet this cross-section of a performance and its audience has been re-created through the eyes of a new kind of mechanized stage director who felt the pulse of industry and science even in the domain of dance, music, and laughter. The space, too, for all its croppings, has a strangely abstract quality, as if an elliptical volume, underlined by the subtle arcing of the upper framing margin, had encapsulated and immobilized the entire scene on both sides of the impossibly tilted stage floor. And the heraldic patterns of gaiety here have become so incisively flat and ornamental that we feel that the Seurat of 1890 had already invented most of the decorative language which, in the next decade, under the banner of Art Nouveau, would dominate everything from posters to subway stations.

Fig. 405 **Jules Marey**, *Running Man*, 1886. Geometric chronophotograph. Collège de France Archives, Paris.

Fig. 406 **Georges Seurat**, *The Channel at Gravelines*, 1890. Oil on canvas, 29 × 36¾".
Indianapolis Museum of Art.

Even in his late landscapes, this look of total, mechanized artifice would overpower Seurat's earlier orientation to an Impressionist world of sunlit grass and trees, and the green of nature would almost vanish from his palette. In the last summer of his life, that of 1890, he returned to the Channel coast and painted four views of the port of Gravelines. In one of these (fig. 406), the bleaching glare of a sunlit day reveals not nature, but the man-made forces that control these coastal waterways, as they were to do in two great engineering enterprises of Seurat's lifetime, the construction of the Suez and Panama canals under the direction of Ferdinand de Lesseps. Strangely devoid of human activity, this serene and silent scene is populated only by docked boats, whose relatively casual disposition is a foil to the absolute order imposed by the white shaft of the lighthouse, with its watery reflection, and the measured beat of the comparably cylindrical forms of the bollards that line the asphalt ground. The parabolic curve of this empty vehicular road then rushes us with startling velocity from foreground to remote horizon, yet remains almost an Art Nouveau surface pattern of attenuated curves that contrast with the rectilinear skeletons of the masts rising above the shoreline.

Seurat died on Easter Sunday, 1891, at the very time this painting was hanging on the walls of the Salon des Indépendants. Even in front of so modest a work, one wonders what the master might have done with the highways and bridges of the twentieth century, had he been granted a normal life-span. Still, in only a decade-long career, he managed to define, both for the 1880s and for generations to come, the possibility of reconciling the modern world of industry and technology with the highest reaches of artistic order and mystery.

Although his genius was inimitable, Seurat's pictorial techniques were not; and given his belief in an objective basis for the making of art, it was inevitable that he should attract a number of followers who could join him under the banner of Neo-Impressionism. Of these, Paul Signac (1863–1935) might be considered the group leader. Having met Seurat in 1884, he continued, after the master's death, to propagate this faith not only in his own paintings, but in a famous text, *From Delacroix to Neo-Impressionism* (1898), in which he outlined a distinguished pedigree for the progress of color theory and practice in the nineteenth century. Like Seurat, he often painted with his meticulous dots the bleak

industrial suburbs of Paris or the shipshape harbors of France; but he was also capable of satirizing some of the arcane, quasi-scientific theories of the period, as in his portrait of the leading proponent of Neo-Impressionism, Fénéon (fig. 407). The painting's full title is: *Against the Enamel of a Background Rhythmic with Beats and Angles, Tones and Colors, Portrait of M. Félix Fénéon in 1890*, an affectionate spoof of the complex theories and diagrams published and discussed by Charles Henry in his efforts to rationalize the aesthetic structure of everything from Japanese prints to paintings by Degas. In it, Henry's fellow theoretician Fénéon is seen as a kind of modern Merlin, who holds top hat and cane in one hand, and a flower in the other, as if about to perform some magical transformation before a hypnotic central node from which banner-like ornamental patterns spiral outward in a diagrammatic inventory of colors and decorative motifs. Stars, astral globes, concentric crescents contribute to the comic effect of occult, exotic mystery, a setting appropriate, say, to the new cult of Theosophy that attracted so many artists. In fact, the painting contains many esoteric references intelligible only to the Signac circle. One knows, at least, that Fénéon was often noted to resemble "Uncle Sam," which may account for the reference to the stars and stripes

behind him; and the flower, a cyclamen, may be a verbal pun on the fanlike, elliptical swirls of the background which seem generated by rotating cyclical rhythms. But apart from such intellectual jokes, the painting stuns us still by its daring espousal of so abstractly conceived and executed a decorative background, as if the schematic motifs of Seurat's late work, especially *Le Chahut*, had been extracted from their literal context and proposed as the dominant theme of a painting. Against this spaceless backdrop of Art Nouveau curves and stylized ornamental fillings, the profile portrait of Fénéon seems an old-fashioned intruder, polarizing almost too clearly that conflict between painting as representation and as abstraction which would become so complex an issue in the art and theory of the next decade.

In general, however, most Neo-Impressionist paintings that followed directly in the wake of Seurat were less flamboyantly adventurous, most often updating, with a progressive-looking technique, such familiar themes as landscape and genre. Outside France, it was Belgium that offered the most receptive audience to this new mode of painting, thanks in good part to a group of twenty liberal-minded artists who called themselves Les XX (Les Vingt) and who, from 1884 to 1893, held annual international exhibitions in

Fig. 407 **Paul Signac**, *M. Félix Fénéon in 1890*, 1890. Oil on canvas, 29⅛ × 36⅝″. The Museum of Modern Art, New York.

Brussels which, beginning in 1887 with the *Grande-Jatte*, presented to the Belgian public the latest works of Seurat, as well as of Signac. Immediate evidence of the impact of Neo-Impressionism can be seen in the early paintings of Signac's exact contemporary Henry van de Velde (1863–1957), who would later reach international prominence as a master of architecture and the decorative arts. In his *Woman at the Window* of 1889 (fig. 408), which was shown the following year both in Brussels at Les XX and in Paris at the Salon des Indépendants, there is nothing particularly modern about the subject, in which the indoor-outdoor contrast of a peasant woman and an open window view of the simplest country houses has deep echoes that go back to seventeenth-century genre painting in the Netherlands. Even more to the point, it restates a familiar motif of his older compatriot Henri de Braekeleer (1840–88), who, also from Antwerp and a student of Leys (see fig. 252) at the local academy, was steeped in nostalgic memories of art and life in the Low Countries before the Industrial Age. In his view of the *Place Teniers in Antwerp* of 1878 (fig. 409), a modern woman looks out from behind one closed window at the old, historic quarter of the city, crowned in the distance by the unfinished, late medieval church of St.-Jacques, a repository of paintings by Rubens and of Flemish tomb monuments. The subtly melancholic mood, a Realist restatement of Friedrich's *Woman by the Window* (see fig. 165), is almost an elegy for a dead and distant world, thoroughly effaced in the next decade by Seurat's pervasive modernity of style and subject. Van de Velde's painting implicitly maintains the quiet, passive tone of this contemplation of a vanishing past; but it also obliterates, as it were, Braekeleer's old-fashioned style in favor

Fig. 409 **Henri de Braekeleer**, *Place Teniers in Antwerp*, 1878. Oil on canvas, 31⅞ × 25¼″. Musée Royal des Beaux-Arts/Koninklijk Museum voor Schone Kunsten, Antwerp.

of a progressive new technique which, as he demonstrates here, can even record, as did his Realist predecessors, reflections on glass.

Quickly transformed into a symbol of pictorial modernity, Neo-Impressionism spread both inside and outside French borders, and its life-span, in varying guises, extended even into the domain of radical new directions in early twentieth-century art, speckling the canvases of Fauvists, Cubists, Futurists, and Orphists. And in the decade of its birth, the 1880s, its impact could be discerned even in the work of artists as anti-scientific in spirit as Gauguin and Van Gogh, those two masters who, together with Seurat and Cézanne, would become for later historians of modern painting a strangely dissimilar quartet of artist-heroes who could be categorized in chronological terms, if in no other way, as Post-Impressionists, artists, that is, who felt the need to construct private pictorial worlds upon the foundations of Impressionism.

Vincent van Gogh

Of these four artist-heroes, whose names would later be canonized in the legends of the founding fathers of modern art, it was the Dutchman Vincent van Gogh (1853–90) who

Fig. 408 **Henry van de Velde**, *Woman at the Window*, 1889. Oil on canvas, 43¾ × 49¼″. Musée Royal des Beaux-Arts/Koninklijk Museum voor Schone Kunsten, Antwerp.

reached mythic proportions in popular culture, in good part because of his tragic life, which could be seen as representing the very paradigm of the great prophet-artist so victimized by a philistine society that suicide appeared to be the only solution. Although Van Gogh's turbulent biography may well have become for many a substitute for his art, there is nevertheless no doubt that the two are often so closely connected as to be almost inseparable. Already as a teenager in a small Dutch village, he was attracted simultaneously to religion and to art, feeling an evangelical mission to communicate his feelings and his beliefs about life and death, the individual and society, through the traditional means of the Bible and through the kind of art that, from Rembrandt up to many modern painters of the 1870s, showed an overt concern for the plight of humanity. Indeed, had he been successful in pursuing a career in the ministry, he might have delayed indefinitely the full-time commitment to drawing and painting that he began to make in 1880, after spending two years in a Belgian coal-mining area proselytizing the Christian faith to the poor souls who spent most of their lives below the earth.

In his wish to record and therefore in some way to call public attention to the suffering of the lower classes, Van Gogh was hardly alone. In the lifelong correspondence of six hundred and fifty-two letters to his brother Theo, who supported him both morally and financially, he often wrote passionately of such major artists as Millet or minor ones as Herkomer (see fig. 361). They, too, had evidenced concern with the lives of the anonymous poor of Europe, in both city and country. And it is characteristic that even in his last year, 1890, he painted a free copy after one of the most depressing illustrations from Doré's 1872 publication about London, a round of prisoners exercising in the confines of a courtyard. In both Belgium and Holland, such subjects were equally familiar. One of Van Gogh's early enthusiasms was the most famous Dutch artist of his century, Jozef Israëls (1824–1911), the leader of the so-called Hague School, whose painters specialized in representing rural landscapes and the simple, often poignant lives of peasants. His work may be typified by a painting of c. 1878, *When One Grows Old* (fig. 410), in which loneliness, a clock, and the chill of winter symbolize in intelligible, popular terms the imminent passing of a poor old woman whose gnarled hands and crude wooden chair evoke a life of hardship in a world where murky shadows offer a spiritualizing, old-master resonance associated with Rembrandt. One wonders, too, if Van Gogh knew the far more original work of his Belgian contemporary Baron Léon Frédéric (1856–1940), who already in the early 1880s was winning fame and prizes with such imposing paintings as *The Chalk Sellers* (fig. 411), a large triptych of 1881–83, whose central panel was shown and acclaimed at the 1882 Brussels Salon. Evoking, with its side panels, the format of many Christian narrative paintings, it displays a

poverty-stricken family of vagrants who huddle on the ground with their food and children against a wintry background of leafless trees, creating a relentlessly grim and socially aware counterpart to the pleasures of an 1860s *Déjeuner sur l'Herbe*. On the horizon, replacing the heavenly city of Jerusalem, is the ugly suburban fringe of Brussels, where a church tower enters into an ironic dialogue with a factory smokestack. The allegorical implications of this secularized scene of a modern calvary are made more explicit in the side panels. At the left, a disconsolate trio of family members move toward us at dawn, on their way to work; and, at the right, they trudge away from us at dusk, as they return to their resting place. Within the context of a Realist documentation of the working-class misery that accelerated under the regime of Léopold II, Frédéric also proposes an almost religious statement about the cycles of life and death within the natural context of morning, noon, and night, a statement whose symbolic, emblematic character is further implied by the compositional and narrative

Fig. 410 **Jozef Israëls**, *When One Grows Old*, c. 1878. Oil on canvas, 64 × 40½". Gemeentemuseum, The Hague.

Fig. 411 **Baron Léon Frédéric**, *The Chalk Sellers*, 1881–83. Oil on canvas, triptych, center panel 6′ 8″ × 8′ 11″, side panels 80 × 46″. Musées Royaux des Beaux-Arts/Koninklijke Musea voor Schone Kunsten, Brussels.

symmetry, and whose insistence on eliciting the viewer's sympathy is underlined by the startling proximity of the figures in the funneling spaces of the side panels.

It was with a comparable fusion of the immediate truths of modern poverty and the ever more remote ideals of Christian faith and morality that Van Gogh himself turned to the daily life of the peasants whom he knew firsthand during a two-year sojourn (December 1883–November 1885) at his family's vicarage in the Dutch village of Nuenen. In his struggle to record this agricultural world of toiling peasants, simple churches, and crude cottages, the work of Millet was a constant inspiration, as clearly evidenced by an earnest, but unpretentious view of two women digging for potatoes, executed in August 1885 (fig. 412). Like Seurat in his own early paintings of farm women harvesting (see fig. 395), Van Gogh found Millet's *Gleaners* (see fig. 223) an image of powerful authority. Despite the craggy clumsiness of the brushwork, Van Gogh's little picture manages to translate the grandly rhyming scheme of its source. Yet the crudity of Van Gogh's painting,

Fig. 412 **Vincent van Gogh**, *Two Peasant Women Digging Potatoes*, August 1885. Oil on canvas, 12½ × 16¾″. Rijksmuseum Kröller-Müller, Otterlo.

Fig. 413 **Vincent van Gogh**, *The Potato Eaters*, April–May 1885. Oil on canvas, 32¼ × 44⅞".
Rijksmuseum Vincent van Gogh, Amsterdam.

especially as applied to so coarse a subject, could also become a virtue, avoiding the softened haze of sentimentality that in the work of Israëls and many belated followers of Millet obscured the harsh truths of their themes. Here, the grueling physical labor is immediately perceived in the strained angularity of elbows and shoulders and the tough grasp of hands on shovels. Peasantry is no longer a remote fiction, nor is it, as in Seurat, an almost diagrammatic element in a lucid design.

It would become even more starkly and inescapably real in Van Gogh's best-known and most complex painting of the Nuenen years, *The Potato Eaters* (fig. 413), created in April–May 1885 as the culmination of drawings and painted sketches of both the individual heads and the entire composition. Here, we are thrust directly into one of the peasant homes Van Gogh knew so well, and participate, at the closest range, in their frugal evening repast (the clock at the left reads 7:00) of potatoes and coffee. Far from depicting generalized peasant types, Van Gogh presents these heads with a startling candor, their knobby, furrowed features almost becoming physiognomic equivalents of the potatoes that provide the sole sustenance for the table and that, in other paintings of the period, Van Gogh would isolate in the most humble and earthy of still lifes. Cloistered in an interior as dark as a coal mine, illuminated only

by the solitary flame of the lamp that hovers above their nightly repast, the potato eaters project a mood of utmost gravity and gloom. They seem to watch each other silently without actually exchanging glances, while the distribution of potatoes and coffee takes on an almost ritualistic sobriety inherited from sacred prototypes. Christianity is here given a token representation in the small framed image of the Crucifixion next to the clock; but the hushed aura of the scene conveys the effect of a Supper at Emmaus, in which the most humble folk at table recognize a sacred presence. The fusion of a peasant meal and a Christian ritual had become an artistic commonplace in nineteenth-century scenes that represented the lower classes saying grace, and in the Low Countries, De Groux's earlier painting of this theme (see fig. 239) is an example which Van Gogh may well have known. But the uncommon potency and conviction of Van Gogh's scene are marks of a unique genius, and of an artist whose empathy with every human being he painted as well as with the inanimate objects that formed an intimate part of their lives is instantly communicated to the spectator.

By any standards, including those of 1885 in Holland, *The Potato Eaters* is impossibly awkward, rivaling the early work of Cézanne for unprofessional clumsiness of drawing and brushwork and for unrefined emotion; but it is exactly

these qualities that give it such conviction. The gnarled, restless contours that caricaturally define faces and clothing; the warped, animate compression of what might have been the simplest one-point perspective scheme; the coarse, thick application of brushstrokes that create a grimy environment of somber earthen tones—such crudities transform a commonplace scene into one of passionate immediacy of feeling, unmitigated by the felicities of the technical skill so impersonally acquired in the academies. Van Gogh emerges here almost as a naïve, primitive artist of such honesty and force that we believe his every brushstroke.

To measure this unexpectedly potent achievement, we may turn to another painting of 1885, by the Munich artist Fritz von Uhde (1848–1911), who made his name with sentimental genre. Titled alternatively *"Come, Jesus, Be Our Guest"* or *Saying Grace* (**fig. 414**), it was immediately exhibited in Germany as well as at the Paris Salon of 1885. Here, the subliminal character of the supernatural in *The Potato Eaters* is made explicit, and the painting also meets, like the work of Uhde's Dutch counterpart Israëls, the professional standards of the day. Again, we are taken to the humble dining room of a peasant's home, with its low ceilings and crude wooden furniture; but now the sacramental act of saying grace before a meal has conjured up the invited presence of Christ himself, who, as in the Supper at Emmaus, enters this lowly but pious home and suggests that even for the most destitute stratum of nineteenth-century souls, salvation through Christianity is possible. This mixture of the natural and the supernatural in Uhde's

work of the mid-1880s was at first controversial, and attacked by the orthodox wing of the Protestant clergy, but its pieties were soon absorbed by popular taste, easily transformed into religious kitsch. Compared with Van Gogh's hard-earned evocation of Christian faith in the darkest of circumstances, Uhde's fusion of these contradictory worlds seems a simplistic solution, as much an artificial formula as his tidy, hygienic representation of a peasant interior.

Even without such explicit Christian references, the aura of sanctity which Van Gogh had intuited in the miserable lives of the poor had become a commonplace in later nineteenth-century painting, providing for middle-class spectators an aesthetic palliative to the grim facts of society outside the museums and galleries. The image even penetrated the poverty-stricken depths of black society in the United States, as in the work of Henry Ossawa Tanner (1859–1937). Having studied with Eakins from 1880 to 1882, he finally moved to Europe in 1891, making his home in Paris, where he was free from the racial prejudices of his own country and where the Salon exhibited his religious paintings. Back on a visit to the States in 1893–94, he painted such scenes as *The Thankful Poor* (**fig. 415**), a black American version of the kind of imagery which had earlier so often inspired Van Gogh. Here, both the aged grandfather and the young boy lower their eyes and heads in an act of Christian gratitude, receiving more sustenance from their steadfast faith than from their spare meal. And as in the work of Israëls and Uhde, a soft veil of light and shadow adds a mood of otherworldly piety that softens the

Fig. 414 **Fritz von Uhde**, *"Come Jesus, Be Our Guest,"* 1885. Oil on canvas, 52 × 66". Nationalgalerie, Berlin.

Fig. 415 **Henry Ossawa Tanner**, *The Thankful Poor*, 1893–94. Oil on canvas, 45 × 35½″. Private collection.

hard facts of poverty which Van Gogh depicted so toughly. Nevertheless, Tanner's painting at least carries the authenticity of firsthand experience among the black poor. Appropriately, it was immediately given to a philanthropic institution, the Pennsylvania School for the Deaf.

Had Van Gogh stayed in the Low Countries, his art might have remained a brutally powerful and personal version of that uneasy reconciliation between contemporary poverty and Christian morality with which the nineteenth century so often struggled. But his growing artistic ambitions, which already included in 1885 the study of old-master paintings in Antwerp and the acquisition of Japanese prints, pushed him toward Paris, where, under the protective roof of his brother Theo, he lived and worked from March 1886 to February 1888, rapidly embracing the latest stylistic innovations of the French painters and turning his eye outward from the depressing social depths of Belgium and Holland to the world of a vast, open city, where people circulated freely in parks and streets and where the constant interchange of people in cafés and restaurants provided a fluid situation of endless potential. Intoxicated by Paris, Van Gogh also tried to master its new art, which in 1886–87 was hovering on the brink of transition from the established styles of the Impressionists to the amazing disclosure, in 1886, of the *Grande-Jatte*. Van Gogh immediately became a disciple of this exciting rush of new styles, in which a clarity of light, color, and dappled brushwork seemed to wipe out the murky black and gray tonalities and the heavily troweled paint that marked so many of his early works.

In *Interior of a Restaurant* of summer 1887 (**fig. 416**), we can hardly recognize the Van Gogh of *The Potato Eaters*. As if he wished to pose for himself a rigorous problem in a totally alien discipline of style and subject, he painted the inside of a restaurant, probably one in the industrial suburb of Asnières, where Seurat and Raffaëlli also painted, and recorded that unnaturally regimented, pristine condition that prevails only before the first diners arrive. Within a lucid, rational perspective scheme that captures and freezes an angled corner, the chairs, tables, upside-down wine glasses, and floral decorations are lined up in orderly grid patterns that permit no intrusion of emotion or of a human presence. Moreover, the brushwork and color also belong to this realm of strict control, for Van Gogh has attempted here the overall mottling of tidy Pointillist dots which he had admired in Seurat's work, and which he was learning about directly from his friendship with Signac. The result is like an arduous lesson in the mastery of a foreign language and a foreign ethos, where the possibility of a compassionate subjectivity is rigorously suppresssed in favor of an objective problem in perspective, geometry, Divisionist color, and Pointillist technique.

In other works of the period, Van Gogh's momentarily strait-jacketing discipline seemed to crack, as in his view of the vegetable gardens near his brother's home in Montmartre, painted also in the summer of 1887 (**fig. 417**).

Fig. 416 **Vincent van Gogh**,
Interior of a Restaurant, summer
1887. Oil on canvas,
18 × 22¼". Rijksmuseum
Kröller-Müller, Otterlo.

Fig. 417 **Vincent van Gogh**,
*Vegetable Gardens in
Montmartre*, summer 1887.
Oil on canvas, 37¾ × 47¼".
Stedelijk Museum, Amsterdam.

Here, too, he works with the broken brushstroke shared, with different inflections, by Monet and Seurat, but an unleashed velocity overcomes the widening scene, recklessly dragging these paint marks with them, like iron filings clustering on a magnetic surface. The exhilarating amplitude and energy unbalance the equilibrium of both the contracted, cropped spaces of the Impressionists and the stable, measured ones of Seurat, resurrecting that quality of sweeping, panoramic breadth which Van Gogh knew from the landscape of his native Holland and from the seventeenth-century painters—Rembrandt, Hobbema, Ruisdael—who depicted it. Indeed, the appearance above the horizon of the X-shaped blades of the windmills that then marked the heights of Montmartre may well have instigated this merging of modern Parisian style and his native Dutch landscape traditions. Van Gogh's stamp, however, is already clear here, not only in negative terms (the adapted Impressionist techniques seem blotchy and roughhewn, the work of an inspired amateur), but in positive ones as well. For Van Gogh seems to have redirected the language of French painting toward a vehicle to convey an urgent involvement with the landscape before him. His own emotions seem to radiate outward toward these scrappy patches of cultivated gardens and to engulf the earth, the sky, and the horizon with an all-embracing love and energy that propel us swiftly from the near path at our feet to the farthest points beyond the crest of the hill.

Different though Van Gogh's art was from that of his Parisian contemporaries, by 1887 he was fully included in their milieu, both professionally and socially. He dreamed of arranging vast permanent exhibitions of their most advanced work throughout Europe, as if he were now propagating the faith of a new art rather than an old religion. He actively organized artistic splinter groups that would seek out restaurants and theaters for the display of their canvases; and, in 1888, he would even arrange to show this view of the Montmartre vegetable gardens as well as two other canvases at the more established Salon des Indépendants. It was in February of that year, too, that Van Gogh left Paris for Arles, where, even in winter, he was dazzled by the sunlight, the intense color, the abundance of this Provençal landscape. For him, accustomed to the overcast, gray winters of Northern Europe, the south of France could even be equated with the exotic beauty of Japan, whose prints, with their clean, unmodulated colors and sharp contours, seemed to come to life in this verdant world of flowers, blue skies, and the yellowest of suns. And as these pure colors surrounded him in life, so, too, did he want them to surround him not only in his own art but in the art of his colleagues. He kept in close touch with Émile Bernard and Paul Gauguin, his painter-friends in the north of France who had been evolving a pictorial style that would treat color as flat, spaceless pattern, and tried to convince them to join him that year in Arles, in the hopes of establishing around him, in this newfound Garden of Eden, a community of artists with a similar vision. It was there that he worked on what he called his "Yellow House," whose interior he planned to decorate with bold colors and whose facilities he hoped could be used as a home and studio for other artists who believed with him in the primacy of color.

The sun of Arles was for Van Gogh a life-giving force, and even by his usual standards, his output in 1888 was prodigious, with over a hundred paintings that chronicle this energetic embrace of a fresh environment and a fresh start. *The Sower*, a work executed in the blaze of the Arles summer (fig. 418), reflects some of these quantum leaps in artistic self-revelation. Its theme is a hallowed one in nineteenth-century painting, the cyclical motif of harvesting and reseeding the earth, and the sower himself is a figure transformed from the work of one of Van Gogh's idols, Millet. But now the bountiful earth is dominated by the disk of the yellow sun, which, located in the exact center of the horizon and radiating stylized beams of light from its incised circular edge, becomes almost a secularized religious emblem, a halo of heavenly light that gives the force of life and growth to the terrestrial world below. Recreating the effect of a Christian altarpiece, the sun's hypnotic centrality is made still more abstract by the audacious rejection of conventional perspective schemes. Here, the fertile land rises steeply from the ragged, choppy brushstrokes of the soil to the tidier, upright brushstrokes of a wheat field that becomes a horizontal frieze of organic vitality. Spread out as a flattened plane, this continuous crust of thick pigment began to translate the language of Impressionism into the bold decorative patterns Van Gogh admired in Japanese prints and in the works of Bernard and Gauguin.

How daringly new *The Sower* was can be partly measured by looking at another painting of the 1880s by one of Van Gogh's earlier enthusiasms, Jules Bastien-Lepage (1848–84), who was raised in a farming village not far from the Belgian border and who also depicted agricultural themes inspired by Millet in a style that adapted some of the innovations of Impressionism. In *Père Jacques*, shown at the Salon of 1882 (fig. 419), the name of the title refers to the old woodsman Bastien-Lepage used as a model for a painting that confronts us with the brutalizing results of a life worn to its end by physical labor in the fields. In a chilly autumnal setting, the woodsman still carries a crushing bundle of faggots on his back while his granddaughter gathers flowers. Van Gogh would surely have approved of the artist's candor in depicting the pathetic, weary features of this human beast of burden, and he might well have admired too the painting's many allegorical implications, which include not only the overt cyclical contrast of youth and age as winter approaches, but perhaps a covert allusion to La Fontaine's fable about a woodsman who, aching

Fig. 418 **Vincent van Gogh**, *The Sower*, summer 1888, Arles. Oil on canvas, 25¼ × 31⅞″. Rijksmuseum Kröller-Müller, Otterlo.

under his labors, suddenly realizes the value of life when his idle wish that death release him from his chores is granted. Moreover, Van Gogh might also have responded favorably to the way in which, without sacrificing the potency of the theme, Bastien-Lepage borrowed the tapestry-like effect of Impressionist landscape, blurring, as conservative critics would complain, many of the details of the figures in a spotty profusion of underbrush. But the results that Van Gogh obtains in *The Sower* from a comparable absorption, not only of the Realist tradition of peasant paintings, with their moralizing overtones, but of the Impressionist impulse to compress such images into a continuous weave of paint, are of a drastically different order. As Van Gogh himself recognized, *The Sower* inaugurates a new phase in his art that would open limitless possibilities.

These possibilities could turn out to be innovations of feeling as well as style; for the artist's precarious psychological equilibrium, which resulted in a breakdown that began just before Christmas of 1888 and included the mutilation of his ear, often swerved from the exultant joy of *The*

Fig. 419 **Jules Bastien-Lepage**, *Père Jacques*, 1881 (Salon of 1882). Oil on canvas, 77½ × 7¹⁄₁₂″. Milwaukee Art Museum, Wisconsin.

Fig. 420 **Vincent van Gogh**, *The Night Café at Arles*, September 1888. Oil on canvas, 28½ × 36¼".
Yale University Art Gallery, New Haven, Connecticut.

Sower, with its paean to the almost supernatural wonder of the earth's fertility, to the deep anxiety revealed in *The Night Café at Arles*, painted in September 1888 (**fig. 420**). A visual inventory of most of the advanced innovations of French painting in 1888—from Gauguin's flat zones of intense, unmodulated color to Seurat's circular aureoles of dotted light that vibrate outward from the hanging gas lamps—*The Night Café* also projects a psychological environment of conflicting emotions, from a hellish, breathless agitation that dizzily funnels us upward into the scene across the converging rush of yellow floorboards, to a barren inertia, in which a waiter in white stands almost like a prison or hospital attendant among his charges, who, at the far corners, sink in lassitude. It is hard to believe that this is the work of the artist who, only a year before, had painted so orderly and so unpopulated a restaurant interior (see fig. 416); for here, the plummeting spaces, the clashing colors, the harsh light fulfill Van Gogh's own ambition "to

express the idea that the café is a place where one can ruin one's self, go mad, or commit a crime . . . to express the power of darkness in a low drinking spot . . . in an atmosphere like a devil's furnace." Moving in extremes from the sower's sunlit heaven to the drinker's gaslit hell, Van Gogh astoundingly succeeds in communicating these desperate feelings without sacrificing either his acute sense of the real and the specific (warped as it is, the clock reads 12:15; and the glasses and the bottles, emptied or partly full, can be counted), or his insistence on imposing the kind of patterned, decorative coherence which had inspired him in Japanese prints and Gauguin's painting.

It is telling that his mind swarmed with the fashionable color theories of the moment, but that he immediately translated them into emotional terms. Earlier, he had written about expressing "the love of two lovers by a marriage of two complementary colors, their mingling and their opposition, the mysterious vibrations of like tones"; and, in

writing about *The Night Café*, he claimed that he wished "to express the terrible passions of humanity by means of red and green," a chromatic contrast which for a Neo-Impressionist might only have been the rational demonstration of a law of optics. Van Gogh's wish was more than granted in the strident collisions of complementary color that pervade the scene, from the shrill juxtaposition of what he called blood-red walls with the acid-green ceiling to the baize billiard table which creates a restless framed ground for the startling red of a ball that is both separate from and part of an odd still life of a long cue and two white balls, so disquieting to post-Freudian viewers aware of Van Gogh's imminent self-mutilation. Whether dealing with the facts of the real world around him, with the adventurous pictorial vocabularies of his French colleagues, or with the artistic theories of the 1880s, Van Gogh transformed everything into a vehicle for his own urgent emotions, leaving us to wonder how he also managed to harness them into compelling works of art.

Of the many marvels that make up Van Gogh's genius, one is his uncanny capacity to project his total visual and emotional attention into anything he painted, animate or inanimate, so that a shoe, a sunflower, a chair, a book could carry as much weight as the image of a human being. In this, he perpetuated the efforts of so many Romantic artists and writers to find all of the world in a blade of grass and to seek out, through intense, staring proximity, the differing scales of their subjects, be they children, animals, or fragments of a landscape. An especially poignant example of this empathy can be seen in a small painting of late May 1889 which depicts a death's-head moth almost camouflaged in its natural habitat of leaves and flowers (**fig. 421**). Regretting that he had to kill the insect in order to paint it, Van Gogh scrutinized it with the eye of a naturalist, bringing it so close to the viewer that we almost feel immersed in and identified with the life and environment of this strange creature of the night. Given the turbulent facts of Van Gogh's psychological biography in the months preceding this work—a sequence of events that included violent conflicts with Gauguin during his two-month sojourn in Arles, followed by a series of nervous breakdowns that resulted in voluntary and involuntary incarcerations in the prisons and mental asylums of first Arles and then nearby St.-Rémy—it is easy to invent a symbolic scenario for this painting, in which the image of the skull on the insect's head is at war with the blossoming life around it. Could it be that the joy elicited by Theo's marriage on April 17 might conquer the gloom of the death's-head? Could the freedom of the winged creature be a symbol of Van Gogh's own wish to escape from literal or metaphoric prisons? Yet no such specific interpretation is ever adequate to translate the full and elusive range of associations, both personal and public, which emanate from Van Gogh's art, an elusiveness which allied him to the Symbolist aesthetic of his French

contemporaries who wished to penetrate, without naming, the mysteries below the visible surfaces of things. Nor would such an interpretation take into account either that the power of this painting lies also in the startlingly bold and animate patterns of organic form, at once as delicate as the scenes of plants and insects familiar to Japanese prints and as forceful as the passions that pervade all of Van Gogh's work.

Such mysteries and such visual triumphs recur throughout the prodigious profusion of some seventy-five paintings that Van Gogh executed in Auvers, near Paris, in what were to be the last two months of his life, from May 21 to July 29, 1890, when he died two days after shooting himself and after writing a last, despondent letter to Theo about his doubts that there would ever be adequate support in the modern world for the modern art that had become the whole of his life. In Auvers, where Pissarro and Cézanne had also painted, Van Gogh lived under the personal as well as professional protection of Dr. Paul Gachet, an odd personality who was well known by the Impressionists, whose works he collected, and who, concerned with nervous disorders, had a part-time practice in Paris. In

Fig. 421 **Vincent van Gogh**, *Death's-Head Moth on an Arum*, May 1889. Oil on canvas, 13 × 9½". Rijksmuseum Vincent van Gogh, Amsterdam.

Fig. 422 **Vincent van Gogh**, *Portrait of Dr. Gachet*, June 1890, Auvers. Oil on canvas, 26 × 22⅜". Musée d'Orsay, Paris.

June, Van Gogh painted the doctor's portrait (**fig. 422**), which in many ways became, like the death's-head moth, a self-portrait. Theo had already noticed the physical similarity between the two men (who were both redheads), and Vincent himself claimed that the doctor, who had in fact written a thesis on melancholy, suffered from a nervous disorder as troubling as his own. Be that as it may, the portrait, as Van Gogh described it, projects not only "an expression of melancholy," but "the heartbroken expression of our time," a mood immediately conveyed by the passive, tilted posture, with hand supporting head, that was a common pose of melancholy in the international repertory of Romantic painting. Even within this aura of depression, which seems to expand to universal dimensions, Van Gogh clung to specific facts related to the doctor himself. Not only did he include the overcoat and white visored cap that the doctor wore the year round, but also a symbolic still life of two novels by the Goncourts and a digitalis plant, the former alluding to the miseries of contemporary life, including the failure of artists like those befriended and patronized by Gachet to achieve their aesthetic goals, the latter alluding to a well-known natural treatment for heart disease, one of Gachet's medical interests. But these particularized and intellectualized symbols are quickly absorbed in the molten contours that dominate the whole, irregularly

throbbing arabesques which seem to emerge from the interior emotional life of the static figure and which are so contagious in their emanations that even the flat background planes of the wall are warped by their rhythms. In works by Seurat and Signac also of 1890, such as *Le Chahut* (see fig. 404) and the portrait of Fénéon (see fig. 407), abstract, curvilinear patterns begin, too, to lead a life of their own, but their effect is of an orderly, diagrammatic decoration. In Van Gogh's portrait, such animated circuits become paths of unruly emotion, discharged from their sitter's, and hence from the artist's, invisible core of feeling.

Although by the time of his death, Van Gogh's work had been seldom shown publicly and only one critic, Georges-Albert Aurier, one of the chief spokesmen for the Symbolist aesthetic, had troubled to write about him, his work became ever more widely known to artists in the 1890s, and to the public at large in the early twentieth century. It was then that the full impact of his legacy could be explored by painters who, under the banners of Fauvism or Expressionism, sought out the most immediate ways of finding a correspondence between art and emotions that could alternate, as they did in Van Gogh's life and art, between exultant joy and paralyzing depression.

Ensor, Klinger, Redon

Because he lived out his last four years in France, where he brought his art to fruition by voraciously absorbing the newest styles of his French painter-friends, Van Gogh has often been assimilated into the history of French painting. Yet his evangelical faith that art was made for life's sake rather than art's sake separates him from most French painters, who had a more cautious view of the limited role that art might play as a savior of souls and society; and his works themselves, with their often clumsy, impetuous touch and turbulent rhythms, are alien to the more decorous professional standards of technique and emotion that prevailed even among the most anti-establishment French painters of the later nineteenth century. In Van Gogh's willingness to sacrifice refinement of brushwork and harmonious structure in order to express his urgent emotions, he stands close to another painter from the Low Countries, the Belgian James Ensor (1860–1949), whose reclusive and often ugly art seems more the product of a unique and disturbing personality than of a shared aesthetic program. Like Van Gogh, Ensor virtually defined the whole of his art in the decade of the 1880s, even though he was to live through the first half of the next century. Again, like Van Gogh, he was swift to adapt the most innovative styles coming from Paris, but at the same time to mold them into his own strange ends.

Thanks to his training in the Brussels Academy, he was technically proficient enough and thematically conventional

enough to have his early scenes of middle-class life accepted not only for exhibition in Brussels, but at the Paris Salon of 1882. Absorbing some of the techniques of Impressionism into what was essentially a late Realist style, he could paint, often with dazzling bravura, the proper comings and goings of the provincial, respectable people he saw in his hometown, the seaside resort of Ostend, where one might take tea, eat oysters, or listen to music in the darkened, overfurnished rooms typical of the period. But soon, the constrictions of this mode of life and art became too repressive for what he wished to say about human behavior, and from below—from a more irrational foundation of terror, violence, fantasy—another, truer world began to emerge.

It already surfaces, in the most startling way, in *Haunted Furniture* (**fig. 423**), a painting of 1885 lost in the destruction of the Ostend Museum during the Second World War. What we see in the surviving photograph is, first, an image of middle-class propriety, a claustrophobic interior glutted with ornate, nineteenth-century versions of the kind of Flemish Renaissance furniture which an earlier Belgian painter, Leys (see fig. 252), would use for his historic reconstructions. A mother knits and a daughter reads, but suddenly, strange fantasy creatures invade the scene. It is like an illustration to a story by Edgar Allan Poe, who was well known in French-speaking countries through Baudelaire's

translations and who would specifically inspire other works by Ensor and his contemporaries. These spooks are both real and imaginary. Insofar as they are palpable representations of skulls and masks, they seem to pertain to the same empirical world as the figures. In fact, they can be read as an abundance of grotesque studio props that, as if for a Halloween party, have been placed in the room. Moreover, to acquire these, Ensor had only to turn to his family's souvenir shop at Ostend, which was crammed with carnival masks that, like those still worn in local Belgian carnivals, might range from comically ugly caricatures of the human face to the face of death itself. Yet these real objects, so much a part of Flemish popular tradition, could also take on a hallucinatory quality, floating, rather than suspended on hooks, assailing middle-class proprieties like demons unleashed from what Freud was soon to call the id.

Ensor used these rich metaphors of mask and skull in many genre interiors, where ghostly invaders mimicked the activities of human inhabitants, but he was soon to put them to far more disquieting and complex use in a huge painting which, completed in 1888, bore the prospective title *The Entry of Christ into Brussels in 1889* (**fig. 424**), an anticipation, that is, of what a Second Coming of Christ in Belgium's capital might look like were it to occur the following year. Projected in these dimensions—it is over

Fig. 423 **James Ensor**, *Haunted Furniture*, 1885. Oil on canvas, 35 × 40½″. Formerly Ensor Museum, Ostend (destroyed during World War II).

Fig. 424 **James Ensor**, *The Entry of Christ into Brussels in 1889*, 1888. Oil on canvas, 8′ 5″ × 12′ 5″.
J. Paul Getty Museum, Los Angeles.

twelve feet wide—Ensor's vision of humanity becomes almost unbearably ugly, a seething, oppressive multitude of masked citizens and marching soldiers who, amidst a flurry of flags and pennants, seem to trample the spectator underfoot as their ranks push forward to invade our space. And, as in works by Ensor's pictorial ancestor Bruegel, this vast, suffocating parade of humanity engulfs and diminishes the figure of Christ so totally that his importance is ignored.

So dense is this work that many of its meanings may still be concealed; but it is at least useful to think about it in several contexts. For one, it should be recalled that Seurat's *Grande-Jatte* (see fig. 399) had been exhibited at Les XX in Brussels in 1887. Could it be that Ensor had wanted to challenge, with his own idea of the truths of the modern world, the Frenchman's false image of society in the 1880s as a serenely stable Arcadia, in which passion, injustice, ugliness had been forever banished? Indeed, Ensor's painting spawns a countersociety to Seurat's in both form and feeling, an image of hideous confusion and congestion created by another kind of human automaton, not inspired by the machine, but by faceless mobs who can lynch and pillage. As a Christian message too, this work may well be a response to an even larger nineteenth-century painting, Wiertz's *Triumph of Christ* (see fig. 152), which, since its exhibition in Brussels in 1848, remained there as a gigantic statement of Catholic faith. Could it be that Ensor wanted

also to discredit his compatriot's anachronistic religious message by revealing the ironic and impossible collision of old-fashioned Christian values with the immoral, corrosive society of his own day? Such a violent clash, in fact, can be seen throughout Ensor's paintings, even in the verbal terms of the contrast between the crude slogan at the right, VIVE JÉSUS, ROI DE BRUXELLES (Long Live Jesus, King of Brussels) and the overhead banner, VIVE LA SOCIALE (Long Live the Socialist State), a reflection of Belgium's welling Socialist movement, which opposed the power of the church in an industrialized country marked by poverty and the repression of strikes. It is a clash seen, too, when we finally locate the minuscule haloed figure of Christ, riding on his donkey on Palm Sunday, 1889. Poignantly present, he is almost reduced to invisibility by the ambient scene of visual and human chaos, in which the faces of modern society are unmasked, to reveal, paradoxically through another kind of mask, their truer selves. Undoubtedly, *The Entry* also carries, like the works of Van Gogh, a multitude of personal meanings referring here not only to caricatural images of the artist's own family but to a projection of his own sense of alienation in the modern world; yet its metaphors are so evocative that they can communicate on many levels, from an account of Belgian labor unrest in the 1880s to a more generalized image of individual values pitted against a hostile society.

The coarse incrustations of pigment that crush the Lilliputian crowds of the extreme background into the close-up masks of the foreground are almost a grotesque parody of the thickly painted, flattened spaces of the Impressionist paintings that Les XX exhibited throughout the 1880s. And it was an unwitting tribute to the abrasive integrity of *The Entry* that this liberal Brussels group refused to exhibit it in 1889 and considered expelling Ensor from their fold. Even for the most tolerant artists of the day, the painting must have appeared, as it still does, an astonishing assault on any conventions of beauty, in which the harsh ugliness of the subject is matched by bilious color, compositional confusion, and the violent collapse of a one-point perspective scheme.

At the end of the 1880s, Ensor painted, if possible, still more heretical paintings than this, of which *The Fall of the Rebel Angels* of 1889 is conspicuous (**fig. 425**). Perhaps to appease their angry, dissident member, Les XX permitted this still more bewildering work to be exhibited with them in 1890. Here again, Ensor seems to be offering a blasphemous version of a sacred Christian theme which had earlier been treated by Wiertz in respectful, neo-Rubensian terms. The spirit, however, is closer to the nightmare views of hell envisioned by the Flemish painter Hieronymus Bosch. Yet this traditional scene of the cosmic moral struggle between the angels of heaven and hell becomes, in Ensor's hands, almost illegible. There are suggestions of a vast rainbow that arcs over the cataclysmic battle, and the archangel St. Michael with his triumphant sword may perhaps be discerned above. Nevertheless, most of the painting seems a ragged explosion of paint smears and squiggles, whose overall pinkness translates Rubensian flesh into a graffiti-

Fig. 425 **James Ensor**, *The Fall of the Rebel Angels*, 1889. Oil on canvas, 43¼ × 52¾″. Koninklijk Museum voor Schone Kunsten/Musée Royal des Beaux-Arts, Antwerp.

like language of violent, childish doodlings, where phantom nudes at once coalesce and shatter. It is probably the memory of a traditional Christian motif here that gives the painting some subliminal coherence; but, finally, we are more awed by Ensor's audacity in finding a painted equivalent of the swarming impulses of good and evil, love and rage, sin and salvation that might be plumbed in the depths of the unconscious. Even the unmodulated colors, hysterical refugees from an Impressionist palette, collide in sour, complementary clashes of pink and green, bearing out again the image of strife that underlines the Christian source.

There may be clues in some of Turner's late works for Ensor's efforts to represent a world of demons and passions, but few explanations can accommodate the full daring and frenzy of such a painting, whose muscular scribbles seem a strange anachronism by even the most adventurous standards of 1889, and look far beyond the early twentieth century to the brutal deformations of figures and pigment found after 1945 in the works of De Kooning, Dubuffet, and the Cobra group. But Ensor's awesome eruption of disorder had echoes in the 1890s, especially in the amateur paintings and photographs of the great Swedish writer August Strindberg (1849–1912). Much as he experimented with oil on canvas, producing almost illegibly turbulent images of infernos and windswept seas, so too did he experiment with the medium of photography, hoping to capture unedited primordial truths about the cosmos. Abandoning both lens and camera, he reduced photography to its essential component, light-sensitive paper. With this, he made not only images of chemical crystallization that offered a path into the mysteries of snow and rock, but, during a sojourn in Austria in 1894, of the night sky. In one of these extraterrestrial images (**fig. 426**), which he called "celestographs," the heavens themselves are mirrored on the photographic plates that he left exposed to a starry firmament which are light-years beyond even the night skies of Van Gogh. Although Strindberg might well have fantasized that these celestographs were somehow scientific records of the most remote galaxies, the ostensibly cosmic confusion of dots and distant lights was probably more the result of chemical changes on the paper. Nevertheless, Strindberg's point goes far beyond astronomy. In the same year, 1894, he published in French an article called "Des arts nouveaux! ou Le hasard dans la production artistique" (On New Forms of Art, or Chance in Artistic Production), a manifesto that venerated the potential of accident in the making of art, of irrational techniques that might correspond not only to seething emotions but to the essential chaos of the universe. Like Ensor, Strindberg preferred turbulent depths to shallow order, announcing in countless ways the goals of many twentieth-century artists. As for Ensor, by 1890 he had stated almost the entire premises of his pessimistic and isolated art, though he would live and

Fig. 426 **August Strindberg**, *Celestographs*, 1894. Photograph. National Library of Sweden.

paint long enough to see himself become virtually a national hero. In 1929, at a time when Freud and the new Surrealist movement offered a more intelligible context for his work, he would be named a baron by his king and would be honored by a retrospective exhibition in which, for the first time, *The Entry of Christ into Brussels* could be seen by a public whose late nineteenth-century ancestors would have been baffled by their compatriot's precocious excursions into the terrifying world of the irrational.

However unique Ensor's willfully ugly, disorderly art may be, his search for truths that lay beyond or below the visible world was shared by many other artists of the 1880s. Even in portraiture, works like Van Gogh's *Dr. Gachet* (see fig. 422) or Romako's *Isabella Reisser* (see fig. 378) began to distort their sitters' faces and bodies in order to disclose grotesque or troubling psychological undercurrents; and in other domains, especially the graphic arts, the pursuit of the irrational, of ways to depict dreams, fantasies, a subterranean imaginative life, accelerated. Among the most

concerted efforts of the decade to record, as it were, the stuff that dreams are made of is found in the prints of the German painter and sculptor Max Klinger (1857–1920), who in 1881 published a suite of ten etchings that illustrated the narrative sequence of a fetishistic dream. The event that prompted this occurred in Berlin, where the artist noticed a lady's glove inadvertently dropped at a roller-skating rink. In the print series, the glove is transformed into a bizarrely anthropomorphic and sexualized being, capable of eluding its passionate pursuer in nightmarish ways. In a particularly alarming plate from *A Glove*, as the series was called, we see a traumatic image of abduction (fig. 427). The ever-desired glove, the limp surrogate of the artist-dreamer's love object, is here carried off in the dead of night in the beak of a pterodactyl-like bird that swiftly flies off over a bush of blooming flowers. At the same moment a pair of desperate hands break helplessly through window glass in the hope of retaining the precious fetish. Especially by comparison with Ensor, Klinger works in a relatively conventional mode. His use of dense and spaceless black grounds as the proper environment for nightmare may depend on his knowledge of Goya's prints; but his oddly hybrid fusion of descriptive literalness and imaginary subject is closest to the work of his teacher Böcklin (see fig. 336). Yet even if his pictorial means are traditional, the ends are nevertheless unforgettable, capturing as they do, through the startling juxtaposition of commonplace objects, that amalgam of terror and sexuality which would later be analyzed by Freud in his epochal *Interpretation of Dreams* (1900). And, as early attempts to make dreams visible, Klinger's prints would also cast their long shadow across the art of such Surrealists as de Chirico and Ernst.

In the same decade in Paris, there was an odd exhibition held in 1883 called "Les Arts Incohérents" (The Incoherent Arts), which featured bizarre experiments, such as a work composed of a live, carrot-munching caged rabbit with a real cord around its neck that ended up in the mouth of a man painted on canvas; and a landscape in which the moon was made of real bread and the trees of real goose feathers. But these heresies, by artists whose names are forgotten, had more the character of proto-Dada jokes in a Gallic spirit than prolonged attempts to explore an irrational world. Nevertheless, serious efforts to chart these territories became more common in France, as in the work of Odilon Redon (1840–1916), who penetrated dreams and fantasies in dark, velvety charcoal drawings and albums of lithographs. Although in his early years he often seemed to perpetuate the more theatrical imagery of masters like Gustave Moreau (see fig. 259), by the time of his first lithograph series of 1879, which he titled *In the Dream*, Redon was clearly his own master, invoking a crepuscular world of menacing shadows where, as in a séance, fantastic visions could appear and disappear. Like Ensor and many of his contemporaries, he revered Poe as he revered the late Goya, masters who seemed to prophesy his own search for an invisible world that offered an alternative to the materialism of the late nineteenth century; and it was timely that Goya's Black Paintings (see figs. 110 and 111) were exhibited in Paris in 1878, at the Exposition Universelle, where, though they were scarcely noticed in the press, they may well have released darker layers of Redon's imagination. In gratitude, he dedicated two of his lithographic albums to these Romantic visionaries of the early nineteenth century. In *The Marsh Flower: A Sad, Human Face*, a plate from *Homage to Goya*, published in 1885 (fig. 428), we have left the empirical world on the other side of closed eyes and are enveloped in a murky domain of prehistoric sea and sky that transport us to the Book of Genesis or to the theories

Fig. 427 **Max Klinger**, *The Abduction* (from *A Glove*), 1881. Etching, printed in black, 4¹¹⁄₁₆ × 10⁹⁄₁₆″. The Museum of Modern Art, New York.

Fig. 428 **Odilon Redon**, *The Marsh Flower: A Sad, Human Face* (Plate 2 from *Homage to Goya*), 1885. Lithograph, printed in black, 10¹³⁄₁₆ × 8″. The Museum of Modern Art, New York.

of Darwin. It is the latter, in fact, which offer the broad inspiration for the fantastic creature, as much sea serpent as primitive plant, that burgeons from the primordial ooze of Redon's imagination. Even stranger, one of its luminous buds has blossomed into a melancholic, disembodied head which, glowing radiantly within the bud's open crescent, almost metamorphoses into a fantastic eclipse in the night sky. One of Redon's closest friends in his native city of Bordeaux was a botanist, Armand Clavaud, who was knowledgeable about new concepts of biological evolution and who encouraged the artist to study the structure of living creatures, even those only visible through microscopes. Typically, Redon transformed these scientific images into private fantasies, so that here, studies of comparative biology or the evolution of man from the lowest forms of life born from the sea and nurtured by the sun are fused into an awesome hallucination. Extracting the terror and the wonder from the speculations of nineteenth-century scientists about the origins of life on this or any other planet, Redon even called one of his albums of prints *The Origins* (1883), creating a dreamworld counterpart to Darwin's *Origin of Species*. Redon's means are somewhat like

Klinger's, insofar as he, too, depends on abrupt juxtapositions or fusions of literally described objects as well as on the frequent use of black to locate us in the immeasurable spaces of nocturnal fantasy; but his graphic techniques offer an infinitely more nuanced range of darkness in which the objects we recognize from the real world lose their palpability and, like phantoms, defy all laws of gravity. It was almost predictable that when, in 1895, Redon decided to turn from his beloved blacks and whites to color, he veered not only toward painting but toward pastel, a medium suitable to the blurred, granular ambience of his prints and drawings.

Although he was an exact contemporary of Monet, and in 1886 even participated in the last Impressionist exhibition, Redon, because of his slow artistic maturation was allied more closely to a younger generation which was gaining definition in the 1880s. Indeed, he helped to found and to direct the Indépendants in Paris, and his work was also shown with Les XX in Brussels, where, at the 1885 exhibition, his *Homage to Goya* must have found in Ensor a kindred spirit. His subjects, in fact, provide a rich cross-section of the concerns of a new generation drawn to the widest range of regressions and escapes from the material facts of middle-class life in the great urban centers of Europe: the organic forms of primitive, often microscopic creatures which would have so rich a legacy in twentieth-century art, from Miró to the early work of the Abstract Expressionists; the distant legends of St. Anthony as recounted by Flaubert or of the Nibelungenlied and Parsifal, as re-created in Wagner's music dramas, which were conquering Paris in the 1880s; the occult mysteries of Eastern religions or the Book of Revelation. Like so many late-nineteenth-century artists who gravitated toward the aesthetic of Symbolism or who, less programmatically, wished somehow to turn inward, Redon had to create a new visual language that might hover, float, and vanish but that could nevertheless stand in firm opposition to the Realist and Impressionist point of view that had ruled until the 1880s.

Paul Gauguin and the Origins of Symbolism

The most spectacular rejection of late nineteenth-century society in an artist's life and art is found in the biography and the work of Paul Gauguin (1848–1903). His nomadic movements, which carried him from his birthplace, Paris, to what he hoped would be ever more primitive and therefore more beautiful and harmonious societies, were synonymous with his search for a remote, unspoiled art that might revitalize the moribund traditions of the West. As a child, he had lived in Peru, with his mother's family, and as a teenager, he had sailed the seas again with the French navy. In 1871, back in Paris, Gauguin suddenly halted his

wanderer's life when he accepted the regimen of working in a stockbroking firm, where, for release, he began to paint in his spare time. By 1881, this amateur could even submit eight paintings to that year's Impressionist exhibition. Two years later, with enormous relief, he quit his job, with the liberating declaration: "From now on I will paint every day."

As might be expected, Gauguin's earliest canvases adapt the prevailing styles of the Impressionist masters, and he was included with them up till their last group exhibition of 1886. That winter he went to the village of Pont-Aven, which, for a new generation of painters, was becoming the Barbizon Forest of the 1880s, a remote spot near the southern coast of Brittany, where sophisticated Parisians hoped to find and usually did find what they presumed, incorrectly, to be a pre-industrial world untroubled by economic problems and inhabited by simple, pious, and picturesque peasants, whose crude but potent folk art could inspire a search for a comparable directness and honesty. Gauguin was to return there in 1888, but not before another ocean voyage. This time, in 1887, he went to Central America and the Caribbean, where he worked on the early construction of the Panama Canal, earning enough money for what would turn out to be a six-month sojourn in Martinique. There, in a foretaste of the South Pacific Garden of Eden to which he would sail in 1891, he was dazzled by the exotic people, the lush colors, the tropical foliage. Adapting the techniques of Impressionism to a totally different climate and vegetation, he would try, as in *Martinique Landscape* (see fig. 431), to capture this paradise. Scattered here and there are the mottled brushstrokes of his Parisian colleagues, but these seem inadequate to represent a fairy-tale Caribbean vista, where the sunlit colors of the sea, of blossoming fruit and plants demanded another palette and another way of applying paint. Throughout, there are tentative efforts in a counter-Impressionist direction—the appearance of incisive contours that keep color in place, the attenuated decorative rhyming of the paired branches of the tall papaya tree at the left, the general heightening of hue that reaches its most intense pitch in the deep blue sea, and the push toward a patterned, shadowless flatness that brings even the distant contour of the mountain in close touch with the foreground vegetation. For a Westerner's eyes, such a landscape was almost mythical, an exotic escape or a place of strange legends and rituals. To depict it meant forging a new style that would have to break definitively with the Realist premises Gauguin had accepted in Paris.

It was in 1888 that such a style was clearly defined, not in exotic Central America, but back in Brittany, in Pont-Aven, where Gauguin worked in close contact with a painter of the next generation, Émile Bernard (1868–1941), whom he had briefly met there two years earlier. Scholars have argued about the priority and importance of Bernard's

art in sparking Gauguin's own search for a personal language; but it is nonetheless clear that, by the fall of 1888, both painters were working in a common style that they hoped might convey not so much the seen world, but a more concealed world of ideas, of feelings, of a magic and mystery that seemed light-years away from the boulevards and department stores of Paris. They even coined a word, "Synthetism," to describe in somewhat vague, conceptual terms their new efforts to offer not a mirror image of the visible world but a more generalized synthetic image that would embody deeper, invisible meanings and emotions.

In Bernard's *Buckwheat Harvesters* (**fig. 429**), painted in September–October 1888 at Pont-Aven, the theme is familiar enough, a variant ultimately on Millet's by then canonic images of agricultural life. But these anonymous Breton peasants are painted as if they were illustrations to a folkloric legend, naïvely flattened and simplified against an intense orange-red ground that, instead of describing a particular wheat field during autumn harvest, conveys an almost primitive, synthetic idea of an enveloping environment of sunbaked earth. Nor are the figures any more individualized, the ruggedly stylized face in the foreground offering a basic type that can serve to evoke the other invisible faces. As for their toil, the standing and stooping motions seem decoratively locked in a bold pattern that freezes the strong oppositions of black and white, orange and yellow in a network of tough, clear outlines.

To create such a willfully simple style, which would reject the infinitely subtle techniques evolved by Realist and Impressionist painters in order to offer a facsimile of something directly perceived, Bernard and Gauguin found nourishment in styles as remote as possible from a modern, Positivist world and even talked about emulating the art of children. The repertory of sources consonant with this attack on post-Renaissance illusionism included Japanese prints; crude popular illustrations (especially the "images d'Épinal" of Brittany); the so-called primitives of Western painting, such as Giotto; the art of Egypt and Mesopotamia; many facets of medieval art, especially stained-glass windows, with their intense, luminous colors contained in the linear patterns of the leading, and cloisonné enamels, in which opaque, flat colors are similarly defined by metal partitions. It was the latter art form, in fact, which provided the visually descriptive term "Cloisonism," invented in 1888 by the critic Édouard Dujardin to describe the work of the painter Louis Anquetin, but easily expandable to include the analogous new styles developed in the circle of Gauguin and Bernard, as well as many aspects of the work of their mutual friend Van Gogh. Such sources of inspiration were not in themselves new to the 1880s. From the late eighteenth century on, artists as diverse as Flaxman and Manet had been able to absorb a wide variety of art that rejected the modeling and the fictive spaces of the Renaissance tradition. Yet this recurrent impulse in modern

Fig. 429 **Émile Bernard**, *Buckwheat Harvesters, Pont-Aven*, September–October 1888. Oil on canvas, 29¼ × 36″. Collection Josefowitz, Switzerland.

painting found new impetus in the 1880s, at a time when so many artists found the prevailing values of late nineteenth-century society bankrupt. For Bernard's painting also conveys an outsider's romanticized awe of the unshaken faith and simple, harmonious cycles of peasant life, which here even have Christian overtones, the buckwheat of the harvest often being used for the Host of the Holy Communion.

It was the religious steadfastness of many Breton peasants that also attracted Bernard and Gauguin, who both aspired—through an immersion of what to them seemed an unpolluted culture miraculously preserved in modern France—to a virtual revival of Christian art. Already in September 1888, Gauguin had attempted a religious theme in the new Cloisonist style, a peasant's vision, inspired by a sermon, of Jacob wrestling with the Angel. Attempting to bridge the huge gulf between his self-conscious search for the primitive and the genuine naïveté of these Christian

believers, he offered the painting to a local church, whose priest, suspicious and uncomprehending of Gauguin's holy image, refused it. Gauguin's religious paintings were, in fact, unorthodox in more ways than the sophisticated crudeness of their style. In the *Yellow Christ* (**fig. 430**), probably painted in September 1889, the Western traditions of painting Christ on the Cross are clearly undermined in what might be called a spectator approach to religion, a viewpoint already proposed in many Romantic images, from Friedrich on, of the adherents, the rituals, and the artifacts of Christianity. For here, Gauguin is, in effect, playing the role not of a believer who creates an image of the Crucifixion, but of an anthropologist-observer, impressed, as he put it, by "the great rustic and superstitious simplicity" of this time-capsule world where that remote Catholic faith which had been so drastically challenged in the nineteenth century still seemed to be preserved. Here the three Breton women, like modern Marys at the Cross, sit steadfastly,

Fig. 430 **Paul Gauguin**, *Yellow Christ*, September 1889. Oil on canvas, 36⅜ × 28¾".
Albright-Knox Art Gallery, Buffalo, N.Y.

Fig. 431 **Paul Gauguin**, *Martinique Landscape*, 1887. Oil on canvas, 44½ × 33½". National Gallery of Scotland, Edinburgh.

their gaze inward, their hands clasped, beneath Gauguin's representation of an actual wooden crucifix hanging on the walls of a chapel at Trémalo. In a folkloric tradition, the crucifix was painted in colors, in this case a yellow tone for the flesh which Gauguin intensified in his pictorial re-creation. Inspired by this crude relic of a venerable faith, he let this golden yellow radiate throughout the landscape, which, as in the *Martinique Landscape* (fig. 431), rises upward at so steep an angle that the simplified contours marking out Christ's torso seem to fuse with the hills beyond. During his ill-fated, brief visit with Van Gogh in Arles the previous winter, Gauguin had written, "I have no

use for shadows . . . since shadows are the *trompe l'oeil* of the sun, I am inclined to suppress them. . . . Put in shadows if you find them useful, or omit them, it is all the same." Here, confirming this revelation, the figures, real or carved, approach this shadowless, immaterial world, and the autumnal orange of the trees is transformed into decorative color cut-outs that convey, through their irregular contours, the sense of biomorphic vitality. Yet Gauguin, as he stated, also permitted himself the artistic license of inconsistency, far more so than Bernard, and he retains, as in the foreground rendering of the starched white Breton coif, passages of shadow (here pinkish-blue, the inheritance of

Impressionism). These vestiges of modeling not only alleviate what might otherwise be an inertly uniform flatness but also help to distinguish the quietly dramatic figures from their setting. Subtle and unorthodox, too, is Gauguin's off-center placement of the crucifix, an asymmetry alien to a primitive representation of so holy an object and one that underscores the viewer's position as a passing witness to a scene that, following Impressionist tradition, is cropped on all sides.

However fresh Gauguin's *Yellow Christ* may look as an almost mythic, childlike re-creation of a primitive age of faith, the impulses behind it were shared by other artists of far less pictorial daring. In the late 1870s, the Munich painter Wilhelm Leibl (1844–1900), who had been known mainly as a German disciple of Courbet, turned, as a refugee from the city, to the simpler and more pious world of the Bavarian peasantry. In *Three Women in Church* (fig. 432), which Leibl painstakingly worked on from 1878 to 1882 with endless sittings by local models, he expressed his attraction to these people, who preserved their folkloric

Fig. 432 **Wilhelm Leibl**, *Three Women in Church*, 1878–82. Oil on wood, 44½ × 30⅜". Kunsthalle, Hamburg.

costumes as they did their Christian rituals. As in the *Yellow Christ*, we are looking not so much at a religious painting as at a painting of people who are still religious; and again we see, as if from a passing angle of vision, a trio of peasant women (as usual, more observant than the men), rapt in the ancient faith inspired by their church and the holy texts they hold. The enduring character of this faith is further implied by the contrast of youth and old age, and we are only left to wonder, as in the case of Gauguin, whether the artist's attitude is one of charitable condescension toward people obviously less complicated than he was, or one of awe and envy at the sight of a faith so difficult to come by in a world of science and machines. The dilemma is like that of modern tourists who, watching a tribal ritual in, say, the South Seas, may be at once unhappy that they cannot experience the strength of so cohesive a religion but pleased that they are undoubtedly superior to, in Gauguin's phrase, this "superstitious simplicity." In Leibl's painting, that simplicity is also reflected in the scrupulous record of everything seen, so meticulously descriptive here that we may even read, magnifying glass in hand, the German Gothic script in the holy book. Such hyperrealism, as in the work of the Pre-Raphaelites, is intended to resurrect another kind of distant naïveté, the incisive drawing and truthful rendering of detail found in such German Renaissance masters as Holbein, whose clean, emblematic silhouetting of forms also attracted Bernard.

Such regression to simpler styles and simpler societies was accompanied, especially in Gauguin's art, by a search for a comparable simplicity of emotion, in which fundamental human feelings of desire, of belief, of fear could be conveyed. For Gauguin, it was only one of the many inadequacies of Impressionism that it could not penetrate, with what he saw as its empirical, scientific orientation, "the mysterious centers of thought." Doubtless, the inward intensity of faith expressed by the Breton women at the base of the yellow Christ would be unimaginable were it painted in Monet's style of the 1880s. Gauguin's pursuit of these elemental human feelings, so thoroughly repressed by the respectable conventions of middle-class society, was constant; and when possible, he allied them to a no less elemental realm of myth and magic. In one of the most potent images of 1889, he resurrects, in his new 'Synthetist' language, the primal terror and shame of *Eve* (fig. 433). Cringing below a tree around which slithers the fateful serpent of sexuality, she holds her hands over her face and ears, as if shutting out the external world in order to be alone with her turbulent emotions. At opposite poles from Bonnat's *Job* (see fig. 374) in its rejection of the empirical world and in its crudely immediate projection of suffering, it is an image which depends on a strange relic from a remote culture, a Peruvian mummy that was exhibited in the 1880s in Paris's ethnological museum (now the Musée de l'Homme). Bound in a crouching position, its skeletal

Fig. 433 **Paul Gauguin**, *Eve*, 1889. Watercolor and pastel on paper, 13¼ × 12¼". Marion Koogler McNay Art Institute, San Antonio, Texas.

arms and hands raised to the blank stare of a skull, it clearly attracted Gauguin as a chilling symbol of primitive terror, which could also be associated with his own ancestry, his mother's family being part Peruvian. His transformation of this grotesque anthropological exhibit was total, offering the experience of anguished guilt, the obverse side of that primitive paradise he also sought on this planet and in his art.

Such an image is both overtly simple and infinitely complex, choosing a consciously stark way of communicating the emotional equivalent of a soundless scream but also evoking with it an infinite number of associations within the viewer, not only of feeling, but of a whole structure of universal symbols that can range from folkloric tales of the loss of virginity to Milton's interpretation of it in *Paradise Lost*, both themes which Gauguin treated elsewhere. It was clear by the late 1880s that not only Gauguin, but many younger artists were pursuing these mysterious directions, and new words had to be coined to describe what was happening. Gauguin's and Bernard's Synthetism, Dujardin's Cloisonism were attempts to do this, but the more embracing word that stuck was Symbolism, as applied to the literary counterpart of these directions in a "Symbolist Manifesto" by Jean Moréas (whose portrait Gauguin would draw in 1891), published in 1886 in the widely read *Figaro Littéraire*. Moréas, claiming Baudelaire as the great prophet of the movement, found in such poets

as Mallarmé, Verlaine, and De Banville the manifestations of this new aesthetic which would totally reject the everyday and the contemporary and move to a world of dreams, of nuances, of sensations. In a schematic summary, Moréas proposed that the new goals of Symbolism were "to objectify the subjective (the externalization of an idea) instead of subjectifying the objective (nature seen through the eyes of a temperament)," thereby reversing totally the premises of Realism. It was quickly realized that comparable ambitions could be found not only in the music dramas of Wagner but in the new novel by Huysmans. Published in 1884, *À Rebours* (Against Nature) turned its back on the writer's earlier viewpoint, allied with Zola's Naturalist accounts of Parisian life, in favor of an exploration of the decadent, world-weary sensibility of its hero, Jean des Esseintes, who, in the seclusion of a home that featured such artificial pleasures as a live tortoise with a jeweled shell, relished the strange art of Moreau and Redon. In March 1891, Georges-Albert Aurier tried to define these new currents in painting in an article in the *Mercure de France* which proclaimed Gauguin as the leader of the Symbolist movement and, in a heady series of conceptual imperatives, declared that this art should be "ideational, symbolic, synthetic, subjective, decorative," words which attempted to describe the various ways in which artists were trying to evoke invisible feelings, dreams, myths in what had to be a visible form, a painted surface whose growingly abstract and decorative character might somehow conjure up these ideas and sensations. Vague as it is, "Symbolism" has nevertheless remained the most useful umbrella term to cover the international manifestations, from the 1880s on, of these subjective pursuits.

It is certainly useful in describing Gauguin's continuing efforts to find in the most remote, exotic places a suitable environment in which to experience elemental emotions and to relive elemental myths. On April 4, 1891, after a farewell banquet presided over by Mallarmé and attended by many Symbolist painters and writers, he embarked at Marseilles for what he hoped would be the most geographically and culturally extreme distance from the modern world. The lure of the French colony of Tahiti, whose balmy, verdant landscape and primitive idols had already been painted by Hodges in 1776 (see fig. 2), had become legendary. Among many of Gauguin's contemporaries to go there was Pierre Loti, the French naval officer and travel writer; his visit, part of his lifelong wanderings over the seven seas, inspired *Rarahu* (1880), one of his many fictional accounts of an exotic world he knew firsthand. Gauguin's own voyage was preceded more immediately by those of the Scottish writer Robert Louis Stevenson (1889) and of two Americans, the historian Henry Adams and his friend the painter John La Farge (1890). But for Gauguin, the distant journey was envisioned as a totally personal commitment in his art and in his life to a civilization which,

GAUGUIN, REPRISED ROMANTICISM, AND CHRISTIAN SYMBOLISM

Paul Gauguin's Yellow Christ *(see fig. 430) combined Synthetism, Cloisonism, medievalism, primitivism, and a personal content linked to earlier Romantic art. Writer Claire Frèches-Thory drew out this aspect of the picture:*

The work aroused the enthusiasm of the writer and critic Octave Mirbeau, who heaped it with praise in a long article for the *Echo de Paris* … : "A rich, disturbing blend of barbaric splendor, Catholic liturgy, Hindu reverie, Gothic imagery, obscure and subtle symbolism." Mirbeau was especially struck by the wistful atmosphere of Gauguin's painting, the dramatic sky reflecting the artist's state of mind at this time of financial and emotional despair. During the period Gauguin was representing himself as the new Christ of painting; he also featured this canvas in the background of a self-portrait in which appeared a rendering of his ceramic with a grotesque head.[76]

This self-identification with Christ, so persistent in his work in Brittany, gave way to a very different conception of Christian symbolism during his time

living in the South Seas. Ia Orana Maria *(see fig. 434) brings these new ideas to life. Gauguin described this picture to Daniel de Monfried, a friend and collector of his work, in a letter sent to Paris dated March 11, 1892:*

An angel with yellow wings reveals Mary and Jesus, Tahitians just the same, to two Tahitian women— nudes dressed in *pareus*, a sort of cotton cloth printed with flowers that can be draped as one likes from the waist. Very somber mountainous background and flowering trees. Dark violet path and emerald green foreground, with bananas at the left—I'm rather happy with it.[77]

Just as in the earlier Yellow Christ *Gauguin faithfully reproduced the hill of Sainte-Marguerite that rises over the village of Pont-Aven, and the wooden cross from the chapel of Trémalo, in* Ia Orana Maria, *he floods the picture with particulars of his surroundings in Tahiti, as described by Frèches-Thory:*

… thatched boathouses in the distance range along pink-tinted sands; coconut palms, a breadfruit tree, hibiscus plants dotted with red flowers and, in the foreground at

left, a *tiare moorea* with sweet-scented white blossoms. To stress further the natural bounty of Tahiti, Gauguin added an exotic still life in the foreground. A little wooden altar, or *fata*, is overladen with a bunch of *fei*, or wild red bananas, a great delicacy, as well as two globes of breadfruit and a native bowl filled with *maia*, or yellow bananas. As if the intensely colored *pareus* worn by the women did not fully satisfy Gauguin's rapacity for color, he imagined how an angel might dress in this faraway land and added a figure in a deep lavender gown with yellow, blue, and purple wing feathers.[78]

On August 30, 1893, Gauguin returned to France from Tahiti, landing at Marseilles with four francs on his person. In November he exhibited some fifty works of art at Paul Durand-Ruel's Paris gallery. Ia Orana Maria *was listed first in the catalogue. It was one of only eleven works that sold, bringing 2000 francs from Michel Manzi, an important collector and friend of Degas. In 1895 Gauguin returned to the South Seas, his imagined paradise, and never again went back to France.*

as in a dream of Jean-Jacques Rousseau, might represent mankind in an unspoiled state.

In his first year in Tahiti, 1891, Gauguin painted an extraordinary tribute to the universality of religion and myth that he had intuited in Brittany, a work on which he inscribed "Ia Orana Maria," a translation into the Maori language of the words "Ave Maria," spoken by Gabriel to the Virgin (fig. 434). This luxuriant image of the tropical paradise dreamed of by Westerners brings with it the viewpoints of a missionary, an anthropologist, and a mythmaker. Resplendent in blue and yellow wings, the Tahitian Angel of the Annunciation floats above the pure white flowers of a young tree and points out to two native women, bare-breasted in their cotton waistcloths (called *pareus*), the vision—or is it a reality?—of a naked infant Jesus seated on the shoulder of his mother, Mary, who also wears a *pareu* but one which covers her breasts. We can guess what Gauguin would have thought of Courbet's quip, "Show me an angel and I will paint one."

Gauguin's idea here continues and complicates the religious images of Brittany, for now the Christian world is translated into Polynesian terms. The foreground still life of exotic fruits may evoke not only the gifts of the Magi but the offerings Tahitians made to the idols of their own Maori religion, whose legends Gauguin was then studying and illustrating in a manuscript he called *L'Ancien culte maori* (The Ancient Maori Religion). Here, the serene, harmonious messages of Christian art and belief, so challenged in Gauguin's century, seem resurrected in a terrestrial paradise freed of guilt, freed of ugly materialism, and freed of an earthbound Realist style that could in no way have evoked such ineffable mysteries. As in medieval Christian art, which Gauguin, like Bernard, had so often admired for its combination of decorativeness and spirituality, abstract symbols can coexist with images, so that the two interlocking haloes of the Virgin and Child seem as compatible with this mythic environment as the words inscribed below on the yellowish ground, the secular counterpart of the gold

Fig. 434 **Paul Gauguin**, *Ia Orana Maria (Ave Maria)*, 1891. Oil on canvas, 44¾ × 34½″. The Metropolitan Museum of Art, New York.

Fig. 435 **Paul-Élie Ranson**,
Christ and Buddha, c. 1890.
Oil on canvas, 26¼ × 20¼".
Private collection.

ground used in the art of the Middle Ages. Moreover, at the 1889 Paris Exposition Universelle, where Javanese gamelan players also inspired Debussy to more nuanced, exotic musical sonorities and harmonies, Gauguin had bought photographs of the sculptural reliefs of the Buddhist temple of Borobudur in Java and, carrying them with him to Tahiti, would use them there as sources for the gracefully rhyming postures of the two Tahitian worshipers, the exotic counterparts of the Three Magi. Fulfilling so many Symbol-ist goals, this gorgeous decorative surface, which seems composed of the very bounty of nature's paradise and which absorbs every color of the tropical rainbow, evokes a multitude of dense associations—the mysteries of Eastern and Western religions, the cyclical fertility of the soil and of its human inhabitants, the possiblity of finding in spirit or in geographic fact a paradise on earth.

As original in idea and sumptuous in result as it is, *Ia Orana Maria* was hardly unique in its mystical wedding of supernatural beliefs from the opposite sides of our planet. Already in 1888, in Paris, a younger group of artists, excited by contact with Gauguin's Breton paintings, banded together in a kind of secret society and called themselves Nabis, from the Hebrew word for prophet. Choosing for their very name an exotic, Near Eastern word, they explored, like devout students of comparative religion, the occult, supernatural aspects of Eastern faiths. In this, they belonged to the late nineteenth century's welling revival of spiritualist doctrines, including the cult of Theosophy, launched in New York in 1875 by the Russian, Mme. Helena Blavatsky and rapidly proselytized in Europe; and the Rosicrucian society, whose esoteric concern with mys-tical symbols and cabalistic writings also attracted many Westerners who wished the most total escape from earthly life in the capitals of Europe and America. In *Christ and Buddha* (**fig. 435**), a painting of c. 1890 by Paul-Élie Ranson (1862–1909), the Nabi most interested in such

occult matters, these crosscurrents are mystically depicted. In the background is the image of a crucified Christ which seems borrowed from Gauguin's *Yellow Christ* (see fig. 430), but this is worshiped by rows of Buddhist monks, whose own deity is represented twice in the seated figure, probably of Siamese origin, and in the huge head at the upper right, which resembles the buddhas at the Temple of Angkor-Wat in Cambodia. And to encompass still other universal religious symbols, the sacred lotus of Hinduism rises in the foreground and a phrase in Arabic, *furusiya nabiy*, which means a "knighthood of prophets" and refers to Ranson and the Nabis, is inscribed at the right. Of this group, which included the Neo-Catholic Maurice Denis and painters of a far less mystical persuasion, Vuillard and Bonnard (see pages 461–63), Ranson represented the most occult extreme. His scaleless, visionary world of floating deities and sacred symbols would proliferate in the even more vaporous and dreamlike fantasies that would soon be shown at the Rosicrucian Salons held in Paris between 1892 and 1897; and his espousal of Theosophic beliefs would find more consequential artistic issue in the work of the pioneers of abstraction, Kandinsky and Mondrian, whose rejection of the material world was also prompted by such mystical teachings.

Compared with Ranson's painting, even the most supernatural of Gauguin's Breton and Tahitian images look earthbound, the result of direct experience. In fact, in a manner that parallels Van Gogh's own fusion of art and life, Gauguin's work closely reflected his emotional and geographic biography. His last decade, which began in paradise, was troubled with medical, financial, and family problems. His return to Paris in 1893 was fraught with difficulties, from an unsuccessful show at Durand-Ruel's gallery to the theft of all his possessions by his Javanese mistress, Annah; and when he decided to go back to Tahiti

in 1895, he was upset to find that Papeete had become yet more polluted by European infiltrations. By the end of 1897, the year he learned of the death of his twenty-year-old daughter, Aline, he stopped corresponding with the Danish wife and five children he had so long ago abandoned in Copenhagen. Deciding to take his own life, he wished to leave a last will and testament in the form of a huge canvas (over twelve feet wide) which, in its title, posed the ultimate trinity of questions, *Where Do We Come From? What Are We? Where Are We Going?* (fig. 436), words which, like a sacred incantation, are inscribed on a flat decorative band in the upper left-hand corner: *D'où venons nous? Qui sommes nous? Où allons nous?* As a counterpart, Gauguin's own signature and date are inscribed at the upper right, giving the whole the character of an exalted suicide note. However, his efforts to kill himself with arsenic failed—he was in fact to die some six years later, in still more miserable circumstances—and the painting was sent to Paris in 1898 for viewing at Ambroise Vollard's gallery, where it elicited sympathetic, but often puzzled responses. The next year Gauguin explained, in a series of three letters, what he had in mind. Following Mallarmé's Symbolist aesthetic, he claimed that the work was "musical," that is, that it should communicate its meaning through an abstract, sensuous surface without a verbal scenario. He nevertheless troubled to itemize and identify some of the figures and narrative events, which begin at the right with a sleeping infant; continue in the center with a young girl, a kind of Tahitian Eve, picking fruit; and conclude at the left with, in Gauguin's words, "an old woman approaching death who seems reconciled and resigned to her throughts" and who looks like an aged version of his traumatized *Eve* of 1889 (see fig. 433). Presiding mysteriously over the scene is, at the left, a Maori idol who, with "both arms mysteriously and rhythmically raised, seems to

Fig. 436 **Paul Gauguin**, *Where Do We Come From? What Are We? Where Are We Going?*, 1897. Oil on canvas, 4′ 6¾″ × 12′ 3½″. Museum of Fine Arts, Boston.

indicate the hereafter." In addition, there are symbolic animals—two cats, a goat, a bird, a lizard—whose meanings may belong to local folklore. But the general sense of the painting is clearly of a sweeping life cycle, which, nurtured by women and the fertility of nature reads, like an exotic language, from right to left under the awesome surveillance of a primitive deity.

Gauguin here felt not only the need to offer his own, as he put it, "philosophical work" on this most lofty theme, but wanted to express himself in terms that would improve upon the most officially acceptable French muralist who might deal with comparably high-minded allegories, Puvis de Chavannes (see fig. 257). As such, Gauguin hoped that his message would resonate to the viewer not through shared public symbols that could be translated by anyone, but rather through the verbally untranslatable effects of the decorative surface of the painting, the visual equivalent of music. In this, what Gauguin hoped to be a final painting that would summarize his aesthetic goals turned out to be prophetic of the ambitions of many twentieth-century artists. But for all its personal avowal, it was also a painting very much of the 1890s, when, as we shall see, more than one artist, aware that the century was drawing to a close, attempted to make grandly philosophical statements about the meaning of life, of history, of society, works which, as Gauguin put it about his own aspirations, would be "comparable to the Gospels."

The 1890s: Postscript and Prologue

Thanks to the magic of round numbers, we think not only in decades, but in centuries; and the prospect of a year numbered 1900 and a century numbered twenty gave the 1890s a special luster. The legerdemain and the hindsight of the historian can turn the decade either forward or backward, depending on whether the 1890s are considered as the prelude to the twentieth century or the finale of the nineteenth. For any proper history of twentieth-century art, to begin only in 1900 would be to ignore the fact that, for the younger artists and architects of the decade, the 1890s could be a time for daring, forward-looking experiment that could shed the past like an old skin and confront the bridge at the turn of the century with the cleanest of slates. By the 1890s, the sheer quantity of routine, pedestrian art for middle-class purchase must have been deadening, equatable with the overwhelming abundance of things for sale in the department stores that expanded from Chicago and New York to London, Paris, Berlin. To see, at the Paris Exposition Universelle of 1889, a display of over one thousand six hundred paintings and drawings by contemporary French artists alone (almost none of whose names is remembered today) and then, at the 1900 Exposition Universelle, almost two thousand works in the same category,

was not only a tribute to the population expansion of the later nineteenth century, but a challenge to any artist to be different from these multitudes. The very words used for many of the new styles and art periodicals that proliferated in that decade—*Art Nouveau, Modern Style, Jugendstil, Arte Joven, Joventut, Nieuwe Kunst*—proclaim in French, English, German, Spanish, Catalan, Dutch this need for newness and rejuvenation; and the historian who seeks out the roots of even the most revolutionary innovations of early twentieth-century art can easily find sources in the 1890s.

Yet, looked at from its past rather than its future, the 1890s can also be thought of as a last and summary chapter of the nineteenth century, in which the Romantics' legacy of introspection and imaginative wanderings in the domain of remote myth and history attains perhaps its last gasp, and in which the century's recurrent efforts to make grand, public statements of mural proportions that might synthesize questions of religion, of philosophy, of society reach a climax. And it was no less a time of art-historical retrospection and the swelling of national pride. At the Exposition Universelle of 1900, there was a contemporary international section which covered the century's final decade and, in the thousands of entries, covered the globe from Peru and Cuba to Turkey and Serbia; but there was also a major stocktaking of France's artistic achievement in the nineteenth century as represented by a survey of its art from 1800 to 1889, which started with Greuze and David and went up to Cézanne, Seurat, and Gauguin. Six years later, across the Rhine, the Germans provided a comparably nationalistic assessment in the 1906 Berlin exhibition of German painting from 1775 to 1875. Already in 1869, just before the outbreak of the Franco-Prussian War, critics noted how the two nations were displaying a welling artistic rivalry.

As the last episode in a history of nineteenth-century painting, the 1890s also present problems of selection. Many major and minor figures who emerged in this decade—Bonnard and Vuillard, for instance—may be most at home here, though their work continues far beyond 1900, whereas others—Matisse, Kandinsky, Mondrian—who also began their careers in the 1890s seem more properly annexed to the history of the next decade. What may best be offered then is an abbreviated, synoptic view of the painting of the 1890s that may ask, to paraphrase the title of Gauguin's testamentary painting of 1897, "Where Did It Come From? What Was It? Where Was It Going?"

Although introspection may be a constant in the human condition and a familiar enough direction in Romantic art, many painters of the 1890s, as if in total rejection of the material and social world around them, turned to reverie, to dream, to an exploration of unnamable sensations and longings. A lone figure in an interior often provided, as it

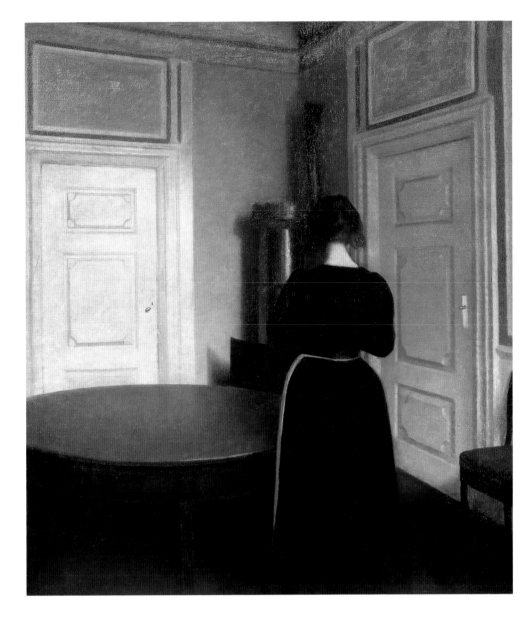

Fig. 437 **Vilhelm Hammershøi**, *Interior, or The Corner of a Dining Room*, 1899. Oil on canvas, 28½ × 26″. Tate Britain, London.

had for Friedrich (see fig. 71), a perfect vehicle for these voyages into the self. Of the variety of rooms that housed this kind of solitude, few are more evocative than those of the Danish painter Vilhelm Hammershøi (1864–1916), whose domestic settings with anonymous figures may at first seem to be extensions of the comfortable interiors painted by a Vermeer or a de Hooch. But in a characteristic painting (fig. 437), we realize that this seventeenth-century Dutch tradition has been totally transformed. The interior is now bare, like a home that has long been devoid of its occupants. The polished round table has nothing on it, the stove seems to give no heat, and the corner angle appears to trap the lone figure who stands, as in many works by Friedrich, with her back to us, so that we can only imagine who she is or what she is feeling. The silence and the inertia are uncommon in a household, more fitting, in fact, to thoughts of loneliness, widowhood, and death. Indeed, the almost total absence of color and the immobility of the light underlines this skeletal chill. In many ways,

Hammershøi's work relates to the tidy interiors and landscapes of his early nineteenth-century compatriots, such as Eckersberg and Købke, offering variations on their sense of lucid geometric order, as in the almost abstract patterns he created from the pure circularity of the stove and the table or from the rectangular wall patterns provided by the door frames and moldings. But the cheerful world of bourgeois comforts has died here. The artist places us in what feels like a domestic coffin.

This sense of ultimate enclosure is shared by many of Hammershøi's contemporaries. The very title of a painting of 1891—*I Lock My Door upon Myself* (fig. 438)—by the Belgian Fernand Khnopff (1858–1921) may pinpoint the same mood as well as some of the historical sources of this slow drift from reality. The English phrase, in fact, comes from "Who Shall Deliver Me?," a poem by Christina Rossetti, Dante Gabriel's younger sister, and the painting seems, if possible, to attenuate still further the aura of dreamy, sensuous languor and aesthetic refinement that

Fig. 438 **Fernand Khnopff**, *I Lock My Door upon Myself*, 1891. Oil on canvas, 28⅜ × 55⅛″.
Neue Pinakothek, Bayerische Staatsgemäldesammlungen, Munich.

Khnopff, an Anglophile, could extract from the traditions inaugurated as far back as the 1860s by Rossetti and Whistler (see figs. 260 and 285). Here, Khnopff's beloved sister, Marguerite, is separated from us by an enigmatic, coffin-like object and confronts us with a somewhat sinister, mesmerizing gaze from beneath her Pre-Raphaelite crown of cascading, auburn hair, as if challenging us to keep our distance from her lonely, morbid reverie. Insofar as the interior over which she presides is a material world at all, it is one of measured refinement, where the thin geometric paneling of screenlike walls and the frail but calculated rhythm of three lilies that bloom and wither in a miniature life cycle extend to eerie extremes the Japanese mode explored by Whistler. Many of the images—the blurred mirror reflections of windows, the soft-focus view of a street scene under the shade at the right—become more dreamlike than real, appropriate to the marble bust of Hypnos, the classical god of sleep, who reigns above and whom a critic misidentified as the bust of Pallas thanks to its famous presence in the mysterious interior of Poe's *Raven*. Already in the 1890s, Khnopff's work was admired by many literary figures of the Symbolist movement, from his compatriot Maurice Maeterlinck to Oscar Wilde, who knew his work from London where it was exhibited with British paintings of a Symbolist inflection. Indeed, Maeterlinck's volume of poems *Serres chaudes* (*Hothouses*, 1889), replete with symbolic flowers, conveys the same aura of world-weary entrapment and the hope of escaping to a more immaterial realm, perhaps death, or perhaps a more

sensual one, where the repressions of nineteenth-century sexual mores might be released.

Even in the work of the most respectable and eminent Victorian painters, the languid escapism of the 1890s can be felt, as in *Flaming June* (fig. 439) by Frederic Leighton (1830–96), exhibited at the Royal Academy in 1895, only a year before the artist's death. As we might expect from the work of a man who had been president of the Royal Academy since 1878, and who was elevated to the peerage the year of his death, this monumentally slumbering figure has the most noble of Western sources, from the exquisitely translucent and animate draperies of the Parthenon sculptures to the heroic torsions of Michelangelo's Medici tombs; and the fullness of the modeling and the accuracy of descriptive detail also give the work an official acceptability that would not be granted to many of Leighton's Symbolist contemporaries who chose more exotic pedigrees and abstract styles for their dreams. Nevertheless, the work also reflects the feel of the 1890s, not only in its voluptuous somnolence, or in its faraway Mediterranean clime where the sea air is perfumed by oleander blossoms, but in its aesthetic refinements. Continuing traditions of artists like Albert Moore (see fig. 356), Leighton here creates the most delicate nuances of hue and tone, with variations of orange and apricot that bathe the figure and convey, almost as in Symbolist doctrine, the title's more explicit evocation of a summer mood of erotic longing. And for all their three-dimensional implications, the trickling linear circuits of the drapery that quiver around the figure, as in an embrace,

also mirror the more insistently flat, curvilinear fantasies familiar to Art Nouveau.

This languid, eroticized mood can even invade the more marmoreal domain of archaeological reconstructions of the ancient world. So it was in the work of Sir Lawrence Alma-Tadema (1836–1912), who was born in Holland and studied in Antwerp with Leys (see fig. 252), finally settling in London in 1870, where the fame and fortune that already had greeted him on the Continent increased. With

his ever more accurate versions of the French Neo-Greek style of Gérôme and Boulanger (see figs. 253 and 256), he would make late nineteenth-century audiences feel that they were actually glimpsing life in the Greek and Roman worlds, as would their grandchildren who watched the movies of D. W. Griffith and Cecil B. De Mille. The events that unfolded in Alma-Tadema's impeccably erudite reconstructions of antiquity were inevitably mirrors of the activities of the Victorian high society in which the artist played

Fig. 439 **Frederic Leighton**, *Flaming June*, exh. Royal Academy 1895. Oil on canvas, 47½ × 47½".
Museo de Arte, Fundación Luis A. Ferré, Ponce, Puerto Rico.

so important a role—the scrutiny and commerce of precious artifacts, the arranging of flowers, the veneration of wine, a lover's squabble. By the 1890s, even these most palpable, polished stage sets could create an environment of sensual reverie. In *Love's Votaries* of 1891 (**fig. 440**), we feel that two eligible Victorian teenagers have been transported to the Roman world, where, lounging amid pillows, fur rugs, and rose petals, and framed behind by the Mediterranean and by a sarcophagus-like bas-relief of languorous dreamers, and in the foreground by a trickling marble fountain with a puckish putto and dolphin, their thoughts turn to the fulfillment of their erotic longings. More companionable and less mysterious than Khnopff's and Leighton's reclusive dreamers, they nevertheless project the same mood of distant yearning, supported here by the arist's much admired classical erudition, which includes an anamorphic Latin inscription from Horace's *Odes* on the rug. It was characteristic, too, of the growing need of late nineteenth-century aesthetes to seal themselves off from modern society that Alma-Tadema, as well as Leighton and Khnopff, built themselves private domestic empires, in which an environment of precious furniture and artifacts relevant to the artists' varying interests could create a hermetic world, untouched by the crassness of the ugly objects produced by factories for the booming department store trade.

The visions conjured up by these imaginative flights of the 1890s could often be supported by texts of myth and legend. The operas of Wagner, for instance, had carried many audiences off to a mystical land where, as in a demonstration of Symbolist theory, music could evoke the distant realms and emotions of the Nordic myths acted out in his *Ring* cycle (first performed in its entirety in 1876), or the dreams of Christian purity and transcendence in his last work *Parsifal* (1877–82), in which the experience of art was meant to take on a sacred character. On both sides of the Atlantic, many painters were inspired by the Wagnerian experience, as were the literary founders of the Paris *Revue Wagnérienne*, which first appeared in 1885, two years after the composer's death. One of these painters was the reclusive American Albert Pinkham Ryder (1847–1917), who is closely allied in mood and theme with his European Symbolist contemporaries but who is often referred to as an isolated and belated Romantic by historians of American painting, a confusion which may indicate, among other things, how often Symbolist art perpetuates, across the nineteenth century, many of the goals of Romanticism. Inspired by literature, from Chaucer to Poe, Ryder was no less drawn to the imaginative narratives staged and set to music by Wagner, as in his moonstruck vision of *Siegfried and the Rhine Maidens* (**fig. 441**), which, according to the artist's own account, was begun at midnight, after attending a New York performance of *Götterdämmerung*, and executed in a frenzy, without food or sleep, in the following forty-eight hours, even though it was later to be reworked considerably before its exhibition in 1891 with the Society of American Artists. All the more intense for its diminutive size (less than two feet square), the painting wafts us into

Fig. 440 **Sir Lawrence Alma-Tadema**, *Love's Votaries*, 1891. Oil on canvas, 34½ × 65¼".
Laing Art Gallery, Newcastle-upon-Tyne.

Fig. 441 **Albert Pinkham Ryder**, *Siegfried and the Rhine Maidens*, 1888–91. Oil on canvas, 19⅞ × 20½″.
National Gallery of Art, Washington, D.C.

a mythical natural setting of cloudswept sky, a glowing full moon, and giant trees that wave their gnarled silhouettes in an atmosphere of penumbral haze. As a hostile New York critic later claimed, the canvas gives "the general impression of an octopus in a flurry," a phrase that unwittingly pinpointed the occasional Art Nouveau character of Ryder's organic rhythms. So dark, so mysteriously remote is this landscape that its occupants would have to be legendary beings, here playing out a scene of awesome destiny, with the Rhine maidens prophesying the doom of Siegfried, who refuses to return the omnipotent

ring to them. A variant on the ubiquitous *femme fatale* theme of the late nineteenth century, the Rhine maidens, bathing in moonlight in a river more easily located in dreams than in Germany, beckon seductively to the Nordic hero, whose horned helmet echoes the erect ears of his stallion.

Remote Nordic myths were explored especially in Scandinavian countries, which tried to seek out individualized identities in the later nineteenth century. So it was in Finland, where in the 1890s the ancient Finnish epic, the *Kalevala*, became a symbol of national resistance at a time

when imperial Russia was trying to absorb Finnish culture into its own. It was in that decade that the Finnish composer Jan Sibelius wrote program music about the adventures of Lemminkäinen, the legendary hero of the *Kalevala*, and that his compatriot and contemporary Akseli Gallen-Kallela (1865–1931) painted the same narrative events. In one of these works, *Lemminkäinen's Mother*, dated 1897 (fig. 442), the mythic milieu might be that of an opera by Wagner, as might the complex symbolic program that deals with love and death, heaven and hell. Here, after attempting to kill the Swan of Hell (at the upper left) in order to find the secret of life and death which it guards, the wounded hero, Lemminkäinen, lying at the edge of the infernal river, is succored by his mother, who sends off a bee to fetch a magic healing balm from a golden fountain. How to depict this fairy-tale legend posed problems. Here, the anatomy of the figures themselves and also the bones, skulls, and candles around the hero's felled body have the reality of studio models as well as of the artifacts in an anthropological display; but the black waters of the river, the flat granular patterns of the tiny pebbles on the shore, the curling locks of the hero's hair, and, above all, the stylized golden rays of the healing sun propose a language of decorative unreality, more appropriate to this mythic ambience. Such a collision of the real and the abstract, endemic to so many nineteenth-century paintings that attempt to move from the natural to the symbolic, as in works by Runge (see fig. 69) or Flandrin (see fig. 155), reached, in fact, a painful deadlock in the 1890s, when many artists kept alternating, often in the same work, between contradictory modes of vision and thought. That Gallen-Kallela's painting may also be looked at as a continuation of Romantic efforts to illustrate remote sagas (the study and publication of the *Kalevala* manuscript were, in fact, results of early nineteenth-century scholarship) is yet another indication of the frequent continuities between Romantic and Symbolist art. It is revealing that the legends of Ossian, as illustrated in the 1790s by such Scandinavians as Abildgaard (see fig. 36), offer a close prototype, separated by exactly a century, for this resurgence of Nordic myth.

Fig. 442 **Akseli Gallen-Kallela**, *Lemminkäinen's Mother*, 1897. Tempera on canvas, 33½ × 46½". Ateneumin Taidemuseo, Helsinki.

Fig. 443 **F. Holland Day**, *Study for the Crucifixion*, c. 1898. Photograph. Library of Congress, Washington, D.C.

Even photography could aspire to a realm so immaterial that we might be convinced that the objective visual data recorded by the camera lens could be transmuted into an image of the supernatural. Of those late nineteenth-century photographers who felt that, despite their presumably earthbound medium, they could be as successful as the Symbolist painters in confronting the mysteries of Christian and classical narrative, the most fervent was the American F. Holland Day (1864–1933), who dared to photograph real youths posing as Hypnos, the same god of sleep who presides over Khnopff's painting (see fig. 438), as well as Orpheus, St. Sebastian, and the Prodigal Son. But the most audacious of Day's lifelong efforts to prove that photography could attain the same imaginative level as painting was his series of variations on the most sacred of all martyrdoms, the Passion of Christ. It was a subject that he may in part have chosen because of the premature death, in 1898, of his friend Aubrey Beardsley (see fig. 455), an artist who had converted to Christianity and who symbolized, with Oscar Wilde, the extremes of aesthetic refinement and decadence. Photographing Jesus on the Cross might have seemed an oxymoron, despite the theatrical precedent of the Oberammergau Passion Play, which Day had once seen, but he rose to the challenge. In an early study (fig. 443), Day envisioned one way of transcending the familiar prejudice that the camera was objective, namely, by rendering what he saw in such soft focus that flesh seems more spirit than substance, almost a mirage of uncommon sacrifice and suffering that even turns the wooden cross into impalpable shadow. Looking backwards, such an image might even be related to the presumably real, but no less supernatural images of Christ imprinted on famous relics, whether Veronica's Veil or the Holy Shroud of Turin. But Day's twilight mood was also shared by many of his Symbolist contemporaries who, like the painter Albert Pinkham Ryder (see fig. 441), dissolved matter with a softened, tonal palette, creating a hazy atmosphere hospitable to probing emotional depths or to dreaming of remote legends. Day's *Study for the Crucifixion* was included in an exhibition of his platinum prints held in 1898 at the Boston Camera Club, where the shock that might have been expected from a photograph of full-frontal male nudity was nevertheless cushioned by the image's overt artiness, which permitted it to slip into a category closer to high art than to the homoerotic photography that flourished at the turn of the century. Not only did the anguished yet ecstatic posture, with its strong sexual charge, allude to Michelangelo's *Bound Slave*, a classic in the Louvre; but the misty scrim of shadow helped to conceal the viewer's confrontation with a model who no longer wore a loincloth. Day soon expanded this supernatural theme, staging the Crucifixions outdoors and using himself as the model for Christ. Now deprived of the tonal artifice familiar to Day's studio photographs, the results were immediately condemned by a public who

Fig. 444 **Jean Delville**, *Orpheus*, 1893. Oil on canvas, 31½ × 39½″. Collection Anne-Marie Gillion Crowet, Brussels.

found this collision of science and faith close to blasphemy. The history of the movies, however, often picked up where Day left off, providing later spectators with many efforts to film the Bible or the martyrdom of Joan of Arc.

Day's subliminal theme of homosexuality, and of worship and sacrifice to the deity of art came in many forms at the end of the century. The theme of Orpheus, which Day explored as well, was one of the most popular. Already in 1865, it was morbidly envisioned in a painting by Moreau (see fig. 259), who, like Baudelaire, also born in the 1820s, provided the Symbolist generation with a mid-century father figure. Perhaps the most memorable of the many 1890s attempts to envision the legend's mixture of the gruesome, the sexual, and the aesthetic, was by the Belgian Jean Delville (1867–1953), who, like many of his Symbolist compatriots, provided a rich background to nurture the dreams of the Belgian Surrealist Magritte. Here (fig. 444), Orpheus's head, torn from his body by the raging

Thracian maidens, whose sex he had spurned for the love of young men, has been flung into the Hebrus River, where, joined to his lyre, it continues to sing. Delville's vision wafts us into an almost Wagnerian *Liebestod* (love-death), as the head of the archetypal Greek musician, his eyes closed in an ecstatic transcendence, is swallowed into enchanted blue waters that mirror the light of the invisible moon and stars above. That Orpheus's head has a feminine cast is explained not only by the fact that Delville used his own wife as a model, but that, in the more effete and arcane circles of the 1890s, androgyny, as in many Eastern religions, was often considered a superior state of being, and one associated with Orpheus's own bisexuality. Delville's painting of 1893 was exhibited the following year in Paris at the third of the Rosicrucian Salons (Salons de la Rose + Croix), a strange new arena for the promotion of the wilder fringes of the Symbolist movement under the direction of its high priest, Joséphin Péladan. Pushing the mystical goals of

the Nabis even further, access to the Salon (which made its debut in 1892 to the sounds of *Parsifal*) could be had only by the most loyal believers in an extreme idealist position, artists who banished all modern or trivial subject matter in favor of pictures which, like Khnopff's *I Lock My Door upon Myself* (see fig. 438), shown with the Rosicrucians in 1893, aimed to leave this world far behind, and who explored a variety of styles that seemed to provide abstract paths to these transcendent directions.

Remote as it might be from the visible world, Delville's *Orpheus* nevertheless depends in good part upon the later evolution of Impressionism, especially in the work of Monet. Its gravity-less, horizon-less expanse is bathed in a mysterious blue, a color favoured by Romantics in search of a more spiritual clime and one whose ethereal associations had a long afterlife in Symbolism and twentieth-century art, from the early Picasso through the Blue-Rider world of Kandinsky and Marc. Moreover its blurred, rippling surfaces offer, despite their tight execution, surprising counterparts to Monet's paintings of the 1890s. In that decade, Monet pursued far more concertedly the idea of series that he had first fully explored in the Gare St.-Lazare

Fig. 445 **Claude Monet**, *Poplars*, 1891. Oil on canvas, 32¼ × 32⅛″. The Metropolitan Museum of Art, New York.

paintings of 1877 (see fig. 353); but his art had also taken an unexpected turn that, coming from the direction of perceptual experience, began to converge with the Symbolist goals of his younger contemporaries. By the 1890s, he had largely left behind him the modern, urban world of Paris and its less populated suburbs and nearby countryside, choosing instead remote, unpopulated corners of landscape which he scrutinized so intensely and so often that they began to take on a phantom quality, dreamlike afterimages that seemed less the objective record of direct, sunlit experience than a subjective recall from behind closed eyes of something once seen.

In 1890, for instance, Monet was struck by the rows of poplars growing along the River Epte, near his new home at Giverny, whose gardens and interior he was in fact to turn into a hothouse of aesthetic refinement that offered an organic counterpart, as it were, to the more artificial contents of the artists' homes of the period. Before these trees were cut down—and Monet made elaborate arrangements to postpone this by reimbursing the probable purchaser of the poplars for the time needed to complete the painting—the artist caught what had become literally their ephemeral beauty in over twenty paintings, of which six were to be exhibited at Durand-Ruel's gallery in 1892, the year of the first Rosicrucian Salon. In one of this series, dated 1891 (fig. 445), we are set afloat in a world no more measurable than Orpheus's blue waters. Substance and reflection, near and far, top and bottom, brilliant yellow sunlight and dark purple shadow are confounded in a meditation upon nature so subjective and penetrating that the visible world seems to have vanished behind a mysterious scrim of paint. It may be ironic that Monet, often considered the most staunch defender of painting nothing but what he could see before him, could join forces, almost in spite of himself, with the Symbolist goals of the 1890s. Even though his reputation as an Impressionist and his generally inconsequential subjects would certainly have excluded him from an exhibition that featured Delville or Khnopff, the aura of otherworldly reverie is not alien to theirs. With their frail, iridescent colors and their never-never land ambience, Monet's *Poplars* might even have served, spread large, as the backdrop for Maeterlinck's famous Symbolist drama *Pelléas et Mélisande* (1892), which, in the next decade, was transformed by Debussy into an opera (1902) whose music, like its characters and emotions, explored the potential of a world so fragile and so whispered that it was perhaps not there at all. Similarly, the gossamer landscape imagery of Debussy's piano music—"Reflections in the Water," "Gardens in the Rain," "Footprints in the Snow"—might as easily have provided, in their sensibility to organic evanescence, the motifs for many of Monet's paintings of the turn of the century. "Art," to quote one of Oscar Wilde's aphorisms, "is at once surface and symbol," and in the 1890s, even an artist as concerned as Monet was with the

documentation of something seen ended by dematerializing a quartet of poplar trees at sunset into an exquisite painted veil behind which unnamable worlds are concealed. Mondrian himself, in his search for enduring mysteries behind the surfaces of nature, could find in a painting such as Monet's *Poplars* clues for the stripping of landscape to its intangible abstract core, whose parallel and perpendicular skeletons, the ghosts of trees and horizons, are already adumbrated. Long-lived—he was to die in 1926 in his eighty-sixth year—Monet continued after the 1890s to explore these new directions, offering for a quarter century an ever more refined extension of that moment in the 1890s when his Impressionism went through the looking glass of the objective world and became part of the Symbolist aesthetic.

Even the disciples of Impressionism reflected, in the 1890s, the shift of style and mood, as may be seen in *Meadow Flowers* (fig. 446), a painting by the American John Henry Twachtman (1853–1902), who, during a three-

Fig. 446 **John Henry Twachtman**, *Meadow Flowers*, c. 1890–1900. Oil on canvas, 33¹⁄₁₆ × 22¹⁄₁₆". The Brooklyn Museum, New York.

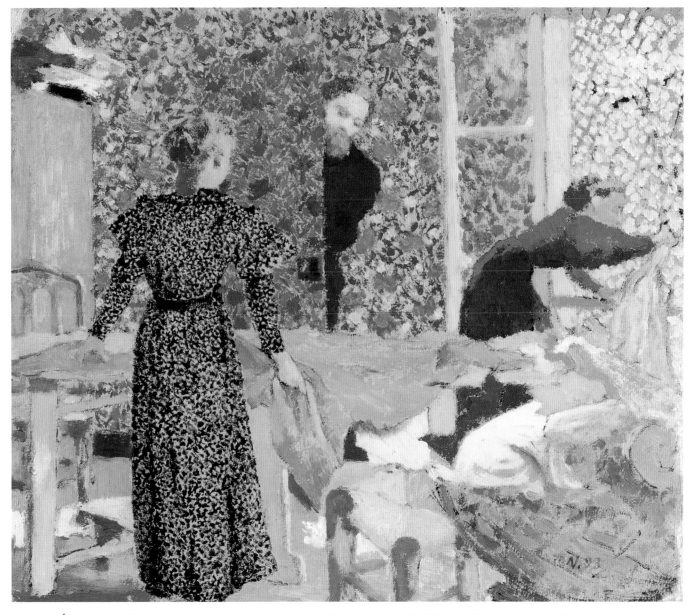

Fig. 447 **Édouard Vuillard**, *The Workroom* (also known as *The Suitor*), 1893. Oil on millboard panel, 12½ × 14⅜".
Smith College Museum of Art, Northampton, Massachusetts.

year sojourn in Paris (1883–85), joined the circle of Monet's American followers. Although it was undoubtedly inspired by a particular growth of wild flowers somewhere on or near the artist's farm property in Cos Cob, Connecticut, it dispenses with any such specificity, immersing us instead in a bewildering profusion of leaves and blossoms that are so cropped, top, sides, and bottom, that any sense of the measurable space of the real world is annihilated in favor of a luxuriant floating surface of colored textures having no beginning, middle, or end. Although the messages that emanate from this fragment of landscape may be less evocative than those of Monet or of his Symbolist contemporaries, it is once again the aesthetic surface that draws us into the painting, as well as reminding us that this is, finally, art and not illusion.

That point is made with endless subtleties by Édouard Vuillard (1868–1940) and Pierre Bonnard (1867–1947), masters who have been annexed to the history of both nineteenth- and twentieth-century painting and who both offer more domesticated variants on that intense pursuit in the 1890s of everything that was artificial in art. In the late 1880s, these two young friends joined the Nabis group, but their orientation veered away from such explorations of occult religious mysteries as Ranson's (see fig. 435) toward a search for the fusion of surface and symbol in the agreeable commonplaces of Parisian experience. In Vuillard's *Workroom* of 1893 (**fig. 447**), a canvas not even fifteen inches wide, we glimpse a scene at once ordinary and magical. The interior is part of the artist's familiar domestic world, a room in which his mother, a dressmaker, is seen

with her bolts and swatches of fabric, accompanied by two other members of the family circle, his sister Marie and her new husband, Ker-Xavier Roussel, himself a distinguished painter and member of the Nabis. But this family portrait is almost entirely camouflaged by the most nuanced tapestry of paint, which, at first inspired by things actually seen—the floral patterns of the wallpaper, the vibrant mottling of the dress material—soon absorbs the human players in a surface both shaggy and refined, as if pigment could be re-created as the most precious tweed. So pervasive is the overall weave of paint that the geometries of walls, tables, windows dissolve into hazy afterimages and the figure of Roussel becomes only a delicately bisected silhouette, floating somewhere between two decorative planes. No less subtle and subdued are the beige and gray tonalities, in which blues, oranges, greens are diminished to the equivalent of whispers or veiled memories. Like his friend Mallarmé, who wanted to dissolve the materiality of objects through the alchemy of poetry, Vuillard sought comparable feats of magic with the images of ordinary things, without, however, violating a sense of continuous and loving contact with a Parisian middle-class milieu of comfort and sweet domesticity. Vuillard also designed sets and programs for the new experimental Théâtre de l'Oeuvre, which, under the direction of Aurélien Lugné-Poë, brought to the Paris stage a brilliant repertory of international drama, from Strindberg and Ibsen to Maeterlinck and Wilde. His own painting, in fact, often reflects the more "naturalistic" staging explored by Lugné-Poë, which, as in the *Workroom*, evoked the accidental comings and goings of real-life motions and activities in which figures may suddenly peek into a room or turn their backs to us. Yet these realistic premises, the inheritance of a Manet or a Degas, have been transformed into a far more dreamlike world of memory and savor. We feel, looking at Vuillard's interiors, that they might provide a perfect setting for a scene from Proust. And, as prophecy, Vuillard's efforts to veil the prosaic facts of everyday reality in a poetic, elusive shuffle of atmospheric planes and textures even point to some of the more mysterious effects of Picasso's and Braque's Analytic Cubism.

"Intimiste" is the French word occasionally used to describe the mood of both Vuillard's and Bonnard's vision of middle-class life, one which pinpoints the flavor of intimate, cozy domesticity that could become a more attainable respite from a public world than the nirvana dreamed of by so many Symbolists. That intimacy could be found both indoors and out, and even when Bonnard, following Manet, painted such a raucous place of Parisian public entertainment as an ice-skating rink, he somehow imposed upon it a sense of elegant privacy and domestic scale that take on the sensuously protective character of a comfortable hotel room. Sharing a familiar late nineteenth-century impulse to propagate the high aesthetic

standards of the more hermetic world of the younger, innovative artist within the public domain, which seemed blighted by the products of factories and commercial artist-hacks, Bonnard in the 1890s adapted the intimate refinement of his genius as an easel painter to the widest aspect of decorative art and illustration, from posters and stained-glass windows to magazine illustrations and screens. In a quartet of narrow panels that were designed as a screen in 1891–92 (fig. 448), Bonnard's mixture of easel painting and more familiar forms of decorative art is so smooth that the traditional gap between high and low art seems never to have existed. Such a work demonstrates, too, the way Bonnard, like so many artists of the 1890s, tended to extract as daringly as possible the most abstract components of the expanding inventory of ever more decorative vocabularies alluding to the real world. But it could also affirm how, as Bonnard's fellow Nabi Maurice Denis stated in 1890, "it is well to remember that a picture—before being a battle horse, a nude woman, or some anecdote—is essentially a plane surface covered with colors assembled in a certain order." One could hardly forget this simple dictum in front of Bonnard's screen, which, like Vuillard's *Workroom*, demands a second or third glance to reveal that beneath the quiet insistence of checkerboard patterns, Pointillist speckles, interlacing arcs, or linear arabesques, there are hide-and-seek views of elegant Paris women. Accompanied by a frolicsome cat or dog, or by other figures in a quartet of different garden settings, they not only display the fashionable dresses and fabrics of the period, but may even evoke memories of the cycle of four seasons, especially in the autumnal tones of the right-hand panel.

Attracted to any trend of the 1880s and 1890s that underscored the artifice of art, Bonnard offers here his own delicate and shadowless variations on everything from the flat Synthetist style of Gauguin and the more agitated currents of Van Gogh's energetic line (as in the description of the dress in the second panel) to the proliferating arabesques of Art Nouveau. In the very idea of these panels of interior decorations, Bonnard shares the vogue for Japanese screens which, for Westerners, could translate the visual world into a series of folding planes that were patently flat and conceived as elegant surfaces to embellish a home. It is telling that Bonnard's adaptation of Japanese decorative ideas even includes the use of his monogram, PB, which recurs in the upper left-hand corner of each panel with subtle color variations that correspond to the palette below. As was often necessary in the posters and book illustrations of the period, flat lettering had to be absorbed into the decorative whole, equating abstract symbols and images in the common ground of a continuous patterned surface, an equation that, like many visual ideas of the 1890s, would have more complex consequences in Cubism.

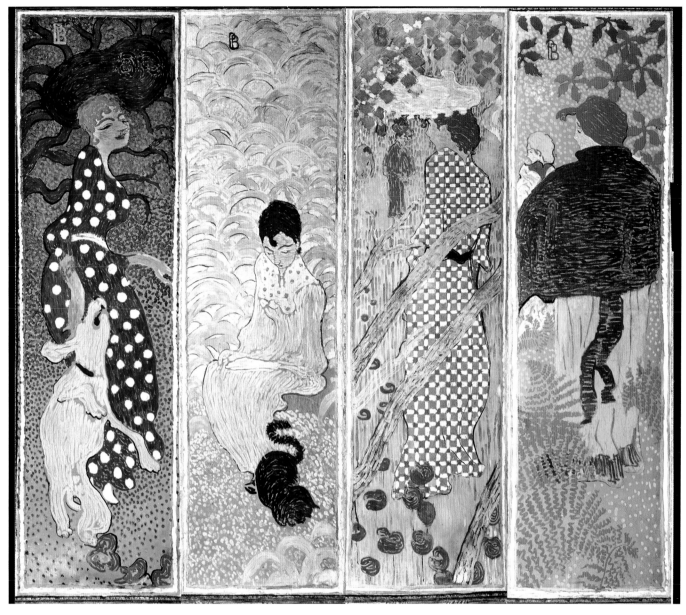

Fig. 448 **Pierre Bonnard**, *Four Panels for a Screen*, 1891–92. Oil on canvas, each panel 63 × 18⅞″.
Collection Mrs. Frank Jay Gould.

Bonnard's willingness to leave the hermetic world of the artist's studio and to extend himself to a more public and utilitarian domain was a familiar direction of the 1890s, and one which, in the popular mind, is best represented by Henri de Toulouse-Lautrec (1864–1901), whose paintings as well as posters have almost a journalistic character of documenting both public and clandestine aspects of Paris social life, from circuses, racetracks, and cafés to bordello scenes of the kind that Degas had recorded with such blunt candor in the late 1870s (see fig. 370). Toulouse-Lautrec's paintings, in fact, may often be thought of as an extremely personal, and more compassionate view of the Paris which Degas chose to depict, and his style, too, is in good part dependent on many of Degas's approaches to cropped angles of vision and the incisive grasp of an expression or a gesture.

In his lithographic posters, however, he is totally his own master, providing the quintessential idea of public life in Paris as the new century approached, at least of that part of "la belle époque" which was studded with the stars of the 1890s entertainment world. Toulouse-Lautrec immortalized many of them, from the American Loïe Fuller, whose renowned butterfly dances with swirling, iridescent chiffon veils made her look like a Symbolist painting come to life, to such Parisians as the *diseuse* Yvette Guilbert or the dancer Jane Avril, whose long life (1868–1943) provided the familiar theatrical biography of childhood misery in the lower depths of Paris, international success (which would take her to London and New York, and which would even permit her to make an appearance in the Lugné-Poë production of Ibsen's *Peer Gynt*), and, finally, old age, neglect, poverty. Although in paintings, Toulouse-Lautrec might

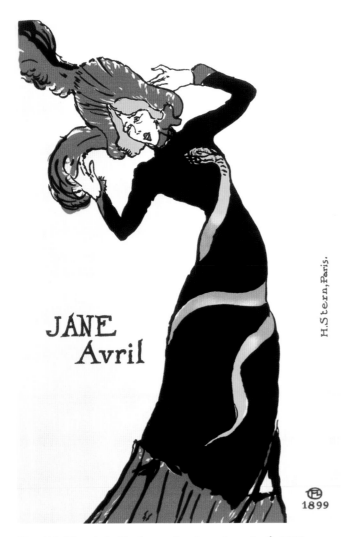

H.Stern,Paris.

JANE
Avril

1899

Fig. 449 **Henri de Toulouse-Lautrec**, *Jane Avril*, 1899. Lithograph, 22 × 14″. Bibliothèque Nationale, Paris.

show the more private, even melancholic side of Jane Avril's life, in his posters, as in one of 1899, she was always on stage (**fig. 449**), advertising her lithe, pointed grace to the pedestrians who saw such advertisements pasted to the kiosks of Paris. By the 1890s, these were so charged with jumbled juxtapositions of words and images that they began to look like popular prophecies of Cubist collages. In this lithograph, Jane Avril might almost be a racy, music-hall version of the elegantly dressed lady with the dog in the first of Bonnard's panels for a screen, for she also shares the decade's sensibility to those attenuated, ductile rhythms which permeated the new designs of the 1890s, from the dresses and furniture of the wealthy to Hector Guimard's entrances for the new Paris subway system, the Métropolitain, whose construction began in time to greet and accommodate visitors who would come to the City of Light in 1900 for the Exposition Universelle. This period look of modernity, literally serpentine in the embroidered snake that sexily slithers around the lean and sinuous sil-houette of Jane Avril, was soon baptized Art Nouveau, after the name of a shop which the German dealer Samuel Bing

opened in Paris in 1895 to sell his new decorative wares from Japan and the entire European continent. Although purists might restrict the use of the term Art Nouveau to the decorative arts and architecture, its visual signature—a thin, pulsating arabesque that seemed to lead an abstract life of its own—could be found throughout the painting of the 1890s. Beginning with the late work of Van Gogh and Seurat, where it could be used as the vehicle of, respectively, urgent emotion or mechanized gaiety (see figs. 422 and 404), it was soon found in countless painted themes and variations, from the tragic to the trivial. In the case of Toulouse-Lautrec's poster, the swift, undulant ascent of these untamable rhythms, flattened like a playing card against a spaceless, neutral ground, reaches a crackling, fiery climax in the yellow and orange of the dancer's blonde hair and huge plumed hat, the whole offering, as it were, a freer, more individualized version of popular entertainment than that proposed by Seurat's dancing automatons, and one compatible with such spectacular interiors of the period as that of Maxim's restaurant in Paris, the touch-stone of Art Nouveau's capacity to be both vivacious and chic.

For many artists of the 1890s, the pleasures, both public and private, of city life as translated into the hedonistic decorative styles of the period had little meaning at a time when the facades of modern society, whether as agreeable as those of Parisian high life or as appalling as those of a Belgian mining town, only concealed more abiding ques-tions about the human condition, questions like those asked by Gauguin about life and death, sex and guilt, the natural and the supernatural. In 1882, when Friedrich Niet-zsche proclaimed that "the greatest modern event—that God is dead, that the belief in the Christian God has become unworthy of belief—has now begun to cast its first shadows over Europe," he, in effect, diagnosed the terrify-ing void that artists would soon rush to fill with other, more private religions. By the 1890s, it was a common ambition to create new kinds of altarpieces that might replace the conventional ones of Christianity, paintings that offered at once personal and public commentaries about human destiny. Often, it was nature with a capital *N*, both the Nature of the Romantics and of Darwin, that seemed to be the vast, controlling force ruling human lives, and through a scrutiny of its powers, a new and modern combination of biology and theology might be achieved.

Even a personal event in the life of an artist, such as the birth and growth of a son, could be aggrandized to these otherworldly dimensions, as was the case with the Swiss painter Ferdinand Hodler (1853–1918). In the 1880s, Hodler worked within local Realist traditions, painting portraits, genre, landscape; and when his son Hector was born in 1887, he soon after painted him as an infant in a terrestrial world. By the 1890s, this world could no longer

encompass his quest for more philosophical statements about life and death. In *The Chosen One* of 1893–94 (fig. 450), Hector, now in his sixth year, is seen almost as a new Christ child, who, naked in the purest of Swiss mountain landscapes, kneels and prays before what appears to be his equivalent in nature, a newly planted tree, sanctified in a square plot of earth. As in Gauguin's *Ia Orana Maria* (see fig. 434), the angels invisible to Courbet have reappeared here as a sextet of guardians who, with the angular gestures of the modern dance, then in its origins, hover over the young Hector in a protective arc, their heads intersecting the more distant arc of the horizon. Although, as with the angel of Rossetti's *Annunciation* (see fig. 245), which Hodler undoubtedly knew, we may still feel the uncomfortable vestiges of the laws of gravity in this feat of supernatural levitation. Hodler made every effort to locate the scene in the mystic, spiritual clime of the 1890s. His work, in fact, was eagerly received in Paris by just those artists who looked toward either a transcendental realm or a remote Arcadia, and his paintings were shown not only at the Rosicrucian Salons, but at the less hermetic Salon du Champ-

de-Mars, one of whose founders, Puvis de Chavannes, early recognized Hodler's formal and spiritual affinities with his own work.

In *The Chosen One*, Hodler also puts into practice his theory of parallelism, which, as evolved in the 1890s, would extract from the complexities of seen nature its underlying unities, here evoked by a compositional skeleton of almost emblematic symmetry, in which like forms are starkly repeated in a solemn, cosmic beat, and in which wiry contours, like the leading on stained-glass windows, isolate each form. The sanctified purity of this iconic effect, as if nature and the human image had been translated into a static, abstract structure, is further borne out by the Alpine environment, in which symbolic spring flowers grow in what seems a sacred meadow at the crest of a hill whose arcing silhouette echoes the globe of the earth below. In this spiritual, unpolluted world of nature even the colors have a holy character, with chilly whites and the palest of blues evoking the virginal domain of snowcapped mountain and sky so familiar to the Swiss. It is telling that, in terms of the overall continuities of the problems facing

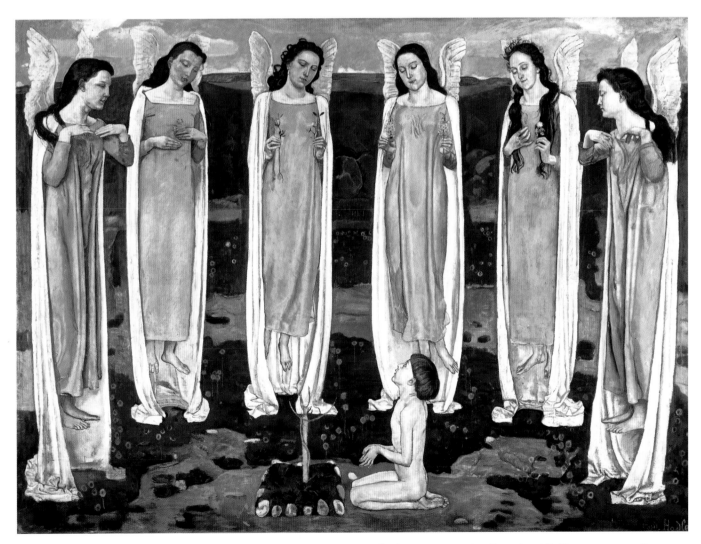

Fig. 450 **Ferdinand Hodler**, *The Chosen One*, 1893–94. Tempera and oil on canvas, 7′ 3½″ × 9′ 10½″. Kunstmuseum, Berne.

nineteenth-century painters, the issues Hodler confronted here are extensions, or perhaps revivals, of those that Runge faced in such paintings as *Morning* (see fig. 69), another private icon of vast ambition, which would replace the vacuities of conventional religious painting with a new, personal amalgam of landscape, figures, and Christianity frozen in a heraldic structure akin to Hodler's own idea of parallelism. The problems and the solutions of the Romantics, in a world where religion had been challenged, often persisted into the late nineteenth century.

Of those painters who, in the 1890s, brought to maturity an art that was visually and emotionally potent enough to transform the secular world into images of almost sacred authority, it was the Norwegian Edvard Munch (1863–1944), who was the most compelling. In 1889 he wrote a diary entry that was virtually a manifesto of these new goals: "No more interiors should be painted, no people reading and women knitting. They should be living people who breathe, feel, suffer, and love. People shall understand the holy quality about them and bare their heads before them as if in church." For the next decade, in fact, he realized that goal in one work after another, stripping emotions to such harrowing, psychological cores that the verities of life, love, death seem laid bare to the viewer. In 1882 in Oslo (then called Christiania), Munch befriended his elder

compatriot Christian Krohg, whose recent painting of a young girl dying of tuberculosis (see fig. 377), in part inspired by the memory of Krohg's own sister's death, must have been an important signpost for the young Munch of this new emotional probing, especially since Munch's own childhood and adolescence had been darkened by the deaths of his mother and sister, both victims of tuberculosis. Munch had explored these gloomy themes in the 1880s, trying to extract drama from a modified Impressionist style; but it was not until after 1889, when he began to spend long periods in Paris, that he found new pictorial languages in which he could disclose his pessimistic view of man's destiny. In *Death in the Sick-room* of c. 1894 (fig. 451), one of many variations on this theme executed at a time his younger brother was dying of tuberculosis, we may recognize both Munch's distinct genius as well as the impact of Van Gogh and Gauguin upon its formation. The shadowless style of Cloisonism, with its flat colors and clear contours, is evident here; but these regressions to decorative simplicity are so highly charged with the immediacy of grief that we feel closer to the anxiety-ridden environment of Van Gogh. Indeed, as in *The Night Café at Arles* (see fig. 420), we are breathlessly rushed into another hell on earth, the floor again being tilted upward at so steep an angle that we cannot keep our physical or emotional

Fig. 451 **Edvard Munch**, *Death in the Sick-room*, c. 1894. Oil on canvas, 59 × 66″. Nasjonalgalleriet, Oslo.

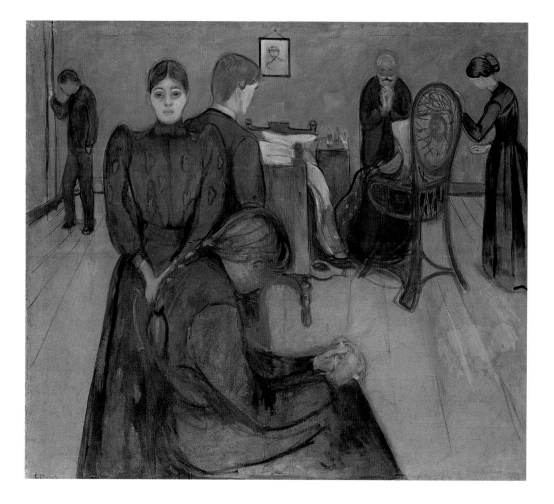

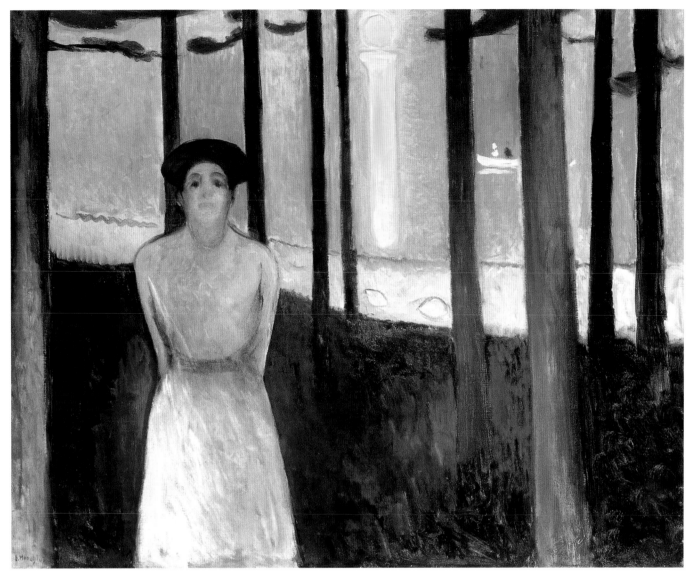

Fig. 452 **Edvard Munch**, *The Voice*, 1893. Oil on canvas, 34½ × 42½″. Museum of Fine Arts, Boston.

distance from this claustrophobic theater of family sorrow. The family is, in fact, Munch's own. It is probably a record of the last moments of his sister, who has momentarily left her sickbed and is seated, her back to us, in the chair at the right; but the event is a fluent fusion of past and present, for the starkly frontal figure is Munch's surviving sister, Inger, as she was in the 1890s, not at the time of earlier family deaths, and the image becomes half the record of a particular event, and half a more generalized statement about grief that transcends the specifics of Munch's traumatic childhood memories. In a stalwart refusal to share the common experience of despair, each family member, young or old, is starkly isolated from the others; yet undulant contours, the earmark of Art Nouveau, begin to fuse the figures and even the furnishings (including the chamber pot) in a slowly throbbing, almost lethal rhythm that permeates the entire scene, a serpentine metaphor for the welling pall of death that overcomes victim and survivors. As in Maeterlinck's Symbolist drama *The Intruder* (1890), death, the

image of the title, transforms the living into strange, puppet-like creatures. In fact, Munch's tragic family scene may well reflect theatrical performances of the 1890s, which so often re-created the dramas of modern life in contemporary domestic settings. Yet unlike, say, the figures in Vuillard's interiors (see fig. 447), Munch's are starkly disposed in an almost Egyptian rigidity of profile and frontal postures which transforms both the archaic residents of Puvis de Chavannes's Arcadias and the modern robots of Seurat's industrial utopias into archetypal symbols of primal emotions, locked forever in the prisons of their passion.

So weighty a sense of tragedy, as if human lives were controlled by the kind of malevolent destiny that stalks the heroes and heroines in the plays by Munch's friend and compatriot Ibsen, pervades even his treatment of sexual love. In *The Voice* of 1893 (**fig. 452**), Munch relives, as he was often to do, the terror of puberty, for the painting is an exorcism of another remembered trauma, in this case, his

first sexual confrontation with a girl who, he later recalled, was older and taller than he was. Just as his sister Inger stares out at us from *The Death Chamber*, forcing our empathy, so here the female temptress assails the spectator directly. Dressed in white, an evocation of her as yet virginal state, she holds her hands behind her back in a gesture that seems at once a repression of physical desire and a concealment of her imminent sexual power over the adolescent Munch, who remembered having to stand on a mound to look into her eyes. The original title of the painting, *Summer Night Mood*, and the landscape of pine trees, water, and moonlight transport us to a kind of Scandinavian rite of spring, a vision of sexual awakening and release in a primitive, nocturnal setting illumined by a full moon whose absolutely vertical, shaftlike reflection is echoed in the trees and the sexually tensed posture of the girl. In the background, a lone boat, occupied by a couple, one painted a spot of black, the other of white, suggests the union of the polarized sexes, male and female, as the culmination of this longing. And the almost schematic perpendicular skeleton of bare tree trunks against stark shore and horizon lines becomes a further reduction of Puvis de

Chavannes's archaic clarity, here cutting as close as possible to the organic bones that unite the biological instinct of human beings to the cycles of nature.

Even in the work of far more decorous and elegant artists of the 1890s this message can be sensed. It is found, for instance, in the work of the refined Bostonian Thomas Dewing (1851–1938), whose *Summer: Moonrise* (fig. 453), the centerpiece of a triptych that would also evoke spring and fall, is contemporary with Munch's *Voice* and was probably exhibited at the Chicago World's Columbian Exposition of 1893. Symbolist in its whispered mood and veiled atmosphere, it permits us to glimpse two fashionably dressed young American women who seem to have left the precincts of a respectable home or perhaps a party to find a natural refuge for their awakening erotic longings. Immersed in the light of the moon, which just peeps over the edge of the tree, they project phantoms of desire, with one of the women stretching her elbows upward in a posture of sexual yearning familiar to the repertory of Munch and the 1890s. Dewing's interpretation of this theme remains within the most socially proper boundaries; and the pervasive bluish tonality makes it clear that the emotional charge is softened and distanced. Yet his effort to find a visual equivalent to some interiorized experience of desire or longing is one shared not only by Munch but by many artists of the 1890s who explored these fringe territories that take us from a world of external facts to one of internal feeling.

Munch's ambitions in this new realm were immense, and he conceived and began to exhibit his works in unified groupings which he conceptualized under the broad title *The Frieze of Life*. When the first of such groups was exhibited in Berlin in 1893, his friend the Polish writer Stanislaw Przybyszewski was prompted to publish an essay on Munch in *Die Neue Rundschau* (February 1894) called "Psychic Naturalism," a phrase which would apply equally to his own pre-Freudian efforts to describe, as in his three-volume novel *Homo Sapiens* (1895–98), the deeper layers of unconscious life that control our behavior. Przybyszewski located Munch as the pivotal figure in the drastic shift from the outer world of observable things, exemplified for him by the work of Liebermann (see fig. 362), to an inner world of feelings that could only be depicted in a more abstract way through colors and linear rhythms. For Munch, such penetration to the roots of human experience often began to reach mythic archetypes, totally metamorphosed, however, into his own symbolic language. One of the themes that gripped him in the 1890s was again sexual, but translated into the blasphemously modern conception of what he called *Madonna*. In a lithographic version of this motif of 1895 (**fig. 454**), Munch created an icon for the modern world, in which the sanctified Christian image of procreation, the Madonna, becomes a fiery, alluring *femme fatale*, here reduced to a waving sea

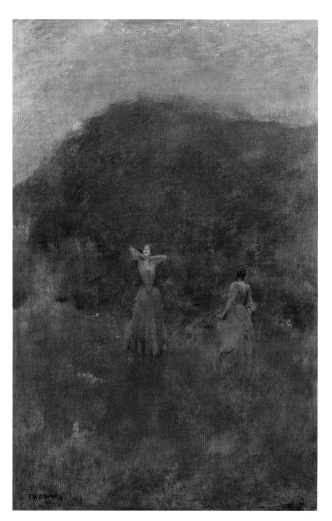

Fig. 453 **Thomas Wilmer Dewing**, *Summer: Moonrise*, c. 1893. Oil on canvas, 50½ × 32½". Detroit Institute of Arts.

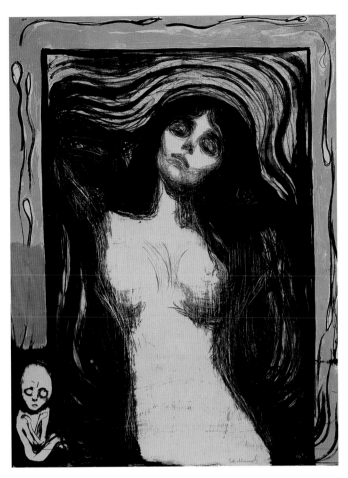

Fig. 454 **Edvard Munch**, *Madonna*, 1895. Color lithograph, 23⅞ × 17½". Munch-Museet, Oslo.

of undulant flesh and tentacular hair that, with irresistible biological and psychological magnetism, tyrannizes the male of the species, as she would do a decade later in Picasso's *Demoiselles d'Avignon*. To complete this pessimistic image of woman as an irrational, animal force created to propagate life, Munch has enframed his Darwinian Madonna, as in a holy image, with a symbolic border that begins, lower left, with a humanoid creature that seems half fetus, half shriveled mummy (the alpha and omega of a life cycle) and continues with a stream of spermatozoa which metamorphose the abstract, whiplash curve motif so common to Art Nouveau design into a microscopic metaphor for a stream of life. Again, Munch's efforts to create a private iconography that would replace traditional Christian symbols revive Romantic goals. His *Madonna* may well be thought of as a sexualized interpretation of Runge's *Morning* (see fig. 69), appropriate to a modern, post-Christian world that lay between Darwin and Freud.

When Munch had his first one-man show in Paris, in June 1896 at Samuel Bing's L'Art Nouveau, Strindberg wrote it up in *La Revue Blanche*, one of the decade's most brilliant periodicals, and offered thumbnail descriptions of each work and motif. Commenting on the Madonna theme

(also called *Conception*), Strindberg pointed to the halo "which crowns the performance of the act, the only *raison d'être* of this creature who has no independent existence," a vision of the *femme fatale* which might equally have applied to his own plays. Performed in Paris and throughout the West, these dramas also constructed modern infernos in which the malevolent sexual forces of the female of the species, whether in a contemporary or an allegorical situation, wrought havoc upon doomed male victims. Such a concept, in part promoted on a lofty philosophical level by the mid-century writings of Schopenhauer, reached its climax in the 1890s. Throughout the nineteenth century, women, assumed to be the intellectual inferiors of men and useful primarily for procreation and domesticity, had been mythologized into polar opposites, virgins and whores. The former, by denying their sexuality, were suitable to the confining proprieties of marriage and family life. The latter, by asserting their sexuality, were suitable for only the most lubricious male fantasies about an animal of sexual prey. In the 1860s, in the work of such artists as Rossetti and Moreau, a repertory of female sexual demons had begun to proliferate—Liliths, Eves, Thracian maidens who had dismembered Orpheus. By the 1880s and 1890s, monsters of temptation and desire, ranging from the Kundry of Wagner's *Parsifal* to the harpies and vampires of Munch, were inflaming the imagination of countless artists, musicians, writers. Of these demonic creatures, it was probably the Salome of biblical legend who loomed largest in the 1890s as the most perverse variation on the *femme fatale*, the evil daughter of Herodias whose lust for St. John the Baptist, who refused to give himself to her, was so unquenchable that it could finally be satisfied only by her kissing his severed head, her reward for performing a lewd dance for King Herod.

Already familiar to French art, poetry, and opera, from Moreau to Mallarmé to Massenet, this lurid tale was vividly interpreted by Oscar Wilde, who wrote in French a play on the theme, which was published in Paris in 1893 and, in 1905, was transformed by Richard Strauss into one of the all-time operatic shockers. The perfect illustrator for Wilde's drama was the short-lived British artist who became for many the very symbol of 1890s effeteness and decadence, Aubrey Beardsley (1872–98), another victim of tuberculosis. As soon as Wilde's *Salome* appeared, Beardsley illustrated in pen and ink its grotesquely orgiastic climax (**fig. 455**), which earned him a commission from John Lane (the publisher of the Art Nouveau periodical *The Yellow Book*) to make an illustrated edition of the play. In this initial drawing for the series, Beardsley offers his own strange mixture of many of the components of 1890s art—the fusion of words and images, the refinement of abstract decorative patterns, and an acute sensibility to the most rarefied sensations, whether aesthetic or erotic. Here, above the French inscription—J'AI BAISÉ TA BOUCHE

IOKANAAN/J'AI BAISÉ TA BOUCHE (I have kissed your mouth, Jokanaan, I have kissed your mouth)—the wicked Salome floats in a spiderweb fantasy of bizarre antennae that conjure up cactus-like tentacles, peacock feathers, quivering tendrils—an exotic hothouse of the senses. As Salome stares with narcissistic fulfillment at the Medusa-like head of John the Baptist, trickles of blood fall into the blackest sea from which an evil flower—almost a literal illustration to Baudelaire's *Flowers of Evil*—grows straight upward with maximum tumescence, in contrast to the wilting bud

at the right. That this sultry dream of sexual metaphors could be expressed so intensely by a language of decorative abstraction was yet another indication of the way the 1890s could mold the artificial components of art into vehicles for the exploration of an ever-widening range of psychological and even sexual sensations, from the primitive forcefulness of Munch's own vision of the *femme fatale* to Beardsley's languid erotic dreams. It is symptomatic that the first serious treatise on byways of sexual behavior, *Psychopathia Sexualis*, by the German physician Richard von

Fig. 455 **Aubrey Beardsley**, *Salome with the Head of John the Baptist*, 1893. Pen drawing, 11 × 6″. Princeton University Library, Princeton, New Jersey.

Fig. 456 **Lovis Corinth**, *Salome*, 1899. Oil on canvas, 50 × 57⅝″. Museum der Bildenden Künste, Leipzig.

Krafft-Ebing, was published in 1886, with an English translation in 1892.

The lure of the Salome story could reach even artists whose aesthetic and personal psychology could hardly have been less like Beardsley's. His polar opposite might be found in Lovis Corinth (1858–1925), a German painter who espoused the Realist aesthetic developed by Liebermann, but who in the 1890s began to use it not only for contemporary subjects but for legendary or imaginative ones, especially those taken from the Bible. In 1899, he essayed the Salome theme (fig. 456), a huge success when it was exhibited the following year at the Berlin Secession group, which, founded in 1892, promoted antiestablishment trends in art. Here, the morbid tale shocks not through its decadent refinement but through its crass reality. The spectacle of a public beheading, followed by a scene of sexual

depravity, is forced upon us as if we were pedestrian eyewitnesses elbowed into the events at Herod's court. The slave who holds the head, the executioner, the degenerate Salome look like studio models who range from athlete to whore, and the bits of exotic costume and decor look like sordid stage props rented for the occasion. In the 1880s, Uhde, in his representations of Christ in the modern world (fig. 414), had already tried to bridge the gulf between the Bible and a Realist aesthetic, but his softened and sweetened mixtures of these two different realms are remote from Corinth's grossly physical reconstructions of biblical scenes. Cropped at the edges, painted with broad, coarse brushstrokes, violent in the confusion of dead and living bodies, Corinth's *Salome* looks more like the world of Berlin criminals and prostitutes than that of the New Testament. By pushing the boundaries of Realism this far, Corinth

Fig. 457 **Edvard Munch**, *The Dance of Life*, 1899–1900. Oil on canvas, 49½ × 75″. Nasjonalgalleriet, Oslo.

already pointed to the more drastic distortions of figures and congested spaces that in a younger German generation would soon be defined as Expressionist.

Even when couched in terms of contemporary experience rather than Christian symbolism, Munch's view of the *femme fatale* took on an iconic quality remote from the harsh, close-up vision of Corinth. His most monumental contribution to this theme was the large painting with which he closed the century, *The Dance of Life* of 1899–1900 (fig. 457), conceived as a climax and summary to his *Frieze of Life* series, a painting which, like Gauguin's *Where Do We Come From? What Are We? Where Are We Going?* (see fig. 436), would provide an almost religious or philosophical speculation on human destiny. The motif here is a familiar one in Scandinavian tradition, the festivals of midsummer celebrating the longest day of the year with folk dances, drink, and love-making, the ultimate release to the life-giving forces of nature after the long, dark, cold winter. The theme was recorded in pleasant, rural terms by one of the most internationally successful painters of his day, the Swede Anders Zorn (1860–1920), who, in *Midsummer Dance* of 1897 (fig. 458), thrusts us into the breathless whirl of Swedish peasants in folk costume dancing through the midsummer night against a background of vernacular wooden architecture. In its appealing,

ethnic subject of folk traditions surviving in an industrial world, and in its bravura brushwork, so appropriate to the dynamic theme, Zorn's painting was a predictable prizewinner when shown at the Paris Exposition Universelle of 1900. Munch's *Dance of Life* is another matter entirely, transforming this annual ritual into a grim sexual narrative that symbolizes, in a three-part cycle, the artist's pessimistic answer to ultimate questions. Resurrecting the hieratic and symmetrical structure of Christian triptych imagery, Munch offers an unholy trinity of women who, like biological demons, preside over human life on earth. At the left, dressed in the white of Christian chastity, a blonde, ripe adolescent quivers with the spring flowers that grow beside her from the kind of flat green meadow that, a decade later, would be occupied far more joyously by Matisse's pagan dancers. As if hypnotized, the virgin gestures toward the central action. Here, the midsummer dance reaches its sexual peak, as a woman in a fiery red robe seems almost literally to inflame and incinerate the man in a black jacket whom Munch, in a recasting of the extreme split between Christian chastity and biological necessity, identified as a priest. Puppet-like in his blind acceptance of her desire, he is surrounded by pulsating red contours that continue the engulfing red of the all-embracing dress which even absorbs his feet and knees in this sexual immolation. At the

Fig. 458 **Anders Zorn**, *Midsummer Dance*, 1897. Oil on canvas, 55⅛ × 38⅝". Nationalmuseum, Stockholm.

right, in a stark polarity to the virgin at the left, the same female figure is now seen in an ashen black, an image of widowhood, consummation, and death, whose clasped hands, doubling as a bony groin, are a ghastly reminder of her former sexual prowess. This *danse macabre* is set against the wild rhythms of other dancing couples, polarized in black and white, whose grosser, more ephemeral passions and energies act as a foil to the solemn, three-part foreground frieze that creates the eternal beat of a human life cycle. Above, a high blue horizon rises over the human scene below, dominated finally by the orb of the full moon which, as in *The Voice* (see fig. 452), casts a phallic reflection on the waters, transforming these modern men and women of the 1890s into mindless pawns in the hands of a pagan nature. Cruel and fearful as it was, this newly explored world of the emotional and biological keys to human life seemed to probe realities far deeper than any found in the world of industrial progress and of flourishing commerce that would be celebrated once again at the 1900 Exposition Universelle, where art would be shown more as entertainment and commodity than as a vehicle for

expressing, like the Christian altarpieces of a lost world, the invisible forces that give order and meaning to our lives.

For some of Munch's contemporaries, these ambitions could even attempt to unify the conflict between nature and technological progress that so many artists—Munch, Hodler, Gauguin—found irreconcilable. A remarkable case in point is a painting by Jan Toorop (1858–1928), who, born of a Dutch family in the colony of Java, almost came by right to that interest in Indonesian art, religion, and music which such contemporaries as Gauguin, Ranson, and Debussy knew only secondhand. In *A New Generation* (**fig. 459**), which was arcane and otherworldly enough to be accepted for exhibition at the first Rosicrucian Salon of 1892, the exotic pastel colors and the intricately woven patterns of attenuated, organic shapes recall the gorgeous refinements of the Javanese batik fabrics which were imported to Holland in the nineteenth century and which offered Western artists another kind of tapestry effect in their decorative inventories of the 1890s. But underneath this frail, membranous surface, Toorop concealed a bizarre allegory that would fuse both private and public, religious

Fig. 459 **Jan Toorop**, *A New Generation*, 1892. Oil on canvas, 38½ × 44″. Museum Boymans-van Beuningen, Rotterdam.

and industrial worlds in a polyglot jungle. Like Hodler's *Chosen One* (see fig. 450), *A New Generation* centers upon the artist's own child, his newborn daughter, Charley (who, in fact, would also become a painter). Seated in a high chair, the infant is surrounded by a jumble of symbols that are largely camouflaged by elements of a fairy-tale forest that overlaps with animated diagrams of the nervous and circulatory systems. In this faraway land, one slowly discerns hidden images—a shadow of a woman in a crumbling doorway, an airborne flurry of a beautiful bird chasing out ugly black crows, a coiling serpent, a statue of Buddha, and then, most surprising, a telegraph pole at the left, crossed by a railroad track that runs across the foreground. This occult mélange of disparate symbols would evoke, within the personal context of the artist's child who faces the

twentieth century, a dream of the future not only in the form of an enchanted landscape of Indonesian inflection, where beauty and goodness replace the withering parent generation associated with the older woman at the left, but also in the form of those familiar nineteenth-century heralds of progress in communication and transportation, the telegraph and the railway. It would be hard to imagine a stranger collision of cultures and symbols.

There were, however, other artists of the 1890s who sought out such synthetic statements about contemporary problems within a more hard-boiled, socially alert context. Of these, the most heroic result came from the Italian Giuseppe Pellizza da Volpedo (1868–1907), whose monumental *Fourth Estate* (fig. 460), a painting over seventeen feet wide, attested to his passionate faith in the Socialist

movement and his belief that art might correct the iniquities of capitalism. Already in the early 1890s, Pellizza had depicted the plight of hungry, striking agricultural workers in his native village, Volpedo, in Piedmont, and then envisaged a panoramic, altar-like painting that would force spectators to confront head-on burning questions about a human destiny far more terrestrial than Toorop's. In 1898, he began to work full time on *The Fourth Estate* in the hopes that its urgent message could reach the vastest international audience at the 1900 Paris Exposition Universelle. In fact, it was not completed until 1901, after laborious preparations, and was first exhibited in Turin the following year. Using as a title a term that was popularized by the French Socialist Jean Jaurès to define a fourth group of social power that would usurp the role of the traditional three—clergy, aristocracy, commoners—Pellizza, in his own words, wanted to attempt "Social painting . . . a crowd of people, workers of the soil, who are intelligent, strong, robust, united, who advance like a torrent, overthrowing every obstacle in their path, who thirst for justice." This army of agricultural workers is led by a trio of leaders—two men and a woman holding a child of the next century—who march toward us with a steady, onward force that has the overwhelming effect of both a populist rally fighting for a high-minded cause and of a stirring operatic chorus that brings down the curtain. Pellizza's disposition of both the leaders and the crowd has, like so many of the grand pictorial speculations of the 1890s, the character of a Christian triptych, in which the central leaders are balanced, left and right, by the

workers who follow them. And the nobility of the postures, as well as the gravely harmonious rhythms of their relentless forward march, are also nurtured on earlier pictorial traditions, for these anonymous peasants have art-historical pedigrees rooted in the figural grandeur of Raphael and Masaccio. Yet even though he looked back to his country's Renaissance heritage for support in the creation of a panoramic icon of modern suffering and protest, Pellizza also turned to the modern technique of Divisionism, stemming from the color theory and practice of Seurat and his Neo-Impressionist disciples in Italy. The purplish sky, for instance, is created by an infinity of red and blue points of paint, and the green landscape border below is enriched by countless minor points of sunlit yellow and orange. Even the earthy beiges and browns of the earth and the clothing are described with minuscule variations of vibrant color that attest to Pellizza's faith in scientific rule as applied to an old-master structure of venerable clarity.

Although Pellizza's painting was neither an artistic nor a political success, except in certain Italian Socialist circles, it did at least propose a coherent view about the major problems of modern life as the nineteenth century drew to a close, and an optimistic faith in the role of art as a means to social progress. It is a far cry, in fact, from another turn-of-the-century speculation on the human condition, a small colored drawing executed in Barcelona in 1898–99 titled *The End of the Road* (**fig. 461**). Although the flat pinwheel pattern of Art Nouveau sinuosity might at first recall the arresting, decorative chic of a Toulouse-Lautrec poster, the

Fig. 460 **Giuseppe Pellizza da Volpedo**, *The Fourth Estate*, 1898–1901. Oil on canvas, 9′ 3¾″ × 17′ 2¾″. Civica Galleria d'Arte Moderna, Milan.

Fig. 461 **Pablo Picasso**,
The End of the Road,
1898–99. Oil wash (?) and
conté crayon on paper,
18⁹⁄₁₆ × 12⅛″.
Solomon R. Guggenheim
Museum, New York.

lethal pulse of these attenuated paths, as they wearily rise to the upper right-hand corner, feels closer to the morbid milieu of Munch. Below, a sorry procession of the ill, the bereaved, the poverty-stricken, both young and old, moves toward its goal. Above, a long cortège of horse-drawn carriages approaches the same point, a cemetery gate over which the skull-like figure of Death waits, scythe in hand. For rich and for poor, the end of the road is the same. The drawing bears the signature of a seventeen-year-old Spaniard, P. Ruiz Picasso, who still retained the surname of his painter-father, José Ruiz Blasco, as well as the less common family name of his mother, María Picasso López.

This precocious teenager was already eager to absorb all he could of modern art and life on the other side of the Pyrenees, and would soon submit paintings to be selected for the Spanish section of the 1900 Paris Exposition Universelle. When the fair opened on May 1, one of them, a death scene, was hung together with one hundred and five paintings by other Spaniards, a tiny drop in the exhibition's international bucket. Six months later, in October, the young Picasso (as he would soon begin to sign his work) at last arrived in Paris for the first time, greeting the twentieth century, which he would make his own, but never forgetting the nineteenth.

Part 4:

❖

1870–1900

SCULPTURE

Introduction

To defy established society, its values and institutions, was easier for writers and painters than for sculptors. To the latter, the late nineteenth century offered vast opportunities for official commissions; the demand for public monuments, which had been comparatively modest before, went beyond all bounds everywhere. Of the total of such monuments in the Western world, it is a safe guess that the great majority were erected, or at least begun, between 1872 and 1900. The United States can probably claim the greatest relative increase with its many hundreds of Civil War memorials. In Italy, hardly a town of any size does not boast a monument to one or more of the heroes of the Risorgimento (most often Garibaldi) and a statue of Dante or perhaps someone of merely local renown. Having achieved political unity, the country faced a peculiarly difficult task of nation building. As Massimo d'Azeglio observed, "Italy exists, but there aren't any Italians yet." The Risorgimento monuments were meant to assert this new national identity, while the statues of luminaries tended to reinforce the far older tradition of pride of place. In Germany, the tension between regional loyalties and a sense of nationhood had been largely resolved in favor of the latter during the interval between the defeat of Napoleon I and the proclamation of the empire in 1871. German monuments commemorating the Franco-Prussian War range from simple memorials to large and blatantly nationalistic celebrations of victory and imperial glory. There were also numerous monuments to the first emperor, Wilhelm I, and to Bismarck, the Iron Chancellor who had been the architect of German unity. Smaller in scale but far larger in number are the statues of national or local figures, dominated by a few great names—Luther, Goethe, Schiller, Beethoven—but with a goodly sprinkling of lesser ones. Austria, with little to celebrate in the political present, fell back upon the Baroque past with monuments to Prince

Eugene and Empress Maria Theresa. Its one popular military hero of recent times, Marshal Radetzky, the arch-enemy of the Risorgimento, was honored with an equestrian statue. In compensation for this paucity of sculptural glorifications of the state, Vienna blossomed forth with countless statues of cultural heroes. Only Paris can boast similar numbers. Nor was the monument craze limited to the major powers; it prevailed, not quite so grandiloquently, in the lesser nations as well, from Scandinavia to South America. Even Japan joined the trend by importing an Italian sculptor, Vincenzo Ragusa, who had established something of a reputation with his Garibaldi monuments, to teach European-style sculpture at the Imperial Academy.

In France the situation was more complex: it had suffered a humiliating defeat and grievous loss of territory, but had re-established the republic, an important gain. The Third Republic, whatever its faults, proved stable enough to survive all crises until 1940. During the 1870s, once the shock of the lost war had worn off, the public mood favored national reconciliation and an image of France as the champion of liberty as against the bitter memories of the defeat at Sedan and the bloodshed crushing the Paris Commune. It was difficult to glorify defeat, but the fallen heroes could still be honored and the republic celebrated. The change of regime also brought to the fore a new choice of hero: the leading figures of the French Revolution, whose monuments served to link the Third Republic with the First.

The proliferation of public monuments in these years inevitably meant that their artistic level as a whole was mediocre or worse, although there are some conspicuous exceptions. What killed the public monument in the end was a combination of factors. One, surely, must have been sheer exhaustion—there was less and less left to celebrate, and ever fewer new ways of celebrating. This may explain what might be called the "Tower of Babel syndrome"

evident in such late examples as the Völkerschlacht-denkmal in Leipzig (1898–1913), commemorating an important victory against Napoleon in 1813, and the Victor Emmanuel Monument in Rome (begun in 1885 but not finished until 1911), both of them enormous (and enormously expensive) architectural structures where the sculptor's contribution is reduced to insignificance, cold and threatening rather than festive in character. Ultimately, however, it was the sculptors themselves who were responsible for the demise of their art. The best of them were no longer willing to produce monuments of the kind the public could accept. From the patrons' point of view, Rodin's *Burghers of Calais*, and especially his *Balzac* (see figs. 488 and 489), subverted the very concept of the public monument, whatever their artistic merits. The *Burghers* were not sufficiently heroic; the *Balzac* a strange, barely human idol. Clearly, there had been a loss of that common understanding which still survived in Dalou's splendidly successful *Triumph of the Republic* (see figs. 478 and 479). The sad story of the monuments planned for the interior of the Pantheon illustrates the same difficulty. Sculptors also conceived public monuments on their own initiative which society did not want, as witness Rodin's and Dalou's monuments to Labor

or Vela's monument to the workers who had built the St. Gotthard railway tunnel (see fig. 492). The demise of the public monument, then, is far more than a symptom of the changing relationship of artist and public. It truly signals the end of an era.

France

The general image of French sculpture of the last quarter of the nineteenth century is dominated by the genius of Rodin to such a degree that none of his contemporaries seems to matter. This one-sided view does a disservice not only to Rodin's coevals but to Rodin himself, who might more fittingly be regarded as the tallest peak of an impressive mountain range rather than a solitary rock.

Success eluded Rodin until he was thirty-seven (see pages 489–99). However, he was far from alone in terms of delayed recognition: most of the French sculptors born during the 1830s followed a similar pattern. Even Falguière, who rose more quickly than the rest, was thirty-six when he won general acclaim with his *Tarcisius* (see fig. 319). And Frémiet, born in 1824, was so discouraged in 1871 that he

Fig. 462 **Auguste Bartholdi**, *The Lion of Belfort*, completed 1880. Red sandstone, height 38′, length 70′. Belfort, France.

considered retiring from his "fruitless twenty-five-year struggle to make a living as a sculptor," yet a year later, he began to receive the honors he had longed for (see page 480). The end of the war brought on an era of opportunity for French sculpture from which Rodin profited along with the rest.

The trauma shared by the entire nation gave sculptors a subject worthy of their deepest political and artistic commitment. An instance of the galvanizing effect of the war is found in the career of Auguste Bartholdi (1834–1904). After brief study with Antoine Étex and Jean-François Soitoux, Bartholdi produced a monument to General Rapp for his home town of Colmar that was shown at the Paris Exposition Universelle of 1855, but his subsequent work had not attracted much notice. On a trip to the Near East with Gérôme, he had encountered Egyptian sculpture, but his ambition to work on the same colossal scale was not realized until after the war, which affected Bartholdi, a passionately Francophile Alsatian, in a far more personal way than it did any other French artist. At the end of 1871, he

accepted with enthusiasm a project for a monument honoring the victims of the recent siege of Belfort. His design, first planned for the soldiers' cemetery, took the shape of a free-standing lion fiercely resisting attack. Bartholdi, however, opted for a more visible site—the rock face below the fortress dominating the town, where it still offers a breathtaking sight. *The Lion of Belfort* (fig. 462) was his opportunity to work on a truly Egyptian scale, four times the size of Thorvaldsen's *Lion of Lucerne* (see fig. 188). Assembled of large blocks of red sandstone on a ledge, the splendid creature, seventy feet long, was completed in 1880. Bartholdi studied lions in the Paris zoo, but the nature of the task pushed him toward simplification and clarity of form.

While he was at work on *The Lion of Belfort*, Bartholdi also designed his most famous monument, the *Statue of Liberty* (or, to use its official title, *Liberty Enlightening the World*; figs. 463 and 464). The idea of presenting a monument to the United States in memory of French assistance during the War of Independence originated among a circle

Fig. 463 **Auguste Bartholdi**, *Statue of Liberty (Liberty Enlightening the World)*, 1875–84. Copper sheeting over iron armature, height of statue 151′ 6″. New York Harbor.

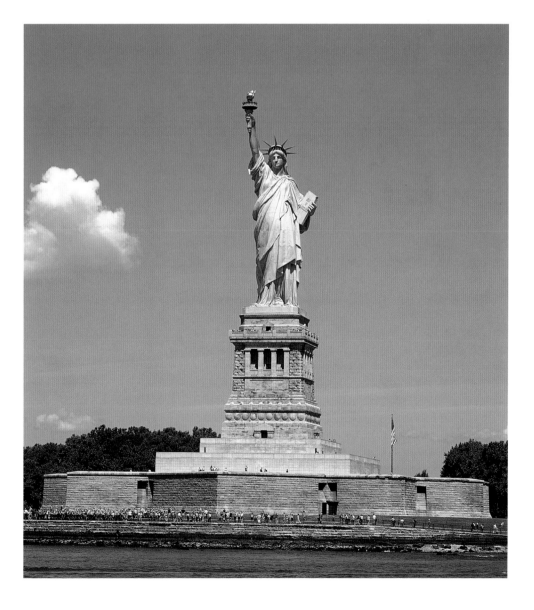

Fig. 464 **Auguste Bartholdi**, *Statue of Liberty* (detail).

of republican intellectuals to promote libertarian ideas in the Second Empire, but the necessary financial support was not forthcoming until 1875, when the Third Republic had been securely established. The statue, in order to have its intended political impact, had to be a gift of the French people, not of the government; its cost—four hundred thousand dollars, a very large sum at that time—was raised by public subscription. The American public raised funds to build the tall pedestal.

Meanwhile, Bartholdi had gone to America to solicit approval for the proposed gift from the president, Ulysses S. Grant, in 1871, when he also selected Bedloe's Island in New York Harbor as the future site. The final model, dating from 1875, shows a classically draped woman holding the torch in her raised right hand and a tablet in her left; with the left foot, on which her weight rests, she steps on the broken shackles of tyranny. The right leg—in accordance with the rules of classical *contrapposto*—is set back, so that the figure seems to be advancing when viewed from the side but looks stationary in the frontal view. Quite apart from the matter of money, a figure one hundred and fifty feet tall presented severe structural problems. It had to be designed in such a way that the statue, after being temporarily erected in Paris, could be reassembled in the United States. Bartholdi found the ideal collaborator in Gustave Eiffel, the future builder of the Eiffel Tower, to engineer a strong iron and steel framework, closely following the shape of the sculpture, on which thin sheets of beaten copper defining the figure were to be attached. Ever since the *Statue of Liberty* was inaugurated in the fall of 1886, its fame as the symbol—one is tempted to say "trademark"—of the United States has been worldwide.

As a piece of sculpture, the *Statue of Liberty* is far less original than *The Lion of Belfort*. Formally and iconographically, it derives from a well-established ancestry reaching back to Canova and beyond. Its conservatism is, however, Bartholdi's conscious choice; he sensed that only a

"timeless" statue could embody the ideal he wanted to glorify. Yet there is a kinship with *The Lion of Belfort* in the shapes. That they each have a form determined by their specific purpose would be evident by comparison with his numerous other works after 1871 in a neo-Baroque style.

Emmanuel Frémiet (1824–1910), although a disciple of his uncle François Rude, began his career as an *animalier*. Despite his devoted study of live animals, he could not hope to compete with Barye, the undisputed master in that field. His only large-scale works before 1871 were two equestrian statues, which may have helped to secure for him the public commission, late in 1872, for a gilt bronze equestrian *Joan of Arc*. Fifteen months later the monument was unveiled, in the beautiful setting of the small Place des Pyramides (**fig. 465**), and at once became an international success (there are replicas as far afield as Portland, Oregon, and Melbourne, Australia). The cult of Joan as a national heroine, who at God's command had rescued France from disaster, has a long history, but the demand for public monuments glorifying her as a military leader was a direct

Fig. 465 **Emmanuel Frémiet**, *Joan of Arc*, 1872–74, 1899. Gilt bronze, over life-size. Place des Pyramides, Paris.

consequence of the French defeat of 1871. They are war memorials in disguise, proclaiming that the Lord is on France's side and might send another emissary to confound the nation's enemies. Frémiet's austere heroine stands in her stirrups, and the flag in her raised right hand further accentuates her height. The entire monument harks back to Verrocchio's *Colleoni* in conception, reflecting an interest in early Italian Renaissance sculpture that had been recently introduced by younger artists (see below).

Although Frémiet was to do several other equestrian monuments of historic figures, the subjects closest to his heart reflect his association, since his student days, with the natural history collections at the Paris zoo and its museum, where he succeeded Barye as professor in 1875. These taught him not only about the structure of specific animals; they stimulated his interest in comparative anatomy and physical anthropology, and the scientific staff must have kept him abreast of the mounting evidence for the evolution of species. What fascinated Frémiet was the confrontation of primitive man with the most powerful "manlike" animals. The subject of his most sensational work, the *Gorilla Carrying Off a Woman* (**fig. 466**) of 1887, had preoccupied him as early as 1859, when he submitted a different version, known today only from a photograph, to the Salon. It had been rejected, while the later group was received with enthusiasm. Baudelaire, who admitted never having seen it, severely condemned the 1859 version, which he called "a vulgar drama" catering to the prurience of the beholder, for among animals "only the ape . . . sometimes shows a human craving for women." This view of the sexual appetite of anthropoid apes was surely shared by Frémiet and the public at large, and continues to be part of present-day folklore, even though it has no basis in fact. Thus Darwin offended both religious and secular opinion in asserting man's descent from apelike ancestors, for his theory contravened not only the scriptural account of Creation but an ingrained set of ideas about the nature of apes. Is it sheer coincidence that the year of Frémiet's first *Gorilla* was also the year of the publication of Darwin's *The Origin of Species?*

The evolution of the theme in Frémiet's mind between the two dates is significant: in the 1859 version, the gorilla is running, dragging the woman behind him. In the final version, the gorilla's posture is defensive, as though he were surrounded by members of the tribe to which the woman belongs. He has picked up a rock as a weapon and, most important of all, he is wounded by a spear thrust in his back (a detail not visible in most photographs). The question, then, becomes not, as Baudelaire thought, whether the ape will succeed in raping his captive, but whether she will survive the assault on the beast. Yet it takes a real effort to free ourselves from the memory of *King Kong* and to acknowledge the savage expressive power of Frémiet's group.

Fig. 466 **Emmanuel Frémiet**, *Gorilla Carrying Off a Woman*, 1887. Plaster, life-size. Musée des Beaux-Arts, Nantes.

The merit of having reawakened an interest in Florentine Renaissance sculpture as a source of inspiration for French sculptors belongs to Paul Dubois (1829–1905). The son of well-to-do parents, he could afford to attend the École des Beaux-Arts and to go to Italy in 1859 for four years of independent study. His delicate *Florentine Singer*, evocative of the singers on Luca della Robbia's *Cantoria*, was dubbed neo-Florentine at the Salon of 1865, and the label stayed with Dubois for the rest of his career. Five years after the war, Dubois undertook the memorial to General Juchault de Lamoricière in Nantes Cathedral, consisting of the marble effigy, a series of low reliefs on the marble housing (designed in Early Renaissance style by the architect Louis Boitte), and life-size bronze seated figures at the corners: personifications Charity, Faith, Military Courage, and Meditation. The model for the entire monument was exhibited to great acclaim at the Paris Exposition Universelle of 1878. Apart from the low reliefs on the housing, only one of the four bronzes, *Military Courage* (**fig. 467**), may be termed neo-Florentine, but its prototypes, a combination of the two dukes in Michelangelo's Medici tombs, are of the sixteenth rather than the fifteenth century. The neo-Florentine label thus fits only loosely what is often cited as

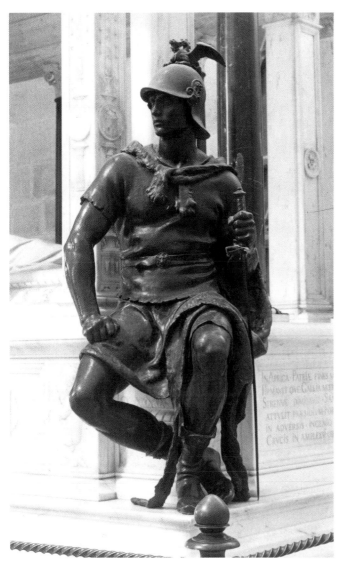

Fig. 467 **Paul Dubois**, *Military Courage* (Lamoricière Monument), 1876. Bronze, life-size. Cathedral, Nantes.

many similar figures. From now on, Chapu specialized in thinly veiled curvaceous young women playing commemorative allegorical roles such as *Youth*, which he made in 1875 for the memorial to Henri Regnault and other students at the École des Beaux-Arts killed during the war. Yet Chapu was able to meet the challenge of the unexpected, as in the tomb of the wife of Duke Ferdinand of Orléans in the family mausoleum built under Louis-Philippe at Dreux (**fig. 468**). The duchess, who died in 1858, had been a Protestant and thus could not be buried in the Catholic chapel. Her remains were placed in a tiny annex built next to the duke's tomb that was linked with the chapel by large openings yet separated from it by a low grill. When Chapu, in the early 1880s, was asked to carve the effigy of the duchess, that of her husband had been in place for several decades; it was a true *gisant*, showing the body of the deceased lying in state. Other effigies at Dreux, especially those of women and children, were less severe, portraying their subjects as if they were asleep. Chapu went a daring step further: his duchess, though reclining, is fully alive and stretches out her right arm through the opening in a touchingly pathetic gesture of love beyond the grave.

The Duchess of Orléans is of course not a portrait properly speaking. The family might have supplied the artist

the prime example of the style, which Dubois himself abandoned in his subsequent work. On the strength of the Lamoricière memorial, Dubois became director of the École des Beaux-Arts, a position he retained until his death.

Henri Chapu (1833–1891), one of the Prix de Rome winners whom Dubois befriended in Italy, showed no neo-Florentine tendencies. Aside from numerous portraits, for which he had a special talent, all his work before 1870 was safely academic, in both style and subject matter, so that he established a modest reputation without attracting particular notice. He had his first great success a few months before the war, at the Salon of 1870, where he showed a life-size plaster, *Joan of Arc at Domrémy*. Joan, looking very much like a modern peasant girl, is sitting on the ground, her hands clasped in prayer, as she glances upward in the direction of the voices. Surely the lost war accounts for the tremendous popularity of the work, furthered by countless reproductions, and Chapu's *Joan* became the progenitor of

Fig. 468 **Henri Chapu**, Tomb of the Duchess of Orléans (detail), 1885. Marble, life-size. Royal Chapel, Dreux.

When Paris was under siege by the Prussians in the winter of 1870–71, Falguière (whose public success during the 1860s is discussed above; see page 478), was stationed on the ramparts of the city as a member of the National Guard, along with Chapu and other artists. In December, after a heavy snowfall, he modeled a colossal snow woman personifying Resistance. The work had a great morale-boosting effect; poets wrote about it and critics acclaimed it as a masterpiece, even though it lasted only until the next thaw. To perpetuate its appearance, the artist at some later date produced a spirited maquette which was subsequently cast in bronze (**fig. 470**). *Resistance* obviously appealed not only to the troops' patriotism but to their *machismo*: this proud nude woman enthroned on a phallic cannon barrel is open to several interpretations.

To the present-day viewer, the "posthumous" bronze sums up Falguière's strangely ambiguous talent. His maquettes are splendid—fresh, spontaneous, freely handled—while his finished large-scale works are disappointing. The most ambitious of them were never executed in permanent materials and, like *Resistance*, are known only from maquettes or illustrations: *The Seine and Its Tributaries*, which decorated the Palais du Trocadéro during the

Fig. 469 **Henri Chapu**, *Alexandre Dumas the Elder* (detail), 1876. Marble, life-size. Comédie Française, Paris.

with whatever pictorial records of her features were available (she had been exiled along with the other members of the Orléans family after the fall of Louis-Philippe in 1848 and died in London ten years later) but likeness, in this instance, was the least of Chapu's concerns. The very opposite is true of what is probably his most memorable portrait bust, that of Alexandre Dumas the Elder of 1876 (**fig. 469**). The author of *The Three Musketeers*, *The Count of Monte Cristo*, and a great many other Romantic tales, who died in 1870 at the age of sixty-eight, had been among the most widely known personalities of the Paris literary scene for decades. Everybody was familiar with his appearance, so that the bust must have been a difficult assignment. On the other hand, Chapu could hardly have hoped for a more gratifying subject, and the result is a masterpiece of characterization. Among the straitlaced official busts in the authors' gallery of the Théâtre Français, *Dumas* stands out for its sheer animal vitality. Chapu here has followed the Baroque tradition of portraits *en négligé*, yet the sitter's personality, blending sensuality, humor, and supreme self-confidence, could never be mistaken for that of an earlier era.

Fig. 470 **Alexandre Falguière**, *Resistance*, after 1870. Bronze, height 23″. Los Angeles County Museum of Art.

Exposition Universelle of 1878, and the huge *Triumph of the Revolution*, which from 1881 to 1886 crowned the Arc de Triomphe de l'Étoile. Their neo-Baroque rhetoric had outlived its time and was no longer taken seriously. Falguière's most popular Salon exhibits were life-size female nudes, such as the *Hunting Nymph* (**fig. 471**), classical only in late sequels to Houdon's *Diana* (see fig. 91). The very qualities for which Houdon's figure had been criticized could be praised in Falguière's: his goddesses conveyed "the breath of modern life" because they were earthy rather than heavenly. Although Falguière was a friend of Rodin (the two artists made portrait busts of each other), his last commission pitted him against Rodin, whose model for a monument to Balzac had been rejected (see page 496) in 1898. Falguière took over the task, producing a Balzac that retained many of the features of Rodin's in less radical form but that was seated on a park bench. While his model won acceptance, neither the conservatives nor the partisans of Rodin were really happy with it.

Falguière's most gifted student at the École des Beaux-Arts during the later 1860s was a fellow Toulousan, Antonin Mercié (1845–1916), who won the Prix de Rome in

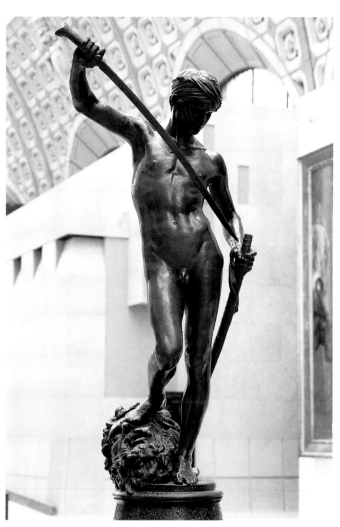

Fig. 472 **Antonin Mercié**, *David*, 1872. Bronze, height 72½". Musée d'Orsay, Paris.

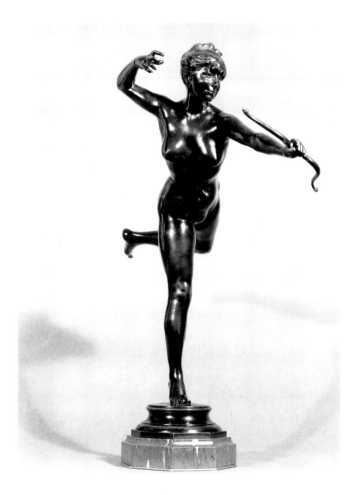

Fig. 471 **Alexandre Falguière**, *Hunting Nymph*, after 1884. Bronze (reduction of life-size original), height 17½". Private collection.

1868 and did not return to Paris until 1873. Mercié showed the plaster model of a statue of David, which the state acquired in bronze. Critical opinion immediately dubbed it neo-Florentine, linked it with Dubois's *Florentine Singer*, and pointed out Mercié's debt to Donatello's bronze *David* (**fig. 472**). The young sculptor's daring to compete with an acknowledged masterpiece of the past was regarded as a welcome sign of serious ambition in the somber atmosphere of the first postwar Salon.

Mercié's next public success, the greatest of his lifetime, *Gloria Victis* (**fig. 473**), was shown at the Salon of 1874. According to a contemporary account, Mercié had, in the fall of 1870 in Rome, modeled a group showing a winged figure of Fame supporting a victorious warrior and had redesigned it when he learned of the French defeat, substituting a dead or dying warrior with a broken saber. The modern shape of that saber is the only detail hinting at the recent war. In every other respect, the group belongs to the ideal world of classical allegory. Fame, rushing forward supported by her mighty wings so that she barely touches the ground, suggests the Victory of Samothrace; she makes

dates from 1890. As a painter, Gérôme had specialized in scenes of daily life in ancient Greece and Rome, rendered with minute realism and archaeological precision; in his sculpture, he retained this allegiance to the ancient world, but with unexpectedly original results. He applied lifelike tints to his marbles and liked to combine a variety of materials, knowing that the ancients had done so. Enamored of the Hellenistic colored terracotta figurines excavated by the French at Tanagra during the 1870s, Gérôme produced the monumental female nude *Tanagra* (**fig. 474**), which caused a sensation at the Salon of 1890. The figure is meant to represent the *Tyche*, the deity personifying the Greek city; she sits on an excavation mound, with a pickax at her feet, and on the palm of her left hand she displays an imitation Tanagra figurine. What immediately strikes, and fascinates, the beholder is the contrast between the realism of the tinted marble nude and her rigid, solemn pose, that of an

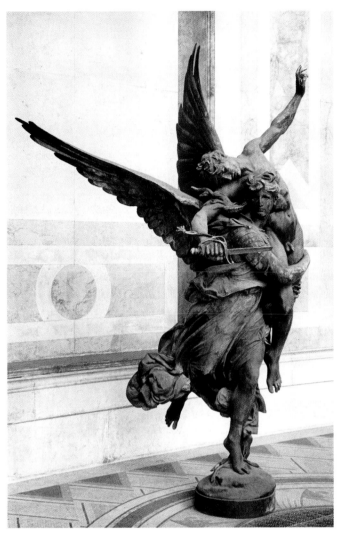

Fig. 473 **Antonin Mercié**, *Gloria Victis*, 1872–75. Bronze, height 10′ 5″. Petit Palais, Paris.

a powerful contrast with the pathetic figure she is carrying, who (except for the saber) might be almost any mythic hero. It was this transposition of a recent, shocking experience into the remote and generalized realm of antiquity that accounts for the overwhelming response of the French public: *Gloria Victis* helped them to come to terms emotionally with the bitter memory of defeat. It was a uniquely fitting war memorial. The first bronze cast went to the city of Paris, and duplicate casts were installed in several other French towns, with a seemingly limitless demand for reductions. At the time of his triumph, Mercié had not quite reached the age of thirty. As a member of the Legion of Honor and the recipient of the highest awards the Salon had to bestow, he became the "safest" official sculptor, collecting honors, and commissions, for another forty-two years.

 That the painter Jean-Léon Gérôme (see pages 268, 270, 360–61, and 363) should have taken up sculpture at the age of fifty-four, in 1878, might be surprising enough. More astonishingly, his most important work in the new medium

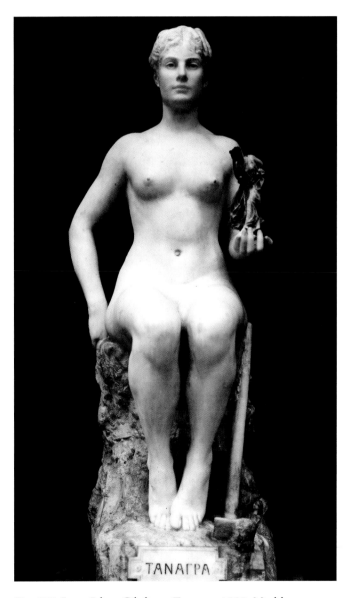

Fig. 474 **Jean-Léon Gérôme**, *Tanagra*, 1890. Marble, life-size. Musée d'Orsay, Paris.

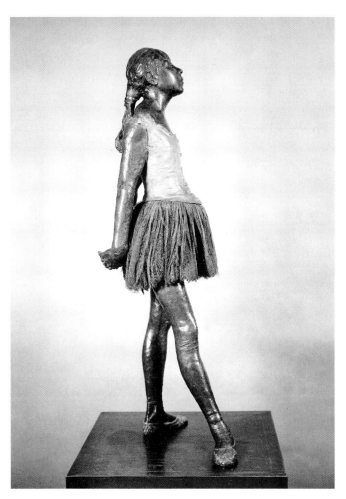

Fig. 475 **Hilaire-Germain-Edgar Degas**, *Little Dancer Fourteen Years Old*, 1881 (wax original). Posthumous bronze cast, with cloth skirt, height 38½". Collection Mr. and Mrs. Nathan Smooke, Los Angeles.

idol disdaining any awareness of her surroundings. It was this air of mystery that endeared *Tanagra* to the then burgeoning Symbolist movement.

Another convert to sculpture in the 1870s, the illustrator Gustave Doré (see pages 374–75), produced some highly original pieces during the few years that remained to him. His most daring work, unfortunately, is known to us only in an old photograph of the plaster he exhibited at the Salon of 1878: under the title *Glory*, it shows a winged genius of fame holding a nude youth whom she decorates with branches of laurel while stabbing him to death. It must have taken considerable courage to present this ironic inversion of *Gloria Victis* to the public so soon after Mercié's triumph.

The most peculiar case of a painter who took up sculpture in the 1870s is certainly that of Edgar Degas (see pages 354, 356, 366–67, and 384). In the Impressionist exhibition of 1881, he caused puzzlement by showing the wax figure, slightly smaller than life-size, of a *Little Dancer Fourteen Years Old*, wearing pink slippers, a gauze skirt, and a silk bodice, and with real hair tied with a ribbon. It was the only

piece he ever exhibited; and it does not resemble, except for the pose, any of the small, loosely modeled (mostly in wax) sculptures found in Degas's studio after his death. Seventy-four of these—about half the total, the rest being in too frail or fragmentary a condition—were issued in a limited edition in bronze during the 1920s. Why he never chose to exhibit any of this oeuvre can only be guessed.

What remains of the *Little Dancer* today is two tinted plasters and a series of bronze casts, partially polychromed and equipped with gauze skirt and silk bodice in order to approximate the effect of the wax original (**fig. 475**). While Degas's other sculpture has been acclaimed by some twentieth-century critics as "Impressionist," nobody could possibly apply that term to the *Little Dancer*. She belongs, rather, to a tradition of superrealistic sculpture in tinted wax combined with actual clothing and hair that had played an important role into the Baroque but survived in the nineteenth century only in the debased form familiar from Mme. Tussaud's museum in London and its equivalents elsewhere. Why did Degas choose to revive this laborious and "unartistic" technique? For two reasons, perhaps: he wanted his piece to be as different as possible from the sculpture of the Salons, and he was intrigued by the tension between the maximally concrete surface and the abstract but powerful directional forces beneath it. The ballet pose, that of a dancer at rest (although a "stage rest"), becomes in his hands an extremely stressful one, so full of sharply contrasting angles that no dancer could maintain it for more than a few moments.

Of all the sculptors discussed so far in this chapter, the one closest to Rodin, in age as well as in talent and ambition, was Jules Dalou (1838–1902). Both had their earliest instruction in art at the Petite École under the gifted teacher Lecoq de Boisboudran, and neither achieved public success during the 1860s. They were friends for many years until professional jealousy drove them apart; Rodin's bust of Dalou is among his most memorable portraits. Dalou's talent was discovered by Carpeaux, who persuaded the youngster's working-class parents to let him enter the Petite École. Two years later he was admitted to the École des Beaux-Arts, which he disliked. After failing four times to win the Prix de Rome, Dalou turned to decorative sculpture for a living, embellishing lavish private houses such as the Hôtel de Païva, where he worked as part of a team led by Carrier-Belleuse (see pages 326–27). By 1870, he had achieved an independent personal style; the plaster of a woman seated in a chair and embroidering, unusual not so much for its choice of a scene from contemporary domestic life as for its ambitious scale—it was life-size—won him a third-class medal and much praise at the Salon of that year.

During the war, Dalou briefly served in the army. As a lifelong Socialist, he sympathized with the Commune, the revolutionary government in Paris during the spring of 1871, and accepted a minor position under it. After its

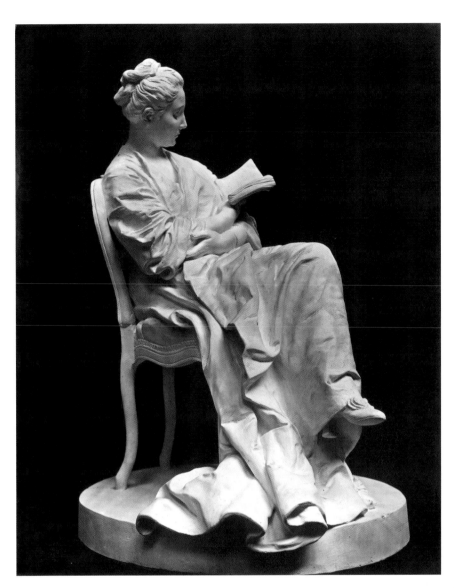

Fig. 476 **Jules Dalou**, *Woman Reading*, c. 1872–75. Plaster, height 22″. Petit Palais, Paris.

collapse, fearing prosecution, he fled to London with his family and did not return to France until after the general amnesty of 1879. The exile proved not only painless but artistically fruitful. At the annual exhibitions of the Royal Academy, he showed domestic subjects—women reading (fig. 476) or nursing their infants—with such success that he soon enjoyed the patronage of the highest social circles. Dalou's style, combining acute observation with a neo-Baroque fullness and dynamism of form, offered a refreshing change from the conservatism of the Albert Memorial (see fig. 326). Dalou was, in fact, the first nineteenth-century sculptor to proclaim his admiration for Bernini, a name that had been shunned ever since the time of Falconet; and Bernini was clearly the source of inspiration for Dalou's life-size terracotta memorial, the *Grandchildren of Queen Victoria Who Had Died in Infancy*, in the Royal Chapel at Windsor Castle.

Personal feeling must have entered into the portrait of Dalou's friend and fellow Socialist Gustave Courbet (fig. 477), who had died in exile in 1877 as a condemned

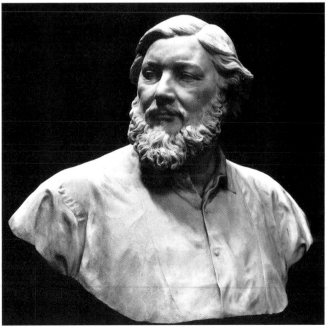

Fig. 477 **Jules Dalou**, *Gustave Courbet*, 1888–90. Marble, life-size. Musée des Beaux-Arts, Besançon.

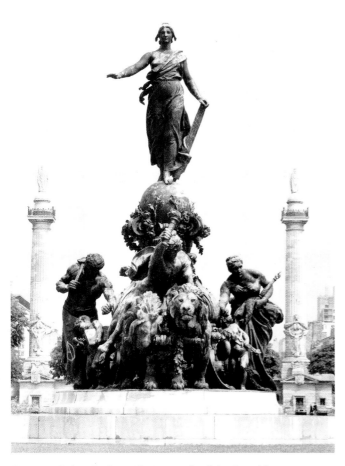

Fig. 478 **Jules Dalou**, *The Triumph of the Republic*, 1879–89 (date of model). Bronze unveiled 1899, over life-size. Place de la Nation, Paris.

Communard (see page 344). The marble bust, a state commission, was modeled in 1888 and carved in 1889–90. It is an act of homage in the grand style of Bernini, in which Courbet, in his open-necked shirt, has a self-assured vitality. By then, Dalou was engaged in *The Triumph of the Republic* (figs. **478** and **479**). In 1879, he had entered a competition sponsored by the city of Paris for a statue of the Republic; while he failed to win it, the jury was so impressed with his model that it recommended execution of both the winning entry and Dalou's. As a result, Paris has two monuments to the Republic: Léopold Morice's rather conventional one on the Place de la République and Dalou's masterpiece on the Place de la Nation. Rejecting the static concept of an architectural base for his design, Dalou revived the triumphal processions of the Renaissance and Baroque. His figure of the Republic, identified by her Phrygian cap and the bundle of rods symbolizing "strength in unity," stands on a globe supported by a chariot that is pulled by two lions, emblematic of the power of the people. They are guided by the genius of Liberty, a nude youth with a torch in his raised right hand; Industry and Justice help to push the chariot on either side, with Abundance following behind, all three of them accompanied by lively putti laden with familiar attributes. Dalou carefully avoided challenging the public with iconographic puzzles and combined down-to-earth realism with energetic action so that even the inanimate parts such as the fruit and flowers seem full of movement. It took Dalou nine years to complete the full-scale plaster, which was installed

Fig. 479 **Jules Dalou**, *Liberty* (detail of *The Triumph of the Republic*).

Fig. 480 **Jules Dalou**, *Truth Denied*, c. 1895. Plaster, height 13½". Petit Palais, Paris.

temporarily in 1889 for a provisional inauguration. The unveiling of the bronze a decade later became a huge popular festival, with many thousands of Parisians taking part.

Dalou, however, did not have to wait until 1889 for public success; the Salon of 1883 had already brought him the long-coveted medal of honor. Despite the honors and acclaim that descended upon him, Dalou never became a member of the establishment. He declined a professorship at the École des Beaux-Arts, and would accept commissions for monuments honoring distinguished individuals only if he felt a personal sympathy or admiration for them. As a passionate defender of Alfred Dreyfus, Dalou expressed his convictions in the powerful figure he called *Truth Denied* (fig. 480), a nude woman sitting on a rock in an attitude of utter dejection. The massive body, compressed as though within an invisible cube, belies the modest scale of this statuette, of which many replicas were sold for the benefit of the cause. Dalou may well have adapted an older composition for this particular purpose; studies of the female nude, in a great variety of poses, had been a favorite subject of his ever since the 1870s, and large numbers of them were found in his studio after his death. The finest of them have a boldness and freedom of

handling equaled only by Degas. Even more impressive were the many terracotta sketches Dalou produced during the 1890s for a monument of his own invention that was destined never to be realized: a "Monument to Workers." The glorification of labor had been a growing concern of artists during the last two decades of the century (see pages 500 and 502–03), and Dalou began his project by studying manual laborers at work, in brilliantly observed sketches carried out with an exemplary economy of means.

Auguste Rodin, it will be recalled (see page 334), had established himself in Brussels. There he readily found employment, in association with the Belgian Antoine-Joseph van Rasbourg, doing decorative sculpture for various building projects. Yet during his six years there, he kept a careful eye on the Paris scene, waiting to return at an appropriate moment. He was working on a life-size nude warrior with a spear in his left hand, which he called *Le Vaincu* (The Defeated One), a memorial to the catastrophic year 1871. Before he sent it to the Salon of 1877, however, he removed the spear and renamed it *The Age of Brass* (fig. 481), substituting a general reference to "a time of sorrow"—as against the happiness of the Golden Age—for the more specific original one. It was this statue that finally brought Rodin public attention and praise. In the winter of

Fig. 481 **Auguste Rodin**, *The Age of Brass*, 1875–77. Bronze, life-size. Ny Carlsberg Glyptotek, Copenhagen.

Fig. 482 **Auguste Rodin**, *St. John the Baptist Preaching*, 1878. Bronze, life-size. Ny Carlsberg Glyptotek, Copenhagen.

1875–76 he had made a trip to Italy, out of admiration for Michelangelo and Italian Renaissance sculpture as a whole. The slender proportions of *The Age of Brass* recall Donatello's bronze *David*, while the gesture of the right arm and the facial expression suggest Michelangelo's *Dying Slave* in the Louvre. If this neo-Florentine flavor was familiar to the Paris public, the anatomical realism of the figure, closely echoing the appearance of the specific model who had posed for it, was not, and an objectionable feature to many. Some critics claimed that the statue had been cast from life. Rodin vehemently denied this, providing photographs of his model, and a public letter signed by many of the most respected sculptors of the time supported him. The controversy not only failed to damage Rodin, it helped to establish him in the public's mind as an artist of importance. As for the accusation itself, however, it was neither

unprecedented nor absurd. The practice of making plaster casts of parts of the human body and keeping them around the studio as guides to anatomical accuracy is documented from the late eighteenth century on and may even go back to ancient Greece. What infuriated Rodin was that he had been charged with a traditional procedure which went against everything he held sacred in art. His own studio in Meudon near Paris contains hundreds of plasters of parts of the human body, much like the piles of casts from life in the studios of older sculptors—except that all of them were freely shaped by his own hands.

At the Salon of 1880, Rodin showed *The Age of Brass* in bronze and the plaster of a second monumental male nude which he had finished two years earlier, *St. John the Baptist Preaching* (**fig. 482**). The two make an instructive contrast. *The Age of Brass* is static, passive, and without a precise

meaning, while *St. John* is all action and movement with an unmistakable subject. A radical by-product of his work on the *St. John* is a *Torso* (**fig. 483**) without a left leg and the right leg terminated just above the knee. As the first of what was to become a long series of such "self-contained fragments," this *Torso*, left in a very rough state of becoming, corresponds to *The Man with the Broken Nose* as an act of liberation.

The 1880s were the most intensely creative decade of Rodin's career. Having established himself at the Salon, he continued his success there with a series of portrait busts representing well-known artistic or literary figures whom he befriended or admired. Later on, he would do commissioned portraits, but those of the early 1880s were done on his own initiative and have a decidedly honorific quality, indicated by his preference for the "timeless" bare chest, as in that of Jules Dalou.

In Rodin's mind there existed a sharp distinction between male and female portraits. His sure grasp of character, of the "passions that surge in them," as he put it, was

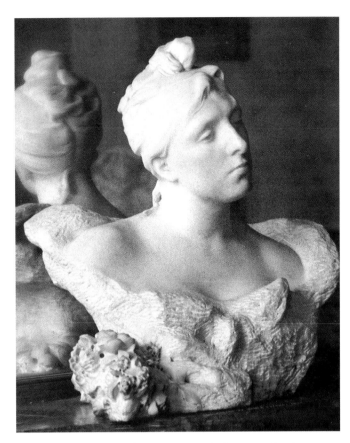

Fig. 484 **Auguste Rodin**, *Luisa Lynch de Mona Vicuña*, 1884. Marble, life-size. Musée Rodin, Paris.

Fig. 483 **Auguste Rodin**, *Torso*, 1877–78 (date of plaster). Bronze before 1889, height 21″. Petit Palais, Paris.

confined to his male sitters. Of women he said, "their nature is not ours"; he felt that presence of a "tender and delicate mystery" which he hesitated to penetrate. These observations, dating from the artist's old age, may sound strange when we recall his passionate early portrait of Rose Beuret (see fig. 320). Even here, however, what strikes us most is the force of Rodin's desire rather than the presence of a clearly defined personality. In the cases of Rose and of Camille Claudel, his very gifted student and mistress for close to fifteen years, he treated them not as sitters but as models whom he transformed at will into the carriers of other identities. Whether or not he was emotionally involved with the sitters, his other female portraits are almost invariably routine records of surface appearances. An exceptional instance that falls halfway between these two extremes is Rodin's portrait of Luisa Lynch de Mona Vicuña (**fig. 484**), which he made, without a commission, in 1884. She and her husband, the Chilean ambassador, were close friends of Rodin, who was indebted to them for introducing him to Paris society. He thus knew Mme. Vicuña well, and this is surely a recognizable likeness, yet there is a hint of melancholy in the features that contrasts strangely with Rodin's alternative title for the work, *Youth*. Rodin conveys the excitement of her presence by leaving her off-shoulder gown unfinished. The soft skin is emphasized by the rough, barely defined dress, from which the

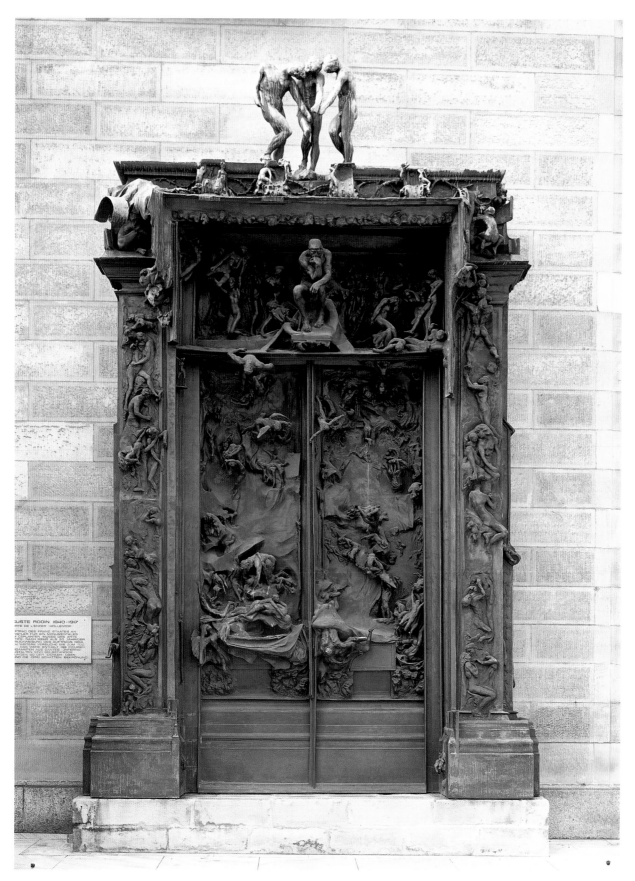

Fig. 485 **Auguste Rodin**, *The Gates of Hell*, 1880–1900. Lost-wax bronze cast, 21 × 13′.
Kunsthaus, Zurich.

sitter seems to emerge as if about to expose her exquisite nudity. The idea obviously derives from the unfinished works of Michelangelo, but with one crucial difference: Michelangelo never planned to leave his sculpture unfinished, while with Rodin, to do so became a conscious aesthetic and dramatic device.

By far the most important single event in Rodin's career occurred in 1880: it was the commission by the state for a sculptured portal, later known as *The Gates of Hell*, for the proposed Museum of Decorative Arts. Rodin set to work immediately; by mid-1884, he had reached a stage near enough to completion to request an estimate of the cost of casting *The Gates* in bronze. Yet he continued to modify and add to his model for another four years. There was another brief spurt of activity in 1899 in preparation for the first public display of the plaster *Gates* in 1900. After that, Rodin never touched *The Gates* again, and there was no question any longer of casting them, since the Museum of Decorative Arts had meanwhile been housed in the Louvre. The existing casts were all made after the artist's death (fig. 485).

When he received the commission, Rodin chose Dante's *Inferno* as his theme and visualized *The Gates* as an actual portal such as Ghiberti's *Gates of Paradise*, which he had seen during his Italian trip, with the reliefs on the doors forming a succession of rectangular panels. For a lintel relief, Rodin began with a central figure of Dante, who was to evolve into *The Thinker*. A few subjects drawn from Dante's poem, notably *Ugolino and His Sons* and *Paolo and Francesca*, derive from this first state of the *Gates*, but Rodin never worked out a program of episodes from the *Inferno* and soon abandoned the framed rectangles, creating in their stead two cavernous panels with a turbulent, uneven background that could absorb as well as extrude a multitude of figures. He further increased their number by animating the architectural framework with sculpture of varied scale and degrees of relief, from the large free-standing *Three Shades* at the top to the tiny figures nestling among the thorny vine just below them and the low reliefs on the pilasters, which appear to continue the program of the main panels. The theme, insofar as it has anything to do with literature, owes more to Baudelaire's *Fleurs du Mal* (Flowers of Evil) than to Dante. Its common denominator is a tragic view of the human condition: guilty passions; desire for ever unfulfilled, whether here or in the beyond; the vain hope of happiness. The critic Gustave Geffroy, writing of *The Gates* in 1889, defined their subject as the endless re-enactment of the sufferings of Adam and Eve; in 1881, Rodin had indeed tried to persuade the government to let him flank *The Gates* with statues of the two. He transformed the *Adam* into the *Three Shades* (essentially the same figure seen from different angles), while *Eve* became an independent work. She is among the numerous progeny of *The Gates*, which for Rodin during the 1880s functioned

as a tremendous seedbed of invention. They made it possible for him to explore the expressive potential of the human body as no other artist had dared to before him (critics have observed that the only figure in *The Gates* whose pose reflects earlier models is *The Thinker*). It is their very prodigality that constitutes both the strength and the weakness of *The Gates*. They are an awe-inspiring whole, yet the endless streams and concatenations of small figures present great difficulties to the beholder who attempts to experience them individually; imprisoned in a structure more than twenty-four feet tall, they tend to dissolve into ornament, into accents of light and dark. Only *The Thinker* and the *Three Shades* stand out clearly. Perhaps Rodin himself sensed how much of what he had put into *The Gates* was likely to be lost on the viewer; that could be why he extracted and enlarged (one is tempted to say, "liberated") so many motifs and presented them as independent works.

The Thinker had the misfortune to become a visual cliché. In the context of *The Gates*, the figure was originally conceived as a generalized image of Dante, the poet who in his mind's eye sees what goes on all around him. Once Rodin decided to detach him from *The Gates*, he became *The Poet-Thinker*, and finally just *The Thinker*. But what kind of thinker? The low brow, the heavy-muscled body with its powerful hands and feet suggested a primitive man to some, a worker to others. Some art historians, aware of how much *The Thinker* owes to Carpeaux's *Ugolino* (see fig. 313), tend to believe that the fame of Rodin's work is rather undeserved.

The Helmet Maker's Beautiful Wife (or, more fully, "She Who Used to Be the Helmet Maker's Beautiful Wife," a line from a lament by the fifteenth-century poet François Villon) is less directly linked with its counterpart on *The Gates*. Rodin's starting point here was the shocking sight of a nude old woman posing for one of his assistants. Fascinated with the aesthetic challenge implicit in such a model, he asked her to pose for him, too, and positioned her in a way expressive of the pitiful frailty of old age (fig. 486). No other work of his demonstrates as forcefully that the beauty of a work of art does not depend on the beauty of the subject. (For Bartolini's hunchback, which had made the same claim half a century before, see page 206.) The poetic title was an afterthought; later on, the figure would also be exhibited as *The Old Courtesan*. It was the statue that suggested the old crone in the lower half of the left-hand pilaster of *The Gates*.

The bronze version of *The Kiss* (fig. 487), which was originally envisaged as Dante's *Paolo and Francesca*, survives in *The Gates* in very different form. *The Kiss* shows the ill-fated pair succumbing to their illicit desire for each other here on earth, not as tortured souls in hell. Passion is reined in by hesitancy. The embrace is not yet complete, and the man's right hand caresses rather than grips the

Fig. 486 **Auguste Rodin**, *The Helmet Maker's Beautiful Wife*, 1880–83. Bronze, height 20″. Musée Rodin, Paris.

woman's thigh. This cast, with its extraordinarily fine patination, was retained by Rodin for himself. Instead of being uniform in color, as is usually the case, its basic greenish tone modulates to brown, with occasional glints of the metal itself. The over life-size marble version of *The Kiss*, carved in 1898, exploits the sensuous softness of the woman's body as against the firmer flesh of the man, both accentuated by the rough surfaces of the block of marble.

In 1884, Rodin learned of the desire of the city government of Calais to erect a monument to Eustache de St.-Pierre, who had delivered himself, along with five other prominent citizens, into the hands of King Edward III as hostages to lift the siege of Calais by the English in 1347 (see page 21). According to the chronicler Jean Froissart, who described the event some decades later, Edward's conditions were harsh indeed: the hostages had to be barefoot and in sackcloth, with ropes around their necks bearing the keys to the city and the fortress, and the king was free to do

with them as he pleased, implying a threat of death. The memory of these civic heroes had been rekindled by the recent war, which had resulted in the loss of so many cities in eastern France to the Germans. What attracted Rodin, however, was the unusual task of a monument honoring a group rather than a single individual. Moreover, by basing his design on Froissart's account, he could be historically accurate, stress the sacrificial spirit of these patriotic martyrs, and avoid the awkward problem of period costume. Rodin's first maquette, which won the competition, shows the hostages moving forward defiantly on top of a tall base suggesting a triumphal arch.

This design, however, soon struck him as too conventionally heroic and psychologically implausible. He abandoned it, along with the tall base, and concentrated on the individual response of each member of the group. He made numerous studies of every figure, every face. In the final form of the monument (**fig. 488**) the six *Burghers of Calais* no longer present themselves as a phalanx; they seem, in fact, hardly aware of each other's presence. What unites them is only their common condition and the low rectangle of ground on which they stand. The beholder, confronting them almost at his own level, is urged to focus on the self-absorbed quality of the figures—unheroic, complex human beings like ourselves. Little wonder that the city fathers of Calais, who had wanted a civic-patriotic public monument, thought the *Burghers* a failure. They would have been far happier with Rodin's first design. What the sculptor gave them, after years of argument and struggle right up to the official unveiling in 1895, no longer shows a specific event writ large enough to be recognized as an exemplary act of sacrifice. It is a monument to human crisis and six varieties of response, deeply moving in its emotional complexity, but for that very reason a private rather than a public monument.

When the Society of Men of Letters decided to sponsor a monument to Honoré de Balzac in 1890, the great novelist had been dead for forty years. The original commission went to Chapu, who produced only a sketch of a seated Balzac before dying in 1891. Émile Zola, the president of the society, asked Rodin to take over the task, which he agreed to finish by January 1893. It took him five additional years to complete what was to be his last, as well as his most daring and controversial, monument. He declared it to be "the sum of my whole life. . . . From the day of its conception, I was a changed man." What, then, did Rodin conceive that cost him such extraordinary effort? Balzac's appearance was well known to all; it had been recorded in sculpture by David d'Angers, in photographs, paintings, even caricatures. Outward resemblance, then, did not pose a problem. But Rodin wanted far more than that—he was searching for a way to cast Balzac's whole personality into visible form, and to do so without the addition of allegorical figures, the habitual props of monuments to genius. The

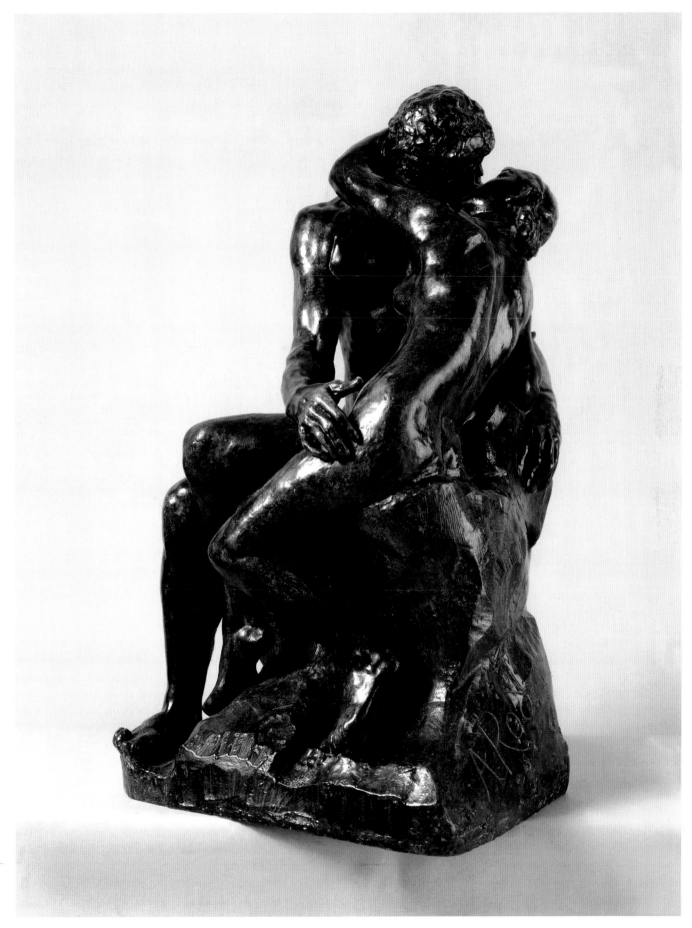

Fig. 487 **Auguste Rodin**, *The Kiss*, 1886. Bronze, height 33⅞″. Private collection.

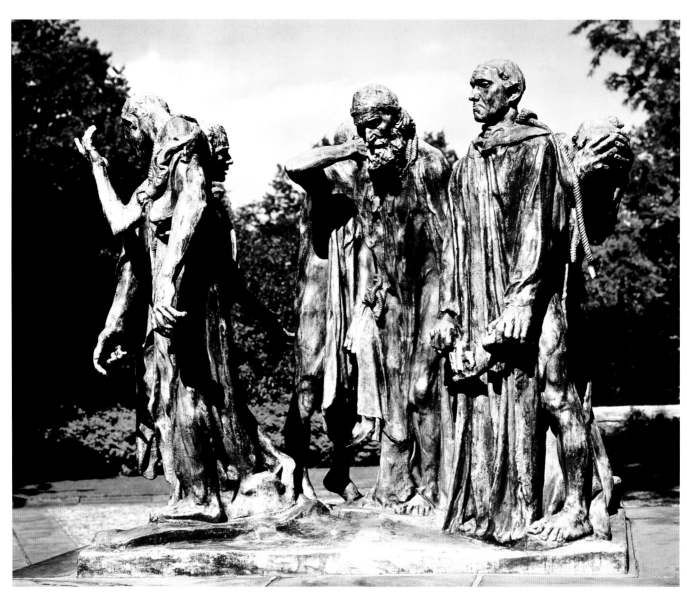

Fig. 488 **Auguste Rodin**, *The Burghers of Calais*, 1885–95. Bronze, height 7′ 7″. Hirshhorn Museum and Sculpture Garden, Smithsonian Institute, Washington, D.C.

final version (fig. 489) gives no hint of the many alternative solutions (more than forty have survived) that preceded it. The one element common to them all is that Balzac is standing. A seated Balzac—as Chapu had visualized him and as Falguière was to show him when the society transferred the commission to him after rejecting Rodin's statue—must have struck Rodin as incompatible with the virile energy he saw in his subject. A standing figure then, but in what pose? Clothed or nude? Rodin had a suit made by Balzac's old tailor, who had kept the measurements; he engaged models whose physical stature resembled Balzac's, only to conclude that modern costume would not do. If "timeless" nudity was to be the solution, and nudity displaying Balzac's stocky, short-legged frame, what attitude would do justice to him? Rodin tried every variety he could think of before he chose to clothe Balzac in the long dressing gown, described by his contemporaries as a

"monk's robe," which he liked to wear while working at night. Here was a "timeless" costume that permitted Rodin to concentrate the viewer's attention on the massive head. Rodin returned to the nude standing figure in *contrapposto* pose, with the right leg forward, and enveloped it in the robe which Balzac has hastily thrown over his shoulders. Whether he knew it or not, Rodin here revived an idea invented by Neoclassic French sculptors so as to avoid the dilemma of nudity versus modern costume: the artist awakes in the middle of the night, seized by a sudden creative impulse, and throws on a covering of some sort before he settles down to put his thoughts on paper. But he looms before us with the frightening insistence of a specter, utterly unaware of his surroundings—the entire figure leans backward to stress its isolation from the beholder. The wide, powerful neck supports a head, proud and agonized at the same time, that is framed by a leonine shock of hair.

Balzac remains a startling sight. Yet when Rodin showed the plaster *Balzac* at the Salon of 1898, his pride of achievement was put to a hard test by the hostility of the public and the rejection of the statue by an association whose members were presumably enlightened.

The *Balzac* raises the often debated question of the relation between Rodin's bronzes and marbles. From the ancient Greeks until the late eighteenth century, bronze had always been regarded as the nobler of the two materials, notwithstanding Michelangelo's and Bernini's preference for marble. Neoclassicism brought about a reversal of this attitude, which persisted until the end of the nineteenth century. Marble was now thought of as the "classic" material, hallowed by its association with Phidias in the Elgin Marbles. There is no reason to doubt that Rodin, too, regarded marble as the nobler material, if only because of his tremendous admiration for Michelangelo. Yet the twentieth century has become accustomed to think of him as essentially a modeler rather than a carver, and his reputation rests mainly on his bronzes. These are valued as exact duplicates of the master's plasters—which indeed they are, for if a series of casts is made at the same time from the same model and by the same process, they can be distinguished from each other only by differences in patination—while the marbles are often dismissed as the work of Rodin's *praticiens* untouched by the master's own hand. Yet, Rodin never saw most of the bronzes by which we know him; they existed in his lifetime only as plaster, while no posthumous marbles are known. Nor can we assume that Rodin necessarily destined those plasters for bronze. The *Balzac* is a good case in point. Why did he never have it cast in bronze, even though a wealthy private collector offered to pay for it? Might it be that he visualized the monument in marble? Its compact shape lent itself to a marble statue. Rodin's contract with the society does not seem to have specified the material of the monument, and Falguière's *Balzac* is of marble; can we not conclude that the society thought of a marble monument all along?

In addition to plasters for study, Rodin kept fragments of his own figures. He liked to scrutinize his huge stock of "parts" for potential use in another context, often reassembling them, for experimental purposes, in strange combinations that afford an intimate glimpse of Rodin's imagination.

Long before he discovered the principle of "add-a-part sculpture," Rodin had practiced the opposite: omitting or subtracting parts of the human figure. A very early work, we recall, was prophetic of this procedure, since *The Man with the Broken Nose* is neither a mask nor a bust. His *Torso* of about 1877 (see fig. 483) was essentially without precedent. The term "torso" was then applicable only to classical statues that through neglect or deliberate mutilation had lost their extremities and often their heads as well. Their aesthetic appeal was acknowledged by the admiration

Fig. 489 **Auguste Rodin**, *Honoré de Balzac*, 1891–98. Plaster, height 9′ 10″. Musée Rodin, Paris.

lavished upon the *Torso Belvedere*, which became the standard attribute of sculpture in allegories of the arts, but no sculptor before Rodin had deliberately made an independent torso (apart from Rude's *Christ on the Cross*; see page 323). By the time Rodin presented the *Torso* to the public in 1888, he had opened up a whole new sculptural field, that of the incomplete figure, which gained its expressive focus through omission.

There is no more striking demonstration of this principle than *Iris, Messenger of the Gods* (fig. 490) of about 1890 (the title, as usual, was an afterthought). A study for it shows the woman complete except for a truncated left arm; in the final, large version, which the sculptor had cast for exhibition purposes, the left arm is cut off immediately above the shoulder and the head has been removed (Rodin

Fig. 490 **Auguste Rodin**, *Iris, Messenger of the Gods*, c. 1890. Bronze, height 37½″. Los Angeles County Museum of Art.

reused it for another figure). What remains is a great leaping form that justifies the title as the study did not. From now on, the incomplete figure was to become part of the modern sculptural tradition.

At the Paris Exposition Universelle of 1900, Rodin presented a vast retrospective exhibition of his work, in a pavilion built at his own expense. He was by now world famous—more so, indeed, than any other artist in whatever medium. He died seventeen years later, after having made arrangements with the state for the Rodin Museum in Paris, to perpetuate his achievements. Some of his late production, before ill health forced him to stop, is of a very high order, but viewed as a whole Rodin added no fundamentally new ideas to his oeuvre after 1900.

Italy

The growing divergence of public and private sculpture—that is, sculpture acceptable to the academy and the official bodies that decided competitions on the one hand, and sculpture seeking new paths and accepted only by a minority of critics and collectors on the other—had made itself felt in Italy even earlier than in France, if we recall the work of Adriano Cecioni (see fig. 324). His small pieces include such challenges to Realism as *Dog Defecating* (fig. 491) and alternatives to it such as a charmingly simplified *Lady Putting on a Glove*. Bohemian in his habits and of a pessimistic temper, Cecioni had a hard time making a living; since he was a gifted caricaturist, drawings were often his livelihood until, a few months before his death, he received a teaching appointment in Florence. He also painted, and was a member of the Macchiaioli (see pages 316–19).

Vincenzo Vela, since 1867 once more a resident of Ligornetto, continued to do public monuments, tomb

Fig. 491 **Adriano Cecioni**, *Dog Defecating*, c. 1880. Plaster, height 3½". Collection Aldo Gonelli, Florence.

sculpture, and portraits in the *verismo* tradition. The opening of the St. Gotthard railway tunnel in 1882, close to ten miles long, was an event of great economic importance since it permitted uninterrupted rail traffic between northwestern Europe and the industrial centers of Turin and Milan. It had been a heroic engineering feat that took close to a decade of blasting and digging. The hero of the day was Alfred Escher, the director of the project, soon to be honored by a monument in front of the main railway station in Zurich. Vela, however, had a very different point of view: most of the workmen were from his part of Switzerland, and he knew how many had lost their lives. On his own initiative, he did a monumental high relief with the title *The Victims of Labor* (fig. 492), in the hope that a bronze cast would be placed at the southern exit of the tunnel. It shows, realistically yet with an impressive air of solemnity, a dead worker being carried out of the tunnel. Like the tunnel itself, *The Victims of Labor* was a pioneer achievement; unlike the occasion that inspired it, however, it met with little enthusiasm. Not until 1932, more than forty years after his death, was Vela's wish fulfilled. Vela was among the adherents of *verismo* who shared a desire to monumentalize the manual worker that anticipates both Dalou and Meunier (see pages 486–89 and 502–03).

Internationally, the best-known Neapolitan sculptor of the late nineteenth century was Vincenzo Gemito (1852–1929). A precocious talent who owed little to formal instruction, Gemito established his reputation before he reached the age of eighteen with a series of sensitively modeled heads of children, distinguished by their serious, troubled expressions. From 1877 to 1880, Gemito showed in the Paris Salon, where his *Fisherboy* (fig. 493), a life-size bronze, caused a mixture of shock and admiration because of its uncompromising Naturalism. Critics must have measured the distance that separates Gemito's nude urchin desperately struggling to hold on to his catch from the now familiar subject's debut half a century earlier (compare fig. 209). In 1887, the artist's career was cut short by mental illness, which incapacitated him for more than two decades. He never recaptured the brilliance of his early years.

After the political unification of the country, many Italian artists and intellectuals succumbed to a mood of disillusionment, a "morning after" emptiness following the high excitement of the Risorgimento. The emotional letdown was most pronounced in Milan, which had lost its role of intellectual, artistic, and political leadership when Rome became the capital of the country in 1870. Against this background, Milan saw the birth of Italy's earliest avant-garde movement, known as the Scapigliatura. The term literally means "dishevelment" but in Milanese dialect had come to be applied to a nonconformist, bohemian life style. Perhaps "movement" is too strong a term for the members of the Scapigliatura, who were linked by personal

Fig. 492
Vincenzo Vela,
The Victims of Labor, 1883.
Plaster, over life-size. Museo Vela. Ligornetto, Switzerland.

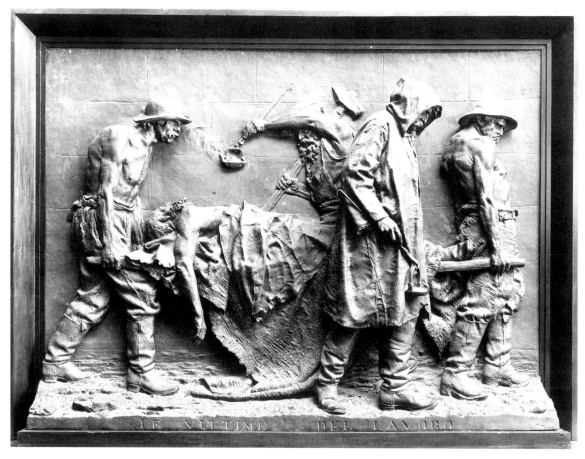

Fig. 493 **Vincenzo Gemito**, *The Fisherboy*, 1877. Bronze, life-size. Museo Nazionale (Bargello), Florence.

friendship and a shared belief in individualism rather than by any clearly articulated goals. They included mainly writers and painters, and a single sculptor, Giuseppe Grandi (1843–94). Trained in the tradition of *verismo* at the academies of Milan and Turin, Grandi is often said to have evolved a "pictorial" style derived from the work of his painter friends Tranquillo Cremona and Daniele Ranzoni. Their sketchy brushwork may indeed have encouraged Grandi to a similarly open and informal treatment in his statuettes, but his goal was to exploit his individual artistic handwriting rather than to achieve a "pictorial" play of light and dark.

Grandi's masterpiece is the monument of the Five Heroic Days, when in 1848 the Milanese rose against the Austrian army and temporarily ejected it from the city. Grandi won the public competition in 1881 and devoted the rest of his life to work on the monument, which was unveiled early in 1895, three months after the sculptor's death (fig. 494). That the jury should have preferred Grandi's design to more conventional solutions is remarkable, for the only traditional element here is the obelisk, and even that has been given a novel shape. Much of the ornament is inspired by that of early medieval Lombard art, so as to stress the local authenticity of every detail. What makes the monument so excitingly original, however, is the dramatic relationship of the figures to the architectural core. In part, Grandi's bold solution reflects his allegiance to *verismo*: instead of the

people and ending with the kneeling mourner. Officially, the monument commemorates those who died in the short-lived revolt (their names are inscribed on the shaft of the obelisk), but Grandi's figures breathe a spirit of heroic energy that converts defeat into triumph.

It was Grandi's small-scale works of the 1870s that had a decisive influence on a young sculptor of much more rebellious temper, Medardo Rosso (1858–1928). Little is known about Rosso's earliest artistic experiences; he emerged as a fully formed sculptor in 1882. His early works include everyday characters reminiscent of Gemito. These subjects are in the tradition of *verismo*, but the handling of the forms evinces a freedom and spontaneity derived from Grandi. As early as 1879, Rosso was a radical anti-traditionalist who abhorred the Renaissance (he compared the beard of Michelangelo's Moses to "a mass of Neapolitan spaghetti"). He had, moreover, been deeply impressed by Baudelaire's essay on sculpture (see pages 214 and 216) and set out to create a new kind of sculpture that would overcome what Baudelaire had defined as the limitations of the medium. To force the beholder to see the sculpture from a "single viewpoint," Rosso worked in a kind of relief, although a relief that obeyed none of the traditional limits. To bridge the gap between tangible form and its envelope of light and atmosphere, he invented a novel technique in

Fig. 494 **Giuseppe Grandi**, Monument to the Five Heroic Days, 1881–95. Bronze and stone, figures over life-size. Milan.

customary static allegories, he chose to have each of the five days re-enacted by a "woman of the people," picking his models with great care. He even acquired a lion and an eagle, since these formed part of his program, representing the Lombard people and the Austrian empire, respectively. The struggle revolves clockwise around the base of the obelisk, beginning with the bellringer who summons the

Fig. 495 **Medardo Rosso**, *The Bookmaker*, 1894. Wax over plaster, height 17″. The Museum of Modern Art, New York.

1883: wax over a core of plaster. The translucent wax interacted with the light to create a kind of fusion of the forms with their environment: here, for once, it was possible to speak of "Impressionist sculpture," although Rosso had created it before his first visit to Paris. This visit lasted only a few months; however, the second, occasioned by the Exposition Universelle of 1889, was to extend over eight years. Among his friends was Rodin. How much the two saw of each other's work remains uncertain, but when the *Balzac* was first exhibited in 1898, Rosso immediately claimed that Rodin was indebted to him for the basic idea of the statue. Certain works of Rosso's, such as *The Bookmaker* of 1894 (**fig. 495**), do share certain features with the *Balzac*, especially the backward tilt and the radical simplification of form. At best, Rosso may have played the role of catalyst in helping Rodin to arrive at the final shape of the *Balzac*. After 1897, Rosso produced only one more work. He was far better known north of the Alps than in his homeland, until Boccioni, in his *Technical Manifesto of Futurist Sculpture* of 1912, acclaimed Rosso's "revolutionary importance."

Belgium

When Rodin was in Brussels following the Franco-Prussian War, the local artistic scene contained no indication that from 1885 to 1905 Belgian sculptors would attain international importance as members of the avant-garde. Politically and socially, Belgium exemplified all the tensions of the later nineteenth century: a conservative government, insensitive to the extremes of wealth and poverty in the country, seemed determined to suppress all protest or attempts at reform. Among the partisans of social reform was Constantin Meunier (1831–1905). Trained in both painting and sculpture, he was a painter, mainly of somber religious scenes, until 1880. Then he experienced an awakening of his social conscience, apparently after spending some time in the industrial and mining regions of the country (he was there at the same time as Van Gogh but the two never met). His paintings of miners and industrial workers left him dissatisfied, however, and his first experiments with sculpture were surely motivated by his search for a more "heroic" medium. The heroism of labor, its pride and its pathos, was to be his theme as a sculptor.

Just when Meunier began to model remains unclear. According to a frequently told story, he borrowed some wax from his friend the sculptor Charles van der Stappen and used it for his first effort, a small head of a puddler, a worker from Belgium's iron industry. Some time between 1885 and 1890 he modeled a life-size bust of *a Puddler* (**fig. 496**) that has an air of pathos, of noble suffering such as befits a "martyr of labor." It also betrays Meunier's considerable debt to Rodin, for whom he always expressed

Fig. 496 **Constantin Meunier**, *Puddler*, c. 1885–90. Bronze, life-size. Private collection.

the greatest admiration. In any event, by 1885 Meunier not only had begun to exhibit his sculpture, he had completed, on a small scale, his two most famous statues, the *Puddler* and the *Stevedore* (**fig. 497**). The proud, challenging pose of the latter was surely meant to offer a conscious contrast to the *Puddler*. A life-size version of the *Stevedore* later became a symbol of Antwerp, Belgium's great port city.

Although he regularly showed his work at the Paris Salon, Meunier evoked little response in France. Perhaps French critical opinion was less impressed by his Realism than by his emphasis on heroic or pathetic poses; Meunier's workers were types rather than individuals, in contrast to those of Dalou, such as the worker of *The Triumph of the Republic* (see **fig. 479**). In one respect, however, Meunier has a clear claim to priority: since the mid-1880s, he had projected a "Monument to Labor," and while his was less ambitious than either Rodin's or Dalou's, he may have stimulated theirs. His chief influence outside his own country can be found in Germany, Austria, and Scandinavia.

The youngest of Belgian nineteenth-century sculptors was George Minne (1866–1941). A native of Ghent, he was trained at the local academy and at the Brussels Academy. Far more important, however, was his friendship with his fellow townsman the poet Maurice Maeterlinck, who introduced him to the Symbolist movement in art and

literature. Minne contributed woodcut illustrations to books by Maeterlinck and by Émile Verhaeren, another important Belgian Symbolist writer, in a linear, Gothicizing style derived from the Arts and Crafts Movement in England. Through these authors Minne was introduced to the Belgian avant-garde group Les XX (see pages 421–22). It was at Les XX, early in 1890, that work by the twenty-three-year-old sculptor was first presented to the public. The earliest piece, dating from 1886, *Mother Grieving over Her Dead Child* (fig. 498), evoked a particularly vicious and scandalized response in the press. Its emaciated body forms, rigid angular pose, and uncompromising

Fig. 498 **George Minne**, *Mother Grieving over Her Dead Child*, 1886. Bronze, height 18″. Musées Royaux des Beaux-Arts/Koninklijke Musea voor Schone Kunsten, Brussels.

Fig. 497 **Constantin Meunier**, *Stevedore*, 1885. Bronze, height 19″. Petit Palais, Paris.

expressiveness were denounced as comparable with the fetishes of African savages. Maeterlinck and Verhaeren defended Minne by praising the freshness of his naïve, childlike vision, and declaring him a "primitive" Giotto. To present-day eyes, Minne's *Mother* appears neither savage nor childlike; its frozen, timeless grief and the simplified, smooth contours have their counterpart in Symbolist painting, yet the precise source of these elements, if indeed there is one, remains elusive. As the work of an artist then barely twenty years old, the *Mother* is an astounding achievement.

Ten years later, the artist produced a figure kneeling with his arms wrapped tightly about himself (fig. 499). In 1898, Minne grouped five such kneeling youths around a circular basin, suggesting so many Narcissuses contemplating their own reflections. The angularity and extreme slenderness of these nudes might call to mind those of Flemish Late Gothic painting (perhaps even the *Last Judgment* of Roger van der Weyden or Memling). After 1900, the demand for

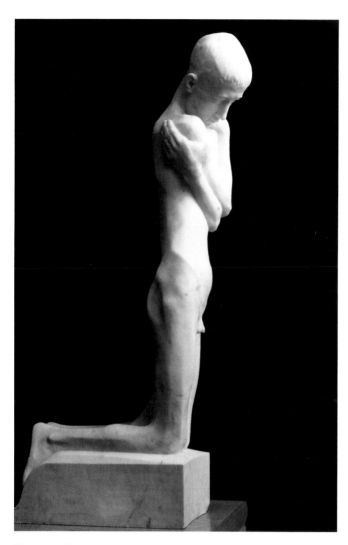

Fig. 499 **George Minne**, *Kneeling Youth*, 1896. Marble, height 30¾". Kunsthistorisches Museum, Vienna.

Minne's revolutionary early pieces led to multiples in two or three materials, especially in Germany and Austria, whereas his later efforts failed to bear out the promise of the preceding years.

Germany

Reinhold Begas, Germany's pioneer of neo-Baroque Naturalism (see fig. 331), found himself busier than ever in the capital of the newly founded German Empire. Working with a large group of assistants, he left a stronger imprint upon the public sculpture of Berlin than any of his predecessors. Much of what he did suffered as a consequence of the Second World War and the later division of the city: his largest work, the monument to Emperor Wilhelm I (fig. 500), was destroyed; the Neptune Fountain and the Bismarck monument have been moved to new locations, and much of his architectural sculpture has disappeared. The Neptune Fountain, designed in 1886 as a free variant on Bernini's Roman fountains, retains to a considerable degree the sensuous charm of the artist's earlier work. The monument to Wilhelm I, erected between 1892 and 1897, was judged a failure from the very start; the sheer quantity and scale of the sculpture seemed unbearable. Now that it is gone, a scrutiny of the available photographic record reveals a good deal of interest.

The reaction against what critics regarded as the nouveau-riche vulgarity of Begas's style crystallized in the

Fig. 500 **Reinhold Begas**, Monument to Emperor Wilhelm I, 1892–97. Bronze, over life-size. Berlin (destroyed).

work of Adolf Hildebrand (1847–1921), who came to stand for a lean Classicism that shunned sensuous effects in self-conscious pursuit of what he termed "the problem of form." Hildebrand began his career as a student at the Munich Academy, then went to Rome in 1867, where he met the painter Hans von Marées (see pages 403–04) and the art critic Conrad Fiedler. In 1874, he settled in Florence, where he remained for more than two decades. He did not present himself to the German public until 1884, at an exhibition in Berlin. In 1889, Hildebrand won first prize in the competition for the monument to Wilhelm I, but the decision of the jury was vetoed by Wilhelm II, who preferred Begas. From this moment on, the two sculptors were pitted against each other: for progressive opinion, Begas represented bad taste arbitrarily imposed on the public by a willful monarch, while Hildebrand embodied not only high art but resistance to the dictates of Berlin. He settled in Munich, where he received his first public commissions as well. His essay *The Problem of Form*, published in 1893, impressed such art historians as Heinrich Wölfflin more than sculptors, who found the text too abstract and theoretical. What remains surprising is the extraordinary influence of Hildebrand's work. By the end of the century, his authority was unquestioned. The life-size nude *Young Man* (**fig. 501**), completed in 1884, usually appears in the Hildebrand literature as the perfect statement of the artist's goal, a modern counterpart of the *Doryphorus*. And it is indeed the classic athlete, redone from nature, as it were. He stands with his feet slightly apart, the left leg advanced just sufficiently to hint at a *contrapposto*. The head is gently tilted; the young man seems lost in his own thoughts. This hint of melancholy must have been Hildebrand's original goal, for he planned to call the piece *Alone*. In the end, what mattered most to him was not the projection of a specific mood but the psychological barrier between the brooding *Young Man* and the beholder. Hildebrand maintained that sculpture is a separate world, more akin to architecture than to that of living beings, and in most of his public commissions the function of the sculpture was essentially to embellish the architecture. These projects all remained on a modest scale, and the sculpture maintained its separate identity.

By far the most interesting German artist during the last two decades of the century was Max Klinger (see fig. 427). The son of well-to-do parents who supported his desire to become a painter, Klinger studied at the academies of Karlsruhe and Berlin, and successfully exhibited his work from 1878 on. He quickly established his reputation as a master etcher. In 1879, he spent six months in Brussels; he went twice to Paris for half a year in 1883, and again in 1885. Where and from whom Klinger learned how to sculpt remains a mystery. In any event, the earliest documented sculpture by him dates from 1885. It was a model, in gilt and tinted plaster, of his *Beethoven*, the artist's most ambitious three-dimensional work. In his own account, he

Fig. 501 **Adolf Hildebrand**, *Young Man*, c. 1877–84. Marble, life-size. Nationalgalerie, Berlin.

compared this *Beethoven* (which has not survived and thus cannot be matched against the final version) to Rodin's *Victor Hugo* and *Thinker*, "which did not yet exist then." Klinger's fascination with color and the combination of various materials in sculpture must also be a fruit of his Paris sojourn, although it is hard to say whether he owed the greatest debt to Cordier (see fig. 309) or Gérôme (see fig. 474). In the *Beethoven* (**fig. 502**), executed between 1897 and 1902, he used an extravagant variety of materials, including several kinds of marble, alabaster, ivory, bronze, amber, semiprecious stones, and mother-of-pearl. Beethoven's throne is placed on an Olympus so high above

Fig. 502 **Max Klinger**, *Beethoven*, 1897–1902. Bronze, marble, ivory, etc., height 10′ 2″.
Museum der Bildenden Künste, Leipzig.

the ground that even the eagle is barely able to reach it. The sides and back of the bronze throne show elaborate reliefs mixing Christian and classical subjects, since to Klinger, Beethoven united these two worlds in his work. The official unveiling of the *Beethoven* in a setting specially created for it was Klinger's greatest public triumph. Yet he was the first to sense the limitations of the monument. In 1904, having just seen a Rodin exhibition, he confessed that "my Beethoven looks terribly playful to me now."

England

British art criticism of the last quarter of the century is full of references to the "New Sculpture." The term was never meant to be a label for a style, except in the very loose

sense of "anything different from what had been possible before the 1870s." The origin of this new attitude, which produced some works of notable distinction, is commonly acknowledged to be the work of a painter—Frederic Leighton (see fig. 439). His life-size bronze *Athlete Wrestling with a Python* (**fig. 503**), when shown at the Royal Academy in 1877, was acclaimed as a milestone in British sculpture. What made Lord Leighton's achievement the more remarkable was the fact that he had no reputation at all as a sculptor. The *Athlete* was, in fact, one of only two monumental statues attempted by Leighton (the other being *The Sluggard* of 1886). Like many painters in the academic tradition, Leighton had been in the habit of modeling small figures as an aid in working out the compositions of his pictures; the *Athlete* began as such a sketch, less than ten inches tall, about 1874. Leighton showed it to his friend Jules Dalou (see

pages 486–89), who urged him to enlarge it. The *Athlete*—about whose mythological identity Leighton was quiet—has a French Neoclassical ancestor, Bosio's *Heracles Fighting Acheloüs in the Form of a Serpent*, a large bronze group of 1824 in the Tuileries. Since George IV ordered a second cast for the park at Windsor, Leighton's chances of knowing the Bosio group were excellent, even though all he took from it was the idea of "man against serpent" and perhaps the extended right arm gripping the animal's neck.

In relation to the state of British sculpture, the *Athlete* was as bold a venture into new territory as Rodin's *Age of Brass* (see fig. 481) was in France (by a singular coincidence, both made their public appearance in 1877). What distinguished the *Athlete* was not only its extraordinarily energetic physical action but a naturalism of anatomic detail unrestrained by considerations of "beauty," except for the head, reminiscent of that of Michelangelo's *David*. There is also a concession to prudery—part of the python serves the purpose of the traditional fig leaf.

The *Athlete* brought Leighton a gold medal at the Paris Exposition Universelle of 1878, and Leighton was elected president of the Royal Academy. Yet, unlike

LEIGHTON'S *ATHLETE WRESTLING WITH A PYTHON*: A RESTLESS MODERNITY

The primary source for Frederic Leighton's Athlete *(see fig. 503) was the famous Hellenistic marble in the Vatican in Rome of Laocoön and his sons beset by serpents, a story from the Trojan Wars. Leighton's contemporaries, such as the sculptors Jules Dalou (who had made a terracotta bust of him in 1874) and George Boehm, and the painter George Henry Boughton, recognized in his sculpture something approaching the Greek and Roman classical works of antiquity. The latter described it as "not merely the spirit of the antique, but the antique itself, and the 'antique' I mean is the everlasting, the best mortal may ever hope to make."[79] Boehm wrote an effusive letter to the artist in 1877:*

I think it the best statue of modern days. I was riveted with admiration and astonishment; and whatever you may think of my judgment, pray take this as my humble and heartfelt tribute to a work of genius, which to my mind ranks nearer "zur Antiken" [to the Antique] than anything I have seen, during my career, produced in any school or country.[80]

But how could a work such as Leighton's be simultaneously "of modern days" and antique? What would be the point? And how did such a work deviate from the Neoclassical sculpture of three-quarters of a century earlier?

As Benedict Read has recently described it, the key to the work is its novel "blend of possibly archetypal background classical imagery (the Laocoön with its writhing muscularity) transfused with the virile naturalism of clenched muscles, protruding veins, complete nudity ..."[81] In this sense, the scientific ethos of the age joined with the early nineteenth-century interest in timeless classicism, a timelessness viewed by the 1870s as banal in sculpture. To invigorate the medium artists needed a new approach—this Leighton provided.

Another modern art historian, Elizabeth Prettejohn, discussed the reason why this work was so compelling to contemporaries:

[The *Athlete*] seems effortlessly to translate the "licked surface" of academic painting into bronze, not only by exploiting the play of light on highly polished metal but by refining surface detail to a degree that startled Victorian critics accustomed to the more generalised surfaces of the neo-classical sculptural tradition ...[82]

Thus the sculpture, by connecting with traditions in many different media and through various nods to other works, represents a kind of compendium of the history of art without having any specific narrative reference. As Prettejohn points out, contemporaries saw it as "an exploration of the body in space, not of a moralisable action extending into time," but one containing the possibility of classical revision, in which "the sculpture liberates itself from the block, swivelling into space to become the autonomous object of modern aesthetics."[83] At the same time, the Athlete delights in realist representation, a particularly non-modernist conceit, and in a concentration on the sensual aesthetics of the male nude:

If the sculpture is an exploration of free form in space, it does not search for abstraction; the pleasure of its spatial extension is inseparable from the flexibility of human limbs stretched to their utmost elasticity, as well as the supple contours of the musculature. Having abandoned the story of Laocoön, Leighton retains the heroism of the figure in the purely physical terms of the muscled body.[84]

In this way, Leighton successfully gave form to his imagined ideal of bronze classical sculpture (of which there were few actual examples for him to study) enlivened by a modern fascination with productions of the past and debates of the present, as well as technological advances in using the material. Athlete Wrestling with a Python, *along with the artist's greatest oil paintings, such as* Flaming June *(see fig. 439), brilliantly synthesized works from the art historical canon. Leighton employed superb technique, powerful design, and narratival ambiguity, free from the standard historical and literary sources, to expand the possibilities of figural traditions in the period.*

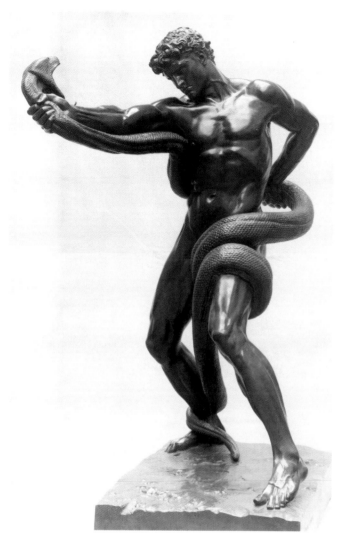

Fig. 503 **Frederic Leighton**, *Athlete Wrestling with a Python*, 1874–77. Bronze, life-size. Tate Britain, London (on deposit at Leighton House).

Gérôme, he did not redirect his energies toward sculpture. He exhibited only two more pieces, neither of them major works.

Despite their pronounced individuality, the New Sculptors shared a number of common characteristics: they were born during the 1850s or soon after; their training included a period of work on the Continent, most often in Paris; bronze—and sometimes other metals—assumed a new importance for them, as did the human nude, even though it usually still needed mythological guise; and it was they who, from the late 1880s on, satisfied the almost limitless demand for monuments to Queen Victoria. At that time, they were at the height of their careers, and monuments of all sorts, public or private, were part of their experience. These commissions provided not only their chief means of livelihood but a link with the sculptural past. The New Sculptors were reformers, not revolutionaries; thanks to them, the decline of the public monument was gentler in Britain than on the Continent. On the other hand, it was

their very moderation that prevented them, on the whole, from reaching a level of quality which commands attention in an international perspective.

Sometimes it is a single work within an artist's oeuvre that achieves this rank, as does the monument to Percy Bysshe Shelley (fig. 504) by Edward Onslow Ford (1852–1901). Trained at the Munich Academy in the early 1870s, Ford joined the New Sculptors after his debut in the Royal Academy in 1875 and soon became one of the most successful artists in England. The Shelley Memorial has a strange history, which may account for its singular position in Ford's oeuvre. It was commissioned, some time during the 1880s, by Lady Shelley, the widow of the poet's son by his second wife, for the Protestant Cemetery in Rome; the intended outdoor setting explains the tall and elaborate base of bronze and colored marble, with its mourning Muse and winged lions. But the monument turned out to be far too large for the available site. The alternative of erecting it to mark the place where the drowned poet's body had been washed ashore near Spezia also proved to be unexpectedly difficult, so Lady Shelley offered the work to Oxford, in 1891. Shelley had been an undergraduate there but had been expelled for his involvement in producing a pamphlet, *The Necessity of Atheism*. While the university trustees pondered their decision, the memorial was shown with spectacular success at the Royal Academy. A site was eventually prepared for the monument to be installed in University College.

Ford's interest centered on the prone nude body of the poet, placed on a slab whose uneven surface suggests the beach. Yet it would be a complete misreading of the artist's intentions to view it as nothing more than a realistic male nude. Ford wanted to engage the viewer's emotions, and he has succeeded in doing so with impressive force and delicacy. The body itself is so sensuously soft and graceful that it was probably carved, in part, from a female model. Among its numerous artistic ancestry, the reclining hermaphrodites of ancient art can certainly claim a place; but so can the *Tarcisius* (see fig. 319) and its prototypes. Without necessarily being aware of every one of these, Ford has woven together these multiple strands into an image of rare distinction.

Of all the New Sculptors, the most venturesome and many-sided was Alfred Gilbert (1854–1934). In 1873 he entered the Royal Academy Schools, hoping to emulate Leighton, but soon found that in order to learn the technical side of sculpture he had to apprentice himself to masters outside the academy. After studying at the École des Beaux-Arts in Paris, where one of his teachers was Frémiet, Gilbert proceeded to Rome. His response to the works of art he encountered in Italy reflects an aspect of his Paris experience that was to prove decisive for the rest of his career: the neo-Florentine trend. What impressed him to the exclusion of everything else were the great bronzes of

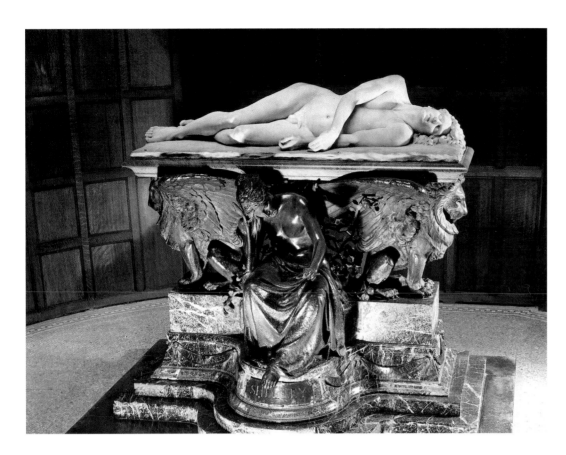

Fig. 504 **Edward Onslow Ford**, Shelley Memorial, completed c. 1890. Marble and bronze, life-size. University College, Oxford.

the Renaissance. His own Neo-Florentine style, however, is characteristically independent and individualistic; its first product, *Perseus Arming* of 1882 (**fig. 505**), profoundly influenced British sculpture for the rest of the century. It is a very unclassical nude, wiry and slender and, above all, caught in the midst of a complex turning movement. The artist's personal touch, his sculptural "handwriting," as it were, has been preserved in the metal surface, due in no small part to the fact that the figure was cast by the lost-wax process, which at that time was rarely used in England for large bronzes.

In 1892, the Prince of Wales (the future Edward VII) commissioned Gilbert to make the tomb of his oldest son, the Duke of Clarence, who had died shortly before. The culmination of Gilbert's career, it is by far the richest of all the tombs in the Albert Memorial Chapel, Windsor (**fig. 506**): the duke's effigy, in military uniform, combines marble, bronze, brass, and aluminum. At its head a large aluminum angel, bent over in grief, holds a huge, intricately wrought crown. Still more elaborate is the bronze grill surrounding the tomb proper, with its profusion of ornament and twelve ivory and bronze statuettes of saints. Although Gilbert showed the plaster model at the Royal Academy in 1894, the monument was delayed by Gilbert's ever-growing personal troubles; in 1899, he found himself in such dire straits that he sold some of the original ivory and metal statuettes off the tomb, replacing them with all-bronze casts. To escape his creditors, he moved to Bruges, where his wife left him, in 1905. In 1926, all but forgotten, he

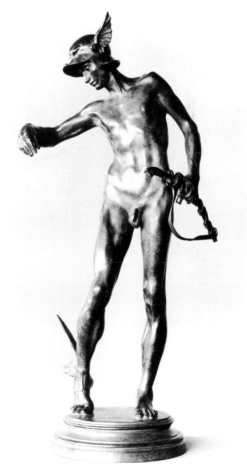

Fig. 505 **Alfred Gilbert**, *Perseus Arming*, 1882. Bronze, height 29". Victoria and Albert Museum, London.

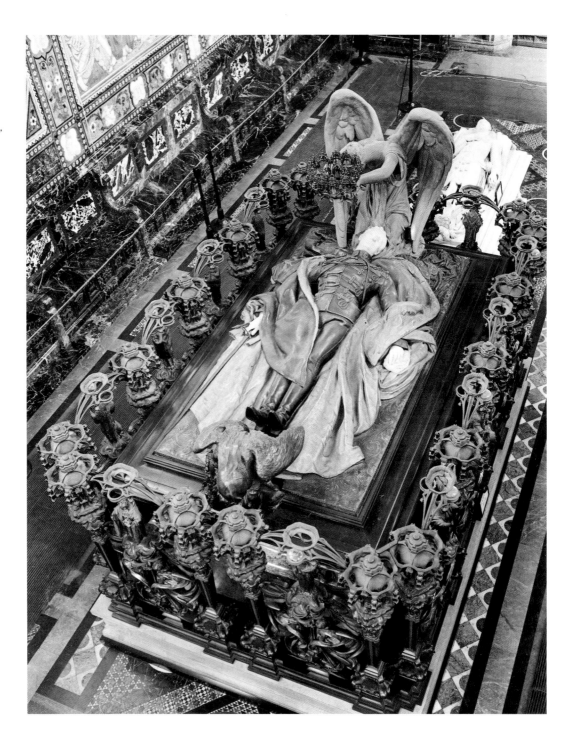

Fig. 506 **Alfred Gilbert**, Tomb of the Duke of Clarence, 1892–99. Marble, bronze, aluminum, ivory, length 10′ 7″. Albert Memorial Chapel, Windsor.

returned to London and was forgiven by the royal family. He supplied the five statuettes still missing from the tomb.

The Clarence Memorial, although somewhat overpowering (and quintessentially Victorian) in its richness of color and texture, is admirable in both technique and design. Gilbert exploited aspects of mixed materials never used before. He became a friend of the professor of metallurgy at the Royal School of Mines, and they experimented with Japanese alloys and casting techniques, which yielded hitherto unknown colorful patinations. He also was the first to use aluminum as a sculptural material on a large scale. In the Clarence Memorial, the contrast between the monochrome aluminum angel and the multi-colored effigy serves to convey different levels of being. Although he died of pneumonia, the duke, sword in hand and resting on his great cloak, gives the impression of a military hero. The realism of the effigy is an extreme contrast to the styles of the grill. Gilbert's repertory of ornament is enormous, ranging from Gothic, Mannerist, and Baroque to his own version of Art Nouveau.

The idea of the grill with its twelve images of saints was borrowed from late medieval tombs, such as that of Henry VII in London. His interest in Gothic links Gilbert with the British Arts and Crafts Movement, as does his passion for new techniques and the use of color in sculpture. Some of the statuettes, notably *The Virgin* (fig. 507), have a strongly

Fig. 507 **Alfred Gilbert**, *The Virgin*, c. 1894–96. Bronze, ivory, and tin, height 19½". Private collection.

medieval look, with the body completely hidden behind the splendidly ornamented, rigid drapery. Of the two known casts of *The Virgin*, the one reproduced here must be the original version made for the memorial but sold by the artist.

The United States

American sculpture of the last three decades of the century is marked by two phenomena new to this country: France superseded Italy as the place to study; and the demand for public sculpture of every sort was such as to overstrain the working capacity of the nation's sculptors, even though their number had grown precipitously. From the late 1860s on, Civil War monuments were commissioned by the hundreds, ranging from mass-produced single figures to triumphal arches such as the Brooklyn Memorial Arch, whose scale and sculptural program rivaled the Arc de Triomphe in Paris, at least quantitatively. Another category, equally substantial, was the sculptural decoration of public buildings. Before the Civil War, this had been largely confined to the nation's capital; now, every federal, state, or municipal building of any importance seemed to cry out for "ennobling" sculpted allegories and personifications (such as the Four Continents by Daniel Chester French attached to the U.S. Customs House in Lower Manhattan). A third category, known to us almost entirely from old photographs, was the embellishment, usually on a huge scale

but made of impermanent materials, of American world's fairs, from that in Philadelphia in 1876 to its successors in Chicago (1893), Buffalo (1901), St. Louis (1904), and San Francisco (1915). This boom ended with the First World War.

The new generation of sculptors who came into prominence during the 1870s did not displace the older generation for some time. Indeed, the great majority of Civil War memorials was entrusted to men whose reputation had been established before the war, such as Randolph Rogers (see page 338).

Nonetheless, American sculpture of the late nineteenth century is dominated by two great names, Augustus Saint-Gaudens and Daniel Chester French. Before discussing their work, however, let us mention an isolated work of another artist which gives evidence of a stylistic alternative very different from the mainstream. William Rimmer, whose *Dying Centaur* was illustrated in Part 3 (see fig. 329), died in 1879. Two years before his death, he produced a plaster *Torso* (fig. 508) exactly contemporary with Rodin's (see fig. 483). It is a reclining figure without head and arms, and with the legs severed just below the level of the crotch, strongly suggestive of a classical reclining torso. A classical source has been claimed for Rodin's first torso, too, extending the puzzling parallel even further.

Augustus Saint-Gaudens (1848–1907), the son of a French father and an Irish mother, was brought to New York from Ireland while still an infant. Bernard Saint-Gaudens, a shoemaker, apprenticed his son to a carver of stone cameos at thirteen; later, his expertise in cameos provided him with an income until he established himself as a sculptor on a monumental scale. At nineteen, he set off to continue his artistic education in Paris, where the family had relatives. The Paris Exposition Universelle of 1867 provided him with a dazzling panorama of French sculpture,

Fig. 509 **Augustus Saint-Gaudens**, *Samuel Gray Ward*, 1881. Plaster, height 19¼″. Saint-Gaudens National Historic Site, Cornish, New Hampshire.

Fig. 508 **William Rimmer**, *Torso*, 1877. Plaster, height 11¼″. Museum of Fine Arts, Boston.

reinforcing his desire to enter the École des Beaux-Arts. After some months he was admitted and worked under François Jouffroy, the teacher of Falguière and Mercié, also carving cameos to earn a living. With the outbreak of the Franco-Prussian War, Saint-Gaudens went to Rome, where he spent two years and received his first commissions for large-scale sculpture. He knew the older American sculptors there but had little contact with them, his own direction having been determined by his Paris experiences. These, it seems, included exposure to the neo-Florentine trend (see page 481), for the only Italian monuments of the past he showed any enthusiasm for were those of the great fifteenth-century sculptors, especially their work in extremely shallow relief. Saint-Gaudens developed a species of portrait panel that combines his experience in carving cameos with his enthusiasm for these reliefs. The best-known example, which exists in several variants, is his portrait of Robert Louis Stevenson of 1887. Their special virtues, however, are best seen in an earlier piece, said to be the lowest relief Saint-Gaudens ever attempted: the half-length portrait of Samuel Gray Ward of 1881 (fig. 509). What makes Saint-Gaudens's reliefs unusual is not only

Fig. 510 **Augustus Saint-Gaudens**, *Diana*, 1893. Bronze, height 9′ 4″ (reduced replica of 13′ original). The Metropolitan Museum of Art, New York.

sensuous appeal. Its neo-Florentine quality, in its elongated proportions and expressive contour, comes to the fore emphatically if we compare this *Diana* with those of Houdon and Falguière (see figs. 91 and 471).

If the *Diana* was the most public of Saint-Gaudens's works, in that for some thirty years millions of New Yorkers could not avoid looking at her, the Adams Memorial (**fig. 511**) is his most private, in both purpose and accessibility. It marks the grave of Marian (Clover) Adams, the wife of Henry, who had taken her own life. It is located in Rock Creek Cemetery, in the nation's capital. Stanford White, a friend of Saint-Gaudens, designed the architectural setting and dense greenery that shield the figure from the path. Henry Adams knew that he did *not* want any of the then familiar types of funerary sculpture but had great difficulty explaining what he *did* want. According to the account of the painter John La Farge, who had brought sculptor and patron together, Adams spoke of a single figure, which was to symbolize "the acceptance, intellectually, of the

Fig. 511 **Augustus Saint-Gaudens**, Adams Memorial, 1886–91. Bronze, slightly over life-size. Rock Creek Cemetery, Washington, D.C.

their shallowness but his ability to combine the immediacy and freshness of a sketch with formal assurance and an exceptional gift for projecting the sitter's character. To emphasize the definitive quality of these panels, the artist added the sitter's name and the date of the work in Roman capitals.

Another witness to the neo-Florentine element in Saint-Gaudens's work is the colossal *Diana* he designed in 1892 to stand as a weathervane on top of the tower of the original Madison Square Garden in New York. Although made of hammered copper sheeting, like the *Statue of Liberty*, to minimize her weight, and kept as flat as a statue could decently be, the *Diana* refused to respond to the wind. Nevertheless, she stood in her original location until the garden was torn down in 1925. Several years later, she entered the Philadelphia Museum. A smaller version, which was never exposed to the elements, is in the Metropolitan Museum of Art (**fig. 510**). It is Saint-Gaudens's only nude, beautifully poised and balanced but utterly (and purposely) devoid of

inevitable." When he commissioned the statue in 1886, he had just returned from Japan, where he acquired a strong interest in certain aspects of Buddhism, which he hoped would be expressed in Saint-Gaudens's image. But he did not want to consult with the sculptor on this difficult task; he told him to go to La Farge instead. No wonder it took Saint-Gaudens five years and many false starts before he completed the present figure, which neither personifies nor symbolizes but rather exemplifies what he termed "mental repose, calm reflection in contrast with the violence or force in nature." These words are a rephrasing of the Buddhist concept of nirvana, the extinction of all passion and desire, which frees the soul from the need for future reincarnation. Saint-Gaudens, then, had to visualize an Eastern idea by Western means; apparently neither Henry Adams nor he ever looked to Eastern art for inspiration. In *The Education of Henry Adams* the author wrote of spending many hours with the figure, whose meaning he described as "the oldest idea known to human thought," yet without defining what he took this idea to be. He was bemused, and confirmed in his pessimistic view of the state of Western civilization, by the puzzlement of visitors, who wanted to know the meaning of the figure and received no answer. It was clearly not a portrait, and the lack of attributes or even of a facial expression betraying her feelings made any label seem inadequate. What the visitor could not easily know was the esoteric Eastern thoughts the figure is meant to embody, or the long line of ancestors in Western art to which it is related. These include the mourning monks on Claus Sluter's tombs in Dijon, Dürer's *Melancholy*, and the anonymous veiled female mourners of earlier nineteenth-century tombs. Still, the Adams Memorial deserves its fame. Here Saint-Gaudens has created, quite independently, an impressive piece of Symbolist sculpture that shares with its European counterparts only the background vibration of Far Eastern religious ideas.

Another of his funerary monuments, a far less enigmatic figure, *Amor Caritas* (1885–98), is derived from an original group modeled for the tomb of New York governor Edwin Morgan; the tomb commission never came to fruition because the angels were destroyed in a fire. However, a single angel cast in bronze, was purchased by the French government, the first work of the artist's to be included in a European museum collection (**fig. 512**). Versions of *Amor Caritas* can be found in a number of American cemeteries, as can similar figures by other sculptors who were inspired by Saint-Gaudens's high relief.

By far the largest body of works within Saint-Gaudens's oeuvre consists of public monuments relating to the Civil War. In these, it is his realism that comes to the fore, but a realism of a highly selective and disciplined kind. He could, for instance, not abide the standard form of public monuments to individuals, a standing figure on a pedestal. In his first public monument of this type, the Farragut monument

(1876–81), which established his reputation, the admiral is standing with legs apart and with a strong wind pulling at his uniform, as he would look on the bridge of his flagship, and the pedestal, designed with the help of Stanford White, became an integral part of the monument rather than a mere support. Similarly, his *Lincoln* for Chicago (1887) is not just standing; he is accompanied by a chair, from which he has just risen, thus placing his pose in a context. While both these monuments are easily the finest of their kind, they were far less of a challenge to Saint-Gaudens than the Shaw Memorial for Boston, which took some fourteen years to complete (it was inaugurated in 1897). Colonel Robert Gould Shaw was killed while leading the 54th Regiment of Massachusetts Infantry, the first all-black

Fig. 512 **Augustus Saint-Gaudens**, *Amor Caritas*, 1885–98. Bronze, height 8′ 8⅛″. Musée d'Orsay, Paris.

Fig. 513 **Augustus Saint-Gaudens**, Robert Gould Shaw Memorial, 1884–97. Bronze, figures slightly over life-size. Beacon Street, Boston.

volunteer regiment of the Civil War. What both Saint-Gaudens and Shaw's family wanted was a memorial honoring the entire regiment as much as the colonel (fig. 513). This dictated the form, a relief of impressive size, but the composition presented severe problems. One was the choice of models for the soldiers; the members of the regiment under Shaw had mostly been killed in action, and the few survivors were old men by now, so the sculptor had to persuade representative individuals to pose for him. Saint-Gaudens's summer studio at Cornish, New Hampshire, contains a considerable number of such heads, which are among the artist's finest portraits. As for the suitability of the female genius with laurel and poppies, opinions may differ (Saint-Gaudens himself was not always sure), yet as a whole the Shaw monument can well claim to be the most moving among all Civil War memorials. Somehow, the meticulous realism of detail strengthens, rather than distracts from, the rhythmic forward movement of these solemn and determined men.

Of the military leaders of the Civil War, William Tecumseh Sherman was the one Saint-Gaudens admired most.

In 1888, he did a splendid bust of the general, based on eighteen sittings of about two hours each. It was thus a foregone conclusion that, less than a year after the general's death in 1891, the Sherman Monument Committee would choose Saint-Gaudens for an equestrian monument. Saint-Gaudens was delighted, and within a year or two had arrived, on a small scale, at the design the monument has today (fig. 514), but other commissions intervened, so that he could not start the full-size version until 1897. The entire group, including the Victory which had been a part of it from the start, was first shown in public at the Paris Exposition Universelle of 1900 and was honored with a *grand prix*. Saint-Gaudens then had the monument shipped to his studio at Cornish, where he applied a double coat of gold leaf to the bronze (not realizing how quickly the gilding would be worn down by wind and weather) and fixed the shape and height of the granite pedestal. By the time the monument was unveiled in 1903, its international fame had already been established. The Victory that precedes, rather than guides, the general is a motif as old as Roman art, where images of equestrian emperors led by

Fig. 514 **Augustus Saint-Gaudens**, General Sherman Monument, unveiled 1903. Bronze, over life-size. Fifth Avenue and 59th Street, New York.

victories appear on coins. The contemporary monument to Wilhelm I by Reinhold Begas furnishes the most immediate precedent (see fig. 500). What is original about Saint-Gaudens's Victory is her delicate, virginal type, even the consciously awkward way she carries the palm frond, and the way she keeps pace with the forward movement of horse and rider. Saint-Gaudens had every right to be proud of what he had achieved. All too often, his work is classed—or rather declassed—as "the American Beaux-Arts style," implying the transplantation from Paris of what the École des Beaux-Arts had to offer at the cost of neglecting some undefined and mythic "native American" quality.

In contrast to the humble origins of Saint-Gaudens, Daniel Chester French (1850–1931) was born with what amounted to a colonial silver spoon in his mouth. The son of a prominent New England lawyer, French was seventeen when the family moved to Concord, Massachusetts, the very citadel of New England literary and intellectual life. Young French showed great aptitude in modeling that warranted serious pursuit, studying anatomy with William Rimmer, drawing with William Morris Hunt, and sculpture with John Q. A. Ward in New York. Soon after, in 1873–74, French produced what must be among the half-dozen best-known statues in America, *The Minute Man*, commissioned

Fig. 515 **Daniel Chester French**, *Gallaudet and His First Deaf-Mute Pupil*, 1888. Bronze, life-size. Gallaudet University, Washington, D.C.

by the town of Concord. French then left to study in Florence for two years with the American sculptor Thomas Ball, whose conservative style fostered a reverential attitude toward the antique. It was not until 1886 that French entered the École des Beaux-Arts. By then, he was an established sculptor at home, and it is a tribute to his humility and determination that he took this step at the age of thirty-six, in order to attend the sculpture classes of Mercié.

French is primarily associated with his allegorical groups of monumental scale attached to buildings, ranging from such traditional personifications as Justice or Truth to programs that would have driven any earlier sculptor to distraction: "Science Controlling the Forces of Steam and Electricity," or "Labor, Art, and the Family"—both of them made for the Boston Post Office about 1882.

French's return from Paris in 1888 marks the true beginning of his career as a serious artist. He soon made the monument to Gallaudet, a pioneer teacher of deaf-mutes, for the Columbia Institute for Deaf-Mutes in Washington (fig. 515). The sculptor was specifically requested to show

Gallaudet teaching his first pupil. The bronze group displays great delicacy of feeling and psychological insight. Gallaudet, seated in an armchair, and the little girl standing next to him make the identical gesture with their right hands. To avoid the impression that the two are simply playing a game, French shows us how desperately serious the child is, not only in her facial expression but in such details as the tense left hand. What does the group owe to French's lessons with Mercié? Nothing so far as the invention is concerned, but everything in the surface finish, which now acknowledges the pleasures of modeling and the variety of textures the process permits.

The Milmore Memorial (fig. 516) is among French's most renowned works. He made it in 1891–92 at the request of the family of Martin Milmore, a sculptor-friend who had died in 1883. French took the plaster model to Paris to be cast, and showed it at the Salon, where it earned a medal and high praise. The large relief—the Angel of Death and the Sculptor are almost figures in the round—exists in a marble version at the Metropolitan Museum,

Fig. 516 **Daniel Chester French**, *Death and the Sculptor* (Milmore Memorial), 1892. Bronze, over life-size. Forest Hills Cemetery, Boston.

New York, and is known to a great many more people than have made the pilgrimage to Forest Hills Cemetery near Boston to see the bronze. The Angel of Death, embedded in the sweeping curves of the wings and the hood that shades her face, is a somewhat grandiloquent specimen of the personifications for which French was famous. French took many liberties with the image of the sculptor whose hand is arrested by Death while he carved a sphinx (an allusion to Milmore's Civil War Memorial at Mount Auburn Cemetery), not the least of which was the widely practiced pretense that sculpture consists of attacking the block directly with mallet and chisel. It has a special irony here, since French must have known that Milmore left all the carving of the sphinx to his elder brother, Joseph. Saint-Gaudens, who in 1892 was organizing a small army of sculptors to do the decorations for the Chicago World's Fair of the following year (he himself wisely stayed clear of these temporary creations), added French to his list mainly because of the Milmore Memorial. French's most visible contribution was the colossal statue of the Republic,

sixty-five feet high, made of straw and plaster over a wooden framework and with the entire garment gilt so as to suggest the chryselephantine colossi of the Greeks. The most honorific commission French ever received, the seated portrait for the Lincoln Memorial in Washington, came to him shortly before the start of the First World War.

Frederick William MacMonnies (1863–1937) did his most impressive work in the 1890s. He began his career as a shop assistant of Saint-Gaudens, who discovered and encouraged his sculptural talent. In Paris, Falguière found him so well trained that he engaged him as an assistant in his private studio. By 1890, MacMonnies had his own private studio in Paris and, through Saint-Gaudens, would soon have an important share in the temporary sculpture for the Chicago World's Fair of 1893. That year, he also produced the bronze *Bacchante with an Infant Faun* (**fig. 517**), which got his name into the headlines of the day. The gregarious MacMonnies gave the first cast to the architect Charles F. McKim, who placed it in the courtyard of the new library McKim and associates had designed for Copley

Square in Boston. The trustees had accepted the gift with some misgivings, as if they had an inkling of the storm that was to break over this life-size image of "wanton nudity and drunkenness." The well-founded rumor that she represented a particular Paris model of whom MacMonnies was very fond only made matters worse. There was an uproar about the portrayal of the woman, who was playing at being a bacchante with more high spirits than conviction. Nobody seems to have worried about the rather unattractive baby. MacMonnies, needless to say, benefited greatly from thus being "banned in Boston." McKim withdrew the statue on the trustees' demand and then offered it to the Metropolitan Museum, which not only accepted it but stood its ground against further attempts to remove the *Bacchante* from public view. His pair of colossal stone *Horse Tamers* (fig. 518), made in 1900 for the Buffalo Pan-

Fig. 518 **Frederick William MacMonnies**, *Horse Tamers*, 1900. Stone, over life-size. Prospect Park, Brooklyn, N.Y.

American Exposition of 1901, ended up in Prospect Park, Brooklyn.

Postscript: The *Fin de Siècle*

That the end of the nineteenth century should be termed the *fin de siècle* by historians of culture is not an arbitrary convention. For nowhere else was the approach of the new century experienced as consciously, and in so great a variety of ways, as in France. As the 1890s wore on, there was an ever sharper division between the official and unofficial, the public and private, the popular and unpopular. The last great mobilization of the sculptural establishment was for the Paris Exposition Universelle of 1900. The decorations of the Pont Alexandre III, the Grand Palais, and the Petit Palais were carried out in permanent materials and have endured over a century, representing an infinitely complex world of allegories and personifications and the work of dozens of sculptors, for example the spectacular quadrigas by Georges Recipon (1860–1920) perched at the corners of the Grand Palais (fig. 519). (Note that these have a close parallel in MacMonnies's *Horse Tamers*.) Recipon's enormous groups celebrating the triumph of Good over Evil in various mythological guises were made of beaten copper sheets to minimize the problem of weight. Even so, they appear practically airborne, propelled by their neo-Baroque élan. For Recipon, the work he did for the fair was the climax of a career that deteriorated rapidly

Fig. 517 **Frederick William MacMonnies**, *Bacchante with an Infant Faun*, 1893. Bronze, life-size. The Metropolitan Museum of Art, New York.

Fig. 519 **Georges Recipon**, Quadriga. Completed 1900. Beaten copper, over life-size. Grand Palais, Paris.

thereafter. For what he had to give, the world had little further demand after 1900.

The various esoteric movements that flourished in the 1890s—the School of Pont-Aven, the Rosicrucians, the Nabis—gave little encouragement to sculpture, even though Paul Gauguin, their chief source of inspiration, had produced both ceramic pieces and wood carvings. These remained almost unknown during his lifetime. The one member of the Nabis brotherhood (see page 448) who did sculpture was Georges Lacombe (1868–1916), who worked under the influence of Gauguin, which, however, reached him mainly indirectly through his mentor Paul Sérusier. Lacombe's personal wealth made it possible for him to

Fig. 520 **George Lacombe**, *Existence*, 1891–92. Wood, length 55". Musée d'Orsay, Paris.

maintain his principle that art should not be exchanged for money. His most radical Nabi production is a carved bed, the headboard of which he called *Existence* (**fig. 520**). The central motif is that age-old symbol of eternity: the snake that bites its own tail. Part of the snake, however, helps to form a face with flat nose and broad lips à la Gauguin—or is it two profiles facing each other? Such calculated ambiguity pervades the panel. None of these semi-abstract, fantastic qualities appear elsewhere in Lacombe's rather limited output.

The other sculptor associated with the Nabis is at the other end of the spectrum from Lacombe: he was poor, and he became one of the "Great Names" of modern art. Aristide Maillol (1861–1944) began as an academic painter in the early 1880s but fell under the influence of Gauguin and Émile Bernard, and during the 1890s was close to the Nabis. He was self-taught as a sculptor; his early works are all on a small scale. His appreciation of Rodin in the mid-1890s was short-lived, and he turned away from the art of the older man having learned only one vital lesson— the formal and expressive potential of the incomplete figure. Maillol finally attempted his first piece of monumental sculpture in 1902, the slightly over life-size, stone *Night* (**fig. 521**). The title is not that of a personification but alludes to the self-contained and self-sufficient character of this powerfully built nude woman, the type Maillol was to prefer for the rest of his career. *Night* makes a telling comparison with what must have been its formal source, Dalou's *Truth Denied* (see fig. 480). We know what Dalou meant to convey, the utter despair of Truth denied in the Dreyfus case. The pose thus is psychologically motivated, and the identity of the figure established by the mirror at her feet. Even her nudity is meaningful, as one of the attributes of truth. No such analysis is possible for Maillol's *Night*. She closes the century with an invitation into the domain of modern art.

Fig. 521 **Aristide Maillol**, *Night*, 1902. Stone, slightly over life-size. Kunstmuseum Winterthur, Switzerland.

Bibliography

PAINTING

The bibliography that would correspond to the period covered in this book, from 1776 to 1900, and to the artists and nations represented, from Abilgaard to Zorn, from Mexico to Finland, would be so vast and unwieldy that many restrictions have had to be made to render it more manageable as a reference tool. For one thing, articles in periodicals have, in general, been excluded. For another, works in English have been favored, in view of the fact that the text is designed to provide a general survey of nineteenth-century art for the English-speaking reader rather than for international scholars. Publications in foreign languages, however, have occasionally been included, especially if they are the only ones available on a relatively obscure subject or artist, or if they are valuable for their compilation of illustrations. In this latter category, the most useful (and reasonably priced) are the complete illustrated catalogues of all the works of a wide range of nineteenth-century painters and sculptors (from Friedrich and Ingres to Boldini and Gauguin) in a series published in Italian by Rizzoli Editore, Milan, and often, but not always, available in English or French editions under such rubrics as *L'opera completa di … ; The Complete Works of … ; L'Oeuvre complet de. …* By and large, recent publications have been stressed, for they usually provide the fullest clues to earlier works on the same subject. Moreover, exhibition catalogues, indicated in the bibliography by an asterisk (*), have been emphasized, since in the later twentieth century, they have become the most up-to-date vehicles for disseminating new facts and ideas in the rapidly changing history of nineteenth-century art.

The painting bibliography is ordered [alphabetically by author/institute] as follows:

I. GENERAL HISTORIES AND REFERENCE BOOKS
These are international in scope and survey all or most of the nineteenth century.
II. NATIONAL SURVEYS
These are national in scope and survey all or most of the nineteenth century.
III. PERIOD STUDIES—INTERNATIONAL AND NATIONAL
These are listed in roughly chronological and thematic order, corresponding broadly to the sequence and disposition of material in the text.
A. c. 1770–1848: Neoclassicism, Romanticism
B. c. 1848–1900: Realism, Pre-Raphaelitism, Aspects of Academic Painting
C. c. 1860–1900: Impressionism, Neo-Impressionism, Post-Impressionism, Symbolism, Art Nouveau
IV. SPECIALIZED TOPICS AND MISCELLANEOUS STUDIES
V. INDIVIDUAL ARTISTS

The last section (V) was compiled largely by Susan Hapgood. The first sections (I–IV) were compiled by the undersigned.

Robert Rosenblum (1984)
[Revised and updated in 2004 by Ariel Plotek.]

I. GENERAL HISTORIES AND REFERENCE BOOKS

Canaday, John, *Mainstreams of Modern Art*, New York, London, 1959.

Eisenman, Stephen F., *Nineteenth Century Art: A Critical History*, London, 1994.

Eitner, Lorenz, *An Outline of Nineteenth-Century European Painting: From David through Cézanne*, New York, 1986.

Hamilton, George Heard, *19th and 20th Century Art*, New York, 1970.

Hofmann, Werner, *The Earthly Paradise, Art in the Nineteenth Century*. New York, London, 1961.

Holt, Elizabeth Gilmore, ed., *From the Classicists to the Impressionists: A Documentary History of Art and Architecture in the Nineteenth Century*, New York, 1966.Norman, Geraldine, *Nineteenth-Century Painters and Painting: A Dictionary*. Berkeley and Los Angeles, 1977.

Novotny, Fritz, *Painting and Sculpture in Europe, 1780–1880* (Pelican History of Art), Baltimore, 1960; 2nd ed., Harmondsworth, 1970.

Reynolds, Donald M., *The Nineteenth Century*, New York, 1985.

Rosen, Charles, *Romanticism and Realism: The Mythology of Nineteenth-Century Art*, New York, 1984.

Schultze, Jürgen, *Art of Nineteenth-Century Europe*, New York, 1970.

Taylor, Joshua C., *Nineteenth-Century Theories of Art*, Berkley, 1987.

II. NATIONAL SURVEYS

Brown, Milton, *American Art to 1900*, New York, 1977.

*Champa,Kermit, *German Painting of the 19th Century*, Yale University Art Gallery, New Haven, 1970.

Finke, Ulrich, *German Painting: From Romanticism to Expressionism*, London, 1974.

Frascina, Francis, *Modernity and Modernism: French Painting in the Nineteenth Century*, New Haven, Conn., 1993.

Gaunt, William, *The Restless Century, Painting in Britain 1800–1900*, London, 1972.

Groseclose, Barbara S., *Nineteenth-Century American Art*, New York, 2000.

Hamilton, George Heard, *The Art and Architecture of Russia* (Pelican History of Art), Harmondsworth, Baltimore, 1954.

Harper, J. Russell, *Painting in Canada, A History*, Toronto, 1977.

Heteren, Marjan van, *The Poetry of Reality: Dutch Painters of the Nineteenth Century*, Amsterdam, 2000.

Leymarie, Jean, *French Painting, the Nineteenth Century*, Geneva, Cleveland, 1962.

Lukomski, G. K., *History of Modern Russian Painting*, London, 1945.

McCulloch, Alan, *The Encyclopedia of Australian Art*, Honolulu, 1994.

*[Metropolitan Museum of Art] *German Masters of the Nineteenth Century*, New York, 1981.

*Monrad, Kasper, *The Golden Age of Danish Painting*, Metropolitan Museum of Art, New York, 1993.

*National Academy of Design, *Nineteenth Century Polish Painting*, New York, 1988.

Novak, Barbara, *American Painting of the Nineteenth Century*, New York, London, 1969.

Smith, Bernard, *Australian Painting, 1788–1860*. Oxford, 1962.

Temple, A. G., *Modern Spanish Painting*, London, 1898.

Turner, Jane, ed., *Encyclopedia of American Art Before 1914*, New York, 1999.

Vaughan, William, *British Painting: The Golden Age from Hogarth to Turner*, London, 1999.

Willard, Ashton Rollins, *Modern Italian Art*, London, 1900.

III. PERIOD STUDIES— INTERNATIONAL AND NATIONAL

A. c. 1770–1848: NEOCLASSICISM, ROMANTICISM

Andrews, Keith, *The Nazarenes: A Brotherhood of German Painters in Rome*, Oxford, 1964.

*[Art Gallery of New South Wales] *French Painting: The Revolutionary Decades, 1760–1830*, Sydney, 1980.

*[The Arts Council of Great Britain] *The Age of Neoclassicism*, London, 1972.

*[Bell Gallery] *All the Banners Wave: Art and War in the Romantic Era, 1792–1851*, List Art Center, Brown University, Providence, R.I., 1982.

Boime, Albert, *Art in the Age of Revolution, 1750–1850*, Chicago, 1987.

Brookner, Anita, *Romanticism and its Discontents*, London, 2000.

Bryson, Norman, *Tradition and Desire from David to Delacroix*, New York, 1984.

——, *Word and Image: French Painting of the Ancien Régime*, New York, 1981; Cambridge, England, 1982.

Clark, Kenneth, *The Romantic Rebellion*, London, New York, 1973.

Conisbee, Philip, *Painting in Eighteenth Century France*, Ithaca, N.Y., 1981.

*[Dahesh Museum of Art] *French Artists in Rome: Ingres to Degas, 1803–1873*, New York, 2003.

*[Detroit Institute of Arts] *French Painting, 1774–1830: The Age of Revolution*, Detroit, 1974–75.

Duncan, Carol, *The Pursuit of Pleasure: The Rococo Revival in French Romantic Art* (Garland Dissertation Series), New York, 1976.

Eitner, Lorenz, ed., *Neoclassicism and Romanticism, 1750–1850* (Sources and Documents in the History of Art), Englewood Cliffs, N.J.; London, 1970; New York, 1989.

Fried, Michael, *Absorption and Theatricality: Painting and the Beholder in the Age of Diderot,*

Berkeley, Los Angeles, 1980; London, 1981; Chicago, 1988.

Friedlaender, Walter, *David to Delacroix*, Cambridge, Mass., 1952.

*Galassi, Peter, *Before Photography: Painting and the Invention of Photography*, The Museum of Modern Art, New York, 1981.

[Garland Library of the History of Art] *Rococo to Romanticism: Art and Architecture 1700–1850*, vol. 10, New York, 1976.

*[Grand Palais] *Ossian*, Paris, 1974.

*Hawes, Louis, *Presences of Nature: British Landscape, 1780–1830*, Yale Center for British Art, New Haven, 1982.

*Herbert, Robert L., *Barbizon Revisited*, Boston Museum of Fine Arts, 1962.

Holt, Elizabeth Gilmore, ed., *The Triumph of Art for the Public: The Emerging Role of Exhibitions and Critics*, New York, 1979.

Honour, Hugh, *Neoclassicism*, Harmondsworth, Baltimore, 1973.

Honour, Hugh, *Romanticism*, London, New York, 1979.

Irwin, David D., *Neoclassicism*, London, 1997.

Keyser, Eugenie de, *The Romantic West, 1789–1850*, New York, 1965.

Kroeber, Karl, *British Romantic Art*, Berkley, 1986.

LeBris, Michel, *Romantics and Romanticism*, New York, 1981.

Levey, Michael, *Rococo to Revolution: Major Trends in Eighteenth-Century Painting*, London, New York, 1966.

Levitine, George, *The Dawn of Bohemianism: The Barbu Rebellion and Primitivism in Neoclassical France*, University Park, Pa., 1978.

Lipschutz, Ilse Hempel, *Spanish Painting and the French Romantics*, Cambridge, Mass., 1972.

*[Musée de l'Ain] *"Le Style Troubadour,"* Bourg-en-Bresse, 1971.

*Noon, Patrick, *Crossing the Channel: British and French Painting in the Age of Romanticism*, Metropolitan Museum of Art, 2003.

Olson, Roberta J. M., *Ottocento: Romanticism and Revolution in 19th-Century Italian Painting*, New York, 1992.

*Parris, Leslie, *Landscape in Britain, c. 1750–1850*, The Tate Gallery, London, 1973.

Paulson, Ronald, *Literary Landscape, Turner and Constable*, New Haven, Conn., 1982.

*[The Philadelphia Museum of Art], *Romantic Art in Britain, 1760–1860*, Philadelphia, 1968.

Praz, Mario, *On Neoclassicism*, London, 1969.

*Pressly, Nancy L., *The Fuseli Circle in Rome: Early Romantic Art of the 1770s*, Yale Center for British Art, New Haven, 1979.

Smith, Bernard, *European Vision and the South Pacific, 1768–1850*, Oxford, 1960.

Rosenblum, Robert, *The International Style of 1800: A Study in Linear Abstraction* (Garland Dissertation Series), New York, 1976.

Rosenblum, Robert, *Modern Painting and the Northern Romantic Tradition: Friedrich to Rothko*, New York, London, 1975.

Rosenblum, Robert, *Transformations in Late Eighteenth Century Art*, Princeton, 1967.

Toman, Rolf, ed., *Neoclassicism and Romanticism: Architecture, Sculpture, Painting, Drawings*, Cologne, 2000.

Turner, Jane, ed., *From David to Ingres: Early 19th-Century French Artists, (Grove Dictionary of Art)*, New York, 2000.

*[University of Maryland Art Gallery] *Search for Innocence: Primitive and Primitivistic Art of the 19th Century*, Maryland, 1975.

*[University of Minnesota Gallery] *The Art of Russia 1800–1850*, Minneapolis, 1978.

Vaughan, William , *German Romanticism and English Art*, New Haven, Conn.; London, 1979.

——, *German Romantic Painting*, London, 1980; New Haven, Conn., 1994.

——, *Romanticism and Art*, London, 1994.

B. c. 1848–1900: REALISM, PRE-RAPHAELITISM, ASPECTS OF ACADEMIC PAINTING

Boase, T. S. R., *English Art 1800–1870* (Oxford History of English Art), Oxford, 1959.

Boime, Albert, *The Academy and French Painting in the Nineteenth Century*, New York, Oxford, 1971.

——, *The Art of the Macchia and the Risorgimento: Representing Culture and Nationalism in Nineteenth-Century Italy*, Chicago, 1993.

Brettell, Richard R., *French Salon Artists, 1800–1900*, New York 1987.

*[Brooklyn Museum] *The Triumph of Realism: An Exhibition of European and American Realist Paintings, 1850–1910*, New York 1967.

Bullen, J. B., *The Pre-Raphaelite Body: Fear and Desire in Painting, Poetry, and Criticism*, New York, 1998.

Casteras, Susan P., and Faxon, Alicia Craig, eds., *Pre-Raphaelite Art in its European Context*, London, 1995.

Celebonović, Aleksa, *Some Call It Kitsch: Masterpieces of Bourgeois Realism*, New York; U.K. ed.: *The Heyday of Salon Painting: Masterpieces of Bourgeois Realism*, London, 1974.

Cheney, Liana De Girolami, ed., *Pre-Raphaelitism and Medievalism in the Arts*, Lewiston, N.Y., 1992.

*Christian, John, ed., *The Last Romantics: The Romantic Tradition in British Art: Burne-Jones to Stanley Spencer*, Barbican Art Gallery, London, 1989.

Chu, Petra Ten Coesschate, *French Realism and the Dutch Masters*, Utrecht, 1974.

Clark, T. J. , *the Absolute Bourgeois: Artists and Politics in France, 1848–1851*, London, New York, 1973 (Paperback: London, Princeton, 1982).

——, *Image of the People: Gustave Courbet and the Second French Republic, 1848–1851*, London, New York, 1973 (Paperback: London, Princeton, 1982).

[The Garland Library of the History of Art] *Painting from 1850 to the Present*, vol. 12, New York, 1976.

*[Grand Palais] *I Macchiaioli*, Paris, 1979.

Harding, James, *Artistes Pompiers: French Academic Art in the Nineteenth Century*, New York, 1979.

Holt, Elizabeth Gilmore, ed., *The Art of All Nations, 1850–1873: The Emerging Role of Artists and Critics*, Princeton, 1981.

Lucie-Smith, Edward, and Dars, Celestine, *How the Rich Lived: The Painter as Witness, 1870–1914*, London, New York, 1976.

——, *Work and Struggle: The Painter as Witness, 1870–1914*, London, New York, 1977.

Mainardi, Patricia, *The End of the Salon: Art and the State in the Early Third Republic*, New York, 1993.

Mayne, Jonathan, trans. and ed., *Art in Paris, 1845–1862: Salons and Other Exhibitions Reviewed by Charles Baudelaire*, London, New York, 1965.

*[Minneapolis Institute of Arts] *Victorian High Renaissance [Watts, Leighton, Moore, Gilbert]*, Minneapolis, 1978.

Needham, Gerald, *19th-Century Realist Art*, New York, 1988.

Nochlin, Linda, *Realism*, Harmondsworth, Baltimore, 1971; new ed., 1990.

——, ed., *Realism and Tradition in Art, 1848–1900* (Sources and Documents in the History of Art), Englewood Cliffs, N.J., 1966.

Novak, Barbara, *Nature and Culture: American Landscape and Painting 1825–1875*, New York, 1980.

*[The Philadelphia Museum of Art] *The Second Empire 1852–1870: Art in France Under Napoleon III*, Philadelphia, 1978.

Ponente, Nello, *The Structures of the Modern World, 1850–1900*, Cleveland, 1965.

Prettejohn, Elizabeth, ed., *After the Pre-Raphaelites: Art and Aestheticism in Victorian England*, New Brunswick, N.J., 1999.

*[Royal Academy of Arts] *The Hague School*, London, 1983.

*[Sterling and Francine Clark Art Institute] *The Elegant Academics: Chroniclers of Nineteenth-Century Parisian Life*, Williamstown, Mass., 1974.

Strong, Roy, *And When Did You Last See Your Father? The Victorian Painter and British History*, London; U.S. ed.: *Recreating the Past: British History and the Victorian Painter*, New York, 1978.

*[Tate Gallery] *The Age of Rossetti, Burne-Jones & Watts: Symbolism in Britain, 1860–1910*, London, 1997.

*[Tate Gallery] *The Pre-Raphaelites*, London, 1984.

*[University of California Museum] *The Cult of Images: Baudelaire and the 19th-Century Media Explosion*, Santa Barbara, 1977.

*Weisberg, Gabriel, *The Realist Tradition: French Painting and Drawing, 1830–1900*, The Cleveland Museum of Art, 1980.

Weisberg, Yvonne M. L., *The Realist Debate: A Bibliography of French Realist Painting, 1830–1885*, New York, 1984.

*Wilmerding, John, et al., *American Light: The Luminist Movement, 1850–1875*, National Gallery of Art, Washington, D.C., 1980.

Wood, Christopher, *The Pre-Raphaelites*, London, New York, 1981.

——, *Victorian Painters*, Woodbridge, Suffolk, 1995.

C. c. 1860–1900: IMPRESSIONISM, NEO-IMPRESSIONISM, POST-IMPRESSIONISM, SYMBOLISM, ART NOUVEAU

Berger, Klaus, *Japonisme in Western Painting from Whistler to Matisse*, New York, 1992.

Boime, Albert, *Art and the French Commune: Imagining Paris After War and Revolution*, Princeton, N.J., 1995.

Broude, Norma, ed., *World Impressionism: The International Movement, 1860–1920*, New York, 1990.

Bullen, J. B., ed., *Post-Impressionists in England*, New York, 1988.

Champa, Kermit, *Studies in Early Impressionism*, New Haven, 1973.

Clark, T. J., *The Painting of Modern Life: Paris in the Art of Manet and his Followers*, Princeton, N.J., revised ed., 1999.

Clement, Russell T., *Neo-Impressionist Painters: A Sourcebook on Georges Seurat, Camille Pissarro, Paul Signac, Théo Van Rysselberghe, Henri Edmond Cross, Charles Angrand, Maximilien Luce, and Albert Dubois-Pillet*, Westport, Conn., 1999.

*Corn, Wanda, *The Color of Mood: American Tonalism, 1880–1910*, M. H. De Young Memorial Museum, San Francisco, 1972.

Dorra, Henri, ed., *Symbolist Art Theories: A Critical Anthology*, Berkeley, 1994.

*Eldredge, Charles C., *American Imagination and Symbolist Painting*, Grey Art Gallery and Study Center, New York University, 1979.

*Gerdts, William H., *American Impressionism*, Henry Art Gallery, University of Washington, Seattle, 1980.

Gerdts, William H., *American Impressionism*, New York, 1984.

Goldwater, Robert, *Symbolism*, London, 1981.

*[Hayward Gallery] *French Symbolist Painters: Moreau, Puvis de Chavannes and Their Followers*, London, 1972.

*Herbert, Robert L., *Neo-Impressionism*, Solomon R. Guggenheim Museum, New York, 1968.

*House, John, *Impressions of France: Monet, Renoir, Pissarro, and Their Rivals*, Museum of Fine Arts, Boston, 1995.

Howard, Jeremy, *Art Nouveau: International and National Styles of Europe*, New York, 1996.

Larsen, Peter Nøgaard, *Symbolism in Danish and European Painting, 1870–1910*, Statens Museum for Kunst, 2000.

*[Los Angeles County Museum of Art] *The Impressionists and the Salon (1874–1886)*, Los Angeles, 1974.

Lucie-Smith, Edward, *Impressionist Women*, New York, 1989.

——, *Symbolist Art*, London, 1972; New York, 1985.

Mathieu, Pierre-Louis, *The Symbolist Generation, 1870–1910*, New York, 1990.

Mauner, George, *The Nabis: Their History and Their Art, 1888–1896* (Garland Dissertation Series), New York, 1978.

*McConkey, Kenneth, *Impressionism in Britain*, Barbican Art Gallery, 1995.

*[Montreal Museum of Fine Arts] *Lost Paradise: Symbolist Europe*, Canada, 1995.

*Moussa M. Domit, *American Impressionist Painting*, National Gallery of Art,Washington, D.C., 1973.

*[Museum of Modern Art] *Art Nouveau: Art and Design at the Turn of the Century*, New York, 1959.

*[The New York Cultural Center] *Painters of the Mind's Eye: Belgian Symbolists and Surrealists*, New York, 1974.

Nochlin, Linda, ed., *Impressionism and Post-Impressionism* (Sources and Documents in the History of Art), Englewood Cliffs, N.J., 1966.

*[Palazzo della Permanente] *Arte e Socialità in Italia: dal Realismo al Simbolismo, 1865–1915*, Milan, 1979.

Parsons, Thomas, *Post-Impressionism: The Rise of Modern Art*, London, 1992.

Rewald, John, *History of Impressionism*, 4th ed., New York, London, 1973.

——, *Post-Impressionism: From Van Gogh to Gauguin*, 2nd ed., New York, London, 1962.

*Rosenblum, Robert, *1900: Art at the Crossroads*, Solomon R. Guggenheim Museum, New York, 2000.

*[Royal Academy of Arts] *Impressionism to Symbolism: The Belgian Avant-Garde 1880–1900*, London, 1994.

*[Royal Academy of Arts; National Gallery of Art] *Post-Impressionism: Cross-Currents in European Painting*, London, 1979–80; Washington, D.C., 1980.

Rubin, James Henry, *Impressionism*, London, 1999.

Schapiro, Meyer, *Impressionism: Reflections and Perceptions*, New York, 1997.

——, *Modern Art: 19th and 20th Centuries: Selected Papers* [on Courbet, Cézanne, Seurat], New York, London, 1978.

Thomson, Belinda, *Impressionism: Origins, Practice, Reception*, New York, 2000.

*Tinterow, Gary, *Origins of Impressionism*, Metropolitan Museum of Art, New York, 1994.

Turner, Jane, ed., *From Monet to Cézanne: Late 19th-Century French Artists*, (The Grove Dictionary of Art), New York, 2000.

*Varnedoe, Kirk, *Northern Light: Realism and Symbolism in Scandinavian Painting, 1880–1910*, Brooklyn Museum, 1982.

*Weinberg, Barbara H., *American Impressionism and Realism: The Painting of Modern Life, 1885–1915*, Metropolitan Museum of Art, New York, 1994.

Weisberg, Gabriel P., *Beyond Impressionism: The Naturalist Impulse*, New York, 1992.

*Welsh-Ovcharov, Bogomila, *Vincent van Gogh and the Birth of Cloisonism*, Art Gallery of Ontario, Toronto, 1981.

*[Wildenstein] *From Realism to Symbolism: Whistler and His World*, New York, 1971.

IV. SPECIALIZED TOPICS AND MISCELLANEOUS STUDIES

Ackerman, Gerald M., *American Orientalists*, Paris, 1994.

Benjamin, Roger, *Orientalist Aesthetics: Art, Colonialism, and French North Africa, 1830–1930*, Berkeley, 2003.

Boime, Albert, *The Art of Exclusion: Representing Blacks in the Nineteenth Century*, Washington, 1990.

Brookner, Anita, *The Genius of the Future: Studies in French Art Criticism*, London, New York, 1971.

Broude, Norma, and Garrard, Mary D., eds., *Feminism and Art History: Questioning the Litany*, New York, 1982.

Broude, Norma, *Impressionism: A Feminist Reading: The Gendering of Art, Science, and Nature in the Nineteenth Century*, New York, 1991.

Buser, Thomas, *Religious Art in Nineteenth Century Europe and America*, Lewiston, N.Y., 2002.

*Edwards, Holly, *Noble Dreams, Wicked Pleasures: Orientalism in America, 1870–1930*, Sterling and Francine Clark Art Institute, 2000.

Fine, Elsa Honing, *Women and Art: A History of Women Painters and Sculptors from the Renaissance to the 20th Century*, Montclair, N.J.: London, 1978.

Garb, Tamar, *Bodies of Modernity: Figure and Flesh in Fin-de-Siècle France*, New York, 1998.

Grigsby, Darcy Grimaldo, *Extremities: Painting Empire in Post-Revolutionary France*, London, 2002.

Hammacher, A. M., *Phantoms of the Imagination: Fantasy in Art and Literature from Blake to Dali*, New York, 1981.

*Harris, Ann Sutherland, and Nochlin, Linda, *Women Artists: 1550–1950*, Los Angeles County Museum of Art, 1976.

Haskell, Francis, *Rediscoveries in Art*, London; Ithaca, N.Y., 1976 (Paperback: Ithaca, N.Y., 1980).

Honour, Hugh, *The New Golden Land: European Images of America from the Discoveries to the Present Time*, London, New York, 1975.

*Kosinski, Dorothy M., *The Artist and The Camera: Degas to Picasso*, Dallas Museum of Art, 1999.

Levey, Michael, *Painting at Court*, London, New York, 1971.

Lockspeiser, Edward, *Music and Painting: A Study in Comparative Ideas from Turner to Schoenberg*, London 1973.

*[Musée d'Orsay] *Le daguerréotype français: un objet photographique*, Paris, 2003.

Nochlin, Linda, *The Politics of Vision: Essays on 19th Century Art and Society*, New York, 1989.

Parry, Ellwood, *The Image of the Indian and the Black Man in American Art, 1590–1900*, New York, 1974.

Pevsner, Nikolaus, *Academies of Art*, London, New York, 1973.

Scharf, Aaron, *Art and Photography*, London, 1968.

Veith, Gene Edward, *Painters of Faith: The Spiritual Landscape in Nineteenth-Century America*, Washington, 2000.

Yeldham, Charlotte, *Women Artists in Nineteenth Century France and England: Their Art Education, Exhibition Opportunities and Membership of Exhibiting Societies and Academies*, New York, 1984.

V. INDIVIDUAL ARTISTS

(arranged alphabetically by the artist's surname)

Barrow, Rosemary J., *Lawrence Alma-Tadema*, New York, 2001.

Jean-Pierre-Alexandre Antigna, Musée des Beaux-Arts d'Orléans, 1978.

Streshinsky, Shirley, *Audubon: Life and Art in the American Wilderness*, New York, 1993.

*Pressly, William L., *James Barry: The Artist as Hero*, The Tate Gallery, London, 1983.

——, *The Life and Art of James Barry*, London; New Haven, Conn., 1981.

Pitman, Dianne W., *Bazille: Purity, Pose and Painting in the 1860s*, University Park, Penn., 1998.

Calloway, Stephen, *Aubrey Beardsley*, New York, 1998.

Snodgrass, Chris, *Aubrey Beardsley: Dandy of the Grotesque*, New York, 1995.

Bindeman, David, *Blake as an Artist*, London, 1977.

——, *William Blake: The Complete Illuminated Works*, London, 2000.

Butlin, Martin, *The Paintings and Drawings of William Blake*, 2 vols., London; New Haven, Conn., 1981.

*Hamlyn, Robin, *William Blake*, Tate Britain, London, 2000.

Arnold Böcklin: 1827–1901, Kunstmuseum Basel, 1977.

Panconi, Tiziano, Giovanni Boldini: L'opera completa, Florence, 2002.

Ashton, Dore and Hare, Denise, *Rosa Bonheur: A Life and a Legend*, New York, London, 1981.

Dauberville, Jean and Henry, *Bonnard: Catalogue raisonné de l'oeuvre peint*, 4 vols., Paris, 1965.

Rewald, John, *Pierre Bonnard*, New York, 1948.

Watkins, Nicholas, *Bonnard*, London, 1994.

Whitfield, Sarah, *Bonnard: Essays*, New York, 1998.

Weisberg, Gabriel P., *Bonvin*, Paris, 1979.

Eugène Boudin, 1824–1898, Musée Eugène Boudin, Honfleur, 1992.

William Bouguereau, Montreal Museum of Fine Arts, 1984.

Louis Boulanger: Peintre-graveur de l'époque romantique, 1806–1867, Musée des Beaux-Arts, Dijon, 1970.

Bourrut Lacouture, Annette, *Jules Breton, Painter of Peasant Life*, New Haven, Conn., 2002.

Bendiner, Kenneth, *The Art of Ford Madox Brown*, University Park, Penn., 1998.

Newman, Teresa, *Ford Madox Brown and the Pre-Raphaelite Circle*, London, 1991.

Burne-Jones: The Paintings, Graphic and Decorative Work of Sir Edward Burne-Jones, Hayward Gallery, London, 1975.

*Wildman, Stephen, *Edward Burne-Jones, Victorian Artist-Dreamer*, Metropolitan Museum of Art, New York, 1998.

Gustave Caillebotte, Urban Impressionist, Art Institute of Chicago, 1995.

Varnedoe, Kirk, *Gustave Caillebotte*, New Haven, Conn., 1987.

Bloch, E. Maurice, *The Paintings of George Caleb Bingham: A Catalogue Raisonné*, Columbia, 1986.

Mary Cassatt, Modern Woman, Art Institute of Chicago, 1998.

Cézanne, Philadelphia Museum of Art, 1996.

Fry, Roger, *Cézanne: A Study of His Development*, London, 1927.

Kendall, Richard, ed., *Cézanne by Himself: Drawings, Paintings, Writings*, Boston, 1988

Rewald, John, *The Paintings of Paul Cézanne: A Catalogue Raisonné*, New York, 1996.

*Rubin, William, ed., *Cézanne: The Late Work*, The Museum of Modern Art, New York, London, 1977.

Schapiro, Meyer, *Paul Cézanne*, New York, London, 1962; new ed., 1988.

Théodore Chassériau, 1819–1856: The Unknown Romantic, Metropolitan Museum of Art, New York, 2002.

Huntington, David C., *The Landscapes of Frederic Edwin Church: Vision of an American Era*, New York, 1966.

Parry, Ellwood, *The Art of Thomas Cole: Ambition and Imagination*, Newark, N.J., 1988.

Merritt, Howard S., *Thomas Cole*, Memorial Art Gallery of the University of Rochester, 1969.

Parris, Leslie, *Constable*, New York, 1993.

Rosenthal, Michael, *Constable*, New York, 1987.

Vaughan, William, *John Constable*, London, 2002.

John Singleton Copley in America, Metropolitan Museum of Art, New York, 1995.

Prown, Jules David, *John Singleton Copley*, 2 vols., Cambridge, Mass., 1966.

Uhr, Horst, *Lovis Corinth*, Berkeley, 1990.

Corot, Metropolitan Museum of Art, New York, 1996.

*Conisbee, Philip, *In the Light of Italy: Corot and Early Open-Air Painting*, National Gallery of Art, Washington, 1996.

Leymarie, Jean, *Corot*, Geneva, London, 1979.

Rajnai, Miklos, *John Sell Cotman: 1782–1842*, Ithaca, 1982.

Gustave Courbet, Royal Academy of Arts, London, 1978.

*Faunce, Sarah, and Nochlin, Linda, *Courbet Reconsidered*, Brooklyn Museum, New York, 1988.

Fried, Michael, *Courbet's Realism*, Chicago, 1990.

Nicolson, Benedict, *Courbet: The Studio of the Painter*, London, New York, 1973.

Nochlin, Linda, *Gustave Courbet: A Study of Style and Society* (Garland Dissertation Series), New York, 1976.

Rubin, James Henry, *Courbet*, London, 1997.

Boime, Albert, *Thomas Couture and the Eclectic Vision*, New Haven, Conn.; London, 1980.

*Van Nimmen, Jane, *Thomas Couture: Paintings and Drawings in American Collections*, University of Maryland Art Gallery, College Park, Md., 1970.

Cozens, Alexander, with a new introd. By Michael Marquusee, *A New Method of Landscape*, London, 1977 (paperback).

Sloan, Kim, *Alexander and John Robert Cozens: The Poetry of Landscape*, New Haven, Conn., 1986.

*Wilton, Andrew, *The Art of Alexander and John Robert Cozens*, Yale Center for British Art, New Haven, 1980.

*Alldridge, Patricia, *The Late Richard Dadd, 1817–1886*, The Tate Gallery, London, 1974.

Greysmith, David, *Richard Dadd: The Rock and Castle of Seclusion*, London, 1973.

Gernsheim, Helmut and Alison, *L. J. M. Daguerre: The History of the Diorama and the Daguerreotype*, London, 1956 (Paperback: New York, 1969).

Dahls Dresden, Nasjonalgalleriet, Oslo, 1980.

*Greenacre, Francis, *Francis Danby, 1793–1861*, Tate Gallery, London, 1989.

Daumier, 1808–1897, National Gallery of Canada, Ottawa, 1999.

Maison, K. E., *Honoré Daumier: Catalogue Raisonné of the Paintings, Watercolours and Drawings*, 2 vols., London, 1968.

Provost, Louis, *Honoré Daumier, a Thematic Guide to the Oeuvre*, New York, 1989.

Brookner, Anita, *Jacques-Louis David*, London, 1980.

David, Louvre, Paris, 1989.

Johnson, Dorothy, *Jacques-Louis David: Art in Metamorphosis*, Princeton, N.J., 1993.

Lee, Simon, *David*, London, 1999.

Schnapper, Antoine, *David*, New York, 1980.

Armstrong, Carol M., *Odd Man Out: Readings of the Work and Reputation of Edgar Degas*, Chicago, 1991.

Degas, Metropolitan Museum of Art, New York, 1988.

Kendall, Richard, ed., *Degas by Himself: Drawings, Prints, Paintings and Writings*, Boston, 1987.

Reff, Theodore, *Degas: The Artist's Mind*, London, 1976.

Delacroix in Morocco, Institut du Monde Arabe, Paris, 1994.

Delacroix: The Late Works, Philadelphia Museum of Art, 1998.

Johnson, Lee, *The Paintings of Eugène Delacroix: A Critical Catalogue, 1816–1831*, 2 vols., Oxford, 1981.

L'opera Pittorica completa di Delacroix, Milan, 1972.

Wellington, Hubert, ed., *The Journal of Eugène Delacroix*, 2nd ed., Oxford, Ithaca, 1980; London, 1995.

Wright, Beth S., *The Cambridge Companion to Delacroix*, New York, 2001.

Bann, Stephen, Paul Delaroche: *History Painted*, Princeton, N.J., 1997.

Malan, Dan, *Gustave Doré: Adrift on Dreams of Splendor*, St. Louis, 1995.

Leclair, Anne, *Louis-Jacques Durameau (1733–1796)*, Paris, 2001.

Lawall, David B., *Asher B. Durand: A Documentary Catalogue of the Narrative and Landscape Paintings* (Garland Dissertation Series), New York, 1978.

Poynton, Marcia, *William Dyce*, Oxford, 1979.

Homer, William Inness, *Thomas Eakins: His Life and Art*, New York, 2002.

*Sewell, Darrel, *Thomas Eakins*, Philadelphia Museum of Art, 2001.

*Conisbee, Philip, et al., *Christoffer Wilhelm Eckersberg 1783–1853*, Washington, 2003.

Becks-Malorny, Ulrike, *James Ensor, 1860–1949: Masks, Death and the Sea*, London, 1999.

*Farmer, John David, *Ensor*, Solomon R. Guggenheim Museum, New York, 1976.

Tricot, Xavier, *James Ensor: Catalogue Raisonné of the Paintings*, London, 1992.

Fantin-Latour, Galerie Nationale du Canada/National Gallery of Canada, Ottawa, 1983.

Lucie-Smith, Edward, *Henri Fantin-Latour*, Oxford, New York, 1977.

*Bindman, David, ed., *John Flaxman*, Royal Academy of Arts, London, 1979; New York, 1980.

Symmons, Sarah, *Flaxman and Europe: The Outline Illustrations and their Influence*, New York, 1984.

Börsch-Supan, *Caspar David Friedrich*, Munich, 1990.

Koerner, Joseph Leo, *Caspar David Friedrich and the Subject of Landscape*, New Haven, Conn., 1990.

Hofmann, Werner, *Caspar David Friedrich*, London, 2000.

L'opera completa di Friedrich, Milan, 1976.

An Exhibition of Paintings by William Powell Frith, R.A., 1819–1909, Whitechapel Art Gallery, London, 1951.

Myrone, Martin, *Henry Fuseli*, Princeton, N.J., 2001.

*Schiff, Gert, *Henry Fuseli: 1741–1825*, The Tate Gallery, London, 1975.

*Brettell, Richard, *The Art of Paul Gauguin*, National Gallery of Art, Washington, 1988.

Cachin, Françoise, *Gauguin*, Paris, 1990.

Thomson, Belinda, ed., *Gauguin by Himself*, Boston, 1993.

Wildenstein, Daniel, *Gauguin: A Savage in the Making: Catalogue Raisonné of the Paintings, 1873–1888*, New York, 2002.

Stamm, Therese Dolan, *Gavarni and the Critics*, Ann Arbor, Mich., 1981.

Alhadeff, Albert, *The Raft of the Medusa: Géricault, Art, and Race*, London, 2002.

Eitner, Lorenz, *Géricault: His Life and Work*, London, 1983.

Géricault, Galeries Nationales du Grand Palais, Paris, 1991.

Tout l'oeuvre peint de Géricault, Paris, 1978.

Ackerman, Gerald M., *The Life and Work of Jean-Léon Gérôme*, New York, 1986.

Bernier, Georges, *Anne-Louis Girodet*, Paris, Brussels, 1975.

Girodet: 1767–1824, Musée de Montargis, Montargis, 1967.

Levitine, George, *Girodet-Trioson: An Inconographical Study* (Garland Dissertation Series), New York, 1978.

Charles Gleyre: 1806–1874, Grey Art Gallery and Study Center, New York University, 1980.

Goya and the Spirit of the Enlightenment, Museum of Fine Arts, Boston, 1989.

Goya, Truth and Fantasy: The Small Paintings, The Royal Academy of Arts, London, 1994.

Hughes, Robert, *Goya*, New York, 2003.

Lafuente Ferrari, Enrique, *Goya: His Complete Etchings, Aquatints and Lithographs*, New York, London, 1962.

Licht, Fred, *Goya*, New York, 2001.

——, ed., *Goya in Perspective*, Englewood Cliffs, N.J., 1973.

Morales y Marín, José Luis, *Goya: A Catalogue of His Paintings*, Saragosa, 1997.

Schickel, Richard, *The World of Goya: 1746–1828*, New York, 1968.

Symmons, Sarah, *Goya*, London, 1998.

Tomlinson, Jane, *Francisco Goya y Lucientes, 1746–1828*, London, 1994.

Brookner, Anita, *Greuze: The Rise and Fall of an Eighteenth-Century Phenomenon*, Greenwich, Conn.; London, 1972.

*Munhall, Edgar, *Greuze the Draftsman*, The Frick Collection, New York, 2002.

*Escholier, Raymond, *Gros: ses amis et ses élèves*, Petit Palais, Paris, 1936.

Constantin Guys, 1802–1895: fleurs du mal: dessins des Musées Carnavalet et du Petit Palais, Musée de la vie romantique, Paris, 2003.

*Stebbins, Theodore E., *Martin Johnson Heade*, Museum of Fine Arts, Boston, 1969.

Stuebe, Isabel Combs, *The Life and Works of William Hodges* (Garland Dissertation Series), New York, 1979.

Hirsh, Sharon, *Ferdinand Hodler*, New York, London, 1982.

——, *Hodler's Symbolist Themes*, Ann Arbor, Mich., 1983.

*Cikosky, Nicolai, *Winslow Homer*, National Gallery of Art, Washington, 1995.

Johns, Elizabeth, *Winslow Homer: The Nature of Observation*, Berkeley, 2002.

Tatham, David, *Winslow Homer and the Pictorial Press*, Syracuse, N.Y., 2003.

Wilmerding, John, *Winslow Homer*, New York, 1972.

Roberts, Leonard, *Arthur Hughes: His Life and Works: A Catalogue Raisonné*, Woodbridge, Suffolk, 1997.

Amor, Anne Clark, *William Holman Hunt, the True Pre-Raphaelite*, London, 1989.

Landow, George P., *William Holman Hunt and Typological Symbolism*, New Haven, Conn.; London, 1979.

Portraits by Ingres: Image of an Epoch, Metropolitan Museum of Art, New York, 1999.

Ribeiro, Aileen, *Ingres in Fashion: Representations of Dress and Appearance in Ingres' Images of Women*, New Haven, Conn., 1999.

Rosenblum, Robert, *Jean-Auguste-Dominique Ingres*, New York, London, 1967; new ed., 1990.

Tout l'oeuvre peint d'Ingres, Paris, 1971.

Vigne, Georges, *Ingres*, New York, 1995.

Cikovsky, Nicolai, *Georges Inness*, New York, 1993.

Sumner, Ann, and Smith, Greg, eds., *Thomas Jones (1742–1803): An Artist Rediscovered*, New Haven, Conn., 2003.

Angelika Kauffman: A Continental Artist in Georgian England, The Royal Pavilion, Brighton, 1992.

Angelika Kauffmann und ihre Zeitgenossen, Voralberger Landesmuseum, Bregenz, 1968.

Christian Købke: 1810–1848, Statens museum for kunst, Copenhagen, 1996.

Fernand Khnopff: 1858–1921, Musée des Arts Décoratifs, Paris, 1979.

Howe, Jeffery W., *The Symbolist Art of Fernand Khnopff*, Ann Arbor, Mich., 1982.

A Glove, and Other Images of Reverie and Apprehension: The Graphic Suites of Max Klinger, Wichita Art Museum, 1971.

Varnedoe, J. Kirk T., with Streicher, Elizabeth, *Graphic Work of Max Klinger*, New York, 1977.

*Ormond, Richard, *Sir Edwin Landseer*, The Philadelphia Museum of Art; London, 1981.

Garlick, Kenneth, *Sir Thomas Lawrence: Portrait of an Age, 1790–1830*, Alexandria, Va., 1993.

——, *Sir Thomas Lawrence: A Complete Catalogue of the Oil Paintings*, New York, 1989.

Ormond, Leonée and Richard, *Lord Leighton*, New Haven, Conn., London, 1975.

Max Liebermann: der Realist und die Phantasie, Hamburger Kunsthalle, 1997.

*Joppien, Rüdiger, *Philippe Jacques de Loutherbourg, R.A.: 1740–1812*, The Iveagh Bequest, Kenwood, London, 1973.

Adler, Kathleen, *Manet*, Oxford, 1986.

Brombert, Beth Archer, *Edouard Manet: Rebel in a Frock Coat*, Boston, 1996.

The Complete Paintings of Manet, New York, 1972.

Gronberg, T. A., ed., *Manet: A Retrospective*, New York, 1988.

Hanson, Anne Coffin, *Manet and the Modern Tradition*, New Haven, Conn.; London, 1977.

Harris, Jean C., *Edouard Manet: The Graphic Work: A Catalogue Raisonné*, San Francisco, 1990.

Manet: 1832–1883, The Metropolitan Museum of Art, New York, 1983.

Mauner, George, *Manet: Peintre-Philosophe: A Study of the Painter's Themes*, University Park, Pa., 1975.

——, *Manet: The Still-Life Paintings*, Walters Art Gallery, Baltimore, 2000.

Reff, Theodore, *Manet: Olympia*, New York, London, 1977.

*Campbell, Michael J., *John Martin: Visionary Printmaker*, York City Art Gallery, 1992.

Adolph Menzel 1815–1905: Between Romanticism and Impressionism, National Gallery of Art, Washington, 1996.

Fried, Michael, *Menzel's Realism: Art and Embodiment in Nineteenth-Century Berlin*, New Haven, Conn., 2002.

Mancoff, Debra N., *John Everett Millais: Beyond the Pre-Raphaelite Brotherhood*, New Haven, Conn., 2001.

Jean-François Millet: Drawn into Light, Sterling and Francine Clark Art Institute, Williamstown, Mass., 1999.

*Murphy, Alexandra R., *Jean-François Millet*, Museum of Fine Arts, Boston, 1984.

House, John, *Claude Monet*, 3rd ed., London, 1991.

Kendall, Richard, *Monet by Himself: Paintings, Drawings, Pastels, Letters*, Boston, 1990.

Monet and Modernism, Kunsthalle der Hypo-Kulturstiftung, Munich, 2001.

Tucker, Paul Hayes, *Claude Monet: Life and Art*, New Haven, Conn., 1995.

Spate, Virginia, *Claude Monet: Life and Work*, New York, 1992.

Asleson, Robyn, *Albert Moore*, London, 2000.

*Lacambre, Geneviève, *Gustave Moreau: Between Epic and Dream*, Art Institute of Chicago, 1999.

Higonnet, Anne, *Berthe Morisot*, New York, 1990.

Heleniak, Kathryn Moore, *William Mulready*, New Haven, Conn.; London, 1980.

Berman, Patricia G., *Munch and Women: Image and Myth*, Alexandria, Va., 1997.

Edvard Munch: Theme and Variation, Albertina, Vienna, 2003.

Heller, Reinhold, *Munch: His Life and Work*, Chicago, 1984.

Woll, Gerd, *Edvard Munch: The Complete Graphic Works*, New York, 2001.

Sir William Quiller Orchardson, Royal Scottish Academy, Edinburgh, 1972.

Lister, Raymond, *A Catalogue Raisonné of the Works of Samuel Palmer*, New York, 1988.

Pissarro, Joachim, *Camille Pissarro*, New York, 1993.

Rewald, John, *Camille Pissarro*, New York, London, 1963.

Price, Aimée Brown, *Pierre Puvis de Chavannes*, New York, 1994.

Shaw, Jennifer L., *Dream States: Puvis de Chavannes, Modernism, and the Fantasy of France*, New Haven, Conn., 2002.

Odilon Redon: Prince of Dreams, 1840–1916, Art Institute of Chicago, 1994.

Werner, Alfred, introd., *The Graphic Works of Odilon Redon*, New York, 1969.

Adriani, Götz, *Renoir*, London, 1999.

L'opera completa di Renoir nel periodo impressionista; 1869–1883, Milan, 1972.

Néret, Gilles, *Renoir: Painter of Happiness, 1841–1919*, Cologne, 2001.

Valkenier, Elizabeth Kridl, *Ilya Repin and the World of Russian Art*, New York, 1990.

Mannings, David, *Sir Joshua Reynolds: A Complete Catalogue of his Paintings*, New Haven, Conn., 2000.

Reynolds, Royal Academy, London, 1986.

Wendorf, Richard, *Sir Joshua Reynolds: The Painter of Society*, Cambridge, Mass., 1996.

Marsh, Jan, *Dante Gabriel Rossetti: Painter and Poet*, London, 1999.

Thomas, Greg M., *Art and Ecology in Nineteenth-Century France: The Landscapes of Théodore Rousseau*, Princeton, N.J., 2000.

Bisanz, Rudolf M., *German Romanticism and Philipp Otto Runge: A Study in Nineteenth-Century Art Theory and Iconography*, DeKalb, Ill., 1970.

Runge in seiner Zeit, Kunsthalle, Hamburg, 1977.

*Broun, Elizabeth, *Albert Pinkham Ryder*, National Museum of American Art, Washington, 1989.

Fairbrother, Trevor J., *John Singer Sargent: The Sensualist*, New Haven, Conn., 2000.

John Singer Sargent, National Gallery of Art, Washington, 1998.

Ormond, Richard, *John Singer Sargent: Complete Paintings*, New Haven, Conn., 1998.

*Herbert, Robert L., *Georges Seurat, 1859–1891*, Metropolitan Museum of Art, New York, 1991.

——, *Seurat: Drawings and Paintings*, New Haven, Conn., 2001.

Madeleine-Perdrillat, Alain, *Seurat*, New York, 1990.

Tout l'oeuvre peint de Seurat, Paris, 1973.

Zimmermann, Michael F., *Seurat and the Art Theory of his Time*, Antwerp, 1991.

Ratliff, Floyd, *Paul Signac and Color in Neo-Impressionism*, New York, 1992.

Signac, 1863–1935, Metropolitan Museum of Art, New York, 2001.

*Szabo, George, *Paul Signac (1863–1935): Paintings, Watercolors, Drawings and Prints*, The Metropolitan Museum of Art, New York, 1977.

*Coles, William A., *Alfred Stevens*, The University of Michigan, Museum of Art, Ann Arbor, 1977.

Evans, Dorinda, The Genius of Gilbert Stuart, Princeton, N.J., 1999.

Doherty, Terence, *The Anatomical Works of George Stubbs*, London, 1974.

*Egerton, Judy, *George Stubbs: Anatomist and Animal Painter*, The Tate Gallery, London, 1976.

George Stubbs, 1724–1806, Tate Gallery, London, 1984.

Parker, Constance-Anne, *Mr. Stubbs: The Horse Painter*, London, 1971.

Marshall, Nancy R., *James Tissot: Victorian Life/Modern Love*, New Haven, Conn., 1999.

Adhémar, Jean, *Toulouse-Lautrec: His Complete Lithographs and Drypoints*, London, New York, 1965.

Murray, Gale B., ed., *Toulouse-Lautrec: A Retrospective*, New York, 1992.

Toulouse-Lautrec, Hayward Gallery, London, 1991.

*Cooper, Helen A., *John Trumbull: The Hand and Spirit of a Painter*, Yale University Art Gallery, New Haven, 1982.

John Trumbull: A Founding Father of American Art, Fordham University, 2001.

Butlin, Martin, and Joll, Evelyn, *The Paintings of J. M. W. Turner*, 2 vols., London, 1977; New Haven, Conn., 1984.

Herrmann, Luke, *Turner Prints: The Engraved Work of J.M.W. Turner*, New York, 1990.

Joll, Evelyn, ed., *The Oxford Companion to J.W.M. Turner*, Oxford, 2001.

Rodner, William S., *J.M.W. Turner: Romantic Painter of the Industrial Revolution*, Berkeley, 1997.

*Boyle, Richard J., *A Retrospective Exhibition, John Henry Twachtman*, Cincinnati art Museum, 1966.

Hulsker, Jan, *The New Complete Van Gogh: Paintings, Drawings, Sketches*, Amsterdam, 1996.

Metzger, Rainer, *Vincent van Gogh: 1853–1890*, Los Angeles, 2003.

Schapiro, Meyer, *Vincent van Gogh*, New York, 1950.

Stein, Susan Alyson, ed., *Van Gogh: A Retrospective*, New York, 1986.

Vincent van Gogh and the Modern Movement, 1890–1914, Van Gogh Museum, Amsterdam, 1990.

——, *Vincent van Gogh: His Paris Period, 1886–1888*, Utrecht, The Hague, 1976.

*Altamirano Piolle, María Elena, *National Homage, José María Velasco (1840–1912): Landscapes of Light, Horizons of the Modern Era*, Museo Nacional de Arte, Mexico City, 1993.

Fritz von Uhde: vom Realismus zum Impressionismus, Kunsthalle Bremen, 1998.

Venetsianof and His School ("Russian Painters" Series), Leningrad, 1973.

Horace Vernet (1789–1863), École Nationale Supérieure des Beaux-Arts, Paris, 1980.

*Baillio, Joseph, *Elisabeth Louise Vigée-LeBrun: 1755–1842*, Kimbell Art Museum, Fort Worth, 1982.

*Cogeval, Guy, *Édouard Vuillard*, National Gallery of Art, Washington, 2003.

Russell, John, *Édouard Vuillard: 1868–1940*, Art Gallery of Ontario, Toronto; London, 1971.

Beckett, Oliver, *The Life and Work of James Ward R.A., 1769–1859: The Forgotten Genius*, Lewes, 1995.

*Gage, John, *G. F. Watts, A Nineteenth Century Phenomenon*, The Whitechapel Art Gallery, London, 1974.

*Loshak, David, *George Frederic Watts, O.M., R.A., 1817–1904*, The Tate Gallery, London, 1954.

Abrams, Ann Uhry, *The Valiant Hero: Benjamin West and Grand-Style History Painting*, Washington, 1985.

Erffa, Helmut von, *The Paintings of Benjamin West*, New Haven, Conn., 1986.

Dorment, Richard, *James NcNeill Whistler*, New York, 1995.

MacDonald, Margaret F., *Whistler, Women, & Fashion*, New York, 2003.

Young, Andrew McLaren; MacDonald, Margaret; and Spencer, Robin, *The Paintings of James McNeill Whistler*, 2 vols., New Haven, Conn., London, 1980.

Moerman, André, A., introd., *Antoine Wiertz: 1806–1865*, *Brussels, 1974.*

*Chiego, William J., *Sir David Wilkie of Scotland (1785–1841)*, North Carolina Museum of Art, Raleigh, 1987.

*Egerton, Judy, *Wright of Derby*, Metropolitan Museum of Art, New York, 1990.

Ormond, Richard, *Franz Xaver Winterhalter and the Courts of Europe, 1830–1870*, National Portrait Gallery, London, 1988.

Asplund, Karl, *Anders Zorn, His Life and Work*, London, 1921.

SCULPTURE

Compiled by David M. Gariff
[Revised and updated in 2004 by Ariel Plotek]

The bibliography for nineteenth-century sculpture in Europe and America is extensive and in many languages. The sources selected for inclusion in the present bibliography closely reflect the national schools and individuals sculptors discussed in the text. Books and exhibition catalogues—the latter denoted by an asterisk (*)—have been stressed. Periodical literature has been kept to a minimum as have such hard-to-obtain works as unpublished theses and dissertations.

The sculpture bibliography is ordered as follows:

I. GENERAL HISTORIES AND REFERENCE BOOKS
II. NATIONAL SURVEYS
 A. Austria/Germany
 B. England
 C. France
 D. Italy
 E. Low Countries
 F. Scandinavia
 G. United States
III. INDIVIDUAL SCULPTORS

I. GENERAL HISTORIES AND REFERENCE BOOKS

Benoist, Luc, *La sculpture romantique*, Paris, 1928.

Berman, Harold, *Bronzes: Sculptors and Founders 1800–1930*, 4 vols., Chicago, 1974–80.

Breuille, Jean-Philippe, ed., *L'art du XIXe siècle: dictionnaire de peinture et de sculpture*, Paris, 1993.

Brizio, Anna Maria, *Ottocento Novecento*, 2 vols., Turin, 1962.

Butler, Ruth, *European Sculpture of the Nineteenth Century*, Washington, 2000.

——, *Western Sculpture: Definition of Man*, Boston, 1975.

Capolavori della Scultura, 10 vols., Milan, 1960s.

Clapp, Jane, *Sculpture Index*, 3 vols., Metuchen, N.J., 1970.

Cooper, Jeremy, *Nineteenth-Century Romantic Bronzes*, Boston, 1975.

Duncan, Alastair, *Art Nouveau Sculpture*, London, 1978.

Hamilton, George Heard, *Painting and Sculpture in Europe, 1880–1940* (Pelican History of Art), Harmondsworth, Baltimore, 1967.

Haskell, Francis, and Penny, Nicholas, *the Most Beautiful Statues: The Taste for Antique Sculpture, 1500–1900*, Oxford, 1981.

Honour, Hugh, *Romanticism*, London, New York, 1979.

*Janson, H. W., ed., *Aspects of 19th-Century Sculpture*, Cleveland Museum of Art, 1975.

——, *19th-Century Sculpture*, New York, 1985.

——, "Observations on Nudity in Neoclassical Art," *Stil und Uberlieferung in der Kunst des Abendlandes* (Acts of 21st International Congress for Art History in Bonn, 1964), Berlin, 1967, 198–207.

——, "Rediscovering Nineteenth-Century Sculpture," *Art Quarterly*, XXXVI, 1974, 411–14.

——, *The Rise and Fall of the Public Monument*, New Orleans, 1976.

Kluxen, Andrea M., *Ästhetische Probleme der Plastik im 19. und 20. Jahrhundert*, Nuremberg, 2001.

La Sculpture du 19e siècle, une mémoire retrouvée, (Rencontres de l'École du Louvre), Paris, 1986.

Le Normand-Romain, Antoinette, et al., *Sculpture: The Adventure of Modern Sculpture in the Nineteenth and Twentieth Centuries*, New York, 1986.

Lerner, Abram, ed., *The Hirshhorn Museum and Sculpture Garden*, New York, 1974.

Licht, Fred, *Sculpture: Nineteenth and Twentieth Centuries* (*A History of Western Sculpture*, ed. John Pope-Hennessy, vol. 4), London; Greenwich, Conn., 1967.

Mackay, James A., *the Dictionary of Western Sculptors in Bronze*, Woodbridge, Suffolk, 1977.

Maltese, Corrado, *La scultura dell'ottocento in Europa*, Milan, 1969.

Millon, Henry A., and Nochlin, Linda, eds., *Art and Architecture in the Service of Politics*, Cambridge, Mass., 1978.

Mittig, Hans-Ernst, and Plagemann, Volker, *Denkmäler im 19. Jahrhundert. Deutung und Kritik*, vol. 20 in *Studien zur Kunst des 19. Jahrhunderts*, Munich, 1972.

Novotny, Fritz, *Painting and Sculpture in Europe, 1780–1880* (Pelican History of Art), Baltimore, 1960; 2nd ed., Harmondsworth, 1970; 1990.

Pingeot, Anne, ed., *Orsay: la sculpture*, Paris, 2003.

Rheims, Maurice, *Nineteenth-Century Sculpture*, New York, 1977.

Vogt, Adolf Max, *Art of the Nineteenth Century*, New York, 1973.

Wassermann, Jeanne, ed., *Metamorphoses in Nineteenth-Century Sculpture*, Boston, 1975.

Wittkower, Rudolf, *Sculpture: Processes and Principles*, New York, 1977; Harmondsworth, 1979.

Zeitler, Rudolf, *Die Kunst des 19. Jahrhunderts* (Propyläen Kunstgeschichte), Berlin, 1966.

II. NATIONAL SURVEYS

A. AUSTRIA/GERMANY

Bloch, Peter, *Das klassische Berlin*, Berlin, 1980.

——, *Skulpturen des 19. Jahrhunderts im Rheinland*, Düsseldorf, 1975.

——, and Theodor Müller, *Geschichte der deutschen Plastik*, vol. 2 in *Deutsche Kunstgeschichte*, Munich, 1953, 600–29.

Boase, Thomas S. R., *English Art, 1800–1870*, Oxford, 1959.

Esdaile, Katherine Ada, *English Church Monuments, 1530–1840*, London, 1940.

Gunnis, Rupert, *Dictionary of British Sculptors 1660 to 1851*, London, 1964.

Haley, Bruce, *Living Forms: Romantics and the Monumental Figure*, Albany, N.Y., 2003.

Janson, H. W., "German Neoclassic Sculpture in International Perspective," *Correlations Between German and Non-German Art in the Nineteenth Century, Yale University Art Gallery Bulletin*, XXXIII, 1972, 4–22.

Micheli, Mario, *La scultura tedesca dell'800*, Milan, 1969.

Molesworth, Hender D., *Sculpture in England: Renaissance to Early XIX Century*, London, 1951.

Osten, Gert von der, *Plastik des 19. Jahrhunderts in Deutschland, Österreich und der Schweiz*, Königstein im Taunus, Munich, Stuttgart, 1961.

Penny, Nicholas, *Church Monuments in Romantic England*, London; New Haven, Conn., 1977.

Pevsner, Nikolaus, et al., *The Buildings of England*, Harmondsworth, 1951–75.

Physick, John, *Designs for English Sculpture 1680–1860*, London, 1969.

Read, Benedict, *Victorian Sculpture*, London; New Haven, Conn., 1982.

Schneider, M., *Denkmäler für Künstler in Frankreich: Ein Thema der Auftragsplastik im 19. Jahrhundert*, Friedberg, 1977.

Sicca, Cinzia Maria, *The Lustrous Trade: Material Culture and the History of Sculpture in England and Italy, c.1700–c.1860*, New York, 2000.

Whinney, Margaret, *English Sculpture, 1720–1830*, London, 1971.

——, *Sculpture in Britain, 1530–1830* (Pelican History of Art), Harmondsworth, Baltimore, 1964.

C. FRANCE

Benoist, Luc, *La sculpture française*, Paris, 1963.

——, *La sculpture romantique*, Paris, 1994.

Boime, Albert, *Hollow Icons, The Politics of Sculpture in Nineteenth-Century France*, Kent, Ohio, 1987.

Documents sur la sculpture française et répertoire des fondateurs du XIXe siècle, (*Archives de l'art français*), Nogent-le-Roi, 1989.

*Fusco, Peter, and Janson, H. W., eds., *The Romantics to Rodin: French Nineteenth-Century Sculpture from North American Collections*, Los Angeles County Museum of Art, 1980.

Hubert, Gérard, *Les Sculpteurs italiens en France sous l'révolution, l'empire et la restauration, 1790–1830*, Paris, 1964.

Kalnein, Wend Graf, and Levey, Michael, *Art and Architecture of the Eighteenth Century in France* (Pelican History of Art), Harmondsworth, Baltimore, 1972.

La Sculpture française au XIXe siècle, Galeries nationales du Grand Palais, Paris, 1986.

Lami, Stanislas, *Dictionnaire des sculpteurs de l'école française au dix-neuviéme siècle*, 4 vols., Paris, 1914–21.

Mackay, James A., *The Animaliers: A Collector's Guide to the Animal Sculptors of the Nineteenth and Twentieth Centuries*, New York, 1973.

*Mirolli, Ruth Butler, and Van Nimmen, Jane, *Nineteenth-Century French Sculpture: Monuments for the Middle Class*, J. B. Speed Art Museum, Louisville, Ky., 1971.

Quand Paris dansait avec Marianne, 1879–1889, Musée du Petit Palais, Paris, 1989.

West, Alison, *From Pigalle to Préault: Neoclassicism and the Sublime in French Sculpture, 1760–1840*, New York, 1998.

D. ITALY

Bolaffi, Giulio, *Dizionario Bolaffi degli Scultori italiani moderni*, Turin, 1972.

——, *Dizionario Enciclopedico Bolaffi, dei Pittori e degli Incisori Italiani*, 11 vols., Turin, 1972–76.

Hubert, Gérard, *La Sculture dans l'Italie napoléonienne*, Paris, 1964.

Lavagnino, Emilio, *L'Arte Moderna*, 2 vols., Turin, 1961.

Marchiori, Giuseppe, *Scultura Italiana dell'Ottocento*, Verona, 1960.

Panzetta, Alfonso, *Dizionario degli scultori italiani dell'ottocento e del primo novecento*, Milan, 1994.

Pirovano, Carlo, *Scultura italiana dal neoclassicismo alle correnti contemporane*, 5 vols., Milan, 1968.

E. LOW COUNTRIES

Bosmant, Jules, *La peinture et la sculpture au pays de Liège de 1793 à nos jours*, Liège, 1930.

Goris, Jan Albert, *Modern Sculpture in Belgium*, New York, 1957.

Pierron, Sander, *La sculpture en Belgique, 1830–1930*, Brussels, 1931.

Van Daalen, P. K., *Nederlandse beeldhouwers in de negenteinde eeuw*, The Hague, 1957.

F. SCANDINAVIA

*Bencard, Ernst Jonas, *Afmagt: dansk billedhuggerkunst 1850–1900*, Thorvaldsens museum, Copenhagen, 2002.

*Munk, Jens Peter, *Dansk skulptur, 1694–1889*, Ny Carlsberg Glyptotek, Copenhagen, 1995.

Rostrup, Haavard, *Moderne skulptur dansk og udenlandsk*, Copenhagen, 1964.

Wennberg, Bo Göte, *French and Scandinavian Sculpture in the Nineteenth Century*, Stockholm, 1978.

G. UNITED STATES

Armstrong, Tom, et al., *200 Years of American Sculpture*, Whitney Museum of American Art, New York, 1976.

Crane, Sylvia E., *White Silence: Greenough, Powers and Crawford, American Sculptors in Nineteenth-Century Italy*, Coral Gables, Fla., 1972.

Craven, Wayne, *Sculpture in America*, New York, 1968.

Ekdahl, Janis, *American Sculpture: A Guide to Information Sources*, Detroit, 1977.

Gerdts, William H., *American Neo-Classical Sculpture: The Marble Resurrection*, New York, 1973.

——, et al., *The White Marmorean Flock: Nineteenth-Century American Women Neoclassical Sculptors*, Vassar College Art Gallery, Poughkeepsie, N.Y., 1972.

Taft, Lorado, *The History of American Sculpture*, new ed., rev., New York, 1969.

SPECIALIZED TOPICS AND MISCELLANEOUS STUDIES

A Fleur de peau: le moulage sur nature au XIX siècle, Musée d'Orsay, Paris, 2001.

*Feke, Stephen, and Curtis, Penelope, eds., *Close Encounters: The Sculptor's Sudio in the Age of the Camera*, Henry Moore Institute, Leeds, 2002.

Kvech-Hoppe, Ulrike, *Der Fries im 19. Jahrhundert: ästhetische und gattungsspezifische Aspekte einer Kunstform*, Dusseldorf, 2000.

Nitsche, Wolfgang, *Das Schaffen der hochklassizistischen deutschen Bildhauer: Akademismus, Romerlebnis, Innovation, und Antikerezeption*, Bergisch Gladbach, 1992.

*Read, Benedict, ed., *Pre-Raphaelite Sculpture*, Matthiesen Gallery, London, 1991.

Reyero, Carlos, *La escultura conmemorativa en España: la edad de oro del monumento público, 1820–1914*, Madrid, 1999.

Robinson, David, *Saving Graces*, New York, 1995.

Savage, Kirk, *Standing Soldiers, Kneeling Slaves: Race, War, and Monument in Nineteenth-Century America*, Princeton, N.J., 1997.

Subirachs, Judit, *L'escultura del segle XIX a Catalunya: del romanticismo al realisme*, Barcelona, 1994.

III. INDIVIDUAL SCULPTORS

(Arranged alphabetically by surname)

Jackson, M. P., "Henry Hugh Armstead," *Magazine of Art*, III, 1880, 420–23.

Bell, Charles Francis, *Annals of Thomas Banks*, Cambridge, 1938.

Gschaedler, André, [Bartholdi] *True Light on the Statue of Liberty and Its Creator*, Narberth, Pa., 1966

Schmitt, J., *Bartholdi: A Certain Idea of Liberty*, Strasbourg, 1986.

Trachtenberg, Marvin, [Bartholdi] *The Statue of Liberty*, New York, 1977.

Vidal, Pierre, *Fréderic-Auguste Bartholdi, 1834–1904: par la main, par l'esprit*, Paris, 1994.

Lorenzo Bartolini, Palazzo Pretorio, Prato, 1978.

Benge, Glenn F., *Antoine-Louis Barye, Sculptor of Romantic Realism*, University Park, Penn., 1984.

Lengyel, Alfonz, *Life and Work of Antoine-Louis Barye*, Dubuque, Iowa, 1963.

*Leroy-Jay Lemaistre, Isabelle, *La griffe et la dent: Antoine Louis Barye: 1795–1875: sculpteur animalier*, Musée des beaux-arts, Lyon, 1996.

Poletti, Michel, *Barye: catalogue raisonné des sculptures*, Paris, 2000.

Meyer, Alfred, G., *Reinhold Begas*, Leipzig, 1901.

Johns, Christopher M. S., *Antonio Canova and the Politics of Patronage in Revolutionary and Napoleonic Europe*, Berkeley, 1998.

Licht, Fred, *Canova*, New York, 1983.

Pavanello, Giuseppe, and Praz, Mario, *L'Opera completa del Canova*, Milan, 1976.

*——, and Romanelli, G., *Antonio Canova*, Museo Correr, Venice, 1992.

Clarétie, Jules, *J.-B. Carpeaux 1827–1875*, Paris, 1875.

Margerie, L. de, *Carpeaux: La Fièvre créatrice*, Paris, 1989.

Wagner, Anne M., *Jean-Baptiste Carpeaux: Sculptor of the Second Empire*, New Haven, Conn., 1986.

——, *Learning to Sculpt: Jean-Baptiste Carpeaux, 1840–1863*, Ph.D. dissertation, Harvard University, Cambridge, Mass., 1980.

Hargrove, June Ellen, "Carrier-Belleuse, Clésinger and Dalou: French Nineteenth-Century Sculptors," *The Minneapolis Institute of Arts Bulletin*, LXI, 1974, 28–43.

——, *The Life and Work of Albert Ernest Carrier-Belleuse*, New York, 1977.

——, "Sculpture et dessins d'Albert Carrier-Belleuse au Musée des Beaux-Arts de Calais," *La revue du Louvre et des musées de France*, XXVI, 1976, 411–24.

Janson, H. W., "Rodin and Carrier-Belleuse: The Vase des Titans," *Art Bulletin*, L. 1968, 278–80.

Ségard, Achille, *Albert Carrier-Belleuse 1824–1887*, Paris, 1928.

Cecioni, Adriano, *Opere e scritti*, Milan, 1932.

Sani, Bernardina, *Cecioni Scultore*, Florence, 1970.

Binfield, C., ed., *Sir Francis Chantrey, Sculptor to an Age, 1781–1841*, Sheffield, 1981.

*Potts, A., ed., *Sir Francis Chantrey, 1781–1841: Sculptor of the Great*, National Portrait Gallery, London, 1983.

Le Normand-Romain, Antoinette, "Henri Chapu: Crayon, encre et terre cuite," *Revue du Louvre*, 4, 1991, 47–63.

*Lussiez, A.-C., ed., *Centenaire Henri Chapu, 1833–1891*, Musée Melun, 1991.

Rocher-Jauneau, M., "Chinard and the Empire Style," *Apollo*, LXXX, 1964, 220-26.

——, *L'Oeuvre de Joseph Chinard (1756–1813) au Musée des beaux-arts de Lyon*, Lyon, 1978.

Estignard, Alexandre, *Clésinger, sa vie, ses oeuvres*, Paris, 1900.

Gourmont, R. de, *Clésinger, notice biographique, catalogue des oeuvres*, Paris, 1903.

Rochette, R., "Sculpteurs modernes: Cortot," *L'Artiste*, V, 1845, 271–75.

Hunisak, John M., *The Sculptor Jules Dalou: Studies in His Style and Imagery*, New York, 1977.

*Holst, C. von, and Gauss, U., eds., *Johann Heinrich Dannecker: Der Bildhauer, der Zeichner*, Staatsgal, Stuttgart, 1987.

Fohr, Robert, *Daumier: sculpteur et peintre*, Paris, 1999.

*Le Men, Segolene, ed., *Daumier et les Parlementaires de 1830–1875*, Palais Bourbon, Paris, 1996.

*Wassermann, Jeanne, et al., *Daumier Sculpture: A Critical and Comparative Study*, Fogg Art Museum, Cambridge, Mass., 1969.

Bruel, André, ed., *Les Carnets de David d'Angers*, Paris, 1958.

Caso, Jacques de, *David d'Angers: Sculptural Communication in the Age of Romanticism*, Princeton, N.J., 1992.

——, *David d'Angers: L'Avenir de la mémoire: Etude sur l'art signalétique à l'époque romantique*, Paris, 1988.

Morant, Henry de, *David d'Angers et son temps*, Angers, 1956.

Reinis, J. G., *The Portrait Medallions of David d'Angers: An Illustrated Catalogue of David's Contemporary and Retrospective Portraits in Bronze*, New York, 1999.

Millard, Charles W., *The Sculpture of Edgar Degas*, Princeton, 1976.

*Pickvance, Ronald, *Degas Sculptor, Van Gogh Museum*, Amsterdam, 1991.

Pingeot, Anne, *Degas Sculptures*, Paris, 1991.

Rewald, John, *Degas, works in Sculpture: A Complete Catalogue*, rev. ed., New York, London, 1957.

Renonciat, A., *La Vie et l'oeuvre de Gustave Doré*, Paris, 1983.

*Aubrey, Françoise, *Paul Dubois, 1859–1938*, Musée Horta, Brussels, 1996.

Finn, David, "Discovering Giovanni Duprè," *Sculpture Review*, 41, 1992, 30–43.

*Fay-Halle, Antoinette, *Falconet à Sèvres, 1757–1766, ou l'art de plaire*, Musée national de la céramique, Sèvres, 2002.

Levitine, George, *The Sculpture of Falconet*, Greenwich, Conn., 1972.

Réau, Louis, *Étienne-Maurice Falconet*, 2 vols., Paris, 1922.

Bénédite, Léonce, *Alexandre Falguière*, Paris, 1902.

Fusco, Peter, "Falguière, the Female Nude, and 'La Résistance,'" *Los Angeles County Museum of Art Bulletin*, XXIII, 1977, 36–50.

Aurenhammer, Hans, *Anton Dominik Fernkorn*, Vienna, 1959.

Janin, Jules, *Notice sur J. Feuchère*, Paris, 1853.

Flaxman, John, *Lectures on Sculpture*, London, 1838.

*Bindman, David, ed., *John Flaxman*, London, 1979; New York, 1980.

Irwin, David, *John Flaxman, 1755–1826: Sculptor, Illustrator, Designer*, London, 1979.

Whinney, Margaret, and Gunnis, Rupert, *The Collection of Models by John Flaxman R.A. at University College, London: A Catalogue and Introduction*, London, 1967.

*Chevillot, C., *Emmanuel Frémiet: La Main et le multiple*, Musée des beaux-arts, Dijon, 1989.

Adams, Adeline, *Daniel Chester French: Sculptor*, Boston, New York, 1932.

Cresson, Margaret, *Journey into Fame: The Life of Daniel Chester French*, Cambridge, Mass., 1947.

Bellonzi, Fortunato, and Frattarolo, Renzo, *Gemito*, Rome, 1962.

*Mantura, B., *Temi di Vincenzo Gemito*, Spoleto, 1989.

Siviero, Carlo, *Gemito*, Naples, 1953.

Ackerman, Gerald M., *The Life and Work of Jean-Léon Gérôme*, London, 1986.

J. L. Gérôme, sculpteur et peintre de l'art officiel, Tanagra Art Gallery, Paris, 1974.

Lafont-Couturier, Hélène, *Gérôme*, Paris, 1998.

Attwood, Philip, "Lifting the Veil: New Light on the Medals of Alfred Gilbert," *Burlington Magazine*, 137, 1995, 92–95.

Dorment, R., *Alfred Gilbert*, New Haven, Conn., 1985.

*——, *Alfred Gilbert: Sculptor and Goldsmith*, Royal Academy, London, 1986.

*Saunders, Richard H., *Horatio Greenough: An American Sculptor's Drawings*, Middlebury College Museum of Art, 1999.

Wright, Nathalia, *Horatio Greenough, the First American Sculptor*, Philadelphia, 1963.

——, ed., *Letters of Horatio Greenough, American Sculptor*, Madison, Wis., 1972.

Esche-Braunfels, Sigrid, *Adolph von Hildebrand, 1847–1921*, Berlin, 1993.

Haas, A., *Adolph von Hildebrand: Das plastische Porträt*, Munich, 1984.

Hildebrand, Adolph von, *Le problème de la forme dans les arts plastiques*, Paris, 2002.

Arnason, H. H., *The Sculptures of Houdon*, New York, 1975.

Chinard, Gilbert, *Houdon in America*, Baltimore, 1930.

Réau, Louis, *Houdon, sa vie et son oeuvre*, 2 vols., Paris, 1964.

*Gleisberg, Dieter, *Max Klinger, 1857–1920, Museum der bildenden Künste Leipzig*, 1992.

Ansieau, Joelle, *Georges Lacombe 1868-1916: catalogue raisonné*, Paris, 1998.

Barringer, Tim, ed., *Frederic Leighton: Antiquity, Renaissance, Modernity*, New Haven, Conn., 1999.

Frederic, Lord Leighton, Eminent Victorian Artist, Royal Academy of Arts, London, 1996.

Gordon, E. A., *The Sculpture of Frederick William MacMonnies*, thesis, New York University, 1998.

Smart, M., *A Flight with Fame: The Life and Art of Frederick MacMonnies, 1863–1937*, Madison, Conn., 1996.

Berger, Ursel, ed., *Aristide Maillol*, New York, 1996.

Lorquin, Bertrand, *Aristide Maillol*, Paris, 1994.

Bessis, H., *Marcello sculpteur*, Fribourg, 1980.

Bovero, Anna, "L'Opera di Carlo Marochetti in Italia," *Emporium*, XX, 1942.

Ward-Jackson, Philip, "Carlo Marochetti et les photographes," *Revue de l'art*, 104, 1994, 43-48.

Vogt, C., "Un Artist oublié: Antonin Mercié," in *La Sculpture du 19e siècle, une mémoire retrouvée, (Rencontres de l'École du Louvre)*, Paris, 1986.

Baudson, P., *Les Trois Vies de Constantin Meunier*, Brussels, 1979.

Christophe, Lucien, *Constantin Meunier*, Antwerp, 1947.

Constantin Meunier Ausstellung, Bergbau Museum, Bochum, Germany, 1970.

Hanotelle, M., *Paris-Bruxelles: Rodin et Meunier – relations des sculpteurs français et belges à la fin du XIXe siècle*, Paris, 1982.

George Minne en de Kunst rond 1900, Ghent, 1982.

Ridder, André de, *George Minne*, Antwerp, 1947.

Baum, Richard M., "Joseph Nollekens: A Neo-Classic Eccentric," *Art Bulletin*, XVI, 1934, 385–95.

Kenworthy-Browne, John, "Terracotta Models by Joseph Nollekens, R.A.," *Sculpture Journal*, 2, 1998, 72–84.

Smith, John Thomas, *Nollekeens and His Times*, London, 1949; new ed., 1986.

Palmer, Erastus Dow, "Philosophy of the Ideal," *The Crayon*, III, 1856, 18–20.

Webster, J. Carson, "Documentation: A Checklist of the Works of Erastus Dow Palmer," *Art Bulletin*, XLIX, 1967, 143–51.

——, *Erastus D. Palmer*, Newark, N.J., 1983.

——, "Erastus D. Palmer: Problems and Possibilities," *The American Art Journal*, IV, 1972, 34–43.

*Gaborit, J.-R., *Jean-Baptiste Piagalle: Sculpture du Museé du Louvre*, Paris, 1985.

Réau, Louis, *Jena-Baptiste Pigalle*, Paris, 1950.

Gardner, Albert T. E., "Hiram Powers and William Rimmer: Two Nineteenth-Century American Sculptors," *Magazine of Art*, XXXVI, 1943, 42–47.

Reynolds, Donald M., *Hiram Powers and His Ideal Sculpture*, New York, 1977.

Wunder, Richard P., *Hiram Powers: Vermont Sculptor*, 2 vols., Taftsville, Vt., 1974; Newark, N.J., 1991.

*Caso, Jacques de, ed., *Statues de chair: Sculptues de James Pradier*, Palais de Luxembourg, Paris, 1986.

*Bellanger, Sylvain, ed., *Auguste Préault: sculpteur romantique: 1809–1879*, Musée d'Orsay, Paris, 1997.

Mower, David, "A. A. Préault," *Art Bulletin*, LXIII, 1981, 288–307.

Christian Daniel Rauch, Berlin, 1981.

Simson, Jutta von, *Christian Daniel Rauch: Oeuvre-Katalog*, Berlin, 1996.

Rimmer, William, *Art Anatomy*, Boston, 1877.

——, *Elements of Design*, Boston, 1864.

*Kirstein, Lincoln, *William Rimmer 1816–1879*, Whitney Museum of American Art, New York, and Museum of Fine Arts, Boston, 1946.

*Weidman, J., *William Rimmer: A Yankee Michelangelo*, Brockton, Mass., 1985.

Butler, Ruth, ed., *Rodin in Perspective*, Englewood Cliffs, N.J., 1980.

——, *Rodin: The Shape of Genius*, New Haven, Conn., 1993.

Caso, Jacques de, and Sanders, Patricia B., *Rodin's Sculpture: A Critical Study of the Spreckels Collection*, San Francisco, 1977.

Descharnes, Robert, and Chabrun, Jean-François, *Auguste Rodin*, London, 1967.

Elsen, Albert, *Rodin*, New York, 1963.

——, *Rodin's Gates of Hell*, Minneapolis, 1960.

——, ed., *Auguste Rodin: Readings on His Life and Work*, Englewood Cliffs, NJ., 1965.

——, ed., *Rodin Rediscovered*, National Gallery of Art, Washington, D.C., 1981.

Grappe, Georges, *Catalogue du Musée Rodin. I. Hôtel Biron. Essai de classement chronologique des oeuvres d'Auguste Rodin*, 5th ed., Paris, 1944.

Janson, H. W., "Rodin and Carrier-Belleuse: The Vase des Titans," *Art Bulletin*, L, 1968, 278–80.

*Lampert, C., *Rodin: Sculpture and Drawings*, Hayward Gallery, London, 1987.

Le Normand-Romain, Antoinette, *Rodin*, Paris, 1997.

*——, ed., *Rodin in Italia*, Académie de France, Rome, 2001.

Mirolli, Ruth Butler, *The Early Work of Rodin and Its Background*, Ph.D. dissertation, Institute of Fine Arts, New York University, 1966.

Rilke, Rainer Maria, *Auguste Rodin*, London, 1946.

Tancock, John L., *The Sculptures of Auguste Rodin*, Philadelphia, 1976.

Varnedoe, Kirk, *Rodin: A Magnificent Obsession*, London, 2001.

Rogers, Millard F., Jr., *Randolph Rogers: American Sculptor in Rome*, n.p., 1971.

*Carmel, Luciano, *Medardo Rosso*, Whitechapel Art Gallery, London, 1994.

*Moure, Gloria, ed., *Medardo Rosso*, Centro de Arte Contemporánea, Santiago de Compostela, 1996.

Sanna, J. de, *Medardo Rosso o la creazione dello spazio moderno*, Milan, 1985.

*Bantel, L., *William Rush, American Sculptor*, Philadelphia, 1982.

Drouot, Henri, *Un Carrière: François Rude*, Dijon, 1958.

Naeve, M. M., "William Rush's Terracotta and Plaster Busts of General Andrew Jackson," *American Art Journal*, XXI, 1989, 19–39.

*Marceau, Henri, *William Rush, 1756–1833, the First Native American Sculptor*, Philadelphia Museum of Art, 1937.

Dryfhout, John H., *The Work of Augustus Saint-Gaudens*, Hanover, N.H.; London, 1982.

*——, and Cox, Beverly, *Augustus Saint-Gaudens: The Portrait Reliefs*, Smithsonian Institution, The National Portrait Gallery, Washington, D.C., 1969.

*Gaich, Catherine, ed., *Augustus Saint-Gaudens: 1848–1907: un maître de la sculpture américaine*, Musée des Augustins, Toulouse, 1999.

Greenthal, K., *Augustus Saint-Gaudens: Master Sculptor*, New York, 1985.

Tharp, Louise, H., *Saint-Gaudens and the Gilded Era*, Boston, Toronto, 1969.

*Maaz, Bernhard, ed., *Johann Gottfried Schadow und die Kunst seiner Zeit*, Kunsthalle, Dusseldorf, 1995.

Schmidt, Martin H., "Ich machte mir eine Büste von Goethe", *Schadows Wilderstreit mit Goethe*, Frankurt, 1995.

*Andersen, J., and Cederlöf, U., *Sergel*, Stockholm, 1991.

Dresdner, Albert, *Johan Tobias Sergel*, Leipzig, 1922.

Johan Tobias Sergel 1740–1814, Kunsthalle, Hamburg, 1975.

Beattie, Susan, *Alfred Stevens*, vol. in *Catalogue of the Drawings Collection of the Royal Institute of British Architects*, Farnborough, 1975.

*——, introd., *Alfred Stevens 1817–1875*, Victoria and Albert Museum, London, 1975.

——, *Alfred Stevens: A Biography with New Material*, London, 1939.

Bogh, Mikkel, *Bertel Thorvaldsen*, Copenhagen, 1997.

*Bott, G., and Spielmann, H., *Künstlerleben in Rom: Bertel Thorvaldsen, der dänische Bildhauer und seine deutschen Freunde*, Nuremberg, 1992.

Janson, H. W., "Thorvaldsen and England," *Bertel Thorvaldsen: Untersuchungen zu seinem Werk und zur Kunst seiner Zeit*, Kunsthalle, Cologne, 1977.

Jørnæs, B., *Billedhuggeren Bertel Thorvaldsens liv og værk*, Copenhagen, 1993.

Licht, Fred, "Thorvaldsen and Continental Tombs of the Neoclassic Period," *Bertel Thorvaldsen: Untersuchungen zu seinem Werk und zur Kunst seiner Zeit*, Kunsthalle, Cologne, 1977.

Sass, Else Kai, *Thorvaldsens Portraetbuster*, 3 vols., Copenhagen, 1963–65.

Manzoni, Romeo, *Vincenzo Vela: l'homme, le patriote, l'artiste*, Lugano, 1995.

Scott, Nancy J., *Vincenzo Vela, 1820–1891*, New York, 1979.

Busco, Marie, *Sir Richard Westmacott, Sculptor*, Cambridge, 1994.

Penny, Nicholas, "The Sculpture of Sir Richard Westmacott," *Apollo*, CII, 1975, 120–27.

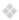

Picture credits

The author and publisher wish to thank the libraries, museums, galleries, and private collections named in the picture captions for permitting the reproduction of works of art in their collections and for supplying the necessary photographs. Photographs from other sources are gratefully acknowledged below. Numbers listed before the sources refer to figure numbers.

PART 1

1 Private Collection. Photo: Sotheby's, London 2 National Trust Photographic Library/John Hammond 3 Derby Museum & Art Gallery 4 Ferdinand Lammot Belin Fund 5 © 2003 Kimbell Art Museum 6, 35, 61, 73, 74 © Tate, London 2004 7 Trumbull Collection 8 Photograph © 1986 The Detroit Institute of Arts 9 The Adolphe D. and Wilkins C. Williams Fund. © Virginia Museum of Fine Arts. Photo: Katherine Wetzel 10, 20, 52 Photo © RMN – Gérard Blot 11, 16, 18, 25, 26, 51, 56, 85 © Photo Josse, Paris 15 Photo © RMN – P. Bernard 17, 42, 130 © The British Museum 19 Studio Berlin, Dijon 22 Photo © RMN – Franck Raux 23 Photo © RMN – Arnaudet 28, 29 Institut Amatller d'Art Hispànic 37, 48, 54 Bridgeman Art Library 38 © Royal Academy of Arts, London/Photo: John Hammond 39 Founders Society Purchase, Robert H. Tannahill Foundation 41 Stiftung Weimarer Klassik und Kunstsammlungen/ Museen 46 Photo: Musées de Poitiers, Ch. Vignaund 47, 53 Photo © RMN 50 Bequest of William Bingham 55 © Studio Basset 57 Photo: Peter Lauri 58 Photo: Öffentliche Kunstsammlung Basel, Martin Bühler 59 Museum of Science and Industry © 2003, Photo Scala Florence/HIP 60 Lady Davis Bequest. Photo: Brian Merrett, MBAM 62 © National Museums & Galleries of Wales 63 Ashmolean Museum, Oxford 64 Photo: Ville de Nantes, Musée des Beaux Arts/Alain Guillard 65 Founders Society Purchase, New Endowment Fund. Photograph © 1997 The Detroit Institute of Arts 67 Photo: Ursula Edelman/Artothek 68 Joachim Blauel/Artothek 69 Hamburger Kunsthalle/BPK, Berlin. Photo: Elke Walford 70 Photo: Elke Walford 71, 72 BPK Berlin 76, 77, 80 National Monuments Record, London 78, 81 Courtauld Institute of Art, London 79 A.F. Kersting, London 83, 86, 93 Caisse Nationale des Monuments et Sites Historique, Paris 84 Dr. Martin Hürlimann, Zollikon, Switzerland 87, 97, 105 H.W. Janson 88 Photo: Graydon Wood, 2002 89 Virginia State Library and Archives 90 Photo: Union Centrale des Arts Décoratifs, Photothèque 92 Bulloz, Paris 95 Bildarchiv der Österreichisches Nationalbibliothek, Vienna 96 Mario Brozzettto, Cartigliano 98 Gabinetto Fotografico, Florence 101, 328 Gift of James H.Ricau and Museum Purchase 102 Bundesdenkmalamt, Vienna 103 Photo: Ursula Edelmann, Frankfurt 104 Bildarchiv Foto Marburg

PART 2

Page 118 & figs. 120, 148, 166, 167, 184 Bridgeman Art Library 107, 108, 206, 209, 212 Photo © RMN 109 Institut Amatller d'Art Hispànic 112 © 2004 Kunsthaus Zürich. All rights reserved 114, 118, 119, 125, 127, 129, 131, 157, 158, 169, 178, 217 © Photo Josse, Paris 117, 295 National Museums Liverpool/The Walker Bridgeman Art Library 123 Photo: C. Theriez 128 Photo: Cussac 132 © The National Gallery London 133 The John H. McFadden Collection 134, 140 © Tate, London 2004 136, 155 AKG-Images 138 Arquivo Nacional de Fotografia, Instituto Portguês de Museus/Photo: José Pessoa 143 © Staatliche Museen Kassel/Brunzel 149, 162, 165, 172 BPK Berlin 152 Photo: Cussac 153 Photo © Giuseppe Schiavinotto 156, 159 AKG-Images/Erich Lessing 161 The Royal Collection © H.M. Queen Elizabeth II 166, 185, 238 Museum Kunst Palace Düsseldorf 168 Photo: Hans Petersen 170 Photo © RMN – Arnaudet 173 Photo: Richard Walker 175 Photo RMN © H. Lewandowski 176 Photo: DOWIC Fotografi 177 Ezra H. Linley Fund 181 Lichtbildwerkstatte, Vienna 184 Bridgeman Art Library 186 Bayer & Mitko/Artothek 188, 189, 193, 200, 205, 208 H.W. Janson 191, 202 A.F. Kersting, London 192 Courtauld Institute of Art, London 197 Alinari

198, 201 Landesbildstelle, Berlin 199 Photo: Hilda Deecke, Berlin 204 Bildarchiv Foto Marburg 207, 215 Bulloz, Paris 208 © Paul M.R. Maeyaert 210, 213 Caisse Nationale des Monuments et Sites Historique, Paris 216 Purchased with funds provided by the Times Mirror Foundation. Photo © 2003 Museum Associates/LACMA 218 Photo © Museum Associates/LACMA

PART 3

Page 226 & figs. 220, 223, 228, 234, 259, 268, 273, 278, 279, 290, 298 259 © Photo Josse, Paris 219 AKG-Images 221 Library of Congress 224 Photo RMN – G. Blot/C. Jean 225, 311 RMN-Gérard Blot 226 Purchased 1978. Photo © National Gallery of Canada 227 Deutsche Fotothek, Dresden 229 Gift of Harry Payne Bingham, 1940. Photograph © 1980 The Metropolitan Museum of Art 235 RMN-Bulloz 237, 238, 245 Bridgeman Art Library 239 Photo: Speltdoorn 240 Purchased 1946. Photo © National Gallery of Canada 244, 245, 246, 250, 260, 262, 285 © Tate, London 2004 247, 274, 299 © Musée Fabre Montpellier – Cliché Frédéric Jaulmes 251 BPK Berlin 254 Photo: Blauel/Gnamm/Artothek 256 Photo © RMN – Arnaudet 257 Photo: Jean Bernard 263 Photo: Geoffrey Clements, New York 265 © Patrimonio Nacional, Madrid 266 Gift of Mrs. Huttleston Rogers 267 Gift of Mr. & Mrs. William L. Richards through the Bray Charitable Trust 269, 282 Photo © RMN – Hérve Lewandowski 270 Purchase, Joyce and Robert Menschel, The Howard Gilman Foundation, Harrison D. Horblit, Harriette and Noel Levine and Paul F. WalterGifts and David Hunter McAlpin Fund, and Gift of Mr. and Mrs. Harry H. Lunn Jr. 1987 272 Photo © RMN – Michèle Bellot 275 Copyright The Frick Collection, New York 276 Widener Collection, 1942 281 Gift of Mrs. Frank B. Porter, 1922. Photograph © 1995 Metropolitan Museum of Art 287 H.O. Havemeyer Collection, Bequest of Mrs. H.O. Havemeyer, 1929. Photograph © 1998 The Metropolitan Museum of Art 289 John G. Johnson Collection, 1917 292 Sotheby's Picture Library, London 293 The Mr. and Mrs Carroll S. Tyson, Jr. Collection, 1963. Photo: Graydon Wood, 2002 294 Photo: Courtesy MacConnal-Mason Gallery, London 297 Gift of Mr. & Mrs. Theodore Bennett 301 Photo: Scala, Florence – courtesy of the Ministero Beni e Att. Culturali 302 Charles Clifton and James G. Forsyth Funds, 1941 304 H.O. Havemeyer Collection, Bequest of Mrs. H.O. Havemeyer, 1929. Photograph © 1989 The Metropolitan Museum of Art 306, 310, 322, 325, 331 H.W. Janson 307 H.G. Evers, Munthal/Hess, Germany 308 Dr. Ruth Butler, Charlestown, Mass. 309 Photo: George Roos, New York 312 Dr. June Hargrove, Cleveland 313a, 311, 320 Caisse Nationale des Monuments et Sites Historique, Paris 313b Funds given by the Josephine Bay Paul and C. Michael Foundation, Inc., and the Charles Ulrick and Josephine Bay Foundation, Inc., and the Fletcher Fund, 1967 315 Roger-Viollet, Paris 316 Photo: © RMN 318 Photo: Lee Sandstead 319 Giraudon, Paris 324 Gabinetto Fotografico, Florence 326 Photo: A.F. Kersting, London 327 Photograph © The Metropolitan Museum of Art 328 Gift of James H. Ricau and Museum Purchase 329 Bequest of Miss Caroline Hunt Rimmer 330 J. Fiegel, Vienna

PART 4

332 Gift of Charles Dudley Porter 333, 341, 512 Photo © RMN – Hérve Lewandowski 335, 414, 500 BPK Berlin 336, 387 Photo: Öffentliche Kunstsammlung Basel, Martin Bühler 337, 375 AKG-Images 338 Acquired through the Kenneth A. and Helen F. Spencer Foundation Acquisitions Fund. Photo: Robert Newcombe 344, 361 National Museums Liverpool/The Walker 345, 351, 384 © Photo Josse, Paris 347, 367, 382, 435 Bridgeman Art Library 348 Bequest of Susan Cornelia Warren 349 Gift of Edward Drummond Libbey 352 Copyright The Frick Collection, New York 353 Bequest from the Collection of Maurice Wertheim, Class 1906/ Bridgeman Art Library 354 Photo: Foto Saporetti, Milan 355 Founders Society Purchase, Dexter M. Ferry Jr. Fund 360, 400, 437 © Tate, London 2004 362 © DACS 2004

363 Photo: Will Brown, 1987 366 Courtesy of the Fogg Art Museum, Harvard University Art Museums, Loan from the Massachusetts General Hospital Photo Collection. Photographic Services © President and Fellows of Harvard College 368 Glasgow Museums: Art Gallery & Museum, Kelvingrove, Glasgow 369 Collection of Mr. and Mrs. Paul Mellon, 1983 372, 510 Corcoran Gallery of Art, Washington 373 Gift of Walter P. Chrysler, Jr. Photo: Scott Wolff 374 Photo © RMN – R.G. Ojeda 376 Knoedler & Co., Inc., New York 377 DuMont Buchverlag, Cologne 379 Gift of the Daughters of Edward Boit in Memory of Their Father 381 Royal Canadian Academy of Arts diploma work, deposited by the artist, Toronto, 1880. Photo © National Gallery of Canada 383 Photo: Christopher Snee for AGNSW 389 The Mr. and Mrs. Carroll S. Tyson Collection 390, 392 Photo: Artothek 393 Purchased with the W.P. Wilstach Fund 395 Gift, Solomon R. Guggenheim, 1941. Photo: David Heald © The Solomon R. Guggenheim Foundation, New York 396 Gift, Solomon R. Guggenheim, 1941 398 Gift of Mr. and Mrs. John D. Rockefeller 3rd. 399 Image © 2001 The Art Institute of Chicago, All Rights Reserved 401 Mr. and Mrs. Lewis Larned Coburn Memorial Collection. Image © The Art Institute of Chicago 402 Bequest of Stephen C. Clark, 1960 403, 371 Photo © RMN – Bulloz 405 © Collège de France 406 Gift of Mrs. James W. Fesler in memory of Daniel W. and Elizabeth C. Marmon 407, 429, 447, 448 © ADAGP, Paris and DACS, London 2004 411 Photo: Speltdoorn 412, 416, 418 Collection Kröller-Müller Museum, Otterlo, The Netherlands 419 Gift of Mrs. E. P. Allis and her daughters in memory of Edward Phelps Allis 420 Bequest of Stephen C. Clark 422 The Art Archive 423, 424, 425 © DACS 2004 426 Mona Loose, The Royal Library, National Library of Sweden 428 Abby Aldrich Rockefeller Purchase Fund 432 Hamburger Kunsthalle/BPK, Berlin. Photo: Elke Walford 433 Collection of the McNay Art Museum, Bequest of Marion Koogler McNay 434 Bequest of Samuel A. Lewisohn 436 Arthur Gordon Tompkins Residuary Fund 438 Photo: Blauel/Gnamm/ Artothek 441 Andrew W. Mellon Collection 442 Antell Collection. Photo: Central Art Archives/Jouko Könönen 444 H.O. Havemeyer Collection, Bequest of Mrs. H.O. Havemeyer, 1929. 449 Bequest of Colonel Frank J. Hecker. Photograph ©1999 The Detroit Institute of Arts 451 Photo: J. Lathion © Nasjonalgalleriet/© Munch Museum/ Munch-Ellingsen Group, BONO, Oslo, DACS, London 2004 452 Ernest Wadsworth Longfellow Fund/ Bridgeman Art Library/© Munch Museum/Munch-Ellingsen Group, BONO, Oslo, DACS, London 2004 454 © Munch Museum/Munch Ellingsen Group/© Munch Museum/Munch-Ellingsen Group, BONO, Oslo, DACS, London 2004 456 Photo: MdbK, Gerstenberger, 1999 457 Photo: © Nasjonalgalleriet/© Munch Museum/Munch-Ellingsen Group, BONO, Oslo, DACS, London 2004 461 Thannhauser Collection, Gift, Justin K. Thannhauser, 1978/Succession Picasso/DACS 2004 462, 467, 469, 473, 478, 479, 484, 489, 492, 496, 501, 509, 510, 518, 519, 520 H.W. Janson 463 Photo: © Angelo Hornak, London 464 Robert Harding Picture Library/Simon Harris 465 Roger-Viollet, Paris 466, 474, 476 Giraudon, Paris 467 © ADAGP, Paris and DACS, London 2004 468, 506 Courtauld Institute of Art, London 470 Gift of Cantor, Fitzgerald Art Foundation. Photo © Museum Associates/LACMA 472 Photo RMN – Jean Schormans 475 Photo © Museum Associates/LACMA 477, 480, 483 Bulloz, Paris 487 Swiss Institute for Art Research, Zurich 490 Gift of the B.G. Cantor Art Foundation/Photo © Museum Associates/LACMA 491, 493 Gabinetto Fotografico, Florence 494 Photo: Mario Carrieri, Milan 495 Acquired through the Lillie P. Bliss Bequest 497 Caisse Nationale des Monuments et Sites Historique, Paris 498 A.C.L. Brussels 499 Kunsthistorisches Museum, Vienna 504 Thomas Photos, Oxford 507 Whyler Photos, Stirling, Scotland 508 Bequest of Miss Caroline Hunt Rimmer 511 Lois Marcus 514 Photo: Courtesy National Park Service/Saint-Gaudens National Historic Site 515 Gallaudet University Archives 517 Photograph © The Metropolitan Museum of Art

Text credits

1 *Letters & Papers of John Singleton Copley and Henry Pelham: 1739–1776*. Boston: The Massachusetts Historical Society, 1914, p. 35.
2 Ibid., pp. 41–42.
3 Ibid., pp. 43–44.
4 Ibid., pp. 43–45.
5 Clark, T.J., *Farewell to an Idea: Episodes from a History of Modernism*. New Haven: Yale University Press, 1999, pp. 38–39.
6 Ibid., p. 40.
7 Ibid., p. 33.
8 Ibid., p. 19.
9 Vaughan, William, and Weston, Helen, eds., *Jacques-Louis David's Marat*. Cambridge: Cambridge University Press, 2000, quoted on pp. 1–2.
10 Licht, Fred, ed., *Goya in Perspective*. New Jersey: Prentice-Hall, Inc., 1973, pp. 17–18.
11 Tomlinson, Janis, *Francisco Goya y Lucientes 1746–1828*. London: Phaidon Press Ltd., 1994, p. 147.
12 Tomlinson, Janis, *Painting in Spain: El Greco to Goya, 1561–1828*. London: Weidenfeld & Nicolson Ltd., 1997 pp. 150–51.
13 Hughes, Robert, *Goya*. New York: Alfred A. Knopf, 2003, pp. 227–29.
14 Vaughan, William, "The first artistic brotherhood: *fraternité* in the Age of Revolution," in *Artistic Brotherhoods in the Nineteenth Century*, quoted on p. 37.
15 Ibid., p. 39.
16 Ibid., pp. 44–45.
17 Frank, Mitchell Benjamin, *German Romantic Painting Redefined: Nazarene Tradition and the Narratives of Romanticism*. Aldershot: Ashgate, 2001, p. 49.
18 Forster-Hahn, Françoise, "Art without a National Centre: German Painting in the Nineteenth Century," in *Spirit of an Age: Nineteenth-Century Paintings from the Nationalgalerie, Berlin*. London: National Gallery Company, 2001, p. 26.
19 Chinard, Gilbert, ed., *Houdon in America*. New York: Arno Press, 1979 (1930), pp. 5–6.
20 Ibid., pp. viii, xv.
21 Ibid., p. viii
22 Ibid, p. 33.
23 Hughes, Robert, *American Visions The Epic History of Art in America*. New York: Alfred A Knopf, 1997, pp. 123–25.
24 Lorenz, E. A. Eitner, *Géricault: His Life and Work*. London: Orbis Publishing, 1983, quoted on p. 162.
25 Ibid., p. 182.
26 Ibid., quoted on p. 197.
27 Cook, E. T., and Wedderburn, Alexander, eds. *The Works of John Ruskin*. London: George Allen, vol. III, 1903, pp. 570–71.
28 Ibid., p. 569.
29 Ibid., vol. XIII, 1904, pp. 161–63.
30 Ibid., vol. III, 1903, p. 571, n 1.
31 Schmied, Wieland, *Caspar David Friedrich* (trans. by Russell Stockman). New York: Harry N. Abrams, Inc., 1995, quoted on p. 100.

32 Hofmann, Werner, *Caspar David Friedrich*. London: Thames & Hudson, 2000 pp. 110–12.
33 Angelika Wesenberg in *Spirit of an Age*, op. cit., p. 70.
34 Börsch-Supan, Helmut, *Caspar David Friedrich*. Munich: Prestel-Verlag, 1990 [1974], p. 154.
35 Charvet, P. E., trans., *Baudelaire: Selected Writings on Art and Literature*. London: Penguin Books, 1972, pp. 99–100.
36 Quoted in Varnedoe, Kirk, lecture of 11 September 1991 at the Institute of Fine Arts, New York University.
37 Baudelaire, Charles, *Art in Paris 1845–1862 Salons and Other Exhibitions* (Jonathan Mayne, ed. and trans.). London: Phaidon Press, 1965, pp. 99–100, p. 205.
38 Ibid., p. 214.
39 Klumpke, Anna, *Rosa Bonheur: The Artist's (Auto)biography* (Gretchen van Slyke, trans.). Ann Arbor: The University of Michigan Press, 1997, pp. 130, 132.
40 Ibid., quoted on pp. 133–34.
41 Ibid., pp. 134–35.
42 Chu, Petra ten-Doesschate, ed. and trans., *Letters of Gustave Courbet*. Chicago and London: University of Chicago Press, 1992, p. 131.
43 Ibid., p. 139.
44 Ibid., p. 140.
45 Arts Council of Great Britain, *Gustave Courbet, 1819–1877*. London, 1978, quoted on p. 77.
46 Faunce, Sarah, and Nochlin, Linda, *Courbet Reconsidered*. New York: The Brooklyn Museum, 1988, p. 39.
47 Wellington, Hubert, ed., *The Journal of Eugène Delacroix* (Lucy Norton, trans.). Ithaca: Cornell University Press, 1980, p. 288.
48 Chu, op. cit., pp. 147 and 155, n. 4.
49 Rossetti, William Michael, ed., *Dante Gabriel Rossetti: His Family-Letters with a Memoir by William Michael Rossetti*. London: Ellis and Elvey, vol. 1, 1895, p. 135.
50 Ruskin, John, "The Pre-Raffaellites" [sic], letter to the editor, *The Times* (London), 20:800, May 13, 1851, pp. 8–9.
51 Wellington, Hubert, ed., *The Journal of Eugène Delacroix*. Ithaca: Cornell University Press, 1980, pp. 280 and 286.
52 Fried, Michael, *Menzel's Realism: Art and Embodiment in Nineteenth-Century Berlin*. New Haven and London: Yale University Press, 2002, p. 12.
53 Ibid., pp. 63–64.
54 Gaiger, Jason, "Modernity in Germany: the many sides of Adolph Menzel," in *The Challenge of the Avant-Garde*. New Haven and London: Yale University Press and the Open University, 1999, p. 109.
55 Keisch, Claude, in *Spirit of an Age*, op. cit., p. 112.
56 Miller, Angela, *The Empire of the Eye: Landscape Representation and American Cultural Politics, 1825–1875*. Ithaca and London: Cornell University Press, 1993, p. 130.

57 Wilton, Andrew, and Barringer, Tim, *American Sublime: Landscape Painting in the United States 1820–1880*. London: Tate Publishing, 2002, pp. 220–21.
58 Ibid., p. 56.
59 Broude, Norma, *The Macchiaioli: Italian Painters of the Nineteenth Century*. New Haven and London: Yale University Press, 1987, p. 153.
60 Ibid., p. 159.
61 Ibid., pp. 162–63.
62 Ibid., p. 161.
63 Boime, Albert, *The Art of the Macchia and the Risorgimento: Representing Culture and Nationalism in Nineteenth-Century Italy*. Chicago and London: The University of Chicago Press, 1993, p. 284.
64 Broude, op. cit., pp. 161–62.
65 Wagner, Anne Middleton, *Jean-Baptiste Carpeaux: Sculptor of the Second Empire*. New Haven and London: Yale University Press, 1986, p. 210.
66 Ibid., p. 227.
67 Ibid., p. 230.
68 Ibid., quoted on p. 238.
69 Ibid., p. 255.
70 Ormond, Richard, and Kilmurray, Elaine, *John Singer Sargent: The Early Portraits. Complete Paintings Volume I*. New Haven and London: Yale University Press, 1998, p. 66.
71 Prettejohn, Elizabeth, *Interpreting Sargent*. London: Tate Gallery Publishing, 1998, pp. 22–23.
72 Ibid., p. 23.
73 Smith, Paul, *Seurat and the Avant-Garde*. New Haven and London: Yale University Press, 1997, quoted on p. 97.
74 Eisenman, Stephen, *Nineteenth Century Art: A Critical History*. 1st ed., New York: Thames & Hudson, 1994, p. 281.
75 Clark, T.J., *Farewell to an Idea: Episodes from a History of Modernism*. New Haven: Yale University Press, 1999, pp. 107–08.
76 Frèches-Thory, Claire, "Yellow Christ," in *The Art of Paul Gauguin*. Ex. Cat., National Gallery of Art, Washington, and The Art Institute of Chicago, 1988, p. 157.
77 Frèches-Thory, Claire, "Ia Orana Maria," in *The Art of Paul Gauguin*. op. cit., p. 243.
78 Ibid., p. 244.
79 Barrington, Emilia (Mrs. Russell Barrington), *The Life, Letters and Work of Frederic Leighton*. 2 vols., New York: The Macmillan Company, 1906, vol. 2, p. 199.
80 Ibid., p. 200.
81 Read, Benedict, 'Leighton and Sculpture' in *Frederic, Lord Leighton: Eminent Victorian Artist*. London: Royal Academy of Arts, 1996, p. 84.
82 Prettejohn, Elizabeth, "The Modernism of Frederic Leighton" in *English Art 1860–1914* (David Peters Corbett and Lara Perry, eds.). New Jersey: Rutgers University Press, 2001, pp. 31–48, p. 36.
83 Ibid., p. 39.
84 Ibid., p. 42.

Index